Under the leadership of

Renaud Donnedieu de Vabres
Ministre de la Culture et de la Communication

and of the **United States Consulate in France**

François Rebsamen
Mayor of Dijon
President, Communauté d'Agglomération of Dijon

Francine Mariani-Ducray
Director, Musées de France

Katharine Lee Reid
Director, The Cleveland Museum of Art

ACKNOWLEDGEMENTS

We would like to express our profound gratitude to all of the individuals who helped make this exhibition possible, especially:

François Rebsamen, Mayor of Dijon and President, Communauté d'Agglomération of Dijon
Francine Mariani-Ducray, Director, Musées de France
Katharine Lee Reid, Director, The Cleveland Museum of Art
Sophie Aurand, General Administrator, Réunion des Musées Nationaux

Our most sincere thanks go to the officials of the museums, libraries, and institutions who, by facilitating the loans of works from their collections, have contributed to the success of this project, as well as to their administrative and technical colleagues:

ANTWERP, Koninklijk Museum voor Schone Kunsten
 Dr. Paul Huvenne, Director
 Yolande Deckers, Scientific Attaché
 Liesbeth Schotsman, Registrar

ANTWERP, Musée Mayer Van den Bergh
 Hans Nieuwdorp, Chief Curator
 Rita Van Dooren, Scientific Officer

AUTUN, Musée Rolin
 Brigitte Maurice-Chabard, Curator

BALTIMORE, Walters Art Museum
 Gary Vikan, Director
 Joaneath Spicer, Curator
 Joan Elizabeth Reid, Registrar
 Barbara Fegley, Associate Registrar

BERLIN, Gemäldegalerie
 Prof. Jan Kelch, Director
 Dr. Rainald Grosshans, Associate Director
 Julie Rolins, Assistant to the Director
 Sabine Pénot, Painting Gallery Assistant

BOSTON, Museum of Fine Arts
 Malcolm Rogers, Director
 Kim Pashko, Registrar
 Julia Valiela, Assistant

BRUGES, Gruuthuse Museum
 Patrick Moenaert, Burgomaster
 Dr. Walter Rycquart, Director
 Manfred Sellink, Chief Curator

BRUGES, Groeningenmuseum
 Till-Holger Borchert, Chief Curator

BRUSSELS, Bibliothèque Royale de Belgique
 Dr. Raphaël De Smedt, Chief Curator
 Dr. Bernard Bousmanne, Curator,

Manuscript Department
 Eric De Gelaen, Exhibition Department
 Sabine Jaucot, Manuscript Department
 Dr. Ann Kelders, Assistant, Manuscript Department

CAMBRIDGE, Fitzwilliam Museum
 Duncan Robinson, Director
 Dr. Stella Panayotova, Assistant Keeper, Manuscripts and Printed Books
 Thyrza Smith, Registrar
 Liz Woods, Assistant Registrar

CHICAGO, Art Institute of Chicago
 James N. Wood, Director
 Bruce Boucher, Éloïse W. Martin Curator, European Art

DIJON, Archives Municipales
 Éliane Lochot, Chief Curator

DIJON, Bibliothèque Municipale
 André-Pierre Syren, Director
 Danielle Ducout, Curator, Département Patrimonial
 Caroline Poulain, Curator

DIJON, Musée Archéologique
 Christian Vernou, Chief Curator
 Frédérique Bouvard, Conservation Attaché

FRIBOURG, Musée d'Art et d'Histoire
 Dr. Yvonne Lehnherr, Director
 Verena Villiger, Curator

GENEVA, Bibliothèque Publique et Universitaire
 Alain Jacquesson, Director
 Patrice Mugny, Cultural Affairs Adviser, City of Geneva
 Barbara Roth, Curator of Manuscripts

GRAY, Musée d'Art Sacré
 Viviane Ivol Le Louarn, Chief Curator, Musées Départementaux of Haute-Saône
 François Javelier, Manager of the Musée d'Art Sacré

HOUSTON, Museum of Fine Arts
 Peter C. Marzio, Director
 Julie Bakke, Registrar
 Erika Franck, Assistant Registrar

KARLSRUHE, Badisches Landmuseum
 Prof. Dr. Harald Siebenmorgen, Director
 Dr. Reinhard Sanger, Curator

LANGRES, Musée d'Art et d'Histoire
 Sophie Serra, Conservation Attaché

LEIDEN, Prentenkabinet of Leiden University
 Dr. Ingeborg Th. Leijerzapf, Director
 Dr. A. Th. Bouwman, Curator, Western Manuscripts

LONDON, British Library
 Lynne Brindley, Director
 Scot McKendrick, Curator, Manuscripts
 Barbara O'Connor, Registrar
 Greg Buzwell, Associate Registrar
 Peter Kidd, Project Officer, Digital Catalogue of Illuminated Manuscripts

MOULIN, Musée Anne-de-Beaujeu
 Nadine Berthelier, Chief Curator
 Bruno Rojouan, President, Syndicat Mixte du Musée

NEW YORK, Alexander Gallery
 Alexander Acevedo

NEW YORK, Metropolitan Museum of Art
 Philippe de Montebello, Director

Musée des Beaux-Arts of Dijon
May 28–September 15, 2004

The Cleveland Museum of Art
October 24, 2004–January 9, 2005

Art from the Court of Burgundy

1364–1419

mba .d

musée des beaux-arts

THE CLEVELAND MUSEUM OF ART

Réunion
des Musées
Nationaux

This exhibition was organized by the Musée des Beaux-Arts
of Dijon and The Cleveland Museum of Art.

It was recognized as an Exhibition of **National Interest** by
the Ministère de la Culture et de la Communication/
Direction des Musées de France, and benefited from the
accompanying special financial support from the French
government. It was also made part of the program of
the **National Celebrations of 2004.**

It was produced with the support of the **City of Dijon,**
the **Direction Régionale des Affaires Culturelles of
Burgundy** (Ministère de la Culture) and the **Conseil
Régional of Burgundy.**

It received support from the **Caisse d'Épargne de
Bourgogne** and the sponsorship of the **Galeries Lafayette**
and the **Hostellerie du Chapeau Rouge.**

In Cleveland the exhibition is supported by an indemnity from
the **Federal Council on the Arts and the Humanities**. Additional
support has been provided by the **Samuel H. Kress Foundation**
and from the **International Partnerships among Museums** (IPAM)
program of the **American Association of Museums** (AAM),
through the generosity of The **Florence Gould Foundation**.
The Cleveland Museum of Art receives operating support from
the **Ohio Arts Council**.

Front cover:
Jean de Marville, Claus Sluter, and Claus de Werve,
mourners from the tomb of Philip the Bold
(1381–1410). Dijon, Musée des Beaux-Arts

Back cover:
Le Livre des Merveilles, Paris, 1410–12.
Paris, Bibliothèque Nationale de France (cat. 47)

© Éditions de la Réunion des musées nationaux, Paris, 2004
© The Cleveland Museum of Art, Cleveland, 2004, for English edition
ISBN: 2-7118-4864-7
EK 38 0065

Peter Barnet, Curator
Julien Chapuis, Associate Curator
Christine E. Brennan, Collections Coordinator
Frances Redding Wallace, Registrar

NEW YORK, The Pierpont Morgan Library
Charles E. Pierce Jr., Director
William M. Voelkle, Curator, Medieval and Renaissance Manuscripts
Lucy Eldridge, Registrar
Patricia Courtney, Associate Registrar
Roger S. Wieck, Curator of Medieval and Renaissance Manuscripts

PADUA, Musei Civici agli Eremitani
Dr. Davide Banzato, Director
Dr. Patrizia Magnani
Dr. Franca Pellegrini, Curator, Department of Modern and Medieval Art

PARIS, Bibliothèque de l'Arsenal
Bruno Blasselle, Director
Danielle Muzerelle, Chief Curator, Manuscripts

PARIS, Bibliothèque Nationale de France
Jean-Noël Jeanneney, President
François Avril, General Curator
Sylviane Dailleau, Manager of Loans to Exhibitions

Thierry Grillet, Delegate for Diffusion Culturelle
Brigitte Robin-Loiseau, Department of External Exhibitions

PARIS, Musée du Louvre
Henri Loyrette, President-Director
Daniel Alcouffe, General Curator, Department of Objets d'Art
Jean-Pierre Cuzin, General Curator, Department of Paintings
Jean-René Gaborit, General Curator, Department of Sculpture
Vincent Pomarède, Chief Curator, Department of Paintings
Françoise Viatte, General Curator, Department of Graphic Arts
Catherine Loisel, Curator, Department of Graphic Arts
Élisabeth Taburet-Delahaye, Chief Curator, Department of Objets d'Art
Dominique Thiébaut, Chief Curator, Department of Paintings

PARIS, Musée National du Moyen Âge–Thermes de Cluny
Viviane Huchard, General Curator, Director
Élisabeth Antoine, Xavier Dectot, Julia Fritsch, Curators
Alain Decouche, Registrar
Jean-Christophe Thon-Tat, Researcher

ROCHESTER, Memorial Art Gallery of the University of Rochester
Grant Holcomb, Director
Nancy Norwood, Curator, European Art
Monica Simpson, Permanent Collection Registrar

SEMUR-EN-AUXOIS, Musée Municipal
Sandrine Balan, Conservation Attaché

TROYES, Musée des Beaux-Arts et d'Archéologie
Chantal Rouquet, Chief Curator

VIENNA, Albertina
Dr. Klaus Albrecht Schröder, Director
Heinz Widauer

VIENNA, Österreichische National-bibliothek
Dr. Johanna Rachinger, General Director
Prof. Ernst Gamillscheg, Director, Department of Manuscripts

WASHINGTON, National Gallery of Art
Earl A. Powell III, Director
Alison Luchs, Associate Curator, European Sculpture
Stephanie Belt, Department of Loans

We also thank the following private collectors:

Count Jean de Chastellux and Philippe de Chastellux

Mr. and Mrs. Gérard Pinette and Matthieu Pinette

and those who wish to remain anonymous

We owe our particular gratitude to the mayors of the municipalities of Burgundy and Franche-Comté who kindly agreed to lend their works:

Raymond Page, Mayor of Arbois (Jura)
Thierry Paquetin, Mayor of Argilly (Côte-d'Or)
Antoine Sanz, Mayor of Auxonne (Côte-d'Or)
Bernard Grandvaux, Mayor of Baume-les-Messieurs (Jura)
G. Balluet, Mayor of Bussy-la-Pesle (Côte-d'Or)
J. Berthet-Bondet, Mayor of Château-Chalon (Jura)
Bernard Jeannin, Mayor of Châteauneuf (Côte-d'Or)
G. Fontheneau, Mayor of Flavigny-sur-Ozerain (Côte-d'Or)
Noël Bernard, Mayor of Genlis (Côte-d'Or) and General Councillor

Philippe Auberger, Mayor of Joigny and Representative of Yonne
Michel Delettre, Mayor of Monceaux-le-Comte (Nièvre)
Yves-Marie Lehmann, Mayor of Poligny (Jura)
Bertrand Ambroise, Mayor of Premeaux-Prissey (Côte-d'Or)
Claude Jourdan, Mayor of Salins-les-Bains (Jura)

as well as their assistants and colleagues, especially, in Poligny, **Danièle Cardon**, deputy assistant, **Marie-Paule Chambrun**, General Director of Services for Poligny and the Comité de Sauvegarde, Mouthiers-le-Vieillard

as well as the Direction du Patrimoine, Ministère de la Culture:
Colette Di Matteo, Inspector General, Historic Monuments
Yves Lescroart, Inspector General, Historic Monuments
Judith Kagan, Chief, Office of Furnishings
Richard Gérôme, Office of Furnishings

to the Direction Régionale des Affaires Culturelles of Burgundy:
Isabelle Denis, Regional Curator of Historic Monuments
Michel Huynh, Curator for the Preservation of Historic Monuments
Bernard Sonnet, Departmental Curator of Antiquities and Objets d'Art, Côte-d'Or

Acknowledgements

Jacques Guérin, Curator, Antiquities and Objets d'Art, Yonne
Anne-Bénédicte Clert, Deputy Curator, Objets d'Art, Yonne
Fabrice Cario, Curator, Antiquities and Objets d'Art, Nièvre

and the Direction Régionale des Affaires Culturelles of Franche-Comté:
Pascal Mignerey, Regional Curator, Historic Monuments
Cécile Uhlmann, Curator for the Regional Preservation of Historic Monuments

Jean-François Ryon, Curator, Antiquities and Objets d'Art, Jura

We are very grateful to all those who, in so many ways, lent their invaluable and steadfast support to the production of this exhibition and to the reopening of the *Well of Moses*:

Yves Berteloot, Deputy Assistant for Culture, Dijon
Thierry Bouchaud, Director of the Galeries Lafayette, Dijon
Daniel Cadoux, Prefect, Région Bourgogne and Département of Côte-d'Or
Thierry Coursin, Director, Office of the Mayor, Dijon
Marie-Josèphe Durnet-Archeray, Deputy City Councillor for Cultural Heritage and Museums, Dijon
Michel Férot, General Director of Services, Dijon
Robert Fohr, Chief of Communications for the Direction des Musées de France
William Frachot, Director, Hostellerie du Chapeau Rouge à Dijon
Jean-Pierre Gillot, Associate Delegate for Heritage, Dijon

Isabelle Julia, Chief Curator of Patrimoine, à l'Inspection Générale des Musées de France
Marie-Christine Labourdette, Regional Director, Affaires Culturelles, Burgundy
Michel Lair, Director, Centre Hospitalier Spécialisé de la Chartreuse
Alain Maire, Chairman of the Board of the Caisse d'Epargne de Bourgogne
Catherine Marquet, Chief, Département du Livre, Réunion des Musées Nationaux
Didier Martin, Deputy Assistant for Tourism, Dijon
François Patriat, President, Conseil Régional, Burgundy
Bernard Perraud, Deputy General Director of Services, Dijon
Jean Piret, Deputy Director for Culture and Tourism, Conseil Régional, Burgundy

Jean-Pierre Sainte-Marie, Museum Advisor, Direction Régionale des Affaires Culturelles, Burgundy
Emmanuel Starcky, Assistant to the Director, Musées de France
Francine Thomas, Director, Affaires Culturelles, Dijon
Pierre Vallaud, Director, Éditions de la Réunion des Musées Nationaux
Charles Vogel, President of the Society of Friends of the Museums of Dijon
Françoise Wassermann, Chief Curator, Département des Publics, Direction des Musées de France

To all those who have given their support and their expertise throughout the preparations for this exhibition, for the opening of the *Well of Moses* and for the production of the catalogue, we would like to express our sincerest thanks:

Isabelle Balandre, Researcher, Department of Objets d'Art, Musée du Louvre
Véronique Bornet, Cultural Affairs Office, United States Embassy
Jérôme Breton, Département Publics, Direction des Musées de France
Pal Céfalvay, Director of the Christian Museum, Esztergom
Ross Duffin, Kulas Professor of Music, Case Western Reserve University
Jean-Luc Duthu, Photographer, Service Régional de l'Inventaire
Lucille Écoffet, Administrative Assistant, Direction des Affaires Culturelles, Dijon
Louis Faton and the Éditions Faton, Dijon
Geneviève François, Design Engineer, Centre National de la Recherche Scientifique, Limoges Enamelware Collection
Françoise Gatouillat, Research Engineer, Stained-glass Unit, Department of Research, Documentation and Inventory
Gilles Huot, Graphic Designer

Erika Kiss, Curator, Magyar Nemzeti Múzeumban, Budapest
Sophie Laporte, Editor, Réunion des Musées Nationaux
Sylvie Le Clech, Chief Curator, Service Régional de l'Inventaire
Katia Lièvre, French Proofreader
Pascale de Maulmin, Inventory Clerk, Preservation of Historic Monuments
Miklos Mojzer, General Director of the Szépmüvészeti Múzeum of Budapest
Claire Mulkai, Translator
Marie-Claude Pascal, Chief Curator of the Historic Preservation District, Dijon
Véronique Recouvrot, Director of Communications, Caisse d'Epargne, Burgundy
Bernard Roux, Supervisor, Historic Preservation District, Dijon
Myrna Sloam, Archivist, The Bryant Library, Roslyn, New York
Jean Torrent, Translator
the architectural, financial, legal and commercial departments of the City of Dijon

and most especially the organizers of the exhibitions dedicated to the "Princes des Fleurs de Lis":
Béatrice de Chancel-Bardelot, Chief Curator, Musées de Bourges
Thierry Crépin-Leblond, Chief Curator, Musées de Blois
Patricia Stirnemann, Musée Condé, Chantilly
Élisabeth Taburet-Delahaye, Chief Curator, Department of Objets d'art, Musée du Louvre
Emmanuelle Toulet, Chief Curator, Musée Condé, Chantilly,

as well as:

Françoise Baron, General Curator Emeritus, Department of Sculpture, Musée du Louvre
Sophie Guillot de Suduiraut, Chief Curator, Department of Sculpture, Musée du Louvre

We would also like to thank the conservators:

Jean Délivré, Conservator
Aubert Gérard, Director, Centre Régional de Restauration et de Conservation des Œuvres d'Art (Franche-Comté), **Anne Gérard, Juliette Lévy**

Dr. Clarice Innocenti, Museo dell'Opificio delle Pietre Dure
Benoît Lafay, Conservator, and the entire team that worked on the restoration of the tomb of Philip the Bold

Laurence Labbe, Conservator, and her team
Philippe Langot, Restorer-conservator, LP3, Semur-en-Auxois, and his team
Thierry Palanque, Conservator-fitter

We thank all those who contributed to the production of the related cultural and scientific events:

For the symposium organized by the École du Louvre and the University of Burgundy to be held 7-9 July 2004.
Philippe Durey, Director, École du Louvre
Claire Barbillon, Director of Research
Danielle Roch-Voury, École du Louvre
Claude Mordant, Professor of Archeology at the University of Burgundy, UMR 5594
Jean Rosen, CNRS-University of Burgundy, UMR 5594
Daniel Russo, Professor of Medieval Art History at the University of Burgundy, UMR 5594

For the seminar in Cleveland on October 30, 2004:
Sherry C. M. Lindquist, Saint Louis University
Élisabeth Taburet-Delahaye, Musée du Louvre
Till-Holger Borchert, Groeningemuseum, Bruges
Dr. Ann Kelders, Bibliothèque Royale de Belgique, Brussels
Prof. Renate Prochno, Institut für Kunstgeschichte, University of Salzburg

And also:
Marie Berne, Director of the Centre Régional du Livre en Bourgogne
Liliane Lecler-Bocaccio, Plastic-art instructor, and author of the activities book
Dominique Mans, Project Leader, Centre Régional du Livre en Bourgogne
Benoît Tainturier, Director of the musical group, "La Salamandre"
François Tainturier, Director of the musical group, "Le Laostic"
Clarissa Rothacker, Faksimile Verlag Luzern

We greatly appreciate all those who lent their assistance to the promotion of the exhibition:

Thierry Bouchaud, Director of the Galeries Lafayette in Dijon
Jean Louis Énet, Editor, Publications Department, Dijon

Jean-Michel Lafond, Director of the Tourism Office
Pascale Lambert, Director of the Comité Départemental de Tourisme, Côte-d'Or

Jean-Louis Laville, Director of the Comité Régional du Tourisme, Burgundy
Aggy Lerolle and **Sylphide de Sonis**, Public Relations Department, Musée du Louvre

And finally we must pay tribute to the tremendous work carried out with devotion and skill by the teams from the Cleveland and Dijon museums.

At the Cleveland Museum of Art:
Katharine Lee Reid, Director; **Charles L. Venable**, Deputy Director for Collections and Programs; **Janet Ashe**, Deputy Director of Administration; **Susan Stevens Jaros**, Deputy Director, Development and External Affairs; **D. Bruce Christman, Kenneth Bé, James George, Lawrence Sisson, Moyna Stanton, Marcia C. Steele**, Conservation; **Jeffrey Strean, JoAnn Dickey, Jeff Falsgraf, Andrew Gutierrez**, Design and Architecture; **Heidi Domine, Marlene Haas**, Exhibitions; **Len Steinbach, Holly Witchey**, Information Technology; **Ann B. Abid, Louis Adrean, Becky Bristol, Christine Edmonson, William Kennedy, Sara Jane Pearman**, Ingalls Library; **Todd Herman, Rachel Rosenzweig**, Medieval Art; **Sylvain Bellenger**, Paintings; **Howard

T. Agriesti, Gary Kirchenbauer, Bruce Shewitz, Photography and Digital Imaging; **Laurence Channing, Barbara J. Bradley, Jane Takac Panza**, Publications; **Mary E. Suzor, Beth A. Gresham, Jeanette Saunders, Bridget Weber**, Registrars; **Joanie O'Brien, Cynthia Rallis, Jack Stinedurf**, Development.

At the Musée des Beaux-Arts of Dijon:
Dominique Bardin, Archivist, **Jacqueline Barnabé**, Reception Manager of the Cultural Department, **Laurent Baudras**, Registrar of Works, **Céline Beck**, Trainee, **Béatrice Caltagirone**, Administrative Assistant, **Rémi Cariel**, Curator, **Jean-François Crochet**, Receiver, Bookstore Manager, **Elsa Debarnot**, Administrative Assistant, **Christine Descatoire**, Curatorial Trainee, **Dominique

Fattelay**, Manager of Budget and Accounting, **Louis Femenias**, Messenger, **Catherine Gras**, Curator, **Pierre Javelier**, Painter, **François Jay**, Photographer, **Pierre-Michel Lafforgue**, Temporary Staff, **Sabine Laillet**, Trainee, **Daniel Le Garrec**, Head of Technical Staff, **Jean-Michel Legendre**, Monteur en Dessin, **Christine Lepeu**, Administrative Staff, **Anne Lhuillier**, Conservation Assistant, **Fanny Mazilly**, Temporary Staff, **Jean-Charles Methy**, Technician, **Alain Monin**, Technician, **Denis Ponard**, Electrician, **Marie-Anne Sabine**, Administrative Staff, **Thierry Sébillon**, Library Manager, **Isabelle Simon**, Administrative Assistant, as well as the team of lecturing guides and plastic-art instructors of the cultural department and the reception and security staffs.

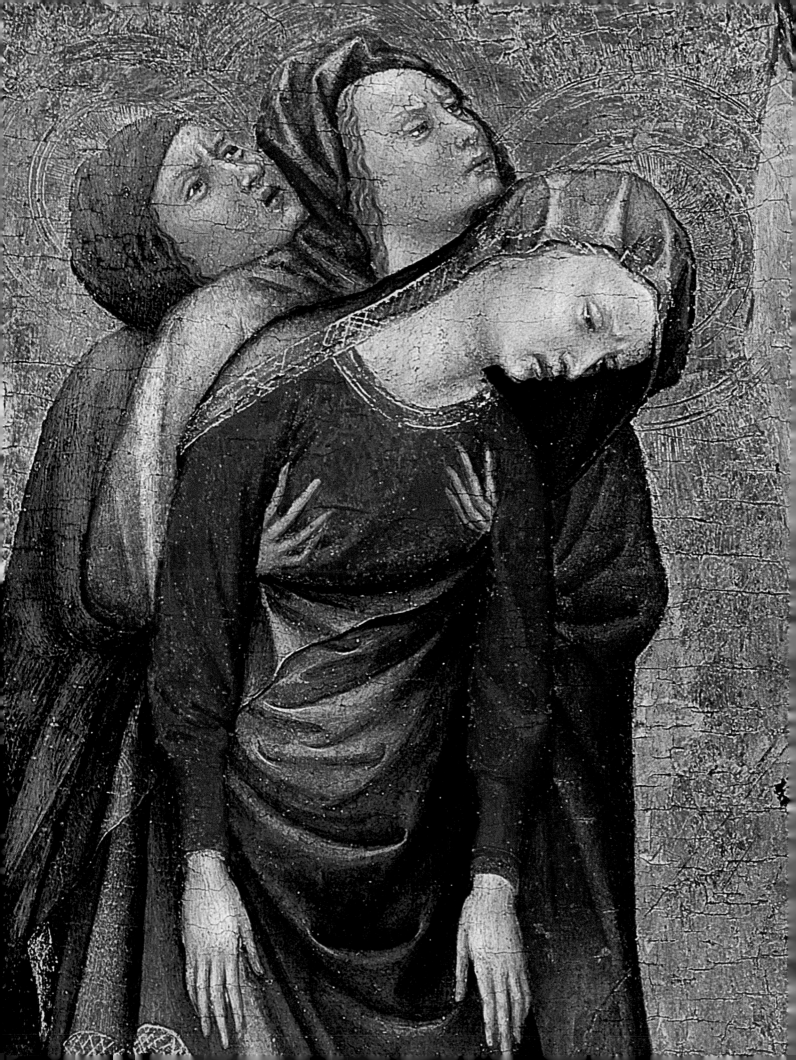

ORGANIZING COMMITTEE

Stephen N. Fliegel
Curator of Medieval Art, The Cleveland Museum of Art

Sophie Jugie
Curator, Musée des Beaux-Arts of Dijon

In collaboration with

Virginie Barthélémy
Project Leader, Musée des Beaux-Arts of Dijon

Agnieszka Laguna-Chevillotte
Project Leader, Musée des Beaux-Arts of Dijon

Marie-Laure Grunenwald
Conservation Attaché, Musée des Beaux-Arts of Dijon

Todd Herman
Kress Fellow, Medieval Art, The Cleveland Museum of Art

Catherine Tran
Conservation Attaché, Musée des Beaux-Arts of Dijon

Detail: *Calvary with a Carthusian Monk,*
Jean de Beaumetz (c. 1335–96).
Paris, Musée du Louvre (cat. 71b).

LIST OF AUTHORS:

Élisabeth Antoine, Curator, Musée National du Moyen Âge–Thermes de Cluny, Paris (É.A.)

Sandrine Balan, Conservation Attaché, Musée Municipal of Semur-en-Auxois (S.B.)

Patrice Beck, Senior Lecturer, University of Paris I, Panthéon-Sorbonne

Céline Berrette, Historian

Till-Holger Borchert, Curator, Groeningemuseum, Bruges (T.-H.B.)

Denise Borlée, University of Strasbourg (D.B.)

Véronique Boucherat, Doctor of Art History (V.B.)

Sophie Cassagnes-Brouquet, Professor of Medieval History at the University of Limoges (S.C.-B.)

Marie-Françoise Damongeot-Bourdat, Bibliothèque Nationale de France (M.-F.D.)

Marguerite Debae, Bibliothèque Royale de Belgique (M.D.)

Priscilla Debouige, doctoral candidate

Xavier Dectot, Curator, Musée National du Moyen Âge–Thermes de Cluny, Paris (X.D.)

François Duceppe-Lamarre, Archeologist, Certifié en Histoire-Géographie (F.D.-L.)

Danielle Ducout, Curator, Heritage Department of the Bibliothèque Municipale, Dijon (D.D.)

Sylvain Faivre, doctoral candidate

Stephen N. Fliegel, Curator of Medieval Art, The Cleveland Museum of Art (S.N.F.)

Georges Frignet, doctoral candidate

Julia Fritsch, Curator, Musée National du Moyen Âge–Thermes de Cluny, Paris (J.F.)

Françoise Gatouillat, Research Engineer CNRS (F.G.)

Marie-Thérèse Gousset, Chief Curator, Bibliothèque Nationale de France (M.-T.G.)

Laurent Hablot, Doctor of History

Todd Herman, Samuel H. Kress Curatorial Fellow, Department of Medieval Art, the Cleveland Museum of Art (T.H.)

Virginie Inguenaud, Curator, Regional Inventory Department of Burgundy

Frédérique Johan, Bibliothèque Royale de Belgique (F.J.)

Sophie Jolivet-Jacquet, Doctor of History

Sophie Jugie, Curator, Musée des Beaux-Arts of Dijon (S.J.)

Emmanuel Laborier, doctoral candidate, Institut National de Recherches Archéologique Préventives (E.L.)

Agnieszka Laguna-Chevillotte, doctoral candidate (A.L.-C.)

Yvonne Lehnherr, Director, Musée d'Art et d'Histoire de Fribourg (Y.L.)

Claudine Lemaire, Bibliothèque Royale de Belgique (C.L.)

Sherry C. M. Lindquist, Ph.D., Saint Louis University

Philippe Lorentz, University of Strasbourg (P.L.)

Michel Maerten, President of the Center for the Study of Fortified Castles of Burgundy, Associate Researcher UMR 5594

Danielle Muzerelle, Chief Curator of Manuscripts at the Bibliothèque de l'Arsenal, Paris (D.M.)

Hans Nieuwdorp, Chief Curator, Musée Mayer Van den Bergh, Antwerp (H.N.)

Ludovic Nys, University of Valenciennes

Matthieu Pinette, Director, Musées d'Amiens, Musée de Picardie

Philippe Plagnieux, Senior Lecturer at the University of Paris X, Nanterre

Marie Pottecher, Musée de Moulins (M.P.)

Prof. Renate Prochno, Institut für Kunstgeschichte, University of Salzburg (R.P.)

Fabrice Rey, Diplôme d'Études Approfondies in Medieval History and Master's Degree in Medieval Art History

Jean Rosen, Researcher, CNRS (J.R.)

Sandrine Roser, Doctor of Medieval Art History (S.R.)

Bertrand Schnerb, Professor of Medieval History at the University of Lille III, Charles-de-Gaulle

Joaneath Spicer, Curator, Walters Art Museum, Baltimore (J.S.)

Vincent Tabbagh, Professor of Medieval History at the University of Burgundy

Élisabeth Taburet-Delahaye, Chief Curator, Department of Objets d'Art, Musée du Louvre, Paris (É.T.-D.)

Gaëlle Tarbochez, doctoral candidate

Céline Vandeuren-David, doctoral candidate, Catholic University of Louvain (C.V.-D.)

Céline Van Hoorebeeck, Scientific Attaché, Manuscript Department of the Bibliothèque Royale de Belgique (C.V.H.)

Sabine Witt, Paris, Magistra Artium (S.W.)

List of abbreviations:

AD: Archives Départementales (Department Archives)

ADCO: Archives Départementales de la Côte-d'Or (Archives of the Department of the Côte-d'Or)

AM: Archives Municipales (Municipal Archives)

AN: Archives Nationales (National Archives)

BM: Bibliothèque Municipale (Municipal Library)

BNF: Bibliothèque Nationale de France (National Library of France)

BPU: Bibliothèque Publique et Universitaire (Public and University Library)

(n. s.): new style, i.e. the current calendar

All dimensions are given in centimeters.

CONTENTS

I. The Patronage of Philip the Bold and John the Fearless (1364–1419)

II. The Chartreuse de Champmol

III. Art in Burgundy, 1360–1420

PREFACE

For a third time, the Musée des Beaux-Arts of Dijon has been honored with the Seal of National Interest by the Ministère de la Culture et de la Communication for one of its exhibitions. Following the successful pattern of *Dresde ou le Rêve des Princes* (Dresden, or the Dream of Princes), organized in 2001 in partnership with the Gemäldegalerie of Dresden, and *Rembrandt et Son École* (Rembrandt and His School), produced in 2003 through an exemplary collaboration with the Hermitage Museum of St. Petersburg, the Musée de Beaux-Arts of Dijon collaborates on this occasion with a leading American museum, the Cleveland Museum of Art. Together, they examine and present to the public, on both sides of the Atlantic, a rich period in the history and the art of Burgundy, that of the first two dukes of the house of Valois, Philip the Bold (1364–1404) and John the Fearless (1404–1419).

The Ministère de la Culture et de la Communication is pleased to add its support to that provided by the city of Dijon for the challenging and original cultural ventures of its museum, and to salute its international alliances. These events have in common not only that they are produced in partnership with some of the most prestigious museums, but also that they highlight a European history of cultural relations and artistic exchanges.

This was obviously the case in the Dresden and Rembrandt exhibitions, which explored through their collections the history of taste in eighteenth-century Europe. Now the Dijon museum turns towards Burgundy's past, and to a period when artistic exchanges were particularly intense and fruitful. Working in Dijon at the end of the fourteenth and the beginning of the fifteenth centuries were not only Burgundians and artists from all over France, who often passed through Paris on the way, but also men from the north. They came from the northern states of the dukes of Burgundy: from Flanders, Artois, Brabant, Gelderland, and Holland. Claus Sluter, the brilliant sculptor of the *Well of Moses*, was, of course, the greatest of them all, and this exhibit gives him the honor he deserves.

This important chapter in International Gothic art evoked in Dijon is echoed elsewhere in France in a series of exhibitions in the spring and summer of 2004. Grouped under the common title "The Princes of the Fleurs de Lis," they are dedicated to the subject of royal and princely patronage in France in 1400. The exhibition that opened in March at the Musée du Louvre, *Paris 1400. Les Arts sous Charles VI* (Paris 1400: Art During the Reign of Charles VI), takes the measure of the exceptional profusion of artistic activity in the Paris workshops during the Valois era, notably in the areas of metalwork, manuscript illumination, and sculpture. The coordinated efforts of the French museums have produced a series of nearly simultaneous tributes to the dukes of Burgundy, Berry, and Orléans. Thus the presentation of the lavish patronage of Philip the Bold and John the Fearless in Dijon is complemented by the evocation of that of Jean de Berry in Bourges and in Chantilly, while that of Louis of Orléans is recounted in Blois. That the subject is not explored solely in Paris, but also in four other cities, reflects the reality of the distribution of princely estates at the end of the Middle Ages. It also illustrates the vitality of our cultural decentralization.

In Dijon, another event was added to the exhibition itself: the reopening of the *Well of Moses* to visitors, after several years of restoration. With the agreement and support of the Centre Hospitalier Spécialisé de la Chartreuse, the city of Dijon wished to closely link the reopening with the exhibition taking place in its museum. The city and its museum maintain exemplary relationships with the decentralized departments of the ministry, with the Direction Regionale des Affaires Culturelles of Burgundy, and especially with the Conservation Régionale des Monuments Historiques, the Service Régional de l'Inventaire and, of course, the Musées de France.

The Seal of National Interest—and the exceptional financial support of the Ministry which goes along with it—recognizes not only the technical quality of the exhibition and the range of the partnerships created, but also the innovative nature of the cultural mediation activities supplementing the exhibition that are aimed at the general public. Among them, we must make special note of the organization of visits adapted for those suffering from visual, hearing, or mental handicaps, as well as the efforts to reach out to those who would not usually visit a museum by bringing presenters to retirement homes or young workers' meeting halls. It is through these kinds of activities that exhibitions of National Interest facilitate the policy of audience development led by the Ministère de la Culture et de la Communication.

Renaud Donnedieu de Vabres
Minister of Culture and Communications

PREFACE

Dijon could never forget that it was, more than six centuries ago, the capital of the dukes of Burgundy. This role, already established under the dukes of the Capetian dynasty, was reasserted by the first duke to come from the royal house of Valois.

By installing on the south tower of the church of Notre-Dame the Jacquemart clock seized from Courtrai after the 1382 battle of Roosebeke, Philip the Bold demonstrated the trust that bound him to the people of Dijon. Of his hôtel in Dijon there remains, at the heart of the ducal palace, the Tour Neuve, built during the 1370s and since renamed the Tour de Bar. Most importantly, Philip the Bold founded, in 1385, the Carthusian monastery of Champmol, where he asked to be buried in the robes of the order, and which became his dynasty's necropolis. Despite the destruction of the monastery by the Revolution and the dispersal of its works of art, Dijon still boasts, in the *Well of Moses*, one of the most sublime masterpieces of late medieval sculpture.

A series of exhibitions in Paris, Chantilly, Blois, and Bourges allow us to rediscover the rich creativity of France in the 1400s and the role played by the kings and princes of the royal family of Valois, all lovers of art and luxury. The brothers of Philip the Bold were none other than King Charles V, the duke of Anjou, of the tapestry of the Apocalypse of Angers, and the duke of Berry, of the *Très Riches Heures*, certainly one of the most celebrated manuscripts of the Middle Ages.

Dijon could not miss the opportunity to be linked with these events, in this year 2004, that invite us to commemorate the six-hundredth anniversary of the death of Philip the Bold, especially now that after several years the restored *Well of Moses* is finally available for us to admire. Thus we can measure the importance of the artistic center in Dijon and the quality of the works produced under the patronage of the dukes.

The exhibition catalogue provides the public with a summary of current knowledge about the patronage of the Philip the Bold and John the Fearless, the Carthusian monastery of Champmol, and art in Burgundy during this period. We are pleased that the exhibition could be organized with the Cleveland Museum of Art, which holds in its collections four mourning figures from the tombs of the dukes and a painted panel from the Carthusian monastery of Champmol. This allows us to admire these works in Dijon, and the presentation of the exhibition on the shores of Lake Erie can only serve to enhance the reputation of Burgundy. The two museums have thus begun to think of many other prospective exchanges and joint projects. We would like to express our deep gratitude to Ms. Katharine Lee Reid and to the team at the Cleveland Museum of Art, as well as to the many who lent works to the exhibition, for their trust and their generosity.

François Rebsamen
Mayor of Dijon
President of the Communauté d'Agglomération of Dijon

Art from the Court of Burgundy

The scope of this exhibition, the period of the first two Valois dukes of Burgundy, Philip the Bold (1364–1404) and his son, John the Fearless (1404–19), represents one of the most brilliant and dynamic phases in French medieval art. It was an era when the cosmopolitan city of Paris served as a principal center for the visual arts, attracting artists from across Europe, and serving as a major supplier of deluxe objects to princes of the Valois court. Philip the Bold, like his brothers Charles V and Jean de Berry, embraced the arts as a vehicle for enhancing his status and displaying his taste. He and his spouse, Margaret of Flanders, acquired works of supreme technical mastery and the highest aesthetic refinement—tapestries, illuminated manuscripts, panel paintings, metalwork, ivories and, of course, sculpture—which form the basis of this exhibition. The Valois dukes of Burgundy commanded vast financial resources, and their collective reigns mark the rise of one of the most sophisticated courts in Europe.

The Burgundian house, and its attendant aristocrats, continued to insist on materialistic ostentation throughout the fifteenth century, flaunting their ability to pay for costly objects to adorn their palaces and residences. Not restricting their artistic interests to secular furnishings alone, Burgundian court artists were often directed to supply ducal religious foundations and private chapels with sculpture, panel paintings, carved and painted altarpieces, and liturgical vessels, as well as illuminated manuscripts. The most prominent of these was the ducal foundation of the Carthusian Charterhouse at Champmol built to house the ducal tombs. The complex featured some of the finest examples of Burgundian court sculpture emanating from the chisels of Claus Sluter and his nephew Claus de Werve, as well as Antoine le Moiturier and Jean de La Huerta. Altarpieces and private devotional diptychs were commissioned from painters Jean de Beaumetz, Jean Malouel, Henri Bellechose, and Melchior Broederlam—all serving at various times as court painters.

The dukes of Burgundy were recognized by their contemporaries as paragons of princely magnificence. Through the munificence of their patronage and the artists attracted to their court, the dukes of Burgundy evolved a Burgundian court style. Their brilliant court became a model for emulation across Europe. Indeed, the mystique of Valois Burgundy fascinates as much today as it did in the early fifteenth century.

The subject of Burgundian court patronage has long been an area of interest to art historians representing several disciplinary fields—medievalists, historians of Netherlandish art, and specialists in the Northern Renaissance. It has also been studied by medium—sculpture, painting, and manuscript illumination predominating. Though there have been several exhibitions during the past fifty years focusing on specific aspects of Burgundy, such as a single medium or a particular duke, this exhibition and its accompanying catalogue mark the first occasion for a comprehensive study of the subject of international scope. Many of the objects are shown together here for the first time. Several works have never been previously shown in the United States. Still others, now in North American collections, are being shown publicly in Europe for the first time in several generations. No previous exhibition on this subject matches the scope and ambition of the present undertaking.

For the Cleveland Museum of Art, the strengths of our medieval collection have been a motivating factor in the organization of the current project. With the museum's important holdings in the field of International Gothic art and its representative works from Valois Burgundy, the present exhibition was a natural scholarly pursuit. The exhibition has been possible through the diligent work of the two organizing curators at the Cleveland Museum of Art and the Musée des Beaux-Arts, Dijon. I wish to thank the many contributors to the catalogue and the numerous lenders to the exhibition from two continents. Without the generosity of the lenders and their extraordinary willingness to share their treasures, this exhibition would never have occurred. Finally, this exhibition marks an important collaboration between the Cleveland Museum of Art and the Musée des Beaux-Arts in Dijon, both important repositories of Burgundian art. I am grateful to the staffs of both institutions for their long and diligent work. I also thank the Mayor and city of Dijon for this collaboration. It is a privilege to present these precious works of art to a larger audience.

Katharine Lee Reid
Director, The Cleveland Museum of Art

Sophie Jugie
Stephen N. Fliegel

By organizing an exhibition devoted to the patronage of Philip the Bold and John the Fearless in 2004, the Musée des Beaux-Arts, Dijon remains true to one of its major fields of research, represented by the two curators who most deeply left their mark on the museum: Févret de Saint-Mémin, curator from 1817 to 1852, and Pierre Quarré, curator from 1938 to 1979.

Févret de Saint-Mémin is well known for the installation of the tombs of Philip the Bold and John the Fearless in the Salle des Gardes (guardroom), which had once been the great hall of the ducal palace, after the completion of the restoration work on the tombs begun by the architect Claude Saint-Père in 1819. Saint-Mémin's work in the 1830s and 1840s was crucial to preserving the relics from the Chartreuse de Champmol. He was also the first to study the financial accounts for the construction of Champmol and to bring forward the name of Claus Sluter. Saint-Mémin devoted himself to convincing "the curious and the scholarly" of "the perfection the arts had already reached a century before their renaissance."

Among the many fields of interest reflected in his abundant bibliography and the numerous exhibitions he organized, Pierre Quarré unquestionably gave special attention to *Le Grand Siècle des ducs de Bourgogne* (Great Century of the Dukes of Burgundy), to quote the name of a very important and exhaustive exhibition presented in Dijon, Brussels, and Amsterdam in 1951. Our exhibition therefore continues the series that began at the Dijon museum in 1949, when *Chefs-d'œuvre de la sculpture bourguignonne du XIVe au XVIe siècle* (Fourteenth- to Sixteenth-century Masterpieces of Burgundian Sculpture) was presented. In 1960, *La Chartreuse de Champmol, foyer d'art au temps des ducs Valois* (The Charterhouse at Champmol, Crucible of the Arts under the Valois Dukes), a show devoted to the Chartreuse de Champmol, revealed the importance of this center of artistic activity at the time of the dukes of Valois to the general public. In 1971, the exhibition *Les Pleurants dans l'art du Moyen Âge en Europe* (Mourners in the Art of the Middle Ages in Europe) brought the high quality and originality of the mourners on the tomb of Philip the Bold to the fore. Between 1972 and 1976, Pierre Quarré methodically devoted shows to the successors of Claus Sluter—Claus de Werve (1976), Jean de La Huerta (1972), and Antoine Le Moiturier (1973)—and to the development of sculpture in Burgundy at the end of the fifteenth century (1974). In 1990, the museum returned to the question of the artistic personality of Claus Sluter with the exhibition *Claus Sluter in Burgundy, Myths and Representations* and an international conference on Claus Sluter, which celebrated another six-hundredth anniversary, that of Sluter's appointment to the head of the ducal sculpture workshop.

As for the Cleveland Museum of Art, its remarkably distinguished collection includes one of the most prestigious French medieval art departments in the United States. The museum owns four of the mourners from the tombs of the dukes and one of the two Calvaries with Carthusians from the charterhouse, which it owes to the perseverance of two directors, William M. Milliken and Sherman E. Lee. We must also mention the work of Patrick De Winter, past curator of the medieval department and the author of a thesis on the patronage of Philip the Bold and a book about the duke's library, among other contributions. Significant exhibitions dedicated to medieval European art such as *Gothic Art 1360–1440* and *Treasures from Medieval France*, both of which emphasized work from Burgundy, were presented in Cleveland under the direction of William D. Wixom in 1963 and 1967, respectively.

The Dijon-Cleveland project resulted from meetings in conjunction with *L'Art au temps des rois maudits. Philippe le Bel et ses fils 1285–1328* (Art at the Time of the Cursed Kings: Philip the Fair and His Sons, 1285–1328), an exhibition presented in Paris in 1998. Both the Dijon and Cleveland museums had begun considering exhibition projects that would allow the public to discover—or rediscover—the splendor of art under the dukes of Burgundy, and which would take into account research that has considerably added to or modified our knowledge of this subject since the exhibitions of the 1970s and 1990s. In a field that includes Sherry M. Lindquist and Renate Prochno's theses about the Chartreuse de Champmol, Pierre Camp's research on the sculptors of Burgundy, Sophie Cassagne-Brouquet's research on its painters, and Patrice Beck and his team's on-site and archival studies of the ducal residences, all the new research material shares a common return to the source documents. The current focus of research on artistic commissions and the status of artists will necessarily be reflected in the exhibition.

The two museums immediately found it natural to combine their ideas and conceive an event that would be seen on both sides of the Atlantic. An ideal date quickly presented itself: 2004, the celebration of the six-hundredth anniversary of the death of Philip the Bold, when there was every reason to believe that the restoration of the *Well of Moses*, under way for several years, would be completed.

It was also quickly decided that the exhibition would be limited to the patronage of the first two dukes, for that period corresponds to the time when the dukes were predominantly active in Burgundy and Paris, while their successors Philip the Good and Charles the Bold preferred the Low Countries. Burgundian artistic production of the era is stylistically coherent. Despite its originality, it remained under the influence of Parisian art, which was then dominant, whereas the pictorial revolution led in the Low Countries by Robert Campin and Jan Van Eyck in the 1420s moved the center of gravity of artistic innovation to Flanders and Brabant, at least for the area west of the Alps.

The collaboration between the two museums has allowed the exhibition to attain a level of development and coherence that

neither could have achieved alone. The Cleveland Museum of Art was able to represent Dijon's interests in dealing with many American and European museums, and Dijon was better positioned to influence French lenders and, particularly, the numerous communities in Burgundy and Franche-Comté that generously agreed to contribute to this event.

While Cleveland and Dijon were planning their exhibition, several other exhibition projects dealing with artistic commissions of the princes of the French royal family were being considered at the Louvre, at Chantilly, at Blois, and at Bourges. Once again, the initially fortuitous similarities between several projects led to their being combined and made synergetic, as it appeared that the various approaches were different enough to reinforce one another without any detrimental effects to the individual exhibitions. In Paris, that city's extremely active artistic center at the time of Charles VI would be evoked; in Chantilly it would be a specific work, the *Très Riches Heures du Duc de Berry;* in Dijon, the two princes' patronage; in Bourges, a lost monument, the Sainte-Chapelle; and Blois would remain faithful to its historicist themes by confronting the surviving results of the patronage of Louis d'Orléans with the troubadour painters' pictorial representations of his dramatic assassination.

The term "princes of the fleurs-de-lis," which was used at the time in reference to members of the royal family, was chosen to link the exhibitions, a general book on art in France around 1400 that will complement the exhibition catalogues, and a colloquium in Paris and Dijon at the beginning of July, while all the exhibitions are open, dedicated to the presentation of additional research.

For those who can visit the Dijon exhibition, whether in person or through reading, it will be enriched by the itinerary we are proposing through the displays of works gathered in Paris, Chantilly, Bourges, and Blois. Similarly, the Cleveland exhibition benefits from a section on Parisian art—merely touched on in Dijon—that will serve to shed light on the genesis of Burgundian artwork for an American audience.

Although Burgundian artistic activity displays an unquestionable originality, particularly in the work of Claus Sluter, it seemed important to take into account its links with Parisian artistic circles. Philip the Bold and John the Fearless shared and contributed to the artistic taste of the princes of their family: Charles V, Jean de Berry, Louis d'Anjou—(brothers of Philip the Bold) and Charles VI and Louis d'Orléans (cousins of John the Fearless). All the princes liked, collected, and occasionally traded manuscripts, tapestries, jewels, and gold- and silver-plated pieces. They did business with the same Parisian artists and important merchants. Certain artists and architects worked for several princes in succession. The paintings executed for Philip the Bold himself, or for his charterhouse, are therefore considered the best examples of Parisian easel painting to have survived to this day. This explains why the *Large Round Pietà*, which carries the coat of arms of Philip the Bold, remained in the Louvre for the *Paris 1400* exhibition in 2004.

The predominant position of artists from the Low Countries in the Paris art scene from very early in the fourteenth century has long been noted. The role played by the Flemish on the ducal work sites of Burgundy must therefore be looked at in this light, as well as in relation to the union of Burgundy and Flanders through the marriage of Philip the Bold and Margaret of Flanders. As a counterpoint to Philip the Bold's commissions in Burgundy, we thought it useful to study his commissions executed in Flanders, in continuation of his father-in-law Louis de Male's activities. These works constitute a privileged moment of the French influence in Flanders.

The artworks gathered to evoke the treasures of the dukes are only, as we know too well, a pale reflection of life at the courts of Burgundy. Though most of the manuscripts have been preserved, thanks to the constant interest of bibliophiles, jewels and silver- and gold-plated objects were regularly destroyed in order to create new pieces. The artifacts shown may seem scant, but, of the complete list of works, "only" the Vienna Cross of the Oath and the Esztergom Calvary are missing. These major but extremely fragile works would have served as a counterpoint to the marvelous jewels presented in the Paris exhibition. Similarly, the tapestry shown did not belong either to Philip the Bold or John the Fearless, but it is contemporary and the ducal inventories attest to its subject. It is equally difficult to account for the ducal residences through objects, whether because the objects have completely disappeared, as is most often the case, or because they have survived in variously altered fragmentary forms. We have therefore presented additional contemporary information on feast decorations, costumes, heraldry and emblems, and devotional themes, along with the core collection of artifacts.

One chapter of the catalogue and a section of the exhibition are specifically devoted to the Chartreuse de Champmol. Despite the destruction and scattering of the charterhouse's collection following the Revolution, a sufficient number of works has been preserved on site in Dijon and in museums around the world to bear witness to the quality of this foundation, made exceptional by the artistic personality of Claus Sluter. The fact that the financial accounts for the construction have been preserved make Champmol a unique case for the late Middle Ages, one where sources allow us a relatively complete view of the genesis of a sizable work site. It remains a very open field of research for historians. Aside from the fragile *Altarpiece of Saint Denis*, we have been able to gather all the surviving works created for the charterhouse during this period. The joint exhibition of the two Calvaries with Carthusians by Jean de Beaumetz and his collaborators is an event in itself. The section on the sources and the posterity of the works of Champmol offers demonstrations that had previously only been attempted on paper.

There is little painting in the section devoted to art in Burgundy under the first two dukes. In fact, little of that era's painting has been preserved. It is therefore most fortunate that we have been able to gather examples of mural painting, easel painting, illumination, and, since the restoration work required on the windows of the château of Chastellux have provided us with the opportunity to show them to the public, stained-glass windows. In sculpture, we obviously had a greater range of choices, because of the abundance of existing statues, whose quantity is probably an accurate reflection of an abundant production. We have taken a fresh look at the artistic personality of Claus de Werve. The catalogue also takes a new approach to the relations between artists and patrons.

The preparation of an exhibition of this size involves smoothing out multiple difficulties and overcoming challenges large and small. May all those who stood by us for many years and believed in our project, especially the owners of the artworks and the authors of the catalogue, accept the expression of our most sincere, and in many cases, friendly, gratitude.

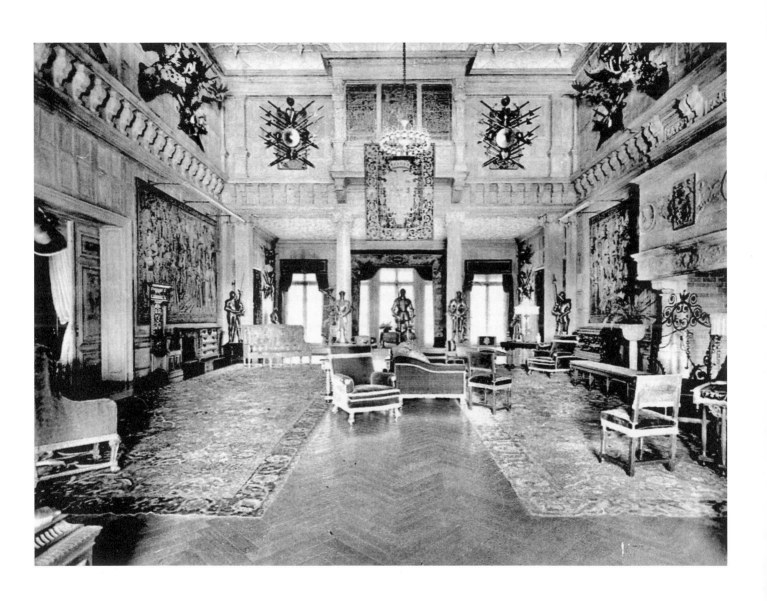

THE COLLECTING OF VALOIS BURGUNDIAN ART IN THE UNITED STATES

STEPHEN N. FLIEGEL

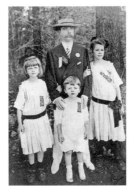

Fig. 1
Clarence Mackay with his three children, Independence Day celebration, 1911.

Fig. 2
Harbor Hill, interior view of the main hall. The Mourners now in Cleveland were displayed in a "Gothic" room just off the main hall.

For Europeans, the focused collecting of medieval works of art was already well established by the second half of the nineteenth century. The collecting of medieval European a rt in the United States is a relatively modern pheno-menon, however, having begun in a serious way during the early decades of the twentieth century. The appearance of significant examples of medieval art on the American shores is the result of many factors. Market conditions and the activity in the United States of certain art dealers of European birth and training played important roles. Joseph and Ernest Brummer, for example, emigrated from Hungary to Paris then to New York where they operated galleries. The Brummers' role in building the medieval collections of American museums was critical: between about 1920 and 1940 they sold more than 400 works to the Metropolitan Museum of Art alone.[1] Other factors behind this collecting in America included the surging interest in medieval European culture among the educated classes as well as the emerging fashion within the country for medieval art and architecture as the favored mode of design for buildings and their ornamentation. The newly found predilection of the Amer-ican elite for the European Middle Ages is in part attributable to the work of John Ruskin and William Morris, who found many American followers of the Gothic Revival and the Arts and Crafts Movement. The initial interest in such works of art by private collectors and public

institutions is largely seen in the opening years of the twen-tieth century and is personified by such names as J. Pier-pont Morgan,[2] Henry Walters, Isabella Stewart Gardner, and Henry Clay Frick.[3] The collections of Morgan and Walters, formed between 1900 and 1920, were the two largest collections of medieval art in the United States at that time. Their legacies today are found in the Metropolitan Museum of Art and the Pierpont Morgan Library in New York as well as the Walters Art Museum in Baltimore.[4] It was the twentieth century that saw the emergence of a viable academic and intellectual context for the appreciation of medieval art. It was also the twentieth century that witnessed the maturation of taste on the part of the American collector, which in turn enabled the reasoned buying of the 1940s and 1950s.[5] It might also be added that no particular interest is evidenced in the United States for collecting works of Burgundian provenance specifically. Rather, collectors seemed to focus upon specific genres or materials. Morgan was fond of precious objects and illuminated manuscripts. Walters amassed a noted collection of medieval manuscripts, which survives today in the museum bearing his name. Other collectors focused on sculpture or painting. Often, medieval works bearing royal or aristocratic provenance were especially fascinating to American collectors, who sought them with great enthusiasm.

American museums such as the Metropolitan Museum, the Cleveland Museum of Art, and the Museum of Fine Arts, Boston were quick to take advantage of their rich endowments and the simultaneous availability on the market of important works of medieval art, especially between the two world wars. The Cleveland Museum of Art was founded in 1913 by industrial philanthropists and opened to the public in June 1916. Cleveland's first director, Frederic Allen Whiting (1873–1959), was a man steeped in the writings of Ruskin and Morris. Whiting

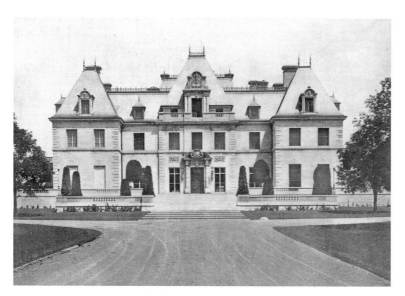

Fig. 3. Harbor Hill, the Clarence Mackay estate at Roslyn on Long Island, New York.

subscribed to the tenets of the Arts and Crafts Movement and, in 1900, before arriving in Cleveland, had served as the first secretary of the Society of Arts and Crafts in Boston. It was under Whiting's directorship that the Cleveland Museum of Art laid the foundations of its future medieval collection with the acquisition of an important collection of arms and armor.[6] Cleveland's second director, William M. Milliken, oversaw the development of his museum's medieval collection between 1919 and 1958, an important period for collecting medieval art in the United States.[7]

Museum directors such as Milliken relied on a generation of art dealers, mainly of European extraction, who arrived in the United States between the two world wars. Often highly trained with academic degrees, and with expertise in European painting, sculpture, and decorative arts of the Middle Ages, these dealers established successful firms in the United States. New York City became the viable center of the international art market, with such dealers as Duveen Brothers, Dikran G. Kelekian, Raphael Stora, the brothers Arnold and Jacques Seligmann, the Brummers, Adolph Goldschmidt, and Rosenberg and Stiebel establishing successful galleries there. Through their galleries passed many of the works of medieval art that now form the collections of America's museums. Such works as a matter of course included works of Burgundian provenance, many of which may be seen in this exhibition.

Preeminent among these Burgundian works is the group of four pleurants (cat. 83) now in the Cleveland Museum of Art—three from the tomb of Philip the Bold

(nos. 18, 35, and 38) and one from the tomb of John the Fearless (no. 67). Together with the acquisition of a panel painting of a Calvary group by Jean de Beaumetz (cat. 71a), court painter to Philip the Bold, and commissioned for one of the Carthusian cells at Champmol, Cleveland had acquired by 1964 a small but highly important group of works of Burgundian provenance.

The fate of the ducal tombs at Champmol and its fabled pleurants is well documented during and following the Revolution—the dismantling of the tombs in 1791, their storage in the Benedictine church of Saint-Bénigne in Dijon, followed by their destruction two years later, saving only the pleurants. Sadly, in the aftermath of the Revolution, sixteen of the eighty-one pleurants had by then disappeared, presumably stolen in an effort to spare their destruction. Following the extensive reconstruction of the tombs or cenotaphs in the former ducal palace in Dijon, now the Musée des Beaux-Arts, in the years after 1819, six pleurants had been gradually returned. Still others, having fallen into private collections and dispersed by local Dijon art dealers, continued their journeys for years to come, eventually being reunited on the restored tombs. Their homecoming followed an effort by the Dijon museum in the late 1930s. Among the missing pleurants was no. 17, which remains the property of the Carnot Collection in Beaune. As noted above, pleurants nos. 18, 35, and 38 from Philip the Bold's tomb and no. 67 from that of John the Fearless are now in the collection of the Cleveland Museum of Art.

All four mourners now in Cleveland were purchased around 1800 by a Dijon collector named Hocquart. The pleurants stayed as a group, subsequently passing to his son-in-law, Vicomte Edouard de Broissia, then to Broissia's son Georges. In 1875, when Georges de Broissia died, the sculptures were placed in the care of an antique dealer from Nancy named Legley, who in turn offered to sell them to the Dijon museum. The municipality turned them down, as Joseph Moreau's replacement figures seemed adequate at the time. The pleurants were instead purchased by Charles Stein, a Parisian dealer. They then passed successively into the collections of Baron Arthur de Schickler and Count de Pourtalès in Paris, before being acquired by the Paris branch of Duveen Brothers in 1919, which the same year shipped them to their New York gallery. By 1922, Clarence Mackay (1874–1938), a New York investment banker, had acquired the four mourners and incorporated them into his eclectic collection of European art.[8]

Mackay exemplified the American magnate of the Gilded Age (fig. 1). His father made his fortune in Nevada silver mining and through the Mackay Radio & Telegraph Co. With his extensive wealth, Clarence Mackay commissioned architect Stanford White to design an opulent

mansion on Long Island, then the setting for many of America's storied rich. It took five years to complete Mackay's massive stone house "Harbor Hill." Until the 1920s most large American mansions were built in the grand European style, and Mackay's house (fig. 2), true to this tradition, was built in the form of a mid seventeenth-century French château. The largest house ever designed by Stanford White, it was located on one of the highest points on Long Island and surrounded by an estate of 600 acres. In the end, Clarence Mackay spent nearly $6 million on Harbor Hill—an enormous sum of money at the time. It was in this dramatic and opulent setting that Mackay displayed his eclectic collection of European art, which was noted principally for its arms and armor (reportedly the finest private collection of this material in the United States). In addition, Mackay collected tapestries, Gothic sculpture, Renaissance sculpture and painting, bronzes, ceramics, stained glass, and furniture (fig. 3).[9] It was here that the four pleurants from the ducal tombs at Champmol came to rest. To furnish the château, White scoured Europe in search of treasures, bringing bring back shiploads of tapestries, paintings, and medieval armor for Mackay's collection. The Mackays entertained lavishly in their showplace home; at a glittering party with 1,200 guests in 1924 for the Prince of Wales (briefly Edward VIII and later Duke of Windsor), the prince reportedly commented: "I am impressed with the grand scale of hospitality on Long Island."

Mackay died on 2 November 1938. The bulk of his collection was dispersed through sale in April 1939. More than 4,000 items were placed with Gimbel Brothers department stores in New York for public sale, as had occurred with the Hearst collection. The most important objects in the Mackay collection, however, were turned over to the dealer Jacques Seligmann who became agent for the estate. Some important items had actually been sold two years before Mackay's death to such institutions as the Metropolitan Museum of Art and the National Gallery of Art in London. The four pleurants had been entrusted to Seligmann for sale.[10]

Dijon was reportedly interested in the return of the pleurants, and the Rijksmuseum attempted to raise funds to acquire them on the grounds that it had no examples of the work of its two famous native sons, Claus Sluter and Claus de Werve. Because Europe was in 1939 engulfed in war, the United States had become the only viable art market. As he sought prospective clients, Seligmann found a keen buyer in William M. Milliken, the Director and Curator of Decorative Arts of the Cleveland Museum of Art. Ten years earlier Milliken had established Cleveland's reputation as a repository for important medieval objects through his acquisition of nine objects from the Guelph Treasure, the former liturgical treasure

of Braunschweig Cathedral.[11] Milliken traveled to New York with Leonard C. Hanna, a trustee and major benefactor of the Cleveland museum. Together, he and Milliken made their selections. The museum acquired one pleurant from each monument, nos. 18 and 67, which were formally accessioned in 1940. Hanna purchased the other two, nos. 35 and 38, for his private collection. It was apparent, however, that these also would come to Cleveland in due course. The formal bequest took place in 1958 upon Hanna's death, and Cleveland thus became the home of four of the esteemed pleurants from the ducal tombs.

Other works of Valois Burgundian art were similarly placed in American collections during the first half of the twentieth century. The exquisite ivory statuette of God the Father from a Trinity group (cat. 97), now in the Museum of Fine Arts, Houston is known to have once been part of the collection of Henri Garnier in Lyons. By the 1930s the ivory had crossed the Atlantic to New York where it was sold by Joseph Brummer to Edith A. and Percy S. Straus, who presented it to the Houston museum in 1944.

Jacques Seligmann was a major agent in placing highly important works of Burgundian art in American museums. Having begun his career in Paris at the age of sixteen in the firm of Maître Paul Chevallier, Seligmann eventually learned the profession by studying with the experts at Hôtel Drouot. In 1880, Seligmann opened a small shop in the rue Mathurins and by 1913 he had opened a gallery in New York at 705 Fifth Avenue. Through Seligmann's firm passed some of the most outstanding productions from Valois Burgundy at the time of Philip the Bold and John the Fearless: the pleurants now in Cleveland; the Virgin and Child from the convent of the Poor Clares at Poligny, attributed to Claus de Werve and now in the Metropolitan Museum; and the two panels from the folding polyptych of Philip the Bold (cat. 74). These panels were sold to Henry Walters in 1919 and are now in the Walters Art Museum, Baltimore. The first half of the twentieth century was a golden age for collecting medieval art in the United States and the formative age for American museums. During this period, the essential character of many American museums was defined. For some, such as Cleveland, the Metropolitan, the Walters, and Houston, the acquisition of sublime works of Burgundian art from the Valois period have given prominent focus to their collections.

NOTES 1. Bruzelius 1991, p. 6.
2. Auchincloss 1990.
3. Sanger 1998.
4. Johnston 1999.
5. Smith 1996.
6. Fliegel 1998, pp. 1–18.

7. Hawley 1991, pp. 101–22.
8. See De Winter 1987, pp. 420–23.
9. See Cortissoz 1931.
10. Seligman 1961.
11. For which see De Winter 1985B, pp. 133–36.

The Patronage of Philip the Bold and John the Fearless (1364–1419)

Cy faillent les rubriches de la table des
croniques du roy charles qui fu filz du roy
iehan.

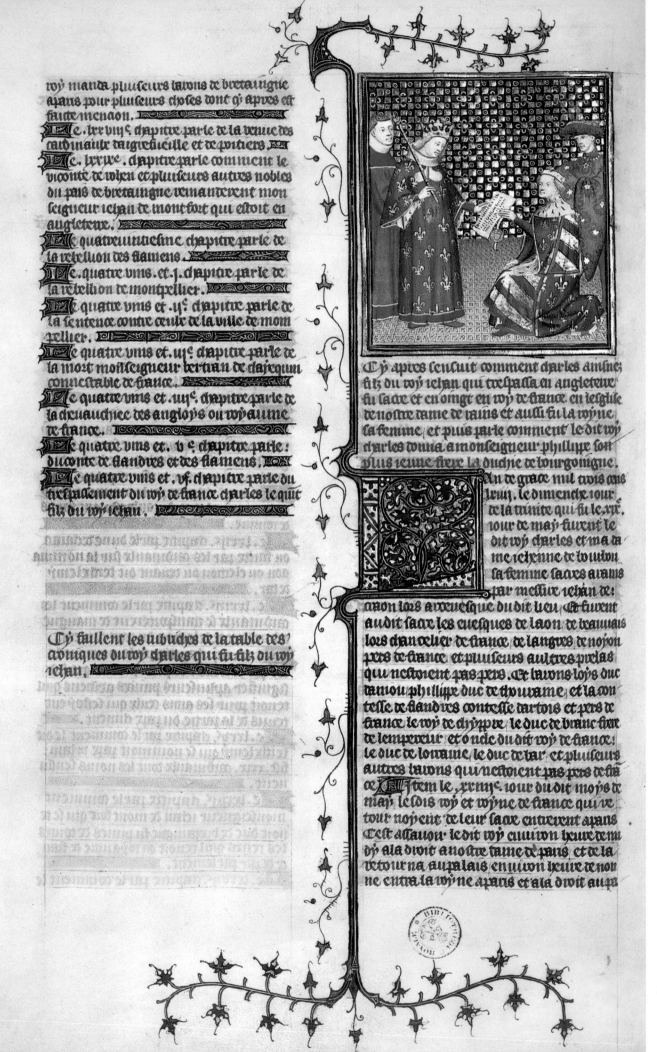

Cy apres sensuit comment charles ainsne
filz du roy iehan qui trespassa en angleterre
fu sacre et enoingt en roy de france en leglise
de nostre dame de rains et aussi fu la royne
sa femme, et puis parle comment le dit roy
charles donna a monseigneur phillippe son
plus ieune frere la duche de bourgoigne.

An de grace mil trois cens
lxiiij, le dimenche iour
de la trinite qui fu le .xix.
iour de may furent le
dit roy charles et ma da
me iehenne de bourbon
sa femme sacres a rains
par messire iehan de
craon lors arcevesque dudit lieu. Et furent
audit sacre les evesques de laon, de beauvais
lors chancelier de france, de langres, de noyon
pers de france, et pluseurs autres prelas
qui nestoient pas pers. Ce furent loys duc
daniou phillippe duc de thouraine, et la con
tesse de flandres contesse dartois et pers de
france, le roy de chippre, le duc de brunc suic
de lempereur, et oncle du dit roy de france,
le duc de lorraine, le duc de bar, et pluseurs
autres barons qui nestoient pas pers de fran
ce. Item le .xxiij. iour dudit moys de
may le dis roy et royne de france qui re
tour noyent de leur sacre entrerent a paris
Cest assavoir le dit roy environ heure de mi
dy ala droit a nostre dame de paris, et de la
retourna au palais environ heure de no
ne. entra la royne a paris et ala droit au pa

Fig. 1

History and Art in Context

Bertrand Schnerb

The Dukes of Burgundy and the Burgundian Principalities (1361–1419)

The Duchy of Burgundy from the Capetians to the Valois

A royal act by John II the Good dated 6 September 1363 marks the birth of Burgundian power.[1] On that date the king of France, second sovereign in the Valois dynasty, had his sealed affixed to the official letters whereby he granted his youngest son, Philip, the duchy of Burgundy and the distinction of eldest peer of France. This duchy was one of the large fiefs held by the crown. Since the beginning of the eleventh century it had been governed by a ducal dynasty stemming from a younger branch of the Capetian line. Closely related to the royal family, with which they periodically had strengthened their bonds through marriage, the dukes of Burgundy "of Capetian stock" had gradually carved out a prominent place for themselves in the kingdom and at court. Hugh IV (Duke of Burgundy 1218–72) had been a loyal supporter of St. Louis (Louis IX of France), and his son, Robert II (duke 1272–1306 and son-in-law of St. Louis), had played an important role in the royal government during the reign of Philip the Fair (Philip IV of France).[2] Eudes IV (son of Robert II, duke 1315–49, and son-in-law of Philip V of France) was in his time one of the most influential barons at the French court.[3]

During the lifetime of Eudes IV, however, the political situation became worrisome. This duke was witness to the extinction of the direct royal branch of the Capetians and the accession of the house of Valois, in the person of King Philip VI in 1328. Certainly these events did not in the least change the political position of the Duke of Burgundy, but they were the prelude to the French-English conflict that broke out in 1337, a war in which

Eudes IV was brutally involved. Being not only Duke of Burgundy, but also Count of Artois, his lands suffered damages caused by the English troops. At the same time the ducal family itself sustained great hardships. In 1346 the only son of Eudes IV, Philip of Burgundy, Count of Boulogne, died during the siege of Aiguillon. Three years later, when plague raged throughout the land, Eudes IV died in turn, leaving as his successor his young grandson Philip, known as Philip I de Rouvres. This prince was only three years old and a regent had to be appointed. His mother, Jeanne, Countess of Boulogne, had remarried, taking as her husband John of France, Duke of Normandy (son of King Philip VI and the future King John II the Good). While waiting for the young Duke of Burgundy to come of age, at fifteen years, the "lease and governance" of his person and his possessions were entrusted to his mother and to his stepfather. The latter, having become king of France in 1350, then found himself in a good position to strengthen even further the alliance uniting the duchy of Burgundy and the crown of France, and for the moment several of his men and counselors entered the ducal administration.[4]

Supervising a large principality such as the duchy of Burgundy during a time of crisis for royal authority constituted an indisputable advantage. This much seemed clear at the time of the terrible period 1356–60. The war with England, which had abated after the fall of Calais and the conclusion of long truces, resumed with greater intensity beginning in 1355. On 19 September 1356, John the Good was defeated and captured by the English on the battlefield of Poitiers. His capture was followed by a phase of extreme confusion. The holder of royal power,

Charles (eldest son of the king, dauphin, Duke of Normandy, and the future King Charles V), had to face up to the foreign war, to subversive attempts on the part of his cousin, Charles II, king of Navarre, and to a virulent political dispute in Paris. Over the course of this crisis, the dauphin Charles benefited notably from the support of the Burgundian nobility.

The duchy did not emerge unscathed from this difficult period. War struck there in 1360, the same period that Philip I de Rouvres came of age at fifteen and was released from his mother and stepfather's oversight. That year Edward III of England, leaving Calais, in effect led a grand cavalcade that brought him as far as Burgundy, and he had to be bribed to depart. The English withdrew, but the respite was short in duration since the period of the Great Companies then arrived. At the same time, a terrible plague epidemic broke out. It was under these circumstances that the young Duke Philip de Rouvres died, on 21 November 1361. His death brought to an end the Capetian branch of the dukes of Burgundy, which had survived the direct royal Capetian branch by only thirty-three years. For ducal Burgundy, as for an earlier generation for the throne of France, the time of the Valois had arrived.

News of the death of Philip de Rouvres reached John the Good who, barely more than one year before, had been freed by the king of England. He knew the desires that could be aroused by the Burgundian succession and he eagerly proclaimed that as the nearest blood relation, he would succeed Philip de Rouvres and reunite the duchy of Burgundy with the realm of the crown. He then made his Joyous Entry into Dijon, distributed gifts and privileges, and named a governor. But this situation, which was far from satisfying for the Burgundians, lasted less than three years. The duchy had its own statute and, since the eleventh century, had been run by princes belonging to the younger branch of the royal family, and they constituted a well-entrenched dynasty in the region. In addition, in 1363, King John, wanting to resume this tradition, decided to annul the formal deed. Thereby, in November 1361 he declared, by letters of patent dated 6 September 1363, the duchy to be inseparably united with the royal realm and granted it to his youngest son, Philip.

The Establishment of Burgundian Power

Philip, "son of the king of France," as his title proclaimed, had been born twenty-one years earlier, from the union of John the Good and Bonne of Luxembourg-Bohemia. He was the youngest of the royal couple's four sons: the eldest, Charles, was the future king Charles V; the second, Louis, Duke of Anjou since 1360, was

destined to establish a prestigious princely line;[5] the third, Jean, Duke of Berry, would become known as a lavish prince and patron.[6] Philip, for his part, had to maintain his rank among the "princes des lis"—his brothers, the royal princes. Still an adolescent, he had shown that, like his father the king, he was endowed with the knightly virtues of valor and loyalty. In September 1356, during the battle of Poitiers, he had remained, unruffled, at the side of the king as the enemy encircled them. He was taken prisoner at the same time as John the Good, he had shared his captivity and had been freed at the same time. A much-loved son, he was repaid by being granted the duchy of Touraine in 1360, and then the duchy of Burgundy in 1363. After the death of John the Good, this second grant was confirmed by Charles V on 2 June 1364 (fig. 1).

Over a period of sixteen years, from 1364 to 1380, Philip the Bold (a nickname gained undoubtedly from his fine showing on the battlefield of Poitiers) was a perfect aide to Charles V, whom he served as warlord, counselor, and diplomat. An important player in the royal strategy, he was used by Charles in 1369 to counter a plan for an English-Flemish alliance. Although Louis de Male, Count of Flanders, was in negotiations with Edward III to marry his daughter and sole heir, Margaret, to an English prince, the king of France hindered this marriage and had the count accept a French marriage. In this manner, on 19 June 1369, Philip the Bold married Margaret de Male in Ghent, in an impressive display of splendor.

For the time being, this marriage brought particularly high hopes to the Duke of Burgundy. His wife, her father's only child, was the designated heir to a vast group of lands made up of five earldoms: the earldom of Nevers and the earldom of Burgundy, or "Franche-Comté," were adjacent to the duchy of Burgundy; the earldom of Artois and the earldom of Flanders constituted a vast territorial block to the north. As for the little earldom of Rethel, along the banks of the middle course of the Meuse, it occupied an intermediary position between these two territorial groups.

With this fine heritage, the earldom of Flanders was unquestionably the most attractive part. Not only did this realm represent considerable resources for the prince, but the totality of holdings was rich, both in terms of agriculture lands and because its towns were a center of manufacturing activity and dynamic trade. Bruges, with its outer harbors of L'Écluse and Damme, was then one of the great centers of international commerce, and colonies of foreign merchants—Italians, Germans, Iberians—had settled there. Bringing in substantial revenues from various levies on the economic activity of its Flemish subjects, the count, for his part, could be considered one of the wealthiest princes in the French realm. However, governing Flanders required great care, since along with the large cities, notably Ghent,

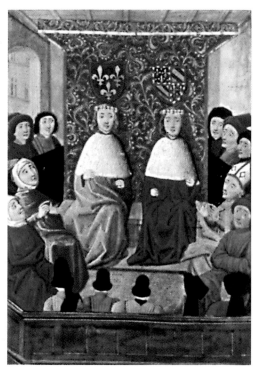

Fig. 2

Bruges, and Ypres, it was necessary to include the three Members of Flanders, the deputies of which had a privileged relationship with the prince. Over the years, Philip the Bold, as son-in-law of Count Louis de Male, would become familiar with the earldom, its wealth, its peculiarities, and its dangers.[7]

Between 1380 and 1385, Flanders was the theater for a civil war that had lasting repercussions for the political, social, and economic life there. Louis de Male was confronted with a rebellion that, beginning in Ghent, soon spread throughout the country. Philip the Bold, concerned about helping his father-in-law and protecting his wife's heritage, intervened, first as a moderator and then as a forceful partisan. In timely fashion, he was able to use the growing influence he enjoyed at the French court to lead the royal government to intervene against the Flemish rebels. In 1380, the death of Charles V and the accession of his son Charles VI at the age of twelve, effectively began the period that is known as the government of uncles. Alongside his brothers Louis I d'Anjou, and Jean de Berry, Philip the Bold, with his nephew the king, played a growing political role (fig. 2). In 1382, noting that Louis de Male found himself in a situation where it was impossible to quell the rebellion, the Duke of Burgundy managed to convince Charles VI and the royal council to organize a military expedition that ended with the Flemish defeat at Westrozebeke on November 27. But the victory won by the French on behalf of Louis de Male and his son-in-law did not bring an end to the conflict. Isolated in Flanders but supported by the English, the Ghent forces continued to fight, and two other sorties in 1383 and in 1384, still did not break their resistance. In January 1384 Louis de Male died at Saint-Omer, leaving Philip the Bold and Margaret the heavy burden of finding a way out of the war.

The recourse to arms had led the warring parties to an impasse, and negotiation was the only way to reach a resolution. And so in December 1385 in Tournai, Philip the Bold and Margaret de Male signed a peace treaty with Ghent. This Peace of Tournai was the point of departure for a long period during which the princely power had to respect the regional identity of the city of Ghent and endeavored to maintain good relations with the various elements of the population there.[8] Nevertheless, the end of the civil war allowed Philip the Bold and his spouse to take full charge of the government of the earldom of Flanders and to inaugurate a policy of active reconstruction that was marked by numerous measures beneficial to the cities, the countryside, and trade. Certain concessions were granted to foreign merchants whose activities had suffered as a result of the civil war, and trade was widely restored, assuring that Flanders would be a hub of commerce.

The attainment of his Flemish legacy and the pacification that followed allowed Philip the Bold to undertake, with the help of a vast team of counselors, a reorganization of the institutions in his principalities. First, he acted to reinforce the effectiveness of financial institutions, especially since, after 1384, the prince could expect to greatly increase his revenues. Before inheriting, in the name of Margaret de Male, the possessions that his father-in-law had held, Duke Philip could scarcely count on the revenues that he drew from his sole duchy of Burgundy and on the generosity of his brother, King Charles V. Depending on whether it was a good year or a bad one, these might range from 100 to 200,000 livres *tournois.* Subsequently, the enormous revenues drawn from Flanders and the royal treasury soared enormously, easily reaching 500,000 livres a year.[9]

The duke's revenues came from different sources—his property, gifts from the king—but taxes were fundamental. The system of taxation entailed the preliminary consent of the prince's subjects. The latter also had to negotiate with the various institutions: in Burgundy or in Artois this was the State, where delegates of the clergy, the nobility, and the cities held power; in Flanders there were "Four Members," representing the cities of Ghent, Bruges, and Ypres, and the territory of Franc de Bruges. One of the constants in the history of Burgundian power was the indispensable dialogue between the prince and

the states. Tax policy depended on this dialogue, which could, as need arose, become fraught and dramatic.[10]

After the Peace of Tournai, Philip the Bold implemented a plan for institutional reform of the legal and finance systems. In 1386 he reorganized the existing judicial bodies and accounting systems that already existed in both Flanders and Burgundy. In Lille he set up a council chamber and an accounting system that, after a few years, gave birth to two separate institutions: the council of Flanders, a court of law for the earldom with sessions in Lille, in Audenarde, and then in Ghent; and an accounting chamber, which remained in Lille. In Dijon, a council and an accounting chamber were likewise organized, and in this manner symmetrical institutions existed in the two groups of principalities that the Duke of Burgundy ruled.

Philip also endowed his government with central institutions, the keystone of which was, beginning in 1385, the office of "chancellor of his eminence the Duke of Burgundy," chief of administration and ducal justice, whose duties continued to grow. The office was personified, from its creation until 1404, by Jean Canard, bishop of Arras, and then, from 1405 to 1419, by Jean de Saulx, feudal lord of Courtivron (fig. 3), two highly competent jurists. A treasurer or governor general supervised the workings of the financial institutions and organized expenditures. A general collector for all taxes followed the duke in his travels. His treasury was supplied by all the regional collectors (one from Flanders and Artois, one from the duchy and earldom of Burgundy) and he was the one who settled the most important expenditures. An officer of the money chamber was in charge of the expenditures for the *hôtel du prince*. This was a body charged with dealing with all the daily necessities of the prince and the members of his family. It was made up of six "offices" (bakery, wine cellar, kitchen, fruit and vegetable larder, stables, carriage house), where some of the personnel were from the nobility. Strictly structured and hierarchical, this institution continued to develop and grow in size; its prestige increased and it became an essential component of the Burgundian court.

Matrimonial Policy

In perhaps unexpected fashion, the wealth of the house of Burgundy stemmed from a marriage. Later, Philip the Bold and his successors developed outright matrimonial strategies. In this regard, the first Valois duke was able to use his family's prolificacy, thanks to which he inaugurated a policy of marriage that allowed him to enter into European alliances. In 1378 he planned a union with the house of Austria, a project that, in 1392, resulted in the marriage of his daughter Catherine of Burgundy to Duke Leopold IV of Hapsburg. In 1385, following bitter nego-

tiations, Philip the Bold and Aubert of Bavaria, regent for the counts of Hainaut, Holland, and Zealand, married their children; Philip's eldest son, John, Count of Nevers (the future Duke John the Fearless) married Margaret of Bavaria, while William of Bavaria married Margaret of Burgundy. Subsequently, in 1401, another daughter of the Duke of Burgundy, Marie, married Amedeus VIII, Count of Savoy. The following year saw the celebration of the marriage of Anthony of Burgundy, Duke Philip's second son, and Jeanne of Luxembourg, daughter of the Count of Saint-Pol.[11].

The alliances with the houses of Austria, Bavaria, Savoy, and Luxembourg greatly expanded the matrimonial prospects of the Duke of Burgundy, but Philip the Bold never forgot that he was the "prince des lis." Following the example of the Capetian dukes, John the Fearless, too, intended to strengthen the bonds that joined his house to the royal branch of the French family. With this intention, he negotiated the marriage of his young children Margaret and Philip to the children of the French crown, and so the former married Louis, the French dauphin, in 1404, and the latter, the future Duke Philip the Good, was married that same year to Michelle of France.

Later, Duke John the Fearless modeled himself on his father and also used marriage as a political tool. In 1406 he organized the union between his niece, Jacqueline of Bavaria (daughter of William, Count of Hainaut, and Margaret of Burgundy), and John of France, Duke of Touraine (son of Charles VI). That same year, he gave his daughter Marie in marriage to Adolphe, Count of Cleves, joining for a significant time the houses of Cleves and Burgundy. Three years later he was the hand behind the second marriage of his brother, Anthony of Burgundy, Duke of Brabant, to Elisabeth of Görlitz, who controlled the government of the duchy of Luxembourg. Finally, in 1418, he was likewise behind the remarriage of his niece Jacqueline to Jean IV, Duke of Brabant, son of Anthony.

The Dukes' Ambitions

Until the accession of Charles the Reckless, the dukes of Burgundy of the house of Valois wanted to play a leading role in the French realm. From this viewpoint, the political legacy of Philip the Bold was important. The first duke in this line was, as a prince of the realm and a senior among peers, a considerable personage in the royal government. At the side of his brother Charles V, he had been an active counselor, a prudent military leader, and a skillful and wise diplomat. With Charles VI's ascension to the throne, in 1380, Philip had become increasingly influential in the royal government. After the death of Louis d'Anjou, in 1384, he was, with his brother Jean de Berry, the spirit of the government of uncles.[12] He served

Fig. 3

as mentor to both the young king and the king's brother Louis of France, future Duke of Orléans, and he was nearly a father to both of them. In 1385, he was the one who found a bride for Charles VI, choosing Elizabeth of Bavaria-Ingolstadt (Isabeau of Bavaria), from the royal family to which he was allied. However, his influence was not absolute, and some of the guidance he gave for royal policies eroded his reputation. The military interventions of the period 1382–84 against the Flemish rebels led some to believe that the Duke of Burgundy was using the financial and military resources of the realm to safeguard his own interests. In other respects some of his foreign policies met with such failure that he was the subject of sharp criticism. Such was the case in 1386 with his plan to disembark in England, which was aborted at great expense. This was again the case in 1388, when he involved the king and all his power in a military expedition against William, Duke of Gueldre, which proved to be both costly and futile. William was clearly an ally of England, but he was above all the adversary of Jeanne, Duchess of Brabant, aunt of Margaret de Male. Upon returning from this disappointing "trip to Germany," Charles VI, who was awaiting his twentieth birthday, politely withdrew from his uncles' guardianship and inaugurated his own government, calling to his side his

father King Charles V's elderly counselors, known as the Marmousets.

Philip the Bold, having lost direct control of the royal government in 1388, still did not fall into disgrace. He continued to sit in council, always playing the role of powerful uncle, and he continued to benefit from royal gifts that filled his coffers. Otherwise, with his brother Jean de Berry, he remained one of the essential actors in the theater of royal diplomacy. In this manner he was an active negotiator when, beginning in 1389–90, Charles VI began a policy of rapprochement with the king of England, Richard II. In fact the Duke of Burgundy was far from hostile to settling the French-English conflict, which would have favored the economic interests of his Flemish subjects. The earldom of Flanders was traditionally a trading partner of England and its economy was dependent on the plentiful trade, then seriously disrupted by the ongoing naval war between the French and the English. During this period, Philip the Bold, without instigating royal policy, still remained a loyal instrument.

The general situation changed, nevertheless, beginning in 1392. In August of that year, King Charles VI fell victim to a sudden dementia. This was the first sign of a madness that would gradually render the king incapable of governing. Beginning with this event, royal authority slowly eroded, and the French court became the theater for a rivalry among the ambitious princes. Philip the Bold and Jean de Berry might have been considered the natural supporters of the crown, but others also aspired to power. In 1392 the youngest brother of the king, Louis, having become Duke of Orléans, was still subject to the authority of his uncles. During the years that followed, however, he showed himself to be an enterprising prince and decided to assert himself as head of the royal government. While Philip the Bold was alive, his clashes with his ambitious nephew were restrained. The stature of the Duke of Burgundy and his influence over the royal family and the court was such that nothing irreparable could be committed. It was quite another story after his death on 27 April 1404.

The Civil War

Philip the Bold's successor, John the Fearless, who was thirty-three years old when his father died, enjoyed a fine reputation. He had drawn unquestionable prestige from his participation in the unsuccessful crusade organized against the Turks in 1396, which ended with the disaster of Nicopolis. Captured by the infidels, then freed for a ransom, John, who then was merely Count of Nevers, had shown great force of character in the face of adversity. Yet his prestige did not approach that of his farther, and when he became Duke of Burgundy, he had scarcely any authority in the kingdom. After his accession, the rivalry

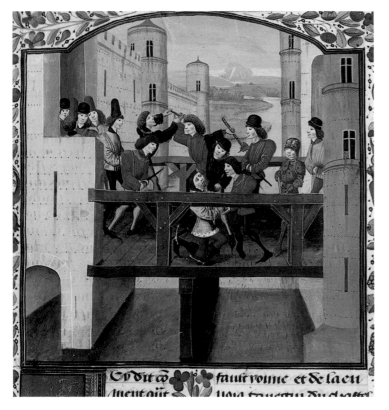

Fig. 4. The assassination of John the Fearless (10 September 1419). Paris, Bibliothèque Nationale de France.

were made of the text and it was widely disseminated. But the ideas that were expressed therein were not the Duke of Burgundy's only claim; backed by military force, on 23 November 1408, less than one year after the murder, he defeated the Liegeois at Othée. With the support of a portion of the population, which began to refer to him as John the Fearless, he seized power, expelling the supporters of the house of Orléans, radically increasing the hostilities.

In 1410, faced with the triumphant Burgundian party, a rival faction formed around Charles, Duke of Orléans (son of Duke Louis), and his father-in-law Bernard VII, Count of Armagnac; it was soon dubbed the Armagnac party. At his point true civil war broke out. The principal prize at stake was control of Paris, the organs of royal government, and the person of the king, Charles VI, who was sinking ever deeper into madness. John the Fearless held sway over the government and the capital until 1413, when the upheavals perpetrated by his supporters, the Cabochiens, provoked a reaction that resulted in his loss of power to the adversary Armagnacs. He was unable to regain power until May 1418, when his troops retook Paris amid terrible massacres, where the Count of Armagnac and a number of his followers perished. Nevertheless the Armagnac party did not disappear, and it found a new leader in the person of the dauphin Charles (the future King Charles VII), last surviving son of Charles VI and Isabeau of Bavaria.

In 1418, the situation was all the more confused since the effects of the civil war had been aggravated by those of war with the English. After 1411 the two conflicting parties alternately called upon the English for assistance, and the weakening of the royal government in the end led the English to resume the war against France. King Henry V of Lancaster, beginning in 1415, took the offensive to reclaim the crown of France. Crushing the French at Agincourt on 25 October, he began the conquest of Normandy two years later. In 1418–19, he was in a position to threaten Paris and its surroundings. Facing this danger, John the Fearless and the dauphin Charles, while negotiating separately with Henry V, drew closer together and, in July 1419, they signed a peace treaty. But a short time later, on 10 September 1419, during a meeting at Montereau-faut-Yonne, the Duke of Burgundy was assassinated by some counselors of the dauphin, who wanted to avenge the deaths of Louis d'Orléans and the Count of Armagnac (fig. 4).

The murder at Montereau was a watershed in the history of the Burgundian state. It was one of the motives that pushed the new Duke of Burgundy, Philip the Good, to ally himself with the king of England. During a fifteen-year period, from 1420 to 1435, he aided and guaranteed English domination in France, until the reversal of the

between the houses of Orléans and Burgundy very rapidly degenerated into violent conflict.[13] After the death of Philip the Bold, Louis d'Orléans undertook to eliminate the Burgundian influence within the royal government. Strengthened by his growing favor at court, he amassed a powerful clientele and a vast network of loyal followers, placing his men in the council and throughout the administrative workings of the realm. His policies were utterly contrary to Burgundian interests, since he not only deprived John the Fearless of the royal gifts that had been so beneficial to the finances of the Duke of Burgundy during the lifetime of Philip the Bold, but he also recommended a resumption of the war with England, after Richard II was deposed by Henry IV of Lancaster.

Between 1404 and 1407, periods of tension alternated with periods of superficial reconciliation; on 23 November 1407, the Duke of Burgundy had his rival, the Duke of Orléans, assassinated right in Paris. This murder, which stunned the entire realm, was the beginning of a long civil war. Even so, the Duke of Burgundy early on attempted to justify his action, launching an unprecedented propaganda campaign. The theologian John Petit drafted a treatise in which the assassination of Louis d'Orléans was presented as a tyrannicide. Many copies

Treaty of Arras. Nonetheless, the reconciliation of the Duke of Burgundy and the king, Charles VII of France, was neither complete nor sincere. Tensions continued and the long-deferred confrontation finally took place when Charles the Reckless, son of Philip the Good, clashed with Louis XI, son of Charles VII. At this time Burgundian power had reached its apogee. Territorial expansion, instituted under Philip the Bold, was pursued under Philip the Good, who united Picardy, Brabant, Hainaut, Holland, Zealand, and Luxembourg under his rule. Charles the Reckless wanted to further increase his possessions, particularly in the Empire. He acquired Haute-Alsace and conquered Gueldre and Lorraine, but then clashed with a coalition bolstered by Swiss confederates. It was during this confrontation that he lost his life, beneath the walls of Nancy on 5 January 1477.

NOTES 1. For more on the history of the Burgundian State, see Vaughan 2002B, 1975; Schnerb 1999.
2. See Petit 1885–1905, and Richard 1986.
3. Cazelles 1958, passim.
4. Cazelles 1982, and Autrand 1994.
5. For more on Louis I of Anjou and his successors, see Robin 1985; Mérindol 1987; Reynaud 2000; Tonnerre and Verry 2003.
6. See mainly Lehoux 1966–68, and Autrand 2000.
7. For more on Flanders and the Burgundian Low Countries, see Blockmans and Prevenier 1983; Blockmans and Prevenier 1999; Nicholas 1992.
8. For more on the relationship of Ghent to Burgundian power, see Boone 1990A; Boone 1990B.
9. For more on tax issues, see Van Nieuwenhuysen 1984; Rauzier 1996.
10. Billioud 1922; Hirschauer 1923; Prevenier 1961; Blockmans 1978; Zoete 1994; Boone 2002, pp. 323–41.
11. Armstrong 1983, pp. 237–42.
12. Autrand 1986.
13. For more on the civil war, see Famiglietti 1986; Schnerb 1988; Guenée 1992.

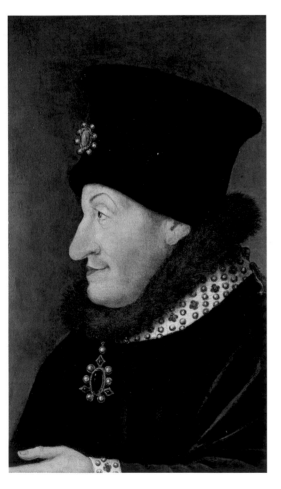

1

Burgundy

Philip the Bold

c. 1400 (original); 17th century (copy)

Oil on wood

42 x 28 cm

Dijon, Musée des Beaux-Arts, inv. 3977

Prov.: Gift of Marschall Spink, London, to the Musée du Louvre, 1950 (RF 1950-45); deposited in the Musée des Beaux-Arts, Dijon, 1951.

Bibl.: Liebreich 1933–35; Sterling 1959A; Sterling 1959B; Meiss and Eisler 1960; Troescher 1966, no. 62, pl. 19; Quarré and Geiger 1968, no. 1; De Winter 1976, p. 765; Comblen-Sonkes 1986, 1: pp. 25–37, 2: pls. VIII–XI; Pächt and De Vaivre 1986; Jugie 1997, pp. 51–53, fig. 1; Prochno 2002, pp. 80–83, fig. 45.

Exh.: Amsterdam 1951, no. 1, pl. 1; Brussels 1951, no. 1; Brussels 1953, no. 88; Dijon 1960, no. 73; Liège 1968, no. 175.

Here we recognize the distinct features of Philip the Bold—the prominent hooked nose, the "circumflex" arch of the eyebrows, the raised corners of the mouth, and the heavy chin—just as they appear in the statue at the portal of the church of the Chartreuse de Champmol. The duke is represented as a bust, his profile to the left, his left arm partially depicted, and his hand placed clumsily before his chest. On his head is a flat black hat embellished with a jewel. His cloak is trimmed at the neck and wrists with fur and with a wide border studded with gems. He wears a pendant and, on his neck, a gold ornament that resembles the seedpod of a plant, which might imply an identification with the Ordre de la Cosse de Genêt (Order of the Broom-Pod).

It is known that a portrait of Philip the Bold was located in the choir of the Chartreuse de Champmol. This work is referenced in the commissioning order for a portrait of Philip the Good in 1436 to the Dijonnais painter Jean de Maisoncelles, also for the charterhouse (Smith 1982); Georges Lengherand, the mayor of Mons and the earliest visitor to provide a description of the charterhouse in 1486, mentions it as well (Smith 1985). The appearance of this lost original is known to us through a print, made at the initiative of the Dijonnais historian Étienne Tabourot in 1587 (Tabourot 1587), which leads us to believe that the painting looked much like it. Tabourot was in effect attempting to provide exact copies of the portraits of dukes that had been created in Burgundy; as he specified: "This figure is based on the marble statue, so carefully made, on the Carthusian tomb in Dijon, and reference to which is made by a painting hung near the large altar, although not by the hand of a great painter."

There are other, later versions of the portrait—painted (for example, c. 1600, Cincinnati Art Museum; Smith 1983), printed (in Montfaucon 1745), and sculpted (sixteenth century, Dijon, Musée des Beaux-Arts)—that show the duke holding his pendant in his hand, in a gesture reminiscent of that of the Duke of Berry in an illumination from his *Grandes*

Heures (Paris, BNF, MS lat. 919, fol. 96r); it is unknown, however, whether this version is closely related to the portrait at Champmol, or a contemporary variation thereof.

There is no source that permits an attribution of this portrait to an individual artist, and the later copies make stylistic attribution difficult. We can thus only take into consideration the painters working for the duke around 1400. Jean Malouel's name has been proposed by Sterling, accepted by Châtelet, but rejected by De Winter.

S.J.

2

**Painter in the employ
of John the Fearless**
(for the original painting)

John the Fearless

c. 1404–10 (original); c. 1500 (copy)

Wood

29 x 21 cm

Inscription on verso: Joan. Intrepid.
D. Brg. Comes Fland. Obiit 1419.
Van Eyck Pinxit.

Paris, Musée du Louvre, inv. MI 831

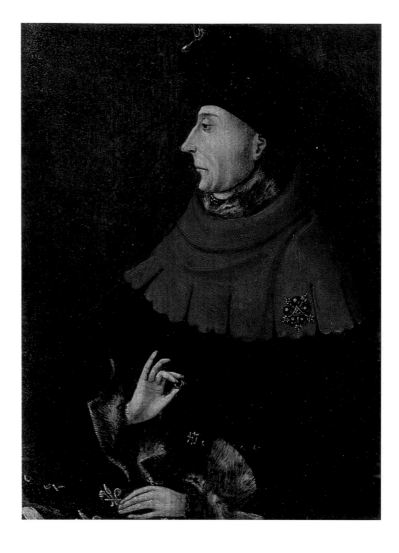

Prov.: Gift of Charles Sauvageot, 1856.

Bibl.: Panofsky 1953, 1: p. 82, no. 3, pp. 171, 385, no. 6; Adhémar 1961; Adhémar 1962 (with bibl.); Sterling and Adhémar 1965, pp. 4–5; Troescher 1966, pp. 79–80, fig. 68; Meiss 1967, 1: pp. 68, 75, fig. 506; Meiss 1974, p. 39; Châtelet 1980, p. 193, no. 11; Fletcher 1984, pp. 16–17, fig. 5; Cassagnes-Brouquet 1996, 3: p. 470; Jugie 1997, pp. 54–55, fig. 4.

Exh.: Rouen and Paris 1956; Paris 1960.

Depicted here from the waist up, his profile to the left, John the Fearless is dressed in a mantle held by a belt and a *camail* decorated with a gold insignia with five pearls; a necklace is detectable beneath the fur of his collar. On his head is a black hat adorned with an ornamental buckle. He holds a gold ring set with a ruby in his right hand; his left hand rests on a table covered with a cloth bearing the heraldic arms of modern Burgundy.

A date for this piece has been proposed by Hélène Adhémar based on the evidence of the ring. It may be an allusion to the ruby purchased by Philip the Bold in 1397 that was modeled on the "count's rubies," which had belonged to Louis de Male and the possession of which symbolized the count of Flanders. This ruby was kept at Saint-Bénigne and given by the abbot to the new duke in turn. The painting would thus correspond to the duchy passing into the possession of John the Fearless in 1404, when he was thirty-three years old, and this specifically Burgundian significance may explain why the coats of arms do not display the lion of Flanders, which was part of the true arms of the second duke. If this hypothesis is correct, the work may be considered a commission either of the duke for Saint-Bénigne or of the abbot of Saint-Bénigne himself.

After its attribution to Jan van Eyck, this work has had various other proposed attributions among the "Franco-Flemish" milieu of the beginning of the fifteenth century. The painter Jean Malouel was appointed by the duke in 1404; he was active in Dijon, and it is known that he received an order for a portrait of John the Fearless in 1413, intended for King Jehan I of Portugal (Sterling 1959B, p. 302).

However, the work does not seem to correspond with what we know of Malouel's artistic personality. The dry precision of the composition evokes the work of a miniaturist; Panofsky has suggested the Limbourg brothers, who were Malouel's nephews. The panel has been dated with the aid of dendrochronology at c. 1500, which would make it an early copy. As opposed to other portraits of John the Fearless, this type was little adopted in paintings or in prints; in particular, there is no trace of a work like it in Burgundy—which is curious, considering the provenance proposed above. Rather, it was the prototype of the portrait at the Chartreuse de Champmol that was reprised in later versions: there, the duke is depicted in prayer, wearing a black hat and, over his cloak, a *camail* adorned with various *rabots* (carpenter's planes), *copeaux* (shavings), and balls or bezants (disks).

S.J.

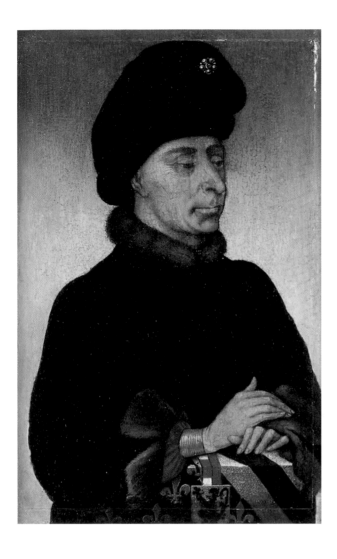

era (the three-quarter pose and black clothing), the portrait reprises certain elements of the Louvre's portrait of John the Fearless (cat. 2): the tablecloth with the coats of arms and certain details in the clothing, such as the hat with a jewel and the collar and sleeves trimmed with fur.

Variants of this work are numerous, but largely of lesser quality. They seem to be more common in the Netherlands than in France. Yet from this original model derives a print from the *Histoire général et particulière de Bourgogne* of Dom Urbain Plancher (1739–41, 3: facing p. 212), who claimed that it was "taken from a Carthusian painting of 1723." In the absence of confirmation from other sources, or of any legacy in later Burgundian portraits, this claim should be considered with prudence.

S.J.

4

Paris

The Coronation Book of Charles V
1365

45 folios (folios 35–80)
29 x 19 cm

London, The British Library,
MS Cotton Tiberius B.VIII

Prov.: King Charles V of France; Sir Robert Cotton.

Bibl.: O'Meara 2001, p. 295, pl. 9.

Exh.: Paris 1981, pp. 324–25, no. 279.

Exhibited in Dijon only

This manuscript is firmly anchored to a specific historic event: the coronation of Charles V as king of France on Trinity Sunday, 19 May 1364, in the cathedral of Reims. The first texts within the manuscript (fols. 35–41) relate to the protocol for the coronation of the king and queen. It was probably originally compiled around 1230 at Reims, early in the reign of St. Louis (Louis IX). This is followed by the coronation oath in Latin and a list of ancient and new peers in France (fols. 41v–42), then by the manuscript's main component: the complete Latin text of the "ordo" or ceremonial (fols. 43–71v). The ordo consists of a collection of prayers, formularies, hymns, and rubrics of

3

Circle of Rogier van der Weyden

John the Fearless
Mid 15th century

Oil on wood
21 x 14 cm

Antwerp, Musée Royal des Beaux-Arts, inv. 540

Prov.: acquired in 1841 with the Van Ertborn collection.

Bibl.: Panofsky 1953, index and fig. 378; Antwerp 1958, p. 128; Châtelet and Faggin 1969, no. 54; Davies 1973, p. 222; Vandenbroek 1985, pp. 28–32; Jugie 1997, p. 57, fig. 7.

Exh.: London 1927, p. 5; Amsterdam 1951, no. 2; Brussels 1951, no. 2; Dijon 1951, no. 5; Bruges 1953, no. 1; Brussels 1953, no. 98; Bruges 1960, no. 2; Detroit 1960, no. 3; Vienna 1962; Liège 1968, no. 176.

A black hat adorned with a jewel on his head, John the Fearless wears a black cloak with red sleeves trimmed with fur. His hands rest on a tablecloth bearing the arms of Burgundy and Flanders.

The issue of this work's date has long troubled historians, who at first felt bound by the date of the subject's death to place the work at the start of the fifteenth century, around 1415. However, the model's pose in three-quarter profile implies a later date, and the work's formal characteristics lead us to connect this style to Rogier van der Weyden. If the painting is considered a work from the middle of the fifteenth century, it could not, however, be a work by his hand.

In retrospect, this painting poses a problem with regard to its sources, and it has been noted that, reverting to the stylistic predilections of Philip the Good's

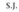

Fol. 48v: Philip the Bold presents the spurs to Charles V.

the liturgical ritual of the investiture. Although Charles is not named in the body of the text, he is identifiable with the ceremony described by the book's colophon, which he wrote and signed: "Ce livre du sacre des Rois de france / est a nous Charles Ve de notre nom / Roy de france et le fimes coriger / ordener, escrire et istorier l'an mccclxv. / Charles" (This, our coronation book of the kings of France / We, Charles V, in our name as king of France / Caused to be edited, numbered, / Written, and illuminated in the year 1365. / Charles)

Further evidence is to be found in the manuscript's cycle of thirty-eight miniatures, which depict in detail the successive acts of the ceremony and the principal participants, through faithful and realistic portraiture. Supplemental details such as costume, insignia, and armorials, leave little doubt that the coronation ceremony is that of Charles V. The miniatures throughout the volume re-enact and reaffirm the ceremony, while introducing the sacred through the depiction of altarpieces, statuary, the Eucharist, and relics. In particular, the divine is mystically represented by the celestial balm contained in a vial called the Sainte Ampoule.

An interesting miniature on folio 48 verso depicts the Duke of Burgundy, Philip the Bold, as he vests the king with his spurs. Although the investiture of the spurs is addressed only briefly in the text

of the *Coronation Book,* the event was deemed significant enough to warrant an entire miniature. This solemn ceremony symbolized the king's role as a knight and soldier of Christ, and established his mission to defend the Church. The king's spurs and sword (seen on the altar with the crown and Sainte Ampoule) establish the king's divinely ordained mission and the almost sacramental character of the event.

The text relates that the spurs should be delivered to the king by the Duke of Burgundy, thus establishing the prominence of this hereditary title. The last Burgundian duke of the Capetian line had died shortly before the death of the last king of France, John the Good. Although John had named his youngest son Philip to the duchy before his death, Philip had not yet been invested as Duke of Burgundy at the time of Charles's coronation in 1364, and one of Charles's first official acts as king was to consolidate his brother's succession. Given the youthful appearance of Philip in this miniature, it seems clear that he participated in the coronation of Charles. Philip wears a surcoat emblazoned with the arms of Burgundy, making this the earliest known miniature attesting to his investiture as duke.

S.N.F.

5

Master of the Policraticus of Charles V

Teachings or Ordinances for a Lord Who Must Govern While away at War

Treatise on Wealth and Poverty
French versions by Jean de Vignay
1384–1404

Parchment; (I)+96+(I) folios; modern numbering in pencil from 1 to 96

24.4 x 17 cm (justification in brown ink, 15 x 10.5 cm); 29LR-28LE, UR=0.5; pricking; 1–12⁸; catchwords, placed inside the boxes, and signatures

Brussels, Bibliothèque Royale de Belgique, inv. MS 11042

PROV.: Executed at the request of Philip the Bold (inventory of 1404: De Winter 1985A, no. 55); Bibliothèque de Bourgogne (inventory of 1420: Doutrepont 1977, no. 137; inventory of 1467–69: Barrois 1830, no. 975; inventory of 1485–87: Barrois 1830, no. 2111); removed by the French in 1794 (scratched stamp of the BNF, Paris [p.e. of fols. 1r and 95r]), returned in 1815 to the Bibliothèque de Bourgogne.

BIBL.: Barrois 1830, p. 154, no. 975, p. 299, no. 2111; Bastin 1946, pp. 77–88; Bayot [undated], p. 205; *Dictionnaire des lettres françaises*, pp. 858–60; Doutrepont 1909, p. 271; Knowles 1952, pp. 389–94; Knowles 1954, pp. 353–83; Sevcenko 1962; Laiou 1968, pp. 386–410; Doutrepont 1977, pp. 91–92, no. 137; Gaspar and Lyna 1984, pp. 367–68, no. 154; Hughes 1984; De Winter 1985A, p. 213, no. 55; Kelders 2003, pp. 214–17.

EXH.: Bruges 1927, p. 14, no. 144; Brussels 1939, p. 30, no. 19; Brussels 1967, p. 74, no. 101; Brussels 1985A, p. 66, no. 54.

Exhibited in Cleveland only

Theodorus Palaeologus (1291–1338), youngest son of the Byzantine emperor Andronicus II, wrote his *Teachings* for the attention of his nephew, the future Andronicus III. After inheriting the marquessate of Monferrat in northern Italy, Theodorus translated his text from Greek into Latin for his own children. The French version, which was handed down through Jean de Vignay, a religious hospitaler working in Paris between 1326 and 1350, now exists in two manuscripts in the Bibliothèque de Bourgogne: the Brussels manuscript 11042; and a codex for which the date of execution is

undoubtedly later by some fifty years (Brussels, KBR, MS 9467). The Greek and Latin versions are lost; these two codices are the last vestiges of this text.

The two miniatures of folios 1 recto and 12 recto have been attributed by Patrick M. De Winter to the Master of the Policraticus of Charles V, based on the illustration of the text of Jean de Salisbury (1115/20–1180), the manuscript of which is in Paris (BNF, fr. 14187).

The first miniature, small in size, is badly damaged; all the silver surfaces have oxidized and the faces of the two figures—perhaps the patron and the translator—probably were retouched during restoration following wear and tear due to rubbing. A standard with the coat of arms of Flanders adorns the trumpet of a legendary figure extended along one of the raised edges of this folio. The second miniature has equally deteriorated; the silver leaf used to depict the soldiers' armor has blackened the parchment through to the reverse side of the folio. The composition is no less interesting, as it represents the recipient of the manuscript and, by deduction, the date of its execution. Philip the Bold is depicted seated before a canopy hung with a tapestry with the four-part coat of arms of Burgundy, giving orders to his army and dressed in emblazoned armor. At the bottom edge, three shields contain, respectively, the coats of arms of the duchy of Burgundy derived from that of France with a *bordure componée*, Flanders, and Burgundy-Comté, making it possible to date the manuscript. It was not until 1384, his father-in-law having died, that Philip inherited the earldom through his wife, Margaret de Male, and thus could insert into his heraldic device the insignia of his new possessions. The reference to the manuscript in the inventory after his death in 1404 establishes its terminus post quem.

F.J.

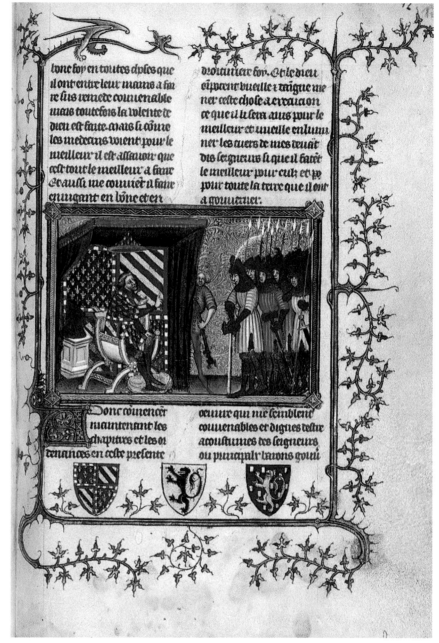

Fol. 12r: Philip the Bold gives orders to his soldiers.

Fol. 217r: The marriage of Philip the Bold and Margaret of Flanders.

6

Paris

Grandes Chroniques de France
c. 1415

2 volumes, 487 folios
39.5 x 25.1 cm

London, The British Library,
MS Cotton Nero E. II

Prov.: not listed in any surviving inventory, but probably produced for a royal patron (the arms of France appear in vol. 1, fol. 2 and vol. 2, fol. 242v); Sir Robert Cotton.

Bibl.: Meiss 1967, pp. 92–95, figs. 419–29; Hedeman 1991, pp. 210–12.

Exhibited in Dijon only

Originally one volume, this manuscript was damaged by fire while in the Cotton Library and is now bound as two. It was extensively illustrated, largely by the prominent Parisian workshops of the Boucicaut and Egerton masters. The Boucicaut Master made the largest contribution and presumably assumed primary responsibility for the book's production. He is noted for his skilled depiction of architecture and his often astonishing spatial effects, both of which are apparent in this manuscript.

The *Grandes Chroniques de France* survives in approximately 130 copies. It is essentially a French translation of the Latin histories compiled, written, and updated by the monks of royal abbey of Saint-Denis, who from the thirteenth century were the official historiographers to the kings of France. Therefore, the *Grandes Chroniques* achieved a quasi-official status that contributed to its popularity. In its original form, it traced the history of the French kings from their origins at Troy to the death of Philip Augustus in 1223. Later revisions drafted at Saint-Denis and at the court in Paris expanded the text to include histories of royal lives from Troy through the accession of Charles VI in 1380. The British Library manuscript belongs to this last group. The *Grandes Chroniques* was traditionally commissioned by royal or courtly patrons, as clearly was the case here.

Among the numerous depictions of royal personalities within this manuscript is a miniature representing the marriage of Philip the Bold, Duke of Burgundy, to Margaret, daughter of Louis de Male, Count of Flanders (fol. 217). This event

took place on 19 June 1369 at Ghent and assured Philip's succession to the five counties of which Margaret was heiress. The inheritance was received at Louis de Male's death in 1384. Within the miniature the duke and duchess turn toward one another before the entrance to a church or chapel. Their hands are joined by an officiating cleric who stands between them. On the flanks, the duke's counselors and the duchess's ladies-in-waiting witness the event.

S.N.F.

7

Paris

Jean Petit, *Defense of the Role of the Duke of Burgundy, John the Fearless, in the Death of Duke Louis d'Orléans*
c. 1410

72 folios
19.3 x 14 cm

Vienna, Österreichischen Nationalbibliothek, Cod. 2657

PROV.: Georg Wilhelm Freiherrn von Hohendorf; preserved in the Hofbibliothek until 1720.

BIBL.: Vaughan 1966/1973; Cartellieri 1970, pp. 36–51; Thoss 1978, pp. 101–2, no. 19, fig. 31; Backhouse 1990.

Exhibited in Dijon only

Jean Petit, a Franciscan writer and orator from Normandy, was under special obligation to the house of Burgundy. He had received financial support for his studies from the ducal treasury, was bound by special oath to John the Fearless, and had been appointed a member of the duke's council with an annual salary. In this manuscript he attempts to justify the Burgundian duke's role in the assassination of his cousin, Louis d'Orléans, brother of King Charles VI, on 24 November 1407.

The perennial antagonism between Burgundy and Orléans grew more intense following the death of Philip the Bold in

Fol. 1v: The lion of Burgundy prevents the wolf of Orléans from carrying off the crown of France.

1404; John the Fearless deeply resented the increased standing of Louis d'Orléans at the French court and the consolidation of his political power. This animosity was also deeply rooted in the shifting balance between the Orléanist and Anglo-Burgundian influence in Paris. John the Fearless acknowledged instigating the murder of Louis, refused to petition the king for pardon and mercy, and demanded credit for a meritorious action. In this position, John was defended by skilled advocates from the University of Paris, among whom Jean Petit was the most prominent. Petit's defense, or justification, of the Burgundian assassination of the duke was also a detailed indictment of Louis. It was soon circulated in manuscript form, of which the Vienna example is a deluxe version.

The principal embellishment of the manuscript is an allegorical miniature (fol. 1v) depicting the lion of Burgundy (symbolizing John the Fearless) as it defeats the wolf of Orléans (Louis d'Orléans) while seizing the crown of France. The combat between the beasts takes place in a rocky landscape before a tent emblazoned with fleurs-de-lis and surmounted with a penon. Beneath the miniature appears the text: "Par force le leu rompt et tire / A ses dens et gris la couronne, / Et le lyon par très grant ire / De sa pate grant coup luy donne" (The wolf roughly mauls the crown / And tugs it with his jaws; / The angry lion knocks him down / With a great blow of his paw).

The illumination is by the workshop of the Bedford Master (active 1405–65), an artist named by Freidrich Winkler after a breviary illustrated for John of Lancaster, Duke of Bedford, English regent in France, 1422–35. The Bedford Master's style became widely diffused; early manuscripts in the Bedford manner were produced in Paris. The workshop is known to have contributed illuminations to manuscripts owned by Duke Jean de Berry and John the Fearless (Brussels, BRB, MS 9024-5).

S.N.F.

8

Bruges?

Enguerrand de Monstrelet, *Chronicle: The Assassination of John the Fearless*
c. 1495

Ink, tempera, and gold on parchment; 266-page manuscript
40.5 x 30 cm

Leyden, Bibliothèque Universitaire, inv. MS VGG F 2, fol. 184

BIBL.: on the assassination of John the Fearless, see Vaughan 1966/1973, pp. 263–86; Guenée 1992, pp. 277–81; Schnerb 1999, pp. 168–71; on Enguerrand de Monstrelet, see Boucquey 1991.

EXH.: Dijon 1951, no. 55.

Exhibited in Dijon only

This illustration, depicting the assassination of John the Fearless in Montereau on 10 September 1419, appears in a book written by Enguerrand de Monstrelet (1390–1453). Monstrelet, an officer from Picardy whose administrative career unfolded mainly at Cambrai, wrote a chronicle covering the years 1400 to 1440 (prior events are narrated in the *Chroniques de France, d'Angleterre et des pays voisins* by Jean Froissart, which covers the period between the crowning of Edward III of England, in 1327, and the death of Richard II, in 1400). Monstrelet's chronicle relies on both written sources and first-hand accounts, critically comparing them against each other. Although it aspires to be an impartial account of the conflicts between the king of France, the king of England, and the Duke of Burgundy, it tends to favor the Burgundian viewpoint. It is but one of the sources giving us an account of the assassination of John the Fearless, to be contrasted with other accounts, such as the ones written by Juvénal des Ursins and the Monk of Saint-Denis, as well as with the official sources, particularly the report written by Philip de Morvillier.

This assassination brought to a head the internal rivalries among members of the royal family; it is known that John the Fearless, whose greatest ambition was to preserve as much influence over the government of Charles VI as his father had held, had ordered the killing of his cousin Louis d'Orléans in 1407. During the following twelve years, civil war raged between Armagnacs and Burgundians for control over the government of France. This military conflict was also a propaganda war, with each side alternately claiming victory and control over the city of Paris. The situation became more complex as war with England resumed, leading to the Agincourt disaster in 1415. Negotiations were started to seek a reconciliation between the dauphin (the future Charles VII) and the Duke of Burgundy. Peace was achieved on 11 July 1419. As Henry V, king of England, pursued his advance towards Paris, John the Fearless persuaded the court to leave the city and sent the king and queen to a safe haven in Troyes. The dauphin, afraid that the Duke of Burgundy would completely take over the government, refused to go to Troyes and proposed a meeting at Montereau.

The duke was killed on the Montereau bridge, as shown in the illuminated manuscript, in the presence of the dauphin. The two princes, each of them accompanied by ten members of his retinue, met on the bridge leading to one of the city gates. Barriers sealed the bridge, holding back the two groups. As the duke was kneeling before the dauphin, he was struck by Tanguy du Châtel. The two sides did of course provide different versions of the event, the dauphin's partisans describing a fight provoked by the duke as he tried to seize the person of the dauphin, while the Burgundians claimed with reason that they had been victims of an ambush. The premeditation was obvious, and the dauphin, undoubtedly influenced by one of his advisers, Jean Louvet, was indeed the instigator of the murder.

The image is surrounded by a frame with an arched top. The gold border is ornamented with flowers and small strawberries in high relief. These are depicted with great accuracy, as is characteristic of the works produced in Ghent and Bruges at the end of the fifteenth century.

S.J.

Fol. 184r: The assassination of John the Fearless.

y fut enfuieuāt
comment quāt
le daulphin
euft visite tout
le paye de tou
raine et de berri il se conuena
a tirer atout vingt mille com
batans a monftreau ou fault
yonne et de la enuoia tāc
ettir du chaftel atoyse dunap

le duc de bourгougne atout
aultant se lettres signees de sa
main par lesquelles il luy es
cripuoit moult affectueusemēt
que pour conclure et aduisar
a la reparation du royaulme
et pour aulcenne ffaire af
faires que merueilleufemēt
luy touchoient il voulfist ve
nir deuers luy a monftreau

Sophie Jugie

The Dukes of Burgundy: Princes of Paris and the Fleur-de-lis

When he received the duchy of Burgundy from his father, John II the Good, Philip the Bold adopted a new coat of arms combining his former arms as a son of France, which were similar to the king's (three golden fleurs-de-lis on a blue background surrounded by a silver and gules [red] border), with the arms of Burgundy (six blue and gold stripes with a gules border). He thus made it clear he was not losing his status as a member of the royal family, even as he was claiming the heritage of the Capetian dukes, or later as he became the master of Flanders, Artois, and the Franche-Comté through his marriage with Margaret of Flanders (1369) and the subsequent death of her father, Louis de Male (1384). As the son of King John, the brother of King Charles V, and the uncle of King Charles VI, Philip the Bold was the top-ranked nobleman in France. Throughout his life he was close to the throne, playing a major political role in the kingdom and a social role at the royal court.[1]

Philip the Bold's princely origins and his close relationship to his brother and nephew, the kings of France, explain why he would surround himself with such pomp. Philip more than anyone upheld his rank with magnificence[2] and spent lavishly to do so, though he derived a significant portion of his income from his proximity to the king and his influence over the government.

Many amazing examples of the duke's lavish lifestyle are gleaned by reading the ducal accounts and inventories or the descriptions of his parties. One such was the visit of King Charles VI to Dijon in 1390,[3] for which preparations began more than a month in advance. As the streets were cleaned and decorated, Philip and his son went out to meet the king in Tournus, and the two courts, forming a single procession, made their entry in Dijon on Sunday, 13 February. A large tent had been set up in the garden behind the ducal palace. The municipal authorities presented six bulls and 100 sheep, Philip offered precious objects and jewels to the king, the princes, and the noblemen of the courts of France and Burgundy. A big banquet was held in the magnificently decorated palace. For three days tournaments took place in the gardens of the abbey of Saint-Étienne, while the Dijon populace enjoyed citywide festivities. Philip showed the king the monastery of Champmol under construction, before escorting him for three days along the road to Paris to the frontier of his ducal domain.

Pomp was a way of life for the Valois princes,[4] and the goal of the several exhibitions organized during the spring and summer of 2004 is to evoke this way of life and study its artistic manifestations.[5]

Philip the Bold shared with his brothers Charles V, Louis d'Anjou, and Jean de Berry a love for beautiful objects that went beyond the requirements of their lavish lifestyle or the need to uphold their rank at court and before their subjects. The brothers were undoubtedly competing with one another as they showed off by exchanging fabulous jeweled objects as New Year's gifts.[6] Their common passion for manuscripts,[7] an art form that requires a one-on-one relationship with the image, was probably stimulated less by ostentation, though it seems to have been fueled by a certain complicity and probable desire for emulation among them. Thus Philip the Bold wanted to own a tapestry on the subject of the Apocalypse because Louis d'Anjou and Jean de Berry already owned such tapestries. The itinerant life of these princes enabled them to keep track of what the others were doing to build, decorate, or renovate their various residences. Once Philip the Bold sent the sculptor Claus Sluter and the painter Jean de Beaumetz on a trip to the château of Mehun-sur-Yèvre to see the work of André Beauneveu, hoping to be able to re-create in Burgundy some of the features of that marvelous château.[8]

Paris, where the court and the princes resided, was the hub of artistic exchange. Because of the princely presence, Paris became a center for the creation of luxury objects in gold or ivory, precious textiles, tapestries, easel paintings, or manuscripts. As evidenced by archival sources[9] and by the objects themselves, it was in Paris that the dukes of Burgundy obtained all kinds of items required by their lavish lifestyle.[10] Unlike other artists who worked exclusively on the dukes' projects in their domains (such as Beaumetz or Sluter), the Parisian suppliers, whether artists or businessmen, were not at the dukes' exclusive service, as they also worked for other members of the royal family and the court. One such was Hennequin du Vivier, goldsmith to the king, who also worked for Philip the Bold. Some, such as the weaver Perrin Beauneveu or the jeweler Henri Orland, received the title of valet to the duke. The objects used by the dukes in their daily life were mostly of Parisian origin.

As Paris was a major European center of the goldsmith's trade, we can surmise that most of the many gold and silver objects, jewels, small statues, reliquaries, and gold and silver plate mentioned in the ducal inventories were made in Paris.

Fig. 1

Some of the tapestries purchased or commissioned by Philip the Bold[11] were woven in Paris. Pierre de Beaumetz, who appears to have worked mostly for the duke and who is known to have supplied twenty-one tapestries, had a workshop and assistants in Paris. Jacques Dourdin, from whom Philip bought thirty-two tapestries, was also a supplier to the king, the queen, and the Duke of Orleans. Nicolas Bataille, well-known for the Apocalypse tapestry made for the Duke of Anjou, delivered to Philip six tapestries representing among others Godefroy de Bouillon, Bertrand du Guesclin, or pastoral scenes.

It is well known that the painters at the service of the dukes of Burgundy, that is, Jean de Beaumetz, Melchior Broederlam, and Jean Malouel, came from their northern lands. However, the dukes did also occasionally employ some Parisian artists: in 1383 Jean d'Orléans supplied a devotional diptych, and in 1396 Colart de Laon painted banners for the Count of Nevers who was leaving for the Nicopolis Crusade.

Most of the manuscripts purchased or commissioned by Philip the Bold were executed in Paris. His major suppliers were the Parisian bookseller Robert Lescuyer, rue Neuve-Notre-Dame, and the workshop of Jean L'Avenant. When he signed a contract with the brothers Limbourg in February 1402, commissioning an illuminated Bible, a project that was to last four years, the artists settled in Paris.[12]

Paris was also a major international trade and banking center where works of art and materials from many countries could be found. Nicolas le Flamant, the top purveyor of garments to the court of Burgundy, imported material from Brussels, Ypes, Malines, and Ghent.

An important role was played by major merchants and bankers established in Paris but hailing from Genoa, Venice, or Lucca, the best known being Dino Rapondi, from Lucca, who also did business in Bruges. Rapondi was in constant contact with the court of France, but was also the top supplier of luxury goods to the court of Burgundy and played a role as a lender and advisor to Philip the Bold. After 1400, Dino Rapondi and his brother Jacques sold to the duke particularly magnificent manuscripts, the *Liber de proprietatibus rerum* by Barthélémy l'Anglais (Brussels, Royal Library, MS 9094), the *Livre des femmes nobles et renommées* by Boccaccio (Paris, Bibliothèque Nationale de France, fr. 12420), and *La Fleur des histoires d'Orient* by the monk Hayton de Coucy (Paris, Bibliothèque Nationale de France, fr. 12201).[13] The Genoese merchant Pierre Labourebien supplied to the duke tapestries and jewels—among them, the Ruby of Burgundy, in a joint transaction with other traders. In 1392 Berthelot Héliot sold to the duke two ivory altarpieces made in the Embriachi workshop that were intended for the Champmol church. A somewhat mysterious work, probably of Italian origin, the Langres ivory *Annunciation* could very well have been purchased in Paris.

Paris was also where the artists working for the ducal residences or religious foundations obtained their materials. For instance, the "alabaster stone" used by Sluter for the recumbent statue on Philip the Bold's tomb was purchased from the Genoese merchant Christoffle de la Mer.[14] The most precious materials used in Burgundian

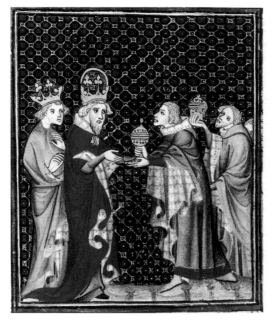

Fig. 2.
Grandes Chroniques de France. Philip the Bold and Jean de Berry bring gifts to the emperor Charles IV. Paris, Bibliothèque Nationale de France, MS fr 2813, fol. 478v.

Fig. 2

goldsmith Hennequin de Haacht, who came originally from Liege. Sometimes a commission given to a supplier elsewhere was executed in Paris: Jean Cosset, from Arras, asked by the duke to provide a tapestry on the subject of the Apocalypse, contacted Robert Poinçon, who was tapestry maker for the Duke of Anjou. Artists of Parisian origin or active in Paris could also be hired by the duke for his building projects in Burgundy. We could mention the young Sluter working for a time in Vincennes, or Drouet de Dammartin, a Parisian master mason who had worked in the construction of the Louvre palace and who later managed the Champmol building project in Dijon, or the Parisian stone polishers who worked on the alabaster for the tomb of Philip the Bold.

It is true that Flemish artists had often settled in Paris before the time of Philip the Bold, but the strong presence of the dukes of Burgundy in Paris certainly reinforced this trend. The political ambitions of the dukes of Anjou in Italy, or later the Milanese marriage of Louis d'Orléans, did not have such a strong impact, but in any case they were instrumental in bringing to Paris numerous Italian merchants and a few artists. The demands of the princely customers, who themselves led an international and itinerant life, did undoubtedly stimulate complex flows of artworks and people, and we should always think of these cross-currents when faced with delicate issues of attribution.[17] In a world characterized by artistic exchange, ruled by princes with apparently very wide-ranging tastes, the question of whether a work of art belongs to one or another school, which has so exercised the historians, is probably meaningless.

projects had to be brought from Paris, such as the blue pigment to decorate the chapel of the château of Argilly[15] or the gold leaf that Jean Malouel needed to gild the altarpieces he was making in 1403 for the church at Champmol.[16]

However, Paris was not the dukes' only supply center. They also made many purchases in their own domains, particularly in the northern lands. We see them ordering tapestries from Arras, or giving a commission to the Dijon

NOTES 1. The following authors may be consulted on the political role of Philip the Bold and John the Fearless: Vaughan 2002A and 2002B; Autrand 1986; Guenée 1992; Schnerb 1998, 1999.
2. Dehaines 1886; Prost 1902–8, vol. 2 (for the years 1363–90); David 1947 (for the years 1391–1404).
3. Petit 1885.
4. See in particular Delahaye 2004.
5. See the catalogs of the exhibitions held in Paris, Chantilly, Bourges and Blois, the joint album and the special issues of *Dossiers de l'art* and *Connaissance des arts* published on the occasion of these exhibitions.

6. Ewert 2000, pp. 5–37, and Buettner 2002, pp. 598–625.
7. De Winter 1985A.
8. Scher 1992, pp. 277–93.
9. Extensive extracts of the accounts of the dukes of Burgundy were published by Dehaines 1886; Prost 1902–8, vol. 2 (for the years 1363–90); David 1947 (for the years 1391–1404).
10. De Winter 1976, pp. 134–59.
11. Rey 2002.
12. De Winter 1985A, p. 107.
13. Ibid., pp. 61–67.

14. Drouot 1932, p. 31, no. 9.
15. Cassagnes-Brouquet 1996, p. 281.
16. Prochno 2002, p. 342.
17. See the suggestions made by Venturelli (2003), who, after noticing the similarity of certain objects described in the inventories of the French and Italian princes, suggested that certain enamels on gold, formerly thought to have been made in Paris, should rather be attributed to artistic centers in Northern Italy, notably Milan.

9

Paris

Pierre Salmon, *Les Demandes Faites par le Roi Charles VI*

c. 1412

260 folios
26.5 x 19.5 cm

Geneva, Bibliothèque Publique et Universitaire, MS fr. 165

PROV.: Petau Collection, Geneva; Bequeathed to the Geneva Library by Ami Lullin, 1765.

BIBL.: Thomas 1979, pp. 98–99, pl. 30; Walther and Wolf 2001, p. 273.

EXH.: Paris 2004, no. 52.

Exhibited in Cleveland only

This manuscript is essentially a political treatise on good government during the reign of Charles VI of France (1380–1422) by Pierre Salmon, one of the king's counselors, taking the form of a dialogue between them. The text presents, in three sections, the duties of a Christian king,

theology, and the Great Schism between Rome and Avignon. Two copies are preserved: the volume in Paris (BNF, MS fr. 23279), now believed to be the original manuscript, and this one, a slightly revised edition, now in Geneva. Both editions were richly decorated by the Boucicaut workshop, whose master was renowned for his engaging and skillful depictions of architectural interiors. The Boucicaut Master is also considered the most innovative landscape miniaturist before the Limbourg brothers.

On folio 4 of the Geneva manuscript, Charles VI is depicted seated on the edge of a magnificent bed with a large canopy emblazoned with gold fleurs-de-lis on a blue ground. The author, Salmon, kneels before the king as he speaks. Standing at the king's right are three figures: Jean de Berry in the center; the Duke of Burgundy, John the Fearless, on the left in a white hat and long pink robe; the third figure, with a baton, may be the Duke of Orléans or the Duke of Anjou.

The texts reflect the complexities of Salmon's relationship with his royal client, who struggled with insurrection and intermittent madness, and whose brother, Louis d'Orléans, had recently been assassinated on the orders of his cousin, John the Fearless, who appears in many of the manuscripts' miniatures. Interestingly, the revised edition omits the earlier dedicatory references to John the Fearless, undoubtedly a tacit acknowledgement of the Burgundian duke's role in the murder.

S.N.F.

10

Paris

Christine de Pizan, *Collected Works*
1410–11

2 volumes, 398 folios
36.5 x 28.5 cm

London, The British Library, MS Harley 4431 (vol. 2)

Prov.: Isabeau of Bavaria; John of Lancaster, Duke of Bedford (1425); Edward Harley (by 1725).

Bibl.: Meiss 1974, 1: pp. 292–96; Hindman 1983A, pp. 93–123; Hindman, 1983B, pp. 102–10.

Exh.: Paris 2004, no. 55.

Exhibited in Cleveland only

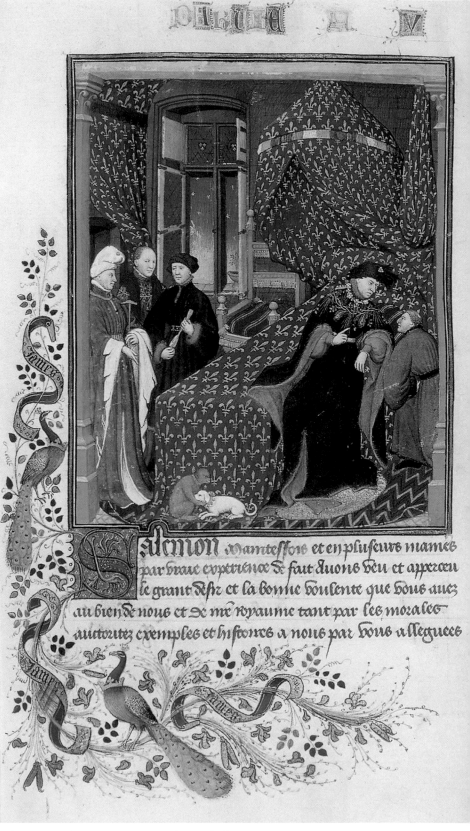

Fol. 4r: Pierre Salmon in conversation with King Charles VI.

Fol. 3r: Christine de Pisan presents her manuscript to Isabeau of Bavaria.

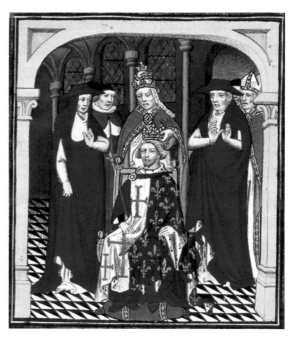

Fol. 173: Charles d'Anjou is crowned by Pope Clement IV.

Probably the most celebrated female author of the Middle Ages, Christine de Pizan received a superior education because of the influence of her father, a scholar at the court of Charles V. Christine read poetry, science, and history, both ancient and modern. Judging from her collected works, she was steeped in French and Italian literature, but her knowledge of Greek and Latin texts seems to have been based largely on French translations. Her works were highly acclaimed and brought her the favor of a number of well-placed patrons, including members of the royal court.

Christine de Pizan produced several manuscripts of her collected works, beautifully illustrated. This superb manuscript, produced for Isabeau of Bavaria, wife of Charles VI of France, is among the better known and more exquisite. A splendid frontispiece or presentation miniature appears on folio 3, which shows the queen seated in her bedchamber, where she receives a large book, bound in red velvet with gold clasps, directly from the hands of Christine. Ladies-in-waiting witness the event.

Twenty-nine of Christine's works—the most complete collection published by 1410–15—are preceded by a dedication in verse that suggests Isabeau commissioned the manuscript, though on other occasions Christine is known to have offered books to members of the royal family on speculation, hoping for remuneration. A slightly earlier volume of her works, preserved in Paris (BNF, MS fr. 606), was probably intended for Louis d'Orléans. The Paris manuscript was acquired by Jean de Berry in 1407, following the assassination of Louis.

The British Library manuscript contains 132 miniatures, some with borders, making it the finest and most densely illuminated copy of Christine's works. Nearly every text includes at least one miniature, usually prefatory; many depict Christine writing. To illustrate the manuscript Christine chose the Master of the Cité des Dames, one of the most prolific illuminators in Paris during the opening decades of the fifteenth century. The Cité des Dames Master collaborated with other Parisian illuminators and workshops, including Jacquemart de Hesdin and probably the Boucicaut Master, who influenced his later work. The manuscript was formerly bound as a single volume, but is now bound as two.

S.N.F.

11

Paris

Boccaccio, *Des Cas des Nobles Hommes et Femmes (On the Fates of Famous Men and Women)*
1409–11

2 volumes, 179 folios and 189 folios
40.5 x 29.2 cm

Geneva, Bibliothèque Publique et Universitaire, MS 190

PROV.: Jean, duc de Berry; Alexandre Petau collection.

BIBL.: Gagnebin 1957, pp. 129–48; Meiss 1967, 1: pp. 98, 310, 357–59; Gagnebin et al. 1976, pp. 83–87, no. 33; Buettner 1996, pp. 15–16.

Exhibited in Cleveland only

The original Latin text by Giovanni Boccaccio (1313–1375) is a catalogue of human misfortune focused on historic figures from Adam and Eve to the French king John the Good, all of whom are judged by the blindfolded Fortuna. Boccaccio wrote his text around 1356–60. He attracted the attention of a French audience at the papal curia in Avignon—a

city filled with clerics, intellectuals, and artists from both France and Italy—during two diplomatic missions, in 1354 and 1365. Laurent de Premierfait's first translation of *Des cas des nobles hommes et femmes*, in 1400, was largely disseminated in Paris, and it became Boccaccio's most popular work in fifteenth-century France. It survives in as many as sixty-nine manuscripts. Premierfait revised his original translation in an expanded version in 1409, which he dedicated to Jean de Berry. This presentation copy is now Geneva MS 190, shown here. It was given to Jean de Berry in 1411 by Margin Gouge, the duke's treasurer and counselor. Philip the Bold and John the Fearless also owned copies of Boccaccio's text.

The Geneva manuscript includes 146 miniatures, decorated letters, and margins from the workshop of the Luçon Master, a leading Parisian illuminator active in the early years of the fifteenth century. He was named by Millard Meiss after a pontifical (Paris, BNF, MS lat. 8886) owned by Etienne Loypeau, bishop of Luçon (1405–7). The Luçon Master's work is noteworthy for its elegance, meticulous finish and detail, and sinuous figures. A specialist in books of hours, he also illuminated secular texts, of which the present manuscript is a superb example. Several of these secular manuscripts were destined for Jean de Berry and his nephew, the Burgundian duke John the Fearless. Geneva MS 190 includes traces of an ex-libris at the end of the second volume that reads "Ce livre est au duc de Berry" followed by the signature "Jehan." The manuscript corresponds with no. 993 in the *Inventaires de Jean, duc de Berry*, edited by Jules Guiffrey.

S.N.F.

12

The Limbourg Brothers

The Belles Heures of Duke Jean de Berry
Use of Paris, 1408–9

225 folios (detached bifolio shown in exhibition)

23.8 x 17 cm

New York, The Metropolitan Museum of Art, The Cloisters Collection, 54.1.1

PROV.: Jean de Berry; Yolanda d'Anjou.

BIBL.: Meiss 1974, 1: pp. 102–42, 331–36; Meiss and Beatson 1974; Thomas 1979, pp. 86–89, pls. 24–25.

Different folios exhibited in Dijon and Cleveland

Duke Jean de Berry, one of Philip the Bold's older brothers, was an even greater bibliophile than the Burgundian duke and maintained a larger library. This famous manuscript is described in Jean de Berry's inventory of 1413. As Millard Meiss observed, the position of the *Belles Heures* in the inventory indicates that the duke received the completed work in 1408 or early 1409 (Meiss 1974, 1: pp. 103). There is stylistic evidence within the manuscript that all three Limbourg brothers—Paul, Herman, and Jean—contributed to its decoration. The brothers completed the *Belles Heures* before turning to the better-known *Très Riches Heures* (Chantilly, Musée Condé) a few years later.

The Limbourgs were natives of Nimwegen in Guelders. Their mother was the sister of the painter Jean Malouel, a salaried artist at the court of Philip the Bold. It was undoubtedly through their uncle's offices that the brothers also entered the service of the duke, for whom they completed a Bible moralisée. Upon the death of Philip the Bold in 1404, the Limbourgs' contract was not renewed by John the Fearless, perhaps as an economizing measure. It was at this time that the brothers entered the exclusive service of Jean de Berry, and upon the death of Jacquemart de Hesdin they seem to have succeeded him as the court miniaturists.

As Meiss observed, the consecutive execution of the *Belles Heures* and the *Très Riches Heures* suggests the duke's insatiable desire to replace one sumptuous book with another. The exceptionally beautiful miniatures in the *Belles Heures* are replete with innovative solutions to problems of form, light, and color. In a typical book of hours, the miniatures are spaced through the text and usually introduce an office or an hour. In the *Belles Heures*, by contrast, the miniatures appear in groups uninterrupted by text. In this way, its exquisite miniatures are less characteristic of a book of hours than the more monumental arts of the painted altarpiece or stained glass. The duke's aesthetic values were no less important in the production of books than his religious ones.

S.N.F.

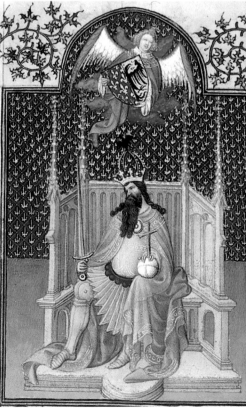

Fol. 174r: St. Charlemagne.

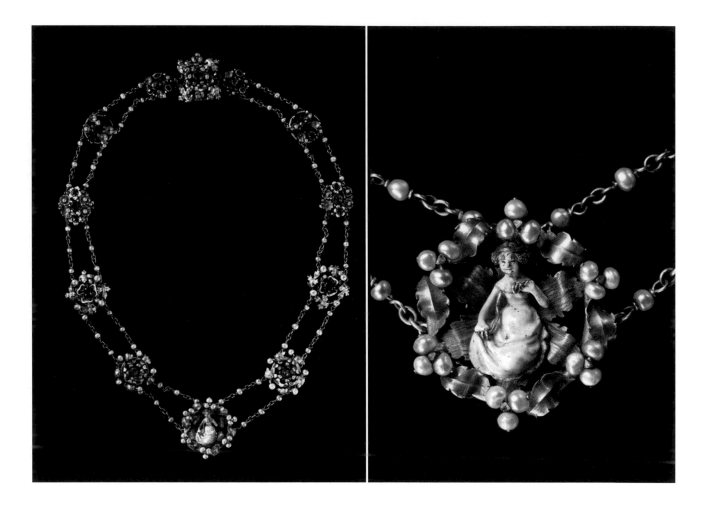

13

Paris

Twelve Medallions Mounted in a Necklace
c. 1400, later modifications

Enameled gold, precious stones, and pearls; additions in silver and colored glass

Significant 19th-century additions; only the white-enameled medallion with a young woman is certifiably authentic (paper by B. Christman, Cleveland Museum of Art); mounted with chains decorated with pearls, Maison André c. 1930 (paper by R. Chardainne, 1958, Cleveland Museum of Art)

Medallion with a young lady, 4.7 x 4.2 cm

Large floral medallion, 4.2 x 3.7 cm

Other medallions: Diam. 3.2 to 2.7 cm

Cleveland, The Cleveland Museum of Art, inv. 1947.507

Prov.: Demotte collection, Paris; G. J. Demotte, New York; Joseph Brummer, New York.

Bibl.: Milliken 1947; Müller and Steingräber 1954, no. 26; Lightbown 1992, p. 170.

Exh.: Detroit 1928, no. 75; Detroit 1960, no. 128; Baltimore 1962, no. 127; Cleveland 1967, no. VI–19; New York 1975, no. 95; Paris 2004, no. 86.

Exhibited in Cleveland only

The medallions, which have loops on the back, must have been sewn on a garment or, more probably, on a headpiece. They remind us of the "gold circlet" of Margaret of Flanders and its twelve medallions, each decorated with a "white lady" (Dehaisnes 1886, p. 858), and also of the "hat" delivered to Isabeau of Bavaria by Jean Clerbourc on 3 January 1398. Isabeau's headpiece had twelve small and twelve large "coins," six of them decorated with a "seated lady in white

enamel" and the other six with a "white flower with little dots enameled in black and red" (AN, KK 41, fol. 11v). The picture of Isabeau of Bavaria's headpiece on the cover of Christine de Pizan's *Œuvres* at the British Library (cat. 10) allows us to understand how these ornaments were used.

The "lady in white enamel" holds an object, perhaps a spindle. She wears a close-fitting and low-necked gown, and her coiffure is held in place by a green-enamel circlet. Leaves similar to the ones represented in these medallions can be seen in illuminated manuscripts and jewelry items. In spite of the modern mount, the medallions in Cleveland are unique items of feminine apparel around 1400.

É.T.D.

Netherlands artist active in Paris

Medallion with Augustus's Vision of the Ara Coeli
c. 1415–20

Painted enamel and gold on silver in a gilded silver frame
Diam. 5.2 cm
Obverse: Emperor Augustus
Reverse: Virgin nursing the Christ child before a sunburst

Baltimore, The Walters Art Museum, 44.462

PROV.: F. W. B. Massey-Manwaring; acquired by Henry Walters around 1914.

BIBL.: Falke 1908, p. 893; Burger 1930, p. 163; Steingräber 1956, pp. 56, 62; Steingräber 1960, col. 43; Verdier 1961, pp. 8–37; Meiss 1963B, p. 151; Pächt 1963A, p. 138; Pächt 1963B, p. 121; Eisler 1964, p. 289; Verdier 1967, pp. 1–2; Meiss 1974, pp. 236, 405; Randall 1979, no. 478; Verdier 1982, pp. 115–19; Foister 2000, p. 127.

EXH.: Baltimore 1962, no. 136; Vienna 1962, no. 485; Munich 1992, no. 16.

Exhibited in Cleveland only

Judged by his style, the artist of this sophisticated painted enamel was probably trained in the circle of the Limbourg brothers as a goldsmith and painter, just as they had been. His choice of subject and interpretation point to an association with their patron Jean de Berry.

Christian authors claimed that a vision of the Virgin and Child as the *ara coeli* (altar of heaven) convinced the Emperor Augustus that one greater than himself would rule. The subject had special resonance for Jean de Berry who commissioned a number of renderings, including one by the Limbourg brothers in the *Très Riches Heures* (fol. 22r), with which this medallion is often compared. In addition, the characterization of Augustus with bushy hair and beard has no counterpart in earlier court-related art and may be an adaptation of a Roman cameo in the collection of the duke (Paris, Louvre; Meiss 1967, fig. 459). Indeed, the face of Augustus, delicately stippled in white and blue-gray grisaille and set off against the dark blue ground, reflects the aesthetic of a cameo. The Walters medallion is also related, in its presentation as a pendant and a portrait of an emperor, to the duke's famous lost "imperial" gold medallions,

mounted as jewels ("joyaux" in the ducal inventory). This is the earliest painted enamel recreating what was then thought to be an event in Roman history. As such, it is a striking distillation of the distinctive response to antiquity found in the French courts of the time.

Technically and stylistically, the closest painted enamels—the beaker in New York, the spoon in Boston, and the enamel in the Victoria and Albert Museum (Munich 1992, no. 13, 14, 15)—could be later works from the same shop; the cloud issuing golden rays of light and rain may be adapted from the Walters medallion, though as decoration rather than narration. The artist of the Walters medallion has been identified as the follower of the Limbourg brothers known as the Master of St. Jerome (Pächt 1963A, Meiss 1963B), and as Arnauld de Limbourg (Verdier 1961), the younger brother of Paul, Herman, and Jean, who was a goldsmith in Nijmegen after 1416 of whom no works are known. It was certainly someone with access to the duke's collections and familiar with the brothers' production.

J.S.

Jean de Clichy, Gautier du Four, and Guillaume Bouyn (Paris)

Prophet (Support for the St. Germain Reliquary of Saint-Germain-des-Prés)
1409

Gilt bronze
13.8 x 8.7 x 7.8 cm

Cleveland, The Cleveland Museum of Art, inv. 1964.360

PROV.: H. Bier collection, London.

BIBL.: Wixom 1966; Egbert 1970; Erlande-Brandenburg 1972.

EXH.: Cleveland 1967, no. VI-20; Cologne 1978, pp. 64–65; Paris 1981, no. 224; Paris 2004, no. 190D.

Exhibited in Cleveland only

The St. Germain reliquary, now lost, is depicted in an engraving executed for Msgr. Bouillart (Paris, Carnavalet Museum, Cabinet des Estampes, G 30505), and descriptions of it also appear in Du Breul (1639) and in an inventory of the abbey's relics and reliquaries made in 1654 (Bapst 1887). Six apostles stood on either of the long sides; on one of the short sides there was a Trinity surrounded by the figures of King Childebert, Abbot Odon, and Abbot Guillaume and on the other there was a statue of St. Germain surrounded by St. Vincent and St. Stephen. During the French Revolution the reliquary was sent to the mint to be melted (1792). A report dated *23 floréal an II* (12 May 1794) indicates that it "produced" 23 marcs (about 6 kilograms) of gold, 186 marcs (about 46 kilograms) of gilt silver, and 10 marcs of silver. It also lists the precious stones removed from the piece, among them 77 sapphires and 50 emeralds (Bapst 1887), many fewer than the number of stones provided in 1409. Two gilt-bronze statuettes representing prophets were perhaps removed at that time or, more probably, during a refurbishment of the reliquary in the first half of the eighteenth century concurrent with the execution of a new altar after drawings by Oppenord (Gaborit-Chopin 1970).

The two prophets, one in Cleveland and the other one in the Louvre (inv. OA 5917), illustrate the role played by Paris in developing and spreading the "international style" in the 1400s. Their authorship was uncertain until Virginie Egbert

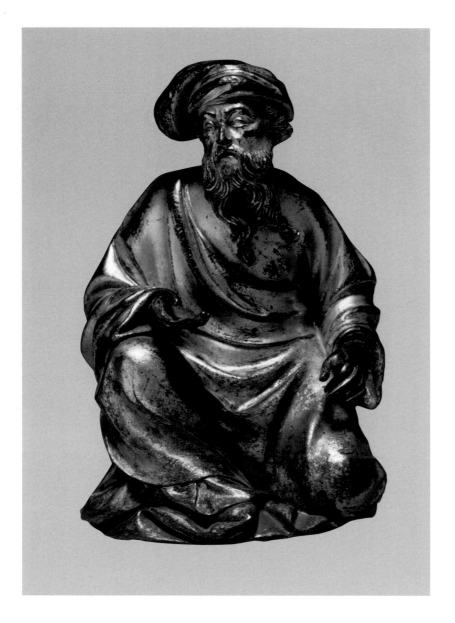

16

Paris?

The Presentation in the Temple
Late 14th century

Marble
63 x 45 x 14 cm

Paris, Musée National du Moyen
Âge–Thermes de Cluny, inv. Cl. 18849

PROV.: Alexandre Du Sommerard collection,
re-inventoried in 1912.

BIBL.: Du Sommerard 1838–46, 1: p. 423
n. L, and Atlas, pl. IV; Troescher 1940; Schmidt
1971; Beaulieu and Beyer 1992, pp. 58, 72;
Heinrichs-Schreiber 1997, p. 90.

EXH.: Vienna 1962, no. 338; Cologne 1978,
no. 51; Paris 1981, no. 79 (with bibliography).

This group is made up of two blocks, from which a portion at the center is missing. Indeed, the altar on which the infant Jesus is set seems too narrow, and the fall of the folds of fabric that cover him is abruptly interrupted between the blocks.

In the absence of a known provenance before it entered the Du Sommerard collection, this work, which is of the highest quality, gave rise to numerous hypotheses. Georg Troescher had attributed it to the late career of André Beauneveu, when he was working in the service of the Jean de Berry, surmising that it was destined for an altarpiece in one of the duke's chapels. Gerhard Schmidt later included it in the group of works around which he reconstructed the figure and oeuvre of Jean de Liège. However, we must attribute this *Presentation* to an anonymous figure whose style is exemplary of the multiplicity and complexity of artistic exchanges in the late fourteenth century. The soft, complex line of the elegant drapery belongs to the tradition of fourteenth-century Parisian sculpture. The influence of Beauneveu is noticeable in the treatment of the elderly Simeon's face, with its strongly incised eyelids, and the profile brings to mind that of the recumbent statue of Charles V. But other features differ from the art of Beauneveu: the moon face and coarse mouth of the servant, or the astonishing face of the infant Jesus, with its determined features, *puer senex* (a young child wise beyond his years).

É.A.

recognized that they are identical to the figures in an engraving in Msgr. Bouillart's book (1724). These two statuettes have often been related to works by Beauneveu (prophets in Jean de Berry's psalm book) and the Vincennes sculptors (supports in the village tower and the chapel). Certain sculptures dating from 1400 to 1410, such as the consoles in the chapel of Saint-Jean-de-Beauvais or those in the church of Marcoussis, show how these early works were at the origin of a fruitful artistic movement in Paris and Île-de-France. The casual postures of these two gilt-bronze prophets, the voluminous and supple folds of their garments, the plastic and contrasted treatment of their faces—frowning forehead, eyes sunk under the eyebrows, prominent cheekbones—and the undulating beard of the Cleveland prophet, are all elements of the Paris style at its best. Although the large St. Germain reliquary was intended for a very prestigious church and was made with high-quality materials and very elaborate ornamentation, the three artists chosen for this commission were not among the best-known Paris goldsmiths. Jean de Clichy is perhaps identical with a guild official of 1362; the other two are not mentioned elsewhere (Henwood 1982). In any case, these statuettes bear witness to the exceptional quality achieved by Paris goldsmiths.

É.T.D.

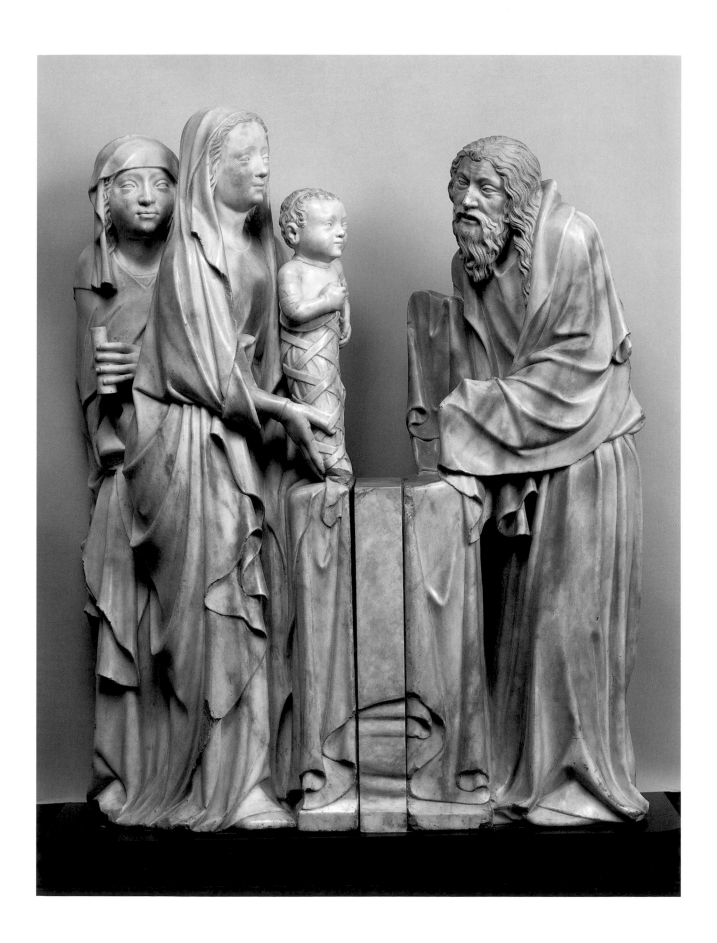

Ludovic Nys

Art in the Court of Flanders at the Time of the Marriage of Philip the Bold and Margaret de Male

With the marriage of Philip the Bold and Margaret de Male in 1369, the Flemish heritage of the Dampierres passed to a member of the French house of Valois.[1] This event was unprecedented. After having defended its integrity for more than a century and a half through bitter battles at Bouvignes, Courtrai, and Mons-en-Pévèle, the territory of the Count of Flanders was to be turned over to a brother of the king of France. The consequences of this dynastic alliance would be considerable, reshaping the geopolitical landscape and shifting the precarious balance between the crowns of France and England. Above all, this change would create favorable conditions for the emergence of a new culture of power and with it, a new artistic culture.

Is it appropriate, as is commonly claimed, to consider that art in the court of Flanders, at the time of the arrival of the first Valois of Burgundy, was a precursor to Van Eyck?[2] The question today seems quite simplistic when posed in these terms. The issue has nationalistic implications: does Van Eyck's art have a Flemish pedigree, deriving its realism from the heart of the purely urban Flemish culture? Or should the emphasis be placed on "clarity," based on the French inspiration, and its new pictorial vision? Already this terminology, or at least its implied meaning, is tainted by presuppositions that fall outside a strictly artistic perspective.

The term "Franco-Flemish art," when viewed from the French perspective, is incorrect and ambiguous; it does not distinguish among the painters, sculptors, and illuminators from the North and those who entered the circles of the French court, or among artists from Flanders and those from Hainaut, Brabant, and Liège. The term also implies that these movements to the South were primarily limited to the reigns of Charles V and Charles VI of Valois, while we now know that this phenomenon was much older. As correctly stated by Françoise Baron,[3] it was due primarily to the unverifiable premise that a very powerful innovative current existed in the former Low Countries, capable of nourishing such geniuses as Claus Sluter and Jean de Marville. These two sculptors, in fact, seem to have worked as French artists, summoned in turn to Dijon, Paris, and Bourges, at the principal properties of the sons of King John II the Good. The fullness of the realism in their stonework, although it has a claim to a Flemish eloquence, as suggested by the carved corbels on the Brussels town hall, actually belonged to a far-reaching international trend that was well represented at the court of the four brothers of the house of Valois. Furthermore, the art of Sluter in Dijon reflects more the tastes of the Valois court of Burgundy than the concrete sensibility thought to be characteristic of the melting pot of Flemish and Brabant urban culture in the towns.

Contrasting the "international gothic" concept with the poorly defined "pre-Eyckian" art[4] presents just as many problems. This term, which, in the jargon of art historians, defines the dominant style of a great number of European courts around 1400, is very general in scope; applied to the context of the former Low Countries, it offers an imperfect picture of the complex reality of artistic exchanges, especially with regard to the French court milieu. However, far from being witnesses to a vague amalgamated style, the masterpieces of "international style," particularly panel paintings, create the impression of dialectical variants or borrowings, through certain style traits and iconographic details. These details can be used as the basis for a more refined and expanded interpretation.

Jozef de Coo's study of the well-known detail of St. Joseph tying his sandals in the Antwerp *Nativity* panel from the *Antwerp-Baltimore Quadriptych* (cat. 74) and Léo Puyvelde's observations regarding the coarse features of St. Joseph quenching his thirst with a flask in the Dijon retable's *The Flight into Egypt* both argue in favor of the vernacular tradition.[5] Yet the remarkable interpretation recently offered by Cyriel Stroo on the Antwerp shutters for the *Infancy of Christ* cycle (work attributed to a Flemish artist who probably came from Champmol)[6] revealed significant links to Parisian art, and more specifically to the close circles of the Master of the Parement de Narbonne and Jacquemart de Hesdin. The course followed by Melchior Broederlam reveals this link most clearly.[7] Although he came from Ypres, where he settled long after his appointment as painter to the Duke of Burgundy, this artist maintained close relations with the artistic circles around the Valois court. Between 1385–86 and 1388–92 he lived and worked, on an apparently permanent basis, in the very French court of Hesdin, with its sumptuous setting and castle that were later inherited by Louis de Male,[8] after the death of Margaret d'Artois in 1382. During his stint as an artisan, he worked on tapestry designs for the weavers of Arras.

The *Annunciation* in the Metropolitan Museum of Art in New York (cat. 101), which was influenced by the composition of the same theme on the back of the left shutter of the same Dijon retable, indirectly echoes this work.[9] The influence of the Siennese formula on the same painted panels of the Dijon altarpiece cannot be understood without the link to French art, through which these Italian influences were able to make their way to Flanders. It is not necessary to imagine, as suggested by Anne Van Buren,[10] a hypothetical journey by this Ypres painter to Italy, nor a trip to Jan Bondolf's studio in Bruges, to explain Broederlam's conversion to courtly forms, and his high level of maturity, when he started to paint the reverse sides of the shutters of the Passion retable at the beginning of the 1390s. His personal contacts with Philip the Bold's entourage, his prolonged stay in Hesdin, his selective collaboration with the weavers of Arras, who were extensive suppliers to the court of Valois, and his trips to Paris between 1390 and 1393, should be sufficient.

Another aspect should be explored: contrast the "international style" of Flanders with the work executed for Louis de Male and his entourage just before the arrival of his future son-in-law at the count's court. Based on the little that can be deduced from the few available contemporary reports and the limited records of lost works, the difference is very evident. The introduction of the "court" style in Flanders represented a rupture no less significant than what occurred more than a half-century later with the Van Eycks. But this rupture, unlike that caused by the art of the Van Eycks, whose genius was rooted both in regional tradition and in court art, must be understood primarily as a result of importing stylistic change. There is no doubt that the marriage of Philip the Bold with the daughter of the Count of Flanders and its political consequences were significant factors of change from an artistic perspective; even taking into consideration a more calligraphic sensitivity in Flanders, starting in the 1370s, art might have followed other more "provincial" paths, as attested by the work on the Bruges town hall, begun in 1372 by the sculptor Jean de Valenciennes.[11]

Art in the Court of Flanders before Contacts with Paris (1346–65)

To understand the patronage of Louis de Male (1346–84), we must first return to Ghent. This was the city favored by the court, a princely presence in an urban landscape. It was in this leading and most rebellious city in Flanders that the count wished to demonstrate his power. This presence would take on an even more overtly political character under the dukes of Burgundy. They no longer resided at Gravensteen, the impressive count's castle built by Philippe of Alsace upon his return from the

Holy Land in 1178. Instead, they sought out less austere accommodations that were better adapted to the requirements of a princely entourage in this era.[12] The first and foremost among the residences in Ghent was called Poterne. Its posterity would remain closely connected to the errant behavior of a count famed for his vigor. Purchased by the Dampierres at the beginning of the fourteenth century, the building was a vast palatial complex. In addition to two apartments designed for private use, the "hostels of Artois and Flanders," it included a huge ceremonial hall known as the "old hall of Flanders." At the same time the Sersanderswalle property was remodeled, or more accurately, it was reconstructed. This property, on the site of the fortification of Ghent's feudal lord, had been confiscated upon the death of the powerful Italian banker Simon de Mirabello (died 9 May 1346).[13] The buildings that would form the Hof ten Walle, and later the Prinsenhof (Court of the Prince), have disappeared, but it is still possible to get a reasonably accurate notion of the site as it appeared after the construction campaigns of the fifteenth and sixteenth centuries from Sanderus's engravings published in 1641. In the center of an island ringed with large moats, whose water was supplied by the nearby Lieve canal, the count's oratory and the chapel stood side by side. Adjoining the chapel's south wall was the large amphitheater built during the first major construction program undertaken by Louis de Male.[14]

Construction was begun in the 1350s, and the vast work was approaching completion some ten years later. This chronology leads us to believe that an individual named Sanders de Tournai delivered sculptures intended for the upper levels of certain buildings (including his "lordship's chamber") in 1361–62.[15] The chapel's painted decoration was begun at the end of 1365, perhaps in anticipation of the marriage of Margaret and Philip the Bold; some of the festivities took place at the Hof ten Walle. This work was entrusted to the painter Jan Van der Asselt. In exchange for an annual pension of 20 pounds he was ordered by the count on 9 September 1365 "to employ his mastery of painting in our chapel in Ghent and elsewhere, where it shall please us, without taking on any other work without our consent and leave."[16] With the granting of this pension, this artist from Ghent attained the status of a true court painter.

The only known decorated manuscripts belonging to Louis de Male were executed during the same period, shortly before the first interactions with Paris in 1365.[17] These are the so-called *Louis de Male Breviary* in Brussels[18] (figs. 1, 2 and cat. 17), as well as the two-volume *Missal* (one for summer and one for winter) in Brussels[19] and The Hague[20] (figs. 3, 4). Forming part of Philip the Bold's bequest to the library of Burgundy, these two manu-

Fig. 1

Fig. 2

Fig. 1. Breviary of Louis de Male, fol. 14r. Brussels, Bibliothèque Royale Albert 1.

Fig. 2. Breviary of Louis de Male, fol. 43r. Brussels, Bibliothèque Royale Albert 1.

Fig. 3. Missal, fol. 115v. Brussels, Bibliothèque Royale Albert 1.

Fig. 4. Missal, fol. 11v. Brussels, Bibliothèque Royale Albert 1.

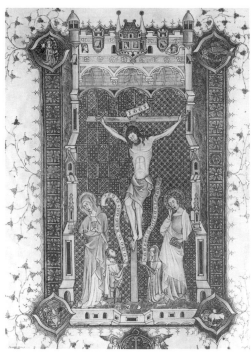

Fig. 3

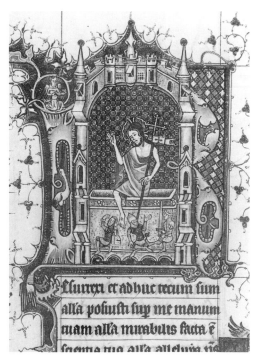

Fig. 4

scripts are closely related in style. In Patrick De Winter's view, they are the work of a Brussels workshop.[21] Judith H. Oliver has suggested more recently that the manuscripts should be attributed to a Mosan atelier (possibly Liège),[22] because of a number of stylistic similarities and the calendar of the missal (Saint-Trond usage). Both assumptions are based on the colophon text of The Hague version that alludes to a man named Arnold van Oreye, Lord of Rummen, Baron of Quaerbecke and Count of Chiny, who is known to have had land in the Mosan region, but who also maintained a close relation-

with J.-P. Esther, who believes that these miniatures in the Brussels and The Hague manuscripts could be the work of court painter Jan Van der Asselt,[26] these biographical details do lead us back to the first hypothesis of a Ghent origin.

As early as 1937, Frédéric Lyna recognized the clear English influence of these two manuscripts.[27] Lynda Dennison reaches similar conclusions in her two recent studies. In particular, some similarities have been established with a group of English manuscripts executed for the Bohun family in the second and third quarter of the

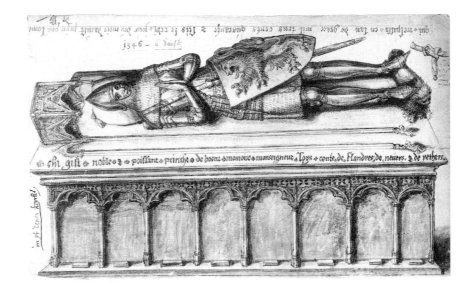

Fig. 5. Memoirs of Antoine de Succa, fol. 90r, *Drawing of the Tomb of Louis de Nevers at Saint-Donat de Bruges.* Brussels, Bibliothèque Royale Albert 1.

ship with the Brabant court.[23] In fact, this biographical argument could also be used to support the Ghent side.[24] The coat of arms of the Count of Flanders and his wife in the Brussels breviary are certainly not a later addition as some have believed, but rather confirm that this work was indeed executed under the orders of Louis de Male.[25] The manuscript also has a calendar for Ghent usage, specifically that of the Benedictine abbey of Saint-Pierre du Mont-Blandin, known for its close ties with the count's family. According to De Winter, this breviary's psalter portion (fols. 14–224) is the Saint-Chapelle usage, which would perhaps suggest a special liturgical purpose for the palace chapel (perhaps that of the Hof ten Walle). In conclusion, it may be significant that Arnold de Rummen, who commissioned the missals of Brussels (a copy was included in the library of the Count of Flanders) and of The Hague, married Elizabeth van Lierde (Isabelle de Zomergem), half-sister of Louis II de Nevers and the widow of the influential Simon de Mirabello. (She was also the illegitimate daughter of Louis I de Nevers, and thus the aunt of Louis de Male!) Without fully agreeing

fourteenth century.[28] It is not important whether one of the artists from the Bohun workshop immigrated to England from Flanders as she suggested, or whether the manuscripts were executed in Flanders by an English artist, or were simply direct influences from English models. The creation of decorated liturgical books showing such stylistic affinities with English illumination casts a special light on a turning point in the count's court during the 1360s. One of the colophons of The Hague missal mentions the year 1366, thus assigning some of the decoration to an earlier date. This makes sense in light of the intense negotiations under way between 1362 and 1364 with the English court to arrange a marriage between the daughter of the Count of Flanders and Edmund Langley, the Earl of Cambridge and the son of Edward III.[29] The regional characteristics nevertheless remain very obvious in the iconography of the decorations in the margins illustrating Flemish proverbs, whose tradition in Ghent was well established by the end of the thirteenth century,[30] and magnificently embodied by illuminators such as Jean de Grise[31] at the beginning of

the fourteenth century. This element of the Brussels breviary, with the coat of arms of the Count of Flanders and his wife, should be emphasized when considering the origin of the manuscripts acquired and executed under the command of Philip the Bold after 1384, which were all of French, and probably Parisian, workmanship.[32]

Several years earlier, toward the middle or the end of the 1350s, Louis de Male commissioned a tomb in the memory of his father, Louis II de Nevers, who was killed in the battle of Crécy on 26 August 1346, and whose remains had been repatriated to the abbey of Saint-Riquier at Saint-Donat in Bruges in 1352.[33] A church register dated between 1358 and 1362, which includes a list of the carved items prepared for delivery, leads to the conclusion that the tomb was almost complete at this time. Although it was destroyed in 1785, several older representations remain. The most reliable, or the most detailed at least, is a drawing from May 1615 by Antoine de Succa (fig. 5), a document that is all the more interesting since it was prepared before the tomb was moved within the church, when several changes had to be made to it.[34] The monument is built in the traditional form of a tomb-mausoleum. On top of the tomb, which older descriptions depict as being of polished black stone (from Tournai or Dinant?), the effigy, dressed in a coat of mail and armor plates, his head resting on a cushion, lies recumbent under a canopy supported by small double columns that frame the effigy, while on the base twenty-four arcatures house statuettes, most likely people carrying shields. We know from Antoine de Succa that these statuettes, as well as the effigy, were made of alabaster, a term that is often incorrectly used in older texts to describe white marble. It seems to have been a novelty in Flanders to use any material of carboniferous calcium that is dark in color. By making this choice, the commissioner of the work wanted to demonstrate his desire to glorify, through this stonework depicting the heroes of Crécy, the Flemish line of the Dampierres. Having been commissioned and completed before the first close ties were made with the Valois court, the monument offers nothing strikingly progressive in its general design, although it does belong to a long tradition of funerary art in this region dating back to the middle of the thirteenth century.

Art in the Court of Flanders at the Time of the Arrival of the Valois of Burgundy (1365–84)

The Anglo-Flemish alliance, although it failed to consecrate the union of Margaret and Edmund Langley, represented an unacceptable threat to the crown of France. Avignon, in the heart of the intrigue, allied itself closely with Charles V. At the same time Charles's younger brother, Philip the Bold, began to make known his French claims to the hand of the daughter of the count, "the noblest, richest, and greatest in all of Christendom," wrote Christine de Pizan. Making use of the same instruments of spiritual jurisdiction that allowed him to veto the wedding plans for Edward III's son, Pope Urban V granted dispensation to Philip and Margaret to marry in 1367, although they were blood relations of the third or fourth degree. The marriage took place in Ghent on 19 June 1369, in the large chapel of the abbey of Saint-Bavon. The celebration, which lasted for three days, included sumptuous festivities,[35] the high points of which were shared between the Saint-Pierre abbey and the Hof ten Walle, which had recently been restored as a luxurious residence. Very quickly, despite his mistrust of Charles V, the count took a liking to his son-in-law. The Valois Duke of Burgundy apparently even began to exercise a certain influence over his father-in-law, probably through the intervention of his wife and her grandmother, the very French Margaret d'Artois.

Nevertheless, the lavish funerary chapel dedicated to St. Catherine, built in Courtrai by Louis de Male right after the marriage (1370–74),[36] did not in any way suggest adherence to the dynastic alliance with the house of Valois. To the contrary, it seemed to be driven by the desire of a prince who wanted above all to have his name inscribed along with the Flemish line of his predecessors. Already the location was highly symbolic. The church of Notre-Dame was situated in the enclosure of the count's most important castle. The funerary chapel was to be adjacent to its choir. Notre-Dame was not only attached to one of the most important of the count's residences, according to Froissart. It was in this

Fig. 6. Chapel of the Counts of Flanders, 1370–74. Collegiate church of Notre-Dame, Courtrai.

Fig. 7. Chapel of the Counts of Flanders, 1370–74, view of the interior. Collegiate church of Notre-Dame, Courtrai.

Fig. 6

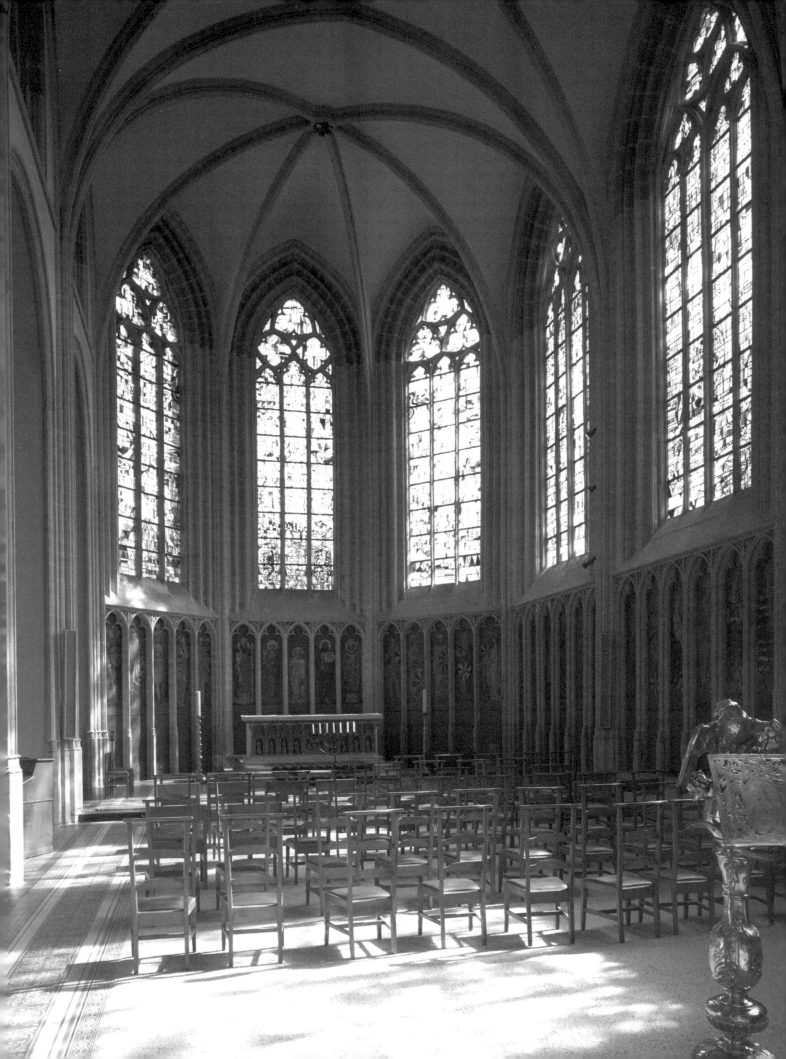

Fig. 8. Chapel of the Counts of Flanders, spandrels, *Scenes of Chivalry,* c. 1372–74. Collegiate church of Notre-Dame, Courtrai.

Fig. 9. Chapel of the Counts of Flanders, spandrels, *The Annunciation* and *The Visitation,* c. 1373–74. Collegiate church of Notre-Dame, Courtrai.

Fig. 10. Chapel of the Counts of Flanders, portraits of the counts of Flanders, drawing executed in 1858 shortly after the discovery, by De Busscher (1872). Collegiate church of Notre-Dame, Courtrai.

Fig. 8

Fig. 9

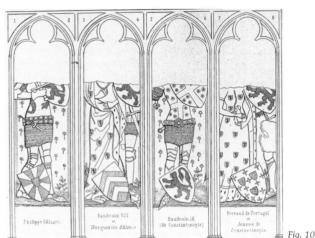

Fig. 10

church that five hundred pairs of golden spurs taken from the bodies of French knights who fell on the battlefield of Courtrai in 1302 were hung, suspended from the vault of one of the radiating chapels, a treasured relic for the people of Flanders.

According to the plans and elevations, this chapel, with a single nave and a large stained-glass window set with stone, was modeled after Sainte-Chapelle in Paris, a prototype for chapels in palaces and castles. Built from Tournai stone, the building, at its exterior at least (fig. 6), is similar to a number of contemporary structures in Tournai that are marked by a certain conservatism: the choirs of Saint-Jacques and Saint-Piat in Tournai, erected between 1350 and 1360, and that of Saint-Pierre in Lessines. The interior structures in white stone (fig. 7), however, are clearly part of a much more progressive Late Gothic tradition that began to flourish in Flanders, initially in Brabant. In particular, the series of fifty-one blind niches on the lower part of the walls under the large stained-glass windows, decorated with their 102 carved spandrels representing scenes from chivalry (fig. 8) and the New Testament (fig. 9), and fantastical animals, corresponds to a characteristic formula of this Brabant style.

Only a small part remains, dating to the early stages of work. It must have been designed to accommodate a plan to paint the blind surfaces with a series of full-length portraits of the counts and countesses of Flanders, beginning with the first four "foresters" (fig. 10). This choice was mandated by the funerary purpose of this dynastic chapel. It is striking to note the close similarity of this genealogical grouping with traditional processions of shield bearers at the bases of the tomb-mausoleums. Even the articulation of the architectural superstructure is modeled on the rhythm of the arcatures. Although it has not yet been proven, is it possible that the inspiration was drawn from the decorative painting of the Ghent chapel in the Hof ten Walle, where work had begun seven years earlier? In any case, the artist in charge of this decorative work in Courtrai was none other than the court painter Jan Van der Asselt, who was still attached at that time to the service of the Count of Flanders.[37]

The construction of the chapel at Courtrai is linked to the construction of a "new tomb" for the effigies of Louis de Male and his wife, Margaret de Brabant. Instead of calling upon a local atelier (in Tourain, Bruges, or Ghent) for this project, as was the case for the tombstone of Louis II de Nevers, an artist of international acclaim was commissioned. A native of Valenciennes and French by adoption, André Beauneveu had worked for Charles V. The purity of the forms he chiseled in the marble was immediately felt in the litany of heraldic processions,

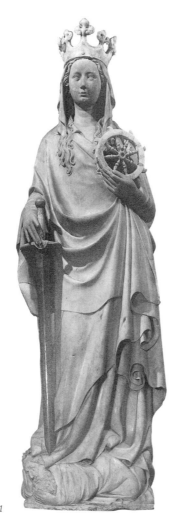

Fig. 11

following the example of Sluter in Dijon, could have been given a work-space or atelier in Ghent by the count, attached to one of his residences? This assumption is at least more convincing than the improbable idea that an atelier existed in the château at Lille. Two inventories of materials for the tomb from the château, prepared between 1388 and 1395,[42] indicate the presence of tools, raw blocks of marble, and wooden models.

The length of time the work took also raises certain questions. There is no doubt that many interruptions during the term of the project slowed the pace of the work, with Beauneveu in Malines from 1374 to 1375, and in Ypres and Cambrai in 1377. The sculptor from Valenciennes, who was knighted in 1371,[43] did not seem to be the type of court artist, like Jan Van der Asselt, who felt that the privilege of receiving an annual pension restricted him to working exclusively for the prince who had commissioned him. Is this why the work on the tomb

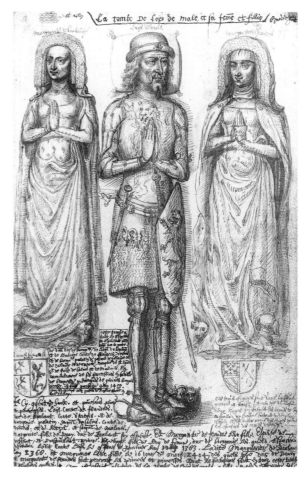

Fig. 12

freed now from any search for illusionism. The figures have a rhythmic cadence with their fluid vestments marked by elegant and aristocratic lines,[38] just as, in illuminated manuscripts, the clarity of the concept of the spatially unified compositions, with anecdotal digressions in the fantastic decoration in the margins, echoed the tight structure of French, the language of the court at that time.[39] All of this leads to the assumption that Philip the Bold chose the sculptor from Valenciennes.

Philip was accompanied on a long tour around Flanders, from March to July 1375, by another well-known French artist, the enigmatic Jean d'Arbois.[40] Documents published by Jan De Cuyper help reconstruct the general chronology and circumstances of the work that began between April and November of 1374. The work was still under way on 5 January 1381, when the count's chamberlain, Henry de Douzy, was sent to the sculptor "in Ghent for our images."[41] Is this a clue that Beauneveu,

was interrupted in 1381?[44] Other political reasons have been offered in response to this question. Beginning in 1379, the revolt in the towns spread fire and bloodshed throughout the duchy. The capture of Courtrai in 1382 was without question one of the most painful moments in the region's history. The defeat must have influenced the count's decision to relinquish his newly built chapel and to select another location for the sepulcher, in his third and last will, dated 29 January 1384.[45] He chose Lille, where the elements of the tomb were transferred in 1386.[46] The famous statue of St. Catherine, still in the chapel of Courtrai today (fig. 11), is the only vestige of the work produced by the sculptor of the court of Charles V. Its stylistic characteristics, together with all the documentary evidence (especially the two pronouncements of 20 May and 1 July 1386, in which the master and lord of the château of Lille authorize the return of the precious marble statue[47] to its Courtrai origins) leave no doubt as to its paternity.[48] The effigies, which had been completed according to the inventory of 1388, assuming it is correct, have disappeared.

However, it is possible that their memory has been preserved for us, through a surprising coincidence. When passing through Lille in February 1602, Antoine de Succa left several drawings of the new tomb built in the chapel of Notre-Dame de la Treille attached to the collegiate church of Saint-Pierre. They show personages from the genealogical line at the tomb's base that were the same as the effigies of Louis de Male, Margaret de Brabant, and their daughter, Margaret de Male, whose remains had been interred in the family vault in 1405 (fig. 12).[49] Destroyed in 1793, this monument had figures made of bronze (or brass), including effigies "with a long *gette* of bronze," commissioned between 1454 and 1455 by Philip the Good from Jacques de Gérines,[50] a caster from Brussels. However, as correctly stated by Claude Gaier,[51] the type of plates used for the count's armor and the way he parted his beard and mustache belonged to a style that was in fashion between 1360 and 1380.

The two female effigies present a more complex problem. While certain details of their costumes, and particularly the crimped hairstyle, point to a date toward the end of the fourteenth century, their general style does not indicate any such specific date. Their proximity could be explained by the assumption that a wood effigy based on an earlier model for Margaret de Brabant was used for casting the effigy of Margaret de Male. It is appropriate to note in this regard that the representation in the same book of Succa's drawings of the wood effigy from the tomb of Jeanne de Brabant, formerly with the Carmelites in Brussels (about 1458–59), is thought to have been recovered from one of the models used by Gérines for the tomb in Lille.[52] It corresponds trait by trait to the effigy

of Margaret de Male and not to that of her mother. Is it possible that Gérines reconstructed, for the tomb in Lille, a more or less reliable copy of the earlier effigies attributed to the chisel of Beauneveu—at least the effigy of Louis de Male, which the inventory of 1388 lists as being "just like the Count of Flanders"? These effigies had been transferred to the château in Lille (located near the collegiate church of Saint-Pierre) before 1386 and may have still been there in 1454–55. Can it be supposed that, if there were technical models executed *ad similitudinem*, the caster or the image cutter responsible for the execution of these models—the possibility that Jean Delemer, who came to Brussels four years later for the tomb of Jeanne de Brabant, had been subcontracted to Lille, should not be dismissed—would have been content to produce the identical images, almost eighty years later, without looking for a way to update their appearance or their garb? Did the caster simply use a mold of the earlier effigies or wood models, included in the inventory of 1388, to cast the bronze and brass effigies?

Under this assumption it would be appropriate to question the stylistic value of the effigies of Lille and the relationship that could be detected with Beauneveu's style. There are differences between the effigy of the count as it appears in Succa's register and that of Charles V in Paris that admittedly do not a priori support the conviction that the work is from the same hand. The sculptor from Valenciennes certainly could have worked from drawn models provided by a local artist, and thus adapted them, indirectly, to the taste of his Flemish patron. This is the most probable explanation. One cannot fail to note that the first mention of this is in the accounts pertaining to the initial expenses for the count's tomb, from April to November 1374,[53] where it is specifically included under the same heading as the court painter Jan Van der Asselt. The two artists, who came from Valenciennes and from Courtrai, seem to have been summoned together to Ghent by the count. All evidence leads to the conclusion that this must have been a preliminary interview, an initial meeting, before the work was begun. Succa's drawing, while it may have been a reutilization of the fourteenth-century effigies, provides valuable evidence that is all the more important since it is paired with a portrait in profile, which can be identified from two representations in the same manuscript from Brussels (fig. 13) and the famous compendium of portraits in Arras[54] (fig. 14). It is the only image that has been passed down to us of the last of the Dampierres.

Reversing a Difficult Succession

Despite the crushing victory of Rozebeke (16 November 1382), the revolt of the towns of Flanders was not finally settled with the death of Louis de Male. It was

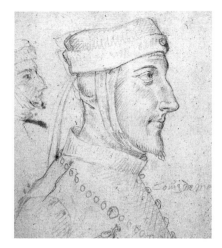

Fig. 13

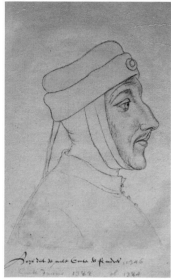

Fig. 14

Fig. 13. Memoirs of Antoine de Succa, fol. 22r, *Portrait in Profile of Louis de Male.* Brussels, Bibliothèque Royale Albert 1.

Fig. 14. Portrait collection, fol. 54r, *Portrait of Louis de Male.* Arras, Bibliothèque Municipale.

not over until the peace of Tournai, on 18 December 1385, which restored to the people of Ghent their privileges, thereby completing the accession of the Valois of Burgundy to the count's throne.[55] Philip the Bold's first task, during these two uncertain years, was to strengthen his fragile authority over his Flemish subjects. The ritual of major ceremonies and joyous entrées were powerful demonstrations of legitimacy, and contributed to this goal. He inaugurated a style that would be used systematically by his successors in the houses of Burgundy and Hapsburg. The first opportunity came his way on 28 February 1384, with the funeral of the Count of Flanders. It was celebrated with great pomp at Saint-Pierre in Lille in the presence of an impressive number of Burgundian and Flemish nobles, magistrates from the towns, and high dignitaries of the Church.[56] Richard Vaughan was right when he recognized that by paying homage to the old dynasty, the new dynasty offered a gesture of investiture, creating a new geopolitical entity that united for the first time, under one government, both Flanders and Burgundy. [57]

One would expect that these ambitious productions, with a message that was meant more to convince than to dissuade, would be reflected in the proliferation of grand artistic commissions. However, that seems not to have

happened. Apart from the inevitable paintings of standards and banners, the ducal orders for Flanders were relatively infrequent. This is especially evident when comparing the sparse list prepared from Flemish documents with what we now know about Burgundian patronage from the inventory of furnishings and general receipts from Dijon, where the introduction of prestigious works drained a large number of artists from the former Low Countries.[58] This observation comes across so clearly that one must ask to what extent this flow of artists to Burgundy may have caused, like the physics law of connected vases, the reversal of an apparent artistic apathy evident in these courts of the North. One good explanation lies in the deteriorating political scene, which was not at all conducive to artistic enterprise; but the diaries of Philip the Bold published by Ernest Petit reveal another part of the story.[59] The worldly horizons of the duke and his close entourage and their pleasure trips, which encouraged the commissioning of works that pleased the eyes first and foremost, were oriented to the South, far from the vast misty plains of Flanders. Although the first Valois of Burgundy included among his assets many sumptuous works for his Burgundian domains, including Champmol and his ducal palace in Dijon, Germolles warranted only more modest works that did not leave the legacy of a sovereign master-builder and patron in the territories "over there."[60] After 1384, there were certainly several projects to restore and enlarge the count's residences, such as Prinsenhof in Brussels, the Hôtel Rihour in Lille, the Hof ten Walle in Ghent and Zaelhof in Ypres; Broederlam worked on the last two.[61] However, is it appropriate to evaluate these investments in comparison to prior and future work, which continued to be described in detail during the fifteenth century in specific accounts and books on construction campaigns, with receipts from the bailiwicks and domains?

In fact, during these difficult times, the urgent needs of Flanders were focused elsewhere. Architectural energy was dominated by large defensive works, which absorbed the essential part of the financial resources. Their strategic nature contrasted with the work on luxurious homes for the happy-go-lucky and "light" lands of Burgundy. After Louis de Male's death, large restoration and reconstruction campaigns were undertaken in most of the count's châteaux that had been ransacked during revolts. These included Audenarde, which had remained faithful to the count, and the fortresses in Antwerp, Beveren, Aardenburg, Ruppelmonde, and Male near Bruges. Beginning in the 1390s, the castles in Lille and Orchies were also included. The marriage contract of 1367 had guaranteed them to the heir of the Count of Flanders through retrocession. In Courtrai, the former count's château, destroyed in 1382, was rebuilt on a new site, at some

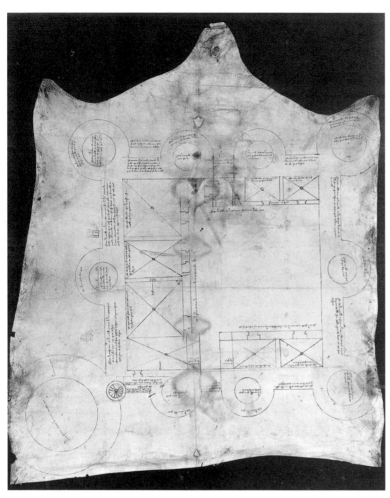

Fig. 15. Plans of the Cathedral of Courtrai, c. 1394. Brussels, Archives Générales du Royaume, maps and plans.

distance from the original.[62] The plan sent by the master mason Henri Heubens in 1394 to the master mason of Saint-Omer, with instructions for him to submit the plan to Philip the Bold for approval,[63] is one of the oldest documents of its type from the former Low Countries (fig. 15). The new stone fortress of Écluse (Sluis) and its "Burgundy Tower," controlling access by sea to Bruges and Damme, in particular, took all of the duke's attention. The choice of master architect reflects the level of importance ascribed to this ambitious enterprise, for which Charles VI was asked to provide financial support in 1402. They called upon a Frenchman named Drouet de Dammartin, who had been promoted to "master architect for all works throughout the country" by letter patent dated 20 February 1384 (not even one month after the death of Louis de Male). He had already distinguished himself on several major works for the Valois family:[64] he had worked on the Louvre for Charles V, and on Jean de Berry's ducal palace in Bourges and his Hôtel de Nesle in Paris. In 1387, another French master craftsman, Raymond du Temple, the royal architect, was also called upon for his expertise.

Artistic Choices for the Great Prince of the West

Some of the artistic choices made by the Duke of Flanders seem to echo the difficult conditions he confronted when acquiring the title of count. From what little can be deduced from the rare surviving written documents and reports, there was a shift in the political atmosphere toward a very French orientation, similar to that observed in the era of royal patronage.[65] The universe of imagery in both ephemeral representations and works created to endure, such as sculptures and tapestries, was no longer confined exclusively to dynastic or devotional purposes. Instead, like these developments, those in art at the courts of the English kings Edward III and Richard II,[66] reveal an awareness, not of style, but of the potential to transform images and works of art into instruments that could legitimize power or serve as propaganda.

The first important commission by the Duke of Flanders, shortly after the death of Louis de Male, carries a message that is not at all ambiguous. In 1385–86, Michel Bernard, the weaver of Arras, received two payments totaling the large amount of 4,140 pounds—the order must have been placed at the beginning of 1384 and not, as has sometimes been suggested, in 1382—for a "cloth of *hauteliche* with the history of Rozebeke.[67] An image commemorating a very recent event, especially one with such broad political implications, would have been perceived by the Flemish subjects of the duke as unprecedented.[68] Had Rozebeke (West-Roosebeke, between Ypres and Roulers) not been the stunning revenge of the French

knights for the victory of the Flemish infantry at Cour-trai? This idea of representing a contemporary episode in a great work of art was more familiar in the milieu of the French court. Philip the Bold himself had no doubt admired a mural of a comparable theme, in the grand gallery of his Hôtel de Conflans, inherited from Margaret d'Artois. It depicted the expedition to Sicily by Robert II d'Artois and was commissioned in his memory by his daughter Mahaut.[69] In later years, Charles VI made similar commissions. In 1397, he ordered Nicolas Bataille and Jacques Dourdin to create a large wall hanging depicting the *Jousts of Saint Denis;* this event had taken place some eight years earlier. A similar piece represented the *Jousts of Saint-Inglevert*, also a contemporary event. In turn, the Duke of Burgundy had commissioned the famous tapestry known as *Berthran de Claiquin* that repre-sents the knightly deeds of Bertrand de Guesclin,[70] noted in the inventory of Charles VI's tapestries in 1422.

The precise origin of the Rozebeke tapestry has never been clearly established, but its presence in the 1536 inventory of Carlos V of Spain supports the supposition that it was indeed woven and intended to remain in Flan-ders. Wolfgang Brassat has suggested that it may have been designed as a decoration for the façade of a building; it would have been hung in a sheltered spot, and served as a sort of artistic history lesson.[71] It seems far more likely that it was meant to be displayed in an enclosed amphitheater. What we know of the design of the halls of the Hof ten Walle and Poterne does not seem compat-ible with the hanging's imposing scale (no less than 40 meters long by 5 meters high). However, the symbolic scale and function of Gravensteen's very spacious great hall in Ghent would be the venue of choice for such an iconographic display. It was a place traditionally linked to the power of the count, even though this vast hall on the ceremonial floor of the château did not become the audi-ence hall of the Council of Flanders until twenty years later in 1407.[72]

Barely three months after the death of Louis de Male, Philip the Bold issued a document revealing that he remained oriented toward Paris, at least in artistic matters. In May 1384[73] he appointed Melchior Broed-erlam as his "painter and personal valet,"[74] a title hith-erto unknown in Flanders. The responsibilities implied[75] by this term were apparently inspired by the customs of the court of Valois.[76] With this position came an annual pension of 200 francs, more than ten times the amount received by his predecessor, who had worked for the count. In contrast to Jan Van der Asselt, Broederlam also received authorization to live in his native city of Ypres, where he continued to manage his atelier.[77] This large

disparity in the treatment of the two artists emphasizes Broederlam's privileged status and, more fundamentally, proclaims the radical change in the relationship between the court artist and his princely patron. This change could only have occurred as a result of directives from the duke himself. It is the image of the artist that is at stake here, an image forged in the melting pot of the court in Paris. Broederlam had indeed held the position of official painter in the court of Louis de Male from 1380 until 1381 (he was "Melsior, his lordship's painter").[78] He had replaced Jan Van der Asselt, who ceased to receive pension payments in 1380 and, quite understandably, entered the service of Philip the Bold in 1384. More prosaic considerations of a political nature may also have played a part in convincing the Burgundian Valois of his choice of father-in-law. The painter came from an old Ypres family. They had taken the count's side from the time his troubles began.

The sculptor Jacques de Baerze[79] also hailed from a city that remained loyal to the count.[80] However, these origins do not seem to have been the primary reason that Broederlam was chosen to paint the two retables of the *Passion* and *The Martyrs of Dijon*. In a later phase of this project, he was asked to paint the reverse side of the shutters. The production of large sculpted wooden reta-bles, a tradition going back to the first half of the four-teenth century in Flanders, did not exist in Burgundy. It was therefore perfectly logical to call upon Jacques de Baerze, a Flemish sculptor, who had carved two large retables for Louis de Male several years earlier. They were installed in the chapel of Louis's Château de Termonde and the abbey of Byloke in Ghent. The real novelty did not lie in the fact that a type of art unfamiliar to Burgun-dians was being exported to Dijon. The more striking development was the treatment of the reverse sides of the shutters of the *Passion* retable, which were painted like panels. A pictorial technique previously reserved for small paintings, generally intended for private devotions and intimate in nature, had been adapted to the large scale of a liturgical altarpiece. Originating on the reverse side of the panels, this technique would be adapted to the interior faces, which were displayed for most of the liturgical year. The exterior faces were used to depict figures in grisaille, evoking the memory of sculptures displayed in niches. The culmination of this evolution in the second quarter of the fifteenth century can be seen in the great triptychs and polyptychs that are entirely painted. A magnificent example is the *Last Judgment* retable in Beaune, another masterpiece of the former Low Countries that remains, to this day, one of the glories of Burgundian collections.

NOTES 1. For an overview of the historical background, refer first to Vaughan 1962, and then to Blockmans and Prevenier 1999, pp. 14–34.

2. For a quick analysis of this issue, see the recent work Borchert 2002, pp. 9–25.

3. Baron 1981, p. 61. Note that the term "Franco-Flemish art" refers back to Courajod (1885, pp. 217–18).

4. This concept of pre-Eyckian art refers back to Lyna (1946–47, pp. 106–18).

5. De Coo 1958, pp. 186–98; De Coo 1960, pp. 222–28; Van Puyvelde 1912, pp. 246–48. Gifford (1995, pp. 357–70) arrived at a similar conclusion based on the study of the pictorial technique of the Baltimore panels of the Antwerp-Baltimore quadriptych. For more recent scholarship, see Mund, Stroo, Goetghebeur, and Nieuwdorp 2003, pp. 255–87.

6. Stroo 2002, pp. 1273–294.

7. For a critical analysis of this issue, see Comblen-Sonkes 1986, pp. 106ff.

8. With regard to Hesdin, refer first to the well-documented work of Anne van Buren-Hagopian, with particular reference to 1985B, pp. 33–55, and 1996, pp. 26–233.

9. For a study of this issue and a bibliography, see Cavallo 1993, pp. 137–47.

10. See the entry "Broederlam, Melchior" in Van Buren 1996, 840–42.

11. On this topic see the reference article, Janssens de Bisthoven 1944, pp. 7–81.

12. Recent work, Boone and Hemptinne 1997, pp. 279–88.

13. With regard to this person, who played an important role at the time of Louis de Nevers, see Rogghé 1958, pp. 5–55, and Kittell 1991, pp. 140–68.

14. Laleman and Stoops (2000, pp. 16ff), and Gelaude, Helskens, Laleman, Laporte, and Stoops 2000, pp. 25–66.

15. Van Elslande 1995, p. 327.

16. Lille, ADN, B 1566, fol. 56v, in Dehaisnes 1886, p. 458. Also see Van Elslande 1987, pp. 422–23.

17. The Somme le Roi in Brussels, Bibliothèque Royale de Belgique (KBR 10320), which according to Patrick De Winter was made and decorated at the request of Louis de Male, was probably commissioned by Philip the Bold. Dominique Vanwijnsberghe has rightly pointed out that the coat of arms of Louis de Male in folio 2 recto is in a position secondary to the monumentally scaled coat of arms of Flanders and Burgundy at the top of the same folio. The presence of the coat of arms of the Count of Flanders may have been no more than a gesture of homage; it is certainly not an indication of the manuscript's provenance. See Bousmanne and Van Hoorebeeck 2000, pp. 226–28.

18. Brussels, BRB, KBR 9427 in Van den Gheyn 1901, no. 512; Gaspar and Lyna 1937, pp. 346–49, no. 144; as a final reference and for a bibliography, see Bousmanne and Van Hoorebeeck 2000, pp. 143–47.

19. Brussels, BRB, KBR 9217 in Van den Gheyn 1901, no. 455; Gaspar and Lyna 1937, pp. 344–46, no. 143, Bousmanne and Van Hoorebeeck 2000, pp. 104–11.

20. The Hague, Rijksmuseum Meermanno-Westreenianum, 10.A.fol.1, as a final reference, see Boeren 1979, pp. 17–18.

21. This suggestion was made by Delaissé (1957A, pp. 256–57, and 1957B, pp. 111–12) and De Winter (1976, pp. 602–13, and 1985A, pp. 227–32, n. 19).

22. This theory was presented by Vandecapelle-Haagdorens (1983), who suggested it was made at an atelier in Saint-Trond. To Oliver (1995, pp. 195–96), who noted the unlikelihood of such an atelier in a remote center such as Saint-Trond, Haagdorens's arguments seem to favor an atelier in Liège.

23. Chestret de Haneffe 1901, col. 248–55, and Baerten 1969, pp. 149–50.

24. Châtelet recently confirmed this opinion (2003, p. 60).

25. De Busscher 1872, pp. 381–421.

26. Esther 1970, col. 22–26.

27. Gaspar and Lyna 1937, pp. 346, 348.

28. Regarding this group of English manuscripts, see Millar 1936, and Dennison 1988. Regarding the Brussels breviary (KBR 9427), which is closely linked to the manuscripts of the "Bohun Workshop," attributing them to an atelier in Ghent, see Dennison 1986, pp. 3–12, 28, and Dennison 2002, pp. 505–36.

29. Vaughan 1962, pp. 4–5.

30. For an overview of this issue, see Carlvant 1978. More recently, Moore 2002, pp. 983–1006.

31. Bober 1947–48, pp. 15–21.

32. Except for the Somme le Roi (see note 17 above), to be attributed to an atelier of the former Low Countries. It would be sufficient here to refer to the list of De Winter 1976, pp. 500–684, and De Winter 1985A, pp. 180ff.

33. A very thorough and authoritative study of the tomb in Bruges was made by Valentin Vermeersch (1976, pp. 45–52). A votive fresco discovered in 1846 in the Leugemeete Chapel in Ghent may depict Louis de Nevers and his son Louis de Male, both dressed in tabards bearing the arms of Flanders, kneeling with hands joined in prayer. For more on this matter, see De Pauw 1899, pp. 254ff, and, more recently (for a bibliography), Bergmans 1998, p. 312.

34. Brussels, BRB, KBR II.1862, fol. 90. See also Brussels 1977, pp. 244–45.

35. See Vaughan 1962, pp. 4–6; Quicke 1947, pp. 139–74, specifically p. 158.

36. Regarding this chapel, see Van de Putte 1875 (outdated study but interesting for its documentary compilation); De Cuyper 1962, pp. 5–54; Van Dorpe 1964, pp. 281–98, and Devliegher 1973, pp. 40–46.

37. Van Elslande 1995, pp. 424ff, and Van der Haeghen 1908, pp. 197–98.

38. Refer to Joubert 1999, pp. 367–84. Regarding Beauneveu's style in the early Low Countries, particularly with regard to the Magi on the south portal of the Hal basilica, see Steyaert 1974, pp. 93ff.

39. See as a final reference Vale 2001, pp. 282–94.

40. See the unedited text (to be published) of a communication from Albert Châtelet, whom we take the opportunity to thank here, given to the Cleveland Museum of Art in 1989. Also see Moench 1986, pp. 220–28.

41. Lille, ADN, B 3236, no. 111758, in Finot 1892, p. 8. As a final reference, for an overview of the biography of André Beauneveu: Scher 1966, regarding the career of Beauneveu in Pays-Bas, pp. 68–96, and, more recently, Valenciennes aux XIVe and XVe siècles 1996, pp. 372–75, comments from F. Baron and L. Nys).

42. Published in Dehaisnes 1886, 2: p. 656.

43. As a final reference, see Warnke 1989, p. 28, list of artists who were knighted, pp. 208–15.

44. The terms of Louis de Male's second will, drawn up around 1381, suggest that work had been suspended as of this date. See Dehaisnes 1886, p. 580, and Van Dorpe 1964, p. 294. "We would place our sepulcher in the church of Courtrai in the chapel of our lady St. Catherine, which we have caused to be built, and wish that our tomb be erected above our body at the instructions of our executors named herein as may seem best to them."

45. A charter dated 1 May 1374 (published in Van de Putte 1875, pp. 5–13) indicates the existence of a previous will, perhaps dating from several years earlier, in which Louis de Male had already expressed the desire to be interred in Courtrai. "We, at our own initiative, with our own goods and for the great affection which we have for our collegial church at Courtrai, have caused to be established and built an entirely new chapel, attached to said church on the southern side, in which we have built our tomb; among other provisions and instructions of our will which we have executed, we have ordered that, to establish and endow our chapel, three chaplains shall celebrate various services and perform almsgiving in perpetuity." In his second will, dated around 1381, Louis de Male again expressed the wish that his remains should be interred in the chapel of Sainte-Catherine in Courtrai (see previous note). These data suggest that Beauneveu had already abandoned work on the tomb by this date, perhaps because of political events. The third and last will, drawn up on 29 January 1384 (Dehaisnes 1886, p. 580; Van Dorpe 1964, p. 294), designates the collegiate church of Saint-Pierre in Lille as his final burial place: "I wish that a tomb be constructed for my body in the Chapel of Notre Dame de la Treille in the Church of St. Pierre by order of my executors, and that candles and cloths of gold and other things necessary and appropriate for my funeral rites be ordered by them."

46. On this topic in particular, see De Cuyper 1962, p. 35.

47. Brussels, AKA, Treasury of the maps of Flanders, CC 1752 (documents dated 20 May and 1 July 1386), in Roggen 1954, pp. 224–25.

48. As a final reference, see Baron 1981, no. 3, pp. 131–32.

49. Brussels, BRB, KBR II.1862, fol. 55r, 56r–58v in Comblen-Sonkes 1986, pp. 169–71.

50. Regarding this tomb, as a final reference, see Morganstern 1992, pp. 140–49.

51. Gaier 1977, 1: pp. 66–67.

52. Campbell 1988, pp. 163–72.

53. Brussels, AKA, CC 2702, fol. 17r in Dehaisnes 1886, pp. 522–24; De Cuyper 1962, pp. 46–52.

54. Brussels, BRB, KBR II.1862, fol. 22r; Arras, Bibliothèque Municipale, MS 266, fol. 54r.

55. Vaughan 1962, pp. 37–38.

56. The account of Louis de Male's funeral is in Brussels, AKA, Chambre des Comptes, Recueils Divers, CC 100, fols. 8r–10v. See Gachard 1837, pp. 222–23.

57. Vaughan 1962, p. 31.

58. On this topic, in particular, see Prost 1902–8, vol. 2; Monget 1898, vol. 1, and the studies of Henri David (1937; 1944A, pp. 137–57; 1944B, pp. 201–28; and 1947).

59. Petit 1888. It is also interesting to look at the accounts of the mansion belonging to the members of the ducal family. See in particular Canat 1860.

60. In addition to Henri David's studies, refer to De Winter 1983, pp. 95–118, and, especially, more recently to Paravicini 1991, pp. 207–63.

61. On this topic, see Dehaisnes 1887, and in particular pp. 12–13.

62. On this topic, see Lavalleye 1930, pp. 157–68; Pauwels 1983, pp. 5–138, and Despriet 1990, pp. 3–9.

63. Brussels, General Royal Archives, Cartes et plans, inv. MS no. 8070 (formerly Chartes de Flandre, 2e série). See comments on this plan in Detroit 1960, p. 354.

64. On this topic, for a general overview, see Bottineau 1973, pp. 237–62.

65. In particular, see Salet 1985, pp. 620–29.

66. On this topic, see Sherborne 1983, pp. 1–27, and Scheifele 1999, pp. 255–71.

67. Laborde 1849, 1: pp. 5, 9. In general, regarding tapestry commissions from Philip the Bold, see Cheyns-Condé 1985, pp. 73–89, in particular pp. 76–77; Joubert 1990, 3: pp. 601–08.

68. On the political nature of this tapestry, see Franke and Welzel 1997, pp. 123–24, and Graf 2001, pp. 199–200.

69. As a final reference, and for a bibliography, see Mérindol 2001, 2: p. 11.

70. On this topic, see Guiffrey 1883, pp. 268–317, in particular pp. 292–94, 311–13; Guiffrey 1886, pp. 35–37, 67. Regarding these tapestries, see also Guiffrey 1887, pp. 59–110, 396–444.

71. Brassat 1992, p. 70 n. 1.

72. As a final reference (and for a bibliography), see Boone and Hemptinne 1997, p. 284.

73. The appointment dates back to May 1384, barely three and a half months after the death of Louis de Male. The first installment for the period from 13 May 1384 to 13 May 1385 was paid in 1385. (25.VI)–1386 (10.III). See Lille, ADN, B 4074, fol. 43r, in Laborde 1849–52, p. 4 n. 22.

74. Regarding Broederlam, see Dehaisnes 1887, and, as a final reference, the summary comments from Anne Van Buren-Hagopian 1985A, no. 10, pp. 840–42.

75. On this topic, see Schwarzkopf 1971, pp. 422–42, in particular pp. 436ff; Martindale 1972, pp. 43–46.

76. And thus to the painter Girard d'Orléans who became painter of the court in 1352 and appeared soon after as the court valet. See Warnke 1989, p. 27. Also see Henwood 1981, pp. 95–102, and, for more general comments, Autrand 1969, pp. 285–338.

77. Warnke 1989, p. 29.

78. Dehaisnes 1887, p. 8.

79. As a final reference see Patrick De Winter in The Dictionary of Art, 16: p. 854. Also see Roggen 1934, pp. 91–107, and Klinckaert 1983–84, nos. 13–14, pp. 10–11, 11–16, 17–19, typed copy.

80. The town victoriously survived the siege of the rebels which took place outside its walls on 19 November 1379; the Count of Flanders had taken refuge there. See Vaughan 1962, p. 21.

17

Breviary, Known as the *Louis de Male Breviary*

Probably c. 1363 and after 1365

Parchment; 228 folios
35.7 x 25 cm
(justification 21.5 x 15.2 cm)

Brussels, Bibliothèque Royale
de Belgique, inv. KBR 9427

PROV.: Bibliothèque de Bourgogne; 1420
inventory (Doutrepont 1977, no. 96);
1467–69 inventory, no. 1124; 1487 inventory,
no. 2015.

BIBL.: Van den Gheyn 1901–48, no. 512;
Baerten 1969; De Winter 1976; Dogaer 1977;
Gaspar-Lyna 1987; Vandecapelle-Haagdorens
1983; Boeren 1988; Oliver 1995.

EXH.: Paris 1951; Liège 1951; Edinburgh
and Brussels 1963; Brussels; 1967; Brussels
and Cologne 1972–73; Louvain 1986.

Exhibited in Dijon only

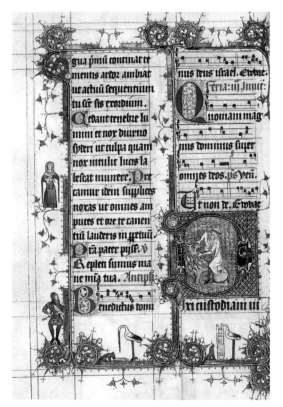

Fol. 62r: Daniel fighting the lion, with scenes from fables in the margins.

This superb breviary (summer section), inventoried in the library of Philip the Good in 1420, features in three places the crest and the coat of arms of Louis de Male, Count of Flanders, which probably overlay earlier coats of arms. The history of this manuscript must be considered together with that of the two-volume missal (cat. 32–33) as well as that of La Haye (Museum Meermanno-Westreenianum, inv. MS 10 A 14). These belonged to Arnold van Oreye, lord of Rummen and last Count of Looz (1363–65), and his spouse, Isabelle de Zomergem (lez-Gand), the illegitimate daughter of Louis de Nevers and a widow whose first husband was an extremely wealthy banker from Ghent. The couple is depicted in folio 19 of the breviary. The history of the codex was written slowly over time. L. Haagdorens is responsible for the identification of the second part of the missal, now in La Haye, which bears a colophon indicating that the manuscript was completed on 12 September 1366 *"a laurentio illuminatore presbitero de andwerpia"* (by Laurent, illuminator and clergyman of Antwerp) while he was staying in Ghent. *"Sic scribi et iluminandi. . . fecit nobilis dominus de rimmen"* (the noble lord of Rummen had him write and illuminate thus). Was Laurent entirely truthful, or did he wrongly take credit for the entire codex?

When the bishop of Liège seized the earldom of Looz in 1365, the Arnold van Oreye and his wife sought refuge in Ghent, where Isabelle owned three properties. Would they have, at this time, created a manuscript bearing the coat of arms of the earldom they had just lost? Or did Laurent write that the manuscript was originally created for the lord of Rummen?

If the superb calendar refers beyond the shadow of a doubt to Ghent, specialists are divided in their opinions regarding the origin of the two volumes. According to Joseph Van den Gheyn, they are from the abbey of Mont-Blandin in Ghent; according to Judith Oliver they are from Liège (bearing in mind the saints cited in the calendar and the two services dedicated to St. Servais and St. Lambert); Patrick De Winter feels they are from Brussels; and according to L. Haagdorens, Saint-Trond is the place of origin (the location indicated in the calendar on the date the relics of St. Trudo and St. Eucherius were transferred; moreover, Saint-Trond is only a few kilometers from the château of the counts of Rummen). It is also conceivable that the breviary was created in Cologne, for at that time this city was a renowned center for the production of sumptuous liturgical manuscripts with the same style of artwork. One plausible explanation for tracing the calendar to Ghent could be that the counts of Rummen, at the height of their splendor, would have commissioned a breviary to use when they were in Ghent. Like the missal, the breviary was acquired by Louis de Male shortly after Arnold de Rummen and Isabelle de Zomergem arrived in Ghent, where, within a few months, Arnold had squandered his wife's fortune (she died on 27 March 1367). In the three manuscripts, the hallmarks and coat of arms of the Rummen were falsified and replaced by the coats of arms of Flanders and Brabant. Similarly, the gold-leaf beading served as supports for small representations of people and animals in the satirical style typical of borders at the time. Some of them allude to idiomatic Flemish expressions or even to fables (fol. 62v). One might wonder whether the work of the miniaturist priest Laurent consisted of erasing, often ineptly, the original indications of ownership in order to add the coat of arms of Louis de Male and his wife, Margaret of Brabant, and updating the manuscript for current tastes by decorating it with droll Flemish motifs. The similarity of style in the drolleries of the three manuscripts is clear and contrasts with the original style of the manuscript, as seen, for example, on the same folio, in the superb initial ornamental letter representing Daniel fighting the lion.

The historiated initial letters have a peculiar quality: the decoration framing the central figure or animal is carefully done in color, while the central section is not, and the rules lines of the parchment are left exposed. It is not clear whether this effect was intended or if this is an unfinished work.

This manuscript bears no inscription indicating its journey to Paris, but the scrape marks, superimposed by stamps of the Koninklijke Bibliotheek (Bibliothèque Royale de Belgique), and a trace left by the red fasces attest to the presence of the manuscript in Paris at the time of the Revolution and its return in 1815.

C.L.

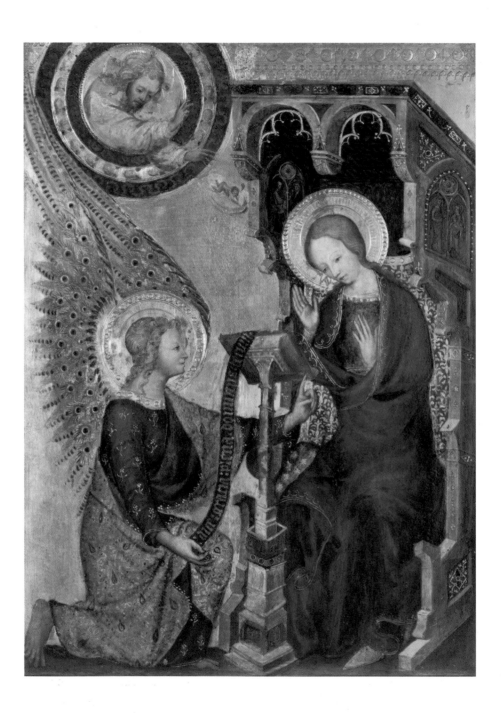

18

Anonymous Franco-Flemish Master

Annunciation

c. 1385–90

Oil on panel
30.8 x 22.5 cm
(with frame 35.2 x 26.7 cm)

Cleveland, The Cleveland Museum of Art, inv. 1954.393

PROV.: John the Fearless(?); Duke of Anhalt-Dessau, 1863 to 1925 (as Duccio); C. A. de Burlet, Berlin; Arthur Sachs, New York and Santa Barbara, 1926.

BIBL.: Robb 1936, pp. 490, 493, no. 13; Frinta 1965, pp. 261–65; Stechow 1974, pp. 21–24, no. 8; Schmidt 1975, pp. 47–63; Scillia 1995, pp. 345–56.

EXH.: Detroit 1928, no. 1; London 1932, no. 1; Paris 1950, no. 6; Cleveland 1963, no. 19.

Judging from its size, this elegant small panel, still in its original frame, probably formed the left half of a portable diptych used for private devotion, as suggested by the missing tooled gesso edge on the right side. The subject of the missing right panel is unknown. However, given the angle of the Virgin and her throne at the right edge, it would probably not have been an image of the donor, but a related scene such as the Crucifixion. The painting's decorative quality and composition are strikingly similar to the *Annunciation* from Baltimore (cat. 74); however, the unusual detail of the Logos in the form of a small nude Christ child descending along golden rays from God the Father can be compared to the *Tapestry of the Annunciation* woven in Tournai (in the county of Hainaut, cat. 10).

The reverse of the painting is richly tooled and partially gilded, and includes the coat of arms belonging to the house of Hainaut. The perimeter decoration of the reverse side also includes a punched decoration of the fleur-de-lis, the royal symbol of France. The painting was commissioned to celebrate a dynastic alliance between Albert of Bavaria, Count of Hainaut and Holland, and Philip the Bold, who as the son of John the Good of France, included the fleur-de-lis in his arms. The alliance took the form of a double marriage in 1385 between Philip's son and daughter, John the Fearless and Margaret of Burgundy, and Albert's children, Margaret of Bavaria and William II, Duke of Bavaria, Count of

Hainaut and Holland. This was an important and expensive commission judging from the generous use of gold leaf, elaborate punching, and pigments of high quality. Philip the Bold was accustomed to commissioning ostentatious and precious objects from leading artists and probably requested the diptych for the marriage of John the Fearless and Margaret of Bavaria (Scillia 1995). The Hainaut arms, associated with Margaret's father, appear on the back of the left panel, while her husband's arms on the reverse of the missing right panel, likely those of Burgundy, would have been visible when the diptych was closed. The subject and the detail of the Christ child are a visual reminder of the expected result of this political maneuver.

The authorship of this painting has been debated. Suggestions have included an anonymous Bohemian master, Jean d'Arbois, or—more convincingly—a Franco-Flemish master. The head of the Virgin Annunciate compares favorably to a small drawing from an artist's model book (Fogg Art Museum, Cambridge) attributed to a Franco-Flemish artist and dated to 1390–1400. Regardless of the painter's identity, he almost certainly painted the so-called *Carrand Diptych*. A clear stylistic link occurs between God the Father and the Virgin in the Cleveland painting and Christ and St. Catherine in the Bargello *Crucifixion*, and the second magus and the Virgin in the Bargello *Adoration*. Likewise, the face of the archangel Gabriel finds a companion in the third magus of the *Adoration*. This argument is strengthened by the appearance of an identical quatrefoil punch in both paintings (Frinta 1965, 264).

T.H.

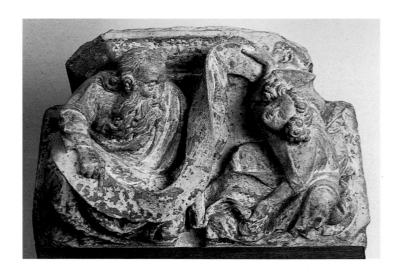

PROV.: taken from the façade of the Bruges city hall; located since the 19th-century restoration at the Gruuthusemuseum.

BIBL.: Janssens-de Bisthoven 1944, pp. 49–50; Vanroose 1970, pp. 57–65; Didier and Steyaert, in Cologne 1978, 1: pp. 81–82; Didier and Recht 1980, pp. 185–86.

EXH.: Ghent 1994.

This sculpture, with its secular theme, was one of a group of historiated consoles depicting religious or secular subjects from the façade of the Bruges city hall. The design was realized by a team of sculptors working under the direction of Jean de Valenciennes between 1376 and 1379.

In the Ghent exhibition catalogue (1994), John Steyaert draws attention to this work, which demonstrates a narrative style, introducing elements of realism that were as prevalent in the Netherlands as in France; indeed, these Bruges consoles are closely related to those on the city hall in Brussels.

The drape of the garment of the woman at the left is modeled in close, concentric folds, rather deeply carved, evoking a strongly plastic impression. Because of this plasticity Steyaert proposed to qualify this sculpture as pre-Sluter, drawing a connection between this depiction of draped cloth and that of the Virgin's robes in the Champmol portal. He further observes that Jean de Marville lived in Bruges during the year 1376, precisely when the sculpture from the city hall façade was being made.

The thrust of this question is to determine the direction of exchange of influences in operation between France and Flanders in the years of Sluter's formation. In other words, some years before Sluter's appearance on the list of stone carvers, masons, and sculptors of Brussels in 1379–80, what was the state of sculpture in Flanders and to what degree could the even younger Sluter have been influenced by it?

S.J.

19

Workshop of Jean de Valenciennes (Bruges)

Console with Lovers and a Woman Washing the Hair of a Man
c. 1376–79

Stone
27 x 47 x 43 cm

Bruges, Gruuthusemuseum, inv. 0.119.VI

20

Virgin and Child
c. 1380

Stone, originally polychrome
98 x 36.5 x 18.9 cm

Antwerp, Museum Mayer van den Bergh, inv. 349

PROV.: Acquired in Bruges in 1893, possible provenance the Saint-Donatien church.

BIBL.: Michel 1924, p. 56; De Coo 1969, p. 140, no. 2133; Didier 1971, pp. 230ff.; Steyaert 1974, pp. 89–90; Nieuwdorp and Annaert 1976–77, pp. 27–35; Hasse 1977, pp. 106–7; Hasse 1978, p. 43; Schmidt 1978, p. 85; Didier and Steyaert 1978, no. 1, pp. 81–82; Didier and Recht 1980, pp. 185–86; Nieuwdorp 1980, p. 20; Didier 1984, pp. 19, 23, 26, 30; Nieuwdorp 1992, pp. 76–77; Smeyers 1993, pp. 30–32; Steyaert 1994, pp. 26–27, 188–89; Frinta 1995, pp. 82–83.

EXH.: Antwerp 1933, 2: no. 158; Cologne 1978, 1: p. 82.

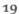

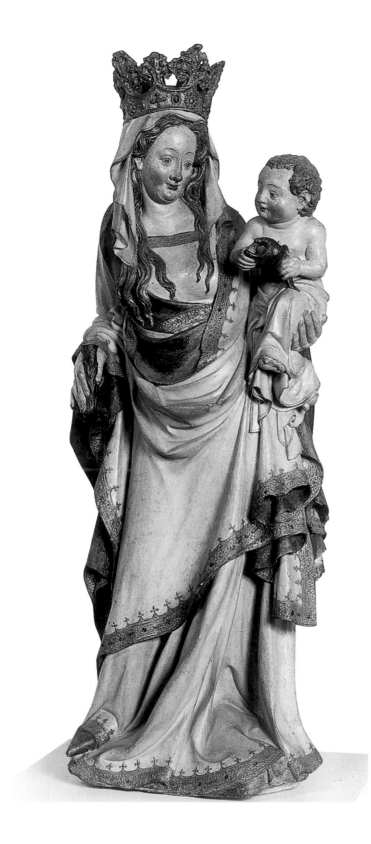

This statue of the Virgin and Child is important in the history of Belgian sculpture, especially the second half of the fourteenth century, which is not well documented. This statue is exceptional because its original polychrome is somewhat intact, extremely rare for a stone sculpture of that time, but made possible in this case by a later protective coating removed between 1970 and 1976.

This work did not draw the interest of art historians until after 1976. Its restoration also called attention to its provenance and location in the Saint-Donatien church in Bruges, which was destroyed in 1799 (Nieuwdorp and Annaert 1976–77). When the piece was exhibited in Cologne in 1978, scholars examined the relationship to its milieu and period (Didier and Steyaert 1978). The work was associated with several decorative sculptures in Bruges dating from 1376 and 1399, as were some of the consoles from the town hall. The style of this Bruges Master of the Madonna of Saint-Donatien is based on models developed in Tournai, like the Virgins of Arbois and Halle (cat. 117).

However, the Bruges sculptor interpreted the movements of the head and the depth of the voluminous folds of the drape with his own personal touch. Sluter's Virgin at the entrance to Champmol seems to reveal these characteristics (see fig. 3, p. 176), which are not found elsewhere. It seems that Sluter was inspired less by the traditions of Brabant or Brussels than by sculpture from Bruges and Flanders, more closely linked to the stylistic evolution of sculpture from Tournai and Paris. If this is true, Sluter's Virgin was based on his knowledge of Bruges sculpture, whether through the intermediary Jean de Manville, who lived there for several months in 1376, or through his own efforts.

Although these influences are not documented, the Madonna of Saint-Donatien remains one of the rare works to be directly compared with Sluter's best works of art in Dijon.

H.N.

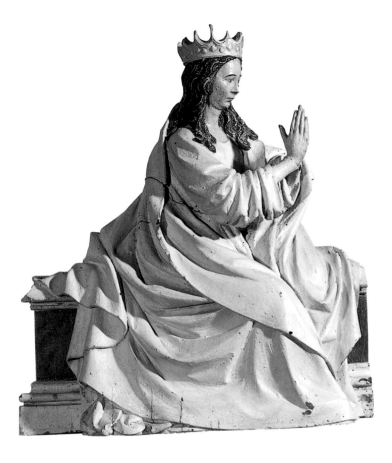
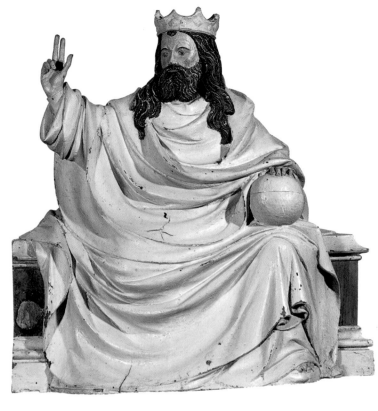

21

Netherlands or Burgundy

The Coronation of the Virgin
c. 1400

Painted wood, repainted
44 x 38 cm (each statuette)

Gray, Musée de l'Art Religieux,
old chapel of the Carmelites,
inv. D 978-6-1 and D 978-6-2

PROV.: from the church of Velloreille-les-
Choye (Haute-Saône).

BIBL.: Gray 1990, no. 36; Didier 1993,
p. 27.

In the collection of the often overlooked Musée d'Art Religieux in Gray, the *Coronation of the Virgin* of Gray has attracted little attention until now. It is probably incomplete—there seems to be a part missing at the center—and was badly served by a later repainting that caused it to be dated to the sixteenth century or fourteenth century. Only Didier (1993) devoted a brief notice to it in his reflection on the artistic personality of Jean de Marville, proposing to situate the group in his circle of influence. Indeed, it is inarguable that the stylistic characteristics of the work, in particular the large drapery in concentric folds, dates it neatly to around 1400.

Jean de Marville's artistic personality is a vexing issue in the history of Burgundian sculpture; it has been addressed by Morand (1991, pp. 53–57), Schmidt (1992), Beaulieu and Beyer (1992, pp. 191–92), and Baudoin (1996, pp. 107–8), all with diverging opinions.

Should we then include this group, which was taken from a church in the Franche-Compté but of whose provenance little else is known, in this study? Even more salient than the connections with Burgundian works—such as the consoles of the Champmol portal, or the fireplace of the Germolles castle, where a similar system of concentric folds is seen on the bust—are the parallels with the figure of God the Father at Hackendover (Ghent 1994, no. 21), which would indicate a Nordic origin for this grouping. Furthermore, the two statuettes are certainly elements from a wooden altarpiece, a form rarely seen in Burgundy except for imports such as the altarpiece of Champmol or, later, those of Ternant.

S.J.

THE RULER, RELIGION, POLITICS, AND ART

RELIGION

Bertrand Schnerb

The Piety and Worship of Philip the Bold and John the Fearless

Confessors and Chaplains

Like all princes of their time, the dukes of Burgundy of the house of Valois kept on hand a clerical staff devoted to their service. The confessor stood at the head of this hierarchy. Chosen from the ranks of the Dominican order, during the course of his career he often attained the position of bishop. Brother Guillaume de Vallan, confessor to Philip the Bold until 1382, became bishop *in partibus* Bethlehem; Philippe Froment, who succeeded him from 1382 to 1396, became bishop of Nevers in 1395. Brother Martin Porée, confessor to John the Fearless from 1398 to 1408, became bishop of Arras in 1407; his successor, Brother Jean Marchant, the duke's confessor from 1408 to 1419, became bishop of Bethlehem in 1411.[1]

The confessor was always assisted by an associate (*socius*), who was designated to succeed him when he left his post and who played a not inconsiderable role. For example, beginning in 1412, Laurent Pignon, socius of Jean Marchant and also confessor to Philip, count of Charolais (the future Duke Philip the Good), was a key figure in the intellectual life of the Burgundy court. The author of a *Traité contre les devineurs* dedicated to John the Fearless, Duke of Burgundy,[2] he subsequently translated the *De origine jurisdictionum* by Durand de Saint-Pourçain and wrote a *Traictié de la cause de la diversité des estaz*.[3] The principal role of the confessor or his socius was to administer the sacrament of penance to the prince, but he might be entrusted with various other duties. And thus in 1386, Brother Philippe Froment purchased a *Catholicon* for the ducal chapel;[4] in 1415, Brother Laurent Pignon went on a pilgrimage by proxy on behalf of John the Fearless.[5]

The chaplain, possibly chosen from among the duke's chaplains, assisted by an under-chaplain and some chaplain's clerics, distributed the moneys that the prince set aside for the poor, relief institutions, convents, monasteries, and churches. "Ordinary alms" were distributed on a daily basis; they represented an outlay of 20 sous per day at the time of Philip the Bold[6] and 8 sous at the time of John the Fearless.[7] However, accounting documents also mention "extraordinary alms" and "secret alms," which, in the latter case, were distributed without revealing the identity of the donor to the beneficiary.

The Chapel

The ducal chapel was an institution that fulfilled essentially liturgical functions. It traveled with the duke as he moved from one location to another and was the designated place for the celebration of religious services at court. It had its own organization, hierarchy, and operations, and beginning in 1397 it was financially and administratively distinct from the ducal residence.[8] At the time of Philip the Bold and John the Fearless, the terms "small chapel" and "grand chapel" were not used. However there was a distinction between a smaller organization, including a number of chaplains assisted by one or two "chapel clerics," responsible for celebrating low masses, and a much more impressive organization, with a musical ensemble made up of singers and choirboys. The chaplains who officiated there were established musicians and the children, chosen for the quality of their voices, received extensive schooling at the prince's expense.

Apparently it was not until 1384 that Philip the Bold had a grand chapel at his disposal, part of which was inher-

Fig. 1

71

ited from his father-in-law, Louis de Male, with the addition of singers recruited from Paris. In 1385 he already had eight chaplains and seven chapel clerics available to him. In the years that followed, the number of chaplains continued to grow, increasing to thirteen in 1386 and leveling off at twenty-one in 1397. Upon the death of his father, John the Fearless did not preserve this grand musical chapel, and the singers consequently were dispersed. For some years the duke employed only two or three chaplains and then fell into the habit of engaging additional clerics from time to time, on the occasion of large liturgical celebrations. This was the case during Holy Week in the year 1407, when John was in Ghent, and six chaplains and four altar boys from the collegiate church of Saint-Pierre de Lille accompanied him to celebrate mass. On other occasions, notably when he was in Paris, the prince "borrowed" clerics from the royal chapel. Beginning in 1409, he filled out the clerical staff of his court, recruiting singers and training the choirboys in Paris. Later, beginning in 1414, he decided to build up his grand chapel again, and took on sixteen chaplains.

The grand chapel of the dukes of Burgundy was directed by a figure who bore the title of first chaplain. Jacques de Templeuve held this office twice, first under Philip the Bold, from 1400 to 1404, then later under John the Fearless, from 1418 to 1419. Born in Arras, it was in Chartres, where he began his career while still a choirboy in the cathedral, that he received his clerical, liturgical, and musical education. His case was not exceptional, and it seems that, at the time of Philip the Bold and John the Fearless, the musical practice of the ducal chapel was in large part influenced by French customs. However other influences were equally at work. Nicolas Grenon, chaplain of John the Fearless from 1412 to 1419 and also known as a composer, undoubtedly trained at the school of Notre-Dame in Paris and was a clergyman at that cathedral. From 1405 to 1412 he also taught liberal arts to the choirboys of the cathedral of Cambrai.

Expressions of Piety

Every day, the Duke of Burgundy went to his private chapel to attend mass, which was celebrated by his chaplains. While the chapel was the setting for the duke's daily devotions, the important dates on the liturgical calendar were marked by special solemnities. Important holidays were celebrated with pomp, and Christmas, Easter, Ascension, Pentecost, Trinity Sunday, Corpus Christi, and All Saints' Day gave rise to particularly elaborate religious ceremonies. The same was true for Marian holidays, which also were the occasion for great celebrations. Anniversary masses also punctuated the year. Thus on 8 April each year, Philip the Bold had masses said for the soul of his father, who had died on 8 April 1364. John

Fig. 2

the Fearless, who also had anniversary masses sung for his parents, had a funeral service celebrated each year for his comrades-in-arms who had died at Nicopolis on 25 September 1396 and at Othée on 23 November 1407.

The worship of saints held an essential place in the religious observances of the court of Burgundy. There as elsewhere, Marian devotions were very much alive, and the dukes manifested their attachment to a number of sanctuaries under the patronage of Notre-Dame. Furthermore, Philip the Bold made a vow at Notre-Dame de Chartres and wore replicas of the Veil of the Virgin, a famous relic preserved in the cathedral.[9] Moreover the prince had a patron saint that he venerated in a personal capacity. John the Fearless was staunchly devoted to St. John the Baptist. Philip the Bold was born on 17 January, feast day of St. Anthony, and the reverence he always showed for this saint was transmitted to his successors. Was this not apparent in December 1404, when John the Fearless, making provisions for the annual 17 January gift of a "plump pig" to Saint-Antoine de Norges,[10] thereby revived a custom established by his father on 17 January 1380?[11] Among the other saints revered by the dukes at the time of Philip the Bold and John the Fearless, mention must be made of a group whose worship was bound to an inherited devotion for the royal family: St. Charlemagne, St. Louis of France, and St. Denis. Their feast days were celebrated with pomp at the court of Burgundy. The warrior saints Michael and

Fig. 3

Fig. 5

Fig. 4

George were likewise honored in a court where the knightly ideal was celebrated, but the influence of the Dominican confessors can doubtless be seen in the devotion the dukes of Burgundy showed toward St. Dominick and St. Thomas Aquinas.

The dukes' personal piety also was translated into the practice of the pilgrimage. First of all, it must be stressed that when the prince traveled about, he always visited the sanctuaries and relics that were to be found at the places he visited; in this way his travels resembled a permanent pilgrimage. But there were other itineraries motivated exclusively by worship, such as the visits of the dukes and duchesses of Burgundy to Notre-Dame du Mont-Roland or to Saint-Claude, and which represented a return to a piety rooted in the Burgundian soil. Long-distance pilgrimages were rarer, such as one undertaken in March 1383 by Philip the Bold, who traveled to Sainte-Catherine de Fierbois as an act of gratitude, following the battle of Westrozebeke.[12] In another instance the prince resorted to a pilgrimage by proxy. In 1378 Philip sent in his place his equerry, Jean de Busseuil, to Saint-Jacques-de-Compostelle; eight years later, under the same conditions, he sent his cupbearer, Gauvignon de Semur.[13] In 1377 he likewise sent Andry Pasté, of the masters of the Dijon chamber of accounts, to Mont-Saint-Michel.[14]

These princes of the house of Burgundy also lent their support to the churches and religious orders in their principalities. To say nothing of the charterhouses that were always beneficiaries of their solicitude, the monastic establishments and the regular canonical communities of the Burgundian territories were often the focus of princely attention. Moreover the dukes took an interest in the fate of the mendicant orders. Not only were the Franciscans, the Dominicans, the Carmelites, and the Augustinians never forgotten in their gifts and alms, but the reformers in these orders also received considerable assistance from the ducal powers. We know that John the Fearless and Margaret of Bavaria gave their support to Colette de Corbie,[15] and that during his important preaching campaign of 1417, Vincent Ferrier received the warmest welcome in the Duke of Burgundy's territory.[16]

Worship and Politics

Political concerns were not absent from the devotional practices of the dukes of Burgundy. Participation in this sort of religious manifestation or attendance at a certain sanctuary could be a means to occupy a certain space and, in the long term, to attempt to capture the sympathy of a population, to the benefit of the prince and his family. For example we know that earlier, under Louis de Male, there was a custom, scrupulously observed by Philip the Bold and then by John the Fearless, to make a yearly offering of a sumptuous woolen or fur-lined robe for the statue in Our Lady of Tournai, during the feast of the Exaltation of the Cross (14 September).[17] Indeed, on this day a grand procession took place, which was a religious event of foremost importance not only for the people of Tournai, but also for Flanders.[18] In the same manner, the Joyous Entry of the duke into the towns of his principalities was an occasion for him to manifest his devotion to the saints, to venerate relics, and to frequent the local sanctuaries. Finally, we have been able to observe that, within a specific political context, John the Fearless marked his presence in Paris by choosing the principal churches of the capital as the settings for his devotions. He celebrated the Marian holidays at Notre-Dame, the feast of St. Anthony at the church of Saint-Antoine-le-Petit, with the Cistercian monks of the abbey of Saint-Antoine-des-Champs, or again at the Bernardine college. He celebrated the feast of St. Francis at the Cordelier church, the feasts of St. Thomas Aquinas and St. Dominick with the Jacobins, and the feast of St. Augustine at the convent of the Augustinians. Furthermore, he made gifts to the patients in the general hospital, to the parish churches such as Saint-André-des-Arts, and Saint-Eustache, and he had alms distributed to the poor of the city.[19] Here, the concerns of the Christian prince clearly coincided with the strategy of the politician.

NOTES 1. Vanderjagt 1985; La Selle 1995.
2. See Veenstra 1998, and Veronese 2001, pp. 113–32.
3. See Vanderjagt 1985.
4. Prost 1902–8, 2: no. 1511.
5. ADCO, B 363.
6. Prost 1902–8, 1: p. 71, no. 2.

7. ADCO, B 5520, fol. 81r-v.
8. See particularly Marix 1939 and Wright 1979.
9. Prost 1902–8, 2: no. 419.
10. Plancher 1974, 3: proof 242.
11. Prost 1902–8, 2: no. 419.
12. Petit 1999.

13. Prost 1902–8, nos. 124 and 1386.
14. Ibid., 1: no. 3103.
15. Lopez 2000, pp. 57–103 and 177–236.
16. Gorce 1923, pp. 2599–260.
17. Prost 1902–13, 2: passim, especially no. 1117.
18. See Dumoulin and Pycke 1992.
19. See Paravicini and Schnerb, forthcoming.

Fabrice Rey

Princely Piety: the Devotions of the Duchesses, Margaret of Flanders and Margaret of Bavaria

(1369–1423) Many of the objects of art and devotion of Margaret of Flanders and Margaret of Bavaria are related to apostles, saints, and virgins, whose depictions adorn reliquaries, panels, statues, and tapestries that the duchesses commissioned or bought. Through the mediation of these objects, Christ and the duchesses' principal patron saints—Our Lady, Margaret, Catherine, Anthony, George, and Denis—were integrated into the daily lives of the duchesses of Burgundy. Their presence more broadly reveals how the worship of saints and their images fit into the belief system, within the larger context of the pursuit of salvation.

The religious practices of the duchesses—offerings, pilgrimages, institutions, artistic commissions—perfectly illustrate this perpetual search for the saints' intercession, which served a dual purpose. The duchesses sought the saints' miracle-working power and protection in general, in order to frame and mark their own terrestrial path. They also and more specifically viewed the benefits of Marian mediation from the perspective of the Last Judgment and eternity.

Practices bound to everyday life often were related to illnesses contracted by a member of the ducal family. Margaret of Flanders thus sent messengers to the sanctuaries that held relics or statues of saints likely to counteract the illness in question. St. Quentin,[1] St. Adrian,[2] St. Mammès,[3] and St. Thibault[4] make numerous appearances in pilgrimage commentaries. It seems that saints associated with proxy-pilgrimages[5] were visited at shrines geographically remote from what would become the Burgundian state. This was the case for St. Louis de Marseille, to whom Margaret of Flanders made a vow. The duchess always saw that the same quantity of wax was sent to this saint, between 66 and 67 kilograms, for the same sum, 30 francs.[6] Facing the multiplication of sanctuaries and the specialization of saints, the faithful could decide which revered figure seemed most likely to resolve their problems. But offerings were most often made in silver, and the duchesses sought above all to attract the benevolence of the saints. These offerings contributed considerably to their restored faith in the usual patron saints. The duchesses' gifts were that "portion of God"[7] that was redistributed through the intercession of his saints.

The worship of saints was founded essentially on the worship of relics, of which the duchesses possessed fragments. For example, there was part of the rib of St. George, or a portion of the "head of St. Anastasia, St. Bartholomew, St. Roman [and] some of the dust that was found at the feet of our Lord," preserved in a painting-reliquary, but also some unidentified teeth, as

Fig. 1
Claus Sluter, *Margaret of Flanders Praying*. Portal of the church at the Chartreuse de Champmol.

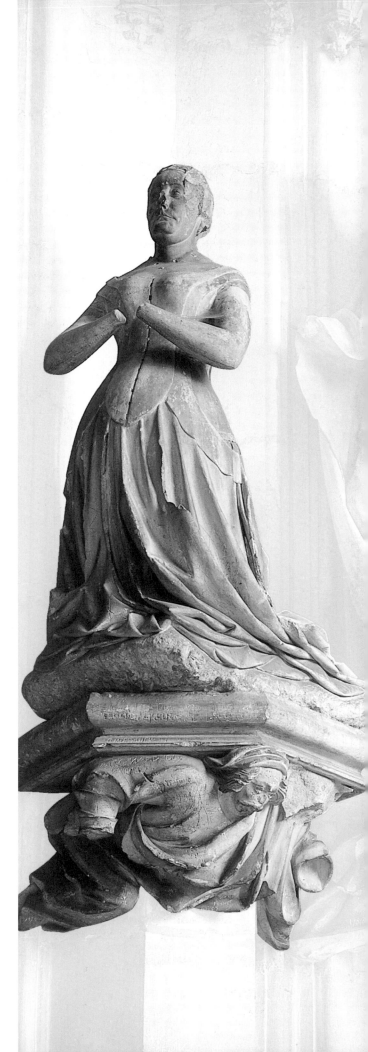

well as an entire set "about which we know of nothing that has been written."[8] But something that must be stressed is the absence of any corporeal relic of Christ and the Virgin, since their bodies were transported to the heavens. There are objects with which they had come into contact, and these items consequently became relics, such as the famous milk of the Virgin, which, as Bernard of Siena commented, "one hundred cows would not have equaled,"[9] and fragments of the true cross filled reliquaries throughout Christendom. Margaret of Bavaria possessed some of the famous Marian liquid,[10] and she also preserved some of the Virgin's oil.[11] Margaret of Flanders always wore on her person a purse that contained a souvenir of the sacrifice of the cross, and she likewise had a "mantle of Our Lady,"[12] perhaps related to the holy tunic of Chartres.[13] Touching the reliquary for the latter was supposed to confer power, for example on the cloth tunics meant to ease childbirth for women of royal blood, and notably for the duchesses of Burgundy.[14]

Saints' relics most effectively represented their *virtus*—earthly remains always aroused reverence—but when statuettes became popular, relics lost their exclusivity. Figurative images of saints were produced above all in the two Marian sanctuaries most favored by the duchesses, Notre-Dame d'Étang[15] and Mont-Roland.[16] But other saints were equally affected by this phenomenon. It was felt that the presence of relics no longer granted greater power to a contract established between oneself and a saint.[17] This belief in part explains the increase in sculpted representations that embellished interior spaces related to the duchesses, where statues and paintings[18] present Our Lady, St. George, and St. Margaret within a shell of pearls,[19] or even an amber image of Our Lady holding the Christ child.[20]

The intervention of these art objects truly brought about a radical change in the connotation of the image in the late Middle Ages, a shift that emerged and enhanced the pedagogical and affective value of religious reproductions in the domestic setting.[21] The duchesses observed, recognized, were stirred by, and turned toward devotions. The presence of Jean Gerson at the Burgundy court is emphatically evident in the emergence of this form of piety. Nominalism seeks to make moral and dogmatic virtues palpable, and in so doing appeals to the feelings as much as to reason, whereby it undertakes to bring the celestial Jerusalem to Earth, to bring the saints closer, to make Christ more human, and simply to bring men closer to God. This domestic piety allowed one, in one's own private chapel and without clerical intermediaries, to meditate on the scenes that paintings and hangings evoked.

From the Annunciation to the Virgin in childbirth, to the Christ child nursed by his mother playing a psalterion,

to a gasping and bleeding Christ, Mother and Son are human.[22] The unique goal of this iconography is to allow the faithful to identify with their savior, contemplating him reduced to the basest of conditions. These depictions provoke compassion and pity. Testimony of an era that indiscriminately mixed "the odor of blood and the scent of roses,"[23] they recall the salvational sacrifice at a moment when the supreme judge seems to have removed himself from men and to have decided their fate. In the world of Margaret of Flanders, the theme of the Passion found numerous occasions for expression, particularly within the context of worship of the holy sacrament or the holy blood of Bruges.[24]

These efforts to humanize Our Lady and Christ—perfectly illustrated by the commissions of Margaret of Flanders and Margaret of Bavaria—were initiated by an entire society, and, when added to the totality of propitiatory practices directed toward the saints, found ultimate purpose in the search for intercessors that might further the attainment of salvation. The floors of the chapel of the château of Germolles, decorated with the motif of the wheel of fortune, attest to this awareness of full divine power and the feeling that one cannot achieve salvation unaided.

The religious sentiment of Margaret of Flanders and Margaret of Bavaria, their devotions, and the practices that ensued from them, were only somewhat original and were the reflection of a society at the time of the International Gothic style. The specificity of this piety resided, rather, in its repercussions with regard to the social affiliations of the two princesses, and in the political coloration that it assumed. The religious practices of the simple believer were greatly amplified by the feeling that one might influence one's eternal fate by increasing the portion one gave back to God.

Politically, the extent of their commissions, the desire for largesse, the wish to make an impression, and Burgundian ambition all gave the duchesses' piety a distinctly ostentatious cast, occasionally resulting in a deviation from their initial objectives. In France at this time, where the acquisition of power favored the status of the patron, amid a Europe at war and a Christendom divided, religious and political practices could not help but overlap. Otherwise there could be no explanation for the sixty-seven reliquaries[25] enumerated in the inventories of the duchesses, where most were devoid of relics and their only worth lay in preciousness and the opportunity for hoarding that they represented. The pairing of St. John the Baptist and St. Catherine, sculpted on the portal of the Carthusian monastery of Champmol and supplanting the traditional patron saints, is nothing more than the embodiment of the royal origins of the ducal couple, just as the worship of St. Louis of Marseille was perpetuated

throughout the fourteenth century among the Valois.[26] The worship of Pierre of Luxembourg,[27] above all, attests to a political devotion, that of the Avignon clan in the wake of the Roman papacy, whose colors had been defended by Catherine of Siena. And then, more generally, faced with the advancing Muslims and the claims of the sultan Beyazid, St. George embodied above all the defender of Christendom.

NOTES 1. Réau 1955–59, p. 1128.
2. Ibid., p. 23.
3. Ibid., p. 867.
4. Prost 1902–8, 1: no. 1974, and Rey 2000–2001, p. 124.
5. In a proxy-pilgrimage, a silent partner designated one of his servants (who had the same Christian name as the saint) to visit a sanctuary, in his name, to make offerings.
6. ADCO, B 1454, fol. 25v (1379).
7. Chiffoleau 1980, p. 215.
8. ADCO, B 302, fol. 10v and 1v (de Noyers inventory).
9. Delaruelle, Labande, and Ourliac 1964, p. 646.
10. ADCO, B 302, second notebook, fol. 1. See Réau 1958, p. 61.
11. ADCO, B 302, second notebook, fol. Iv.
12. Ibid., B 301, packet 2, side 514, fol. 30.
13. The garment that the Virgin was to have worn on the day of the Annunciation and at the birth of Christ.
14. ADCO, B 1438, fol. 21 (December 1372).
15. District of Velars-sur-Ouche, Côte-d'Or.
16. Mont-Roland, district of Jouhe, canton of Rochefort, Jura.
17. Lecomte 1996–97, p. 90.
18. Rey 2000–2001, p. 204.
19. ADCO, B 301, packet 2, side 514, fol. 27v.
20. Ibid., fol. 30.
21. Arasse 1981, p. 131.
22. Rey 2000–2001, p. 204.
23. Rapp 1971, p. 148 (quote from Huizinga).
24. ADCO, B 1435, fol. 76. See Rey 2000–2001, p. 214.
25. Rey 2000–2001, p. 159.
26. Réau 1955–59, p. 820. Born in 1274, he was the eldest son of the king of Naples, Charles II of Anjou, and the grand-nephew of St. Louis.
27. ADCO, B 1473, fol. 58v. The same year, the duke also made an offering to St. Pierre of Luxembourg.

Gaëlle Tarbochez

The Furnishings
of the Ducal
Chapel

To satisfy their religious obligations, the dukes and duchesses of Burgundy turned to the daily religious services provided by a group of priests and clerics at a chapel affiliated with their mansion. These priests used valuable furnishings of great richness, including rare fabrics and colorful church vestments or altar cloths. For example, around 1385 Dino Rapondi brought the duke twelve pieces of golden cloth with "delicate lilies"[1] at 110 francs apiece, and Michel Mercati, a Parisian merchant, sold him a piece of "en graine"[2] purple-dyed velvet around 1394. But the Burgundian dukes' taste for sacred art was particularly satisfied by liturgical gold and silver plate. There were many of the usual objects—chalices, cruets, candleholders—decorating the altar. However, the ducal chapel was especially radiant because of the finely carved crosses and statuettes acquired from Parisian craftsmen such as Henriet Orlant. Especially remarkable are a gold cross worth 900 francs composed of a crucifix set on a base of enameled silver, representing the Nativity, and four gold angels holding depictions of the Virgin, the apostles, and "Jews."[3] In 1395, Philip the Bold gave 1,708 francs to Henriet Orlant for two other extraordinary pieces:[4] a statuette of St. Michael in gilded silver, on a silver pedestal, weighing 55 marcs; and a gilded silver cross weighing more than 50 marcs on which were represented "a compassionate god," a Virgin, St. John, the four Evangelists, and some angels. The same year, the duke also ordered a statue of the Virgin, crowned in gilded silver and holding Jesus in her right arm, seated on a base decorated with enamel and her own coat of arms. Seeded with pearls and encrusted with ivory, this statue weighed 33 marcs and cost 506 francs.[5] Philip the Bold also bought a "holy water basin"[6] and a silver ewer worth 200 francs from Jehannin Foucet, a silversmith from Dijon. Among the "jewels of the chapel"[7] were also objects depicting the crucifix, reliquaries, rosaries (in coral, crystal, or amber) and carved altar pieces (in gold, ivory, or alabaster). These objects, enhanced with pearls or stones, were decorated with the coats of arms of the dukes and duchesses and went with them wherever they traveled. Chests, some of which served as portable altars,[8] were used regularly for transportation and special cases protected the most valuable pieces. Even so, there were frequent repairs. In 1396, many pieces were brought back to Parisian workshops to be refinished or to undergo modifications, such as the installation of a removable reliquary in a statue of St. John the Baptist.[9] In fact, the splendor of the Burgundy court was quite evident in the luxury of the liturgical decoration of the ducal chapel. For example, some implements were not essential to the celebration of the Eucharist but were supplementary. Furthermore, the Burgundian dukes offered gifts to other "princes of the lilies" in the form of religious statues, similar to their own.

NOTES 1. ADCO, B 1463, fol. 80v.
2. Ibid., B 1503, fol. 135. The "graine" meant the scale insect, used to dye luxurious cloth, which was scarlet, a color symbolizing power and wealth.
3. Ibid., B 1463, fol. 94.
4. Ibid., B 1508, fol. 119.
5. Ibid.
6. Ibid., B 1463, fol. 99v.
7. Bibliothèque Municipale Dijon, MS 2211.
8. ADCO, B 1503, fol. 157. In 1394–95, Pierre du Four provided two chests for the duchesses' chapel, "one of which served as the altar," and a large trunk to store the ornaments and the tapestries.
9. Ibid., B 1511, fol. 82v.

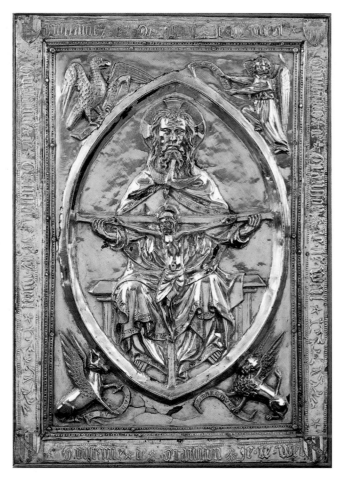

BIBL.: *Artistic Fribourg*, pl. IX; Hilber 1919, pp. 24–40; Reiners 1943, p. 92; Strub 1956, 2: pp. 156–57, fig. 160; Deuchler 1963, pp. 150–52; Otavsky 1985, pp. 7–14.

EXH.: Geneva 1896, no. 795; Bern 1936, no. 48; Amsterdam 1951, no. 232; Brussels 1951, no. 213; Dijon 1951, no. 165; Fribourg 1955, no. 247; Paris 1967, no. 57; Coppet 1967, no. 70; Bern 1969, no. 164; Nantes 1972, no. 46; Mechelen 1973, no. 509; Cologne 1978, 1: pp. 311–12; Fribourg 1983, no. 51; Athens 1986, no. 31.

Exhibited in Dijon only

These two silver plaques bearing the name, coat of arms, and motto of Guillaume de Grandson have always been recognized as spoils of war taken by Burgundy.

One plaque features St. John the Baptist and St. Mary Magdalene, and the other the Holy Trinity. These iconographic figures appear beneath the throne of grace, surrounded by symbols of the four Evangelists, bearing amulets with their names. The plaques are surrounded by bands of sheet silver stamped with the name of the donor, "Guillaume de Grandson," and his motto, "I watch over him," as well as foliage and stars.

These two plaques are fragments of a larger ensemble, which was probably part of a reliquary diptych that was dismantled in the eighteenth century. Paul Hilber, and then Karel Otavsky, were able to prove this through the 1555 inventory of the convent of the Cordeliers order in Grandson, in which these works are mentioned. The convent, founded by Othon I in the latter years of the thirteenth century, was closely tied to Grandson and certain members of the family were buried there. There is a strong probability that the Cordeliers took the reliquary to Fribourg at the time of the Reformation. The 1661 inventory of the collegiate church of Saint-Nicholas mentions it, and the chronicler Heinrich Fuchs described it in 1687 in the following way: "Reliquiarium argenteum Domini Wilhelmi de Grandson ad instar libri" (another reliquary of Guillaume de Grandson in the form of a book). According to ancient inventories, the relics were found in small compartments built within a plaque of wood. The most precise description appears in the work of Caspar Lang, published in 1694. Interpreting his description, it would appear likely that the two plaques decorated the exterior. On the obverse side of the reliquary, one found the Trinity, and on the reverse, John the Baptist and Mary Magdalene, while the small emblazoned tablets were probably affixed to the inside and served to separate the compartments. The inscription mentioned by Lang, which testified to the gift of the reliquary in 1373, has been obscured.

22

The Trinity, Saint John the Baptist, and Saint Mary Magdalene
c. 1370–80

Silver mounted on new wood panel, partially gilded, embossed, chiseled, pricked, and engraved

The Trinity, 39.7 x 28 cm

John the Baptist and Mary Magdalene, 39.7 x 26.8 cm

Inscriptions, around the circumference: The name "Guilliaume de Gransson" and the motto "I watch over him," interspersed with the Grandson coat of arms

Fribourg, Musée d'Art et d'Histoire, inv. 45971–2

PROV.: deposited to the Musée d'Art et d'Histoire Fribourg in 1879 by the collegiate church of Saint-Nicolas, Fribourg.

After they were dismantled in the eighteenth century, reproductions made at the end of the nineteenth century provide a very loose and partially erroneous interpretation of how the work was put together. The plaques were given to the Musée d'Art et d'Histoire Fribourg in 1879, restored between 1920 and 1930 and mounted on a core of wood, while the emblazoned tablets were also rearranged. Four of them bearing the coat of arms of Guillaume de Grandson also appear on the fresco in the cloister of the church of Ressudens and were placed at angles in scenes representing John the Baptist and Mary Magdalene. To represent the Trinity, one of the four, in the shape of a shield, bears an unidentified coat of arms.

The lords of Grandson were always tied to the house of Savoy, a fact which led Otavsky to assume that the reliquary had been created in Chambéry, where the counts of Savoy lived. An artistic center whose reputation spread beyond regional boundaries, it has been proven that the fourteenth-century counts placed all their orders, so to speak, at Chambéry. The majority of the works that were created there were intended for the treasury of the chapel of Chambéry castle. This interpretation is, however, no more than a hypothesis: according to Otavsky, other centers, notably the episcopal cities of Lausanne and Geneva, for example, could equally have been considered.

Y.L.

23

Paris

The Gotha Missal
c. 1370–72

164 folios
27.2 x 19.5 cm

Cleveland, The Cleveland Museum of Art, inv. 1962.287

PROV.: J. B. Huhn (acquired in Paris about 1720); Dukes of Gotha (1745); Earl of Denbigh (until 1950); Apsley Cherry-Gerrard, England; and Mrs. Gordon Mathias, England (until 1961); [Sotheby's, London (5 June 1961), lot 177]; H. P. Kraus, New York.

BIBL.: *Catalogue 100*, pp. 32–39; Wixom 1963, pp. 158–73; De Winter 1985A, p. 185, figs. 101, 211.

EXH.: Cleveland 1967, no. VI–3.

This manuscript acquired its name from its eighteenth-century owners, the German dukes of Gotha. The volume's decoration falls stylistically within a large corpus of manuscripts produced in Paris for the Valois king Charles V, or aristocratic manuscripts contemporaneous with them. The calendar and use of the missal are Parisian. It contains a cycle of twenty-three small miniatures, plus two facing full-page miniatures marking the introduction to the

canon of the Mass that are traditional subjects for this part of a missal, a *Crucifixion* and a *Majestas Domini* (fols. 63v–64). The style of page layout and border decoration are also decisively Parisian. The meandering ivy vines prevalent in the borders of the manuscript were by the 1370s a distinctive hallmark of Parisian manuscript painting.

Authorship of the book's miniatures has been much discussed. Most of them, the two full-page and twenty-one of the small miniatures, would appear to be the work of the Master of the Boqueteaux. The salient characteristics of this style include distinctive mushroom-like trees. The figures seen in the miniatures are painted mostly in grisaille, which is characteristic of a number of manuscripts made for Charles V. The missal's grisaille figures are set against colored backgrounds to achieve contrasting effects and sharp tonalities. The overall effect is clearly one of sumptuousness and refinement.

The Master of the Boqueteaux was a popular artist at the court of Charles V, and the style known for him was fairly common in Paris at mid century, not exclusive to a single master or workshop. Millard Meiss has suggested that this "master" was actually several artists who were influenced by one chief source, perhaps Jean Bondol of Bruges, whose name is recorded in an inscription for the frontispiece for the *Bible Historiale of Charles V* (The Hague, Meermanno-Westreenianum, MS 10 B 23, fol. 1).

Two small miniatures at the beginning of the volume were added later, probably at the beginning of the fifteenth century: a *Dieu de pitié* and a *Resurrection* (fol. 1). They are clearly by another hand, and here also opinions about authorship have varied. Recent study relates these miniatures to the oeuvre of an illuminator known as the Maître du Livre des Femmes Nobles et Renommées de Philippe le Hardi, active about 1402–4. Among those works are a *Golden Legend* (Paris, BNF, MS fr. 242); a *Bible historiale* mentioned in the inventory of Jean de Berry in 1402 (Paris, BNF, MS fr. 159); and Hayton de Courcy's *Fleur des histoires de terre d'Orient* (Paris, BNF, MS fr. 12201), one of three copies acquired by Philip the Bold.

Based upon the involvement of the Master of the Boqueteaux, it has been argued that the volume was made for King Charles V, which is very possible. While the manuscript has no royal portraits or colophon, given the book's magnificent decoration, it would seem that it was made for a Valois prince, if not for the king himself.

S.N.F.

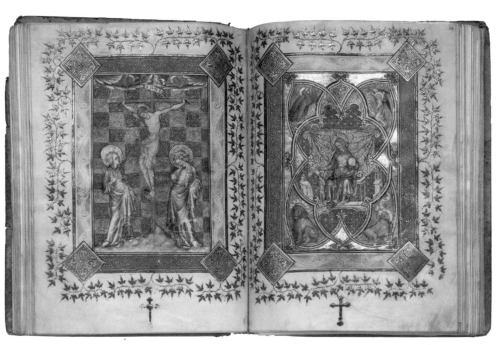

Fol. 63v–64r: The Crucifixion; Christ in Majesty.

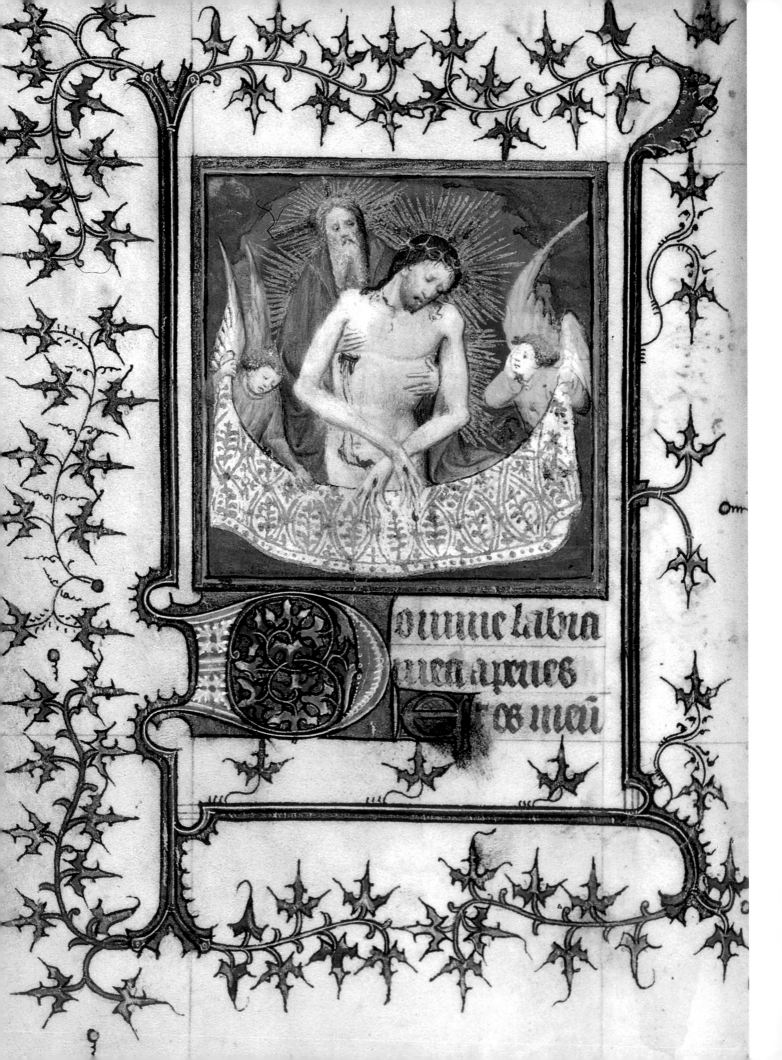

ounine labra
mea a pues
tuos mei

24

Nantes

Book of Hours

1402

218 folios

14 x 10 cm

New York, The Pierpont Morgan Library, MS M.515

Prov.: Guillaume Mauléon; Mazzerie Family (17th century); J. Pierpont Morgan (purchased from Leo S. Olschki in 1912); J. P Morgan.

Bibl.: Meiss 1974, 1: pp. 104, 336, 383, fig. 412; De Winter 1985A, pp. 6, 100, fig. 207.

This manuscript is signed by its scribe, Yves Lucas, in three locations, including the colophon on folio 216 verso in which he states that the volume was written and illuminated in Nantes in 1402. On folio 94, at the end of the Office of the Virgin, an inscription now erased identified the original owner, Guillaume Mauléon. The decoration consists of eleven half-page miniatures, many with ornamental borders. All are in the style of an artist identified by Millard Meiss and named the Master of the Coronation of the Virgin, or Coronation Master, after the frontispiece miniature in a manuscript of the *Golden Legend* (Paris, BNF, MS fr. 242). According to Meiss, at least two miniatures in this book of hours are by the master himself: the *Crucifixion* (fol. 125) and the *God of Mercy* (fol. 130v). The illuminator and his assistants were Parisian, but they must have been willing to accept a commission in Brittany, if the colophon is correct. Patrick De Winter rejected Meiss's attribution and substituted the name Maître du Livre des Femmes Nobles et Renommées de Philippe le Hardi, in whose oeuvre he included manuscripts owned by Jean de Berry and Philip the Bold. Although the illuminator's period of activity was brief, about 1402–4, his works clearly found favor among the ducal courts of the Valois.

S.N.F.

POLITICS

Laurent Hablot

The Use of Emblems by Philip the Bold and John the Fearless

The first dukes of Burgundy of the house of Valois were leaders in the use of emblems in the late Middle Ages in Europe. "Great consumers of emblems" according to Michel Pastoureau, they unstintingly drew on such expressions of rank and participated actively in the elaboration of a new system of symbols, namely heraldic devices. These emblems, which probably came into being at the court of Edward III of England with his Order of the Garter in the mid fourteenth century, consisted of a type of representation that was free from all compositional rules and associated with specific colors, letters, and a short sentence or saying. An emblem provided a prince with a much more personal sign than his coat of arms, his inherited lineage, or his fief. Such insignia also offered a prince a way to honor those under his patronage, granting them the right to use all or part of these symbolic representations on items of clothing or jewelry. Some of these devices were shared only within the select framework of specific orders, papal institutions that were spreading rapidly throughout all Europe during the years 1345–55.

While Charles V continued the innovations of his father, John II the Good, and his Order of the Star, it was principally in the wake of the return of the king from captivity in England, following the Treaty of Brétigny, that these new symbols were developed in France. Duke Jean de Berry and Louis II, Duke of Bourbon, stand out as the initiators of this new style—the former with his device of the bear and the saying "LE TEMPS VENRA" (The day will return), 1365, and the latter with his introduction of two heraldic devices in 1366: a sash bearing the word "Espérance" (hope) and the *écu d'or* (golden shield). Their

brothers Louis d'Anjou and Philip of Burgundy, and various princes such as Charles II of Navarre, Louis de Male, and Jean Galéas Visconti, quickly followed suit. Like the dukes, these princes soon discerned the potential inherent in this new tool of power, which could represent and foster loyalty among members of the court.

The marriage of Philip the Bold in 1369 seems to have played a decisive role in his choice of emblems. Probably influenced by his father-in-law, Louis de Male, as much as by his brothers, the duke initially appears to have vacillated among several figures—the greyhound, the swan, and the tassel—before finally adopting a resolutely courtly array of symbols in honor of his wife, Margaret of Flanders: a daisy (or marguerite), the initials "PM" (Philip and Margaret), and the colors red and white. Around 1380 he added the oak branch and the ambiguous saying "Y ME TARDE" (I am waiting), which perhaps hid the suppressed ambition of the co-regent of the kingdom. In 1403, like most of his relatives, Philip the Bold established a heraldic device, the Order of the Golden Tree, shared only by some carefully chosen relatives. The emblem consists of a necklace of gold-plate, perhaps depicting daisies, supporting a pendant made up of a golden tree alongside an eagle and a lion—two grand figures from the Valois para-heraldic bestiary—resting against a crescent underscored by a fillet bearing the saying "EN LOYAUTE" (In loyalty). According to Pastoureau, the necklace pendant even might have been an allusion to the myth of the Golden Fleece, but the duke's obligations and his death in 1404 suggest a date earlier than that of the first Burgundian order.

Margaret of Flanders also used an abundant system of emblems, which included the initials "PM" and the duke's daisy emblem. In this case, however, her symbols are distinguished from those of her spouse by the recurrent use of the sheep (borrowed from Louis de Male), the color green, the hawthorn, and the thistle.

In keeping with curial fashion in the final years of the fourteenth century, the ducal couple greatly expanded the use of emblems, which were displayed in almost obsessive manner in their living environment: as decoration on their residences from floor tiles to ceiling paneling; on their clothing, including the most minor accessories such as garters; on everyday objects such as dishes, saddlery, and furniture. The abundant use of emblems made the prince omnipresent to his entourage and his authority increased accordingly, as he marked everything around him, including people. Within a studied hierarchy of social realms, courtiers and servants of the duke were allowed to partake of his emblems to varying degrees: from kitchen-help wearing rough livery of a single color to relatives, who were gratified to wear a mantle similar to that of Philip the Bold and necklaces of the ducal order. The consistent use of these emblems was particularly conspicuous when Margaret of Flanders established a model sheepfold at Germolles and encouraged pastoral literature, echoing her heraldic devices.

To choose their own devices, henceforth an unavoidable sign of the princely condition, the six children of the Duke and Duchess of Burgundy drew principally from their parents' vocabulary of emblems, favoring subjects from

Fig. 2

Fig. 1

Fig. 1. Paving tiles from Germolles with the sheep and the thistle, heraldic devices of Margaret of Flanders.

Fig. 2. Token with the plane and the motto "ICH HALS MCH," issued by John the Fearless around 1410. Paris, collection of CNRJMM.

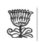

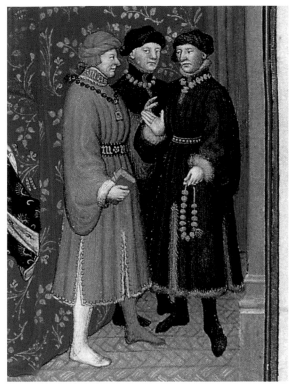

Fig. 3

Fig. 4

the plant world. Thus the daisy, the letter "M" (for Margaret), the sheep, and the oak leaf are found in the heraldic devices of Margaret of Hainaut, Marie of Savoy, and probably Catherine of Austria, whereas Anthony of Brabant chose the raspberry bush branch and Philip of Nevers the oak and the borage plant.

Until 1391, the eldest son, John of Nevers (the future John the Fearless, Duke of Burgundy), also seemed to be content to use the oak leaf. As with his father, John's marriage, in this case to Margaret of Bavaria in 1385, motivated him to adopt his own emblem, composed of a hops branch along with the saying "ICH HALTZ MICH" (I am silent), probably the basis for a political message. Around 1390, he broke with the bucolic register of Burgundian heraldic devices, adopting a new emblem, an iron helmet known as a German hat. Paired with the hops branch was the following saying, transcribed into Flemish: "ICH SWIGHE" (I am silent). Times change. In 1406, John of Burgundy, who had been duke for two years, chose as his emblem a level plane, which symbolized his political program related to the theme of Good Government. Associated with various phrases expressing "I am silent" (ICH HALT MICH or ICH HOUD), this figure takes on a decidedly aggressive tone in opposition to the house of Orleans. During this same period, through a trick of transcription,

the placid "ICH SWIGHE" was transformed into an ironic "ICH SINGHE" (I sing). Hops and level plane dominated the ducal vocabulary of emblems until 1419. Even so, on certain occasions, John the Fearless revived his parental emblems. Oak and hawthorn mingle with hops, the sheep is presented as the designated victim of the Orleans wolf, and the level plane is associated with the figure of the tree developed within the curial order of Philip the Bold, which the new duke was perhaps attempting to reactivate. Between 1410 and 1413 the device of the level, a tool of reconstruction, supplanted all others; the following year saw the introduction of the industrious bee on its hive, which represented the duke and acted as a sign to his supporters. In more consistent manner, John the Fearless chose for his initials the letters "M" or "MY" (Margaret and John), and alternating combinations of green, white, and black for his colors; in 1411 he settled on the tricolor combination of green, white, and black.

With John the Fearless, the princely use of emblems thus took on a new dimension. Without losing any of their initial functions and in order to set apart the prince and his followers, his heraldic devices assumed a more precise message and became a veritable tool of political propaganda, whose import continued to grow for the dukes of Burgundy.

25

Burgundy?

Small Messenger's Box
Early 15th century (before 1419?)

Copper, chased enamel (enamel almost entirely disappeared), traces of gilding
5.5 x 4.4 x 1.2 cm

Paris, Musée National du Moyen Âge–Thermes de Cluny, inv. C1.17707

Prov.: former collection Victor Gay; anonymous gift, 1909.

Bibl.: Rupin 1890, p. 576; Allemagne 1928, 1: p. 161.

Exh.: Paris 1889, p. 93, no. 573; Riquewihr 1971, p. 13.

Designated in the museum's inventory manuscript as a "small-scale imitation of a messenger's box," this object, whose history remains unknown, is embellished with the arms of John the Fearless, Duke of Burgundy.

Between approximately 1350 and 1560, the sources reproduced in Victor Gay's *Glossaire archéologique* mention only boxes in silver or gold, most of which are depicted with coats of arms. Here, the object is not made of precious metal, and neither are three other examples preserved respectively in the museums of Clermont-Ferrand, Nantes, and the Musée National du Moyen Âge in Paris. The most interesting thing about this object is that it is much smaller than the boxes mentioned above, which in general measure between 10 and 15 centimeters in height. As there is no lock, the box undoubtedly closed with the help of a small hook that slipped into the ring that crosses over the lid, mounted on a hinge. It seems that the loops usually soldered onto the flat backs of these boxes, which allowed them to be attached to a belt, never existed on this one.

R. E. J. Weber has suggested that in the late fourteenth century the messenger box lost its practical function and became almost exclusively decorative. No longer worn on the hips, it was displayed on the coat or around the neck, like a distinctive sign, with easily visible coats of arms. This is how it is depicted in an illuminated manuscript created in Augsburg around 1401–2. A similar example, 6 centimeters high, from the end of the Gothic era, has been identified in the Hattingen museum in the Ruhr. The lid does not open, eliminating the box's entire function. Finally, one might wonder if it might have been a toy meant for a child.

J.F.

Sophie Jolivet-Jacquet and Sylvain Faivre

Ephemeral Art: Ceremonial Dress and Decor at the Court of Burgundy

In today's world the creative act—art—maintains a relationship with transcendence and eternity. In this regard the Middle Ages were utterly different, since these two horizons were the private domain of religion. Art now belongs to everyday life and exists within a purely human sense of time, but time at court was very specific: a succession of events, a sequence of idealized moments. Court art proved to be ephemeral and was meant to transform each action into a ceremony, each moment into an event. Dress and decor at the court of Burgundy formed the core of this ephemeral art, which heightened, embellished, and gave meaning to each daily activity.

We must understand dress to mean the totality of garments worn by an individual at a given moment in accordance with a precise and significant sequence of events. The decor for ceremonial events must be understood in a theatrical sense as the setting for theatrical performance, an environment within which the protagonists would evolve, in response to a programmed design that could involve such elements as hangings, banners, and their arrangement in space. Dress and decor were closely interwoven, since they were part of the visual display presented to the eyes of spectators and guests.

These events in courtly life most often were associated with a meal, a ceremony, games and other amusements,

all backed by numerous motives: political (treaties, meetings), family-related (birthday and lifetime milestones), chivalrous (dubbings, crusades), religious (holidays in the liturgical calendar, worship associated with family celebration), or military. These events could be combined in the same ceremony, lending each a particular tone. For example, the princely marriage was a family, political, and religious celebration and was associated with elements of chivalry such as games. The physical management of the unfolding of the ceremony was entrusted to an official "responsible for the expenditures," who organized and controlled the successful development of preparations. But the concept of dress and decor was always left to the assessment of the prince, who could offer advice at all stages of the production.

All these events had their own logic, an original message to transmit, and they were at once recurring and unique. Each ceremony was thought out according to precise criteria, in which the weight of tradition, custom, and protocol mixed with clothing and decorative fashions of the moment. But they all were simultaneously an expression of luxury, trends, and messages.

Expression of Luxury

The first thing that draws the eye of anyone who peruses the Burgundian accounts is the brilliant materials that went into the clothing made for the prince and some of his entourage, which seemed to turn official dress into an art of luxury. In 1403 the trousseau that Mary of Burgundy brought to her marriage to the Count of Savoy[1] included four cloaks, three of which were cut from the finest woolen cloth, ruby-colored scarlet[2] and British green, and lined in gray[3] and white[4] squirrel fur. The most sumptuous piece was a long trailing cloak of crimson velvet lined with four hundred white ermine skins.

This sartorial art emphasized noble materials, principally different cloths of silk and wool and furs. Moreover, the garments were preponderantly valued at the cost of the materials, while their fabrication represented only a tiny portion of their worth. In the aforementioned trousseau, the duke chose to give his daughter entire pieces of cloth to "make a dress when she pleased," rather than finished garments. Opulence was reinforced by rich colors in tones of red, black, green, blue, and purple—much sought after, since they were saturated and thus difficult to produce. These cloths were patterned or brocaded with threads of gold and silk forming designs on the surface or in relief. The designs were rarely specified in accounts but exceptions do provide evidence of their magnificence. In February 1396, Duke Philip the Bold had a greatcoat made from damask strewn with crimson silk roses.[5]

With regard to luxurious materials, the extravagant mentality at the turn of the fourteenth to the fifteenth centuries could not refrain from all sorts of ornaments designed to embellish clothing. The foremost of them was embroidery, with colored or metallic threads, sometimes with the addition of pieces of colored cloth or different materials to create relief effects. In 1396, John the Fearless took along on the Nicopolis Crusade a greatcoat made from an English green cloth, embroidered to his specifications and decorated with red bands of embroidery twisted with branches of hops. Ribbons and fringes were also much in evidence, both generally and on this garment, which was edged in green silk. The appeal of this sort of decoration was bound up with a characteristic of the medieval eye, which "read" the garment as a surface of superimposed planes—background, embroidery or other additions, ribbons, etc.—and not as a colored mix against a single surface, which would have been too close to stripes, a motif with pejorative connotations. Other garments also had pieces of precious metal stitched onto the fabric.

Henri David has described in detail the finery of Philip the Bold, at least that which seemed most notable to him. According to David, the growth of the first Valois duke's fortune allowed him to devote himself to his passion for beautiful and opulent finery,[6] constantly replaced in order to keep up with trends in fashion.

The Expression of Trends

Courtly society was fashionable society. While this presentation is too brief to describe clothing and its methodical stylistic development under the two first Valois dukes,[7] we can at least propose some guidelines for fashion at the turn of the century, with regard to the illustrations presented here. Court style at that time favored long and ample garments. A belt, tailored to size, was worn over a broadly flared, long-sleeved greatcoat. The edges often were cut out of and/or accentuated with a contrasting material, cloths of another color, or fur. For men, beneath this outer garment, one could glimpse a doublet or coat and tights that covered the legs as far as the thighs. The wearing of hats, quite popular with Philip the Bold in the late fourteenth century (160 between 1392 and 1394),[8] declined, and fashion focused on velvet hats and hoods, rather than felt hats. For women, dresses were low-cut, perhaps loose-fitting and off-the-shoulder, or on the contrary, very high-necked, but the length prevented the legs from being seen. Colors were quite varied, but black and gray were already held in high regard and flourished under Philip the Good. Jewels, clasps, and necklaces gracefully enhanced the clothing.

Colors, shapes of garments, and accessories, as well as the way they were organized, defined a silhouette that did not expose the body, but modeled it in accordance with the aesthetic preferences of the moment.[9] There was a golden rule that provided a fundamental guideline: each

Fig. 1. Boccaccio, *Famous Women*, Paris, c. 1402. Paris, Bibliothèque Nationale de France, MS fr. 12420, fol. 93.

Fig. 2. Christine de Pizan, *Epistre d'Othéa,* c. 1404–9. Paris, Bibliothèque Nationale de France, MS fr. 606, fol. 35.

Fig. 1

Fig. 2

must wear the garments that correspond to his rank and social status. Notions of hierarchy and "correct measure" were the principal messages distilled through clothing.

The Staging of Messages

The ornamentation of finery could be purely festive, such as the small golden or silver bells that important figures wore by the hundreds. In other cases it was symbolic, such as the golden chips worn on the clothing of John the Fearless, indicating his desire to smooth out the gnarled staff, emblem of his rival, Louis d'Orléans.

This example demonstrates the role these ornaments played in interpreting clothing as a whole. They represented not only social situations, but also the fundamental character of the wearer or the event connected to the garment. Thus when John the Fearless left for Nicopolis in order to be dubbed there, he took golden ribbons from Cyprus to sew onto his clothing when he received his new knighthood. A new station in life demanded a new decoration for a new garment.

This metonymic relationship between the part and the whole is found in festival decor, in which theme, colors, and materials must correspond to clothing. In Nicopolis, John the Fearless wore green tights and a green greatcoat, already alluded to, over a jacket and *housse* of vermilion satin.[10] In its shape, this garment showed what the Crusade signified for him: the initiatory test that would reveal his essence as a knight by cutting short his youth. From the outside in, moving toward the heart, the

garment went from green to red, from the color of youth to that of the knight. This same composition was found in the prince's military campaign accommodations. His pavilion was made of green satin with green and vermilion furnishings, and the inner chamber was hung with vermilion satin and contained only red furnishings.

The cart that carried Mary of Burgundy when she left for Savoy matched her cloak of red damask, for it was hung on the interior with three cloths of the same material. The exterior was clad in vermilion scarlet. Likewise the carriage was in the image of Mary, who departed haloed in red, a nuptial color, in harmony with her spouse. The decor seemed like a continuation of the clothing, extending its meaning to the entire ceremony.

And so beyond playing an aesthetic role, clothing and decor had a social and political function, since they manifested to everyone ideas or messages, and also the place that an individual recognized for himself or claimed within society. This explains why clothing was an ephemeral art. It was an art because of the complexity of the clothing and decor used for meaningful ceremonies, and because of their luxury and beauty. It was ephemeral because these creations existed in the service of an event, a particular moment in the life of the princes. And the implications of the importance of this art to the court of Burgundy can be seen in the court system of the time, in which the princes built their glory and power not only at the point of the sword, but also at that of the tailor's needle.

NOTES 1. ADCO, B1538, fols. 207–32.

2. The term scarlet denotes both the color and the type of material.

3. Made from assembling the gray backs of squirrels from northern countries.

4. Made from assembling the white bellies of squirrels. Once put together, the white bellies with gray edges give the piece a slight striped effect.

5. ADCO, B 1508, fols. 129v and following.

6. Taken from the accounts, his descriptions focus on clothing for ceremonies and celebrations; see David 1947, pp. 64–89, 159–64.

7. A methodical description of the court dress of Philip the Bold and its evolution still needs to be compiled, but one can find, in addition to excerpts published by David 1947, some items in Beaulieu and Bayle 1956.

Generally speaking, the most recent and best-documented summary is Mane and Piponnier 1995.

8. David 1947, p. 86.

9. For this idea of silhouette and modeling of the fashionable body, see Blanc 1997.

10. A *housse* is a garment with open and hanging sleeves, worn beneath a coat or jacket.

Paris

Table Fountain
c. 1320–40

Gilt-silver and translucent enamels
31.1 x 24.1 cm

Cleveland, The Cleveland Museum of
Art, inv. 1924.859

Prov.: said to have been discovered
in a garden in Istanbul; acquired in Paris
[M. & R. Stora], 1924.
Bibl.: Fliegel 2002, pp. 6–49; Milliken
1925, pp. 36–39.
Exh.: Paris 1981, no. 191; Cleveland 1967,
no. VI-18; Baltimore 1962, no. 126.

The Cleveland *Table Fountain* is the
most complete example known to have
survived from the Middle Ages. Smaller
fragments of similar fountains are
preserved in Antwerp and Santiago de
Compostela. It is known from inventories
that such objects once existed in large
numbers. The 1363 inventory of Charles V
mentions two fountains, while that of his
brother Louis I d'Anjou (1368) lists an
astonishing thirty-eight fountains. Given
the fragile nature of their mechanisms and
the preciousness of their materials,
medieval table fountains must have been
short-lived. Some must have been made
for temporary use and linked to some
great ceremonial or social event. Although
the Cleveland fountain was made before
the period of Philip the Bold, it exemplifies
a genre of object that would have been
well known to the Burgundian duke.

The Cleveland fountain is extraordinary
in conception. It was designed as a
fanciful but completely functional
mechanism. In addition to serving as an
extravagant work of art to be admired for
the beauty of its craftsmanship, it was
clearly a feat of technical ingenuity
intended to entertain guests through the
motion of cascading water and the
accompanying sound of ringing bells.

The fountain is a three-tiered assembly
of individual sections of cut and bent
sheet metal with architectural elements,
cast and chased figures, and a series of
enameled plaques representing drolleries,
some of which play musical instruments.
Water wheels and bells were added to
capture motion and sound. The entire
assembly is an exquisite piece of Gothic
architecture in miniature.

Originally, the fountain stood in a large
catch basin. Water, pumped through a

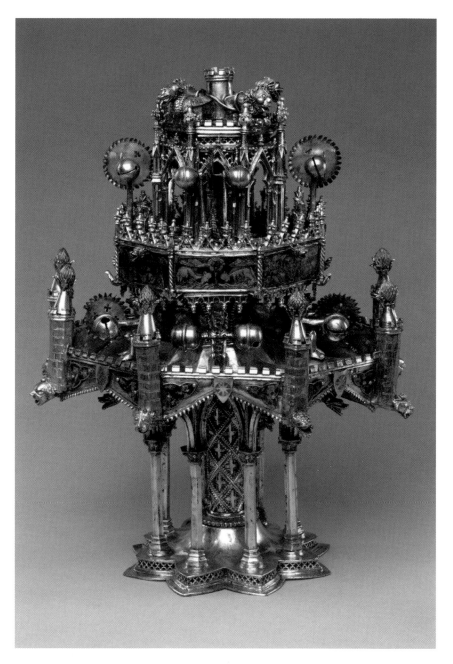

central tube, emerged at the top through
a series of nozzles (shaped as animals and
drolleries) in jets that forced the rotation
of the wheels and rang the tiny bells. The
water gradually cascaded from one level
to the next through gargoyle heads, only
to refill the catch basin for another cycle.

The suggestion that such fountains
were intended to be used on banqueting
tables is not supported by the evidence.
Inventories do not refer to these objects
as "table" fountains, and contemporary
miniatures of banqueting scenes do not
depict such objects. They are generally

associated with rose water. It seems more
likely that, secondary to their interest as
objects of entertainment, they were
intended to serve as room scenters
mounted on tripods or small side tables.

S.N.F.

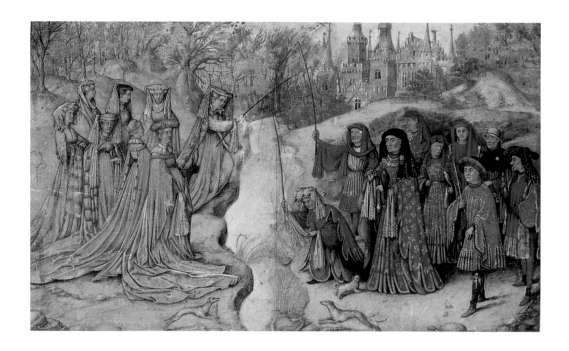

27

Low Countries

The Fishing Party

Late 16th-century copy of
a 15th-century original (c. 1440?)

Pen and ink, watercolor with gold
highlights and white gouache;
on two sheets arched at the top,
juxtaposed and completed in the upper
corners to form a rectangle; affixed
to wood
Image, 22.9 x 37.5 cm;
sheet, 24.4 x 38.8 cm

At the top, on the framing strip,
in gilded letters: VETERVM
BVRGVNDIAE DVCVM
CONJVGVMQVE FILIORVM
FILIARVMQUE HABITVS AC
VESTITVS

Paris, Musée du Louvre, Department
of Prints and Drawings, inv. 20.674

PROV.: mentioned in the inventory taken
after the death of Emperor Matias of Austria
in 1619; then in the imperial painting gallery
of Vienna in 1784; acquired by the Louvre in
1806.

BIBL.: Kurtz 1956; Van Luttervelt 1975;
Lugt 1968, no. 10; Sterling 1976, p. 19, fig. 22;
Duverger 1977, p. 173; Châtelet 1980,
pp. 28–30, 97, no. 21; Dhanens 1980, p. 162,
fig. 113; Ninane 1985–88.

Exhibited in Dijon only

Two groups of sumptuously dressed
figures face each other, nine gentlemen to
the right and eight ladies to the left, on
both sides of a stream. Three of them are
fishing; four are carrying falcons on their
fists. The inscription identifies the drawing
as a depiction of some "former dukes of
Burgundy, their wives, their sons, and
their daughters, dressed befitting their
station."

This suggestion is contradicted by the
presence of the necklace of the order of
St. Anthony, recognizable by its bell,
which some of the figures wear. The order
was founded in 1382 by Albert I, Duke of
Bavaria, Count of Hainaut, Holland, and
Zeeland. Thus this may be a group portrait
of three generations of dukes of Bavaria in
the Low Countries. Nearly all the figures
have been identified through comparison
with portraits. The young generation
occupies the center of the composition; it
has been suggested that the woman who
holds a fishing pole is Jacqueline of Bavaria
and the figures facing her are her four
successive husbands. The last, Frank van
Borsele, would be the principal male
figure, dressed in a sumptuous mantle.
The man holding a scepter may be
William VI of Bavaria, and Albert I would
be the figure at the extreme right, wearing
a hat and holding a falcon. Lucie Ninane
thinks that the original composition was
created at the behest of the last husband
of Jacqueline of Bavaria, after her death in
1436. The confusion with the court of
Burgundy can be explained by the
incorporation of Jacqueline of Baravia's
inheritance into the states of Burgundy.

Like the *Outdoor Party in the Burgundian
Court* (cat. 60), the *Fishing Party* presents
an image of the leisure activities of the
court in the Low Countries. Taking into
account the work's retrospective character
and its probably allegorical intentions, this
image cannot be viewed as a
"photographic" reproduction of a reality.
However it does have the merit of
conveying the sophisticated ambience of
courts related to that of Burgundy,
particularly in the extravagant clothing,
detailed with precision. Such "stagings" of
life could also be found at the court of
Burgundy; a 1420 inventory of tapestries
of the Duke of Burgundy mentions "Nine
large tapestries and two of less high-warp,
embroidered in gold, with falcons, plovers,
and partridges, and the figures of the late
lord Duke Jehan and madam the duchess
his wife, both standing and on horseback"
(cited by Campbell 1990, p. 47).

The original arched shape of the sheets,
which were glued together to make a
customary rectangle, invite the suggestion
that the drawing could instead be a copy
of a fresco located in a vaulted space of a
princely residence. While we know of no
interiors of this type in the Low Countries
or in Burgundy, they did exist, and the
greatest artists contributed to them.
Indeed, Jan Van Eyck worked on the decor
of the palace of Jean of Bavaria in La Haye,
and earlier, Melchior Broederlam
decorated the château of Hesdin.

S.J.

Sophie Cassagnes-Brouquet
Artists to the Dukes

of Burgundy

From the anonymous mass of artists working in Burgundy under the Valois dukes, only a few names emerge that are associated with the rare works preserved in museums: Jean de Beaumetz, Jean Malouel, Henri Bellechose, Claus Sluter, Jean de Marville, and Claus de Werve. These creative individuals all belonged to the privileged group of court artists, recruited by the dukes of Burgundy and paid by the accounting office of Dijon. Their legacy has been handed down through the ages, thanks to ample documentation. The court artist was an extraordinary individual, distinguished from other artists by his privileged status, a certain affluence, and not least important, an awareness of his superiority.

Recruitment

We cannot be certain of the Duke of Burgundy's intentions once he hired an artist. Despite their dryness of style, the letters patent that describe the recruitment of a given painter, glass artist, or sculptor point to a few avenues to research. They generally omit any mention of the terms and conditions of the artist's employment and address only the financial arrangements.

The initiative came from the court, a fact made particularly clear in 1393, when Philip the Bold sent the son of his painter Hue de Boulogne to apprentice himself to Melchior Broederlam in Ypres.[1] Here, as on numerous occasions, family ties played a role, contributing to the establishment of veritable dynasties of artists. The Boulogne family is the clearest example of this practice, but it is just as evident in Burgundy in the careers of the sculptors Claus Sluter and his nephew Claus de Werve. That Jean Malouel found favor with the Duke of Burgundy no doubt contributed to the hiring of his nephews, the Limbourg brothers, to create a bible for Philip the Bold in 1402.[2]

At the turn of the fourteenth century, the first of the Valois grand dukes, Philip the Bold, cut a figure as a prince whose attentions turned toward the broad European horizon, and he recruited his painters, sculptors, and architects from every country in Europe.

His first painter, Jean d'Arbois, was perhaps originally from the earldom of Burgundy, but when the duke took an interest in him in May 1373, he was living in northern Italy, and a horseman was sent to find him.[3] The letters patent, which name him to the position of painter to Philip the Bold, say nothing about the latter's motivation, but we can reasonably assume that Jean d'Arbois's fame had reached as far as Paris. Having turned his attentions to Italy, Philip the Bold then recruited his other painters and his two glass artists from among the many Franco-Flemish artists present in the capital of the kingdom. Jean de Beaumetz had lived in Paris since at least 1371. His stay ended in 1376 when on 5 May, the Duke of Burgundy engaged him as painter and *valet de chambre*, at the wage of 4 gros per day, to replace the deceased Jean d'Arbois.[4]

It was thus in Paris that the Duke of Burgundy made the acquaintance of his second painter, to whom he rapidly entrusted large work sites within the duchy. However, no text specifies or informs us about who arranged this meeting. This is not the case for his third painter, Jean Malouel, the son of a family living in Nimègue, in the duchy of Gueldre.[5] His father, Wilhelm Malouel, was employed as a painter of standards and coats of arms for the court of Gueldre. It is perhaps due to the protection of the Duchess of Gueldre, Catherine of Bavaria, that Jean Malouel worked in Paris in the autumn of 1396 on behalf of Isabeau of Bavaria, queen of France.[6] Most likely he came to the attention of Philip the Bold at that time. On 5 August 1397, the duke conferred upon him the title of painter and valet de chambre.[7]

Philip the Bold's glass painters had the same northern origins, but the circumstances of their appointments remain more vague. The first among them, Jehan de Thiais, who came from the Maastricht area, was working in Dijon in 1382 with the title of master glass artist and valet de chambre to the duke, but we do not know the terms and conditions of his employment.[8] His successor, Robert le Cuvelier of Cambrai, appears to have worked with him and took over from him as a matter of course, beginning in February 1389. The duke also made the acquaintance of the master builder Drouet de Dammartin and the sculptor Jean de Marville in Paris.

Philip the Bold made good use of his Paris connections to recruit the most remarkable painters, sculptor, architects, and glass artists from Paris, which was the capital of the arts at the turn of the century. In this way he channeled some of the creative forces of Franco-Flemish art in the direction of his duchy.

John the Fearless, who, in pursuit of his own political ambitions, was quite willing to live in Paris rather than his own duchy, broke with the tradition established by his father. He did not call upon one of the seasoned members

Fig. 1

Fig. 1a

of the artistic elite of the time, but instead looked to an artist working in Dijon. Appearances, however, can be deceiving. Certainly Henri Bellechose was originally from Breda en Brabant. Thus it appears that he followed the path of his two brilliant predecessors, who settled in Burgundy in order to fulfill the artistic needs of a demanding prince. In reality, however, Jean Malouel was more famous than Bellechose when John the Fearless named him painter and valet de chambre on 23 May 1415. The fact that Bellechose was not reimbursed for his move, and the speed of his appointment, suggest that he was already in Dijon, perhaps as a valet de chambre in the workshop of the ducal painter.[9]

The position of ducal glass artist remained vacant after 1393, when Robert de Cambrai fled Dijon with the advance payment he had received for work planned for the ducal oratory in the Carthusian monastery,[10] and from this date major work on the monastery ceased. Meanwhile, word quickly spread of the need for a good artist, one capable of overseeing the maintenance of the ducal windows. In 1415 the prince chose Jean Arossignol, originally from Villebichot on the Côte-d'Or. Thus the principality under John the Fearless was notable for the narrowing of its artistic horizons, and its willingness to simplify and render more modest the procedure of recruiting court artists.

Wages, Gifts, and Bonuses

The attainment of the title of ducal painter, glass artist, sculptor, or illuminator brought relative security, which translated into regular wages. The mode of payment to artists employed in Burgundy worked according to two different norms: payment of a fixed salary, by the day or by the year, and payment by each piece of work. The first method applied to the work of painters, architects, and sculptors, the second to that of glass artists and illuminators.

The wages of ducal painters were based on the workday. Jean de Beaumetz received a salary of 6 gros, 4 for himself and 2 for a valet de chambre he was obliged to keep on hand, beginning in 1379. The ducal painter's salary remained at this level throughout his entire career in Burgundy. The modesty of this salary and its stagnation did not indicate displeasure on the part of the prince. On the contrary, he showed his approval with numerous bonuses. This salary was therefore nothing other than some sort of guaranteed "minimum" wage. It should also be emphasized that artists were also free to work for other clients. Wages were paid annually or in two payments, one in spring and one in autumn, at Pentecost and on All Saints' Day.

A study of wages allows us to discern a preferential hierarchy among the prince's artists. It is incontestable that Dukes Philip the Bold and John the Fearless considered Jean Malouel their most talented artist, closely followed by Jean d'Arbois and Jean de Beaumetz.

Jean de Marville, for his part, earned 8 gros per day for himself and his 2 valets de chambre. Upon his death, the sale of his property brought in 347.75 gros. He owned three horses.[11] Claus de Werve received a wage of 8 gros per day, or 243 pounds per year, but in 1427 this sum was

reduced, as were the wages of Henri Bellechose, to 150 francs per year.[12]

Glass artists and illuminators seem to have occupied a slightly lower position on the pay scale. The two first ducal glass artists, Jehan de Thiais and Robert de Cambrai, were paid for each piece of work and do not appear to have earned a regular salary. After Robert de Cambrai took flight, the ducal administration balked at engaging and appointing a new glass artist. Instead, they called upon artists who were already working in Dijon. It was not until 1415 that Jean Arossignol, having proven himself in numerous workshops, obtained this appointment. Nonetheless, no glass artist was ever again conferred the privileged status of valet de chambre.

Wages were not an artist's only income. Payment by the piece and by the day was customary, as were gifts, which were often quite generous. Thus the career of Jean de Beaumetz should not be viewed solely in terms of his modest wage of 6 gros per day, for these humble terms were mitigated by the prince's generosity. Like many members of the court, the painter and valet de chambre received allowances. The phrasing employed by the accounting office underscores the prince's good will and the fact that these gifts were given freely: "To Jehan Maluel painter and valet de chambre of my Lord, to whom said Lord bestows as special favor the sum of 100 gold escuz for his good services rendered every day in the past and in hope for more and abundant time to come, by the letters patent of said Lord, for these works consigned in Arras on the 12th day of November in the year 1400 and hereby delivered to the court with receipt for these 100 francs."[13]

Gifts were not limited to the artists holding the title of valet de chambre, such as Jean de Beaumetz, Jean Malouel, or the glass artist Jehan de Thiais. They also applied to the ordinary glass artist Robert de Cambrai.[14] Once again, Philip the Bold showed himself to be the most generous of patrons; after his death gifts of this sort became more unusual.

These favors took two forms: some were specific and had to be applied to the purchase of a horse or a garment; others were more regular in nature, the kind of bonuses associated with the satisfaction the prince took in an artist's work. These gifts often were as much as 100 francs.

Monetary rewards alone do not sum up all the advantages of a court artist. Housing might also be a gift. When he arrived in Dijon in 1376, Jean de Beaumetz was granted a workshop and lodging right in the heart of the ducal residence,[15] a common practice in Burgundy. Jean de Marville was housed in a residence that the duke had

Fig. 2

Fig. 1. The signature and seal of Claus Sluter, ADCO, B 387.

Fig. 2. Petition of Claus de Werve for a tax abatement, 30 March 1424. Dijon, Archives Municipales.

Fig. 2a. Detail of Claus de Werve's petition: self-portrait.

Fig. 2a

Fig. 3. Drawing of the funerary statue of Claus de Werve, formerly in Saint-Étienne de Dijon. Paris, Bibliothèque Nationale de France.

Claus Sluter received a gift of money to pay the "physicians and apothecaries" after an illness.[20] An artist who died young often left behind a widow and young children. Here again, the prince's generosity came into play. The prince's high regard for an artist did not end with the death of the artist himself, but was extended to his entire family.[21] The pension granted by John the Fearless to Eloye Malouel, widow of Jean, attests to this practice. The text of the ducal letter patent, as recorded in the financial ledger of the Salins salt works, expresses the prince's concern for an unusual painter, described by the duke as "one of the good workers in his craft who while living was a symbol of France."[22]

Vivid proof of the privileged relationship between the court painter and the prince, this text places the relationship between patron and artist on a plane of mutual respect and opens up interesting perspectives on the status of the court artist.

Artists and the Prince

Ducal painters, glass artists, illuminators, and sculptors, whether or not they were valets de chambre, were all dependent on the prince for their wages. Brought into ducal domestic service, the artist, from that point forward, considered himself personally bound to the duke in a manner characteristic of the feudal mentality. This found expression in the oath that every court artist had to take upon his arrival in Burgundy. In the prince's absence, his representatives administered the oath, as with a vassal.[23]

The title of valet de chambre was not granted automatically; it was apparently reserved for the most appreciated artists and more often awarded to painters than to glass artists. Jean d'Arbois, Jean de Beaumetz, Jean Malouel, and Henri Bellechose enjoyed this benefit, whereas Jehan de Thiais was the only glass artist to receive it. These artists were close to the princes and accompanied them on journeys, particularly in the court of Philip the Bold.

This closeness is reflected in the language, however inexpressive, of the financial ledgers. The same phrases were always used to express ducal favor: "in special thanks, the sum of 100 gold escuz for good services he has rendered every day in the past and in hope for time to come." It was thus that Philip the Bold expressed satisfaction with his painter in 1401.[24] Other phrases insist on the need to complete the work in progress because the prince takes such delight in it.

Sometimes the prince's good will was expressed in more explicit terms, particularly in the text cited above regarding the pension paid to the widow of Jean Malouel. There, John the Fearless openly stated that the deceased painter was considered in his time to be one of the

restored in 1385, and Claus Sluter was also provided housing, located near the accounting office, on what is now the rue de l'Ecole-de-droit, then known to residents of Dijon as the "house of Claus."[16]

Another significant advantage, passed down from ancient times, was exemption from paying taxes. It was thus that Jean de Beaumetz, taxed for the considerable sum of 4 francs in 1385, received a dispensation for the entire payment.[17] In effect, the ducal painter was granted a noble title by Philip the Bold in 1382, as indicated in the Registry of Seals (tax registry) of Dijon.[18] Jean Malouel was granted the same tax dispensation.

The court artist appears to have been privileged from an economic standpoint in that he was guaranteed a regular wage, often modest, but greatly augmented by more generous gifts. Moreover, he benefited from other advantages that protected him from the uncertainties of life. In fact, it was not unusual for the prince to come to the artist's aid when the latter found himself in difficult circumstances. In 1402, Jean Malouel received a sum of money after a long illness that had forced him to interrupt work at the Carthusian monastery of Champmol.[19]

greatest painters in the realm. As we have seen, this privileged relationship between artist and prince was expressed at major turning points in the life of the painter or glass artist: marriage, old age, and death. It was an enormous advantage but could also prove fragile. The death of the prince sometimes resulted in a severing of bonds, and the court artist had to wait to be recognized by the new duke. The succession from Philip the Bold to John the Fearless unfolded without difficulty, and artists were re-appointed to their positions rather quickly and at the same pay.

Artists at Work

Thanks to the preservation of many financial ledgers, which are true mines of information, among all the artists of the medieval period it is the court artists whose working conditions we know best.

First, the court artist rarely worked alone. The prince obliged him to take on one or two valets de chambre, whose pay was taken into account in the artist's own wage. The two or three people who made up the regular personnel of the ducal workshop were sometimes forced to take on numerous valets de chambre. The large projects begun under Philip the Bold compelled Jean de Beaumetz to recruit others to work with him. The record was reached in 1390, with the hiring of nineteen valets de chambre who worked day and night (candles were purchased so the workers could see at night) to prepare the jousting harnesses for the duke and his son for a fête hosted by the king at Saint-Denis.[25]

What was the individual role of the painter on such projects? In the first place, he seems to have been a coordinator, and he supplied the models and saw that those executing the work followed them faithfully. This was particularly important on the site of the Carthusian monastery at Champmol, where Jean de Beaumetz supervised a large team of painters to whom he assigned tasks. Claus Sluter was also at the head of a group of sculptors of disparate origins.

Thus the court artist was an artist but also a project manager who directed a team and did not work alone.[26] The variety of tasks for which he was responsible prohibited him from doing so. Though the sculpture workshop seems to have been devoted mainly to the decoration of the Carthusian monastery at Champmol and the tomb of Philip the Bold, the court painters were engaged in many different activities. We are not concerned here with describing them in detail, but rather of noting their diversity: decorative mural painting, painting on wood panels, portraits, and devotional panels. Decorations for funerals included humble tasks such as painting the duchess's wagon or coats of arms on a triangular banner. Art history has established a hierarchy of values among all these activities, with preference given to panel painting over mural painting. But was this really true at the time?

NOTES 1. Dehaisnes 1886, 2: p. 707; Châtelet 1994, p. 323.
2. ADCO, Accounts of Jehan Chousat, tax collector of Burgundy, B 1532, fol. 323, 1402–3.
3. Ibid., General Accounts, B 144, fol. 49, 7 June 1373.
4. Dehaisnes 1886, p 532; Monget 1898–1905, 1: p. 115; Prost 1902–8, 1: p. 512, no. 2713.
5. Gorissen 1954, pp. 153–80.
6. Troescher 1966, pp. 67–68, raises the hypothesis of a voyage by Malouel to Italy prior to his stay in Paris; at the moment, however, no documentation allows confirmation of this.
7. ADCO, General Accounts, B 15, fol. 47, mentioned by Monget 1898, 1: p. 293.
8. Ibid., Accounts of the district of Dijon, B 4431, fol. 33v.
9. Ibid., General Accounts, B 15, fol. 113r.
10. Monget 1898–1905, 1: p. 246.
11. Camp 1990, pp. 39–41.
12. Ibid., p. 70.
13. ADCO, General Tax Office of Burgundy, B 1526, fol. 172v, 1401.
14. Ibid., Accounts from the building of the Carthusian monastery at Champmol, B 116722, fol. 27: "To

Robert de Cambray, glass artist, in payment for the work he completed and in special thanks for the fine services performed in his craft as glass artist for ten works at the Carthusian monastery, pay to him . . . by mandate this 12th day of February 1340, 20 francs."
15. Ibid., Accounts of the district of Dijon, B 4422, fol. 37v: Regnaut de Gray, locksmith, "residing in Dijon, made a lock to guard the work of Jean de Beaumetz, painter, and the colors of Monsieur the Duke in the ducal residence in Dijon."
16. Monget 1898–1905, 2: p. 104; Chamagne 1980, p. 153.
17. AMD, M 61, Accounts of the city 1385, fol. 215v: "default in payment for the fees of Saint Jean parish, Jehan de Beaumetz, 4 francs."
18. ADCO, B 11487, fol. 150 verso, 1381: "Jean de Beaumetz painter 3 sols"; fol. 248, 1382: "Beaumez [sic] and his wife 40 sols"; fol. 330v, 1383: "Beaulmes and his wife 40 sols, crossed out and emphasized in the margin"; fol. 404, 1384: "Beaulmex and his noble wife"; fol. 478, 1385: "Beaulmex and his noble wife."

19. Ibid., Accounts from the building site of the Carthusian monastery of Champmol, B 11674, fol. 133v, 4 April 1402.
20. Ibid., General Tax Office of Burgundy, B 1466, fol. 143.
21. His painter, Jean Malouel, in payment for the ransom of his nephews, taken hostage in Brussels in May 1400 (ibid., B 1519, fols. 158–59).
22. Ibid., Accounts of the ducal salt works in Salins, B 5968, fols. 38v–39, 15 October 1415.
23. Ibid., General Accounts, B 15, fol. 113r, 12 August 1415.
24. Ibid., B 1526, fol. 172.
25. Ibid., B 1476, fols. 34–35: "for candles to provide light for the workers laboring at night on necessary work, 2 francs."
26. The court painter could hire a subcontractor, which Melchior Broederlam probably did for the two altarpieces at Champmol, and Jean de Beaumetz proceeded in like fashion when he resorted to the workshop of Picornet.

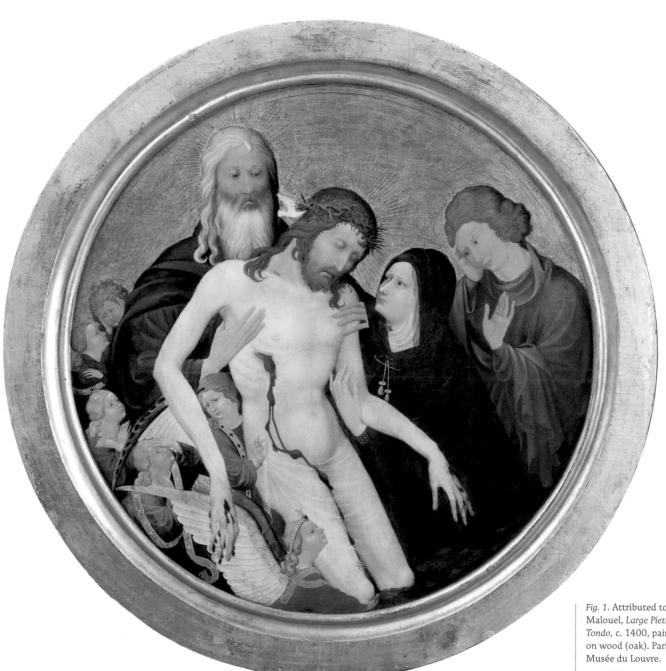

Fig. 1. Attributed to Jean Malouel, *Large Pietà Tondo*, c. 1400, painting on wood (oak). Paris, Musée du Louvre.

Overleaf
Fig. 2. Attributed to Jean Malouel, *Virgin and Child Surrounded by Angels*, c. 1410–15, painting on original canvas. Berlin, Gemäldegalerie, Staatliche Museen Preussischer Kulturbesitz.

TREASURES OF THE PRINCES

Philippe Lorentz

The Painters of Philip the Bold and John the Fearless in Dijon

Our knowledge of easel painting around 1400 north of the Alps is extremely sketchy, particularly because of the rarity of extant works. The dearth of material available for historical analysis is sometimes attributed to the fact that patrons of that time preferred paintings in books, and it is true that illuminated manuscripts have survived in great numbers, particularly in the geographic area of France. But we forget that most of the works painted on wood were meant to imitate the appearance of goldsmiths' "tableaux." At the time, these were the only pictures deemed worthy of being recorded in inventories because of the value of their constituent materials (gold, silver, gemstones, pearls), which were likely to be recycled for other uses. In contrast, much less value was placed on paintings, which were rarely inventoried. Only a thin coat of gold masked the lack of value of their support—wood—and gave them the appearance of precious objects; there was nothing, in short, that might guarantee their perpetuity. The frequent loss of paintings on wood thus makes it difficult to establish a satisfactory geographic map of the centers of pictorial production around 1400. In conjunction with the 1962 Council of Europe exhibition devoted to European art around 1400, Charles Sterling defined the "International Gothic" as "a victorious homogeneity of national frontiers."[1] This label likewise seems to legitimize the uncertainties that historians find when addressing the geographical origins of works of art. The production of certain centers, the importance and vitality of which are nevertheless attested to in the sources, remains mysterious. The most flagrant case is Paris, the capital and the sole very large city in the French kingdom where artists and patrons converged and where in 1391 the presence of no less than some thirty painters was counted.[2] In the first of two volumes devoted to medieval painting in Paris, Sterling lists only six painted panels in the early fifteenth century,[3] and the

Parisian origin of these works is more than likely controversial.

An artistic center of more modest size arose in Dijon at the behest of Philip the Bold, however, with the enterprise continued by his son John the Fearless. This generated pictorial activity that can be more fully discerned today, thanks to a handful of works of Dijonnaise provenance and an abundance of documentation from the ducal archives—particularly from the accounting records of the Carthusian monastery at Champmol. In the first of his "long specialized articles,"[4] which appeared a half-century ago, Sterling, thanks to the uncontestable identification of two works, *Crucifixion with a Carthusian Monk* (cat. 71a–b), with two of the twenty-six paintings for the monks' cells at Champmol that were commissioned in 1388 by Philip the Bold from his official painter, Jean de Beaumetz,[5] indirectly reinforced the attribution to Jean Malouel, successor to Beaumetz, for the *Large Pietà Tondo* now in the Louvre (fig. 1). This work was painted around 1400 for Philip the Bold, and until now, the suggestion of Beaumetz's authorship has been as acceptable as that of Malouel.[6]

Nicole Reynaud has also made an essential contribution to the subject of Burgundian painting around 1400, providing proof that the large altarpiece depicting *St. Denis's Last Communion and Martyrdom* (see fig. 1, p. 199) is not the work of Jean Malouel (who died in 1415), but of his successor, the Brabant painter Henri Bellechose. In 1416 Bellechose was commissioned to "perfect a painting of the life of Saint Denis." It was thought that this might be one of the five "wood panels" painted by Malouel, beginning in 1398, for the altars of "certain chapels" in the church of the Carthusian monastery at Champmol. The erroneous transcription of one of the documents concerning this commission led to the belief that one of the five paintings had the same

dimensions as the St. Denis altarpiece. And so this work logically would have been completed ("perfected") by Bellechose. But Reynaud's careful reading of the archival documents has brought to light the differences in proportions between the "panel" mentioned in the payment of 1398 and this altarpiece, which henceforth must be attributed solely to Bellechose.[7] Its stylistic consistency, moreover, seems to exclude authorship by two different hands.

Precise knowledge about works by Jean de Beaumetz, Jean Malouel, and Henri Bellechose—the three painters from the Low Countries who came to Dijon to work under Philip the Bold and John the Fearless[8]—clearly enables us to appreciate the pictorial milieu in Burgundy more fully than that in most other centers of artistic activity at the time of the International Gothic. These paintings form a priori a particularly coherent group. An analysis of their style, which reveals Italian inflections—Sienese in particular—combined with a curvilinear elegance typical of the Parisian tradition, reflects a remarkable continuity over three generations of painters. Even before Sterling's seminal article (1955), critics had detected affinities between numerous works in this group. Writing about the Louvre *Crucifixion with a Carthusian Monk* (cat. 71b)—then in the Chalandon collection in Lyon—Louis Demonts attributed this panel to the painter of the St. Denis altarpiece, then identified with Jean Malouel.[9] Sterling pointed out that the St. John at the foot of the cross in the two depictions of the *Crucifixion with a Carthusian Monk,* "with his massive and tilted head," were "hardly similar" to the *Large Pietà Tondo.* Likewise, even more obvious similarities between the *Large Pietà Tondo* and the St. Denis altarpiece had been emphasized frequently, particularly the striking resemblance between the childlike heads of the angels, with their receding chins, and that of Christ, though the treatment of the figure in the tondo is more delicate.[10]

Insofar as these paintings form a coherent stylistic group, painted by artists from different regions in the Low Countries and brought to Dijon by Philip the Bold, is it possible to say that they are the result of a "school"—that is, a center of activity that provided the necessary conditions for the transmission of specific artistic forms (concentration of artists in a given place, organization into workshops, and establishment of these conditions for a length of time)? The available information that would allow us to attempt to respond to this question remains extremely fragmentary, and it would be best to admit that the two works that have been key to identifying Jean de Beaumetz give us a far from complete view of this artist's style. Thus we would need to know about a wider range of compositions, such as the winged triptych that the duke purchased in 1390 for the altar of

the ducal oratory in the Carthusian monastery at Champmol—the only work mentioned in the sources for which the subject is specified.[11] Beaumetz, who was working with André Beauneveu in Valenciennes in 1361, was engaged by Philip the Bold in 1376 in Paris and immediately dispatched to Dijon, where he remained for twenty years as official painter for the prince (1376–96). The great number and variety of works that he created (decorative projects, painting of flags, polychrome application to statues) imply, and archival sources confirm, that he was supported by a workshop with "laborers" who carried out his orders. Among these works, the stylistic differences between the two depictions of the *Crucifixion with a Carthusian Monk* reflect two different artistic hands,[12] which must have been the result of a collaboration. However it is clear that the concept behind the complete series of paintings for the monks' cells belonged to the artist who was in charge.

The idea we are able to form of the art of Jean de Beaumetz's successor, Jean Malouel, is also extremely fragmentary, but more varied. We do not know how this painter, originally from Gueldre (in the northern region of the Low Countries) succeeded in attracting the attention of Philip the Bold. The alliances between the Valois and Wittelsbach families might be of interest in this regard. In 1379, a Wittelsbach princess, Catherine of Bavaria, a relative of the queen of France, Isabeau of Bavaria, had wed Guillaume I of Gueldre, for whom Guillaume Malouel, father of Jean, worked. The latter must have received his initial training in the family workshop in Nimègue. In 1396–97 he was in Paris, where he provided the queen of France with "34 patterns to make cloths of gold on velvet of several colors and [heraldic] devices."[13] It seems that in the capital, the Duke of Burgundy engaged Malouel's services that same year, 1397. But the artist was probably in Dijon in 1395.[14] During this period, Beaumetz, still active, was working on the paintings for the cells of the Carthusian monastery.

The only two paintings now attributed to Jean Malouel, the *Large Pietà Tondo* and the *Virgin and Child Surrounded by Angels* (fig. 2),[15] are the work of an artistic figure of the highest order, someone who was receptive to the formal innovations of his time. The differences in the treatment of the figure in the two pieces demonstrate at what point the painter began to pay attention to the plastic density in the art of Claus Sluter, who was working alongside him in Dijon. An important portrait of John the Fearless (cat. 2), unjustly ignored by historians of portraiture, still strikingly attests to Malouel's innovative talents. This likeness, faithfully copied in the sixteenth century at an undoubtedly much reduced scale compared to the original, dates back to 1404. It was painted to commemorate the prince's accession to the

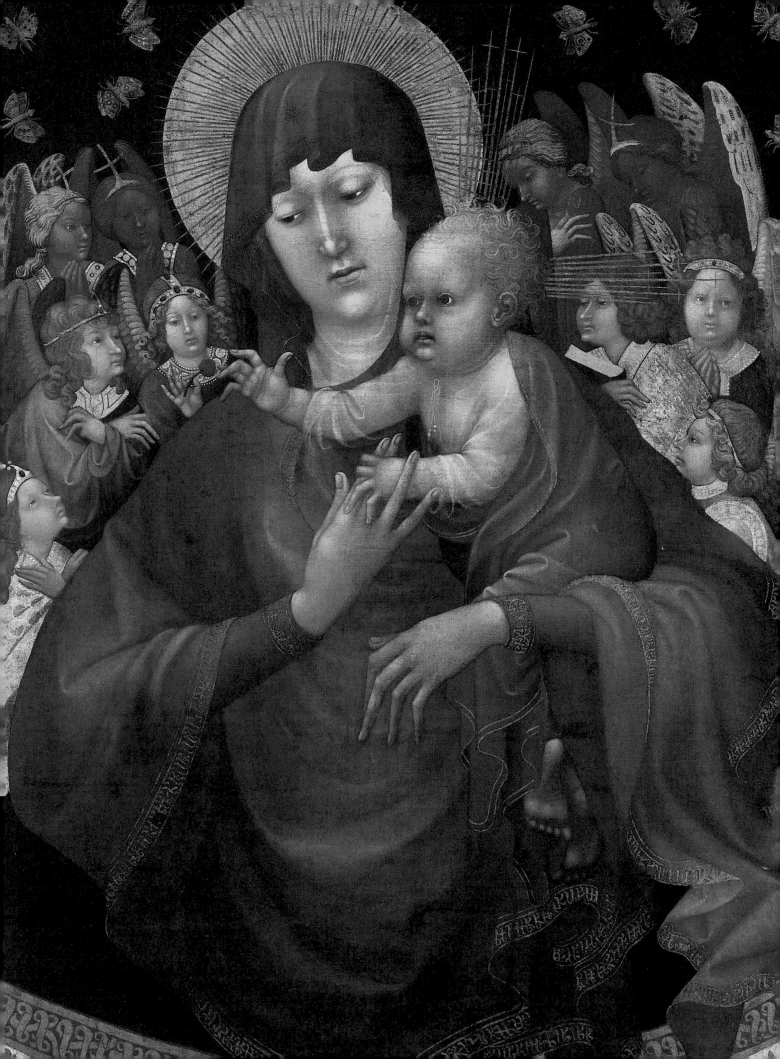

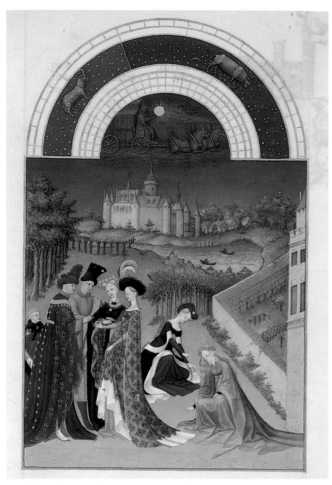

Fig. 3

duchy of Burgundy upon the death of his father, Philip the Bold. In his right hand, John the Fearless holds the ring that the abbot of Saint-Bénigne in Dijon solemnly handed over to each new duke upon his investiture.[16] This elaborate depiction is the first known example in Western painting of a large-scale court portrait. The sitter is not shown in small bust format, but in a larger view, from the waist up. He is resting with the entire breadth of his forearms on a table that is covered with a carpet ornamented with the coat of arms of Burgundy. A half-century before Jean Fouquet and his *Portrait of Charles VII,* Malouel seems to have been the inventor of this enlarged and solemn formula for an official portrait.[17] There can be no doubt that he is the author of this *Portrait of John the Fearless.* The slender character of the image and the extreme refinement of the gesture of the right hand bring to mind the worldly elegance of the figures in the *Large Pietà Tondo* and to a considerable extent resemble some of the figures that populate the miniatures of the Limbourg brothers, nephews of Jean Malouel.[18] Thus it is not surprising that Erwin Panofsky thought about attributing this portrait to the painter of the miniature of April in the calendar of the *Très Riches Heures* of Jean de Berry (fig. 3).[19]

If we were to know more about the works of Malouel, who must have been an artist of great importance, we would likewise be better able to understand the art of the Limbourg brothers and their sources. Thus we can ask whether the Carthusian monk donor in the Louvre *Crucifixion* by Jean de Beaumetz (fig. 4) was reworked by

Fig. 4

Fig. 5

Fig. 3. Limbourg brothers, *Très Riches Heures de Jean de Berry,* Calendar: the month of April, fol. 4v, c. 1411–16, painting on parchment. Chantilly, Musée Condé.

Fig. 4. Jean de Beaumetz, *Crucifixion with a Carthusian Monk,* detail: the donor, c. 1389–95, painting on wood (oak). Paris, Musée du Louvre.

Fig. 5. Limbourg brothers, *Belles Heures de Jean de Berry, The Plague in Rome,* fol. 73v, c. 1406–9, painting on parchment. New York, The Metropolitan Museum of Art, The Cloisters.

Fig. 6

Fig. 7

Fig. 6. Melchior Broederlam, *Crucifixion Altarpiece,* detail from left wing: the Virgin of the Annunciation, c. 1394–99, painting on wood (oak). Dijon, Musée des Beaux-Arts.

fig. 7. Master of the Remedy of Fortune, *Saint-Denis Missal,* Initial O: *Miracle of the Stag Sheltered in the Church of Saint-Denis,* fol. 261, c. 1350, painting on parchment. London, Victoria and Albert Museum, MS 1346–1891 (to be restored).

Malouel and passed on to his nephews. The latter—with a great deal of audacity—placed similar figures, draped and seen in foreshortened view, in certain miniatures in the *Belles Heures de Jean de Berry* (fig. 5). If this motif did develop in this manner, then it would seem more likely that Malouel passed through the workshop of his predecessor in 1395. What we can say is that Malouel and the Limbourg brothers could have seen two panels in Paris by Beaumetz, which Philip the Bold had moved from Dijon in 1396.[20]

It appears that Philip the Bold and John the Fearless availed themselves of excellent painters in Burgundy. While we do not know the earlier history of Henri Bellechose of Brabant, who was Malouel's successor as official ducal painter—his presence in Dijon is mentioned for the first time in 1415[21]—archival sources attest that Beaumetz and Malouel did spend time in Paris. Because of their continual attachment to the French court, the two first Valois dukes of Burgundy, who resided most of the time in Paris, attracted to Dijon painters who had first worked in the capital. These artists apparently maintained their ties to extremely productive Parisian circles. The stylistic similarities that brought them together and contributed to the coherence of art in Burgundy around 1400 can be explained in part by a common pictorial culture acquired in Paris, marked by a steady Italian influence. The *Crucifixion Altarpiece* (cat. 70) was completed in Ypres in 1399 by the Flemish artist Melchior Broederlam—a contemporary of Malouel—and destined for the Carthusian monastery at Champmol. In the left wing, the edicule (kiosk) that shelters the Virgin of the Annunciation (fig. 6), with its exaggerated perspective, faithfully revives a device employed around 1350 in a missal intended for Saint-Denis by the Master of the Remedy of Fortune, a Parisian illuminator who made the effective rendering of depth his central concern (fig. 7). Jean de Beaumetz from Artois, Henri Bellechose from Flanders, and Jean Malouel from Gueldre all took Parisian art as a source. Paradoxically, the works that they created in Dijon and in Flanders for the dukes of Burgundy afford us a way to survey what might have been a part of the pictorial production in Paris around 1400.

NOTES 1. Sterling 1962, p. 66.
2. Henwood 1981, pp. 95–102.
3. Sterling 1987, 1: nos. 39, 42, 45, 47, 49, 58.
4. Reynaud 1992, p. 47.
5. Sterling 1955, pp. 57–82.
6. See especially Durrieu 1907, 1918–19, pp. 78–80; Ring 1949, no. 53; Sterling 1938, p. 59 n. 42.
7. Reynaud 1961, pp. 175–76 n. 4–5.
8. And the same is true for Henri Bellechose in the service of Philip the Good, from 1419 until the artist's death between 1440 and 1444 (see Joubert 1994, pp. 452–53).
9. Demonts 1936, pp. 247–48.
10. Panofsky 1953, p. 85.
11. Regarding the central panel depicting the *Coronation of the Virgin* and, on the wings, the *Annunciation* and the *Visitation,* see Monget 1898–1905, 1: p. 200.
12. See Sterling 1938, no. 5; Wixom 1974, pp. 12–15; Thiébaut, in Paris 1981, pp. 376–77 n. 326.
13. AN, KK 41st, fol. 1=117v.
14. Van Buren-Hagopian 1996, p. 487 n. 15.
15. Meiss and Eisler 1960, pp. 232–40.
16. Adhémar 1962, 1: p. 7.
17. In borrowing this type of composition from Malouel (or from another court painter working in the International Gothic style), Fouquet updates it, abandoning the profile view for the three-quarter view, in the Flemish manner.
18. Lorentz in Paris 2004, pp. 262–63.
19. Panofsky 1953, p. 82 n. 9.
20. Sterling 1938, p. 258 n. 3.
21. Since the *St. Denis Altarpiece* (fig. 2) has numerous similarities with the *Large Pietà Tondo* by Malouel, one can deduce that Bellechose trained, at least in part, near his predecessor. For more on Bellechose, see, finally, Smeyers 1996, pp. 639–41.

Claudine Lemaire

The Burgundy

Library

The collection of the Bibliothèque de Bourgogne comprised books and texts from the libraries of Philip the Bold (1342–1404), John the Fearless (1371–1419), Philip the Good (1396–1467), and Charles the Reckless (Charles the Bold) (1433–1477); authenticated by inventories of the time; maintained in the bequests of Mary of Burgundy (1457–1482), the wife of Holy Roman Emperor Maximillian I (1459–1519), of their son Philip the Fair, King of Castile (1478–1506), and of his son Holy Roman Emperor Charles V (1500–1558); and conserved at the Bibliothèque Royale de Belgique. The Bibliothèque de Bourgogne's early status is known through an inventory compiled in 1404, after the death of Philip the Bold while he was on a pilgrimage to Halle in Brabant; this document cites some seventy manuscripts.

In 1420, upon the death of John the Fearless, another inventory was taken, describing in detail 248 books, including 67 held in the chapel. Of course, a number of these derived from the library of John's father and of his mother, Margaret de Male, Countess of Flanders (c. 1350–1405). So luxuriously were they produced that the descriptions of their bindings in this inventory make a kind of imaginary stroll through a fabulous exhibition of books. The Bibliothèque Royale de Belgique holds another fifty-five manuscripts mentioned in this inventory. The system utilized in the inventories of the Bibliothèque de Bourgogne—as in those of the libraries of the French kings—makes the identification of a manuscript infallible, as long as there were no folios missing at the start or end of the texts. In addition to the format and the description of the binding, the inventory mentions the *incipit* on the second page of text (very rarely a prologue or table of contents), and the *explicit* at the end. The latter appeared on the first line of either the recto or the verso of the final folio (that is, of the explicit proper).

The inventory that was drawn up after the death of Philip the Good includes 865 works, of which 97 were in the jurisdiction of the chapel. A number of missals, breviaries, and books of hours pertaining to the duke's private devotion are not included in this inventory, but do reappear in later inventories. However, the twenty-seven manuscripts listed in Dijon in 1477, after the death of Charles the Reckless, and entered into the collection of the Duke of La Trémoïlle, have not been positively identified, their description being too general.

The final three "Burgundian inventories" were made in Ghent, Brussels, and Bruges, in 1485, 1487, and 1504 respectively. These were the last taken because the tradition of inventorying after the death of the sovereign or of the *garde-joyaux* (the "keeper of the jewels," in charge of the library) was not maintained after the deaths of Charles the Reckless, Mary of Burgundy, and Philip the Fair. These inventories accounted for a total of 606 works (with a slight increase in number during the short reign of Charles the Reckless, and some works not included in the inventory of 1469). It is probable that manuscripts held in other residences were not inventoried.

The resulting picture of the Bibliothèque de Bourgogne is that of a medieval-style royal library: texts of moral or religious inspiration predominate, there are numerous tales of chivalry and *chansons*, the omnipresence of Christine de Pizan, an interest in the Near East (dreams of Crusades!), the history of the provinces and their relation to ducal authority (with an emphasis on Trojan roots), and antique and contemporary books relating to princely education and the principals of good government. Double and even triple copies of texts are frequently found. With Charles the Bold there came a certain humanistic orientation. Mary of Burgundy took no great interest in the Bibliothèque de Bourgogne, neither did Philip the Fair (who died too young), nor Charles V (man of war before all else); instead, it was overseen by two successive governors whom the emperor had designated to represent him to the Low Countries: his aunt Margaret of Austria (1480–1530), regent of the Netherlands, and her successor, Mary of Hungary.

The Bibliothèque de Bourgogne was inherited by Philip II, King of Spain (1527–1598), upon the death of his father, Holy Roman Emperor Charles V. Rejecting the suggestion of an overly zealous counselor that the library be transferred to Madrid, the king signed a decree ordering the regrouping in Brussels of the books that had already been disseminated among various royal residences in the Low Countries (The Hague, Bruges, Ghent, Brussels, Mariemont, Turnhout). In 1559, Philip II created the position of librarian at the Bibliothèque de Bourgogne, which he assigned to Viglius de Aytta, head of his private council, having beforehand selected a number of manuscripts for the royal library, which he had just founded at the alcazar in Madrid. Later, Philip II bequeathed his collections of books and manuscripts to the Escorial, a monastery outside Madrid. A portion of this bequest perished in a fire at the monastery in 1671. The precise number of manuscripts brought in by Philip II is not known; only a few precious liturgical books that belonged to Margaret of Austria and Mary of Hungary, survived.

An inventory taken in 1577 in Brussels, after the death of the garde-joyaux of the time, mentions 649 manuscripts, including those from the personal library of Margaret of Austria, which she had bequeathed to her nephew, Charles V.

Over the course of the following centuries, the Bibliothèque de Bourgogne was administered by governors general, appointed initially by Madrid, and by Vienna from 1731, when the Low Countries came under Austrian rule. Certain particularly valuable pieces were moved to Vienna—for example, a book of hours that had belonged to Margaret de Male entered the imperial library in 1722; around the time of the Revolution, Dominique Vivant Denon took this book to Paris, where it has remained (BNF, lat. acq. no. 3187).

An early misfortune befell the Bibliothèque de Bourgogne in February 1731: a fire devastated the Palace of Brussels one glacially cold night—so cold, indeed, that any water that might have suppressed the flames froze on the spot. It is said that the manuscripts, which had been kept in the tower that stood over the Place des Bailles, were thrown from the windows. The librarian of the time noted the disappearance of a number of works, although the sources vary about the exact quantity. Archives and manuscripts that were saved from the fire were transferred to the lower floor of the Palace of Brussels's large chapel, the only area to have survived intact. It was here, between 1737 and 1752, that archivist Jean-Baptiste Godefroye, from Lille, worked; he was appointed to travel throughout the Low Countries and to make copies of all archives concerning France. Godefroye also examined the collection of books from the Bibliothèque de Bourgogne, and wrote up a detailed description of 492 manuscripts in the French language.

After Brussels was taken by French troops in 1746—one of the final episodes in the endless Spanish war of succession—the Bibliothèque de Bourgogne was visited by a parliamentary counselor from Besançon, who took (surreptitiously, but with the approval of Abbé Sallier, librarian of Louis XV) 114 manuscripts for the king's library. The librarian in charge at Brussels estimated the number of works removed at seventy-seven. The parliamentary counselor seized, along with this war trophy, a number of manuscripts intended for the French minister of war, the Count d'Argenson. Purchased by his nephew, the Marquis de Paulmy, founder of the Bibliothèque de l'Arsenal, these books remain to this day the pearls of that institution. In 1899, Henry Martin, compiler of the library's catalogue, counted forty-seven of them (although upon verification it seems that the number was actually slightly higher). In 1770, implementing a clause in the Treaty of Aix-la-Chapelle bringing an end to the war, France restored 76 of the 114 manuscripts from the library of the king of France, 53 of which belonged to the Bibliothèque de Bourgogne.

This confiscation followed by partial restitution was only a prelude to what happened when the French revolutionary troops were unleashed on Europe. It is known that the armies were followed by "extraction committees," whose job was to systematically pillage the cultural treasures from conquered countries for the benefit of the city of Paris, intended to become the receptacle of the artistic, cultural, and scientific world of the Republic. There are numerous indications that certain members of these "extraction committees" were apprised of specific places to visit and objects to seize in museums, churches, and libraries—monastic, royal, and private. The exact number of books taken from the Bibliothèque de Bourgogne is not known, as it was pillaged several times in the course of the year 1794. The first and most important confiscation (twenty-four crates) was not recorded by a receipt of delivery; in the second raid, some 171 manuscripts, as well as a number of printed books, headed to Paris. Upon their arrival, these books were generally carefully inventoried into "deposits" set up for this purpose, but a portion of the treasures from the Bibliothèque de Bourgogne were delivered directly to Joseph Van Praet, conservator of manuscripts for the newly designated Bibliothèque Nationale, before the contents of the crates could be unloaded into the "deposits." The receipts signed by Van Praet, pertaining to the books from Belgian provinces entered into the collections of the Bibliothèque Nationale, account for 4,142 items—but these mention only the formats, and not the titles, of the books.

After Napoleon's defeat, an article of the preliminary peace treaty signed in Paris in 1814 stipulated the return of the artworks to their countries of origin. For the Low Countries, this delicate job was assigned, by the king of Holland (Belgium having been reunited with the northern provinces), to Pierre Lammens, conservator of the University of Ghent's library. In October 1815, Lammens went to the Bibliothèque Nationale. His task was far from easy: there were no precise inventories available, and the staff in place was hardly cooperative. Working "from two in the morning until three P.M.," Lammens managed, in the course of a month, to recover some 1,500 books. His inventory list comprised 930 items; the others, which had been "stored in an attic . . . do not merit description." A good number of these books did not come from the Bibliothèque de Bourgogne, but from other libraries of the Low Countries and the principality of Liège. Lammens recovered "around forty volumes in folio, written on vellum and decorated with miniatures . . . taken from the home library of the ancestors of our august Sovereign," which were sent to The Hague upon his return to Brussels.

It is no longer possible to give a precise enumeration of the manuscripts still in the collections of France's Bibliothèque Nationale. The library of Philip the Good included around 120 manuscripts in Latin, by such classical writers as Sallust, Valerius Maximus, Cicero (a dozen), Ovid, Seneca, Juvenal, and Boethius. The majority were never recovered. Still to be tackled also are the incipits and explicits of the numerous books of chansons and ballads

cited in the inventory of Philip the Good, of which only three have been recovered—although similar manuscripts are conserved in Paris and in other libraries abroad. Although such manuscripts, commonly found in the royal libraries of the day, have been the objects of research conducted by (principally American) musicologists, and the lists of their incipits have been published, the possibility of their pertinence to the Bibliothèque de Bourgogne has not been proposed, as the incipit of the second folio does not necessarily correspond to the incipit of a chanson.

To date, around seventy manuscripts deriving from the Bibliothèque de Bourgogne have been identified in the collection of France's Bibliothèque Nationale. Among them are works that belonged to Philip the Bold and John the Fearless. Four of these are presented in this exhibition; a fifth, lent by the Bibliothèque de l'Arsenal, was one of the items taken from Brussels in 1746.

During the French incursions into Belgium, the manuscripts belonging to the library of Charles V, preserved in the library of Philip the Good, remained in France even after the two confiscations. It is known that a large portion of this library was given by Charles VI to the Duke

of Bedford, regent, who took it to England in 1424. Under circumstances that are not entirely clear, Philip the Good and Lord Louis de Gruuthuse (also a great bibliophile) took the opportunity in England to purchase certain manuscripts that had belonged to the greatest book collector of the day. It is likely that these acquisitions were made through the mediation of Louis de Gruuthuse during his diplomatic sojourn in England, when he was received at the home of the Duke of Bedford.

Apart from the pieces conserved at the Bibliothèque de l'Arsenal, six manuscripts belonging to the Bibliothèque de Bourgogne were accounted for in other Paris libraries or collections, and six more in other French provinces. Little is known of the various expeditions that dispersed some forty-five manuscripts of Philip the Good among twenty libraries throughout Europe and America.

In 1836, 1837, 1888, 1960, 1993, and 2001, the department of manuscripts at the Bibliothèque Royale de Belgique was able to purchase books described in the Burgundy inventories. Currently, it holds 276 manuscripts deriving from the Burgundy collection, of which seven were identified only recently.

PHILIP THE BOLD

Fol. 11r: The story of Rachel.

28

Paris

Bible Moralisée (Bible with Illustrations and Interpretations)
c. 1349–52

Parchment; 321 folios
34 x 29 cm

Paris, Bibliothèque Nationale de France, inv. MS fr. 167

PROV.: Probably commissioned by John the Good; Charles V? (perhaps identifiable with the *Bible toute historiée* (*Complete Illustrated Bible*) listed in the 1380 inventory of the Librairie de Louvre); restored c. 1370–80 following damage by moisture, under circumstances that are uncertain but which may be connected with the defeat and imprisonment of John the Good by the Black Prince (Edward, Prince of Wales) at the battle of Poitiers in 1356; Library of the Dukes of Burgundy, from Philip the Bold (inventory of 1401) to Charles the Reckless (inventory of 1467); Pierre II de Beaujeu, Duke of Bourbon; restored to the royal collections upon seizure of the properties of High Constable Charles de Bourbon in 1523.

BIBL.: Durrieu 1895, 2: pp. 103, 114–18; Laborde 1927, 5: pp. 92–102, pl. 724–38; Avril 1978, pp. 23, 25, 35, pl. 19–20.

EXH.: Paris 1981, no. 272.

Exhibited in Dijon only

The *Bible moralisée,* created in the entourage of the royal family during the regency of Blanche of Castile, was part of a movement that began in the thirteenth century to make the scriptures more accessible to lay people. An allegorical or moral explanation is provided for every two or three verses, with an illustration for each passage. Because of its cost, this type of Bible with its exceptionally rich iconographic cycle had few imitators. This example, written in French and Latin on four-column pages, contains 5,112 grisaille images. François Avril has determined that it was the collaborative creation of about fifteen artists, including Jean de Montmartre, who according to the royal accounts was chosen by John the Good to serve as managing artist for this vast program. Two stylistic currents are apparent in this group of illuminators: one faithful to the heritage of Jean Pucelle, but sometimes characterized by a certain mannerism, and the other oriented toward a search for naturalism, with the Master of the Remède

de Fortune (Paris, BNF, MS fr. 1586) being the most representative.

The grisailles of folio 11 were executed by an artist whose style falls halfway between the two trends. It depicts the story of Rachel (Genesis 35:16), who dies giving birth to Benjamin. The commentator compares this death to the abolition of the Old Law, represented by the figure of the Synagogue losing her crown.

M.-T.G.

29

Workshop of the Boqueteaux Master (Paris)

Aristotle, *Ethics*

French translation by Nicole Oresme

c. 1372

In French. Parchment; 224 folios
31.8 x 21.6 cm (justification 20.8 x 15 cm); 2 columns, 35 written lines; gothic lettering of text; modern binding (1970)

Brussels, Bibliothèque Royale de Belgique, inv. MS 9505–9506

PROV.: Librairie du Louvre: 1373 inventory *recolé* in 1380 (Delisle 1907, no. 481); Bibliothèque de Bourgogne: 1404 inventory (De Winter 1985A, no. 66); 1420 inventory (Doutrepont 1977, no. 91); 1467–69 inventory (Barrois 1830, no. 912); 1485 inventory (Barrois 1830, no. 1613); removed by the French in 1794; returned in 1815 to the Bibliothèque de Bourgogne.

BIBL.: Barrois 1830, p. 147, no. 912, pp. 227–28, no. 1613; Delisle 1880, pp. 257–75; Van den Gheyn 1904, p. 336, no. 2902; Delisle 1907, 1: pp. 254–55, no. LV; 2: pp. 81–82, no. 481; Doutrepont 1909, pp. 121–22; Menut 1940; Meiss 1974, p. 418; Doutrepont 1977, pp. 51–52, no. 91; Sherman 1977, pp. 320–30; Avril 1978, p. 105, pl. 33; De Winter 1982A, p. 803; Gaspar-Lyna 1984, pp. 354–56, no. 148, pl. LXXVIII; De Winter 1985A, pp. 10, 50, 87–88, 141, no. 66, pp. 222–25, no. 17, p. 263 and figs. 103–4; Sherman 1995.

EXH.: Brussels 1958, no. 39; Brussels 1967, no. 215, p. 16; Brussels 1985A, no. 16; Brussels 1985B, no. 14.

Exhibited in Cleveland only

The inhabitants of Brussels understood the French translation of Aristotle's *Ethics*, created at the request of Charles V of France by Nicole Oresme (c. 1322–1382), in the manner shown by the colophon

Fol. 1r: Nichole Oresme presents his book to Charles V.

(fol. 224r): "At the request of the very noble, powerful and excellent prince Charles, by grace of God, King of France, was this book translated from Latin into French by the honorable and discreet master Nicole Oresme, master of theology and senior member of the church of Notre Dame de Rouen, in the year of grace M.CCC.LXXII." This is probably an official copy of the one intended for presentation to the monarch. Originally, this manuscript of the *Ethics,* the first text in the trilogy of Aristotle's moral works, would have been accompanied by a codex including *Philosophy and Economy*, also translated by Oresme, and housed today in a private collection.

The inventory of the Librairie du Louvre, drawn up in 1373 by the keeper of these jewels, Gilles Malet, and revised seven years later by Jean Blanchet, indicated for the first time the existence of this copy of the *Ethics* in the royal French collections.

On 7 October 1380, just a few weeks after the death of Charles V, the volume was nonetheless borrowed by Louis I d'Anjou. Patrick De Winter suggested that Philip the Bold came into possession of this manuscript by borrowing it once again from the house of Anjou. In either case, the *Ethics* was a valued item among the books belonging to the first Duke of Burgundy, surveyed in 1404. Afterward, the codex never left the shelves of the Burgundy library, where it appeared regularly in the inventories of the fifteenth century.

The iconographic program, consisting of ten quatrefoil miniatures, as well as the decorations in the margins, was once again attributed to the workshop of the Boqueteaux Master in Paris. This work must have been executed slightly later than 1372, the transcription date of this superb copy, particularly noteworthy for its elegance and balance of design.

C.V.H.

30

Paris

Roman du Chatelain de Coucy (Romance of the Castellan de Coucy)

c. 1376
160 folios
23 x 14.5 cm

Paris, Bibliothèque Nationale de France, inv. MS fr. 15098

PROV.: Library of the Dukes of Burgundy (inventories of 1405, no. 111; 1420, 1467, and 1487). Entered the royal collections in the eighteenth century (Suppl. fr. 633.20; binding with coat of arms of Louis XV).

BIBL.: De Winter 1985A, pp. 90, 150, 233–34, 445, figs. 143–44; Omont 1895-96, 1: p. 314.

Exhibited in Cleveland only

We owe this romance written in octosyllabic verse at the end of the thirteenth century to one Jakemes, who reveals his name in a rebus at the end. The hero of these knightly and amorous adventures is the noble troubadour Guy de Thourotte, Castellan of Coucy, who died during the crossing of the Aegean Sea in the Fourth Crusade (1204). The poet-knight is presented under the name Renaut de Coucy, who is enamored of the Lady du Fayel. Her husband, secretly aware of their liaison, maneuvers his rival into departing on the Crusade. Renaut is killed in battle, and his squire, Gobert, brings back his embalmed heart to Lady du Fayel. But the jealous husband gets possession of the precious relic and has it cooked and served to his wife at dinner, after which he tells her the terrible truth. The painting on folio 157 verso tells the end of this story in the form of a diptych. In the left panel, Gobert holds the casket containing the heart of the Castellan de Coucy, while Lord du Fayel gives his wife the message informing her of the fate of her lover. In the right panel the lady, on her deathbed, is mourned by the faithful squire and two attendants.

According to François Avril, this illustration is attributable to the Master of the Livre du Sacre de Charles V, at a late stage of his career. A follower of the Master of the Remède de Fortune, he was also influenced by the Master of the Bible of Jean de Sy, but did not achieve the same degree of mastery. Here, however, he has succeeded in exploiting the small space available to depict the tragic end of the story. The border is a gilded molding with

escaping tendrils of ivy peopled with a butterfly and birds (an owl, a goldfinch, and a tree creeper), while at the bottom of the margin a greyhound pursues a hare.

M.-T.G.

Fol. 157r: The death of Lady du Fayel.

et des dedius que len prient. pour iij. causes. ¶ La premiere si est / ncment que qui vient les aime il ne peust que il ne face et que

Fol. 73r: Hunting with falcons.

31

Paris

Henri de Ferrières, *Le Livre du Roi Modus et de la Reine Ratio (The Book of King Practice and Queen Theory)*
1379

Parchment; 178 folios
30.5 x 21.5 cm

Paris, Bibliothèque Nationale de France, inv. MS fr. 12399

PROV.: Charles de Tries, Count de Dammartin, companion in arms of Bertrand du Guesclin (coat of arms by the principal artist on fol. 2v); Library of the Dukes of Burgundy.

BIBL.: Tilander 1932; Nordenfalk 1955, pp. 14, figs. 1–3, 19, 27–33.

EXH.: Paris 1981, no. 288.

Exhibited in Cleveland only

The name of the author, Henri de Ferrières, is inscribed in a wheel-shaped anagram at the end of the manuscript. This Norman gentleman attended the hunts of Charles IV (1322–1328) in Breteuil, and

allusions to the individuals and the events of the time justify the hypothesis that he wrote his work between 1354 and 1374. This version, dated 1370 (fol. 177v), is the oldest of the thirty-six copies preserved. It is composed of two parts, the *Livre des deduits* (Book of Hunting Parties) and the *Songe de pestilence* (Dream of Pestilence). The treatise on hunting is presented in the form of dialogues between King Practice, an expert in hunting, and Queen Theory, and several other questioners. These conversations also provide an opportunity for numerous digressions on morals, rich in symbolism and allegory, on the various types of game, including noble animals such as the stag and "stinking" animals such as the wild boar.

The group of sixty-three illustrations scattered throughout the text are the work of an illuminator who, according to François Avril, may have trained with the Master of the Livre du Sacre of Charles V (London, BL, MS Cotton Tiberius B.VIII). His activity is documented from 1374 until around 1390. Despite a rather crude technique and stiff style, the scenes are nevertheless lively and closely observed. The scene on folio 73 is taken from the section on hawking. Two hunters have just released their falcons, while the dogs in front of them have flushed birds.

M.-T.G.

32

Workshop of the Bouqueteaux Master (Paris)

Prayerbook of Philip the Bold
c. 1376–78

In Latin and French. Parchment; 310 folios

28.4 x 20.4 cm (justification 16 x 10.4 cm); average of 26 written lines; writing cursive text letters; binding from the 18th century in red leather with coat of arms of Louis XV

Brussels, Bibliothèque Royale de Belgique, inv. MS 10392

PROV.: Bibliothèque de Bourgogne: 1404 inventory (De Winter 1985A, no. 25); 1420 inventory (Doutrepont 1977, no. 5); missing 1467–69 inventory; 1487 inventory (Barrois 1830, no. 2031); removed by the Viscount d'Argenson for Louis XV in 1746; returned in 1770; removed by the French in 1794; returned in 1815 to the Bibliothèque de Bourgogne.

BIBL.: Barrois 1830, p. 289, no. 2031; Van den Gheyn 1901, pp. 478–80, no. 767; De Winter 1975, pp. 179, 190; Doutrepont 1977, pp. 4–5, no. 5; De Winter 1982B, pp. 786–842;

Gaspar and Lyna 1984, pp. 349–51, no. 145, pl. LXXVIa–b; De Winter 1985A, pp. 49, 69, 88–90, 127, no. 25, pp. 182–94, no. 2, figs. 108, 125; Bousmanne and Van Hoorebeeck 2000, pp. 229–42.

Eхн.: Vienna 1962, no. 121; Brussels 1967, no. 53.

Exhibited in Dijon only

This prayerbook constitutes the second volume of a pair of devotional books, of which the first original volume, known as the *Grandes Heures de Philippe le Hardi*, was divided in two to create two distinct manuscripts (cat. 33).

The inventory of his library, conducted in Paris in May 1404 after the death of Philip the Bold, specifically mentions "two big books of hours of Our Lady, the cross, the Holy Spirit, the dead, and several views and other sufferings, serving all the days in the oratory of our Lord." The transcription of this manuscript and the *Grandes Heures* appears to have been executed by Jean L'Avenant, a transcriber-editor whose name appears in the royal accounts from 1350 on. Several payments spread out between September 1376 and January 1379 (n.s.) were paid to him for "certain writing which he did for Monsignor for his devotion" as well as "for two books that he delivered and gave to Monsignor." The transcription of Jean L'Avenant included very few corrections and the columns revealed certain initials with small dragons that were not lacking in finesse (fols. 222r, 230–31). The choice of texts would have been dictated by the ducal confessor, Guillaume Valen. The six miniatures (fols. 1r, 13v, 38v, 66r, 67r, and 78r) are attributed to the Parisian workshop of the Master of Bouqueteaux, to whom many other manuscripts ordered by Philip the Bold are equally attributed; Philip is represented in prayer on folio 1 recto. Finally, the accounts provide other precise indications on the binding. From January to April 1379, different sums were thus allocated to Perrin of Lille for having provided an "estuiz" for "Monsignor's hours," or again to the goldsmith Josset de Halle for his creation of "two gold clasps for the book of Monsignor in which there are many prayers." The monogram "P-M" (for Philip and Margaret) as well as the coat of arms of the first Duke of Burgundy inscribed in a floral decoration are still visible on the edges.

C.V.H.

Fol. 1r: Philip the Bold at prayer.

33

Fragments of a Book of Prayers of Philip the Bold,
Known as the *Grandes Heures*
c. 1376–78 and c. 1450

Parchment; 144 pages;
folios 19 recto–63 recto, with later additions

25 x 17 cm (justification variable)

Brussels, Bibliothèque Royale de Belgique, MS inv. 11035–37

Prov.: Bibliothèque de Bourgogne: inventory of the library of Philip the Bold, 1404 (De Winter 1985, no. 2); inventory of 1420 (Doutrepont 1977, no. 4); absent from subsequent inventories until 1577; first confiscation by the French in 1748; returned in 1770; second confiscation in 1794; returned in 1815.

Bibl.: Laborde 1849–52, 1: p. 181, 2: pp. 387–89; Réau 1955–59, 2: part 2, pp. 708–9; Köster 1965, pp. 459–504; De Winter 1976, pp. 241–51; Köster 1979, pp. 77–133; Wormald and Giles 1982, 1: pp. 479–99; Gaspar and Lyna 1984, 1: pp. 419–23; Köster 1984, pp. 87–95; De Winter 1985A, pp. 192–93; Bousmanne, Cockshaw, and Schmidt 1996, pp. 186 and 197–200; Van Buren, Marrow, and Pettenati 1996, p. 521; Bousmanne 1997, pp. 242–46; Randall 1997, nos. 263 and 273.

Exh.: Louvain 1993, no. 46.

Exhibited in Dijon only

Fol. 6v: Virgin of the Crescent Moon.

In the process of a very detailed investigation, Patrick De Winter discovered that this manuscript, as well as another incomplete manuscript (cat. 32), constitute fragments from Philip the Bold's *Grandes Heures*. Jean Miélot, secretary-translator and copyist to Philip the Good, completed it with the symbol of St. Athanasius at the head of the codex and with numerous prayers in Latin, often with their French translations and accompanying texts (this system corresponds with that used in the older part of the book of prayers). F. Wormald and P. M. Giles have attributed the *Grandes Heures* to the copyist Jean L'Avenant, based on the similarity of format, justification, and alignment to a book of prayers of Philip the Bold, also in Brussels (BRB, MS 10392). The copyist received payments between 1376 and 1378 for his work on the two manuscripts. Only folios 19 recto to 63 recto derive from the original document. In 1451, Dreux Jehan, miniaturist and, possibly, bookbinder for Philip the Good, was paid for the restoration and binding of two volumes of the *Grandes Heures de Monseigneur*. The

unfortunate inversions of the books, as well as the loss of folios, likely date from this point (the original manuscript was not folioed). Although absent from later inventories, the first volume is cited in the inventory of 1577, without *explicit*, but with the new *incipit* attributed to Jean Miélot. It is unknown whether the second volume had already disappeared from the Bibliothèque de Bourgogne at the time.

From the original volume, 11 large and 105 small miniatures are still extant in the Cambridge volume; added elements include some miniatures in the text and images of devotion or pilgrimage on the extracted pages, representing St. Veronica and the holy veil, very probably of Flemish origin, framing two prayers, one to Veronica and the other to the veil. These miniatures are typical of Philip the Good's devotion to images, which was also revealed in the many pilgrimage-medals that were affixed into margins of the manuscript. They have all disappeared, but their impressions were carefully collected

by Köster, who counted more than forty-five in the two volumes together. The miniature in folio 6 verso (the recto is blank), *The Virgin of the Crescent Moon*, the margins of which have been trimmed, may derive from another codex. According to De Winter, it might have been realized by an artist whose style is linked to that of the Limbourg brothers. Millard Meiss has suggested that it should be attributed to the Master of the Breviary of John the Fearless, and places it in Paris at the start of the fifteenth century. The iconography of this Virgin is fairly particular, and has no correspondence with the *Virgin of the Apocalypse*, stepping upon the foot of the moon, symbol of evil or the devil. Here, the Virgin is represented from the waist up, cradled by the moon's crescent, and two angels prepare to adorn her head (as in Jan van Eyck's *Virgin of the Chancellor Rolin*) with a crown full of stars, whereas the crown of the *Virgin of the Apocalypse* has only twelve.

C.L.

34

Paris and Brussels

The Grandes Heures of Philip the Bold

Paris, 1376–78, 1390; Brussels, 1450–55

257 folios
25.3 x 17.8 cm

Cambridge, The Fitzwilliam Museum, MS 3-1954

Prov.: Purbrook Heath House, Mrs. W. F. Harvey; Viscount Lee of Fareham; his bequest, 1947; presented to the Fitzwilliam Museum by his widow, 1954.

Bibl.: De Winter 1982B, pp. 786–842; De Winter 1985A, pp. 189–94, figs. 113–16.

Exh.: Cambridge 1993, no. 46.

The *Grandes Heures* was highly prized by Philip the Bold. According to the inventories of his library made at the time of his death, the duke used it on a daily basis in his oratory. The manuscript is a complex compilation of texts and decoration added in three distinct phases over seventy-three years. The oldest section dates to 1376–78, when Philip paid the copyist Jean l'Avenant to produce its texts. L'Avenant, a major *écrivain* in Paris during the second half of the fourteenth century, was instrumental in the production of books for John the Good of France and his sons. Miniatures in this original section appear to reflect a collaboration of two Parisian workshops. The large miniatures were painted by the Master of the Boqueteaux, while the majority of the small miniatures are by the Master of the Coronation Book of Charles V. Philip had this manuscript unbound in order to add some additional prayers around 1390.

At the death of Philip the Bold, the manuscript passed to his heir, John the Fearless, along with the duke's entire library. After John's assassination in 1419, it became the property of the third Duke of Burgundy, the young Philip the Good, who commissioned further additions around 1440. They include a gathering of Memoriae of saints venerated in Hainaut and Flanders. Patrick De Winter has argued that the volume received several additions shortly after 1419 to adapt it for use by Margaret of Bavaria, widow of John the Fearless. Recently discovered documents have shown that after September 1451, Philip the Good ordered the then-unwieldy manuscript renovated and rebound as two separate volumes. The second volume is today in the Bibliothèque Royale de Belgique in Brussels (MS 11035-37), its illustrations by another generation of artists.

The Fitzwilliam volume includes a rich cycle of miniatures of which two are particularly worthy of note. The *Annunciation* (fol. 13) includes a small portrait of Philip the Bold in prayer within a historiated letter beneath the main scene. Unfortunately, the arms of Burgundy that once emblazoned the *bas-de-page* have been obliterated. The miniature representing the *Flight into Egypt* (fol. 21r) is compositionally similar to the same scene painted by Melchior Broederlam on the reverse wing of his *Altarpiece of the Crucifixion* (Dijon, Musée des Beaux-Arts) between 1393 and 1399.

Wear on many of the manuscript's miniatures, as well as imprints of religious medals, which were sometimes sewn into books of hours, suggest that the *Grandes Heures* received intense devotional use from its original and subsequent owners.

Fol. 13r: The Annunciation.

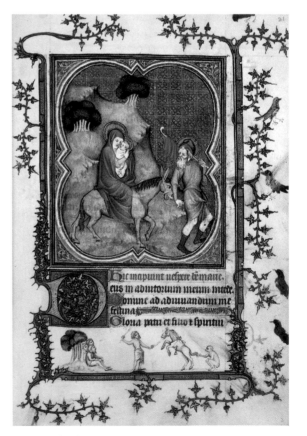

Fol. 21r: The Flight into Egypt.

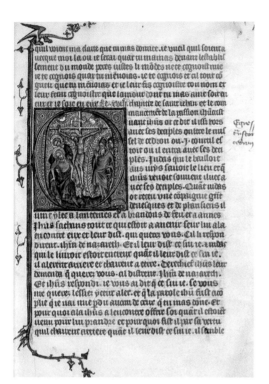

Fol. 127r: The Crucifixion.

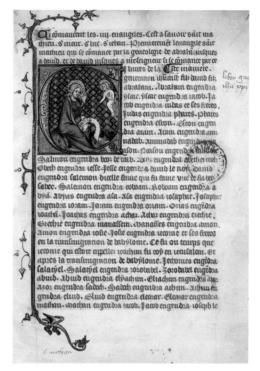

Fol. 102v: St. Mathew.

The manuscript was clearly revered by the first duke's successors for its associations with the founder of the dynasty.

<div align="right">S. N. F.</div>

35

Workshop of the Master of the Coronation of Charles VI (Paris)

The Four Evangelists

c. 1380

In French. Parchment; 133 folios
20.7 x 15.1 cm (justification
15.8 x 12 cm); 31 lines; 16 signatures
of 8 pages, the last of 4 pages;
pricking; fragments of instructions for
the miniaturist in the lower margin of
fols. 1r, 37r, and 62r

Brussels, Bibliothèque Royale de Belgique, inv. MS 10993

PROV.: Bibliothèque de Bourgogne: inventory of the library of Philip the Bold, 1404 (De Winter 1985A, p. 170, no. 192); inventory of 1420 (Doutrepont, 1977, no. 213); inventory of 1467–69 (Barrois, 1830, no. 1134); inventory of 1485–487 (Barrois, 1830, no. 2074); confiscated by the French in 1794 (stamp of the Paris, BNF in fols. 1r and

133v) and restored to the Bibliothèque de Bourgogne in 1815.

BIBL.: Barrois 1830, p. 171, no. 1134, p. 295, no. 2074; Berger 1884, p. 424; Van den Gheyn 1901, p. 46, no. 97; Meiss 1974, p. 419; Doutrepont 1977, p. 144, no. 213; Gaspar-Lyna 1984, p. 351, no. 146; De Winter 1985A, p. 170, no. 192, pp. 253–54.

EXH.: Brussels, 1967, p. 15, no. 10.

Exhibited in Dijon only

This manuscript contains the four gospels in an anonymous thirteenth-century French version. Each gospel begins with a large historiated initial representing the author (fols. 1, 37, 62, and 102v). A fifth historiated initial in folio 127 shows a calvary (John, chap. 18). Patrick De Winter attributes the illustrations to two followers of the Master of the Miniature of the Coronation of Charles VI. According to the Burgundian chronicles, "When Madame [Margaret of Flanders] was about to give birth to Philip of Burgundy [her third son, born on 8 October 1389] she wished to have near her the Gospel or book of St. John which was at Saint-Vivant de Vergy and had it brought to her" (Paris, BNF, Coll. Bourg., 26, fol. 327). De Winter speculates that this could be that book.

The inventory drawn up between 1485 and 1487 describes the binding of the book at that period: "Another covered with green silk, with two clasps of gilded

silver, with the arms of Flanders and Réthel, historiated and entitled the gospels in French." These are the arms of Margaret, the wife of Philip the Bold.

<div align="right">M.D.</div>

36

Southern? Low Countries

Laurent du Bois, *The King's Survey*

last quarter of the 14th century

In French. Parchment; 112 folios
30 x 22.5 cm (justification
21 x 15.5 cm); 2 columns, 33 written
lines; written in cursive textual letters;
18th-century binding in blue-green
washleather

Brussels, Bibliothèque Royale de Belgique, inv. MS 10320

PROV.: Bibliothèque de Bourgogne: Louis de Male? 1405 inventory (De Winter 1985A, no. 197); 1420 inventory (Doutrepont 1977, no. 178); 1467–69 inventory (Barrois 1830, no. 1460); 1487 inventory (Barrois 1830, no. 1919); removed by the French in 1794; returned in 1815 to the Bibliothèque de Bourgogne.

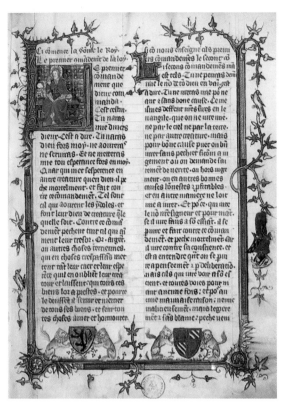

Fol. 2r: The Benediction.

affirmed that Philip the Bold, who would have inherited this book of Louis de Male's through the intermediary of Margaret of Flanders, would then have had to paint his coat of arms over those of his father-in-law.

Recently however, Dominique Vanwijnsberghe has picked apart these various hypotheses. An attentive examination of the codex indicates, in fact, that the arms of Flanders and Burgundy, indeed authentic and original, do not appear to be painted over those of Louis de Male. According to him, it is rather a question of understanding the heraldic decoration at the bottom of the page as a sign of homage, rather than an indication of provenance. As to where this volume was executed—France, Tournai, Bruges, or Ghent—this, too, has often been debated. The general workmanship of the manuscript and its only historiated initial (fol. 2r), a Christ in Benediction, already allows one to glimpse a pre-Eyckian creation. Since then, Vanwijnsberghe has proposed that this codex be considered a product of the southern Low Countries, executed in the last quarter of the fourteenth century.

C.V.H.

BIBL.: Barrois 1830, p. 210, no. 1460, p. 274, no. 1919; Tinbergen 1900–1907, p. 72; Van den Gheyn 1903, p. 404, no. 2295; De Winter 1975, pp. 173–98; De Winter 1976, pp. 655–57; Doutrepont 1977, pp. 116–17, no. 178; De Winter 1985A, pp. 81, 87, 171, no. 197, pp. 254–55, no. 35 and fig. 65.

EXH.: Brussels 1967, no. 47.

Exhibited in Cleveland only

Several hypotheses have been raised with regard to the origins and location of the site of the creation of this copy of *The King's Survey*, a manual of moral and religious instruction written in 1297 by the Dominican Laurent du Bois. Controversy has arisen regarding the heraldic decoration outside the margin of the frontispiece, which features the coat of arms of Louis de Male with crest, as well as those of Margaret of Flanders, and, on the bottom of the page, the lions of Philip the Bold, of even more imposing dimensions. According to Georges Doutrepont (1977, p. 117), this codex can be identified as one that Philip the Bold purchased around 1377 from Robert Lescuyer, illuminator and bookseller at the university of Paris. This possibility was cast aside by other authors, some basing their disagreement on stylistic elements, others on the heraldic order. Patrick De Winter thus

37

Paris

Philippe de Mézières, *The Lamentable and Consoling Epistle on the Defeat of the King of Hungary by the Turks at Nicopolis*
between 1397 and 1404

In French. Parchment; 67 folios

28.5 x 21 cm (justification 19.8 x 13.4 cm); average of 30 written lines; written in cursive text letters; bound in the 18th century in red leather with the coat of arms of Louis XV

Brussels, Bibliothèque Royale de Belgique, inv. MS 10486

PROV.: Bibliothèque de Bourgogne: not listed in the inventory of the books of Philip the Bold; 1420 inventory (Doutrepont 1977, no. 119); 1467–69 inventory (Barrois 1830, no. 1480); 1487 inventory (Barrois 1830, no. 1878); removed by the Viscount d'Argenson for Louis XV in 1746; returned in 1770; removed by the French in 1794; returned in 1815 to the Bibliothèque de Bourgogne.

Fol. 2r: Coat of arms of Philip the Bold.

BIBL.: Barrois 1830, pp. 212–13, no. 1480, pp. 268–69, no. 1878; Doutrepont 1909, pp. 239–41; Bayot s.d., p. 159; Doutrepont 1977, pp. 74–76, no. 119; De Winter 1985A, pp. 29, 174, no. 218, pp. 259–60, no. 38 and fig. 247.

EXH.: Brussels 1967, no. 212.

Exhibited in Dijon only

Son of minor nobility of l'Amiénois, Philippe de Mézières (around 1327–1405) was profoundly shaken by the pilgrimage he made to the Holy Land when he was just twenty years old. From that point forward, this officer of Pierre de Lusignan and advisor to Charles V could not stop envisioning ways to carry out his dream of a crusade. He went so far as to imagine the formation of a holy army, constituted by order of knighthood—the Order of the Passion of Jesus Christ. *The Lamentable and Consoling Epistle* was composed in the wake of the stinging defeat inflicted in 1396 on the French-Burgundian army by the troops of the Sultan Beyazid at Nicopolis, in Bulgaria. Dedicated "especially" to Philip the Bold, Philippe de Mézières identifies himself here as "an old and solitary man of the Celestins of Paris, who, due to his great sins, is not worthy of being named." He also addressed this long epistle to "all the kings, princes, barons and commoners of the Catholic faith."

Probably created in Paris between 1397 and 1404, the Brussels manuscript is the only one to have preserved this text. The frontispiece folio is decorated with an elegant gold and blue column in the margin, extended by foliage and vine leaves in gold, red, and blue. The codex bears the coat of arms of Philip the Bold in the area of the title line of folio 2 verso, and might correspond, despite its modest workmanship, to the copy offered by Philippe de Mézières to the Duke of Burgundy. The 1404 inventory of Philip the Bold's library, located in the Hotel d'Artois, does not, however, indicate such. Several explanations can be considered: it is always possible that the editors omitted this from their document; perhaps the book was kept in a location other than the Paris residence; or perhaps John the Fearless intervened and became the owner of *The Lamentable and Consoling Epistle* between the time of his father's death and the completion of the funerary catalog. This would not be surprising, given that John the Fearless, then Duke of Nevers, had himself been taken prisoner in the battle of Nicopolis and was freed for a considerable ransom. From that point on, the manuscript appeared regularly in the inventories of the Burgundy library in 1420, in 1467–69, and in 1487.

C.V.H.

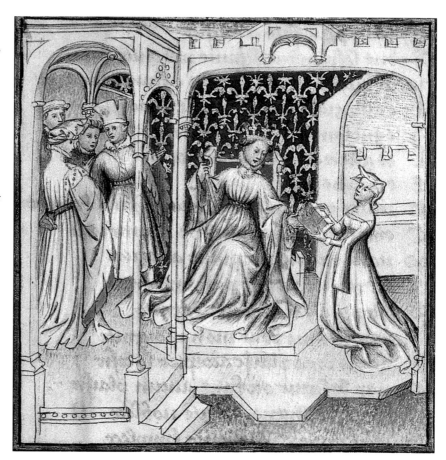

Fol. 1r: Christine de Pizan presents her book.

38

Master of the Coronation (Paris)

Christine de Pizan, *Le Livre du Chemin de Longue Estude*
1403

Parchment; 100 folios

29.4 x 21 cm (justification with pencil 18.5 x 9.4 cm); 32 to 34 lines; 1–2⁸, 3¹⁰,4–11⁸,12¹⁰; pricking, catchwords

Brussels, Bibliothèque Royale de Belgique, inv. MS 10982

PROV.: Bibliothèque de Bourgogne: inventory of the library of Philip the Bold, 1404 (De Winter 1985A, p. 141, no. 63); inventory of 1420 (Doutrepont 1977, no. 130); inventory of 1467–69 (Barrois 1830, no. 1574); inventory of 1485–87 (Barrois 1830, no. 1826); confiscated by the French in 1794 (stamp of Paris, BNF scraped off in fols. 1r and 100r) and restored to the Bibliothèque de Bourgogne in 1815.

BIBL.: Barrois 1830, p. 223, no. 1574, p. 261, no. 1826; Doutrepont 1909, p. 276; Schaefer 1937, p. 165, fig. 48, p. 180, figs. 101–5; Pizan 1974; Avril 1975, p. 50; Doutrepont, 1977, p. 86, no. 130; De Winter 1982, pp. 335–75; Gaspar-Lyna 1984, no. 180, pp. 433–35; De Winter 1985, p. 141, no. 63, pp. 218–19.

EXH.: Brussels 1967, no. 152, p. 104.

Exhibited in Cleveland only

Le Livre de Chemin de longue estude, an allegorical poem in 6,392 verses, was written between 5 October 1402 (the date indicated in verses 185–88) and 20 March 1403, when Christine de Pizan gave a copy of the work to Jean de Berry. The book was dedicated to Charles V and to the princes of the fleurs-de-lis, who are the arbiters of the debate within the poem, which recounts the events of a dream. Inspired by Dante, Boethius, and John Mandeville, the author tells how she embarked upon a dream journey, guided by the Cumean sibyl. The sibyl first reveals the Fountain of Wisdom and tells her that the road they are following is "reserved for the erudite": it is the path of "long estude" (lengthy study). After traversing the countries of the Orient,

they approach the terrestrial paradise. They then ascend to the heavens by the ladder of Speculation. They see the queens who govern the world: Wisdom, Nobility, Chivalry, and Riches; in their midst Reason is enthroned. She hears the Earth's entreaty to remedy the vices and other crimes of her children. The best solution would be to entrust the governance of the world to a single man. But must he not be wise, noble, knightly, and rich? Reason and her advisors decide that the debate should be judged on earth by the princes and the king of France, to whom the work is dedicated. Christine de Pizan presented the copy of *Le Livre du Chemin de longue estude* to Philip the Bold between 20 March and 30 September 1403. According to Patrick De Winter, the Duke of Burgundy gave the writer a silver-gilt goblet weighing 1,233.45 grams for "a book" on 30 September. Although the title is not specified, the gift certainly seems to be an expression of gratitude for the *Chemin de longue estude*.

The illustration program consists of six miniatures executed in grisaille by the artist who had illustrated a copy of the same work, presented to Jean de Berry (Paris, BNF, MS fr. 1188). These two copies of *Chemin de longue estude* are almost identical. In François Avril's view, the illustration of both volumes should be attributed to the Master of the Coronation. A second copy of *Chemin de longue estude* appears in the inventory of 1420 (Brussels, BRB, MS 10983); this copy is illustrated with only four grisaille miniatures executed in a more mannered style. It was no doubt given by Christine de Pizan to another member of the house of Burgundy, perhaps to Anthony of Brabant, Philip the Bold's second son, who also valued her works.

M.D.

39

Master of the Othéa Epistle (Paris)

Christine de Pizan, *Le Livre de la Mutacion de Fortune*
November–December 1403

Parchment; 190 folios
34.7 x 25.5 cm (justification in pencil 21 x 17.4 cm); 33 to 36 lines, 2 columns; 1, 1–18⁸, 19¹²⁻¹, 20–22⁸, 23¹⁰; pricking, signature in pencil, and in brown or red ink, catchwords

Brussels, Bibliothèque Royale de Belgique, inv. MS 9508

Prov.: Bibliothèque de Bourgogne: inventory of the library of Philip the Bold, 1404 (De Winter 1985A, p. 139, no. 61); inventory of 1420 (Doutrepont, 1977, no. 98); inventory of 1467–69 (Barrois 1830, no. 907); inventory of 1485–87 (Barrois 1830, no. 1799); confiscated by the French in 1794 (stamp of the Paris, BNF in fols. 1r and 188v) and restored to the Bibliothèque de Bourgogne in 1815.

Bibl.: Barrois 1830, p. 146, no. 907, pp. 257–58, no. 1799; Doutrepont 1909, pp. 275–76; Schaefer 1937, pl. 52; Pizan 1959–66; Meiss 1967, pp. 299, 358; Meiss 1974, pp. 8–12, 291–92, 388; Doutrepont 1977, pp. 57–58, no. 98; Ouy and Reno 1980, pp. 221–38; De Winter 1982, pp. 335–75; Gaspar and Lyna 1984, pp. 436–37, no. 182; De Winter 1985A, p. 139, no. 61, pp. 215–17.

Exh.: Edinburgh and Brussels 1963, no. 40, p. 38; Brussels 1967, no. 154, p. 105; Brussels 1986, no. 6, p. 12.

Exhibited in Dijon only

Le livre de la mutacion de Fortune is the most significant and important of Christine de Pizan's rhymed works. It comprises 23,636 octosyllabic verses and a prose passage after verse 8748. This lengthy allegorical poem is an essay on universal and philosophical history divided into seven parts. The central character is Lady Fortune, with the author presenting herself as the lady's "servant." The work was begun in August 1400 and completed on 18 November 1403. Christine de Pizan drew most of her material from the *Histoire Ancienne jusqu'à César*, the *Ovide Moralisé*, the *Livre du Trésor* by Brunetto Latini, and the *Consolation of Philosophy* by Boethius. The inspiration for the third part was the *Jeu des échecs moralisé* by Jacques de Cessoles.

Fol. 2r: Christine de Pizan at her work table.

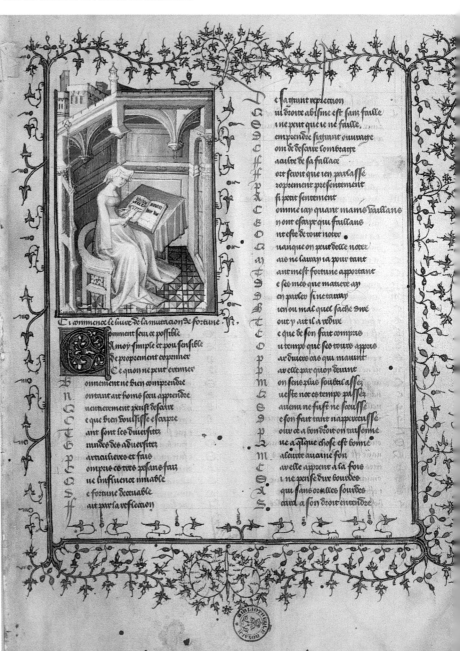

Less than two months after completion, she presented this copy of *Mutacion de Fortune* to Philip the Bold. In her *Livre des fais et bonnes meurs du sage roy Charles V*, the author mentions that she had on that day offered "my volume called on the mutability of Fortune to the very mighty prince, My Lord of Burgundy . . . who with gracious humility received it very kindly and with great delight" (1: pp. 6–7). A marginal note in folio 26 recto, probably written by Christine de Pizan, "Here begins what I can write in a day," reveals how hastily this copy was executed. Other details—irregular ruling, initials sketched in but not completed, numerous blank spaces—also demonstrate a desire for rapid completion of the manuscript. In Charity Willard's view, the numerous scraped erasures and corrections show that the writer herself contributed to the copying and revision of the Burgundian edition. She commissioned the Master of the Othéa Epistle and his assistants to illuminate and illustrate four copies of the *Mutacion*. All have the same program of illustration, which includes six miniatures: this copy, given to Philip the Bold, another presented to Jean de Berry in March 1404 (The Hague, Kon. Bible. 78 D 12), and two other copies (formerly Phillipps no. 207 and the MS 494 in the Musée Condé, Chantilly), whose recipients were almost certainly other Valois princes.

M.D.

101, 152, no. 6, p. 373, fig. 458; Verdier 1980, p. 103; Sterling 1987, p. 274, fig. 183, p. 279; Lindquist 2002, pp. 46, 61–65, 76, 89–91, 97, 102, 147–48, figs. 39–76.

Exhibited in Dijon only

According to a note in the table of contents, the *Festes nouvelles* that follows *La Légende dorée* was translated from Latin into French by a "maître en théologie de l'ordre de Notre-Dame du Carme, l'an mil quatre cens et deux" (a Master of Theology of the Order of Our Lady of Mount Carmel, in the year fourteen hundred and two): Jean Golein (d. 1403), one of the most productive translators at work during the reign of Charles V. This work was certainly painted immediately after the appearance of this calendar of new feast days for use in Paris.

It starts on folio A with a Coronation of the Virgin, by the artist known as the Master of the Coronation of the Virgin, who was also the principal artist of a French version of Boccaccio's *De mulieribus claris*, biographies of famous women, executed in 1402 for Philip the Bold, Duke

of Burgundy (*Cleres et nobles femmes*, Paris, BNF, MS fr. 12420). The Flemish-trained artist demonstrated all his skill here in a large miniature characterized by delicacy of modeling. He used tiny brush strokes in a technique closer to painting than to illumination. In a solid blue sky peopled with angels and the four Evangelists with their symbols, a medallion-shaped opening focuses the viewer's gaze on the scene of the Coronation of the Virgin, constructed in a simple and unified space. The richness of the coloring does not disrupt the harmony characteristic of the compositions of this artist. The border is the work of an ornamentalist who also worked on the Boccaccio manuscript mentioned above.

The other illustrations, grisailles on painted backgrounds and fields, are attributable to several illuminators who, like the Master of the Coronation of the Virgin, also worked on the *Bible historiale* (Paris, BNF, MS fr. 159), executed in Paris around 1400.

M.-T. G.

40

Jacques de Voragine (Paris)
La Légende dorée (The Golden Legend), translated from the Latin by Jean de Vignay

Jean Golein, *Festes Nouvelles (New Feastdays)*

c. 1403

Parchment; folios A to D + 336 folios
39.5 x 28 cm

Paris, Bibliothèque Nationale de France, inv. MS fr. 242

Prov.: This work entered the royal collections in the seventeenth century (on fol. A: number *Regius 6888²*) and was part of the king's library in Versailles (on the fly leaf: *Versailles 239*).

Bibl.: Meiss 1967, pp. 252, 355, 387, no. 68, p. 400, no. 33; Meiss 1968, pp. 34, 63,

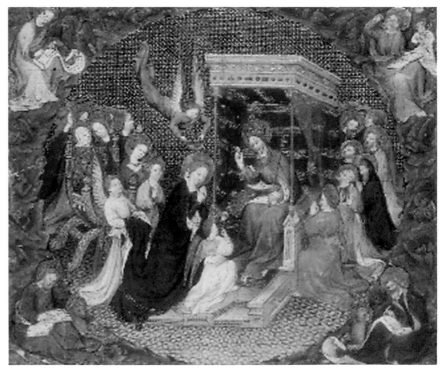

Fol. Ar: The Coronation of the Virgin.

JOHN THE FEARLESS

41

Paris

Grandes Chroniques de France

c. 1390

Parchment; 470 folios

40.5 x 30.5 cm; 32 miniatures; olive leather binding with coat of arms of the Viscount d'Argenson

Paris, Bibliothèque Nationale de France, Arsenal, inv. MS 5223 Rés

BIBL.: Doutrepont 1977, no. 239; Avril 1969, pp. 291–98; De Winter 1985A, pp. 92, 166–67; Hedeman 1991, pp. 233–34; Camille 1996, pp. 102–3; Rouse 2000, 1: pp. 293–96, 2: pp. 27, 216.

Exhibited in Dijon only

These chronicles of France, or chronicles of the life of Saint-Denis, are a kind of official history of France, up to the coronation of Charles VI. They are described in detail in the inventory of 1420 (fol. 168v): "item: another large book of the chronicles of France, covered in silk and black damask, on which the clasps are cut and raised, beginning on the first leaf *between the great sea*, and on the last *as one would say*." There is thus no doubt that this manuscript belonged to John the Fearless, but it is not possible, because of the vagaries of preceding inventories, to know the book's earlier history. Based on archival resources, Patrick De Winter suggests that this book be identified with the manuscript given to Philip the Bold on New Year's Day 1397 by Guillaume Malet, "Master of the king's residence," in compensation for silverware. Similarly, he suggests that this is the manuscript loaned to Isabeau of Bavaria by Philip the Bold in 1398 and recovered in 1401 with the silk cover bought from Dino Rapondi, a hypothesis raised by Michael Camille, justified by the date the manuscript was made and yet without any real basis.

Furthermore, only one copy of the *Chroniques* was found in the inventory of Philip the Bold in 1404, and that would be the one now in Brussels (Bibliothèque Royale Albert Ier, MS 4).

The thirty-two grisailles that adorn this volume are the work of an artist close to the style of the Master of the Bible of Jean de Sy. One would have liked to identify it with Perrin Rémy or Remiet, a well-known artist working around 1368, but whose involvement one can only piece together through two notes left for the illuminator, which François Avril studied, and about which there remain differing interpretations. Remiet seems to have worked on several copies of the *Grandes Chroniques de France* and to have worked for Regnault du Montet, one of the most important booksellers of the time and a purveyor to the Valois princes. The manuscript appears in several inventories of the Bibliothèque de Bourgogne until 1748. At that point it passed into the collection of the Viscount d'Argenson, and then in 1764 into that of his nephew, the Marquis de Paulmy, founder of the Arsenal library.　D.M.

42

Missal from Sainte-Chapelle in Paris

Late 14th century, early 15th century

Parchment; (II) + 525 + I(II) folios; modern numbering in pencil from 1 to 525; old-style numbering, missing on the following: the calendar, the diptych, and the 11 last folios

40 x 28.5 cm (justification in pink ink, 26.5 x 17.5 cm); 31LR-30LE, UR=0.9 cm; notebooks generally organized into 8 leaves except the first and numbers 23 and 24; catchwords

Brussels, Bibliothèque Royale de Belgique, inv. MS 9125

PROV.: Bibliothèque de Bourgogne: inventory of 1420 (Doutrepont 1977, no. 51); Bibliothèque du Roi, Paris: Louvre inventory of 1423, no. 215; Bibliothèque de Bourgogne: inventory of 1487 (Barrois 1830, no. 1988); removed by the French in 1794 (stamps of Paris, BNF on fols. 1r and 525v); restored in 1815 to the Bibliothèque de Bourgogne.

BIBL.: Barrois 1830, p. 283, no. 1988; *Inventory of 1423* 1867, p. 65, no. 215; Van den Gheyn 1901–48, 1: pp. 271–72, no. 443; Delisle 1907, 1: pp. 158–60, 2: p. 31, no. 165bis; Doutrepont 1977, pp. 23–24, no. 51; Gaspar-Lyna 1984, pp. 396–99, no. 166; De Winter 1985A, pp. 122–23, no. 3, p. 296; Lemaire 1994, pp. 294–98; Châtelet 2000.

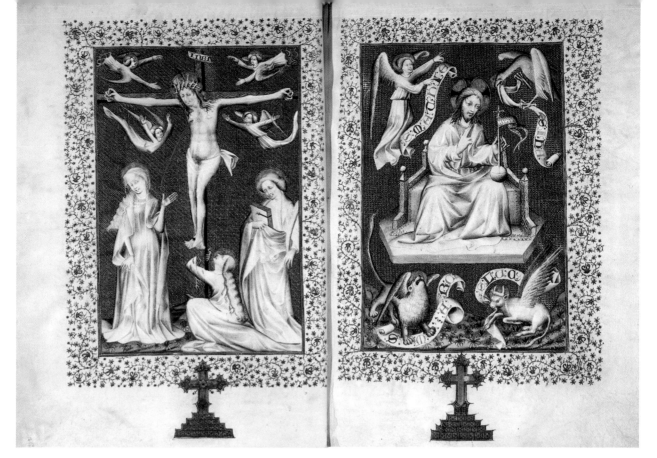

Fols. 177v–8r: The Crucifixion, and God the Father surrounded by the symbols of the Evangelists.

Exh.: Brussels 1958, pp. 82–85, no. 17; Brussels 1967, pp. 18–19, no. 13; Brussels 1986, pp. 8–9, no. 4.

Exhibited in Cleveland only

There is no question about the provenance of this manuscript since Joseph Van den Gheyn discovered that certain saints in the calendar were those specifically honored at Sainte-Chapelle in Paris. Yet the identity of the patron is not indicated. The date of 1409 was long proposed as the terminus ante quem, because of a note written on the calendar on 13 October that mentions the obituary of Michel de Creney, bishop of Auxerre and confessor to Charles VI. This note, in addition to a second one that records the death of Charles VI himself, encouraged the opinion that the manuscript was commissioned by this sovereign. Despite the temptation to come to this conclusion, these two annotations require, at very least, more critical analysis. First, they are not contemporary with the execution of the manuscript, which appears in the Burgundian inventory of 1420, while the king of France died in 1422. More interestingly, it is very probable that they were written by the same hand. In fact, the obituary of the king is written in the bottom margin, while that of his confessor is written on the line for 13 October—indicating a clear distinction between the two men—apparently using the same ink and at the same time. Considering that

only an Armagnac sympathizer would have rewritten such death notices, and given that the manuscript was found in the Louvre inventory prepared in 1423 at the behest of the Duke of Bedford, this date of 1409 no longer holds as a terminus ante quem.

All the same, a systematic analysis of the manuscript and a stylistic examination of the miniatures suggest that it must have been created at the very end of the fourteenth century or at the beginning of the fifteenth century. The grisaille tones of the diptych inserted between folios 177 and 180 have an unmistakable resemblance to those magnificent examples from the Parisian workshops active around 1400, even if they are clearly inferior on a technical and simply aesthetic level. However, the work in the ornamental backgrounds, as well as that in the star-studded borders—utterly atypical—is remarkable. While no specific workshop has been mentioned with certainty until now, it is essential to pay particular attention to the suggestion of Patrick De Winter, who places the miniatures in this manuscript within a circle close to the artistic milieu of Avignon. Indeed, the iconography of some of the New Testament episodes shows figures in Italianate attitudes against an ornamental background in the manner of a diptych. This, together with the delicate borders, might instead indicate a southern workshop. F.J.

43

Livre de l'information des rois et des princes (Book of Information for Kings and Princes)

French version by Jean Golein
Early 15th century

Parchment; ii + 104 folios; modern numbering in black ink from 1 to 104 (the first two folios are not numbered)

36 x 20.8 cm (justification in brown ink, 20 x 13.7 cm); 40 / 41LR-39 / 40LE, UR numbered approximately; 0.4 / 0.6 cm; pricking; 1⁴⁻², 2–14⁸; catchwords, signatures

Brussels, Bibliothèque Royale de Belgique, inv. MS 9475

Prov.: Executed at the request of Jean the Fearless; Bibliothèque de Bourgogne: inventory of 1420 (Doutrepont 1977, no. 115); inventory of 1467–69 (Barrois 1830, no. 927); inventory of 1485–89 (Barrois 1830, no. 1808); removed by the French in 1794 (stamps of the Paris, BNF on fols. 1r and 104r); returned in 1815 to the Bibliothèque de Bourgogne.

Bibl.: Barrois 1830, p. 149, no. 927, p. 259, no. 1808; Van den Gheyn 1901–48, 3: p. 29, no. 1609; Tourneur 1956, pp. 300–323; Van Buren 1973, pp. 93–107; Doutrepont 1977, p. 72, no. 115; Nordenfalk 1977, pp. 324–41;

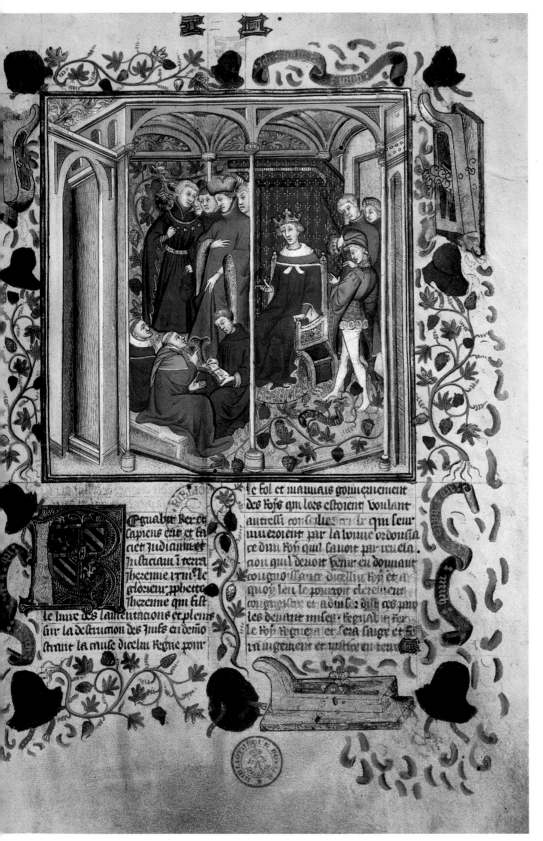

Fol. 1r: The author dictates his text to a copyist before the king of France and high officials.

Gaspar-Lyna 1984, pp. 442–43, no. 186; *Dictionnaire des lettres françaises*, pp. 543, 713, 787–88; Pastoureau 1996, pp. 99–106; Johan 2003, pp. 115–18.

Exh.: Brussels 1967, pp. 69–70, no 93; Brussels 1985A, pp. 67–68, no. 57; Brussels 1985B, p. 38, no. 46.

Exhibited in Dijon only

The *Livre de l'information des rois et des princes* (Book of Information for Kings and Princes) was translated for Charles V of France in 1379 by Jean Golein, doctor of theology and member of the Carmelite order. It fits within the tradition of works of an educational nature, meant both to provide the sovereign with indispensable knowledge about the political sphere and for his moral elevation. The text is divided into four books: the first deals with the person of the king and the essential virtues that he must possess; the second addresses his obligations to his family, his people, and himself ("regimen"); the third book counsels wisdom ("sapientia"); and the last teaches the values of justice ("justitia").

Each book opens with a miniature that, except for the first, represents a synthesis of the content of the portion of the book that follows. All seem to have been executed by a single artist whose skill is notable in terms of the balanced compositions and the modeling of the fine, delicate figures. Yet the juxtaposition of tones creates rather harsh contrasts, and the colored areas are then filled with plant motifs recalling those of the side borders. These borders, made up of green foliage which extends into cinquefoil leaves and gilded pinecones, are unique. It is important to note the presence of the hop flower, one of the numerous symbols chosen by John the Fearless. In addition to his coats of arms, painted in the four initial images that open each book, other specific references to Duke John can be found in the decoration of the margins, such as the German-style headgear and the planes with shavings. Chosen as a symbol by the duke in 1405, the planes actually refer to a knotty wooden club, emblem of his enemy, Louis d'Orléans. As for the shavings, they signify the smoothing down of the club. The motto "Ich haltz mich" could refer to the nationality of his wife, Margaret of Bavaria. But this could equally be seen as parallel to the Dutch saying "Ick zwighe," or "Ik houd." The hats are also related to his wife. In fact, a 1420 inventory of jewels—published by the Count of Laborde—mentions a necklace decorated with eight planes and some "German-style hats, known as *barruiers*, covered with loops and golden ornaments, on top of leather," similar to those depicted in the borders of this manuscript.

F.J.

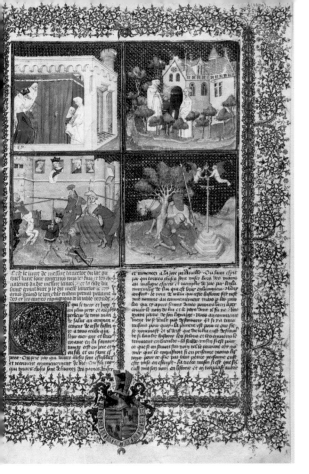

44

Paris

Legends of the Holy Grail: Merlin, Sir Lancelot of the Lake
Early 15th century (before 1407)

Parchment; 624 folios
46 x 31.3 cm; 2 columns,
45 miniatures, lemon-yellow leather-binding, bearing the arms of the
Viscount d'Argenson

Paris, Bibliothèque Nationale de
France, Arsenal, inv. MS 3479 Rés

Legends of the Holy Grail: Sir Lancelot of the Lake, The Quest of the Holy Grail, The Death of King Arthur
Early 15th century (before 1407)

Parchment; 678 folios
46 x 31.3 cm; 2 columns,
80 miniatures, lemon-yellow leather-binding, bearing the arms of the
Viscount d'Argenson

Paris, Bibliothèque Nationale de
France, Arsenal, inv. MS 3480 Rés

BIBL.: Prost 1890–91, pp. 349–59; Martin 1899, p. 116; Doutrepont 1906, no. 68; Micha 1960, pp. 180–82; Meiss 1974, 1: pp. 373–80; on Lancelot, see De Winter 1985A, p. 156, no. 134; Debae 1995; on the holy grail, see Rollet 1998; Rouse 2000, 1: p. 296.

EXH.: Brussels 1967, no. 18.

Exhibited in Cleveland only

An immense thirteenth-century novel written in prose, a complete compendium of the legends of Sir Arthur, mainly inspired by the work of Robert de Boron, as well as that of Chrétien de Troyes, the Lancelot-Grail legend was widely read until the fifteenth century, as demonstrated by the large number of extant manuscripts, many copies of which are well-known and lavishly illustrated. These two manuscripts represent the complete set of the five-part novel. They are surely similar to those described after the death of John the Fearless in a 1420 inventory "of books remaining in his residence in Dijon" (fol. 147): "first of all, a huge book containing the history of Sir Lancelot of the Lake, written on parchment, in standard script, historical material and illuminated, in two columns, beginning on the first leaf [be]*fore my eyes*, and on the last *received by him*, covered in vermilion velvet,

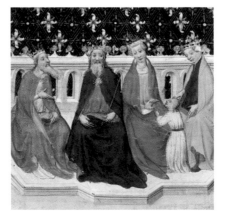

affixed with nine large gilded nails and four similar clasps."

Everything leads one to believe that this is the story of Sir Lancelot for which an order by the duke of 21 February 1407 (n.s.) stipulates payment of 300 gold écus to Jacques Rapondi, his usual provider, "for having made a large book for this Lord, all the tales of Sir Lancelot of the Lake and of the Holy Grail, as well as King Arthur." Moreover, one can further link this book to Lancelot by the decoration, which is in a style very similar to that which Regnault du Montet had sold to the Jean de Berry in January 1405 for 300 écus (Paris, BNF, MS fr 117–20), which Millard Meiss considers to be the twin of this manuscript. Regnault du Montet would have overseen the production of both volumes.

The decoration of these two manuscripts is lavish; the first page of the first volume opens with a large miniature in four compartments, representing episodes from the life of Sir Lancelot.

One recognizes the work of several hands in the collection of illustrations: the Master of the Cité des Dames, the Master of the Clères Femmes, and a minor artist, quite inferior, whom François Avril assumed was associated with the Master of the Second Novel of the Rose of the Duke de Berry, from the circle of the Master of the Clères Femmes.

The manuscripts appear again in the inventory of 1467, after the death of Philip the Good, and then were handed down at an undetermined time to the collection of Philippe de Croy, who added his coat of arms to the binding, below the first leaf. Margaret of Austria purchased them in 1511. In 1559 they were added to the Bibliothèque de Bourgogne in Brussels and appeared regularly in the inventories until 1748. The Viscount d'Argenson, who was then minister of war, recovered them on a visit to Brussels and bequeathed them in 1764 to his nephew, the Marquis de Paulmy. Their value at that time was estimated at 400 pounds. D. M.

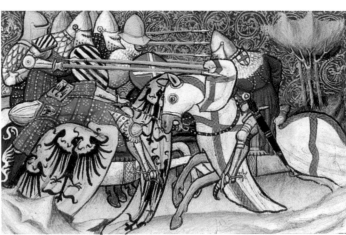

Fol. 172v: St. Andrew.

45

Ghent?

Book of Hours
after 1406 and before 1419

Parchment; [I-II] + 252 + [III] folios
14 x 10 cm

Paris, Bibliothèque Nationale de
France, inv. MS n.a.l. 3055

Prov.: commissioned by John the Fearless,
Duke of Burgundy (1404–1419). He must have
given it to his daughter Mary of Burgundy, who
married Adolphe IV of Clèves in 1406. (See the
episode of the knight with the swan, on folio
28 verso, an allusion to the legendary origins of
the House of Clèves.) It was in the possession
of Gaspard de Hennin-Liétard, a monk at Saint-
Aubert de Cambrai (fols. 201v–2) in 1623, and
later that of Louis de Beauquesne (fol. 203). In
1772 it belonged to a Mr. Lhermitte
(fol. 203v); in the 19th century it was in the
possession of C. Benvignat, an architect in Lille
(fols. [II] and 251v). It was acquired by the
Bibliothèque Nationale de France in 1939
(Paris, Hôtel Drouot sale, 22 May 1939).

Bibl.: Leroquais 1939; Van Moé 1939,
pp. 416–17; Mirot 1940, pp. 225–27;
Nordenfalk 1977; Samaran and Marichal 1981,
4: 1, p. 257; Vanwijnsberghe 1995, p. 285,
no. 4, p. 287, no. 8; Smeyers and Cardon 1996,
p. 163, fig. 3.

Exhibited in Cleveland only

The information provided by the
calendar points to a Flemish origin for this
small manuscript, which is confirmed by
the style of the decoration. The paintings
are attributable to the Master of Guillebert
de Mets, whose hand is apparent in several
works executed for the court of Burgundy
and in the *Hours* (Paris, Bibliothèque
Nationale de France, inv. MS n.a.l. 3112).
The initials of the *Hours*, with their
branching decorations, present the same
formal characteristics as those of this
manuscript.

In the striking painting on folio 172
verso, St. Andrew, dressed in a scarlet
tunic, is nailed to an X-shaped cross, whose
arms repeat the diagonals of the
composition. The emblematic gilded
carpenter's plane and mason's level on
either side of him are echoed in the
delicate gold mesh screen on the blue
background. Small flowers grow out of the
ground around the arms of John the
Fearless. Thread-like foliage escapes from
the fillet frame around the image. The light
green border consists of a series of large
alternating orange, blue, and pale pink
acanthus leaves on a gold ground. A
notable freedom characterizes the pictorial
technique and the expressive modeling of
the saint's face.

M.-T. G.

Fol. 86v: The Adoration of the Magi.

46

Paris

Book of Hours
c. 1410–11

213 folios
17.6 x 12.5 cm

New York, Alexander Acevedo,
Alexander Gallery

Prov.: by descent to the Dukes of Savoi(?);
private collections in North America since 1878.

Bibl.: unpublished; [Sotheby's, London,
7 December 1999, lot 43].

Exhibited in Cleveland only

This highly important manuscript has
until recently remained unrecorded and
unpublished. Its principal illuminator is
without question the Master of the
Breviary of John the Fearless, an
accomplished artist active in the household
of Jean de Berry from 1406 until about
1412. After 1412–13, the Breviary Master
left the service of the Duke of Berry and
joined the household of his nephew, John
the Fearless, Duke of Burgundy.

This same artist is known to have
contributed to the illumination of the

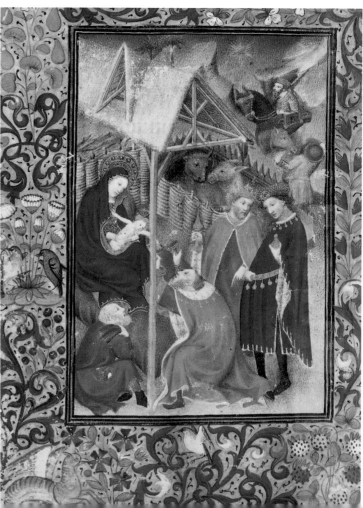

prestigious *Très Riches Heures* (Chantilly, Musée Condé) and also the *Belles Heures* (New York, Metropolitan Museum of Art). Both were commissioned by Jean de Berry, as this manuscript probably was. The stylistic affinities of the present volume to those at Chantilly and New York are apparent throughout. The Breviary Master also depended heavily on the Limbourgs for models, to the extent that he was thought by some scholars to be one of the brothers.

The manuscript includes sixteen full-page and one very large miniature. Additions were made in 1475 by Antoine de Lohny (formerly the Saluces Master) and again in 1490, at which time the floral borders in liquid gold were added. With a remarkable ability to adapt miniatures from other manuscripts, the Breviary Master copied six miniatures very closely from the *Très Belles Heures* of Jean de Berry, painted by Jacquemart de Hesdin about 1401 (Brussels, BRB, MS 11060-61). Through his association with the Limbourgs, the Breviary Master would have presumably had access to their drawings as well as familiarity with the duke's library. His great technical skills, evident in this manuscript, show remarkable similarity with aspects of Italianate naturalism—a command of rich, at times dazzling colors, and an interest in the play of light upon his subjects. The Breviary Master may have been trained as a goldsmith and showed supreme technical mastery in stippling, tooling, and burnishing his gold surfaces. Raised and stippled gold is to be found in every miniature by him throughout the manuscript.

S.N.F.

Fol. 226r: Brother Hayton presents his book to John the Fearless.

47

Paris

Marco Polo, *Le Livre de Merveilles (The Book of Wonders)*

1410–12

297 folios
42 x 29 cm

Paris, Bibliothèque Nationale de Paris, inv. MS fr. 2810

PROV.: given by John the Fearless, Duke of Burgundy, to his uncle Jean, Duke de Berry, as a New Year's gift of 1413; Jacques d'Armagnac, Count de la Marche, Duke of Nemours; the dukes of Bourbon; became part of the royal collections when the properties of High Constable Charles de Bourbon were seized in 1523.

BIBL.: Panofsky 1953, p. 54, no. 1, p. 55, no. 4, pp. 76, 244; Porcher 1959, p. 66, pl. LXXV; Meiss 1968, pp. 116–22 and passim; Gousset 1999.

Exhibited in Dijon only

Marco Polo's book *Le livre des merveilles du monde (The Book of Wonders of the World)* is known in English as *The Travels of Marco Polo*. The French title provided the title for this manuscript, a large collected series of travel writings, all translated from the Latin by Jean Le Long (d. 1383). This collection of works on the Middle East and the Far East reveal the political concerns of John the Fearless, Duke of Burgundy, who commissioned it. Plans for crusades held firm through the fourteenth century. In addition, John the Fearless had participated in the crusade against the Ottoman Turks, had been taken prisoner in 1396, and had been released in 1402 in connection with the victory of Tamerlane over Sultan Beyazid.

The work of the two scribes is accompanied by a lavish sequence of illustrations by a team of artists dominated by the Boucicaut Master, the Mazarine Master, the Egerton Master, and the Bedford Master, probably early in their careers. In some paintings the collaborations are so close that the mixture of styles becomes at times inextricable. It is to the Mazarine Master that we owe the superb dedication scene at the beginning of the book of Brother Hayton (fol. 226r). The painter has positioned this dedication of the work to John the Fearless in a very unified space. The portrait of the duke, in a garment bearing his emblems—the plane and the hop vine—is striking, to judge by other works of the period. In the frame painted by the Egerton Master, we find the hop vine in conjunction with the device "Ich singhe." The quadrilobes marking the angles were retouched when the manuscript was in the possession of Jacques d'Armagnac.

M.-T.G.

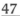

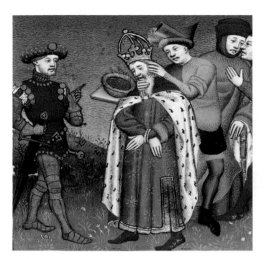

Fol. 380v.

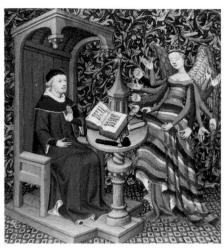

Fol. 229r: Fortune appears to Boccaccio.

48

Paris

Boccaccio, *The Histories of Noble Men and Women*
Translated from the Latin by Laurent de Premierfait
c. 1412

Parchment; 405 folios
40.2 x 29.8 cm; 150 miniatures; olive leather binding with coat of arms of the Viscount d'Argenson

Paris, Bibliothèque Nationale de France, Arsenal, inv. MS 5193 Rés

BIBL.: Doutrepont 1906, no. 82; Martin 1911; Meiss 1968, pp. 37, 47, 50, 54, 102, figs. 385, 393, 395; Bozzolo 1973, pp. 16–23, 51–52; Meiss 1974, passim; Tesnière 1999, pp. 76–80; Tesnière 2002, pp. 387–401; Hedeman 2003.

EXH.: Paris 1975, no. 101; Paris 1980 no. 67.

Exhibited in Dijon only

At the request of the Jean de Berry, Laurent de Premierfait undertook a second translation of the *De casibus* of Boccaccio, which he completed on 15 April 1409. Heavily reworked from the first translation of 1400, this translation added numerous clarifications and insertions to Boccaccio's text. This summary of the misfortunes and violent deaths of famous individuals, almost all from antiquity, was a didactic work whose purpose was to provide a moral and Christian education. The book was widely read, as seen by the large number of extant manuscripts (more than twenty-four), the majority of which are lavishly illustrated.

There were two copies of Boccaccio in the library of John the Fearless. This one is described in the 1420 inventory as "another book called Boccaccio, a history of noble men, written on parchment, in alphabet letters, bound in black damask and bearing two clasps of gilded silver." A note in the inventory indicates that it had been loaned to "my Lady," Margaret of Bavaria, his wife. It is listed again in the inventory of 1423 and again in 1467, at the time of the death of Philip the Good, at that point already rebound in "violet-colored satin."

We know of five manuscripts of this translation dating from the years 1410–20. This example was copied for John the Fearless, and another was copied for Jean de Berry (Geneva, Bibliothèque Publique et Universitaire, Fr 190). They were probably illustrated according to the instructions of the author. The iconographic program is complex and lends itself to several Christian, Humanist, and, above all, political readings; it reflects the period of acute French-British conflict in which the Duke of Berry and the Duke of Burgundy were involved, to varying degrees. After the fratricidal assassination of Louis d'Orléans in 1407, we sense the desire of the Jean de Berry, who ordered this work and sought to oversee its components, to link this story to the tragic fate of humanity and the heroes of antiquity.

It is generally thought that the manuscript in Geneva, attributed to the Master of Luçon, served as a model for this work. The miniatures are for the most part attributed to an artist whom Millard Meiss calls the Master of the Cité des Dames who appears to have specialized in historic manuscripts and the vernacular and executed several Boccaccio manuscripts. One can also recognize, however, the hand of a student of the Master of Adelphes and

that of a student of the Master of the Duke of Bedford.

This volume is routinely described in the inventories of the Burgundy library until 1748, the date on which the Viscount d'Argenson added the work to his collections and then bequeathed it to his nephew, the Marquis de Paulmy.

D.M.

49

Workshop of the Master of the Cleres Femmes of the Duke de Berry (Paris)

Workshop of the Master of Virgil (Paris)

Guyart des Moulins, *Bible Historiale*, vol. II
between 1410 and 1415

Parchment; 263 folios
39.7 x 28.7 cm (justification 26.5 x 18.7 cm); 2 columns, 54 lines; 33 signatures of 8 pages; catchwords; an old foliation continues in red ink through the two volumes from 1 to 294 and from 295 to 557 (in Roman numerals), proving that the manuscript was originally in a single volume.

Brussels, Bibliothèque Royale de Belgique, inv. MS 9025

PROV.: Bibliothèque de Bourgogne: inventory of 1467–69 (Barrois 1830, nos. 720 and 1505); inventory of 1485–87 (Barrois 1830, no. 1727); confiscated by the French (stamp of the Paris, BNF in fols. 1r and 263r) and restored to the Bibliothèque de Bourgogne in 1815.

BIBL.: Barrois 1830, p. 125, no. 720, p. 215, no. 1505, p. 247, no. 1727; Peignot 1841, pp. 35–36; Berger 1884, pp. 217, 294–95, 422; Prost 1890–91, p. 362; Durrieu 1895, pp. 82–87; Van den Gheyn 1901, 1: p. 42, no. 90; Doutrepont 1909, p. 201; Meiss 1967, p. 356; Meiss 1974, pp. 374, 378, 411, 418; Gaspar-Lyna 1987, 2: pp. 1–6, no. 199; Debae 1995, p. 51, no. 29.

EXH.: Brussels 1967, no. 5.

Exhibited in Cleveland only

The first complete translation of the Bible into French was made at the University of Paris toward the middle of the thirteenth century during the reign of St. Louis (Louis IX). Fifty years after this translation, Guyart des Moulins, canon of

Fol. 175r: The Tree of Jesse.

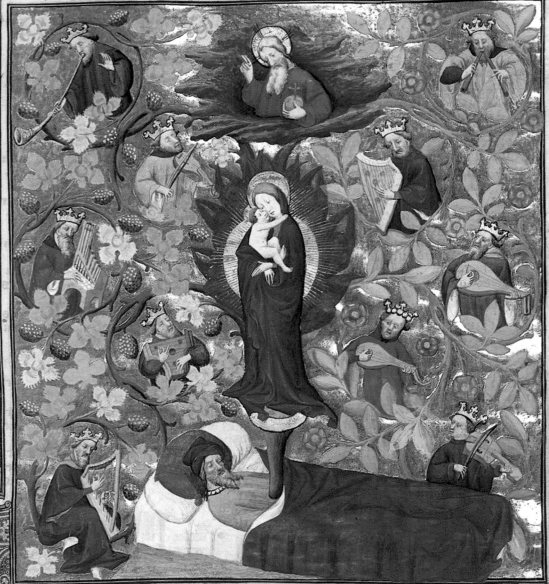

Cy commencent les euuangiles pnne
rement de saint matheu leuuägeliste. J.
Et liure de la genera
tion ihucrist fils de
dauid fils dabraha
abraham engendra
ysaac. ysaac engen
dra iacob. iacob en
gendra iudam et
ses freres. iuda en
gendra phares et arim de thamar. pha
res engendra esron. esron engendra arã.

aram engendra aminadab. aminadab
engendra nason. nason engendra sal
mon. salmon engendra booz de raab. booz
engendra obeth. Obeth engēdra iesse
iesse engendra dauid le roy. dauid en
gendra salemon de celle qui fu femme
vrie et fut bersabee. salmon engēdra
roboam. roboam engendra abiam. A
byas engendra asa. asa engendra io
saphat. iosaphat engendra ioram. io
nas engendra oziam. ozias engendra
ioatham. ioathas engendra achaz. Achaz

Aire in Artois, undertook a free translation of the *Historia scolastica*, the story of the Bible written in Latin by Pierre Comestor around 1175. This translation, known as the *Bible historiale*, is more than just a simple translation of his work; it is actually a juxtaposition of the Bible and the *Histoire*, combining biblical text with a free translation of the *Historia scolastica*. Completed in 1295, the work must have been considered unsatisfactory, because there is only one manuscript version without any interpolation. Also, from the time the *Bible historiale* was completed, it was retouched and adjusted to allow more space for the biblical text. Samuel Berger has classified completed story bibles into three families—small, medium, and large—based on the amount of translated biblical text they contain. This example falls into the "large" category.

The first volume (MS 9024) ends with the Psalms; the second (MS 9025) begins with Proverbs and concludes with Revelation. The second volume contains thirty-three miniatures, provided by several artists from different workshops. Millard Meiss attributes the frontispieces (fol. 1r), representing the teachings and the judgment of Solomon, and the miniature of the Tree of Jesse (fol. 145r) to the workshop of the Master of the Cleres Femmes of the Duke of Berry. The miniature in folio 135 verso and the twenty-four miniatures illustrating folios 159 verso to 259 verso are by the workshop of the Virgil Master.

Shortly before 1415, Jean Chousat, one of the duke's counselors, loaned a richly historiated and illuminated French bible to Margaret of Bavaria, the wife of John the Fearless. The duchess of Burgundy kept the borrowed manuscript for an extended period and asked the duke to purchase it. In an order dated 6 August 1415, John the Fearless instructed his confessor, the bishop Jean Marchant, and representatives of his treasury in Dijon to proceed with an evaluation of the manuscript. Guillaume Courtot, Jean Bonost, and Jean Marchant completed the process on the following 22 September and estimated the value of the manuscript at 500 gold ecus. Jean Chousat refused to accept this sum, settling for 450 francs. Confident of the archival evidence, Durrieu has proved that that this bible is indeed this same manuscript. The comparison of accounting records of 1415, published by Prost, with the inventories of 1467–69 and 1485–87, confirms this assertion. Although it entered the duke's collection in 1415, this *Bible historiale* is not mentioned in the inventory of 1420.

M.D.

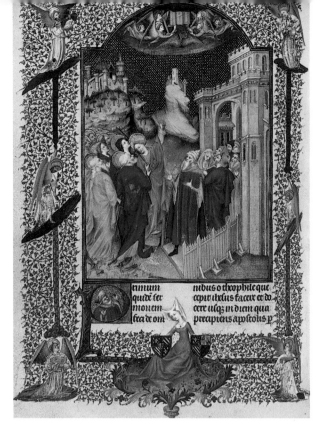

Fol. 188v: The Ascension.

50

Paris

Breviary of John the Fearless
c. 1413–19

452 folios
25 x 17.5 cm

London, The British Library, MS Harley 2897

PROV.: John the Fearless or Margaret of Bavaria; George Suttie; Robert Harley.

BIBL.: Porcher, 1953, pp. 11–14, 25ff; Meiss 1974, 1: pp. 325–26.

Exhibited in Cleveland only

This manuscript is the second half of a breviary originally designed as a single volume but subsequently divided into two (British Library, Additional MS 35311 forms volume one). Included in volume two are the calendar, psalter, ordinarium, and other texts, illustrated by some sixty-one miniatures. On folio 188 verso, in the lower margin beneath the miniature of the Ascension, a seated young woman holds the arms of Duke John the Fearless and his wife, Margaret of Bavaria, which suggests that the manuscript was made either for the duke or for his wife. However, as Millard Meiss observes, this breviary does not appear in the duke's inventory made in 1420, just after his death, or in Margaret's inventory of 1423 (Meiss 1974, 1: p. 325). Victor Leroquais assumed that the British Library manuscript is the Paris Breviary that the duke had in his possession when he was murdered at Montereau in 1419 (Leroquais 1939, p. 71). However, because the calendar and use of Harley 2897 are Roman and not Parisian, it is probably a different breviary. According to Meiss, the rubrics in French and the presence of St. Margaret and St. Agatha (twice) may suggest that the breviary was made for the duchess rather than the duke. It has been noted that on 22 May 1412 John the Fearless gave his wife 300 francs "pour la façon d'un bréviaire et autres livres qu'elle fait faire" (Doutrepont 1909, p. 200).

The majority of the manuscript's miniatures were painted by the Master of the Breviary of John the Fearless, an artist named by Meiss after his work on this breviary. His illuminations are represented elsewhere in this exhibition (cat. 46). The Breviary Master worked with and was influenced by the celebrated Limbourg brothers. He is noted for his use of dazzling colors and his skill with gold, especially his burnishing, punching, and tooling of gilded areas. Other artists or their workshops who contributed miniatures to this breviary are the Egerton Master, Guillebert de Metz, and the Humilities Master.

S.N.F.

Fabrice Rey

The Tapestry

Collections

After Philip the Bold became Count of Flanders in 1384, his patronage caused tapestry production to grow exponentially in the Low Countries. Flanders, which had traditionally manufactured wool cloth, was then suffering from the competition of English drapers,[1] and needed to restructure its economy. The duke felt that tapestry manufacturing would give an economic lift to the area. Thus, a new luxury industry was created at a time when princes were becoming ever more powerful and discriminating. The duke's power became enhanced by the glowing reputation that soon attached to Arras tapestries and spread all the way to the confines of Europe. These new luxury items even aroused the covetousness of the sultan Beyazid, who "would be very pleased to own *haute-lice* (high-warp) tapestries made in Arras."[2]

The key purpose of art in the second half of the fourteenth century was to transpose, with clarity and immediacy, narratives about God and the saints in the heavenly Jerusalem. In keeping with this religious theme, all the protector saints of Burgundy, from St. Anthony to St. Margaret, without forgetting St. Denis and St. George, were depicted in the tapestry collections of Philip the Bold and Margaret of Flanders, although the most prevalent subjects were scenes of the life of Mary and Jesus, so beloved by the faithful at the end of the Middle Ages. Unfortunately, it is difficult to analyze the motifs depicted in these tapestries, as there is little information about them. Many refer to the life of the Virgin, her crowning (as queen of heaven), episodes of her childhood, the Annunciation, the Nativity, and scenes illustrating her motherly love. There are also representations of the "five joys of the Virgin," a thirteenth-century theme that had been popular at a time when the faithful preferred to dwell on the happy aspects of Mary's life. But in the fourteenth century more somber scenes were emphasized, such as her dormition[3] or the pietà where she is holding her bloodied Son. Passion scenes were also woven in great numbers, as the cult of the "man of sorrows"[4] was very popular in this period. Art then focused on the crucial moment when human ignominy reached its paroxysm, and when Christ at the height of his glory fulfilled his redemptive mission.[5] These images should not, however, be seen as an indulgence in macabre tastes but as an homage to the sacrifice made by the Son of God. They are, in fact, part of a trend to humanize the iconographic program.

The complex religious and secular tales appreciated by the medieval public found an ideal support in the tapestry medium, which does not require stories to be summarized but rather allows them to develop endlessly. Subjects were often derived from medieval literature, wholly devoted to the values of chivalry, the figure of the knight, courtly love, and pride in lineage.

Courtly love, conceived as an adventure,[6] is a key decorative subject in the tapestries of Philip the Bold, cofounder with Louis de Bourbon of the court of love, and of Margaret of Flanders. The presence of the god of love[7] as a character relates to Christine de Pisan's struggles to bring about chivalrous respect for women and the poor.[8] Illustrious and esteem-enhancing feminine figures appear in many tapestries, such as the "Nine ladies" (derived from the book *Des femmes nobles et renommées*, owned by the duke), or Semiramis, mythical queen of Babylon and embodiment of beauty.

Tapestries also depicted heroes and knights such as Alexander, Hector, Fierabras, Godefroy de Bouillon, Charlemagne, and also Judas Maccabeus, St. George, or David, Clovis, and Bertrand du Guesclin. These mythical characters had great appeal at a time when noblemen were attempting to re-establish the prestige and importance of chivalry by preserving or recreating the old chivalrous rituals, or inventing them anew. The heroes and knights in the tapestries were role models for a "society that performs for its own entertainment,"[9] which explains the many characters from the Arthurian cycle in the Burgundian tapestry collections. Indeed, such idealized chivalrous values underlie many episodes of the life of Philip the Bold, from the foundation of the Order of the Star "after the fashion of the Round Table that once existed in the time of King Arthur"[10] to the sumptuous feasts organized in May 1389 in another attempt to recreate King Arthur's court.[11] But although the world of chivalry espoused by the duke and commemorated in the tapestries never existed, chivalrous values were also seen as a means to promote nationalistic sentiment in the midst of the Hundred Years War. It is for this reason that a pantheon of knights, such as Hector, Alexander, Clovis, and Charlemagne, was later linked to the French kings and in particular to the Valois dynasty.

Pastoral scenes, very popular in the late fourteenth century, appear also very frequently in Philip the Bold's tapestries and even more so in those of his wife, Margaret of Flanders. Shepherds and shepherdesses, together with their lambs and sheep, are frequent decorative motifs in the ducal homes and especially in Germolles, the most complete and perhaps the only prototype of the decora-

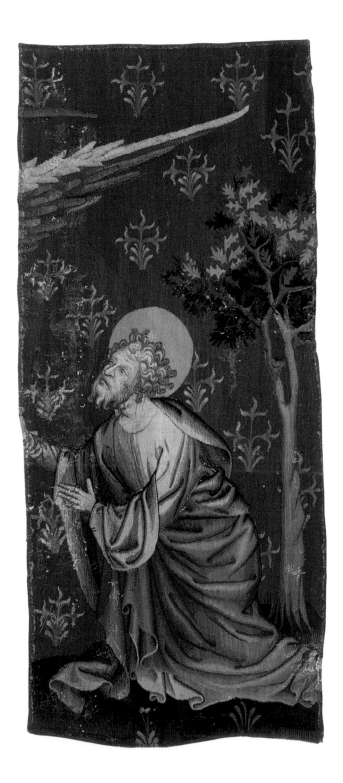

tive pastoral style that was then a fad among the upper classes.[12] The pastoral theme became so popular that many characters, for instance Paris or St. Margaret, were depicted as shepherds and shepherdesses. Margaret was indeed tending her sheep when she caught the eye of the Roman prefect of Asia, Olibrius. She rejected his advances and was martyred.[13]

The exaltation of the idyllic and peaceful pastoral life by opposition to the corrupt and artificial life in courts and cities, a literary trend that was beginning to gather strength in the late Middle Ages, was illustrated by Christine de Pisan in her book *Dit de la Pastourel*.[14] Idealized shepherds and shepherdesses lead a delightful life and are at the height of fashion in poetry and music. They can be seen picking walnuts or hazelnuts, making straw hats, or harvesting grapes. In the famous *Pastorale* by Claus Sluter, Philip the Bold and Margaret of Flanders are represented under an elm tree surrounded by lambs and sheep, living the pastoral life.

Philip the Bold and Margaret of Flanders, who together owned more than two hundred tapestries[15] illustrating major literary themes of the late fourteenth century, can be placed among the most accomplished intellectuals of their time. The duke and his duchess were not, however, driven only by an interest in literature. When they decided to affirm their power by promoting tapestry weaving as one of the first luxury industries, they were also pursuing territorial and political ends and using tapestries as a propaganda vehicle. Philip the Bold had very astutely realized that this new and original medium was uniquely suited to spread his religious, cultural, and political message. Tapestries, a symbol of the duke's lavish lifestyle and his generosity, were also used to impress his courtiers and to secure their allegiance. Indeed, tapestries and wine were the symbolic gifts given by the duke to the aristocratic and religious elite in pursuit of his political and diplomatic ambitions.

Fig. 1.
Fragment of a tapestry: The Apocalypse, St. John before the angel. *Apocalypse of Louis d'Anjou* (scene 83). Angers, Musée du Château.

NOTES 1. Joubert, Lefébure, and Bertrand 1995, p. 13.
2. Paris 1973–75, p. 18. That was the sultan's answer to Philip the Bold when the duke offered him tapestries to pay the ransom of his son Jean.
3. Mâle 1908, new ed. 1995, p. 123.
4. Ibid., p. 86.

5. Rey 2000–2001, p. 212.
6. Zink 1972, p. 101.
7. Extracted from *Épître au dieu d'Amour* (Pinet 1974, p. 66).
8. Ibid., p. 67.
9. Chastel 1992, p. 193.

10. Autrand 1994, p. 93 (quoted by J. Froissart).
11. Ibid., p. 217.
12. Rey 2002, p. 135.
13. Zink 1972, p. 9.
14. Ibid., p. 106.
15. Rey 2001–2002, p. 166.

Tapestry Collection of Philip the Bold

- Emperor Alexander, 900 francs.
- Two lovers, 50 francs.
- St. Anne, Cyprus gold thread, lot of two tapestries at 1,100 gold crowns.
- St. Anthony (two tapestries), gold thread.
- The Apocalypse (six tapestries), 648 square meters, 108 square meters each, gold thread, 5,000 francs.
- Tree, lion, and elephant.
- Pastoral scenes (two tapestries), gold thread.
- King Arthur (four tapestries).
- Auberi le Bourgoin, conqueror of the king of Frisia, 14.7 x 3.5 meters, fine Arras thread, lot of five tapestries at 1,200 francs.
- The Battle of the Thirty, 120 francs.
- Bégon (who conquered the daughter of the king of Lorraine), 14.7 x 3.5 meters, 100 francs.
- Shepherdesses, gold thread.
- Shepherdesses, 6.3 x 2.45 meters, lot of four tapestries at 1,200 francs.
- Pastoral scenes (six tapestries).
- Shepherds, 9.1 x 3.15 meters, gold thread, lot of six tapestries at 700 francs.
- Shepherds, 7.7 x 2.8 meters, lot of six tapestries at 700 francs.
- Shepherds and shepherdesses, 12.6 x 2.8 meters, 120 francs.
- The deeds of Bertrand du Guesclin, formerly Constable of France, Cyprus gold thread, 800 francs.
- Bertrand du Guesclin, 4.9 x 2.45 meters, lot of six tapestries at 700 francs.
- Bertrand du Guesclin, lot of five tapestries at 849 francs.
- St. Catherine.
- Charlemagne, 16.8 x 3.65 meters, gold thread, lot of five tapestries at 849 francs.
- "Hunting scene and farcical play."
- Hunting scenes, 56 square meters, Cyprus gold and silver thread, 200 francs.
- The Heritage castle (allegory), 12.6 x 3.67 meters, lot of five tapestries at 849 francs.
- The Heritage castle, 12.6 x 3.67 meters, gold thread, lot of six tapestries at 700 francs.
- Knights and ladies, 160 francs.
- The Count of Sancerre.
- The Credo, 26.4 x 4.8 meters, fine Cyprus gold thread, 1,400 francs.
- A lady between two lovers.
- Ladies, 8.4 x 0.7 meters, fine Arras thread, lot of five tapestries at 1,200 francs.
- The dance of the shepherds.
- St. Denis, fine Arras thread and Cyprus gold and silver threads, 800 francs.
- "Dévorements d'amants et d'enfants" (Lovers and children cavorting?), gold thread.
- God of love, said to be the god of the shepherds.
- The ten knights and nine ladies, 24 x 4.8 meters, fine Arras thread and fine Cyprus gold and silver threads, 2,600 francs.
- The ten wishes (three tapestries), 84.7 square meters, Cyprus gold and silver threads, 400 francs.
- "Gifts" of knights and ladies, 11.2 x 3.85 meters, gold thread, lot of six tapestries at 700 francs.
- Doon de Mayence (four tapestries).
- Doon de la Roche, gold thread, 600 francs.
- The twelve months.
- The emperor of Greece and the king of Frisia ("who fought against each other"), 11.9 x 3.15 meters, lot of five at 1,200 francs.
- Fame (allegory, three tapestries), 158.4 square meters, fine Arras thread and Cyprus gold thread, 3,000 gold crowns.

- The don of a king of Cyprus ("how he went to seek adventures"), fine Arras thread and gold thread, 320 francs.
- Florence de Rome (five tapestries), gold thread.
- Frotmont de Bordeaux, large tapestry, 365 francs 10 Parisian sols.
- St. Georges, 21 meters long, gold thread, 700 francs.
- Girart, son of the king of Frisia ("how he bid farewell to his mother and sister and went to seek adventures of which he found enough that were to his credit"), 12.6 x 3.5 meters, lot of five tapestries at 1,200 francs.
- Godefroy de Bouillon, 14 x 3.5 meters, gold thread, lot of six at 700 francs.
- Guillaume de Bomercy (his story), gold thread.
- Guillaume d'Orenge, 100 francs.
- Guy de Roménie (hunting tapestry of), 19.6 x 4.55 meters, gold thread, lot of three tapestries at 1,100 francs.
- Harpin de Bourges, gold thread.
- Hector of Troy.
- Hector of Troy, Cyprus gold thread, 200 francs.
- Jason ("how he conquered the golden fleece," two tapestries), 1,125 francs.
- Jourdain de Blaye, gold thread, lot of two tapestries at 2,520 francs.
- Judas Maccabeus (the deeds of, four tapestries), 90 francs.
- Lion de Bourges, 105 square meters, fine Arras thread and Cyprus gold thread, 1,000 francs.
- Mahomet, 32.2 x 4.2 meters, fine Cyprus gold thread, 1,200 francs.
- Mainet (two tapestries), gold thread.
- Daisies (eight tapestries), 170.45 square meters.
- The mirror of Rome (four tapestries).
- The Entombment of Christ, 7 x 3.15 square meters, lot of two tapestries at 1,000 francs.
- Sheep.
- The nine ladies, 117.6 square meters, fine Arras thread and Cyprus gold and silver threads.
- The nine knights and nine ladies, gold thread.
- The five joys of the Virgin, Cyprus gold thread, 250 francs.
- The crowning of the Virgin, 10.15 x 4.9 meters, gold thread, lot of two tapestries at 1,000 francs.
- The crowning of the Virgin, gold thread, 200 francs.
- The Virgin Mary (several stories of her life), 5.4 x 3 meters, Cyprus gold thread and silk, 350 francs.
- The Virgin Mary (a story of her life), 12 square meters, 200 francs.
- The Virgin Mary (her death), gold and silk thread, 600 crowns.
- Octavian of Rome.
- The Passion of Christ, gold and silk thread, 250 francs.
- Perceval of Wales, 11.2 x 3.5 meters, gold thread, lot of five tapestries at 849 francs.
- The golden apple, gold thread, lot of two tapestries at 2,520 francs.
- The queen of Ireland or Iceland[1] (six tapestries).
- The Resurrection of the Lord, gold thread.
- The king and the twelve peers of France, Cyprus gold thread, 2,500 francs.
- The king and the twelve peers of France, 109.23 square meters, fine Cyprus gold thread and silk, 600 gold crowns.
- The king of Frisia, 14 x 3.5 square meters, Arras thread, 140 francs.
- "Le Roman de la Rose," Cyprus gold thread, 1,000 francs.
- The battle of Rosebecque (three tapestries), 39.2 x 4.9 meters, Cyprus gold and silver threads, 2,600 francs.
- Semiramis of Babylon (her story), Cyprus gold thread.

- The seven arts of science, 100 francs.
- The seven wise men, Cyprus gold thread, lot of two tapestries at 2,100 gold crowns.
- The seven virtues and the seven vices, 93.6 square meters, fine Arras thread and Cyprus gold thread, 2,700 francs.
- The seven virtues and the seven vices, gold thread.
- Seramnes (four tapestries).
- Thamar the pious.
- The orchard of nature (allegory), 28 gold francs.
- The orchard of sustenance (allegory).
- Yseult and Jacob, 14 x 3.5 meters, gold thread, lot of five tapestries at 849 francs.

Tapestry Collection of Margaret of Flanders[2]

- Eagles carrying millet garlands, large tapestry.
- The emperor Alexander.
- Golden tree under which is a flock of sheep surrounded by a shepherd and a shepherdess (two tapestries), large tapestries, gold thread.
- White columbines.
- Aymeri de Narbonne and his six sons.
- The battle of Cocherel.
- Pastoral scenes (two tapestries), large tapestries.
- Shepherd and shepherdess around a golden tree, large tapestry, gold thread.
- Shepherds and shepherdesses with sheep under a golden tree, gold thread.
- Shepherd and shepherdess weaving straw hats accompanied by sheep and "small groups" of sheep, large tapestry, gold thread.
- Shepherd and shepherdess weaving straw hats accompanied by sheep and "small groups" of sheep near several golden trees, large tapestry.
- Kindness and loyalty (allegory).
- Sheep (four tapestries).
- Sheep (two tapestries), large tapestries.
- Cassamus and Alexander.
- Knight killing a beast.
- Doves, large tapestry.
- A crucifix and the four Evangelists.
- David killing Goliath.
- Ladies defending a castle.
- God of love, Juno, Pallas, and Venus.
- Doon de Mayence.
- "The emperor of the panther king."
- Blue fleur-de-lis and a small bench.
- Fountain and lady planting a pot of marjoram.
- St. George, large tapestry.
- Godefroy de Bouillon, large tapestry.
- Short-nosed William, large tapestry.
- Crowned lion in the center with four compas[3] and four horns surrounded by white and blue columbines and other flowers (two tapestries).
- The Maccabeus and King Antiochos, large tapestry.
- Manfred's defeat at the hands of Charles the Conqueror, Count of Anjou, large tapestry.
- The wedding of a lord's daughter "and it is written therein how it was made in Arras at the house of Haton the potter."
- Meliant and the beast.
- Pavilions and in a circle a lion and a white escutcheon hung from his neck.
- Figures playing "haucepie."
- Several large figures playing "herbette" and dominos and other small figures involved in "deflatemens d'enfant" (children's games?).
- Several figures, white and black sheep.
- The "Roi tristre preudon."[4]
- The peacock's wishes.
- The peacock's wishes (two tapestries).
- Waves, (two tapestries), large tapestry.

NOTES 1. This tapestry has two different names in the inventory and in the account books.
2. The descriptions of the duchess's tapestries are not as complete, as they come from the inventory made at her death, whereas the description of the duke's tapestries is extracted from the general ledger accounts. The prices are not the original prices but appraisals made after his death.
3. "Compas" are circles surrounding coats of arms or symbols, undoubtedly to highlight them.
4. Perhaps this means the chivalrous sad king.

51

Southern Netherlands, possibly Arras

Tapestry of the History of Jourdain de Blaye: The Meeting of Fromont and Girart
c. 1380–1400

Wool, 6 warp threads per cm; several metal threads

328 x 380 cm

Padua, Museo Civico, inv. 614

PROV.: in the palace of the Santa Croce family at the beginning of the 19th century; purchased by the municipality in 1835; in the Museo Civico since 1882.

BIBL.: Dehaisnes 1886, 2: p. 639; Hulst 1960, no. 2, pp. 7–16, 296, ill.; Dembowski 1969; Stucky-Schürer 1972, pp. 75–78; Lestoquoy 1978, pp. 42–45; Joubert, Lefébure, and Bertrand 1995, p. 23, ill., p. 64, no. 4; Rey 2002, pp. 34–36, 42–43, 127–128, ill. Annex VII.

EXH.: Paris 1973, no. 5; Turin 1979, no. 62; Paris 1981, no. 335.

Exhibited in Dijon only

According to an accounting of the General Receiver's Office of Flanders for the period from 11 March 1386 to 10 March 1387, 2,500 livres were paid to Jehan Dourdin for his furnishing to Philip the Bold "*Il tapis sarranois ouvrés à or, de la fachon d'Arras, dont il a eu l'un de ystore de la Pomme d'or, et l'autre l'istoire de Jourdain de Blaye*" (Two Arras-style tapestries worked with gold, one recounting the story of the Golden Apple, the other the story of Jourdain de Blaye). Jehan Dourdin (more often referred to as Jacques Dourdin in the sources) was a major tapestry producer, probably a native of Arras (he is sometimes referred to as an "Arras tapestry maker," and he owned land on the outskirts of the city), and a regular supplier of tapestries to the Duke of Burgundy as well as to Charles VI, Isabeau of Bavaria, and Louis d'Orléans (Joubert 1990; Rey 2002, p. 232).

Since tapestry is by definition a technique that permits reproduction of a motif in several copies, it cannot be definitively stated that the Padua tapestry is that of Philip the Bold. None of the numerous tapestries owned by Philip the Bold and John the Fearless survives. This Padua tapestry at least enables us to evoke the everyday setting of the court of Burgundy and its fondness for nonreligious subjects, insofar as it is the oldest surviving illustration of a fashionable story.

The tale of Jourdain de Blaye is one of the many that grew up around the legend of Charlemagne in the thirteenth century. It is a sequel to the story of Amis and Amiles.

Fromont is a nephew of Hardrez, who is killed by Amis in the defense of his companion Amiles and Belissant, the daughter of Charlemagne. To avenge the death of his uncle, Fromont goes to Blaye, the home of Girart (son of Amis), kills Girart and his wife, and kidnaps a child who he thinks is their son, Jourdain. In fact, however, Renier de Vautamise, who has custody of the child, has substituted his own son for Jourdain. After numerous adventures, Jourdain overcomes Fromont, who dies an agonizing death.

The scene is introduced by the storyteller, the figure at the left with mouth open and hands raised. The inscription above his head, written in Picard, summarizes the story: "*Fromons fist Renier traveillier / tant que son fil ala baillier / a morir pour Jourdain sauver / sen signeyr quas fons vault lever / mais Jourdains puis vengeance en fist / sus Fromont telle qui souffist.*" (Fromont had Renier tortured while his son went to fight and die in order to save Jourdain, son of the lord who had brought him up. Jourdain took revenge and made Fromont suffer the same fate.)

For the trip to Blaye, Fromont takes ship at Bordeaux, in the company of soldiers with banners bearing his initial. He is warmly welcomed by Girart, his wife, and their retinue, before their castle. The following stanzas describe the scene:
Regardes de Bordiaus Fromon / qui par mer va en de dromon / a Blaives pour Gerat traiir / ses neveu sens fait ahair.
"*Girart, dieve vous croisse bonté / mes je vous vieng par amisté / veir en Blaives vo maison / cat mout vous aing c'est bien raison.*"
"*Oncles, bien soiiés vous venus / d'amour sui bien a vous tenus / car noblement me venés vir / honnerer vous doy et server.*"
(Watch as Fromont puts out to sea from Bordeaux to Blaye to betray Girart, his nephew, who has done nothing to deserve hatred.
"Girart, may God keep you in His care. I come in friendship to visit your household in Blaye, because many people love you, and rightly so."
"Uncle, welcome. By love I am bound to honor and serve you, because you have nobly come to see me.")

The scene is positioned clearly between a foreground filled with plants and animals and a background of rocks surmounted by trees. The sky is festooned with clouds. The artist who prepared the cartoon paid careful attention to the description of the boats, castles, and particularly the costumes, in the style of the closing years of the fourteenth century.

S.J.

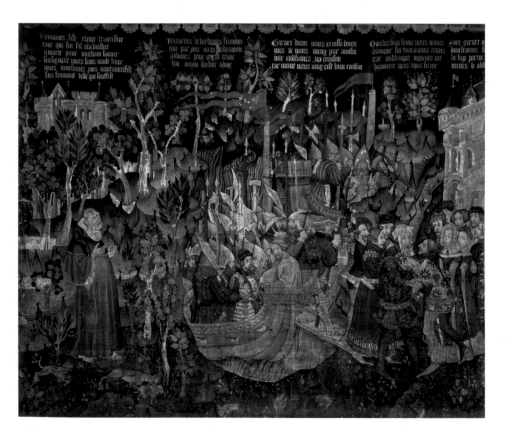

Élisabeth Taburet-Delahaye

Gold and Silver

The role of the first two Valois dukes in the development of the goldsmith's art in Burgundy is difficult to assess. Although Philip the Bold commissioned jewels and precious objects, his older brothers—the king Charles V, the dukes Louis d'Anjou and Jean de Berry—were also keen collectors. The relative abundance of Burgundian documentary sources on sumptuary fashions in the 1400s—rock crystal vases, jewels enameled in white, or cameo portraits—has lead to a misleading tendency to consider this or that object representative of Burgundian practice, to the point where some authors have argued that there is no such thing as a typically Burgundian style in metalware.[1]

Philip the Bold's accounts show many payments for gold and silver objects, such as crosses and reliquaries, pieces of "plate" for the table or the sideboard, jewels, and clothing ornaments. These were either for the duke's own use or to give as gifts. Like other noblemen of his era, the Duke of Burgundy commissioned precious objects for a ceremonial entry into a town, a wedding, New Year's gifts, etc. His patronage played a significant role in promoting some innovations that began to appear in the 1400s, such as the fashion for enameled gold jewelry. In 1352 the accounts of John the Good mention for the first time gold jewels with red and white enamel, and plate with incised decoration.[2] Fifteen years later, in 1367, there is mention of a white-enamel decoration for a gold belt made for the duke's youngest son.[3] At the beginning of the reign of Charles VI in 1380, the duke (who was then the king's guardian) was a major force behind the fashion for white-enameled jewels decorated with animals, angels, or gentlewomen. The records show that Philip the Bold gave great quantities of these jewels as New Year gifts in the years 1382–93.[4] The duchess owned an impressive collection, which was minutely described in the inventories prepared at her death in 1405.[5] In 1389–90 the records show commissions of enameled gold "pictures," or devotional altarpieces, depicting the Trinity or the suffering Christ. For instance, a "large Trinity picture" weighing sixteen marcs that was purchased for six thousand francs from the Genoese merchant Pierre Labourebien to be given to the duke's brother Jean de Berry on 1 January 1389, or a "gold picture enameled inside and out depicting the history of Our Lady of the Tomb of Our Lord" that was given the following year to Queen Isabeau.[6] Many formal innovations characterizing the 1390s can also be attributed to the duke's influence. In particular, he promoted the vogue for necklaces and was one of the first to wear a jeweled purse or bracelet.[7] Philip the Bold also started giving gifts of small gold statues of saints, most often the protectors of the kingdom or the patron saints of the beneficiary. For instance, on St. John's Day in 1380 he gave Jean de Berry a "gold image of St. John the Baptist standing in a gold forest." The records show a payment in 1387–88 to the Parisian goldsmith Renequin de Harlem—whose name indicates his origins—for this statue and for a St. Catherine for the duke's own chapel; the accounts also mention a payment to the merchant Henriet Orlant for a St. Margaret in enameled gold for the ducal chapel.[8] In 1392, the Duke of Berry received from Philip the Bold as a New Year's gift a gold statue of St. Louis, followed by many other statues of saints.[9] In 1397 the king received a St. Michael in white-enameled gold. This statue, which was pawned to Louis le Barbu, brother of the queen, and was later given by him to the Ingolstadt treasury in 1441, is known through a painted reproduction now in Munich, in the Bayerisches Nationalmuseum.[10]

Like all the princes of his era, Philip the Bold liked precious stones, such as rubies and diamonds, and often gave them away as New Year's gifts. For instance, 108 diamonds were given in 1401 and 320 the following year.[11] Exceptionally, Eva Kovács was able to prove that one of these jewels, the so-called "three brothers brooch" lost by Charles the Bold on the Grandson battlefield in 1476 and known through a watercolor in the Basle museum, was the same piece that had been delivered by the Parisian goldsmith Hermann Ruissel in 1398.[12]

Margaret of Flanders's more discreet role should not be underestimated. It is known for instance that the Calvary given by Matthias Corvin to the Esztergom cathedral (fig. 1) had been given by the duchess to her husband on 1 January 1403, as it was accurately described in the inventory prepared at the duke's death the following year. By its precious materials, technical quality, style, expressivity, and modernity, this very innovative work is emblematic of the art of the 1400s.[13]

John the Fearless did not have his father's financial resources, and his jewelry purchases were necessarily more restrained. Diamonds, which were then beginning to be facet cut, were his favorite stones. The accounts show that in 1419 the duke purchased from the Parisian jewelers Conrad de Roder and Pierre Chamirau seventeen diamonds cut "in point," square or rectangular, as New Year's gifts to be given to family members and courtiers.[14]

The jewels and objects commissioned by John the Fearless for himself or as gifts, such as rings, necklaces, brooches, and rosary beads, were often decorated with his personal emblem, a wood plane.[15] Examples of this practice are the ring in the Musée du Louvre (cat. 55), engraved on the inside with a plane in yellow enamel, or the Karlsruhe cup (cat. 53), decorated with incised planes and hop leaves.

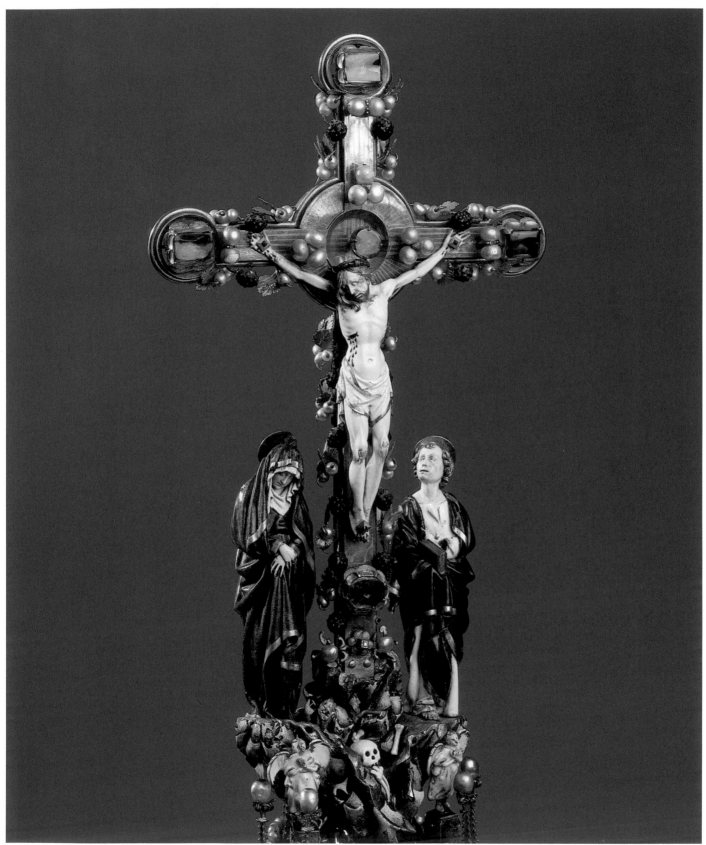

Fig. 1

Fig. 1.
Crucifixion given by
Magaret of Flanders to
Philip the Bold as a New
Year's gift, 1403.
Esztergom, cathedral
treasury.

Fig. 2.
Medallion with a portrait
of Philip the Bold,
traditionally identified
as Philip the Good, Paris,
c. 1400. Munich,
Schatzkammer der
Resident.

Fig. 3.
Cross of the sermon of
the Golden Fleece, Paris,
before 1401; at the base,
a case with the arms of
Jean de Berry, 1453–67.
Vienna, Geistliche
Schatzkammer.

Fig. 3

Fig. 2

for the duke from 1385 onward before becoming goldsmith to Charles VI.[16] He also favored merchants and money changers of French or Italian origin established in Paris: Simon de Dammartin, Guillaume Sanguin, André Giffart, Michaut de Lallier, Henriet Orlant, Pierre Labourebien, and Dino Rapondi, who was the duke's maître d'hôtel and advisor.[17] The duke also dealt with Dijon goldsmiths such as Guillaume, Oudot des Grès, André de Morrey, Hennequin de Hacht, Thomas Destampes (from Arras), Jehan de Braban (from Bruges), and occasionally with goldsmiths in Lille or Boulogne-sur-Mer, but these purchases were run-of-the-mill objects that did not require sophisticated techniques or exceptional talent.[18]

John the Fearless made purchases from his father's purveyors in Paris, in particular Jean Mainfroy. He also patronized newcomers, such as the Paris jewelers who provided the diamonds given for the New Year in 1419 or the Dijon goldsmiths Thomas Lorote and Jehan Vilain. The latter, "the duke's goldsmith," was probably a Parisian who had moved to Burgundy (a goldsmith of the same name is mentioned in Paris from 1399 to 1412, at the service of Louis d'Orléans and then of the dauphin Louis de Guyenne).[19] But most of John's purchases were made in the Flemish cities, in particular Bruges, home of Gérard Clutin, Thierry Van Stanere, "servant and goldsmith to my lord," and Louis le Blazere.[20] The latter supplied on 1 January 1416, a "gold picture with a Virgin enameled in white" given by the duke to his advisor Nicole d'Estrées.[21] This devotional altarpiece is the first mention of an enameled gold jewel supplied by a Flemish goldsmith and a sure sign of the fact that artistic creation was shifting its center of gravity toward the Flemish lands of the duchy of Burgundy.

Although it is true that Philip the Bold and John the Fearless were instrumental in the development of the goldsmith's art in the late fourteenth and early fifteenth centuries, there is no such thing as a distinctive Burgundian style. Most of the dukes' purchases were made not in their own domains but in Paris, which was at the time a major manufacturing and trading center for metalware and other sumptuary arts. Philip the Bold granted the title of "duke's goldsmith and equerry" to the Parisian Jean Mainfroy, who also served the duke's son until 1417. He also made purchases from the best Paris goldsmiths such as Hennequin du Vivier, "the king's goldsmith" (from 1382 to 1390), and Hermann Ruissel, who worked

NOTES 1. Somers Cocks 1977.
2. Gaborit-Chopin 1987.
3. Payment to Paris goldsmith Vinant de Couloingne (Koln) for gold and labor to make "a gold belt with enameled white eagles and swans, that he made and delivered to my lord" (Prost 1902, no. 719, cited by Kovács 1975).
4. Petit 1888, pp. 512ff: the duke gave several white-enameled brooches as New Year's gifts in 1382, among them a fleur-de-lis to the king and a "white dog" to the seigneur d'Arquel; Prost 1908–13, no. 1215ff.
5. Dehaisnes 1886, pp. 855ff.
6. Prost 1908–13, no. 3103; Petit 1888, p. 532.
7. About the necklaces, see Lightbown (1992, pp. 282–83), who describes in particular a necklace purchased from Hermann Ruissel in 1388 (Prost 1908, no. 2735) and mentions the many necklaces of various types and decorations described in the 1405 inventory of Margaret of Flanders (see note 5); about the necklaces made in 1403 on occasion of the creation of a short-lived "order of the golden tree"

bearing a pendant with a golden tree surrounded by a lion and an eagle enameled in white and the words "in loyalty," see David 1945, p. 29, and Lightbown 1992, p. 260. About the purses: mention of the purchase of a "gold purse with about 120 paternoster signs" from Paris goldsmith Laurencin Malaquin in 1373 (Prost 1908–13, no. 1768) and the purchase of a fancier purse made of gold and decorated with oak and elm leaves, with rubies, sapphires, and pearls in 1403 (David 1945, pp. 37–38). About the bracelets, see Lightbown 1992, pp. 295–96.
8. Dehaisnes 1886, pp. 648–49 (accounts from 1 July 1387 to 1 February 1389).
9. See most recently Hirschbiegel 2003, nos. 518 (1392, St. Louis) 625 (1394, St. Anthony), 681 (1395, St. Catherine), 730 (1396, St. Denis), 929 (1398, St. Andrew), 1008 (1399, St. Philip), 1103 (1401, St. James), 1186 (1402, St. Thomas), 1253 (1403, St. John the Evangelist), 1305 (1404, St. Anthony).
10. Paris 2004, no. 93.
11. David 1945, p. 27.

12. Kovács 2004 (posthumous work that includes all the research by this historian on fourteenth- and fifteenth-century French gold and silver, only some of which has been published); for the objects lost at Grandson, see Deuchler 1963.
13. Kovács 1975 and 1983.
14. Mollat and Favreau 1965, nos. 271–72 (order of 1 January 1419).
15. For instance the 315 planes, made of gold and decorated with diamonds, that were given as New Year's gifts in 1406 (Petit 1888, p. 585).
16. Henwood 1982.
17. Dehaisnes 1886, pp. 605–6ff.
18. Ibid., pp. 520ff; Prost 1908–13, passim.
19. Mollat and Favreau 1966, nos. 1940, 2175, 2301, 2723, 3423, 3861, 386; BNF fr 32511, fol. 7v.
20. Mollat and Favreau 1965, no. 574; ibid., 1966, nos. 8166, 9776.
21. Mollat and Favreau 1965, no. 574, order of 4 January 1416. Preceded, however, by the "petit coulon [dove?]" in white enamel added by Jean de Brabant.

52

Paris

The Trinity

c. 1400–10 for the medallion of the
Trinity; probably between 1884 and
1897 for the setting

Gold, enamel, and pearls
Setting: Diam. 12.6 cm
God the Father: H. 5.9 cm

Washington, National Gallery of Art,
inv. 1942.9.287

Prov.: Pope Alexander VI?; Francisco
Doctor, Madrid, 1884; J. E. Taylor, before
1897–1912; sale, Christie's, London, 1–4 and
9–10 July 1912; Widener collection, Elkins
Park, Pennsylvania, as of 1913; Widener
bequest, 1942.

Bibl.: Dehaisnes 1886, 2: p. 829; Tait 1992,
pp. 120–21, 126, nos. 27–32, figs. 10–16;
Washington 1993, pp. 48–53 (note by Alison
Luchs, with bibliography); Venturelli 2003,
pp. 22–24.

Exh.: London 1897, no. 242b.

The medallion, which consists of enamel
on a gold sculpture in the round,
represents the bust of God the Father
emerging from clouds holding Christ on
the cross and surrounded by four angels.
The Holy Ghost, appearing in the form of a
dove, unites the Father and the Son.

Partially because of the disservice done
it by a modern setting, the authenticity of
this medallion has been questioned by
Hugh Tait. Investigations undertaken for
the preparation of the catalogue of
medieval and Renaissance objects in the
National Gallery of Art led Alison Luchs to
conclude that the object was authentic.

The technique and the style are indeed in
keeping with known examples of enamel on
gold sculptures in the round, a type of
production that is generally traced to Paris
in the 1400s. The object in question bears
striking resemblance both to the British
Museum's *Reliquary of the Holy Thorn*, which
probably belonged to Jean de Berry, and to
the prophets of the calvary in Esztergom.

The comparison of the *Trinity* with an
item in an inventory of Philip the Bold's
belongings is particularly telling: "item,
another pendant with a white-enamelled
gold relief of a Trinity in the middle, with
about four angels, outfitted with fourteen
crops, two sapphires and thirty-four pearls,"
which was present in 1404 in the duke's
chapel. Of course, it is not absolutely
certain that this *Trinity* is the object
described in the inventory. But it has been

accurately pointed out that though devotion to the Trinity was not limited to Philip the Bold, it was certainly dear to him. The Chartreuse de Champmol, for instance, was dedicated to the Virgin Mary and the Trinity. Nonetheless, Paola Venturelli recently drew attention to an inventory of jewels that belonged to Gian Galeazzo [Jean Galéas] Visconti and were pawned through a Milanese tradesman in 1402 and 1403. One of the items is described as "*magiestatem unam rotondam factam cum Deo Patro smaltato de albo cum eius filio in cruce in brach[io] in medio et angelis in circuitu*" (a majesty with God the Father enamelled in white with his Son on the cross in his arms in the middle and angels around him). The very active Milanese artistic milieu, which was stimulated by the brilliant court of the Sforzas, was then completely capable of competing with the Parisian enamelists. Venturelli proposes that we attribute certain enameled gold sculptures in the round to a center of production in Northern Italy, whose relationship with the graphic work of Giovannino de'Grassi she underlines.

There is nothing surprising about such a coincidence in a period that has been referred to as International Gothic. Goldsmiths, merchants, and princes traveled, objects circulated and were traded, were offered as gifts, or brought as parts of a dowry. It will be recalled that Louis d'Orléans, the brother of Charles VI, married Valentine Visconti. It is far from unthinkable that during the same period highly similar objects could have been created for courts on both sides of the Alps.

S.J.

53

Paris, Burgundy, or South Netherlands

Hanap Goblet with the Devices of John the Fearless
1405–19

Silver, decorated with pouncing and gilding
H. 23.7 cm, Diam. of neck 11 cm, Diam. of foot 10.4 cm

Karlsruhe, Badisches Landesmuseum, inv. 65/63

Prov.: acquired in 1965.

Bibl.: JSKBW 1966; Karlsruhe 1976, p. 34, fig. 148; Somers Cocks 1977, p. 183, fig. 3; Lightbown 1978, pp. 24, 75–74, pls. 24, 25; Fritz 1982, fig. 503, p. 256, no. 503; Fritz 1986, p. 3325, fig. 18.

Exh.: Karlsruhe 1966, no. 57; Munich 1995, no. 22.

This *hanap* goblet has a bulging cup on a fairly tall foot and a similar, slightly smaller cover with a knob that is a smaller version of the cup and its foot. The entire outer surface of the goblet is covered with a delicate pounced decoration of waving hop vines and carpenter's planes. The pounced motifs are to some extent concealed by the gilding that was applied over the entire silver surface, apparently at a later date. The hop vine and the carpenter's plane are known to have become the personal devices of John the Fearless in 1392 and 1405, respectively.

This is probably the goblet described in the inventory drawn up in 1420, following the death of John the Fearless: "*I hannap d'argent blanc couvert cizelé à feluillages et raboz pesant III. m[arcs] II o[nces]*" (One hanap goblet, white metal, with a cover, engraved with foliage and carpenter's planes, weighing 3 marks 2 ounces), and also from an undated inventory of Charles le Téméraire: "*une autre coupe blanche, verrée, à la devise de rabotz, à un fritelet doré et pise III m[arcs] III o[nce]*" (Another white goblet, partly gilt, bearing the device of carpenter's planes, with gilt knob on the cover, weighing 3 marks 3 ounces.) This description would accord with the Karlsruhe hanap goblet, which weighs 820 grams.

Objects of this type are in any case attested to in contemporary miniatures. A similar goblet, without a cover, is visible on the sideboard in the famous "January" miniature in the *Très Riches Heures* of the Duke of Berry. Pounced decoration is very characteristic of the period from 1380 to 1400, and particularly of Parisian goldsmith work. The St. Agnes cup (London, British Museum), the Goldene Rössl (Altötting, Cathedral Treasury), and the Mérode cup (London, Victoria and Albert Museum) are particularly ornate examples. It appears on various supports and on works created in centers other than Paris. It can also be seen in manuscript paintings, as in an *Annunciation* by the Boucicaut Master (Paris, Bibliothèque Mazarine, MS 469, fol. 13), in panel paintings, for example the Cleveland *Carthusian Calvary* (cat. 71a) from Dijon, and in the frames of the panels by Melchior Broederlam.

S.J.

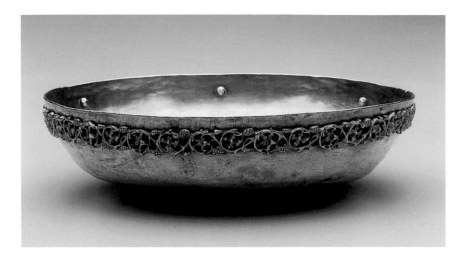

54

Dijon

Cup with the Coat of Arms of John the Fearless
between 1404 and 1419

Repoussé silver, engraved decoration, cast decoration added

H. 4.4 cm, Diam. 16.8 cm

Stamp, on the bottom, exterior: a shield with coat of arms of Burgundy, having in chief at left a fleur-de-lis, at right a Gothic uppercase "D."

Coat of arms, engraved on the bottom, outside, arms of John the Fearless

Boston, Museum of Fine Arts, inv. 48.264

Prov.: Samuel Montague Swathling collection, London; sale, Christies, 6 May 1924, no. 68; William Randolph Hearst collection, New York; International Studio Art Corp., New York; Joseph Brummer collection, New York; acquired in 1948.

Bibl.: Jones 1930, p. 221; *Bulletin of the Museum of Fine Arts, Boston*, p. 87, fig. 43; Salet 1957; Netzer 1991, no. 38, pp. 117–18; Réveillon 1999, no. 3, p. 348.

Exh.: London 1901, no. 4; New York 1975, no. 50.

This footless cup with a slightly convex bottom belongs to a class of drinking cups known as *tasse* or *hanap* and attested to in the fourteenth century. The decorative gilt and cast border of hop vines, crudely attached by means of six rivets, would appear to prevent its use for this purpose, but could be a later addition.

The object is interesting because it bears coats of arms that are recognizably those of John the Fearless or of Philip the Good before 1430, and an unusually large shield with the arms of Flanders. The hop-vine foliage is an argument for its ownership by John the Fearless. Objects of this type with coats of arms are regularly mentioned in inventories from the ducal court.

The piece is also important because of its stamp, an example of the oldest known type of Dijon stamps. Considered to be the stamp of a city rather than a master, it would thus confirm the use at the court of Burgundy of goldsmith's objects produced in Dijon.

S.J.

55

Paris

Ring of John the Fearless
c. 1410 (before 1419)

Gold, agate, jet, emerald, ruby; translucent enamel on gold

H. 1.5, Diam. 2.3 cm

The inscription on the outside of the ring has been deleted, only the letter "C" at either end remains. One stone is missing.

Partly deleted inscription inside the ring: *Vere* [filius Dei erat] *iste* ("He was indeed the son of God," Matthew 27:54)

Paris, Musée du Louvre, Art Objects Department, inv. OA 9524

Prov.: Private collection, England (Binns, 1867); E. Guilhou, Paris (auction catalog, London, Sotheby's, 9–12 November 1937, no. 618); Bl. de Montesquiou-Fezensac, Paris; anonymous gift, 1951.

Bibl.: Seymour de Ricci 1912, no. 1161; Delahaye 2001 (with bibliography).

Exh.: Paris, 1967, no. 241; Paris 2004, no. 66.

The profile of John the Fearless, Duke of Burgundy (1404–19), is similar to the one that appears in folio 226 of the *Livre des merveilles* in the Bibliothèque Nationale de France (cat. 47); inside the ring a wood plane, emblem of the duke since at least 1406 (Laborde 1849, no. 84), is enameled in orange yellow.

The fashion for jewels with cameo portraits grew stronger in the 1400s; Jean de Berry had two rings with his portrait "in cameo." Both of them were New Year's gifts, one given by his son-in-law Jean de Bourbon in 1409, the other by his grandson Charles, Count of Eu, in 1413 (Guiffrey 1894–96, nos. 606 and 611).

The accounts of Louis de Guyenne, son-in-law of John the Fearless, mention a "gold ring, with a cameo, a sapphire, and an emerald, which is the portrait of my lord of Burgundy" given to the duke on 1 January 1412, and supplied by the goldsmith Jean Nicolas (Paris 2004, no. 73); this description does not quite fit the Louvre ring, which has a jet stone and a ruby, although the two rings must have been very similar. In any case, the document evidences that jewels of this type were made by Paris goldsmiths.

É.T.-D

Sicily

Annunciation
end of the 14th century

Statuettes: ivory, heightened with
polychromy and gold; base: ebony with
marquetry borders
27.5 x 18.5 x 8.5 cm (overall)
Casket: leather, metal decoration,
traces of polychromy
33.5 x 30 x 12.5 cm

Langres, Musée d'Art et d'Histoire,
inv. 844.3.4

PROV.: Don Pierre Guyot de Giey, 1842.

BIBL.: Brocart 1900, 1917; Koechlin 1924,
pp. 319–20; Grodecki 1947, p. 107,
pl. XXXVIII; Tardy 1966, fig. p. 65;
Leeuwenberg 1969, pp. 313–32;
Gaborit-Chopin 1970, 1978, p. 171; Salet
1990, p. 18.

EXH.: Amsterdam 1951, no. 185.

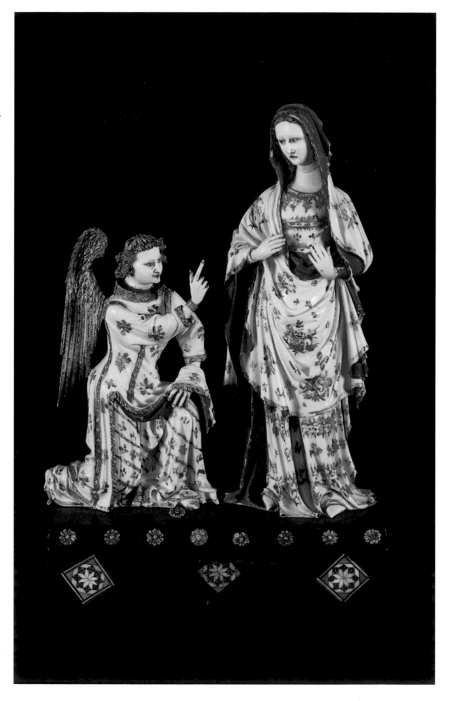

The statuettes of the Virgin and the
archangel Gabriel are attached to an
ebony base encrusted with small ivory
rosettes and geometric motifs. Traces of a
pin in the base suggest that there may
have been a third item, probably a lily in a
vase, between the two figures. The
archangel, on its knees before the Virgin,
is raising its right hand and index finger,
while the Virgin gestures in surprise with
both hands.

This work is associated with Philip the
Bold on the basis of its housing, a wooden
casket sheathed in black leather and
decorated with circular metal fittings
representing figures of fantastic birds,
rabbits, and rosettes that were originally
painted. In the center are the arms of the
first Valois duke of Burgundy. This object
is comparable to the casket containing the
Croix du Serment of the *Toison d'Or*
(Vienna, Schatzkammer), which bears the
arms of Jean de Berry. The case is a perfect
fit for the sculpture group.

Unfortunately, no mention of an item
clearly identifiable with this piece has
been found in the inventories or accounts
of the duke, and its early provenance is
unknown. It has been a subject of
puzzlement and even censure by
historians (Leeuwenberg). The heavy-
handed, ill-conceived polychromy applied
at a later date does not appear to conceal
any remains of earlier painting, according
to a study done in 1987 by Juliette Lévy
and Agnès Cascio. Despite the quality of
the draperies, the sculpture itself is
surprisingly cold in feeling. No connection
with French ivory pieces can be
established. Its greatest affinity is with the
Trapani ivories of Sicily. The ivory
altarpieces of the Champmol Carthusian
monastery, produced by the workshops of
Baldassare Embraichi, are known to have
been acquired by Philip the Bold from his
valet Berthelot Héliot, who probably
obtained them on the Paris market. It is
tempting to imagine that this may also be
true of the *Annunciation*.

S.J.

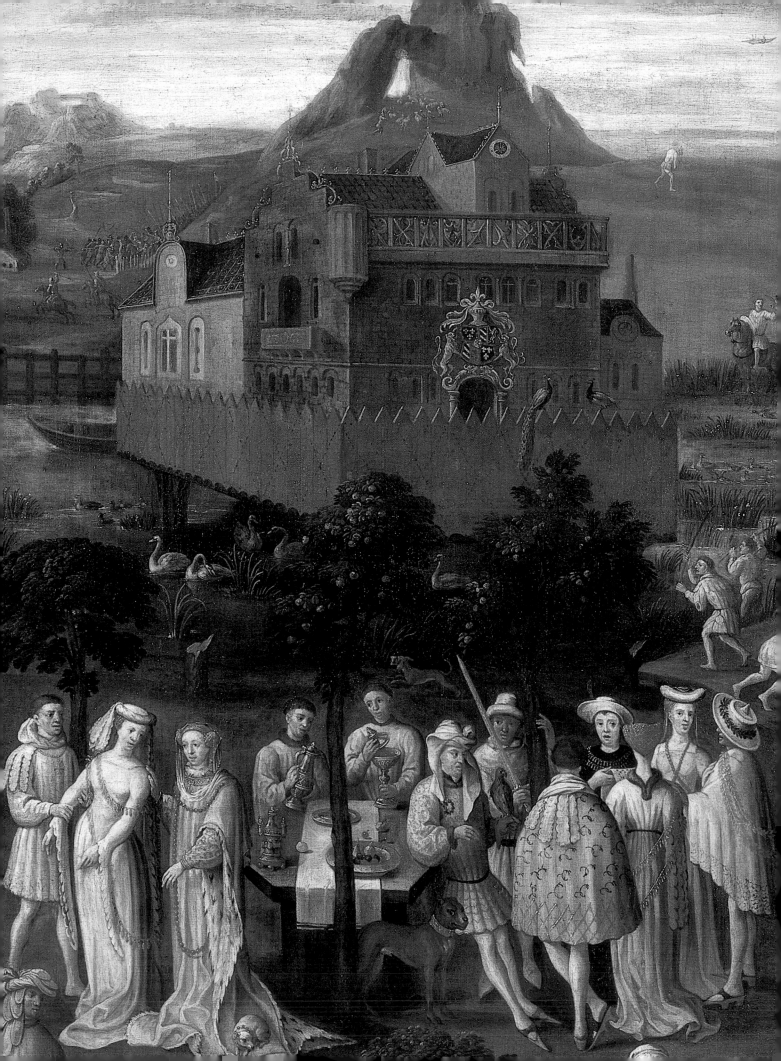

The Ducal Residences

Burgundy

Patrice Beck

The Ducal Residences: Architecture as the Theater of Power

The fifty or so properties available to the Valois dukes in Burgundy, inherited for the most part from their Capetian predecessors, were equipped not only with functional facilities—farms and storerooms for private use, defenses, administrative and legal premises for implementing seigniorial and public power—but also residential complexes, more or less developed and suitable for occasional visits from the duke, his family, and his court. It is true that many residences, far from strategic routes, never received princely visits. Before the year 1369 and his marriage to Margaret of Flanders, Philip the Bold frequented only a scant dozen: Dijon, quite obviously, and, in the immediate proximity of the capital, the châteaux of Rouvres, Talant, and Argilly; to the south, the residences in Beaune and Chalon; to the north, along the routes that led to France, besides the lovely town of Semur, the châteaux of Aisey, Aignay, and Montbard. Subsequently, above all after the death of his brother, Charles V (1382), and his father-in-law, Louis de Male (1384), we know that his time was increasingly taken up by Paris and Flanders, and this was even more true for his successor, John the Fearless. They consequently made more frequent use of the Artois mansion in Paris and the nearby country houses in Conflans and Beauté-sur-Marne, homes in Ghent, Bruges, and Lille in Flanders, residences in Arras and Hesdin, in Artois. All the same, the princely presence remained notably assured in Burgundy by the duchess, and the park property, simultaneously useful and a symbol of ducal power, was perfectly maintained on the whole.

Some sites were favored and became the focus of technological and political investments, and in the last two decades of the fourteenth century developed into quite remarkable and remarked upon laboratories of innova-

Fig. 1.
Outdoor Party of the Burgundian Court, French School, 17th-century copy. Dijon, Musée des Beaux-Arts (cat. 60).

Fig. 2.
Places cited in the text.

tion: Aisey-sur-Seine and its deer park, Dijon and its palace, Rouvres and Germolles with their gardens and farms. This can be seen in several series of accounting documents from both low-ranking levels—manors—and central decision-making and supervisory bodies that handled general revenues.

The building site of the Carthusian monastery of Champmol stands out, it is true, and it has no rivals. But the other establishments deserve the same attention and the same quality of research, both in the materials used and in the specialists employed. The facilities at Germolles, financed by Margaret of Flanders, swallowed up at least 25,000 francs, the equivalent of 820 years of daily salary for a laborer. The conception and realization of surviving works, such as the conveniences and decoration, were everywhere entrusted to the finest artists and artisans of the time, who could work equally in Champmol, Rouvres, Germolles, or Argilly or in Aisey or Dijon. The name of certain contributors—Burgundians, French, or Flemish—have remained justly famous: the master mason, Drouet de Dammartin; the sculptors Jean de Marville and Claus Sluter; the painter Jean de Beaumetz. But others, unjustly forgotten, might be mentioned, since they all worked on the embellishment of these residences and thus for the comfort and glory of their owners. There were the gardeners Perrenot Papiot, Jean Petitvallet, and Jean Canenier. At the châteaux in Dijon, Rouvres, or Germolles, they alternately conceived and implemented the arbors, courtyards, flower parterres, orchards, and kitchen gardens surrounding the residence. The hydraulic engineers Perreau and Bernard de Lantenay, supervised the running water devices for the ducal residences of Dijon, Lantenay, Termolles, Aisey, Aignay, and Salmaise. And there were the tile and brickmakers of Argilly and the nearby workshops of Montot and Gerland, which furnished on request glazed floor tiles and armaments for the lordship, glazed and decorated tiles of "horses, deer, pigs, dogs, wolves, and other beasts." All were full participants in the dukes' exploitation of their architecture as a staging of power and authority.

The sites in question initially appear to have suffered badly. They have been the subject of extensive damage,

Fig. 3

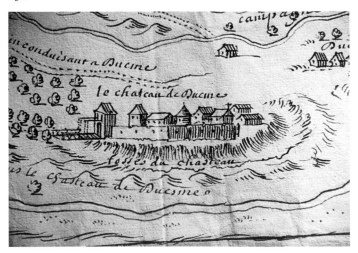

Fig. 4

Fig. 3.
Cover for manor house management accounts for Germolles "pour l'an feny à la St Martin M CCCC et II." Floridas is the name of the person who held the position of chatelaine at that time (ADCO, B 4788-2).

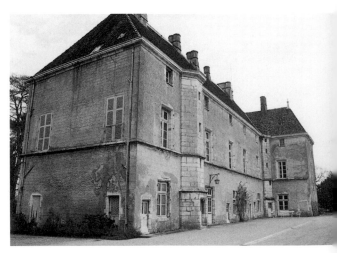

Fig. 6

Fig. 5

accidental or planned, and today many are reduced to barely visible ruins. Argilly is distinguished only by its topography; only some wall sections remain above ground level at Aisey; at Rouvres there are only one tower and a well; at Talant there is a storehouse, at Saulx the ruins of a chapel. . . . The others, less than a dozen, have fared better, but the gaps and transformations are often considerable. The impressive remnants at Duesme have become overrun with vegetation. The four towers of the château at Villaines-en-Duesmois are undergoing restoration, but the enclosing walls and the interior fixtures have totally or nearly entirely disappeared. At Montbard, the surrounding fortification now only encloses the gardens of Buffon, the installation of which was preceded by considerable demolition of the residential areas. At Chenôve, while the storeroom was largely preserved during its reconstruction during the period 1400–1404, the ducal residence that was built is no longer evoked in the buildings, except for the occasional arched lintel. In Dijon, the current configuration of the palace is above all due to architects of the fifteenth and seventeenth centuries. The same is true at Beaune, where the residence and storeroom of the dukes, today occupied by the vineyard and wine museum, seems to have been considerably reworked from the time of Philip the Good. In Salmaise, the general organization of the residence is apparently preserved, but only the western rampart and its attached turret do not appear to have suffered extensive refurbishing. Germolles has been considerably reduced, but dendrochronolgy carried out on the timber frame and the paneling in the present-day dwelling point to a dating of autumn-winter 1384–85 for the former and between 1385 and 1405 for the latter.

The data that exist might seem miscellaneous, and studies carried out are still very partial in scope. But they are already sufficiently meaningful, particularly in the case of the extant turrets in Dijon, Salmaise, Champmol, Beaune, or Germolles, to bear witness to the conceptual and technical unity of the work carried out overall.

Fig. 7

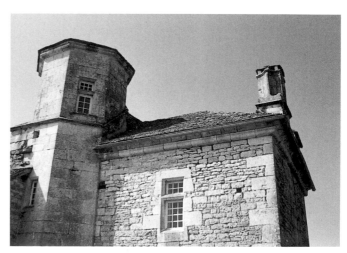

Fig. 8

 139

Sophie Cassagnes-Brouquet

Decor of the Ducal Residences

The extensive work undertaken in Burgundy under Philip the Bold made him the greatest patron of all the Valois dukes. It is often said the legendary building project at Champmol united the greatest artists of the time, sculptors as well as painters. Philip's commissions for pictures and manuscripts are also celebrated. But the Burgundian archives disclose a less prominent yet important part of the ducal patronage, the residential architecture,[1] which is now almost completely destroyed. Most of Philip the Bold's châteaux disappeared early on, barely 150 years after they were built. At the time of the religious wars, others were completely abandoned, which led to their ruin.

Fig. 1

When Philip the Bold was granted the duchy of Burgundy on 2 June 1364, he inherited one of the greatest principalities of the kingdom. The ducal possessions were in the care of the overseers who managed the prince's lands. They lived in about forty of the châteaux, which were centers for husbandry but also seats of seigniorial power. These feudal fortresses were, along with the urban palace in Dijon, the prince's places of residence.

In the years following his accession to the duchy in Burgundy, Philip the Bold stayed most frequently in Paris at the Artois mansion or at the Conflans château. Not until after his marriage to Margaret, the heiress of Flanders, did the ducal couple begin to stay part of the year in the duchy. The prince, often called to his northern states or to Paris, allowed the duchess to represent him in Burgundy.

Aside from the specific example of the ducal palace in Dijon, which functioned both as a residence and as a symbol of the prince's presence in the capital of the duchy, the châteaux can be divided into three categories: the manors where Philip the Bold came occasionally to hunt or in transit, the true ducal residences, and finally the centers of ducal power, which seemed more like public buildings, even if this distinction is not really operative in a feudal principality. These centers of power were urban monuments, inherited from the Capetian dynasty. They were set up in the capitals of the overseers' districts or in the most important boroughs such as Autun, Chalon, Avallon, Mâcon, Nevers, or even Semur. Their job was to demonstrate the ducal presence and to make the prince the focus of attention. Great care was taken to represent the ducal coat of arms.

The principal ducal residences were in the heart of Burgundy, not far from Dijon, and at times even in the immediate vicinity, such as the Talant château, which dominated and overlooked the city, and the château in Rouvres, located very near it, in the open country of Saône. Germolles provided the most specific example of a country dwelling. It was given to the duchess, who maintained control over the building site.

The extent of the construction accomplished under Philip the Bold is not surprising. Residential architecture was enormously important. At first, the new Duke of Burgundy restored only a few of his forty or so inherited residences when urgently necessary, but his marriage in 1369 gave him the means for a more ambitious artistic policy. The years 1370–80 saw an increase in the number of paintings and glassworks. Windows were installed in the ducal chapel in Dijon, in the duchess's room, in the châteaux in Villanines-en-Duesmois and Montreal, but most importantly in Rouvres, Argilly, and Montbard. After 1390, the business of the kingdom absorbed Philip the Bold, and subsequently his heir, John of Nevers (the future John the Fearless), and construction sites became more rare in Burgundy.

The accounts of the manor allow us to visualize the decor that no longer exists. Purchases in bright colors predominated, with a preference for red and green. They distinguished the rooms and their occupants: at Rouvres, the duke's room was green. Rooms at Germolles and Argilly were decorated with repetitive stenciled motifs: sheep at Argilly, ewes at Germolles. Sometimes more complex decorations involved repetitive motifs of flowers, roses, and daisies and, most important, heraldic devices and symbols. The painting of the chapels was the most

Fig. 1.
Germolles, wall
decorations in the room
of the Countess of
Nevers.

Fig. 2.
Stained-glass windows
from Saint-Jean church,
now in the neo-gothic
chapel at Champmol.
Coats of arms were
common in the stained-
glass windows of ducal
residences.

Fig. 2

elaborate, perhaps including figures such as angels. The oratories were also decorated with painted statues at Montbard, Semur-en-Auxois, and Salmaise. The roofs were adorned with banners and emblazoned weather-vanes. The windows were generally panels of diamond-shaped white glass, bordered with colored glass and occasionally a shield with the coat of arms of the duke or duchess in the center. When King Charles VI came to Dijon in February of 1390, the Salmaise château, where the court stayed, received a complete redecorating: "To Jehan le Bourcet of Dijon, glassworker, for seventy-one pieces of glass *litez* and decorated with coats of arms that he installed and fitted in the Castle of Salmaise . . . six plates of glass decorated with the coats of arms of my lord the King of Royne, the Duke of Burgundy, my lady the Duchess, my lord of Touraingne, the Earl of Nevers and my Lady the countess his wife."[2] The glassworkers less frequently created figures, for example, angels in the bedroom of John of Nevers, the heir of Burgundy at Rouvres. The most elaborate works were found in the chapels: authentic stained-glass windows representing saints on socles covered by canopies, like those in the Argilly oratory that were created by the ducal glassworker Jehan de Thiais.

NOTES

1. ADCO, series B, accounts from the Manors.
2. Ibid., accounts from the Salmaise Manor, B6053, fol. 19.

Patrice Beck

The Royal Residences

in Dijon
The general layout and aesthetic of all the existing premises can be credited largely to the architects of Louis XIV, particularly Jules Hardouin-Mansart, who between 1685 and 1689 completed the state palace and planned the Place Royale. Some of the oldest elements survive, but they are in large part a legacy of the period of Philip the Good. The tall tower that rises 52 meters above the ground was completed in 1458 and justly bears the name of the third Valois Duke of Burgundy. The body of the adjoining dwelling was built between 1450 and 1455; the ribbed roofing and the monumental chimneys of the kitchens date to 1433.

There are only subtle traces of earlier renovations, which can be attributed to the period of the two first Valois dukes. The location of the wells near the kitchens,

a staircase, and some ribbed vaults on the dwelling's ground floor, as well as the Brancion tower, which predated the tower of Philip the Good, all survived a fire that occurred in 1417, as did a new tower, built in 1370 and known as the tour de Bar since 1430.

Failing in-depth archaeological excavations and studies of the site, there are archival documents that provide a great deal of information about the facilities from the time of Philip the Bold and John the Fearless. These documents provide scattered data, revealed over periods of construction, restoration, and maintenance of the site. They are nevertheless significant in that they reveal both a certain luxury that developed there and the heterogeneous and fragmented nature of the whole; princely rank decreed the former condition, and the encroaching urban

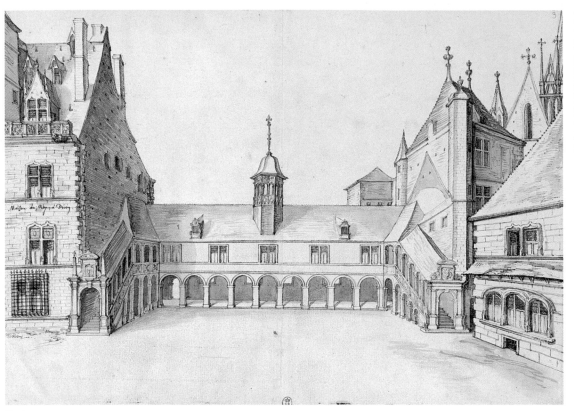

Fig. 1

Fig. 1.
View of the King's House in Dijon, drawing by Brother Etienne Martellange, architect of the Jesuit order (1569–1641).

Fig. 2.
ADCO, B 4431, ordinary account of revenues for the bailiwick of Dijon for the year 1387–88, work in the gardens of the ducal residences in Dijon, fol. 33v; "To Jehan Petit Varlot, gardener residing in Rouvre, to whom is owed for his labor and salary for having taken care of the orchard and also the wooden trellises, arches and other works in the garden which is behind the stables of the farmyard of the guest quarters of his lordship in Dijon, this much is known, the previous year 1348."

Fig. 3.
The new tower, known as the tour de Bar.

setting and gradual establishment of various elements explain the latter.

The grand residences, protected by turreted walls and surrounded by cobbled yards, flower gardens, and wooded areas as well as grassy meadows, consist of the Brancion tower, the new tower, and the body of the dwelling with heavy tile and lava-stone covering. The buildings contained the galleries and the large and small rooms facing them, the oratory and the chapel, as well as the princely chambers provided with a "bathing chamber," wardrobes, and "courtly chambers." The walls of the oratory were paneled, those of the chapel were decorated in painting by Jean de Beaumetz in 1375–76. The "coated and whitewashed" walls of the apartments were broken by fireplaces and "casements in panels of white Argonne glass, edged in color and emblazoned with two escutcheons, one with the arms of my lordship and the other with my lady." The fixtures, particularly the staircase facing the new tower, use white stone from Asnières, and pieces of the floors are covered with "leaden," that is glazed, terracotta tiles. These tiles can also bear princely heraldry, as in certain galleries for which, in 1416, a carpenter was ordered to make "a wooden mold for which there is a plane and a daisy."

On the other side of the paved courtyard, without doubt on the site of the kitchens rebuilt under Philip the Good, the kitchen is "paved with surfaces of stone." With its "stoves" and its "equipment for boiling, cauldrons, and frying pans," it has running water brought by "lead barrels" protected by a wooden frame from the neighboring well. It is moreover flanked by an oven, a pantry, and a dairy "where they watch over the milk of our young lordships."

Fig. 2

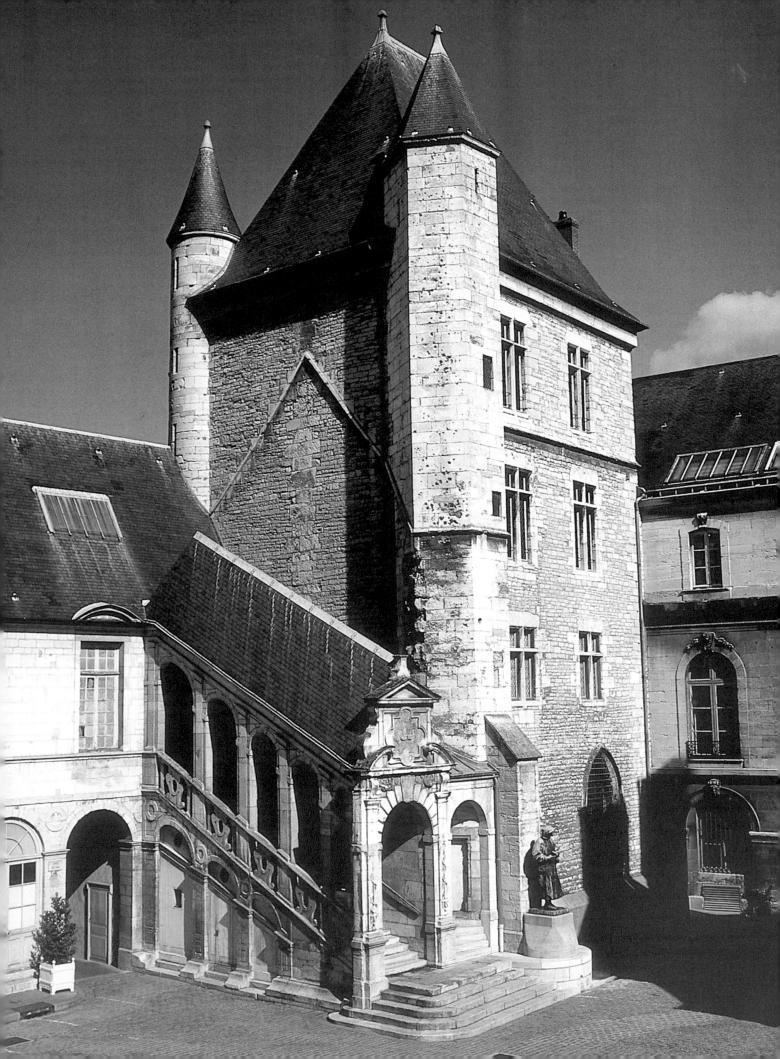

Beyond one of the city streets, spanned by just one wooden gallery, is the farmyard, made up of courtyards, gardens, and buildings containing the "incubators" and "his lordship's large stables," as well as buildings furnished with the same amenities and comforts. Notably, "master Thomas the Physician" stayed there, and Jean de Marville had his "workroom" there. In 1384–85 a forge was there as well, the bellows of which were repaired, as well as "five arches for placing and looking at the alabaster stones for the tombstone, which had to be worked on for his lordship."

In addition to the Treasury room, which occupied the lower chamber of the new tower, the administrative sphere was divided between two centers. The "house of the chancellery was located in front of his lordship's house" and, behind a large garden, "the large counting house" was laid out. The latter was built during the years 1370–72 and included storerooms, the treasurer's apartments, and, preceded by an antechamber, the chamber of accounts, for which a purchase was made in 1378–79 of "six writing cases and six *queumes* with enameled silver handles, made in Paris."

Céline Berrette

The Beaune Mansions: Ducal Residences?

From 1347 to 1420, the accounts of the *châtellenie* (landed estate) of Beaune, Pommard, and Volnay, which are kept in the provincial archives of the Côte-d'Or,[1] recorded the renovations and repairs made during this period to many ducal properties in Beaune: the house of the wine press, the Dienat house, and three "mansions belonging to my lord"—the mansion "where the parliament meets," the mansion "where the chatelain lives," and the mansion where "the presidents of the parliament" (fig. 1) reside.

The mansions of the chatelain and the parliament are mentioned together from 1356 to 1400. After this date, the mansion "where the chatelain lives" disappears from the sources until 1415, indicating that no repair work was performed in the building during this period. In 1400–1401, the mansion "where the presidents reside when they come to hold my lord's parliament" appears in the historical sources. Some believe this is a new name given to the mansion of the parliament or the mansion of the chatelain. Yet it is probable, although hard to prove, that it indicates three different residences. It should be noted, however, that in some paragraphs the overseer is unclear about the nature of the "mansions belonging to my lord," which can cause confusion for historians.

The Mansion of the Overseer

The chatelain's mansion was located next to a farmhouse with a stable. A "chamber" (an unidentified room) near the farmhouse was mentioned in 1392. Behind the mansion, there was a courtyard or walled garden with two access doors, one in front and one in back.

Very little information is known about the outside appearance of this building and the layout of the rooms. The roof was originally covered with flat stones placed on top of "aissaimes" (perhaps wooden shingles). Roof tiles are not mentioned until 1413–15. The walls were joined with lime mortar. The chatelain lived in an attached tower. In 1386 some rooms were renovated and a new room was built near the door.

A "great hall," "chambers," a kitchen, a cellar, and a "bottle storage room" are the major rooms mentioned. The walls had at least eight windows: two in the kitchen, three in the tower, three in the great hall. The hall is the only room with a stone slab floor. The other rooms had wooden floors covered with mud, which served as insulation. The floors and the rafters were maintained by "chapuis," carpenters from Beaune and its surrounding areas. Oak and fir trees from the Argilly forests provided wood to make boards and rafters, as well as doors and windows.

The accounts say little about the interior layout of the mansion. The "great hall" is near the tower; one chamber is located near the kitchen, the other near the door.

The Mansion of the Presidents of the Parliament

This mansion also had a tower where "twenty-six steps" of a staircase were repaired. The only rooms were two large halls and two chambers. The "upstairs hall" (from which we can deduce that the building had two stories) had a stone slab floor like the great hall of the mansion of the overseer. In 1400 mention was made of "retreats" (latrines) near the chamber where "the pres-

Fig. 1.
Possibly the mansion of the presidents of the parliament (now the wine museum).

Fig. 1

ident lives," the only indication of the presence of any conveniences. The walls were repaired and a new tile roof installed. A "walk over the walls" (a gallery) was "covered with a roof" and coated with "packed mud" mortar. The gallery had previously been dismantled, rebuilt, and cemented. In 1415–16 only the gallery was covered with roof tiles, while the rest of the building seemingly still had a flat stone roof. In 1421–22 the accounts of the chatelaine mention a "small gallery in the mansion of my aforementioned lord in the aforementioned Beaune where the lord chancellor lives," with a tile-covered roof, which could be a reference to the mansion of the presidents of the parliament. An inventory in the accounts of the chatelain does not include any luxury or ostentatious items, and the description of the buildings does not mention any outside or inside decoration.

The Cellars of the Dukes

The archives allow us to identify at least three cellars. The chatelain's mansion had a "bottle storage room." The "large cellar" of the dukes was located "below the parliament hall, near the staircase leading to the aforementioned parliament hall, under the auditory," and the small cellar was at the "Dienat house." The "treuils" (wine presses) were regularly maintained. For instance, some parts of the "matis" (the platform where the grapes are dumped) were replaced.

The current buildings do not match the descriptions found in the fourteenth- and fifteenth-century sources. However, the west wing of wine museum, with its staircase tower, gallery, and the number of rooms, has significant similarities with the description of the mansion of the presidents of the parliament.

NOTES
1. ADCO, B 3136–201 (châtellenie of Beaune, Pommard, and Volnay).

Michel Maerten

The Germolles
Château

Among the Burgundian ducal residences, the château of Germolles stands out because of its excellent condition. In fact, it is the only château whose original buildings preserve mural paintings that date from the end of the fourteenth century. A recent dendrochronology study verified the presence of beams and fragments of wainscoting in situ from the same era as the construction.

Located 8 kilometers northwest of the city of Chalon-sur-Saône, Germolles became part of the ducal holdings in 1380, following a judicial process in which it was confiscated in favor of Philip the Bold. In 1381, he gave it to Margaret of Flanders, who then proceeded to transform the fortress into a luxurious residence equipped with all of the modern conveniences of that time. The duchess benefited from the considerable monetary resources put at her disposal by Philip the Bold to finance the renovations that began in 1381. In 1390, sufficient progress had been made at the building site for Charles VI of France, Philip the Bold's nephew, to visit there.

Margaret of Flanders enlisted the support of the best artisans and artists: the architect and master mason Drouet de Dammartin, the painters Jean de Beaumetz and Arnoul Picornet, and the sculptors Jean de Marville and Claus Sluter, who were hired, among others, to decorate the Chartreuse de Champmol. The painting began in 1388 and continued under the direction of Jean de Beaumetz until 1393.[1]

At Germolles, the pictorial illustrations were made up mainly of painted rural motifs (thistles, daisies, roses, sheep), heraldic motifs ("Y ME TARDE," I am waiting) and initials ("P" and "M"). Although research shows that the decor depicted sheep in the audience chamber, the paintings by Arnoul Picornet in the Countess of Nevers's room are all that survive: the "P" (for Philip) and the "M" (for Margaret) against a light green background alternate with thistles.[2]

According to the accounts, a part of the artistic creation was found preserved under the modern coat of paint that covered the walls of the rooms on the first floor. Two-toned, engraved tiles that covered the floor in various rooms were also discovered, but not in their original location. It is worth noting that some of the motifs of these tiles (flowers and sheep) were specially created for Germolles. As for the sculpture, only certain elements were saved from the ravages of time. Unfortunately there is nothing left of the group that represented the duchess and duke under an elm, surrounded by sheep. We know from documented accounts that this work was done by Claus Sluter in 1393 in stone that came from the Asnières-les-Dijon quarry.

Yet the desire to change the old fortress into a residence that was comfortably and luxuriously decorated did not completely eliminate the concerns of maintaining a certain level of defense. The rectangular courtyard surrounded by a moat was preserved in order to marry the

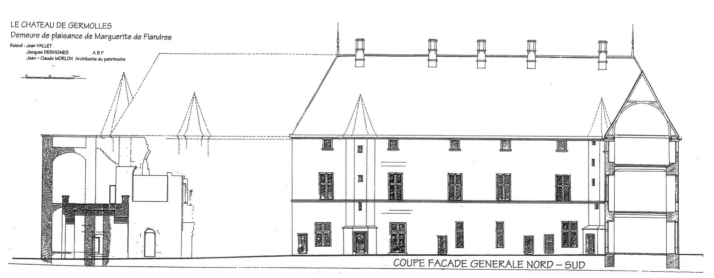

LE CHATEAU DE GERMOLLES
Demeure de plaisance de Marguerite de Flandres
Relevé : Jean VALLET
Jacques DESVIGNES A B F
Jean – Claude MORLON Architecte du patrimoine

COUPE FACADE GENERALE NORD – SUD

Fig. 1

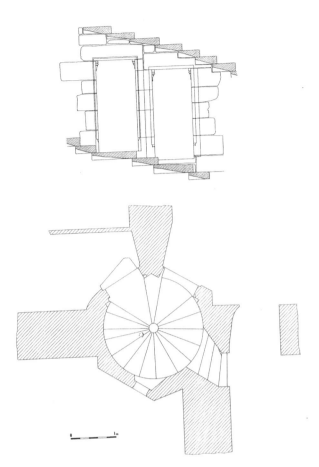

Fig. 1. Germolles, elevation of the west façade. J. Vallet, J. Desvignes & J.-Cl. Morlon.

Fig. 2. Germolles, elevation and section of the staircase and doors of the first floor in the building's central staircase. J. Vallet.

Fig. 3. Germolles, wall decoration, the initial "P" in the anteroom known as that of the Countess of Nevers. L. Blondaux.

Fig. 2

Fig. 3

old construction to the new. To reach the château, it was necessary to go first through a door, flanked by two circular towers, that faced north, toward the agricultural outbuildings in the farmyard (barn, sheepfold, wine press). This particularly vulnerable part of the fortification was placed under the protection of the Virgin Mary. A statue of her, created by Sluter's studio in 1399, adorned the summit. To the left, as you enter the château, was the wing that housed the duchess's suite and her small chapel overhanging the fortress's ancient chapel. The right wing included a storeroom with an arch of intersecting ribs. It overhung a great room that was accessible by a staircase whose door was adorned with a tympanum of the Duke of Burgundy's coat of arms. In this room, the molded jambs of an enormous fireplace still exist. Its mantelpiece, richly decorated with figures, was brought to the ground floor of the château's current entrance hall.

Demonstrating the fine line between artistic creation and the power of princes, Germolles represents an exemplary landmark of the movement to transform and improve the châteaux that survived at the end of the fourteenth century, foreshadowing the Renaissance. Unfortunately, as with a number of the châteaux that displayed an abundance of weather vanes and other iron banners embedded in the top of the roofs, Germolles had been struck by lightning many times and partially burned at the end of the nineteenth century. Its ruins are still inspiring and well worth seeing.

NOTES

1. Cassagnes-Brouquet 1996, 1–2: pp. 387–90; 3: pp. 49–50, 533 and passim.
2. DRAC Burgundy, Regional Department of Inventory, research on mural paintings, Mellecey file, Germolles Château. The château was listed as a historic monument by decree on 12 June 1989.

57

Château de Germolles, Burgundy

c. 1385–90

1 – Ten Paving Tiles

Glazed terracotta, with engobe decoration

13 x 13 x 2 cm (average)

a – Open design: diamonds elaborated alternately with fleurs-de-lis and budded crosses

b – Open design: interlacings

c – Open design: stylized foliage

d – Sun

e – Rose

f – Thistle

g – Circular compositional element with four tiles: stag

h – Circular compositional element with four tiles: stag and quadruped

i – Linear compositional element with two tiles: sheep lying beneath a tree

j – Lion

c

g

d

h

a

e

i

b

f

j

2 – Attempt to Restore a Checkerboard Paving Stone

Glazed terracotta, with engobe decoration

13 x 13 x 2 cm (average)

– Four tiles representing a daisy alternating with five solid yellow tiles

3 – Three Fragmentary Paving Tiles

Glazed terracotta, with engobe decoration

19 x 19 x 2.5 cm (average) (restored)

a – The wheel of fortune turning toward the right (three fragments)

b – The wheel of fortune turning toward the left (two fragments)

c – St. George slaying the dragon (three fragments)

a *b* *c*

Despite the ravages of time, the exceptionally well-preserved buildings of the Germolles château still have significant elements that give an idea of the quality of the decorations originally conceived to embellish the architecture of this country palace. Sculptures, wall paintings, and paving tiles give an indication of the original decorations. The paving tiles form an immense group. Still used in the garret dwellings or discovered during explorations carried out in 1960 and 1970, either quite by chance or during other work, they form a collection that includes several thousand elements, both fragmentary and complete.

The technique used for the fabrication of the tiles is common for this type of production in the late Middle Ages. Each piece was cast in a mold, then dried outdoors (footprints of animals—cats, dogs, birds—left certain proof of this). With the exception of certain types, their size is standard: 13 cm wide by 13 cm long and 2 cm deep. For the decorated tiles, a small board supporting the relief decoration was applied to a still-malleable piece, impressing the design, which was later filled with a light engobe. Finally, a lead glaze was applied to each tile before it was fired. This glaze accentuates the contrasts between the red color of the clay and the yellow of the engobe. Solid tiles, which form the largest group, were simply covered in a monochrome coat (black or yellow, more rarely green or brown) before being glazed and fired.

The ducal accounts give us useful information about the origins of the tiles and their date of installation, without which, however, it would be impossible to attribute a certain type of production to a

certain factory. Thus, in 1387, 7,400 "lead paving stones" were provided by a tilemaker from Argilly (Renaudin le Bourruet), while Marie, the tilemaker from Longchamp, delivered "1,200 tablets of lead paving stones" and Perrin, tilemaker from Montot, supplied 10,100 tiles.

The decorated tiles of Germolles, which have thirty-six different subjects, can be classified into two major categories: first, closed heraldic and plant subjects, that is, each piece is autonomous—sun (1d), rose (1e), thistle (1f), daisy (2)—or open and functioning in sets of two, four, or even more, to form a pattern—diamonds (1a), interlacings (1b), stylized foliage (1c); and second, closed figurative subjects—lion (1j), wheel of fortune (3a and b), St. George (3c) or open ones—stag (1g), stag and quadruped (1h), sheep lying under a tree (1i).

Some of these tiles seems to have been created exclusively for Germolles; thus the wheel of fortune, the St. George, and especially the motif of the sheep lying beneath a tree are not found at any other site. Other common tiles, however, may have been found in different dwelling places that are not inevitably linked to the ducal court. The subject of the sheep is recurrent at Germolles and echoes the activities developed at this site and that gave rise to various works—sculptures or tapestries—located in the château. The graphic quality of this tile, which contrasts with the delightful schematization seen in most of the others (a legacy of the early fourteenth century), might lead one to hypothesize that a specific artist created the corresponding sketch. Why not infer, for example, that Jean de Beaumetz, called to Germolles to work on the wall decorations, may have provided the lovely model for this depiction?

Most of the paving tiles at Germolles were not found in place. Apart from the great hall, which might have contained the remains of in situ paving including the thistles (which will have to be established by future, methodical explorations), all the tiles have come to light as the result of chance discovery and later re-use. Thus one cannot propose specifics regarding the layout of the flooring. Contemporary sites in France where the flooring is in place likewise provide clues that allow one to imagine the formulation of this "carpet," which is often complex and uses different designs in a single space. The number of solid tiles discovered leads one to believe that they were combined with the decorated pieces to form the compositions, where the less elaborate designs might be checkerboard patterns (no. 2). One certainty, however, has been established: the flooring decorations corresponded to those on the walls. Thus it can be proposed that the rooms on the second floor, with walls where thistle, rose, or daisy designs were discovered, executed in paint by Jean de Beaumetz and his workshop, must have been characterized by the same design that was repeated consistently on the walls, the ceiling joists, and the floor.

M.P.

Emmanuel Laborier

Montbard, a Capetian Fortress for the Duchesses

The site of the château of Montbard, built on an outcropping—a hill that remained in place during the erosion of limestone layers—dominates the Brenne valley. Owned by the town since 1885, it is surrounded by gardens, the legacy of a terraced park laid out beginning in 1732 by Georges Louis Leclerc, Count of Buffon and holder of the seigneurial rights attached to the royal château. Buffon destroyed the basic building elements, preserving only the large tower of Aubespin, three-quarters of the disintegrated walls that edged the upper terrace of the park, the Saint-Louis tower, and a group of cellars, which he reorganized. But what remains of the main building with its large hall and the ducal apartments, the lodgings of the lady of the manor, the Saint-Louis chapel, the drawbridge spanning the trench—in short, those elements mentioned in the texts and that constituted the château beginning in the fourteenth century? Classified as a historical monument, since 1991 the Buffon gardens have been the subject of restoration work, during which many precautionary archaeological interventions have yielded information about the medieval château.

The lords of Montbard appear in texts in the late fourteenth century, and their fortress is cited between 1104 and 1113. There is no information about the form the noble residence took, but the church of Saint-Urse has an arcade from the eleventh century. In 1200 the Duke of Burgundy became Lord of Montbard. Part of the ramparts pierced for archery can be dated to the year 1230, indicating that defensive structures had been completed. Around 1295, Duke Eudes IV purchased the lands and buildings in the vicinity of the residence[1] and proceeded to rebuild the château, which covered the whole of the natural promontory, connecting the parish church of Saint-Urse and the fortress buildings, which were for the most part transformed. A study of the elevations makes it possible to date this grand architectural program to around 1300; during this period the fortress took on the

Fig. 1.
Château de Montbard, general view of the site from the east.

Fig. 2.
Château de Montbard, plan of Buffon park today, with the remains of the medieval château (Saint-Urse church, the Aubespin tower, the Saint-Louis tower, and the great wine cellars). The locations of medieval construction (italics), identified from documentary sources, are based on archeological data.

Fig. 1

Fig. 2

Fig. 3.
Château de Montbard, rampart and Aubespin tower, view toward the northwest.

Fig. 3

general design that it maintained until its dismantling. Thus the château that Philip the Bold first saw in 1364 was already well established.

Today, accounting documents are the primary tools for visualizing the Valois dukes' contribution to the fortress.[2] Regular maintenance work on the tile or lava stone roofs, the replacement of the most rapidly aging wood fittings, and the constant renovation of door frames and windows were occasions to modernize the appearance of the buildings. It was likewise necessary to keep up the fortress's defenses, to repair the ramparts and drawbridges, and, in 1474, to open up numerous gunner holes in the walls. But only the presence of the ducal family justified interior conversion work that dealt with the spaces' decoration and comfort. The duchess, Margaret of Flanders, who

discovered Montbard during her arrival in the duchy in 1370, stayed there on a regular basis, giving birth there to two of her daughters, Margaret of Hainaut in 1374 and Catherine of Austria in 1378. In 1374, in addition to renovation work carried out in the duchess's apartments, "wood railings were installed around the fonts of the church of said place, for the baptism of the child." Then in 1378–79, fireplaces were built from large stones in the children's bedrooms. While her son John the Fearless was Duke of Burgundy, defensive construction work predominated, and when "the Armagnacs pushed back the fires"

in 1417, repairs to the gates of the large doors were necessary. Finally, in 1419, Philip the Good came to Montbard to visit his mother, Margaret of Bavaria, at the time of the assassination of his father, John the Fearless. Montbard, an important piece of the landed estate of the duchy, also served as a residence for the duchesses, who participated in the maintenance and improvement of this Capetian fortress.

NOTES
1. ADCO, B1261.
2. Ibid., B5300–B5341, Accounts of the Estate.

Georges Frignet

The Château

de Rouvres

This château, one of the favorite residences of the dukes of Burgundy, was built under the Capetian dukes, perhaps in the thirteenth century, within a fertile agricultural region. It was close to both Dijon, the capital, and Cîteaux, the large abbey that sheltered the dynasty's tombs.

Under the two first dukes of the house of Valois, the duchesses Margaret of Flanders and then Margaret of Bavaria made long and frequent sojourns there when their husbands were detained in Paris to attend to state business. Under Philip the Good, interest in the château waned, and only a small number of the duke's relatives, including the princes of Nevers, his nephews, lived there some of the time.

Charles the Reckless spent only one day there during his entire lifetime, on the eve of his solemn entry into Dijon. Under his princedom the château served as the prison of the Duchess of Savoy, sister of Louis XI.

After the duchy became attached to the crown, the château continued to decline and little by little fell into ruin, reaching total collapse in 1636. Finally, during the Thirty Years War, it was destroyed by canon and then set afire, as was the entire village of Rouvres. Nonetheless, impressive ruins survived, which under the reign of Louis XV were used as stone quarries; eventually, the ditches were filled in and the land divided into plots. No traces of the château remain save for some iconographical representations, and it is no longer known except through texts.[1]

At the beginning of the fifteenth century, it was a venerable compound: a large group of buildings—half

fortress, half dwelling—surrounded by wide and deep trenches and a tall stone wall reinforced by towers. Arriving from the village, which was not fortified, one crossed a drawbridge over the first trench and passed through a fortified doorway flanked by two towers into the farmyard, which contained the farm buildings and lodging for certain officers. One then passed over another drawbridge and another trench before entering the courtyard through a second fortified door, known as the door to the keep, also flanked by two towers. At this point one arrived at the château itself. The building was vast, including cellars partially below ground, a raised ground floor, a second floor, and a garret level. In fact there was a succession of pavilions of different sizes, overlapping one another, with roofs, often of flat multicolored tiles, studded with chimneys, pinnacle turrets, spires, lanterns, a monumental clock, and banners. All very colorful, it dominated the rooftops of the village and must have made a grand impression. Thus the château was a prestigious structure, but also a family dwelling, made up of a great number of rooms, very comfortable for the time, with its many chimneys, windbreaks, retreats, and places of leisure.

This complex, court, and farmyard covered more than one hectare and was considerably enlarged above all by a dozen hectares of gardens—some kitchen gardens, some ornamental—which supplied the ducal family with fruits and vegetables and a place to walk and frolic.

NOTES
1. ADCO, B 5742 to B 5840, Accounts of the châtellenie, 1341–1629.

58

Burgundy, Argilly tileworks
(Côte-d'Or)?

Tiles from the Château de Rouvres-en-Plaine

Twenty-nine fragments of tiles from the castle of Rouvres-en-Plaine, with different designs, such as oak leaves, lilies, dragon, lion, cinquefoil
Late 14th century

Glazed terracotta, engobe design

Because of the original shape of the tiles and their extremely fragmentary condition, it is not possible to estimate their original dimensions

Dijon, Musée Archéologique, inv. 2003.3.1–29

PROV.: from the castle of Rouvres-en-Plaine; unspecified how they came to be part of the inventories.

BIBL.: Pinette 1981; Bon 1992; van Lemmen 1993.

EXH.: Autun 1981, nos. 60–83.

Very few of the two-color glazed tiles, reputed to have come from the floors of the château de Rouvres-en-Plaine, survive. However, those now in the archaeological museum in Dijon make it possible to see that this work is exceptional in terms of both its inventiveness and its originality.[1] A rich iconography emerges in a dozen markedly unusual small pieces of various shapes and sizes—squares, circles, triangles, diamonds, ovals, arcs of circles, curls, strips—where symbolic elements such as oaks, fleur-de-lis, and rampant lions exist alongside an imaginary bestiary teeming amid leafy foliage and inscriptions. In addition to the motifs specific to this iconography, there are scattered elements, overlapping one another and grouped with black, yellow, and green monochrome tiles, sometimes encrusted with rosettes. These fragments work together to form sophisticated designs, organized into an overall grouping comparable to inlay work that, unfortunately, it is impossible for us to reconstruct. Unique in ducal Burgundian residences, these tiles somewhat evoke the "mosaic" floors that decorate the floors of the great thirteenth-century abbeys,[2] or even, in another technique, the contemporary faience floors in the château of Jean de Berry in Mehan-sur-Yèvre.[3]

NOTES
1. See Autun 1981, p. 36. Most of these pieces are in the Musée Archéologique in Dijon, but there are also some fragments in the city's Musée des Beaux-Arts.
2. For example, and for want of a more plausible comparative element, the marble "cosmatesque" floor of Westminster Abbey gives an idea of the effect produced by this type of workmanship (see van Lemmen 1993, p. 17).
3. See Bon 1992, color pls. C to X.

FIGS. 1–2. Tile fragments, possibly from Rouvres-en-Plaine. Dijon, Musée des Beaux-Arts.

J.R.

Priscillia Debouige

Philip the Bold's Château at Argilly

(1363–1404) The village of Argilly, in the Côte-d'Or region of France, is located between Dijon and Beaune, near Nuits-Saint-Georges; the ducal château is northwest of the village.

Destroyed in 1590 by the Holy Catholic League, all that is left today are mounded ruins: a man-made, quadrangular courtyard with rounded corners, approximately 70 meters in diameter, surrounded by moats 45–55 meters wide, with a slope of about 5 meters (fig. 1). Some village buildings used materials from the site (fig. 4).

Although archaeological knowledge of the site is very limited, exceptionally detailed written sources underscore its political and economic as well as architectural importance. The first known reference to the château dates back to 1030. The Capetian dukes would have used it as a "country cottage." Robert II rebuilt and fortified it with fourteen towers in 1297, and in 1345[1] Eudes IV added a chapel. But it was under the Valois dukes of Burgundy, and particularly during Philip the Bold's reign (1363–1404), that the building seems to have been in its glory. One of his favorite residences, he carried out extensive restoration and improvements there. The study of various sources provides an overview of the building at the end of the fourteenth century.

The topography and aerial photographs suggest a generally regular plan, with an entry to the château southwest of the courtyard. According to the official records of 1518, the farmyard was located there, "at the exit" of the château (fig. 2).

Although the acreage is modest, the building seems to represent an obvious pursuit of grandeur and ostentation. Take the defense structures as examples: the number of towers that supported the courtyard and the exceptionally wide moats filled with water. The enormous entrance protected by an arched drawbridge connected to a fixed bridge (fig. 3) was flanked by two round towers. The portal was lavishly painted and decorated with statues in the style of the Château de Rouvres.

The same holds true for details in the residential quarters. The rooms, which were arranged around a central courtyard, were on two levels. Public life took place upstairs, around the great hall that Philip the Bold had had completely renovated between 1366 and 1395. Topped by a "capital," it is reached from the courtyard by a staircase. It had no fewer than four fireplaces, one of which was colossal, encircled by two spiral staircases and nine sculpted windows. Most likely this staircase was copied in 1383 from the château of the duke's brother

Fig. 1

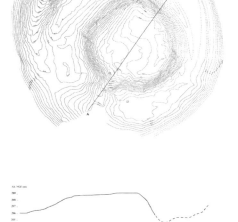

Fig. 2

Fig. 4

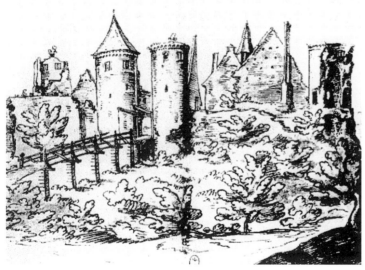

Fig. 3

Charles V of France. In addition, the roof was redone in glazed tiles decorated with the ducal coat of arms. Surrounded by less luxurious areas, notably a "small pavilion" and a "small hall," the great hall was also connected to the kitchen, which, like most of the other servants quarters, was located on the ground floor.

The private apartments were probably grouped together. Those of the duke and duchess were on both floors, and the private rooms were equipped with wardrobes. Many other bedrooms that accommodated the ducal couple's entourage were also mentioned, for example, those for Guy de la Trémoïlle or the duchess's "ladies." Most of these private apartments were painted and tiled, and equipped with fireplaces. Covered walkways bordered the different rooms allowing for privacy.

The chapel, however, was clearly the focus of the duke's attention. Located in the middle of the upper courtyard and graced with two oratories, it was made of two-toned glazed brick and roofed in glazed tiles; the texts mention the statues of the twelve apostles decorating the building. The majority of the restoration between 1380 and 1390 was devoted to this decoration, for which Philip the Bold called upon the painters Jean de Beaumetz and Arnoul Picornet and the master glass artist Jehan de Thiais.[2] It seems then that the d'Argilly château resembled a home more than a fortress, in view of the considerable care that the duke brought to its decoration. It underscores his generosity and power during his reign, as do the Germolles and Rouvres châteaux, among others.

NOTES
1. Courtépée 1967, pp. 373–75.
2. Cassagnes-Brouquet 1996, pp. 384–87.

59

Burgundy, Argilly tileworks?

Floors in the Château d'Argilly

Thirty-seven fragments of tiles from the castle of Argilly, with four different designs: Interlaced, chevron-patterned, square-pattern, checkered
Late 14th century

Glazed terracotta, engobe design
Estimated original dimensions of each tile, 16 x 16 cm

Dijon, Musée des Beaux-Arts, inv. 1946-7-13-513

Prov.: uncovered during excavations by Pierre Quarré in 1995 at the site of the castle of Argilly.

Bibl.: Bergeret 1899, vol. 14, and 1900, vol. 15; Quarré 1970, pp. 48–50; Quarré 1963–69, vol. 26: pp. 99–103.

The château d'Argilly, the very name of which evokes *argile*, or clay, had numerous and remarkable ceramic tile compositions, the principal one adorning the chapel.[1] "From the place where the sacristy was located up to the door," the exterior walls were ornamented with a frieze of glazed bricks in yellow, brown, and green, on a block that formed a long, encircling inscription "in a single line straightaway, at a height of from 10 to 12 feet," accompanied by chevrons, fleur-de-lis, and cinquefoil shapes. Some of the tiles were "coats of arms of the Lordship" and zoomorphic ridge tiles, produced on site by the tile industry in Argilly from 1360 until the late fourteenth century. The floors were likewise for the most part ornamented with two-toned glazed tiles, brown-red and yellow, some of which had been discovered during the excavations of Pierre Quarré.[2]

J. R.

NOTES
1. For all the following information, see Bergeret 1899 and 1900. The author, who published color plates, stated that he had "collected some fragments on site," but we do not know where they are now.
2. See Quarré 1970, pp. 48–50, and 1963–69, pp. 99–103, as well as the interesting report on file at the Musée des Beaux-Arts in Dijon.

FIGS. 1–5. Lead-glazed paving tiles, various designs, from the excavations of Pierre Quarrée. Dijon, Musée des Beaux-Arts.

PARIS

Philippe Plagnieux

The Artois Mansion: Paris Residence of John the Fearless

Between 6 February 1409 and 15 May 1411, John the Fearless built the principal part of the Artois mansion, his main residence in Paris. Commissioned to do the work was his master builder, Robert de Helbuterne, who had become architect for the city of Paris thanks to his patron's support. The endeavor cost close to 10,000 royal pounds, some of which had been advanced by Guillaume Sanguin, a Parisian money-changer and one of the duke's followers. Related documents also reveal several other names: Jean Bonnart and Thérin de Marmont, masons; Rolin de La Haye, carpenter; Merlin Plante, ironsmith; Marc de Bruxelles, glassworker;

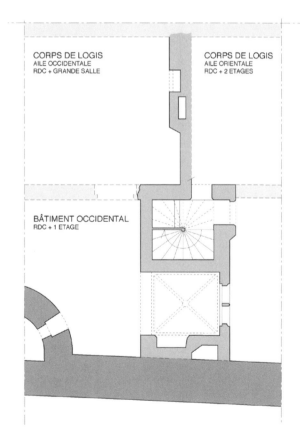

Fig. 1

CORPS DE LOGIS
AILE OCCIDENTALE
RDC + GRANDE SALLE

CORPS DE LOGIS
AILE ORIENTALE
RDC + 2 ETAGES

BÂTIMENT OCCIDENTAL
RDC + 1 ETAGE

Fig. 2

ENCEINTE DE PHILIPPE-AUGUSTE

TOUR JEAN-SANS-PEUR ET LOGIS
parties conservées

TOUR JEAN-SANS-PEUR ET LOGIS
parties restituées

Fig. 1.
Tower of John the
Fearless, main (east)
façade, drawing by
G. Huillard, 1877. Paris,
Musée Carnavalet.

Fig. 2.
Schematic reproduction
of the plan of the
mansion built by Robert
de Helbuterne for John
the Fearless.

Fig. 3.
Tower of John the
Fearless, section with
reproduction of original
floors.

Fig. 4.
Tower of John the
Fearless, arches in the
staircase.

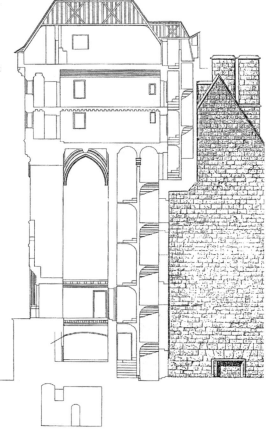

Fig. 3

ancient ramparts of Philip Augustus to the south. The two upper bedrooms were situated along the whole height of the tower, which allowed for surveillance of the entrances.

Primarily, this building conveyed a political message emphasizing the duke's victory over his adversaries. Following his men's assassination of Louis d'Orléans, John the Fearless had to flee the capital. The next year, on 28 October 1408, he returned in triumph and ordered the construction of this new part of the Artois mansion, where the murderers of the Duke of Orléans had taken refuge, and which the Armagnacs had threatened to destroy. On this building the Duke of Burgundy's coat of arms and mottos were represented many times over, particularly the plane and the level. As for the diagonal ribs of the magnificent arch over the staircase (fig. 4), they were transformed into symbols referring to the dukes and duchesses: oak for Philip the Bold, hawthorn for Margaret of Flanders, and hop for John the Fearless.

Fig. 4

and Amaury Gonel, quarry owner, who in 1419 pleaded with Philip the Bold to pay him for the limestone that he had delivered "for the new Paris mansion that he had had built during Duke Jehan's [John II the Good] lifetime, and the father of my aforementioned lord." It is also possible that the duke's sculptor, Claus de Werve, was involved in the work; he was in Paris in 1411–12.

The only portion remaining of this huge building is the tower of John the Fearless (fig. 1). According to documents, it was encircled by large Gothic pediments bearing the coats of arms of the duke and duchess. The tower shelters the grand staircase placed at the junction of the two wings of the dwelling; the dividing wall still exists (figs. 2 and 3). On the north side, the staircase separated the upper rooms of the main part of the building while the narrow rooms on the south side led to a building on two levels to the west, as well as to the wall of the

The Low Countries

François Duceppe-Lamarre

The Ducal Residence at Hesdin and its Place in Courtly Art under Philip the Bold and his Son (1384–1419)

When Philip the Bold inherited the Low Country territories in 1384, he faced military unrest in Flanders but not in Artois. This fact partly explains why he went to Artois less often on his visits to his northern lands (one-third of the trips from 1369 to 1383, and two-thirds from 1384 to 1404). When in Artois, he stayed most often at Arras but frequently visited the ducal residence at Hesdin (fig. 1). Hesdin had been a favorite of the counts of Flanders and Artois, who built a château and a game park with many amenities within a 2,000-hectare hunting reserve in the Canche River basin (fig. 2). More art treasures were added to Hesdin during the reigns of Philip the Bold and of John the Fearless in the realms of architecture, the visual arts, the mechanical arts, and landscape design.

The dukes sponsored architectural works in stone or wood, managed by masons (*maîtres d'œuvre*) or carpenters (*maîtres charpentiers*), respectively. High construction

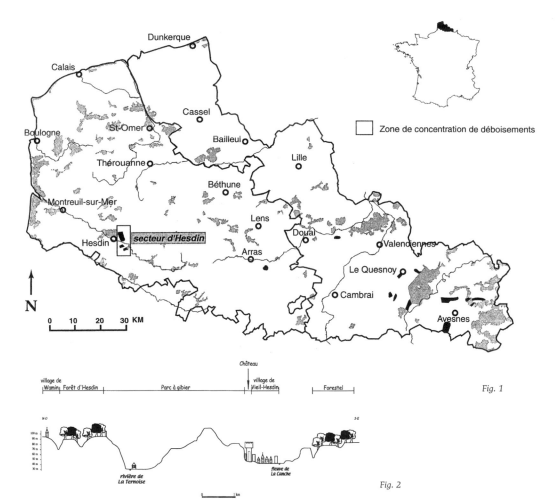

Fig. 1.
Map of the area.

Fig. 2.
The Canche River basin near the ducal residence at Hesdin.

costs ate up almost all the income from the Hesdin domain (that is, 8,646 livres) from 1393 to 1396, according to Andrée Van Nieuwenhuysen (1984). The tasks performed by local labor included harvesting stone and wood from quarries and forests, cutting and transporting these raw materials, building lime ovens, and, eventually, maintenance. There were numerous buildings: the château and its chapel, a lodge, pavilion, gallery, manor house, and several utilitarian structures. Periodic maintenance was essential; for instance, in 1378, the château and the wall required masonry work, and a new kitchen was built in the game park.

Although after the period under discussion, Jan van Eyck, who worked for Duke Philip the Good, stayed at Hesdin in the summer of 1431, according to archival sources. On this basis, Anne Van Buren-Hagopian (1985) attributes to him a painting entitled *Jardin d'amour de Philippe le Bon dans les jardins du château de Hesdin (Garden of Love of Philip the Good in the Gardens of the Château of Hesdin)*, a work known to us by a late sixteenth-century copy (cat. 60, *Outdoor Party of the Burgundian Court*). According to the most recent research, the costumes allow us to date the original painting to about 1410–20. An analysis of the scene shows an outdoor party (*fête champêtre*) in the Burgundian court with music, dance, and falconry. We do not know whether it depicts a historical event in a specific location during the duke's lifetime, or whether it is primarily a work of the artist's imagination.

From 1384 to 1419, the dukes supported many painters, among them Pierre Dubois, Melchior Broederlam, Jean le Voleur, and Laurent de Boulogne and his son Hue. These artists painted sculptures, decorated walls and ceilings with frescoes, and designed coats of arms for the ducal banners. During the reign of Philip the Bold, Jean le Voleur was also responsible for painting the floor tiles at Hesdin under the direction of Melchior Broederlam. Tapestries, commissioned from Paris or Arras, decorated the buildings of the Hesdin palace complex.

The mechanical arts, by which we mean anything built with a mechanism, from automatons to waterworks, are another dimension of the Burgundian dukes' patronage. It is known that a group of artisans engaged in the mechanical arts were active in the Hesdin palace complex and had already worked for the counts of Artois building automatons, a pergola, a sundial, fountains, and several hydraulic works. It should be noted that neither the mechanical arts nor the game park are oriental inventions imported when Robert II d'Artois returned from Italy, as Marguerite Charageat and Anne Élisabeth Cléty wrote perhaps too hastily. However, some ideas or designs probably hark back to this Mediterranean period, for example, the pergola, a cage-like structure filled with living or mechanical birds, and an artificial tree. The general outline of this structure— the French term for which, *gloriette*, derives from the Arabic—was inspired by an Arabo-Norman palace in Sicily where the count of Artois stayed. Early fourteenth-century records mention automatons in a gallery near the château and in a garden pavilion located in the northern area of the game park.

The garden pavilion built under the patronage of the counts of Artois is the one depicted in the *Outdoor Party of the Burgundian Court* mentioned above. The records mention a ducal employee, the "maistre des engins d'esbattement" or master of the mechanical toys, who was in charge of maintaining the automatons. It is known that Laurent de Boulogne, his son Hue, and Pierre Dubois held this post and that they were also responsible for the birds in the pergola. According to Cléty, the cistern and the water pipes in the gallery near the château were maintained under Philip the Bold and John the Fearless so that the sculpted faces would keep on spraying water on the amazed visitors.

The Burgundian dukes also embellished the surroundings of the Hesdin residence. Much had already been done by the counts of Flanders and Artois, who built a stone wall around the Artois hills, enclosing forests, open prairies, and ponds in the Canche River basin. The wall marked a triple separation—economic, territorial, and social/legal—of the princely domain from the surrounding agricultural environment. Early fourteenth-century records describe vineyards, rose gardens, and orchards with apple and pear trees. Mention is also made of a labyrinth consisting of vines. Various animal habitats were created to add to the aristocratic decor: marshes for the swans and herons, a horse farm, a deer park, a bird cage, and a zoo populated by local wild animals and exotic animals.

The all-encompassing patronage of Philip the Bold, and to a lesser extent that of John the Fearless, is characteristic of a princely lifestyle. At Hesdin, the buildings and their surroundings, as well as the artworks, provide a background for the pan-European politics of the Burgundian dynasty.

60

French School

Outdoor Party of the Burgundian Court
17th-century copy

Oil on canvas
161 x 117 cm

Dijon, Musée des Beaux-Arts, inv. 3981

PROV.: acquired in 1951.

BIBL.: Vaivre 1985, pp. 313–39; Van Buren-Hagopian 1985B, pp. 185–92; Turcsány 1989, p. 32–41, pls. 50–72; Châtelet 1999, pp. 70–75, 77; Jugie 1999, pp. 59–69, 76–77.

This landscape is painted with such accuracy that its actual location can be identified. The scene depicted is also a valuable record of the interaction between man and nature in the late Middle Ages, as it shows figures, animals, and vegetation in various landscapes, either natural or man-made.

The landscape features suggest that the scene depicts the Ternoise valley looking toward the west. We must, however, surmise that in his composition the artist voluntarily omitted the wall that surrounded the Hesdin game park in medieval times, and that he could see the village of Grigny from his vantage point. Mountains with jagged peaks were added to the background in the sixteenth century, helping to balance the picture by deepening the perspective.

The background is connected to the foreground by a watery environment—running and still water—that fills the middle ground of the picture. Reeds grow in the marshes populated by aquatic birds and dotted with little houses on stilts. The early fourteenth-century records mention a "pavilion on the marshes" in the northern area of the Hesdin game park, which could have been the model for this little house. However, this is not the only instance of a pavilion on stilts in a painting of this period; there is another one, next to a fortified site, in the background of a *Visitation* by the M. S. Master in Budapest (fig. 1).

Open areas predominate in the picture, with grassy lawns and trees but no flowers. The foreground depicts an orchard whose fruits—cherries, apples, pears—are aesthetically placed on a central table. The painter does not show us rabbits or deer, or exotic animals (although Philip the Bold owned several buffalo and a camel), but only the horses and dogs that participate in the hunt. He highlights the importance of the central figure by placing the largest dog at his feet and the largest bird of prey (without a hood) on his glove. In the marshes a falconry hunt of aquatic birds—swans, ducks, but not herons—is in progress, although it cannot be seen very clearly in the Dijon copy which, unlike the Versailles copy (fig. 2), omits a scene depicting the capture of a swan.

F.D.-L.

FIG. 1. M. S. Master, *Visitation*, 1506, oil on wood. Budapest, Magyar Nemzeti Galéria.

FIG. 2. *Jardin d'amour à la cour de Philippe le Bon, dans les jardins du château de Hesdin*, 1431, 16th-century copy, oil on canvas glued onto wood, French school. National Museum and Estate of Versailles.

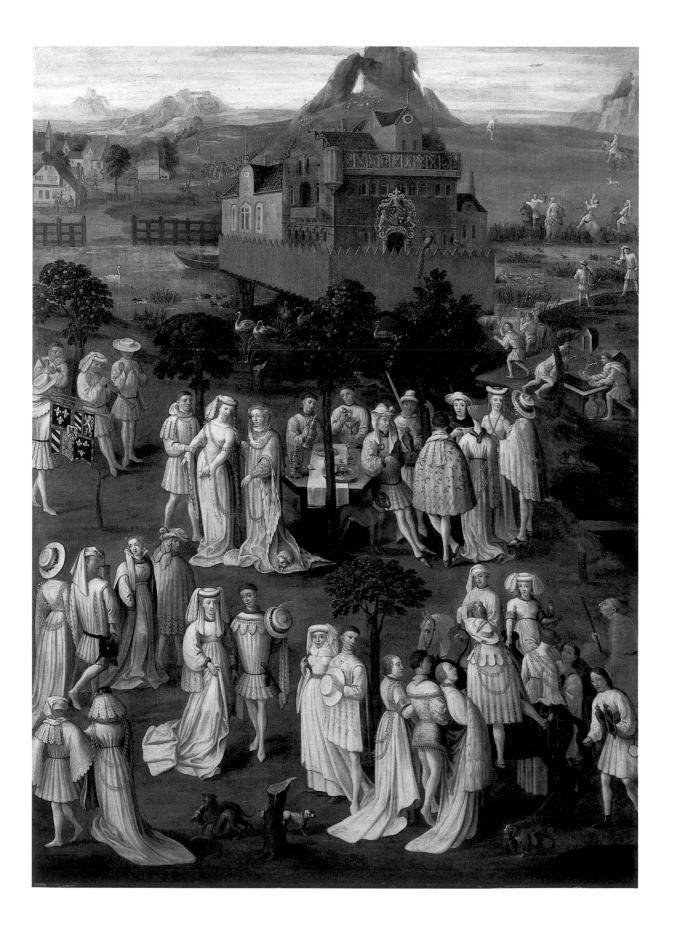

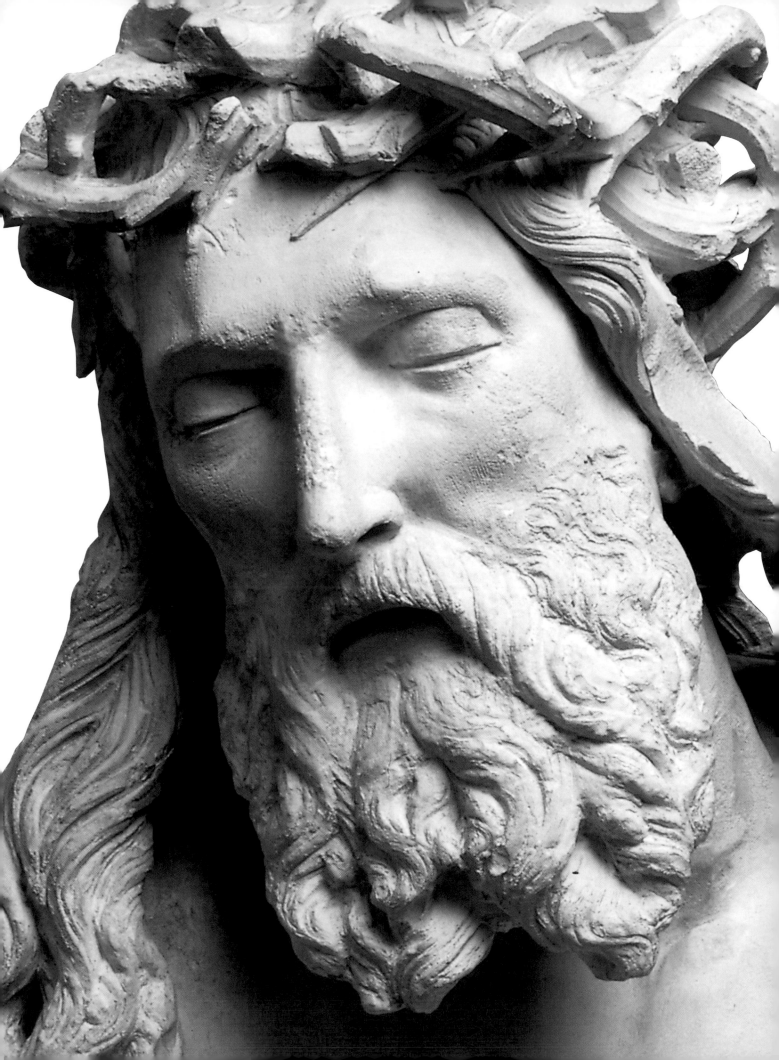

The Chartreuse de Champmol

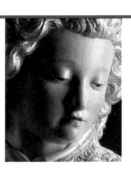

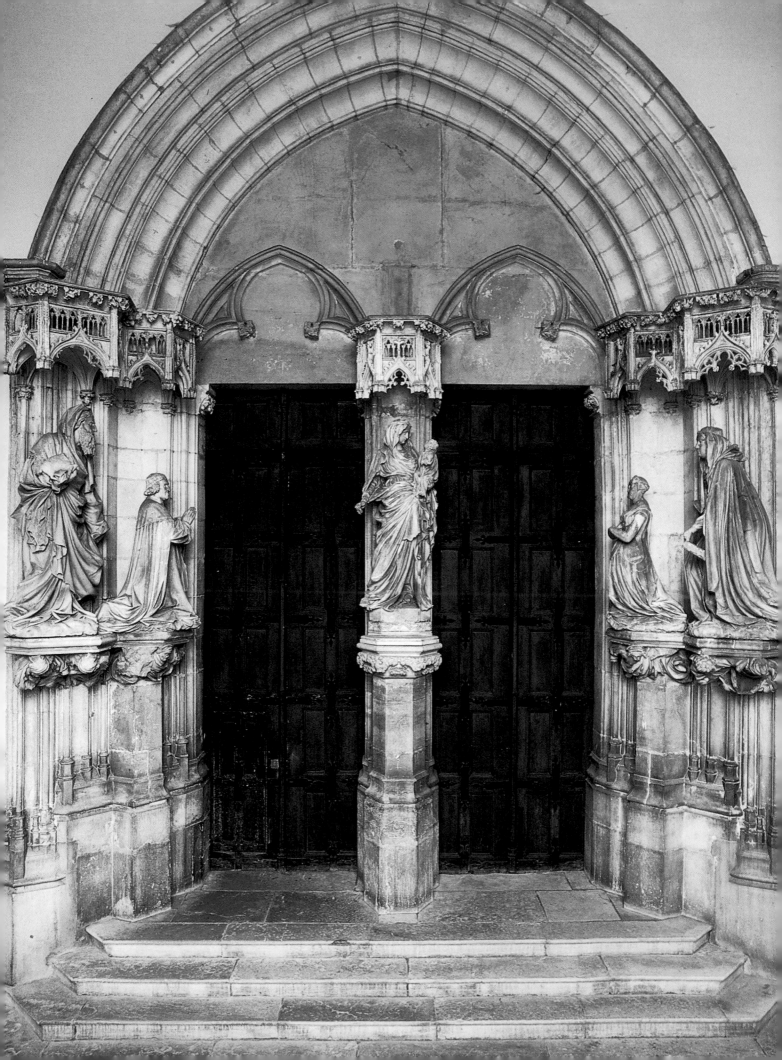

Introduction: Religious Institutions Founded by the Dukes

Vincent Tabbagh

The Pious Foundations of Philip the Bold and John the Fearless, (1360–1420)

Philip the Bold cannot truly be regarded as a major founder of institutions or religious services, and his eldest son even less so. Champmol, with its twenty-four Carthusian monks, five lay brothers, one prior, fifteen hundred books, and forty loads of salt in yearly income, was impressive in scale but modest compared to the duke's political and financial power. Its most dazzling features were its architecture and the accumulation of works by the finest artists of the time. Michel Pintoin, a member of the religious order of Saint-Denis, is correct when he notes that Duke Philip was little inclined toward generosity to the churches.[1] For several of them, he forgave debts related to donations they had received, but this loss in earnings undoubtedly did not offset the amounts paid by all the institutions that did not obtain this favor.[2] In his will dated 13 September 1386, he made provision for numerous donations to establish masses and commemorations, for example in Cîteaux, Clairvaux, Saint-Antoine de Viennois, the abbey of Saint-Claude in the Jura, and in the ducal chapel of Dijon, where he wanted to establish two yearly commemorations and one daily mass said by four permanent chaplains, among other benefices. But all this, often destined to replace institutions mandated by the will of Philip I de Rouvres but not fulfilled, would never be implemented, because of the state of ducal finances in 1404.[3]

Philip the Bold showed a certain generosity toward churches that lay outside his domain, such as the cathedrals of Troyes and Lisieux, but his name is rarely noted in records of memorial services. His charity to communities for the most part was an attempt to stimulate building projects. John the Fearless received some promises of perpetual masses in return for writing off debts, which were forgiven only when they were for minimal amounts. He secured two obituary commemorations in Paris, one at

the Carthusian monastery of Vauvert and the other at the cathedral, along with one for his parents in the latter church, which likewise was associated with his victories. He also instituted a mass to be celebrated every 24 September, to commemorate his victory over the people of Liège in 1408.[4] Thus it mattered little that his brutal death prevented the duke from drawing up a will.[5]

Though the fact that John the Fearless distanced himself from the usual practice of establishing multiple institutions can be explained by the importance he gave to political and military concerns, these priorities were rooted in his father's approach to religious practice. Philip the Bold was a pious man of regular habits, surrounded by a chapel that, according to Michel Pintoin, attained much greater size and splendor than that of his ancestors. He participated in the growth of personal and private prayer that characterized his era. To him, this seemed more useful to individual salvation than a perpetual commemoration maintained during the centuries by masses sung every day or year. This is why he looked to one order, the Carthusians, among whom he had never truly practiced, rather than to the white- or black-robed Benedictines preferred by his predecessors. In Champmol, solitary prayer sufficed for him, and he did not seek to associate personally with particular groups through specific intercessory prayers or special connections. Both the traditions he established and the will he drew up required the Carthusians to cloak themselves in simple habits. It was only after his death, and not at his request, that the prior of the great charterhouse granted him full monastic privileges, namely complete participation in both the spiritual benefits that God granted to the order and the rewards accumulated by him in heaven. His recumbent statue, which shows his hands clasped in a gesture of personal prayer, is surrounded by weeping

Fig. 1. Portal of the church of the Chartreuse de Champmol. 167

figures, their wails ranging from one mouth to another, amid the small columns of the crypt.

Throughout his life, Philip the Bold had wanted to be closely related to another order, the Dominicans, who sought to encourage personal conversion rather than prayer for the dead. He entrusted them with the care of his soul and he adhered to their most debated theological position, the rejection of the Immaculate Conception. In 1404 he established at Notre-Dame, near the large confraternity of priests and citizens of Paris, a mass on the great holidays devoted to the Virgin: 1 February, 25 March, 15 August, and 8 September. He did not provide for 8 December, the date set aside to venerate Mary's conception.[6] He embraced the influence of his chaplain, Jean Gerson, who deemed the multiplication of new institutions to be useless, preferring the ordinary services of the past.[7] In his opinion ancestors could be venerated through their imitation more than through prayers on their behalf. The founding of Champmol was inspired directly by that of Bourgfontaine, another double Carthusian monastery, founded in 1325 by his grandfather, Charles of Valois, at the heart of his realm, to house his family's tomb, later magnificently preserved by Philip VI.[8] This religious sensibility was harmonious with the duke's political choices,

and his lack of interest in commemorative institutions set him in opposition to the milieu of the Marmousets, which was intensely involved with such practices, particularly around the Celestine convent in Paris.

The withdrawal of Eucharistic intercessory prayers for himself or for his ancestors led to the development of patronage. Private prayer consisted of recitation by the high priests throughout the Church, but this too changed, in exercises proposed by the authors of pious treatises, to the contemplation of images and, indeed, to the internal construction of a stage where one could relive the entire holy story. In Champmol, using stone, wood, and colors, the duke built this sacred representation, which the pious man could picture in his prayers, within the privacy of his small chapel. An artistic commission in itself became a form of prayer and pious labor. The numerous statues, paintings, and altars that he gathered around his tomb achieve their purpose in the glorification of a figure, a family, and a dynasty. But they likewise have salvational value, forcefully appropriated by the coats of arms with which they are adorned. For him, in his approach to salvation, the surface of the tomb replaces the altar of the mass, and the small statues of weeping figures renew the singing of the psalms at vigils for the dead.

NOTES 1. *Chronique du religieux de Saint-Denys*, p. 147.
2. ADCO, B 11622. Debts were forgiven from the abbey of Châtillon-sur-Seine, the Carmelites of Dijon, and the priests in charge of Notre-Dame de Dijon, for example, but those of Notre-Dame d'Auxonne paid 400 livres, in 1396, for 12 livres in land and loans.
3. Ibid., B 309. For Cîteaux, where he chose to be buried, Philip I de Rouvres provided an annuity of

only 500 livres, and his successor provided only 100 livres. The former gave 2,000 florins to the parish churches, hospitals, and hospices; the latter left 1,000 francs (Plancher 1974, 2: evidence no. 304).
4. *Obituaires de la province de Sens*, 1: pp. 216–18, 220–21; 2: p. 703.
5. However, in 1380, Margaret of Flanders established a daily mass, in memory of her own mother, at the

ducal chapel; moreover she made provision for another tradition of this type, for herself, at the same location (Rey 2000–2001, p. 112).
6. *Obituaires de la province de Sens*, 2: pp. 834–35, 838–39.
7. Mansi 1903–27, 26: col. 1060.
8. Gruys 1976–78, 2: 248.

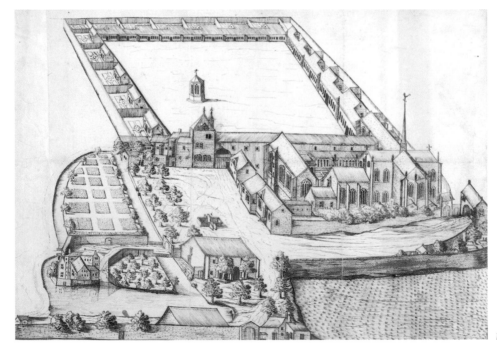

Fig. 1.
View in perspective of the Chartreuse de Champmol by Aimé Piron, 1686. Dijon, Bibliothèque Municipale.

Fig. 2.
Plan of the church (reconstruction by Renate Prochno).

Fig. 3.
Plan of the site c. 1760. Dijon, Archives Municipales.

Fig. 1

A WELL-DOCUMENTED
CONSTRUCTION SITE

Renate Prochno
The Origins and History of the Chartreuse

Plans for building the Chartreuse de Champmol date from at least 1377. During this year Philip the Bold purchased the plot of land that would be expanded through the acquisition of further acreage in 1383. By 10 September 1377, the "accounts for construction" of the charterhouse were already in existence. The date of the first stone's placement was not the feast day of one of the Carthusian saints, but rather that of St. Bernard de Clairvaux, 20 August 1383. With this decision, the founder clearly indicated that this project was truly under the auspices of the duchy of Burgundy.[1]

It was necessary to wait until the Flemish inheritance passed into Burgundy's possession before the construction of the building could be funded. The actual start of Champmol's construction dates from 13 March 1385.[2] After the list of all the names and titles of the founder, the protection of the divine powers are invoked: God, the Holy Trinity, the Virgin Mary, and all the saints. The charterhouse is dedicated to them, and the monastery's seal,

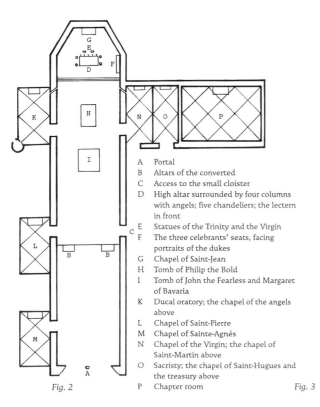

A Portal
B Altars of the converted
C Access to the small cloister
D High altar surrounded by four columns with angels; five chandeliers; the lectern in front
E Statues of the Trinity and the Virgin
F The three celebrants' seats, facing portraits of the dukes
G Chapel of Saint-Jean
H Tomb of Philip the Bold
I Tomb of John the Fearless and Margaret of Bavaria
K Ducal oratory; the chapel of the angels above
L Chapel of Saint-Pierre
M Chapel of Sainte-Agnés
N Chapel of the Virgin; the chapel of Saint-Martin above
O Sacristy; the chapel of Saint-Hugues and the treasury above
P Chapter room

Fig. 2

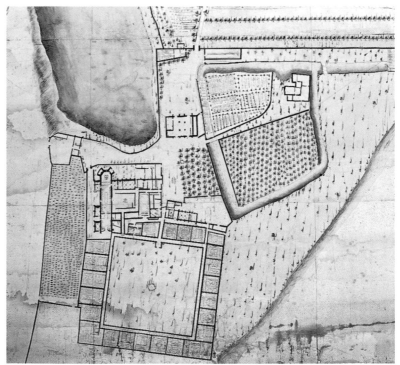

Fig. 3

Figs. 4 and 5.
Turret and staircase.

Fig. 6.
Arcades of the Little Cloister reinstalled in the Jardin de l'Arquebuse in Dijon.

Fig. 7.
The interior of the Champmol church from the west c. 1780; engraving by Née after Lallemand. Dijon, Musée des Beaux-Arts.

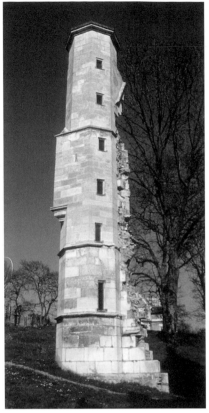

Fig. 4

Fig. 5

Fig. 6

representing the Trinity, was therefore depicted in several places in the charterhouse itself.

The monastery was erected fairly quickly:[3] on 24 May 1388, a celebration was held and the building was consecrated to the Trinity. In 1387, Jean de Berry had called in the architect Drouet de Dammartin, and the duke returned regularly during the course of construction for inspection visits. The work progressed apace, which was ultimately to the detriment of the building's structure; it was not long before endless repairs would be required. By 1401, and then again in 1410, the large cloister threatened to collapse, which was avoided only by taking the necessary measures as quickly as possible.[4] After the building's consecration, construction continued, carried out by a smaller group of workers. The work was essentially completed around 1410, when the tomb of Philip the Bold was installed in the choir.

In the 1780s, the monastery underwent an important renovation during the course of which numerous elements from the original structure were lost. In April 1791, during the French Revolution, as the possessions of the church were passing into the hands of the state, an inventory was made of the building's furnishings.[5] On 19 and 20 April 1791, the Carthusians were driven from the Champmol monastery; shortly thereafter, on 4 May, the monastic buildings were sold to Emmanuel Crétet.[6] The state retained ownership of the furnishings, some of which were moved to Sainte-Bénigne and others sold; as to the rest, a large portion had already been stolen. On 5 May 1792, Crétet sold the remaining stones of the church to Louis Deleu le Jeune, who began demolition in the month of July, intending to quarry the stones of the old monastery grounds. The 1951 excavations revealed that the most deeply entrenched foundation stones had been dug out.[7]

The monastery was located just outside Dijon, toward the west, on the northern bank of the Ouche River. As was customary with the Carthusians, the monastery's property was divided into two separate parts: the church, with a small cloister and chapter room, the refectory, and admin-

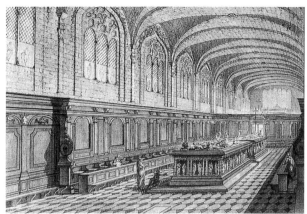

Fig. 7

northern side, the church comprised three chapels. The one situated closest to the choir served as the ducal oratory and consisted of two levels. The parvis onto which the portal opened was connected to the large cloister. Against the northern flank of the cloister, the building nearest to the portal of the church was the visitors' room, or *parloir*.[10] At the southern side of the church, by the smaller cloister, was the chapel of the Virgin, with adjoining sacristy, and on the second level were the chapels of St. Martin and St. Hugh, which, with the ducal oratory, formed a sort of faux transcept.[11] The chapter room followed, on a lower level; all these structures together formed the west side of the small cloister. The sacristan's cell, which adjoined the chapter room, was almost in alignment with the refectory, which was situated on the southern side of the small cloister. The kitchen and the administrative buildings abutted the southwest side of the refectory. The west wing of the small cloister was markedly delimited by other administrative buildings, interrupted only by a passageway to the large cloister. It was on this side that Malouel painted his "ymages."[12] The archways of the small cloister were adorned with scenes of Christ's Passion.[13] At the middle of the small cloister was a fountain, which served the administrative needs.

All that now remains of the church are the portal with its statues and the shell of a stairwell, the pillar of the *Well of Moses*, elements from the fountain of the small cloister, and part of the entryway leading to the monastery. Some archways of the small cloister were transformed into small loggias and moved to the garden of nearby Arquebuse.[14]

istrative buildings; and the large cloister, with the monks' cells and gardens. At Champmol, the church was situated in the northeast corner of the land; the adjoining administrative buildings were toward the south. A fairly basic map, drawn around 1760, exists of the site.[8] The cloister, with its 102-meter-long sides, occupied the largest part of the enclosure; it delineates an almost perfect square but abuts the southwest side of the church, forming an obtuse angle. This particularity may undoubtedly be explained by the unstable nature of the terrain, for all the buildings were constructed on the banks of the Ouche.[9] In the middle of the large cloister rose the great fountain, known today as the *Well of Moses*.

The main portal, with its five over-life-size statues, was located in the eastern façade of the church. Along its

NOTES 1. ADCO, B 1461, fols. 100–109.
2. Ibid., 46 H 774, partially reproduced in Dijon 1960, and almost in its entirety in Monget 1898–1905, 1: pp. 37–39.
3. ADCO, 46 H 774. On the history of the construction, see Kleinclausz 1905; Troescher 1932; Liebreich 1936; David 1951; Morand 1991. There are certain specifics in Aubert 1928; Drouot 1932; on the portal, see Erlande-Brandenburg 1972; Husson 1990; Goodgal-Salem 1992; Prochno 2002.
4. ADCO, B 11673, fols. 107, 190.
5. Ibid., Q2 832, partially reproduced in Monget 1905, 3: pp. 61–92.
6. Monget 1898–1905, 3: pp. 94ff.
7. Quarré 1954, pp. 245ff.
8. AMD, inv. 4, fig. 782.
9. The sale of the land in 1383 can no doubt be explained for the same reason. There must have been problems of shifting sand.
10. ADCO, B 11673, fol. 132v. This parvis does not appear on the 1760 map; work must have been executed at some point in the intervening years that changed the layout.
11. David (1951, p. 34) indicates erroneously that the chapel of the Virgin replaced the sacristy.
12. ADCO, B 11673, fol. 25v; Prochno 2002, p. 213.
13. ADCO, B 11671, fol. 355v.
14. Quarré, in Dijon 1960C, p. 4.

Sherry C. M. Lindquist

The Organization of the Construction Site at the Chartreuse de Champmol

The Chartreuse de Champmol, which was one of the most costly projects undertaken by Philip the Bold, a duke famous for his lavish spending, has always been considered the perfect example of the spectacular monuments that made the reputation of the Valois of Burgundy.[1] This building, intended to house the graves of the dukes of Burgundy, is undoubtedly one of the most important monuments of the late Middle Ages and of the beginning of the modern period. It is also one of the best documented.

The abundance of nearly daily accounts of the evolution of the work provides an idea of the project's scale and attests to the participation of hundreds of administrators, master craftsmen, and laborers, as well as of Philip the Bold and Margaret of Flanders, who commissioned the work, and also of the Carthusians.[2] These documents are the basis on which art historians have worked to retrieve the names of artists of the late Middle Ages and detailed histories of their careers and traces of lost works, to

reconstitute the now-demolished monument, and to understand more clearly the functioning of certain workshops.[3] However, though the documents clearly demonstrate that artistic production at Champmol was supervised by a complex administrative structure, historians rarely recognize this administrative aspect as an essential element of patronage of the dukes of Burgundy.[4] Formulaic expressions, repeated over thousands of pages of the register of accounts, have often been cut from published extracts of the archives of Champmol. Consequently, we lose track of the continuity of procedures involved in the production of works of art.[5] The principal sources reveal that, to interpret the works of art at Champmol, we must keep in mind not only the influence of the patrons, the master craftsmen, and the workshops, but also of the administrative structure that coordinated the overall organization of the work site.

The Champmol registers reflect the administrative system imposed by Philip the Bold on his territories when the counts of Artois, Rethel, Burgundy, and Flanders were his guests in the early 1380s.[6] In Dijon, a council of ducal officers, the chamber of accounts, was established to supervise the financial and legal interests of Philip and Margaret in the southern territories. This was the period during which the couple began to implement their plans to build a Carthusian monastery near Dijon. While Philip the Bold's administrative reform responded to the pragmatic requirements of the duchy's expansion, the Chartreuse de Champmol expressed the fundamental ideological needs of the new center of government. As Paul Binski has noted, "as royal government became increasingly associated with specific places such as London and Paris, the royal burial place took on a greater significance within the State as a sign of this new centralization."[7] The very scale of the monument to be built at Champmol required special administrative measures, which are listed in the document at the beginning of the registers of accounts for Champmol.[8]

In fact, the duke appointed one of his principal financial officers, Amiot Arnaud, to supervise expenses.[9] Arnaud used a pay scale established for the duke's other construction sites to remunerate anyone who worked on the Champmol site and could present a certificate from the prior, Dreuhe Feliz, "licensed in law, advisor to the Duke" or "Regnaudot de Janley, clerk for the work at Champmol."[10] The endorsement of one of these three individuals was required for payment to master masons and master carpenters, but any of the master craftsmen could attest to the number of work days accomplished by a laborer or the purchase of materials, probably when it concerned their respective trades. It is significant that no documents required the joint agreements of the heads of ducal finances, of the Carthusians, and of the master

craftsmen. The Carthusians did, however, have the opportunity to meet with administrators and craftsmen to discuss the progress of the work.[11] Each of the parties surely expected various types of rewards for earning the approval of the duke and duchess while managing to take into account the requirements of the Carthusian order, which sometimes diverged from those of the duke on the ideological level.

Even a simple note in the Champmol registers, such as the inscription of the appointment of Claus Sluter as "a sculpture craftsman" for the duke, reveals the interaction of multiple participants within a complex bureaucracy.[12] In this case the duke instructed one of his financial officers, Jehan d'Auxonne, to pay Sluter the same salary his predecessor, Jean de Marville, had received. Sluter would only receive this sum if he hired apprentices ("valets"), as Marville had. Sluter was responsible for his apprentices and also had to verify the number of days for which all the other assistants ("helpers") were to be paid. The sculptor enjoyed considerable autonomy: he could obtain advances for materials, was to be paid "without contradiction" by the financial officer, and could attest to the workmen's labor "by swearing to it on his conscience and name." The power conferred upon Sluter allowed him to approve contracts on the one hand and finished work on the other. The terms employed in these accounts emphasize Sluter's honesty ("on his conscience") and testify to the level of responsibility implied by the power of certification, and thereby committing the duke's funds. Indeed, financial officers generally took care to note the names of those who had provided the certifications when they paid out funds, and Sluter even had a seal that allowed him to authenticate them (fig. 1). The document recommends that Sluter only declare his assistants' work days if they had actually been dedicated to the duke's work site and not to other projects, which leads us to assume that Sluter was allowed to work on outside commissions, so long as he did not bill the duke for hours his employees spent on other projects.[13] In fact, the duke's instructions provided oversight of both the certifier and the financial officer, for the documents were copied and preserved in the chamber of accounts.

The accounts also reveal the procedures implemented to ensure quality control.[14] In addition to the meetings mentioned above, master craftsmen frequently co-certified payments and shared the responsibility for their production by reciprocally inspecting and approving each other's work.[15] Similarly, master craftsmen worked closely with the duke's administrators and the Carthusians' prior, who also co-certified expenses.[16] Inspectors were regularly appointed to "see," "visit,"[17] or "advise on" the progress at certain work sites, which indicates that artists and craftsmen were accountable to the ducal hierarchy in

Fig. 1
Seal of Claus Sluter.

roughly the same manner as the duke's other officers. In 1386, for example, the duke appointed Jehan Creté and Oudart de Trigny to "see, visit, and reform, this work, which is under the responsibility of the said chamber of accounts of my lord of Dijon."[18] The terms used by the registers, and notably those used in the order of appointment of Claus Sluter, emphasize the duties rather than the individual. This act stipulates, among other things, seamless continuity from Marville to Sluter, as well as the eventual replacement of Jehan d'Auxonne by one or several people. Such a blurring of the roles of administrators and craftsmen, operating within a vast administrative structure, has a notable impact on our understanding of patron-artist relations, of the status and identity of artists at the court of the dukes of Burgundy, as well as of their artistic practices and production.

With the exception of relations between Philip the Bold and Claus Sluter,[19] the repetitive, dry, and formal language of the registers does not really denote an intimate relationship between artist and patron such as occurred during the Renaissance, as described by art historians. The accounts mention regular visits from the duke and duchess to the artists' workshops, and also attest to the fact that Philip was occasionally informed about the progress of the construction site by messenger.[20] Though Philip and Margaret took their roles as patrons very seriously, we do not have any evidence that they followed the creation of any particular work of art from its conception to its completion. At Champmol, they counted on the administrators and the artists to anticipate their desires and govern the construction site during their frequent absences.[21]

The master craftsmen, like the administrators in favor at the ducal court, could enjoy substantial advantages when they succeeded in satisfying the dukes, who we know gave craftsmen bonuses, though the meaning of these gifts is not always very clear.[22] According to certain

analyses, these bonuses were rewards for particularly beautiful works of art, which seems to confirm a very assured aesthetic sense, on the part of both the patron and the artist.[23] These gifts, which were also granted to the creators of works of lesser quality, could also have been made for a different reason, such as the nature of the relationship between a lord and an artist.[24] Burgundian society in the late Middle Ages placed great importance on the exchange of gifts, and their distribution increased the power and prestige of the donor.[25] This habit of seeing the lord as a dispenser of gifts can in fact explain why, in certain registers, payments for specific services are qualified as "gifts," which implies that the artist was obliged to work for his lord with or without remuneration.[26]

Certain master craftsmen improved their social and financial status through their roles in the duchy's bureaucracy. It is significant that they were paid for a long-term commitment rather than receiving a daily salary, which required a receipt, as we have seen was the case with Sluter's assistants. With the 8 gros per day and 365 days per year stipulated in his contract, Sluter made about 250 francs a year, plus gifts from the duke and revenue from private commissions.[27] He therefore made more than a secretary for the duke, who was paid 50 to 100 francs a year.[28] Like the duke's other employees, master craftsmen such as Claus Sluter were occasionally given the title of "valet," which gave the bearer of the title official status in the ducal household.[29] Since the right to approach the duke, even when it was implicit, conferred a certain prestige upon his subjects, being a member of his household bestowed social status.[30]

The working relations craftsmen maintained with the administrators and the Carthusians also had implications for the way works of art at Champmol were created and even for their meaning. Even works in which a patron was especially interested depended on an artistic center with a complex administrative structure for their realization. Certain workshop practices facilitated the collaboration of various participants, notably in the production of plans, models, and patterns.[31] Art historians have frequently interpreted the examples of the models at our disposal as ways for a workshop to convey the distinctive touch of the master, as an explanation for the longevity of certain styles or the existence of later copies, and also as a means by which the patron could exercise some control over his commission.[32] Templates and models were certainly used for these purposes. But, in the context of the collaboration between workshops and the construction site at Champmol, these patterns offered craftsmen, administrators, or even the entire chamber of accounts, a convenient way of approving a project. The registers show that Jean de Liège replaced Jean de Fenain to complete the

stalls of the choir and that the final work differed from the plans approved by the chamber of accounts.[33] After a few discussions, the certifiers agreed that the modifications made by Jean de Liège deserved a salary bonus. The plaster model that Sluter's workshop made before sculpting the cloister's Calvary (for the *Well of Moses*) probably allowed the prior to contribute theological information at an early stage of this masterpiece's conception.[34] Other works of art at Champmol bear the traces of the multiple craftsmen who participated over successive stages of the construction, and it is possible that models may have played a part in the evolution of these works.[35]

Stimulated by a common purpose, frequent consultations, and generous financing, the artists hired to work on the construction site of Champmol achieved a substantial accomplishment in a limited amount of time. The organization of this site leads us to believe that the artistic collaboration between the participants differed from the traditional approach, in which creative innovation was attributed to the genius of an artist associated with an enlightened patron. Rather than attempting to stand out from institutional structures, the Burgundian sculptors who worked at Champmol defined their identity and elevated their social status through the ducal administration, particularly because their responsibilities and revenues brought them markedly closer to the increasingly powerful urban class of bourgeois professionals.[36] Given this context, rather than focusing our attention on a few artists and a few isolated masterpieces, it is in our interest to interpret the artistic creations at the Chartreuse de Champmol as the result of an overall plan, elaborated in concert by the various participants in order to anticipate the duke and duchess's desires, while satisfying the needs of the Carthusians occupying the site.[37] The bureaucratic aspect of artistic production at Champmol therefore facilitated a model of artistic creation based on collaboration. It offered artists the possibility of establishing themselves in the social order and led to the creation of a recognizable aesthetic associated with a specific place, the Chartreuse de Champmol, in Dijon.

NOTES 1. Regarding notable Burgundian monuments, see the classic work by Huizinga 2002; Kipling 1977; Cartellieri 1970, among others.
2. The registers of accounts concerning Champmol are kept in Dijon, ADCO, B 11670–675. All the archival references in this contribution are from this department. For the extracts of accounts cited, notably see Monget 1898–1905 and Prochno 2002.
3. Specialists have paid special attention to the career of sculptor Claus Sluter. See Kleinclausz 1905; Troescher 1932; Liebreich 1936; David 1951; Morand 1991. Prochno (2002) has pieced together the lost monument.
4. I also dealt with this subject in Lindquist 2002, pp. 15–28.
5. See, for example, Frisch 1971, pp. 115–128.
6. Vaughan 1962, pp. 113–50; Pocquet du Haut 1937, pp. 40–53. The principal edict was published by Riandey 1908, p. 175.
7. Binski 1996, p. 60.
8. ADCO, B 11670, fol. 11; Lindquist 2002, annex 2.
9. Arnaut was one of the four heads of ducal finances whom Philip the Bold eventually ennobled; Vaughan 1962, p. 223.
10. These administrators' titles appear sporadically throughout the accounts: for Dreuhe Feliz, ADCO, B 11670, fol. 168r, for Regnaudot de Janley, B 11670, fol. 9r.
11. Regarding these meetings, occasionally interpreted as "Richtfeste" marking the achievement of certain phases of work, see Lindquist 2002, pp. 17–18.
12. ADCO, B 4434, fol. 20, transcribed in the annex and partially transcribed by Monget 1898–1905, p. 406; Troescher 1932, pp. 170–71, no 146; Prochno 2002, p. 276.
13. Regarding Sluter's potential outside commissions, see Camp 1990, p. 44.
14. Which did not prevent the existence of mediocre work at Champmol, for instance, in the field of masonry, among others. See Lindquist 2002, p. 22.
15. This regularly appears throughout the accounts: see, for example, ADCO B 11670, fols. 86v, 111v, 233r, 271r, 282r; B 11671, fols. 7, 175v, 183v; B 11672, fol. 169v; and B 11673, fol. 134r.
16. For examples of expenses co-certified by the duke's officers and the master craftsmen, see ADCO, B 11670, fols. 58v, 146r; B 11671, fols. 81v, 97v, 157v, 158v, 173v–174v, 179–180, 189v, 208v; B 11672, fols. 9r, 43v, 44r, 121v; B 11673, fols. 16v, 143r. For examples of expenses co-certified by the prior and the master craftsmen and/or the

duke's officers, see B 11672, fol. 30v; B 11673, fol. 13v.
17. Regarding the notion of supervision implied by the terms "see" and "visit," see Lindquist 2002, pp. 17–19.
18. ADCO, B 1465, fol. 40v, cited in Vaughan 1962, pp. 116–17.
19. Both Henri David and Patrick De Winter describe Philip the Bold as a well-advised connoisseur; see David 1947, and De Winter 1976. In Huizinga's view (2002, p. 257), Sluter was even tragically "subject to the will of a patron prince."
20. During one of her visits, the duchess offered the masons a gift of wine; ADCO, B 11671, fol. 273r. The duke also offered wine to the workers who were making his gravestone when he visited Marville's workshop; B 1467, fol. 65r. Regarding messages to the duke possibly containing accounts of a meeting, B 11671, fol. 244r; B 11673, fol. 58; Lindquist 2002, p. 24, annex 3.
21. ADCO, B 11671, fol. 244r; Lindquist 2002, p. 20.
22. Regarding the extent and the significance of gifts made to the workers at Champmol, see ibid., pp. 20–21.
23. Notably see Troescher 1932, pp. 64, 82, 95.
24. Lindquist 2002, pp. 20–22.
25. See Buettner 2002, pp. 598–625.
26. See ADCO, B 11671, fols. 353v–354r, transcribed in Lindquist 2002, p. 25.
27. Monget estimates that 12 gros was roughly equivalent to one franc; Monget 1898–1905, p. 66.
28. High-ranking secretaries could however make up to 1000 francs a year; see Vaughan 1962, p. 222.
29. For a list of Philip the Bold's "valets," see Monget 1898–1905, p. 66.
30. In his description of the court of Philip the Good, Paravicini (1991A, p. 72) notes that intimacy with the duke represented a "source of unofficial power."
31. In the accounts, they are also referred to by the word "traiz" (lines). The architect and project manager Drouet de Dammartin had constructed special frames on which, with the help of his assistants, he "made lines [sketches] of said works"; ADCO, B 11670, fol. 86. For other references to "patterns" and "lines," see B 11670, fols. 273r, 274r; B 11671, fols. 189v and 260v; B 11672, fol. 30v; and B 11673, fols. 25v and 44.
32. Chédeau 1999, p. 492.
33. For further details regarding this commission, and for a more complete bibliography, see Lindquist 2002, p. 21.

34. A reference to a plaster model can be found in ADCO, B 11670, fol. 42; and B 11673, fol. 25v. On the other hand, Chédeau (1999, p. 493) argues for the head of the workshop's preponderance by suggesting that the model allowed Sluter to exercise total control over the work.
35. This is the case, for example, of the famous sculptures on the church's portal, which have traditionally been attributed to a single artist, Claus Sluter, though specialists are well aware that the plans were originally drawn by the architect Drouet de Dammartin, that Sluter's predecessor Jean de Marville began the work, and that both sculptors were helped by assistants. In fact, the collective nature of the enterprise can be confirmed by the presence of a certain number of names inscribed in the folds of the clothing of several statues, and particularly concentrated on the duke's statue. According to Quarré (1954–58, p. 186), one of the names, "de Busseul," was the name of an official of the court rather than that of a sculptor. Camp (1990, pp. 40–41) does not agree regarding this matter; according to him all those signing were craftsmen. He also suggests that certain names on the statues are those of assistants and apprentices who worked in Marville and Sluter's workshops. For an up-to-date recapitulation of the statues on the portal, see Prochno 2002, pp. 22–45.
36. In fact, a few master craftsmen of Champmol or members of their families married members of this social class: the daughter of Jean de Marville, Humblelote (?), married a certain Jean Fraignot, who became general financial collector of Burgundy (Vaughan 1962, p. 121). Claus Sluter's nephew, Claus de Werve, married the daughter of a relatively wealthy bourgeois, Quentin Damy, who was married to the niece of Amiot Arnaut, Champmol's financial officer (Camp 1990, pp. 64–66). The painter Jean de Beaumetz was ennobled, which we can see in the tax register: in 1382, he paid 40 sols, but in 1383, he was registered as a nobleman and was therefore exempt from taxes (ADCO, B 11487, fols. 247v and 330r). I would like to thank Céline Vandeuren-David for her assistance in interpreting these registers.
37. I will demonstrate the particularities of this overall plan in an upcoming book.

ARTISTIC ACHIEVEMENT AT CHAMPMOL UNDER PHILIP THE BOLD AND JOHN THE FEARLESS

Renate Prochno

The Portal

Champmol was built as the ducal family mausoleum, where its members would wait until the Last Judgment. Its entryway, or portal, is therefore dedicated to the Virgin Mary, intercessor for the human race, alongside her son, Jesus, fulfilling his office as judge. The duke and duchess, on their knees, are depicted life-size in the jamb of the portal. They address their prayers to the Queen of Heaven and her Son, who stand at the portal's *trumeau*, or central pier, accompanied by St. John the Baptist and St. Catherine, their protectors. The portal thus takes on a symbolic value as gateway to Paradise, or *porta coeli*.

Jean de Marville began construction of this portal around 1384. He was inspired by the Paris churches built by the royal family, in particular the Celestine church constructed between 1365 and 1370. The portal of that church, with its figure of St. Peter Celestine at the trumeau, was flanked by larger-than-life-size standing figures of Charles V and his wife, Jeanne de Bourbon;[1] these statues were probably made by Jean de Thoiry.[2] The Celestine monastery served as a reliquary for the hearts and entrails of members of the royal family and also housed the Orléans family tomb;[3] this last fact undoubtedly played a determining part in the choice of the Celestine church as a model for the Valois tomb. The north portal of the Saint-Nicaise chapel, which was part of the Hôpital des Quinze-Vingts, presented an analogous arrangement: the likenesses of St. Louis (Louis IX of France), its founder, his wife, Margaret of Provence, and their son, Philip III of France (the Bold), were depicted in the portal's jamb. Other portals of the same type existed in Saint-Yves and at the chapel of the college of Beauvais in Paris, where Charles V himself placed the cornerstone on 30 January 1374. It would thus seem that in his initial plans, Duke Philip wished that his own likeness should be erected at the entrance to his church—as his brother in Paris, the king of France, had desired.

In July 1389, after Marville's death, Claus Sluter assumed direction of the Champmol studio. Early on, he applied himself to the continuation of his predecessor's project[4] and made the baldachins following Marville's original concepts. He also carved the statue of the Virgin.[5] This figure of Mary is thus most likely the first work that Sluter realized from his own ideas. Never before in France had a figure so charged with tension been seen.[6]

Shortly after the visit from the Duke of Burgundy, Sluter modified the conception of the portal.[7] The revised plan basically corresponds with the monument as we know it today. It was agreed that the duke and the duchess should be attended by their protector saints. In order to allow the necessary space for the installation of the new sculptures, the portal's jamb was widened in December 1390.[8] The statues of the saints were installed in July and August of 1391.[9] The figure of the duchess was installed almost exactly two years later.[10] This new conception required the fabrication of new daises—which jut out forcefully from the façade—but these were added several years after the sculptures.[11] These elements all reinforced Sluter's fundamental idea: to allow the figures ample room for "movement" within the space.[12] This innovation shattered the traditional constraints of the architectural framework.

The available sources do not reveal whether Sluter kept the bases on which the duke and duchess kneel or if he created new ones. The interior pedestals, bearing the royal couple's coat of arms, have been attributed to Marville—as their lack of elegance should perhaps not be attributed to Sluter. However, there are no extant works of the same style proven to be by Marville that might serve as a basis of comparison and support this hypothesis. Furthermore, the exterior bases, adorned with conversing prophets and philosophers carved by Sluter, are wide enough for the statues that they support, which

Fig. 1.
Jean de Marville and
Claus Sluter, portal of the
church of the Chartreuse
de Champmol,
1385–1401, as it is today.

Fig. 2.
Portal of L'Église des
Celestins in Paris.
Engraving by Millin.

Fig. 3.
The Virgin from the
Champmol portal.

Fig. 4.
Philip the Bold presented
by St. John the Baptist.

Fig. 5.
Marguerite of Flanders
presented by
St. Catherine.

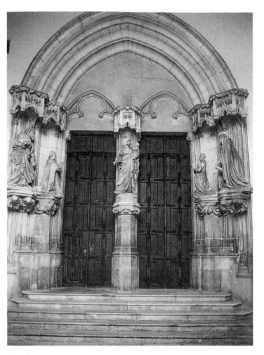

Fig. 1

PORTAIL DES CELESTINS.

Fig. 2

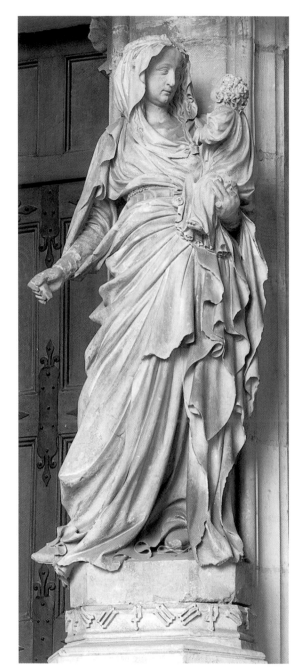

Fig. 3

is not the case with the interior bases. We may thus suppose that Sluter retained the interior bases, which were made by Marville's hand.[13]

As Sluter had already conceived his Virgin according to the portal plans originally outlined by Marville, it was necessary after these modifications to add an element in order to raise the central pillar by one foot. This element would ultimately be inserted into the pedestal: the initials of the founders ("P" and "M").[14] Next, the dais, too, had to be raised. The new version, by Sluter, is now lost. Its realization took several years.[15] Various documents mention that it was adorned with angels, which is inaccurate:[16] the architectural elements depicted—ribs, flying buttresses, pinnacles—evoke the heavenly Jerusalem. At the same time, the dimensions of this dais create a link between the figures of the founders and the statue of the Virgin. The portal's composition made this connection

necessary, as the duke and duchess look toward Mary without her responding directly to their gazes; as for the baby Jesus, his eyes are raised toward heaven. The current dais is a work of the twentieth century; it reproduces the model of those above the jamb statues, and thus provides no clear idea of the original dais.

Sluter drew his models largely from Flanders, where figures of kneeling donors were placed in the portals of numerous religious buildings—for example, at the church of Saint-Claire in Saint-Omer (1322–25)—and also in several funerary paintings of the deceased attended by their protector saints. The realism of the portraits is typical of the style of funerary monuments realized by Jean de Liège, such as the tomb of Philippa de Hainaut at Westminster Abbey (1366). In 1364 in Saint-Denis, André Beauneveu began the creation of the double tomb for John II the Good (d. 1364) and Philip VI (d. 1350), his

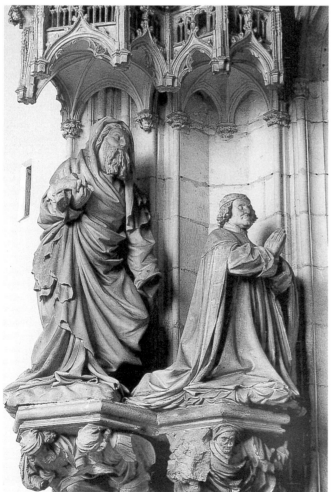

Fig. 4

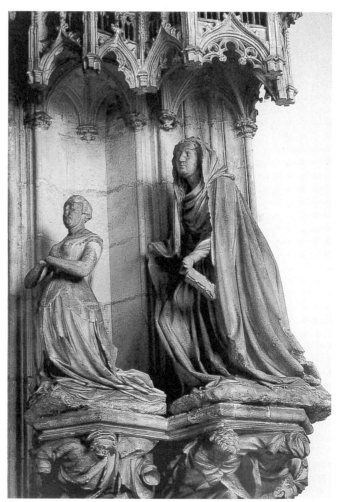

Fig. 5

Fig. 6.
Antoine de Succa,
*Mahaut d'Artois and
Othon de Bourgogne
from the portal of the
church of Saint-Omer,*
1601. Brussels,
Bibliothèque Royale,
MS no. II, 1862,
fol. 41.

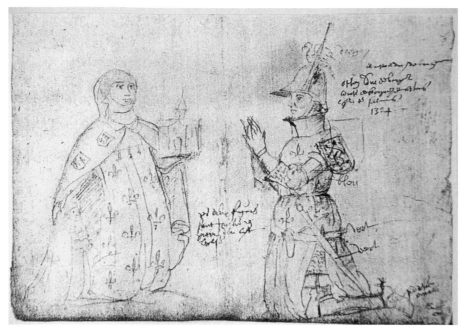

Fig. 6

father, kings of France. Other works of the same style, such as sculptures that adorned the spiral stairway ("la vis") at the Louvre[17] or at the Bastille,[18] are today lost.

Margaret of Flanders never thought to have her tomb at Champmol; she clearly intended to rest in peace *ad aeternam* near her father, Louis de Male, in the chapel of the Flemish counts at Courtrai.[19] This chapel was dedicated to St. Catherine. In dividing its tombs between Champmol and Flanders, the dynasty intended to symbolize its double sovereignty.

St. John the Baptist was the patron saint of John the Good, father of Philip the Bold, as well as the patron saint of France, but he was also, along with St. Andrew, the protector of Burgundy. John the Baptist thus was among the favorite saints of Charles V, who had decided to rest in peace in the chapel dedicated to him at Saint-Denis. It is very possible that the choice to represent this saint in the portal of Champmol was thus an allusion to the king of France and, at the same time, to the princely dignity of Philip, who is also seen here in recumbent effigy. The original anchorite, John the Baptist was a figure of singular importance to the Carthusians, and the Virgin of the trumeau embodied the porta coeli for all, including the monks. Because of this portal, Duke Philip and Duchess Margaret came to symbolize the awareness of their identity and rank: in representing them as both founders and devout sovereigns, it united the iconographies of the Valois, of Flanders, and of the Carthusians.

NOTES 1. Erlande-Brandenburg 1972B, p. 220 n. 39, in reference to Guilhermy 1848, pp. 435ff.
2. Erlande-Brandenburg 1972B, p. 218 n. 36, p. 220.
3. Beurrier 1634, 1: p. 280.
4. ADCO, B 4434, fols. 20–20v; Roggen 1937, p. 152ff.
5. Troescher 1932, p. 19; Liebreich and David 1935, p. 342 n. 4; Goodgal-Salem 1987–89, pp. 265, 283.
6. In 1376, Marville spent 172 days in Brussels, under the orders of the Duke of Burgundy; Sluter's name was inscribed in the list of Brussels stone carvers and sculptors for the years 1379–81.
7. Following Liebreich and David (1935, p. 335), Husson (1990, p. 26) and Schmidt (1993, p. 143) indicate the possibility that the modification of the plans was decided while Marville was alive, but no documentation exists to support this hypothesis.
8. ADCO, B 11671, fols. 345v–346; Liebreich and David 1935, pp. 338ff; Goodgal-Salem 1987–89, p. 275; Husson 1990, p. 25.
9. ADCO, B 11672, fols. 9v–10.

10. Ibid., fols. 74–74v, 9 December 1393. Monget 1898–1905, 1: p. 251; Liebreich and David 1935, p. 347.
11. ADCO, B 11672, fol. 46v; B 4449, fol. 19; B 4450, fol. 29; Roggen 1937, pp. 168ff, 170.
12. The impression of a theatrical set is further accentuated by the generous extension of the platforms beyond their consoles. Such a comparison should be made prudently, however, given that very little is known of the dramatic arts of this era and of their means of expression. Schmidt 1993, p. 144.
13. For an overview and an evaluation of the various sides of this debate, see Prochno 2002, pp. 32ff.
14. ADCO, B 11671, fol. 346.
15. Ibid., B 11672, fols. 49v–50; B 11672, fol. 157v; 158, 162v; B 4446, fols. 22–22v, 24; Liebreich and David 1935, p. 348; Roggen 1937, p. 163, 166.
16. ADCO, B 11672, fol. 6v: "plus[ieur]s angles de p[ier]res qui sont et doivent ester audit tabernacle." This refers to the payment for the transport of

stones and the fabrication of "angles." This was given as the sum of 6.5 francs, although the invoice for the transport was raised to 24 francs. This can only mean "pierres d'angle" (cornerstones) and not "angels," as is further demonstrated in other sources. The angels are generally designated by the terms "anges," "angeles," or "angeloz"; there is no mention of them in the documents relating to the dais of the Virgin. See also Goodgal-Salem 1987–89, p. 279.
17. Pradel 1951, p. 283; Sherman 1969, pp. 58–60.
18. Erlande-Brandenburg 1972A, pp. 329–31.
19. On the particular veneration that the ducal couple held for St. John the Baptist and St. Catherine, see David 1951, pp. 72ff; Mérindol 1988, pp. 291–94; Mérindol 1992, p. 171.

Renate Prochno
The Church
and Its Interior

Plan

The church, with its single nave, ends in a choir of three parts. The exterior length was 60.41 meters, with an interior width of 10.96 meters and a ceiling height of 15.73 meters.[1] The windows of the choir and the nave measured approximately 2.6 meters in width and more than 8 meters in height.[2] On the western façade, there was a tall lancet window with six parts (see fig. 7, p. 171);[3] the whole building must have given the impression of great space and light. The nave was overhung by a wooden barrel vault,[4] supported by grouped pillars and

a tight succession of "lymandes" (wooden laths) painted blue and gold and displaying coats of arms and vine motifs, leading up to a horizontal gold cornice, the "lythe."[5]

In the middle of the nave, a slype (narrow passage) separated the monks' choir from that of the lay brethren (see fig. 2, p. 169). The door that opened onto this choir probably bore a resemblance to that of the chapel in Bourges (fig. 1).[6] There were twenty-five stalls.[7] Two altars were placed against the eastern wall,[8] which held

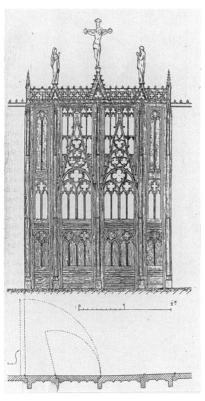

Fig. 1

Fig. 1.
Reconstruction of the doors to the rood loft of the Sainte-Chapelle, Bourges, after Gauchery, 1919–1920.

Fig. 2.
Jean Colombes, *Très Riches Heures de Jean de Berry: the Mass*, Chantilly, Musée Condé, MS 65/1284, fol. 158.

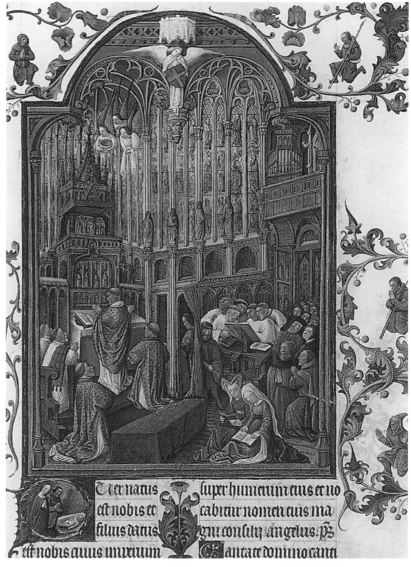

Fig. 2

Fig. 3.
Lectern of Jean de Joés,
c. 1370. Tongern, L'Eglise
Notre-Dame.

Fig. 4.
Triple canopy over the seats
of the celebrants, wood.
Dijon, Musée des Beaux-
Arts.

Fig. 5.
Burgundian, end of the
fifteenth century, *Portrait
of Philip the Bold*, alabaster.
Dijon, Musée des Beaux-
Arts.

Fig. 6.
Gilquin, *Plan of the Tombs
of the Dukes of Burgundy*,
watercolor. Paris,
Bibliothèque Nationale
de France, MS new acq.
Fr 5916, fol. 58v–59r.

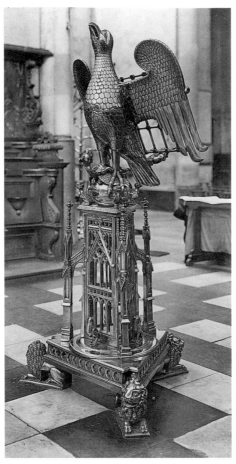

Fig. 3

Fig. 4

paintings of St. Denis by Jean de Beaumetz (fig. 1, p. 199) and of St. George (cat. 100).

On the eastern side, the monks' choir included no fewer than seventy-two stalls, though the charterhouse housed only twenty-four monks;[9] this reveals the foresight of the plans, as the church would receive numerous guests at certain funeral ceremonies. The main altar was topped with a carved and gilded altarpiece.[10] Four brass columns, adorned with angels bearing the *Arma Christi* (Instruments of the Passion) and the arms of the ducal couple, surrounded the altar; these columns also functioned as supports for the awnings. Behind the altar were five candleholders and Marville's *Trinity*, placed on a raised pedestal.[11] The tabernacle, with its elongated form, recalls the tabernacle visible in a miniature by Jean Colombe (fig. 2).[12] The sculpted eagle at the center of the choir was made at the same time as the columns around the altar.[13] The lectern resembles that constructed by a relative of Colart Joseph for the church of Notre-Dame in Tongres (fig. 3).[14] Atop a dais designed by Jean de Liège—preserved (fig. 4), along with the back of a chair (cat. 61)—the three seats of the celebrants occupied a large part of the eastern wall.

Fig. 5

The painted portraits of the Valois princes were hung on the wall facing the three seats. In comparing the oldest copies that have come down to us, it has been suggested that a series of small alabaster reliefs (fig. 5)[15] most faithfully reproduce the paintings.[16] These portraits probably were intended to uphold the memory of the founders. Below the portraits, a stairway led to the crypt—as is depicted in a watercolor by Gilquin.[17] This was built in 1404, after the death of Philip. A second tomb was installed in 1420 and a third in 1474. It is in this crypt that the ducal family rests in lead caskets placed upon

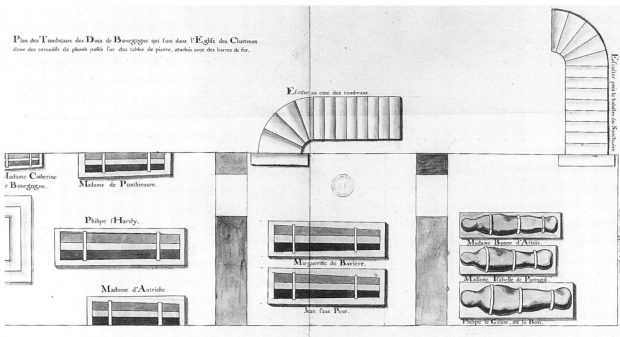

Fig. 6

slabs of stone under the protection of the Holy Trinity. Several funerary paintings adorn the walls.[18]

The nave, reserved for the monks and lay brethren, was deliberately decorated with sobriety—the iconography underlines the devotion of the Carthusian cult to the Passion of Christ and the holy cross, whereas in the chapels, which were founded by the high dignitaries of Burgundy, the decor reflects great pomp. Thus were reunited, under a single roof, the court's requirements of self-representation and the Carthusians' ideal of poverty.

NOTES 1. ADCO, B 11671, fols. 232v–33v; Baudot, Bibliothèque Municipale Dijon, MS 2081, p. 166; Prochno 2002, pp. 46ff.
2. ADCO, B 11671, fols. 230v–32v.
3. Ibid., fol. 71v.
4. Richard-Rivoire 1992, p. 250.
5. ADCO, B 11671, fols. 117–18, 183, 188, 195, 227v–30, 242v, 297, 353v.
6. Ibid., fols. 188v, 272.
7. Ibid., fols. 57v, 60v, 189, 303v, 307v. Richard-Rivoire 1992, pp. 252ff.
8. ADCO, B 11671, fols. 263v, 284.

9. For example, ibid., fols. 124v, 189v, 219, 275v, 303v; Richard-Rivoire 1992, p. 252.
10. ADCO, Q2 282, art. 86.
11. ADCO, B 1671, fols. 173v–74. For a study of various reconstructions of the pedestal, see Prochno 2002, pp. 68ff.
12. *Les très riches heures de Jean de Berry*, Chantilly, Musée Condé, MS 65/1284, fol. 158, Christmas Mass.
13. ADCO, B 11671, fols. 108v, 128, 245v–46, 290v–91, 307v–8v, 337v, 357, 360–60v; Baudot, Bibliothèque Municipal Dijon, MS 2081, p. 167.

14. H. 200 cm, c. 1370, signed; Squilbeck 1941, pp. 348ff.
15. Dijon, Musée des Beaux-Arts, first half of the sixteenth century, alabaster, traces of paint, H. 15–17 cm.
16. For an analysis of this cycle of portraits, their copies, and their probable attributions, see Prochno 2002, pp. 79–92.
17. Gilquin, *Le Caveau*, Paris, Bibliothèque Nationale de France, MS new acq. Fr. 5916, fols. 28v–29.
18. On this crypt, see Prochno 2002, pp. 76ff.

61

Jean de Liège
(active in Dijon, 1381–1403)

Seatback with Coat of Arms of John the Fearless
1399–1400

Oak

120 x 80 cm

Coat of arms of John the Fearless, of Franche-Comté, and of Rethel

Dijon, Musée des Beaux-Arts, inv. CA 1419 B

Prov.: originates from the Chartreuse de Champmol; Fyot de Mimeure gift, 1823.

Bibl.: Dijon 1883, no. 1419; Champeaux 1885, p. 95; Chabeuf 1909–13; Quarré 1957; Quarré 1960C, no. 6; Beaulieu and Beyer 1992, pp. 188–89; Richard 1992, pp. 255–56; Broillet and Schätti 1994, p. 5; Baudoin 1996, pp. 344–45; Charles 1999, p. 74; Prochno 2002, pp. 73–75.

Exh.: Rotterdam 1950, no. 2; Amsterdam 1951, no. 280; Brussels 1951, no. 263; York 1957, no. 11; Dijon 1960C, no. 18; Vienna 1962, no. 376; Paris 1964, no. 162; Dijon 1965, no. 3; Liège 1968, no. 88; Paris 1981–82, no. 96 and p. 433; Amiens 1983, no. 1; Dijon 1984, no. 79.

In the church at Champmol, the monks' choir and the lay choir were outfitted with walnut stalls. In 1388 the carpenter Jean de Liège was paid for the seventy-two stalls in the monks' choir, and Jean de Fenain was remunerated the same year for "the chairs in the small lay choir," of which there were twenty-five. In 1389, Jean de Fenain was also paid to install a partition and a door between the two choirs.

The monks' stalls were completed in 1400; the only decorative element of which we have a part is the triple seat of the officiants (the priest, the deacon, and the subdeacon), which was to the right of the altar. Jean de Liège received the commission in 1399. It was specified that these chairs needed to be "outfitted with capitals and decorated with pictures and the coat of arms of said lord," and reference

quatrefoil alternate between the coats of arms of Rethel and Franche-Comté, while four musician angels are interspersed between them. The angels play the unichord, the recorder, the viol, and the hurdy-gurdy, instruments in use at the court of Burgundy that are precisely rendered on the seatback.

We must also mention the "Jean de Liège problem," without bringing it to a resolution. Although the carpenter's work can be traced in Dijon and on the Champmol work site from 1381 to 1403, the same name is recorded elsewhere. It is certain that he cannot be confused with the famous Jean de Liège, who died in 1381 and was the creator of the tomb of Philippa de Hainaut, the tomb of the heart of Charles V in Rouen, and the tombs of the entrails of Charles IV and Jeanne d'Évreux. It also seems doubtful that he was the same Jean de Liège who worked for the Count of Savoy between 1383 and 1399. Could he possibly have been the Jean de Liège who worked on the Hôtel Saint-Pol in Paris in 1399?

S.J.

62

Workshop of Colart Joseph
(from Dinan, active in Dijon, c. 1390)

Right Eye of an Eagle from a Lectern of the Chartreuse de Champmol

c. 1390

Glass, paper

Diam. 4.7 cm

Accompanied by an 18th-century playing card (cardboard, 7 x 5.3 cm) representing the jack of clubs and bearing the inscription: "doublet alleged to be a carbuncle constituting one of the eyes of the eagle from the lectern of the Carthusian church of Champmol near Dijon," in the handwriting of Louis-Bénigne Baudot.

Dijon, Musée des Beaux-Arts, inv. Sup 00–65–1 (eye) and Sup 00–65–2 (paper)

PROV.: originates from the Chartreuse de Champmol; collection of Louis-Bénigne Baudot, Dijon, in 1796; Breuil collection; entered the Musée des Beaux-Arts with the bequest of the Breuil collection in 1972?

BIBL.: the object itself has never been written about; on the lectern; Monget 1898–1905, 1: pp. 146, 172, 198, 2: pp. 81, 143–45; Prochno 2002, pp. 71–72.

was made to a "sketch" for the carpenter to follow. Jean de Liège was eventually remunerated, in 1400, for having "completed a greater piece of work, with greater labor, than was described in the sketch." While the stalls of the two choirs disappeared during the renovations to the charterhouse in 1772, the officiants' seat was saved and moved to the Saint-Pierre chapel, where Baudot saw it in 1792. The monument still elicited admiration from viewers such as Gilquin, who described it in 1736 as "one of the most beautiful remains of Gothic architecture. Though it is overly burdened with sculptural ornaments, one cannot help but notice the infinite delicacy and extraordinary patience that went into it."

The piece of furniture in question consists of three seats under a canopy surmounted by pinnacles. The upper parts of the seatbacks featured angels carrying the coat of arms of the duke, the duchess, and their eldest son, who was then Count of Nevers. The lower part showed other family armorial bearings in alternation with angels playing various musical instruments. The external sides featured scenes representing the Nativity.

The two elements that have survived are the canopy and the seatback with the coat of arms of John the Fearless. The canopy (p. 180, fig. 4) probably stayed in the charterhouse and was given to the museum in 1810 by the widow of Emmanuel Crétet, the man who bought the Champmol property in 1791. Heavily restored, the piece was completed and repainted in an imitation wood style, and is not currently in a state to be displayed. The triple canopy surmounted with pinnacles currently in the church in Morogues sur Cher, which comes from the sainte-chapelle of the Duke of Ferry in Bourges, is probably quite similar to the upper part of the Champmol chair.

However, the panel with the coat of arms of John the Fearless, which was given to the museum in 1823, has survived in a remarkably good state, allowing us to assess the quality of Jean de Liège's work. On the upper part, which finishes in a Gothic top rail, two kneeling angels carry the shield of John the Fearless. On the lower part, three rows of three shields in

This very modest relic has hitherto never been mentioned. It was found in the storage space of the Musée des Beaux-Arts in an envelope on which Pierre Quarré, the museum's curator from 1933 to 1979, had noted its direct provenance: "Breuil collection." There is every reason to believe the inscription that accompanies this convex glass disc and its paper marked with concentric black ink circles. It was written by Louis-Bénigne Baudot, the Dijon scholar whose account of Champmol during the revolution in Dijon is essential. It is in keeping with a passage from his notes written on 4 May 1796 (Dijon, Bibliothèque Municipale, MS 2081, p. 167): "the afore-mentioned eye is a piece of crystal painted red behind which there is a piece of paper painted with blackish circles. The left eye was also a dark round piece and is white without paint, they each have a diameter of 2 li[nes]. I own them."

The lectern was described as follows by the 1791 inventory of the charterhouse:

"a big eagle in copper with his foot also in copper which is supported by three copper lions, with a steel lectern. The eagle in question has a red stone and a white stone for eyes." They appear to have been kept by Emmanuel Crétet, the buyer of the property, for some time.

The circumstances of the creation of this lectern are well known, thanks to the Champmol construction accounts. It was made and delivered in 1390 by a Dinan foundryman, Colart Joseph, one of the duke's gunners, who had come to Dijon to work on the Champmol work site. Colart Joseph also delivered the candleholders and the four columns that surrounded the altar. The columns featured four angels, one of which held the coat of arms of the duke and duchess, another the duke's helmet, and the last two the instruments of the Passion. Prochno (2002, p. 180, fig. 3) correctly suggests that we envision this lectern based on the lectern by Jan de Joès in Notre-Dame de Tongres.

S.J.

Renate Prochno

The Chapels

In the inventory that was drawn up during the Revolution, the chevet of Champmol is designated as the "chapel known as Saint John's."[1] For the chapel's altar, Jean de Berry, brother of Duke Philip the Bold, made a donation of a thousand *senta aurea*, altar hangings, a silver reliquary containing relics of three Apostles, and an ivory tablet.[2] The altarpiece of the Crucifixion, carved by Jacques de Baerze and painted by Melchior Broederlam, was also located in this chapel; its iconography represented the patrons and protector saints of the donor and his family.

To the left of the choir, the ducal oratory comprised two levels and formed the northern branch of the building's faux-transept. From the summer of 1393, the sources designate the upper chapel with the name "chapelle des angles."[3] Following a mistake in transcription by Monget, the lower level then became known as the "chapelle des anges."[4] It was claimed that this appellation was based on the existence of a frieze or console decorated with angels. In fact, it was a console with two angels bearing coats of arms, which was incorporated into the spiral staircase.[5]

The exterior access was by way of this spiral stairway, which was surmounted by a carved Trinity.[6] The second access, a double portal with *trumeau* (central pier) and doorframe, opened onto steps leading to the choir of the church.[7] A narrow lucarne (dormer) offered a view onto the main altar;[8] a mantelpiece was installed in the western wall.[9] Above the altar, a lancet window was deco-rated with figures of St. Anthony, whose feast day was celebrated on Philip's birthday, and St. Catherine, the patron saint of Philip's wife, bordered by the ducal coats of arms and interlaced initials. Crowning the window, an oculus displayed the figure of God the Father.[10] The north wall contained two large windows[11] that featured repre-sentations of the Virgin nursing the Christ child and of John the Baptist.[12] The pavement was decorated with hunting scenes as well as daisies and broom-flowers, personal emblems of the royal couple;[13] the tilework before the altar depicted the armorial bearings of Burgundy and Flanders[14] (cat. 64). The walls of both lower and upper chapels were covered with oak paneling, called "wood of Illande"; the ceiling vaults of the lower chapel were adorned with boiseries (decorative woodwork).[15] The six clustered pillars and the ribs were entirely gilded; the window-frames, in the form of slim half-columns, were painted in lapis lazuli and decorated from the arch in gilded flowers, as was the case with the double arches.[16]

The altar[17] featured a carved altarpiece, which Jean de Beaumetz gilded in 1390.[18] The central section showed the Death of Mary, her Assumption, and her Coronation, while the lateral wings represented the Annunciation and the Visitation;[19] from these elements, it may be concluded that the lower chapel was dedicated to the Virgin. Such iconography is unusual; we are aware of only one other altarpiece on which were depicted these same scenes from

Fig. 1a

Fig. 1b

Fig. 1c

Fig. 1a.
Fragments presumed to be of the statue of St. John the Baptist from the ducal oratory at Champmol. Dijon, Musée des Beaux-Arts.

Fig. 1b.
Fragment presumed to be of the figure of St. Catherine from the Chapel of the Angels. Dijon, Musée des Beaux-Arts.

Fig. 1c.
Fragment presumed to be of the red cloak lined with ermine from the figure of the suffering Christ. Dijon, Musée des Beaux-Arts.

the life of Mary: that of the chapel of Ternant,[20] which Jean de Ternant and Isabeau de Roye founded between 1444 and 1454, when they had a new chapel, intended to serve as their tomb, built in their castle.[21] Erected above the altar in the ducal oratory was a statue of the Virgin, surrounded by St. John the Baptist (fig. 1a) and St. Anthony, the protector saints of the duke. Jean de Beaumetz covered the sculptures with a layer of gold and clothed St. Anthony in the black garment of his order.[22] There were paintings hanging on the walls of the chapel.[23]

The upper level, the "chapelle des anges," was also furnished with a mantelpiece in the west wall[24] and a lucarne that looked onto the main altar.[25] The windows were furnished with stained glass, which Sluter acquired in Malines.[26] Yet the narrow lucarne that gave a view onto the main altar was never reworked. The boiserie reached all the way to the architraves.[27] The secondary colonnettes and the vault ribs were painted blue and adorned with decorative elements of gold, which was also probably the case with the quoins, carved in the form of interlacing branches. Considering the phenomenal quantities of gold leaf used, it may be supposed that the entirety of the ceiling vault was gilded.[28] On the altar were displayed three ivory tablets, the style of which is linked with those from the Embriachi studio. The first two depicted the Passion of Christ (cat. 66) and scenes from the life of St. John the Baptist;[29] nothing is known of the iconography of the third tablet.[30]

In December 1393, a life-size statue of St. George (cat. 65) was installed in the "chapelle des anges" (ducal oratory),[31] and, like the figures on the portal, this one was never painted.[32] In 1396, a statue of St. Michael, by Sluter, was installed. This work presents an iconographic particularity: here the archangel is engaged not with a dragon, but with a devil in chains.[33] One other occurrence of this motif is known, from Jean de Berry's painted miniatures: his *Belles Heures* are illustrated with a St. Michael killing a black devil with a chain wrapped around his neck.[34] St. George and St. Michael were certainly placed

on pedestals against the north wall, as a balanced pair.[35] They flanked a third statue, of St. Catherine or the suffering Christ.[36] The St. Catherine should unquestionably be attributed to Sluter, as it was carved in the same stone and also unpainted (fig. 1b)[37]. Other fragments[38] allow us to reconstitute the suffering Christ (fig. 1c), but here both the stone used and the mode of working the surfaces are different from those of Sluter, and we cannot

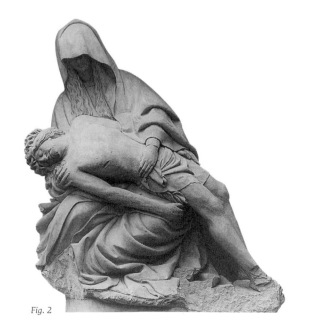

Fig. 2

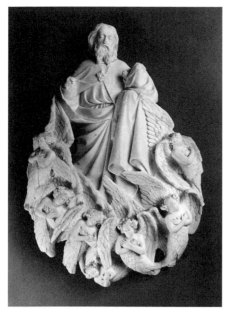

Fig. 3

say with certainty if it is a sculpture by him or, more likely, should be attributed to Marville.[39] In 1394, an "ymage de Dieu" was hung in the "chapelle des anges," affixed with a particularly sturdy metal fastener.[40] This detail leads to the hypothesis that the sculpture may have been suspended from the ceiling; its identification has given rise to much discussion.[41] According to the most plausible supposition, it was a figure of God the Father; a similar motif was discovered on a relief dating from the start of the fifteenth century in Bourges (fig. 3).[42] Another sculpture depicted a "Holy Spirit,"[43] which was probably a representation of a eucharistic dove.[44].

The iconographic plan thus united worldly and eschatological themes. As a knight, St. George was an emblem of the aristocracy. His counterpart, the archangel Michael, was depicted here first as a Christian knight, though his office as the weigher of souls on the day of the Last Judgment was also evoked; furthermore, he was the *princeps militiae angelorum* and patron saint of France. The statue of St. Catherine was present as she was the protectress saint of the duchess and of Flanders. The suffering Christ and the ivory altarpiece depicted the insults inflicted on Jesus during the Passion, leading to the redemption of the human race. All of these representations, alongside the "ymage de Dieu" and the "Holy Spirit," are references to the patronage of the charterhouse. In the final analysis, this grouping of images was an attempt to fit together these two agendas—Christian and political—and thus the political issues and the hopes for redemption and admission to Paradise were treated on an equal footing.

Next, on the north side, was the adjoining chapel of St. Peter, reserved for the first chamberlain and close friend Guy de La Trémoïlle, Sire of Sully (1343–1397).[45] This chapel was reached from the nave, passing via an entryway with two doors.[46] Like the ducal oratory, it was surmounted by two archways on intersecting ribs, supported by six clustered pillars placed at four corners and at the center of the long sides of the rectangle that outlined the building.[47] The arches and pillars were probably painted red, as in the oratory, and decorated in ornate motifs with pewter leaf. On the floor, the ceramic squares matched those on the oratory's pavement.[48] The large windows gave the chapel much light: the one above the altar was in three segments, prominently displaying the chapel's patron saint, framed with ducal coats of arms.[49]

In front of this window was a statue of St. George, probably by Sluter.[50] St. George was the personal patron saint of Guy de La Trémoïlle.[51] In his will, La Trémoïlle had ordered that his tomb be built of marble in the chapel of St. Peter and be topped with the statue of his recumbent figure.[52] In 1398, his widow, Marie of Sully, ordered the construction of the monument;[53] a year later, she gave 200 francs to Jean de Thoiry in payment for its realization.[54] It could be suggested that a pair of hands, today at the Louvre museum, are the only vestige that remains from this recumbent figure, though it has not been definitively established that they derive from Champmol.[55] The documents concerning Champmol mention, beyond the two tombs of the ducal couple, only that of La Trémoïlle; if we accept that the hands at the Louvre derive from the charterhouse, we must then conclude that they are those from the tomb of the chamberlain of Burgundy—and a work, hitherto unindexed, by Jean de Thoiry.

The chapel of St. Agnes was side by side with the portal. The sources do not specify the donor. Its portal,[56] which opened onto the lay brethren's choir, reproduced that in the chapel of St. Peter, as did the vaulted ceiling,[57] the pavement,[58] and the windows.[59] In the window above the altar, there was probably depicted the chapel's patron saint and, above her, the Christian symbol of the pelican.[60] The altar was in all likelihood decorated with a painting by Malouel, illustrating episodes from the life of St. Agnes.[61] Before the window of the altar, Baudot observed a sculpture of the Education of the Virgin,[62] which was not preserved. This work, made by Claus de Werve,[63] was conceived under Sluter's direction; however, it is unknown whether it was de Werve's project, or if he was following an idea of Sluter's. There are numerous carved groups with this same motif to be found in Burgundy (cat. 90).

On the south side, four chapels formed a faux-transept, symmetrical with the ducal oratory. On the ground level, the chapel of the Virgin was exactly opposite it. With the exception of the chapel dedicated to the Virgin, all the chapels were roughcast with limestone.[64] Their pavements

were made with the same squares as in the north section.[65] For architectural reasons, the chapels were lit only by two windows, with three sections each: one over the altar, the other in the eastern façade.[66]

Guillaume de La Trémoïlle, Count of Joigny (c. 1345–1397), counselor and chamberlain of Philip the Bold, Charles V, and Charles VI,[67] endowed the chapel with 2,000 francs and silver liturgical accessories,[68] and he was buried there, before the altar.[69] The portal of this chapel corresponded almost exactly to that of the ducal oratory, which faced it.[70] The central lancet of the window that opened above the altar held a figure of the patron saint of the chapel: a crowned Virgin on a dais.[71] Like the oratory, the chapel had a narrow lucarne from which one could attend Mass celebrated before the main altar.[72] The altar table held a painting by Malouel.[73] The chapel was painted, but there exists no document concerning its iconography.[74]

A simple doorway gave access to adjoining sacristy. Oudart de Chaseron—who had given a donation of 500 francs to the sacristy[75]—was another of Philip the Bold's friends. In the sacristy there was an armoire where the keys to other chapels were kept;[76] there was also a second armoire or coffer, which held the altar-hangings.[77]

Pierre de La Trémoïlle, Lord of Dours, the youngest of the La Trémoïlle brothers,[78] gave the sum of 500 francs to the chapel of St. Martin, which was situated above the chapel of the Virgin.[79] Nothing is known of the possible decorative elements here, neither painting nor sculptures. The altarpiece was of wood, its treatment extremely simple.[80]

The chapel of St. Hugh was located above the sacristy. This place, dedicated to St. Hugh of Grenoble, a Burgundian and Carthusian, was the treasury of Champmol.[81] The window that opened above the altar was adorned with a figurative representation, probably the figure of the chapel's patron saint.[82] This altar too was decorated sparsely.[83] In one coffer were relics and images of small size,[84] in another, the Carthusians' silver money.[85]

Along one of its shorter sides, the chapter room abutted the sacristy; behind the opposing wall was the sacristan's cell. John of Vienna, intimate of Philip the Bold, made a donation of 500 francs for the chapter room, the same sum given to the sacristy and the chapel of St. Martin by their respective donors.[86] Its three naves each had two bays and were simply roughcast in limestone.[87] The three windows that opened symmetrically in the eastern and western façades featured figurative motifs of which nothing is known today; on the lucarnes that opened onto the small cloister were depicted the figures of the Virgin and Christ, as well as St. Peter and St. Paul.[89] The stalls were aligned along the walls.[90] On the altar, from the autumn of 1399, was the Altarpiece of the Martyrs—also called the Altarpiece of the Saints—created by Jacques de Baerze and Melchior Broederlam. The room was also appointed with a pietà and a lectern of forged iron. These two works had been bought in Paris by Philip the Bold.[91] It may have been this pietà that inspired the numerous similar sculptures that we find in Burgundy (fig. 2).[92]

The chapels of the southern flank and the chapter room were essentially reserved for the use of the Carthusians. While the strictly "monastic" chapels were sparingly laid out, in conformity with the Carthusian order's ideal of poverty, and the private chapels of the court sparkled brilliantly, the chapel of the Virgin held the middle ground. At the same time, the iconographic palette used for the decoration of the chapels seems to present two distinct sides: the monks reflecting an emphasis on the veneration that they held for their saints and for the Passion of Christ, and the court demonstrating its predilection—other than the Virgin, depicted in her role as intercessor—for saints who came from various chivalric orders. The spatial separation of the "monastic" chapels from the "earthly" chapels allowed for the fulfillment of the respective needs of both.

NOTES 1. ADCO, Q2 832.
2. Ibid., 1F–16, pp. 187ff.
3. Ibid., B 11672, fol. 73v.
4. Monget 1898–1905, 1: p. 55. See also Lindquist 1995, pp. 64–68, and Prochno 2002, pp. 137ff.
5. ADCO, B 11670, fols. 146v–47.
6. Ibid., Baudot, p. 230.
7. Ibid., p. 223.
8. ADCO, B 11671, fol. 272; Baudot, p. 224.
9. Ibid., Baudot, p. 233; B 11670, fols. 95v, 96, 293v–94; B 11671, fols. 76–76v, 79–79v, 95.
10. Ibid., Baudot, p. 224.
11. Ibid., B 11671, fols. 231–31v.
12. Ibid., Baudot, p. 224.
13. Ibid., B 11671, fols. 292, 292v; B 11672, fols. 22v, 45v; Quarré 1947B; Quarré 1953.
14. Ibid., Baudot, p. 225.
15. Ibid., pp. 224ff.
16. Ibid., p. 225.
17. Ibid., B 11671, fol. 159.
18. Ibid., fols. 353v–54.
19. Georges Lengherand, who visited the Chartreuse de Champmol on 20 February 1486, left us a description of the altarpiece. Smith 1985, pp. 1ff.
20. On the altar of the Virgin, see Journet 1963; Didier 1967.
21. On this new building and the donations made on

this occasion, see Prochno 2002, pp. 147–50.
22. ADCO, B 11671, fol. 348v; Baudot, p. 225.
23. Ibid., B 11672, fol. 19.
24. Ibid., fol. 50.
25. Ibid., B 11671, fols. 272, 345; B 11673, fol. 195.
26. Ibid., B 11673, fol. 197; B 1463bis, fol. 159v.
27. Ibid., B 11672, fols. 13, 47, 50v, 53, 82.
28. Ibid., fols. 58, 88, 88v–89, 122–22v.
29. Ibid., fol. 90v.
30. Ibid., 1F–16, p. 188.
31. Ibid., B 11672, fol. 43v.
32. On the fragments, see Troescher 1932, p. 76; Quarré 1954, p. 252; Mersmann 1969; Bichler 1992, p. 28.
33. ADCO, B 11672, fol. 167v.
34. Prochno 2002, pp. 161ff. The Belles Heures of Jean de Berry, fol. 158r. According to Meiss (1967, pp. 9, 18), the manuscript was illuminated by the Limbourg brothers and completed in 1408–9.
35. ADCO, B 11672, fol. 167v.
36. Prochno 2002, pp. 160–62.
37. Quarré 1954, pp. 252ff.
38. Ibid., p. 253.
39. On the question of attribution see ibid., pp. 253ff; Morand 1991, pp. 325ff; Prochno 2002, p. 164.
40. ADCO, B 11672, fol. 119.
41. A summary of this question can be found in Prochno 2002, p. 162ff.

42. Liebreich 1936, pp. 168ff.
43. ADCO, H 46, Carthusian accounts, 1404–21, fol. 49v; Liebreich 1936, p. 170.
44. David 1951, p. 132, alludes to a "jewel" of Philip the Bold: a "Holy Spirit" "séant en une chaire" and holding "une fiolle," that is, a small bottle holding holy oil.
45. On his biography, see La Trémoïlle 1890, pp. IX–XII.
46. ADCO, B 11671, fol. 209. Baudot, p. 226, indicates measurements of 5.03 x 8.77 m. This difference may doubtless be explained by the fact that at the moment when Baudot made his record, the chapel was obstructed with numerous building elements from the other chapels, which must have made an exact record impossible.
47. Ibid., B 11671, fol. 208v.
48. Ibid., fol. 292v.
49. Ibid., fols. 297, 250. Baudot (p. 226) erroneously identifies this figure with that of Christ.
50. Ibid., B 11672, fol. 74.
51. La Trémoïlle 1887, p. 233ff.
52. Sainte-Marthe 1667, p. 119.
53. The source is cited in La Trémoïlle 1887, pp. 84ff.
54. The source is cited in ibid., p. 88.
55. Louvre 1922, part 1, no. 225; Baron 1996, p. 201. These belonged to the Victor Gay collection and were acquired in 1909.

NOTES 56. ADCO, B 11671, fol. 81.
57. Ibid., fols. 207v, 232v–33; B 11670, fol. 105v.
58. Ibid., B 11671, fol. 292v.
59. Ibid., B 11670, fol. 187v; B 11671, fol. 75v.
60. Ibid., Baudot, p. 227.
61. Ibid., B 11673, fol. 13; Dehaisnes 1886, 2: p. 769; Dimier 1936, p. 208; Prochno 2002, pp. 204ff.
62. ADCO, Baudot, p. 227.
63. Ibid., B 4447, fol. 23v; Roggen 1937, p. 166.
64. ADCO, B 11671, fol. 233v.
65. Ibid., fol. 292v.
66. Ibid., fols. 231–31v, fol. 250.
67. Concerning his biography, see La Trémoïlle 1887, p. 250.
68. Paris, Bibliothèque Nationale de France, lat. MS 13872.
69. ADCO, 1F–16, p. 184, and Le Couteulx 1890, p. 330. The copies of records of deaths sometimes confuse the first names of Guy and Guiot, and thus Guillaume. But on the basis of the donations, which are always identified with the name of their donor,

we can determine with certitude which pertains to whom.
70. ADCO, B 11671, fol. 197; B 11670, fol. 92.
71. Ibid., B 11671, fols. 231–231v. After an error of Monget (1898–1905, 1: p. 135), it was long thought that this source pertained to the ducal oratory just opposite, and thus supposed that this was a sculpture from the studio of Marville, which would have been placed on the upper level, before a window of three sections.
72. ADCO, B 11671, fols. 272, 349.
73. Prochno 2002, pp. 204–06.
74. ADCO, B 11672. fols. 88v–89, 122.
75. Ibid., 1F–16, p. 188f. On the personality of the donor, see Vaughan 1962, pp. 97, 109.
76. ADCO, B 11673, fols. 44v, 50v, 51.
77. Ibid., B 11670, fols. 273v, 276v.
78. La Trémoïlle 1887, pp. 251ff; Vaughan 1962, p. 219; Caron 1987, p. 162; Aubert de La Chenaye-Desbois 1969, in particular pp. 188ff.

79. Paris, Bibliothèque Nationale de France, lat. MS 13872.
80. ADCO, B 11673, fol. 11.
81. Ibid., fol. 50v.
82. Ibid., B 11671, fol. 299v; B 11672, fol. 26.
83. Ibid., B 11673, fols. 44v, 46v, 50v.
84. Ibid., B 11670, fol. 276v; Smith 1985, p. 2.
85. ADCO, B 11673, fol. 106v.
86. Ibid., 1F–16, p. 188.
87. Ibid., B 11671, fol. 233.
88. Ibid., fol. 232.
89. Ibid., fol. 355.
90. Ibid., fol. 271, carved by Jean de Liège.
91. Ibid., fol. 362. On this Pietà from the chapter room, a misunderstanding in the earliest studies of Sluter's work assigned it to him. It was Monget (1898–1905, 1: p. 213) who gave a truncated version of the historical document, so that the Parisian provenance of the statue was no longer mentioned.
92. Liebreich 1936, p. 171.

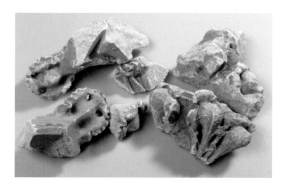

63

Sculpture: **Workshop of Jean de Marville** or **Claus Sluter**

Polychromy: **Workshop of Jean de Beaumetz**

Structural Fragments from the Ducal Oratory

1389–94

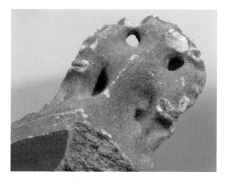

Stone, traces of polychromy and gilding

Dijon, Musée des Beaux-Arts, inv. 4159–22 to 4159–34

Prov.: found during excavations led by Pierre Quarré in 1952 on the site of the oratory of the church of the Chartreuse de Champmol.

Bibl.: Quarré 1952–54, p. 26; Morand 1991, pp. 322–29; Prochno 2002, p. 144, no. 151.

Exh.: Dijon 1990, pp. 49–53.

These fragments, which were found by Pierre Quarré during an excavation of the site of the ducal oratory of the church of the Charreuse de Champmol, are all that remain of decorations that the construction accounts (see Cassagnes-Brouquet 1996, pp. 423–24; Prochno 2002, pp. 143–44) lead us to imagine as particularly sumptuous. One can identify fragments of arcatures, metal foliage, and motifs from armorial bearings, which were probably the stripes of old Burgundy. We know that angels holding coats of arms were installed in several places. The traces of red, blue, and gold perfectly correspond to the references in the accounts: gold and azure, the most expensive colors, were widely used throughout the two floors of

the oratory and apparently relate to the duke's royal lineage. In 1792, Baudot described the lower chapel in the following way: "This vault with two keystones is supported by six pilasters, each of which consists of six columns, all entirely gilded, from top to bottom, even along the vault, and the other columns are painted sky blue with gilded flowers from the point where the vaults begin."

In a church that must have been relatively sober in style, the oratory's splendor was certainly striking. With its wood paneling, its ornamental tiling bearing the ducal coat of arms, its stained-glass windows, and its chimney, it was a truly princely place and probably close to what could be found in the oratories of residences in Dijon, Rouvres, Argilly, or Germolles. This was not the only place in the charterhouse where secular decorative habits swept away the Carthusians' austere aspirations. The parlor, a room situated to the south of the church and opening onto the large cloister, was given a decoration of metallic hop foliage bearing the coats of arms of Burgundy and Flanders, mottos, and the initials "P" and "M." It is the type of decoration that would have suited an "audience chamber," or reception room, in a ducal residence.

S.J.

64

Jean de Gironne, Spanish artisan
hired by Philip the Bold
(active in Dijon, 1383–89)

Four Fragments
**Pieced Together as One Tile with
Burgundian Motifs**

Two Fragments Pieced
**Together as Two Tiles Depicting
the Lion of Flanders**
1383–85

Terracotta glazed with blue and white
faience
Estimated original dimensions of each
tile: 18 x 18 cm

Perrin de Longchamp
(active in Montot tileworks, late
14th century)

Four Tiles with Hunting
Scenes
1388–90

Glazed terracotta, with allover engobe
design
Estimated original dimensions of each
tile: 17 x 17 cm

Five Tiles with Plant and
Geometric Motifs
1388–90

Glazed terracotta, with allover engobe
design
Estimated original dimensions of each
tile: 13 x 13 cm

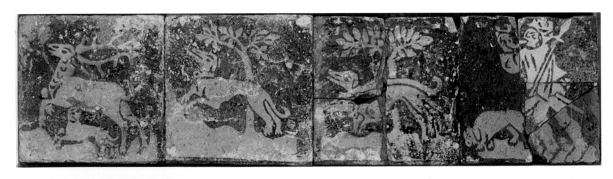

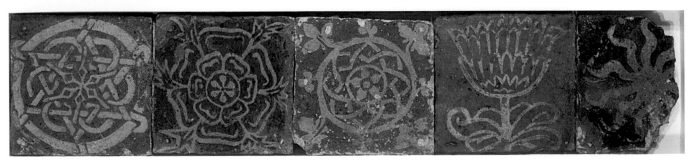

Dijon, Musée des Beaux-Arts,
inv. 4160-1-1 to 4160-1-4, 4160-2-1
and 4160-2-2, 4161-1-1 to 4161-1-4;
4161-5, 4161-6, 4161-7, 4161-8,
4161-10, 4161-11

Prov.: uncovered during excavations by
Pierre Quarré in 1952 at the site of the oratory
of the Carthusian Monastery of Champmol.

Bibl.: Quarré 1954–58; Pinette 1981;
Norton 1984; Bon 1992; Rosen 2001; Rosen
and Picon, forthcoming.

Exh.: Autun 1981; Bourg-en-Bresse 2000,
pp. 66–69.

These tiles, uncovered by Pierre Quarré
in 1951–52,[1] were made using two very
different ceramic techniques. Those
decorated with hunting scenes,
interlacings, roses and rosettes, daisies,
suns, and broom flowers are identical to
tiles found at Germolles and Argilly.[2] They
are bicolor, beige and brown, with a
transparent glaze, decorated with slip, and
fired only once. Made according to the
traditional medieval technique, this type
of tile had been used in upper-class
residences since the thirteenth century.
However, two of these tiles are made of
stanniferous faience, a very expensive
Spanish technique of Abbassid origin that
was at the time a novelty in the
Burgundian region. Faience is fired a first
time and then covered with an opaque
glaze containing a mineral oxide. The coat
of arms—the old bands of Burgundy and
the lion of Flanders—were painted in
cobalt blue on a white glaze before the
second firing.

The archives show that many of the
slip-decorated tiles, and in particular the
ones featuring hunting scenes, were made
by a local tilemaker, Perrin de Longchamp,
and came from the Montot ducal
tileworks in Trouhans, near Saint-Jean-de-
Losne. However, the book of "Accounts of
the Carthusian Monastery, by Louis Pasté"
(1377–86)[3] reveals to us that the maker of
the faience tiles datable to the years
1383–85 is a certain "master Jehan de
Gironne," one of three Spanish ceramists
sent to France by the Duke of Gerone in
1383, at the request of Jean de Berry.[4]
Master Jehan went to the court of Philip
the Bold in Dijon specifically to make
"floor tiles and other tile items for the said
construction site at Champmol [and] to
make colors to paint the tiles" and left in
1389 "without saying goodbye."[5]

While the tilemakers are well identified,
it is difficult to determine accurately the
manufacturing locations. We can confirm
that the Montot tileworks made tiles of
both types: laboratory analyses[6] show that
the clay of some of the faience tiles is
identical in composition to the bicolor slip-
decorated tiles that covered the floor of
the ducal chapel and, undoubtedly, also
the floor of the church and the chapter
room. This is not surprising, as it is well
known that Jehan de Gironne managed
the Montot tileworks from 1383 to 1388,
together with Perrin the tilemaker.[7] The
production of other tileworks was also
used: analysis results indicate that several
tiles could have come from the Aubigny-en-
Plaine workshop, not far from Montot, for
which we have benchmark analyses.[8]

Sometimes materials were brought from
far away: thus, Jehan de Gironne went on
"several trips to Tarpigney across the Saône
[river] to fetch clay to make floor tiles and
other tile items for the building that my
aforementioned lord is having built at the
said Champmol."[9] Finally, one of the
faience tiles has a different composition
and could come from Dijon itself, where
Jehan de Gironne built in 1383 "a large
oven for the said construction site . . . in
the mansion of the lord of Trouhans."[10]
We find here a typical pattern: a foreign
artisan possessing a new technique
becomes the associate of and works for a
time with a local artisan operating within
the traditional structure, before opening
his own workshop. Furthermore, the size
and the importance of the Champmol
construction site required rounding up all
the available experts and simultaneously
using several workshops.

The report of an eyewitness named
Louis-Bénigne Baudot, dated 1792[11] and
written shortly before the destruction of
the building, luckily confirms the
hierarchical placement of these ceramics
in the ducal chapel. The floor was covered
with the slip-decorated tiles, whose
dominant colors were beige and reddish
brown, featuring a hunt cycle repeated
several times and probably bearing also
the symbols of the ducal couple—the sun
and the daisy. The bicolor blue-and-white
faience tiles decorated with the coat of
arms of the duke and duchess were placed
in a privileged location, the steps to the
main altar. The representation of a scene
of dedication to Philip the Good around
1448[12] gives us a pretty good idea of this
placement and the resulting effect. This
arrangement of colors and symbols
following a predefined iconographic
program was probably designed by Jean de
Beaumetz, who was responsible for the
mostly gold and blue wall decorations
(intended to be in harmony with the rest
of the chapel), as well as the stained-glass
windows. The faience tiles allowed white
to be introduced into the decorating
scheme, and even more important, blue,
which was then a real novelty in ceramics.

We should also mention in this respect
the château of Mehun-sur-Yèvre, where
faience floors spelling out in blue and
white the personal emblems of Jean de
Berry, brother of Philip the Bold, were
used in the same period on a much larger
and unprecedented scale.[13]

In spite of or perhaps thanks to their
rarity, these faience tiles symbolically
uniting husband and wife, purposely
placed in the most prestigious and yet
most intimate area of the building, are of
the utmost importance. They point to an
influence of Moslem Spain that is not
apparent in any of the other decorative
elements used in the building. The ducal
chapel in the monastery of Champmol,
a meeting ground for two ceramic
techniques developed in different cultural
universes, is an early harbinger of the
victory two centuries later of faience, the
ceramic of modern times, over glazed clay,
the ceramic of the Middle Ages. Whether
these new tiles were used elsewhere in
Burgundy remains unknown.[14].

J.R.

NOTES
1. Quarré 1954–58, pp. 66–67, 234–40.
2. Autun 1981.
3. ADCO, B 11670, fol. 217, 30 October 1384.
4. Bon 1992.
5. Quarré 1954–58, pp. 234–40; Norton 1984, p. 156; Bourg-en-Bresse 2000, pp. 65–72; Rosen 2001, p. 35.
6. Made at the ceramology laboratory of the Lyon CNRS (UMR 5138), and read by Maurice Picon.
7. Unfortunately, we have not yet been able to locate these tileworks with any accuracy, which could have provided comparison samples crucial for the analysis.
8. It should be noted that this workshop also supplied the pavement tiles for the Hôtel-Dieu of Beaune in 1447, archival data confirmed by laboratory analyses.
9. Étrepigney, in Franche-Comté (across the Saône river), whose kaolinitic clay deposits were well-known in the Middle Ages and up to modern times.
10. This oven did probably lean against the wall of the old fortress tower, known as the St. Bénigne Tower, in what is now the courtyard of the Hôtel Fyot de Mimeure (see Rosen 2001, p. 37).
11. Bourg-en-Bresse 2000, p. 71, no. 6.
12. See "Le livre des conquêtes et faits d'Alexandre," Paris, BNF, MS fr 9342 fol. 5, repr. in Bourg-en-Bresse 2000, p. 70, fig. 8.
13. Bon 1992.
14. Jugie in Bourg-en-Bresse 2000 (p. 71) has already raised this issue.

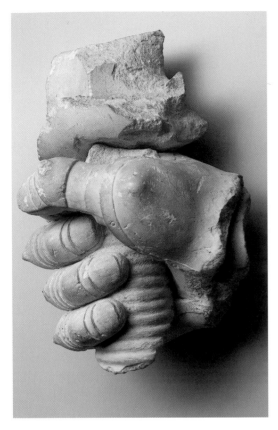

Fig. 1

65

Claus Sluter (d. Dijon, 1406)

Fragments of the Statue of St. George
1392–93

Stone

W. 12 cm

Dijon, Musée des Beaux-Arts, inv. 4159

Prov.: Chartreuse de Champmol.

Bibl.: Troescher 1932, p. 76; Quarré 1954; Quarré 1960C, no. 8; Mersmann 1969; Verdier 1975, p. 67; Didier and Steyaert 1978, 1: p. 57; Morand 1991, pp. 86–87, 119, 316, 322, 325–26; Schmidt 1992, pp. 144ff; Prochno 2002, pp. 160–61.

Exh.: Dijon 1960, no. 17; Dijon 1990.

These fragments of an iron-gloved hand, and the additional fragments of a sword (fig. 1) and the claws of a dragon (fig. 2), as well as elements of drapery, were excavated in 1951 by Pierre Quarré. They are presumed to be parts of a statue of St. George, for which Sluter received a

delivery of stones in 1392 (ADCO, B 11671, fol. 43v), and which was installed in December 1393 in the "chapel of the angels" (ibid., fol. 74v).

The size of the hand leads us to conclude that the figure of St. George was approximately life-size. The dragon's claws, twice as long as the hand of the saint, and the jutting vertebrae on the tail of the monster, indicate that the animal must have had a very frightening aspect. These are also distinguished—as are all of Sluter's works—by an extraordinarily differentiated rendering of the various beings or objects depicted: the horned, scaly skin of the dragon, the metallic polish of the gauntlet. This virtuosity in the representation of textures is characteristic of Sluter.

Returning to an observation of Troescher's, Mersmann notes that the figure of St. George is clearly distinguishable in its style from the figures of saints on the Champmol altarpiece of the Passion (cat. 68), thus indicating that it is a copy of another sculpture. Its lively delicacy contrasts with the monumentality of Sluter's standing figures. Schmidt too supports the notion that this representation of St. George should be interpreted as a kind of distant echo of Sluter's style, rather than following Mersmann's hypothesis that it is a copy.

This hypothesis is also rendered plausible by the existence of another sculpture, in wood, which corresponds to the same model as that of the Dijon

altarpiece (unknown provenance; once in Salzburg, Neuhaus castle, currently in Zagreb, collection Ante and Wiltrud Topic, Mimara Art Collection, H. 52.6 cm). But here—in contrast to St. George on the Passion altarpiece—the figure holds his shield in his left hand, while the visor of his helmet is open, though the knight makes no gesture to raise it. The statue in Zagreb is more coherent than that of the altarpiece—in which the sword is wedged between helmet and shield in such a way that if the saint were to deliver the death-blow, he would strike his own helmet—and evinces less tension in the gesture of his raised hands, which brings it even closer to its model.

Didier and Steyaert (1978, 1: p. 57) find it probable that the sculpture of the altarpiece of the Passion was realized before that of St. George by Sluter; they also infer a direct relation between Sluter's statue and two others. Yet, they refer the woodcarvings of de Baerze to a Parisian model, of the type seen in a French miniature, painted c. 1380–85 (Meiss 1967, 2: fig. 611). In his garb and his bearing, the soldier in that piece, engaged as he is in the Massacre of the Innocents, is "practically identical," as the author writes, to St. George of the altarpiece. But the similarity of garb is dictated by the sartorial styles of the time and does not prove the relation here as that of model and copy.

R.P.

Fig. 2

Workshop of Baldassare Embriachi
(Florence or Venice)

Oratory of the Duchesses of Burgundy
Before 1393

Bone and wood and bone inlay

130 x 75 cm

Restoration by A. Cascio and J. Lévy, 2003

Paris, Musée National du Moyen Âge–Thermes de Cluny, inv. Cl. 17051

Prov.: acquired from M. May, 1848.

Bibl.: Courtépée 1777, p. 247; Barbier 1857, pp. 3, 23–37; Molinier 1896, p. 206; Monget 1898–1905,1: pp. 240–42; Schlosser 1899, p. 241; Koechlin 1924, pp. 9–10; Leeuwenberg 1969; Gaborit-Chopin 1970; Gaborit-Chopin 1978, pp. 170–73; Trexler 1978; Bercé 1979, pp. 329, 331; Tomasi 2001, p. 52.

Exh.: Dijon 1960, no. 56.

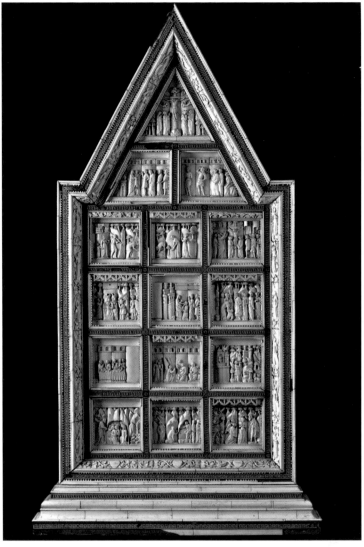

Paradoxically, while the time-honored history of this altarpiece panel, known as the *Oratory of the Duchesses of Burgundy*, is simple, its journey until the nineteenth century, before it entered the national collections, seems complex. Through his manservant Berthelot Heliot, Philip the Bold purchased the work in 1393, along with another panel devoted to the history of St. John the Baptist, and he had it placed in the Carthusian monastery of Champmol, where it remained until the Revolution. Beginning in the late eighteenth century, things became more complicated, since descriptions of the monastery mention not two, but three panels, confirmed by the inventory of the monastery's furnishings, compiled in 1791. Both the subject and the future of this third panel remain unknown, but the two first panels can be traced precisely. Purchased along with the monastery by a certain M. Crétet, they entered the personal collection of Claude Hoin, curator of the Dijon museum, who gave them to a collector, M. Bertholomey. Like many collectors of that time, the latter seems to have taken great liberties with these works, dismantling some to restore others. And so when he sold the altarpiece of St. John the Baptist to Alexandre du Sommerard in 1841, only the medieval frame remained, the rest composed of modern additions of dubious execution. As for the altarpiece of the *Passion of Christ*, he reassembled it, but used pieces from other old works of similar fabrication.

Certain substitutions are obvious, such as the three scenes mounted on a box devoted to the story of Pyramus and Thisbe, where one of the small panels still shows the hole from the lock, or the second Crucifixion scene, placed in the fourth row. Moreover, an examination of modifications the restorer had to make in order to adapt these small panels to the spaces reveals other changes. In fact, the only parts that seem original are the lower row, the two left scenes in the second row, and the two upper rows, with the exception of the small left panel of the left scene in the next-to-last row. Here again, one cannot exclude the possibility that the scene of the baptism, positioned here very early in the chronological sequence, instead came from the panel devoted to St. John the Baptist.

Some of the original pieces that survive are no less revealing of the working methods of the workshop directed by Baldassare Ubriachi, which functioned as a business established by a merchant to respond to the demand for such items. The mediocre quality of the bone, which is often very thin and where the carving for the most part suggests a spongy material, scarcely encourages one to see this piece, the earliest dated production of the workshop, as the result of a commission from Philip the Bold to an artist. On the contrary, it was probably a work produced for the market and acquired by the duke's manservant because it fulfilled certain requirements: a rather grandiose appearance and execution in the manner of Italian art of the time, taking precedence over quality of the materials. In this way it differs profoundly from the altarpiece commissioned by Jean de Berry and offered to the priory of Poissy (Paris, Musée du Louvre).

X.D.

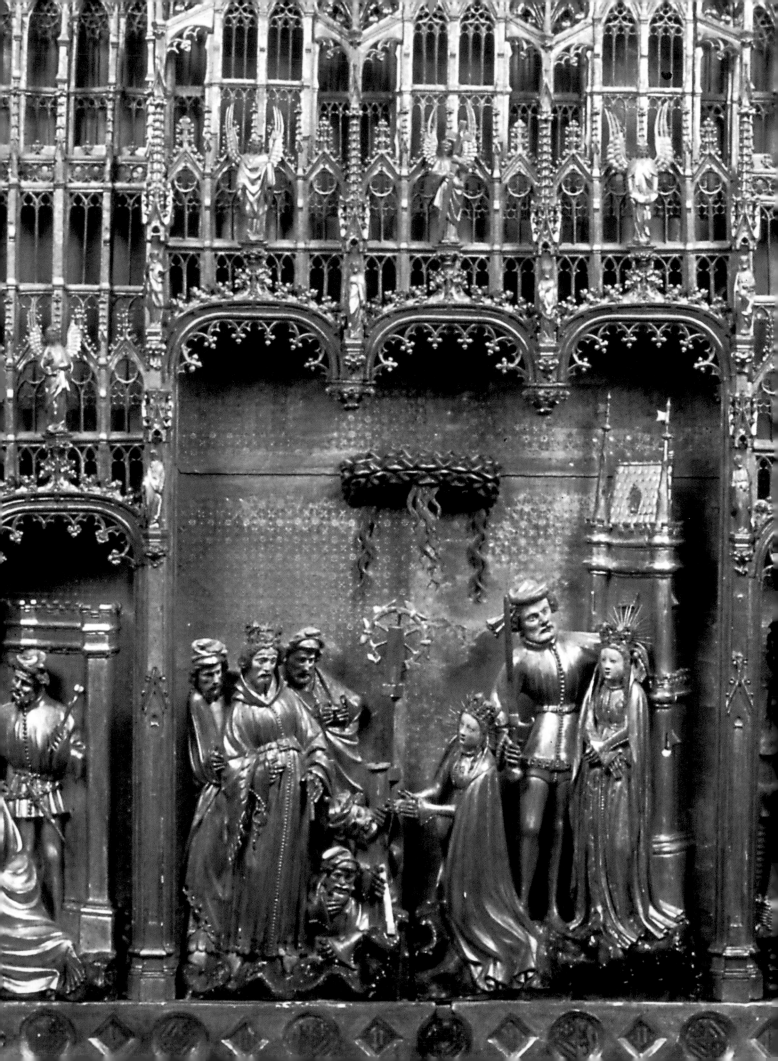

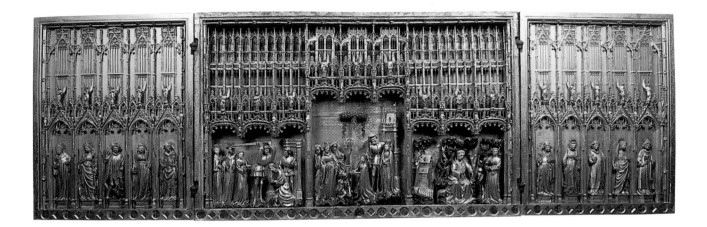

67

Jacques de Baerze (active in Termonde, end of 14th century)

Melchior Broederlam (established in Ypres, activities documented 1381–1410)

Altarpiece of Saints and Martyrs

In the center: the *Beheading of John the Baptist*, the *Martyrdom of St. Catherine* and the *Temptation of St. Anthony*
Left wing: a *Holy Bishop*, a *Holy Martyr*, *St. Michael Fighting a Devil*, *St. Apollonia Carrying Her Tooth with Pincers*, and *St. Denis*
Right wing: *St. Augustine, with the Burning Heart of the Divine Love*, *St. Martha and the Tarasconus Dragon*, *St. Vincent with a Bunch of Grapes*, a *Holy Martyr*, and a *Deacon*
1390–99

Gilded wood and polychromy
H. 159, L. central part 252, L. each wing 125 cm
Coat of arms and initials of Philip the Bold and Margaret of Flanders at bottom.

Dijon, Musée des Beaux-Arts, inv. CA 1420 B

PROV.: originates from the Chartreuse de Champmol, transferred to the Saint-Bénigne cathedral in 1792; transferred to the museum in 1827.

BIBL.: Févret de Saint-Mémin 1847C, pp. 36–40; Dijon 1883, no. 1420; Monget 1898–1905, 1: pp. 201–11; Joliet 1922; Roggen 1934; Quarré 1960C, no. 5, pl. III–V; Mersmann 1969; Didier 1975; Comblen-Sonkes 1986, 1: pp. 70–158, 2: pl. XXXVI–CIX (with detailed bibliography to that date); Bichler 1992; Lindquist 1995; Franke and Welzel 1997, fig. 84; Jacobs 1998, p. 11, repr.; Prigent 1999, pp. 562–64, 566–67, 569, fig. 6; Prochno 2002, pp. 60, 128–36, 188–90.

EXH.: Dijon 1951, no. 117; Dijon 1960, no. 20; Vienna 1962, no. 375; Termonde 1970, no. 42; Ghent 1975, no. 536; Cologne 1978, pp. 56–58.

Exhibited in Dijon only

As the histories of the *Altarpiece of Saints and Martyrs* and the *Altarpiece of the Crucifixion* (see cats. 68, 70) are inseparable, we will describe them jointly. They were commissioned from Jacques de Baerze, a sculptor installed in Termonde, in 1390. It appears that he began work on the altarpieces in Termonde before moving his workshop to Dijon in August 1391. Curiously, the altarpieces were sent back to the Low Countries at the end of 1392, where they were painted and gilded in Ypres by Melchior de Broederlam. Broederlam personally returned the altarpieces to Dijon. In 1399 the two altarpieces were installed. The *Altarpiece of Saints and Martyrs* was placed on the altar of the chapter room, and the *Altarpiece of the Crucifixion* was installed on the altar of the Saint-Jean chapel, which was founded by Jean de Berry behind the high altar.

The accounts also reveal that Jacques de Baerze received an additional commission, in 1394, for a third altarpiece of sculpted wood, intended for the charterhouse's high altar. Yet we do not have many details regarding this altarpiece, which may well have been replaced during the modernization of the church. It is quite likely that the gilded wood altar surmounted by two

angels, described by the erudite Baudot in 1792, was of a later date, for it is not described as "Gothic."

The *Altarpiece of Saints and Martyrs* bears many traces of its illustrious sponsor. The initials and coats of arms of Philip the Bold (quartered shield of France and old Burgundy) and Margaret of Flanders (divided between Burgundy and Flanders) alternate along its lower string course. The lives of the martyrs St. John and St. Catherine and the Temptation of St. Anthony, which appear on the central body beneath arcatures—those in the middle are raised up in order to create an impression of hierarchy and symmetry— were not chosen haphazardly. St. John and St. Catherine, who appear as the duke and duchess's protectors on the portal, were at the heart of the duke's piety and, in general, that of the Valois family; St. Catherine was also associated with the family of the counts of Flanders. St. Anthony was the saint of the duke's day of birth (on these iconographic questions, see Mérindol 1989 and 1992).

Yet the details of the overall iconographic significance of the saints that alternate on the lateral wings escape us. Those saints made recognizable by their attributes were worshiped in the late Middle Ages for their powers of intercession.

These two altarpieces, in which we already find the convention of scenes composed of characters under arcatures— which are beyond spectacular, thanks to their delicacy—are the oldest surviving examples of those Flemish altarpieces in which the cities of Brussels, Antwerp, and Mechelen specialized throughout the fifteenth century and the beginning of the following century. Yet it seems that similar types of altarpieces already existed in Flanders, since the first payment received by Jacques de Baerze for the construction

of the altarpieces, in 1390, specifies that one altarpiece should reproduce the altarpiece of the Termonde church and the other should reproduce the altarpiece at the La Biloque abbey in Ghent. Were these other works by Jacques de Baerze himself? Philip the Bold unquestionably went to Flanders in search of expertise unknown to Burgundian and even Parisian artisans.

The open wings on Jacques de Baerze's sculpture, which are nearly entirely gilded, offer a splendid vision, which explicitly borrows from the goldsmith's art in the indented shapes of the structure, the decorated molding of the flowerets, and the nearly metallic folds of the drapes. The polychromy highlights were meticulously executed.

Mersmann, Didier (and Cologne 1978), and Bichler have paid specific attention to trying to define Jacques de Baerze's style and to place him in a Flemish context. Indeed, though the artist lived in Dijon from 1391 to 1392, it is clear that he was not particularly influenced by Sluter's work. The two altarpieces display remarkable unity, and it remains difficult to define a "progression" from one to the other. The types of characters are echoed by contemporary painting in the Low Countries, such as those seen on the small devotional altarpieces in Champmol (cats. 72–74), perhaps more than by Broederlam's art. As for sculpture, the suggested comparisons with the sculptures of the Bruges city hall (Bichler 1992, pp. 29–30) are very convincing.

S.J.

68

Jacques de Baerze (active in Termonde, end of 14th century)

Melchior Broederlam (established in Ypres, activities documented 1381–1410)

Altarpiece of the Crucifixion (open)

In the center: the *Adoration of the Magi*, the *Crucifixion*, and the *Entombment*
Left wing: *St. George Fighting the Dragon, St. Madeleine with Her Jar of Perfume, St. John the Evangelist with His Poisoned Chalice, St. Catherine with Her Wheel, St. Christopher Carrying Christ*

Right wing: *St. Anthony and His Pig, St. Margaret and Her Dragon, a Holy King with a Sword, St. Barbara and Her Tower, possibly St. Josse of Ponthieu*
1390–99

Gilded and polychromed wood
H. 167, L. central part 252, L. each wing 125 cm
Initials of Philip the Bold and Margaret of Flanders in the frames of the painted wings

Dijon, Musée des Beaux-Arts, inv. CA 1420 A

PROV.: originates from the Chartreuse de Champmol, transferred to the Saint-Bénigne cathedral in 1792; transferred to the museum in 1819.

BIBL.: Févret de Saint-Mémin 1847C, pp. 36–40; Dijon 1883, no. 1420; Monget 1898–1905, 1: pp. 201–11; Joliet 1922; Roggen 1934; Quarré 1960C, no. 4, pl. II, IV–V; Didier 1975; Comblen-Sonkes 1986, 1: pp. 70–158, 2: pl. XXXVI–CIX (with detailed bibliography to that date); Bichler 1992, pp. 23–35, repr.; Lindquist 1995; Franke and Welzel 1997, fig. 85; Jacobs 1998, p. 13, repr.; Prochno 2002, pp. 128–36.

EXH.: Paris 1923, no. 1; Dijon 1951, no. 116; Dijon 1960, no. 19; Vienna 1962, no. 375; Ghent 1975, no. 536; Cologne 1978, pp. 56–58.

Exhibited in Dijon only

The peculiar shape of the altarpiece is what strikes the viewer at first glance, especially when it is compared to the simple rectangular shape of the *Altarpiece of Saints and Martyrs* (cat. 67). Although the raised central section is not surprising, since this technique is familiar from late Flemish altarpieces, the two triangular elements are absolutely unique. Perhaps one should not look to the internal logic of the composition for an explanation, for the triangular elements could have been due to a structural constraint, such as a vault spring, because of the emplacement of the altarpiece by the wall of the church's apse.

The *Altarpiece of the Crucifixion* is dedicated to the childhood and Passion of Christ. It has kept its painted wings, with scenes from the childhood. The sequence is therefore followed from the outside (*Annunciation, Visitation, Presentation in the Temple*) to the inside (*Adoration of the Magi, Crucifixion, Entombment*). Images of particularly venerated saints alternate on the lateral wings. The remarkable figure of St. George, on the extreme left, remains the most admired for the image it gives us of an elegant young knight.

S.J.

69

Jacques de Baerze (active in Termonde, end of 14th century)

Corpus of Christ from the Altarpiece of the Crucifixion
1391–99

Gilded and polychromed walnut
H. 27.9 cm

Chicago, The Art Institute of Chicago, inv. 1944.1370

PROV.: belonged to Paul Buffet, Dijon sculptor who worked on the restoration of the altarpieces; given by Buffet to François Dameron, who died in 1900; his widow, who sold it between 1900 and 1906; collection of Marcel Bing; gift of Honoré Palmer, 1944.

BIBL.: Vitry 1907; Chabeuf 1906–10; Goetz 1950; Bichler 1992, pp. 28–29, fig. 7; Chicago 1993, p. 93; Prochno 2002, p. 133.

Exhibited in Cleveland only

When the Chartreuse de Champmol was closed during the Revolution, the two altarpieces known as "portable chapels of the duchesses of Burgundy" were preserved by the nation, and transferred in 1792 to the old Sainte-Bénigne abbey

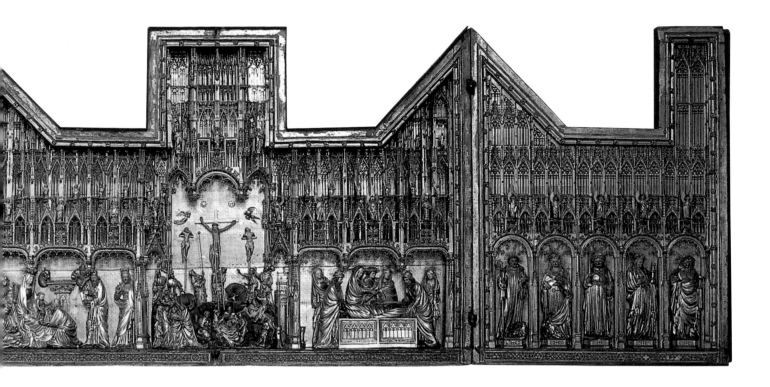

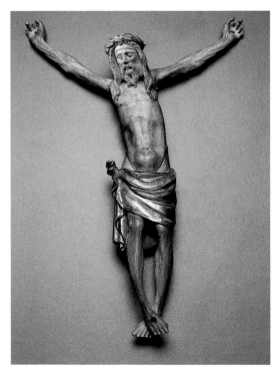

church, which has since become a cathedral. When the church was made into a temple of reason, the altarpieces were stored in a neighboring abbey palace. They were returned to Sainte-Bénigne in 1797 but carelessly stored in a chapel, and their condition probably deteriorated at that time. At the request of Févret de Saint-Mémin, the *Altarpiece of the Crucifixion* was brought into the museum's collection in 1819, as was the *Altarpiece of Saints and Martyrs,* which was more heavily damaged, in 1825. The two altarpieces were restored under the direction of Saint-Mémin and were installed in the guardroom in 1852.

The study undertaken in 2003 by two teams of restorers, Aubert Gérard's team for the *Altarpiece of the Crucifixion* and Laurence Labbe's team for the *Altarpiece of Saints and Martyrs,* made it possible to map the restorations and to learn more about the materials and the techniques used to realize them. The most important nineteenth-century intervention concerned the creation of new wings for the *Altarpiece of Saints and Martyrs.* The arcatures that line the upper part, which do not truly correspond to those on the central part of the altarpiece and are not of the same type as those on the other altarpiece, were rebuilt. The two altarpieces' other arcatures were quite heavily restored, but faithfully, and all the statuettes beneath them are recent. The groups on the central parts of the altarpieces and all but one of the

statuettes of saints on the wings are original. Although the gilding was occasionally heavily retouched, the polychromy is predominantly original and is of extraordinarily high quality.

It is unknown under what circumstances the statuette of Christ was removed from the *Altarpiece of the Crucifixion.* It is possible that it was lost when it was stored at Saint-Bénigne, like the St. George that museum curator Févret de Saint-Mémin bought back from the Lyon collector Carrand, or the king removing his crown from the *Adoration of the Magi,* which de Saint-Mémin bought from a Dijon archaeologist, Joanne. Yet it is more likely that it was replaced by a smaller statuette at the time of the restoration, since the Christ was once owned by the sculptor Paul Buffet, who was among the altarpiece's restorers. Buffet gave it to Paul Dameron, a sculptor and professor of the Dijon school of fine arts who had been his student and who, according to Chabeuf's account, intended to leave it to the Dijon museum.

There can be no doubt that the statuette belongs to the altarpiece. The face with the strong nose is emphatically like the face of Christ in the *Entombment.* The anatomy was very carefully crafted and was clearly made with a concern for realism.

S.J.

70

Melchior Broederlam (established in Ypres, activities documented 1381–1410)

Altarpiece of the Crucifixion (closed)

Left wing: The *Annunciation* and the *Visitation*
Right wing: The *Presentation in the Temple* and the *Flight to Egypt*
1393–99

Oil on wood
Left wing (with frame):
165.5 x 124.9 cm, width of frame 8.7 cm

Right wing (with frame): 165 x 130 cm, width of the frame 11 cm

Dijon, Musée des Beaux-Arts, inv. CA 1420 A

PROV.: Chartreuse de Champmol, transferred to the Saint-Bénigne cathedral in 1792; transferred to the museum in 1819; an in-depth study of the altarpiece was carried out by the IRPA in June 2003, under the direction of Myriam Serck-Dewaide and Cyril Stroo.

BIBL.: Févret de Saint-Mémin 1847C, pp. 1–34; Dijon 1883, no. 1420; Monget 1898–1905, 1: pp. 210–11; Kleinclausz 1906, pp. 253–28, repr.; Tovell 1950, pp. 33–40, ill.; Panofsky 1953, 1: pp. 88–89, 2: pl. 50, Troescher 1966, repr. 79–80; Hinkey 1976; Comblen-Sonkes 1986, 1: pp. 70–158, 2: pl. XXXVI–CIX (with detailed bibliography to that date); Minott 1994; Lindquist 1995; Cassagnes-Brouquet 1996, pp. 436–40; Prochno 2002, pp. 128–36.

EXH.: Paris 1923, no. 1; Dijon 1951, no. 1; Dijon 1960, no. 35.

Exhibited in Dijon only

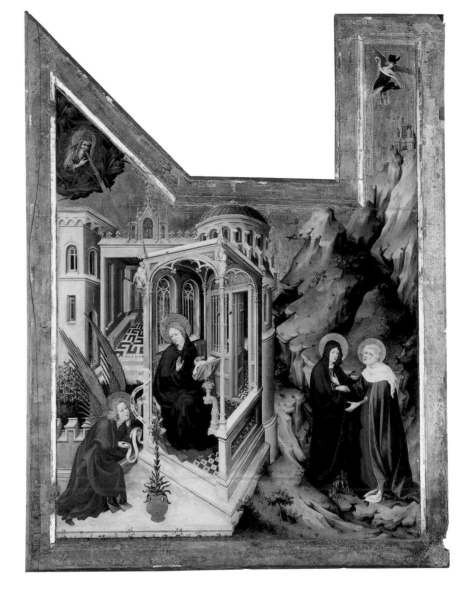

Thanks to the financial accounts of the construction of the Chartreuse de Champmol, the history of the painted decorations of the *Altarpiece of the Crucifixion* (see also cat. 68) and the *Altarpiece of Saints and Martyrs* (cat. 67) is well documented. The two altarpieces are inseparable on this score, despite the fact that the latter lost the paint on its wings, apparently even before the Revolution. At the end of 1392, Jacques de Baerze took responsibility for the transportation of the two Dijon altarpieces to Ypres and delivered them to Melchior Broederlam, who had made a contractual commitment with the duke to paint and gild the altarpieces, and to supply the necessary paints, gold, and tools. He worked with the assistance of collaborators whose names are unknown.

In 1399, Broederlam finished his work and brought the two altarpieces back to Champmol in crates covered in oilcloth. On 14 August 1399, a commission consisting of Sluter, Jean Malouel, Guillaume de Beaumetz (nephew of the late Jean de Beaumetz), the goldsmith Hannequin de Haacht, and members of the revenue court took delivery of the altarpieces. The *Altarpiece of the Crucifixion* was installed on an altar behind the choir that had been founded by the Duke of Berry. It is worth noting that at the time of the original commission, Jacques de Baerze was paid 400 francs for the two sculpted altarpieces, while Broerderlam later received 800 francs for the gilding and painting.

Philip the Bold had therefore gone to his official painter in Flanders, Melchior Broederlam, who had previously been official painter of Louis de Male, for whom he had worked for several years in the Château d'Hesdin. In fact, the panels are the only attested works by Broederlam to have survived to the present day.

Both the gilded background highlighted with punched motifs and the brilliant colors among which the most expensive pigment, ultramarine, stands out testify to the refined and precious quality of Melchior Broederlam's work. His mastery of polychromy is equal to his mastery of wood gilding. Certain details, such as the veil on the manger in the *Nativity*, are extremely

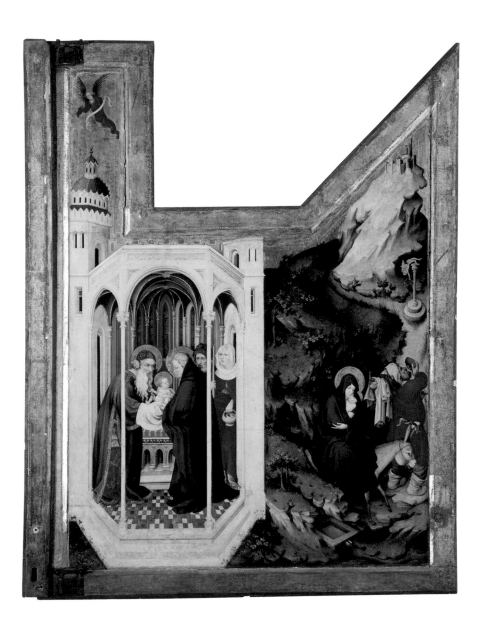

of the *Presentation in the Temple*, which is derived from Sienese masters and, more particularly, Ambrogio Lorenzetti. The paintings also owe a great deal to the art of the Parisian illuminators, in the elegance of the gestures and the drapes and the beauty of the colors. Broederlam's taste for the extremely precise rendering of vegetation in the Virgin Mary's garden, or for fabrics similar to Italian silks, along with his realist touches such as the figure of Joseph drinking in the *Flight to Egypt*, his experiments with perspective and the rendering of light, and the presence of numerous concrete details with symbolic content make Broederlam the precursor of the Flemish primitives. Though we are left with few works by which to judge him, he certainly seems far ahead of the other painters who were active at Champmol.

The particularities of the altarpiece's iconography are absolutely remarkable and deserve extensive study in their own right. Broederlam had to adapt his compositions to the very unusual format of the panels. He resolved the question of the coexistence of two scenes on the same panel by alternating outdoor and indoor scenes. He made the most of the upper indented parts in order to integrate them into the composition.

On the left wing, in the *Annunciation*, the angel kneeling before the Virgin Mary holds a phylactery bearing the evangelical salutation. The painting includes numerous elements symbolic of Mary's virginity (the enclosed garden, the lily, the rays of light passing through the window without breaking the glass), of the Trinity (the triple window, the lamp with three lights), and of the passage from the Old Law to the New Law (the statuettes of the prophets on the portico, the oriental-looking tower contrasted with the Gothic loggia). The encounter between the Virgin Mary and her cousin Elisabeth, who is carrying the unborn John the Baptist, takes place outside. The small trees are not on the same scale as the human figures. The castle on the hill and the bird that flies over the scene link the landscape and the gilded background.

On the right wing, in the *Presentation in the Temple,* the old man Simeon receives the infant Jesus with his hands covered by a veil. Behind the Virgin Mary, Joseph stands with a lady-in-waiting holding a candle and an offering of two turtledoves in a basket. In the *Flight to Egypt,* the Virgin Mary sits on her donkey and carries the infant Jesus, while Joseph walks next to her, with his bundle tied to a stick. As the infant Jesus passes, the idols of Egypt fall over, apparently of their own accord.

s.j.

delicate and can only be seen up close. An in-depth examination confirms the unity that exists between the paintings and the sculptures. Certain fabrics, such as those found in various garments or the material of the cushion beneath the Virgin Mary in the *Adoration of the Magi* or the *Annunciation*, were rendered in the same way, whether in two or three dimensions. Many of the techniques that would be used in the altarpieces of Brabant throughout the fifteenth and sixteenth centuries were already in use here, but at a higher degree of refinement.

Because of their exceptional quality, these paintings are essential landmarks of late fourteenth-century painting. The

bibliography covering these works is considerable: historians have attempted to situate them in the Flemish, German, French, Italian, even Bohemian pictorial traditions, when their quality and ambition is, in fact, without equivalent in contemporary easel painting, or what has been preserved of it. At this level of perfection, the work almost seems difficult to analyze. The art of Broederlam can be considered as emblematic of International Gothic, through the perfectly accomplished synthesis it offers of characters taken from different sources. Broederlam's knowledge of Italian painting is perceptible in the gilded background and the Byzantine-tradition rocks, and also in the composition

Sophie Jugie

The Paintings

The financial accounts for the construction of the Chartreuse de Champmol allow us to know which painters were at work on the site with a degree of precision that is rare for the medieval period.[1] Jean de Beaumetz, who had been hired by Philip the Bold in 1376 as a painter and a valet de chambre, began working at Champmol in March 1387. Jean de Beaumetz headed a workshop that included about ten people but whose exact personnel varied periodically: Arnoul Picornet, his principal collaborator as of 1377, Colin Amant, Perreaul and Jehan Gentilhomme, Jacques de Bar-sur-Aube, Girart le Fort de La Rochelle, Guillemin Gasse, Huguenin and Thévenin Marin, Henri de Bâle, then the painters Horriot, Girart de La Chapelle, Guillaume de Francheville, Girard de Nivelles, Torquin de Gand, Jean Chataul. Until May 1388, this team was busy working on the church's paneling, which consisted of the "lymandes," panels covered in painted canvas that were used to form the vault, and a "lyte" (litre), a large horizontal band running at the base of the vault decorated with the ducal armorial bearings. Starting in March 1389, the workshop set to work on the mural decorations and the polychromy of the statues in the oratory, then of those in the other chapels.

The same team was responsible for the creation of the altarpieces and the devotional paintings. In March 1389 Jean de Beaumetz and his workshop made twenty-four panels (plus two for the prior) representing "The Crucifixion with the Virgin Mary and the holy women, St. John, and a Carthusian." These panels were intended to assist the Carthusians in individual meditation in their cells. Two of these panels have survived to the present day, one in Paris (cat. 71b) and one in the Cleveland Museum (cat. 71a). Though their general composition is identical, notable differences exist between the two panels. The most obvious differences are in the gold background, which is solid in the Paris panel, but decorated with a setting of punched branches in the Cleveland panel. There are also more subtle differences in the way the rendering of the figures was conceived and in the varying degrees of the colors' brightness. These differences can evidently be explained by the participation of Jean de Beaumetz's collaborators Girart de La Chapelle and Jean Gentil. Beaumetz was also commissioned to make a large altarpiece, for which the wood panel was provided by the carpenter Jean de Fenain. In 1390 Beaumetz was paid for a triptych with the *Crowning of the Virgin Mary* in the center, the *Annunciation* on the right, and the *Visitation* on the left. The triptych was placed in the lower chapel of the oratory.

After Beaumetz's death on 16 October 1396, Jean Malouel was chosen to be appointed painter and valet de chambre on 5 August 1397. In 1398, he was remunerated for an altarpiece representing the apostles and St. Anthony intended for the upper chapel of the ducal oratory. Yet we have no information concerning the iconography of other panels of which Malouel was put in charge and that were delivered by the carpenter Daniel Hobel. Malouel also continued working on the mural decorations, including the paintings in the Saint-Jean chapel, the walls of the parlor, and the top of the doors leading from the small to the large cloister, from the small cloister to the church, and from the large cloister to the parlor. He was also responsible for the polychromy of the *Well of Moses* (1402), then of the tomb of Philip the Bold (1410).

Malouel's successor, Henri Bellechose, was appointed as painter on 23 May 1415 and received a payment on 23 May 1416 for paints intended "both to perfect a painting of the life of St. Denis and to make a painting of the passing of the glorious Virgin Mary." Historians have extensively discussed the term "perfect." They have speculated that the work in question was begun by Malouel and completed by Bellechose, or that the altarpiece was made by Bellechose alone, which, given the painting's homogeneous style, is a more plausible hypothesis. The *Altarpiece of St. Denis* (fig. 1) was intended for installation on an altar in the lay choir. The *Death of the Virgin Mary* was not necessarily intended for the charterhouse.

Three small altarpieces also seem to originate from Champmol, but with varying degrees of certainty, and it has proved impossible to specify where they were placed. They are first mentioned in the Revolutionary inventories or in inventories of nineteenth-century collections. The altarpieces in question are the *Triptych of the Trinity* in Berlin (cat. 72), the *Tabernacle of the Virgin Mary* in Antwerp (cat. 73), and the *Polyptych of the Life of Christ* shared by Antwerp and Baltimore (cat. 74). None of these precious altarpieces, whose scale tend to suggest private devotional practices, can be attributed to the workshop of Jean de Beaumetz, at least in so far as it is defined by the two Calvaries with Carthusians. The altarpieces resemble late fourteenth-century Dutch production. Were they painted in the ducal workshop? Were they specifically made for Champmol or were they bought in Paris or Flanders? Were they due to a ducal commission or were they offered as presents by members of the ducal entourage? The examples set by the *Altarpiece of the Crucifixion* (cat. 68) and the *Altarpiece of Saints and Martyrs*, sculpted by Jacques de Baerze and painted and gilded by Melchior Broederlam (cat. 67), prove that the duke did not deprive himself of the services of artists outside of Dijon and Paris.

Curiously, an equally precious but far earlier work of Italian origin could also be found in the charterhouse: *The*

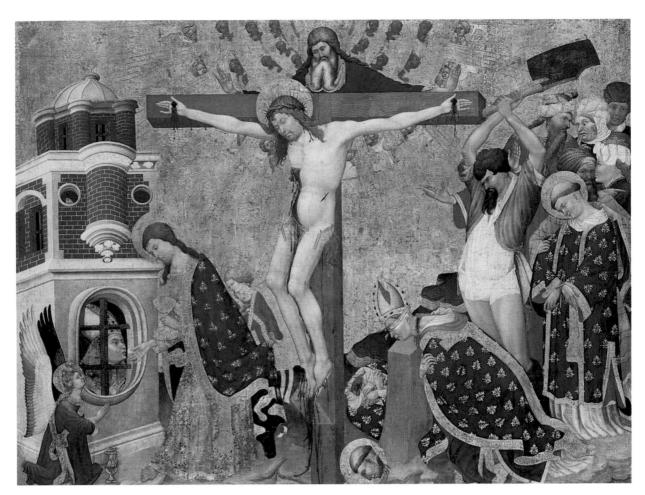

Orsini Polyptych, a recognized work by Simone Martini dating from about 1330, currently shared by museums in Paris, Antwerp, and Berlin. It might have been presented as a gift by Cardinal Orsini, the papal legate in France, when he promulgated indulgences for pilgrimages to the charterhouse in 1418. The date agreed upon for the polyptych's arrival in Champmol obviously determines our judgment of its influence upon the style of Jean de Beaumetz, who could have become acquainted with the school of Siena through other sources.

It must finally be mentioned that the portraits of the dukes of Burgundy—at least the first three—were in the church's choir. They are mentioned for the first time at the

end of the fifteenth century, and served as models for numerous sixteenth- and seventeenth-century replicas. Evidence of the commission for Philip the Good's portrait was traced back to a Dijon painter, Jean de Maisoncelles, and the year 1436, but it is likely that the portrait of Philip the Bold was placed in the choir from the beginning, and that his successors merely carried on the tradition. During a period when portraiture was starting to become a genre in its own right, Philip the Bold was certainly inspired by Flemish examples. The Champmol portraits were probably intended both to maintain the memory of the founder and his descendants among the Carthusians, whose mission it was to pray for them, and to affirm the dynastic continuity.

NOTES 1. Given the abundant bibliography concerning the art of Champmol, and the fact that all the works contemporary to the construction of the charterhouse, with the exception of the *Altarpiece of St. Denis,* are in the exhibition, we have taken the liberty of referring the reader to the explanatory notes concerning individual works, and of limiting additional references to Cassagnes-Brouquet (1996, pp. 406–61, 471–72) and Prochno (2002, pp. 54–58, 195–206, 210–11), which abundantly cite both sources and the bibliography.

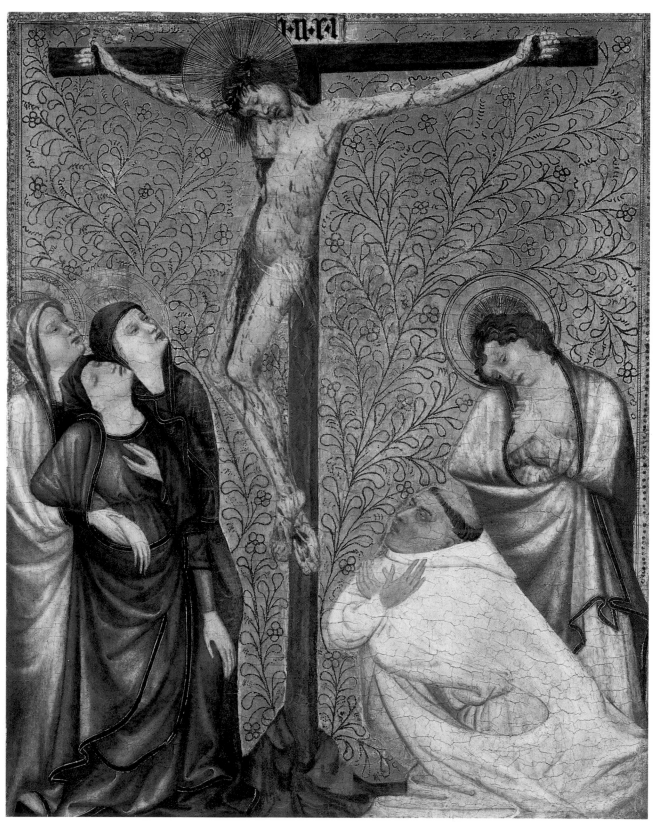

71a

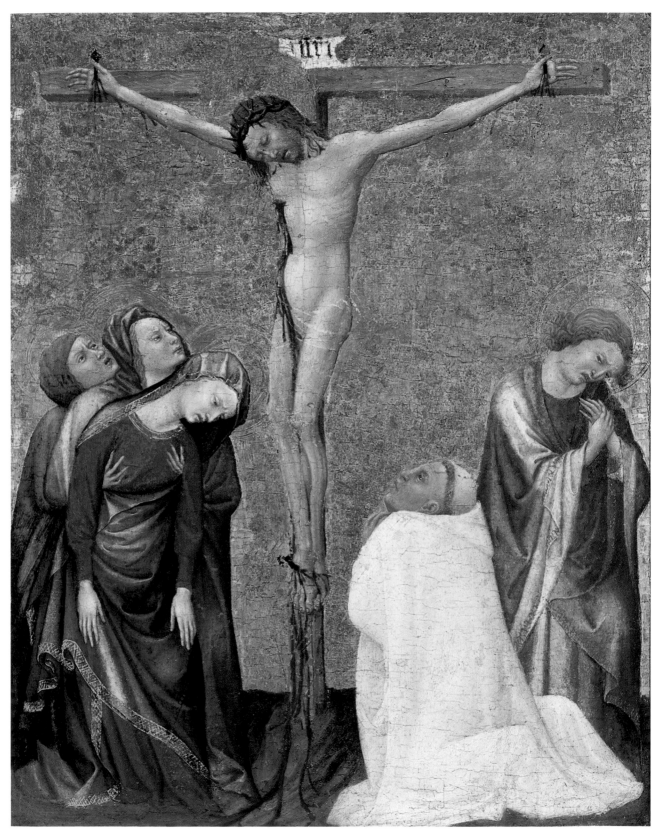

71b

Previous pages

71A–B

Jean de Beaumetz (c. 1335–1396) and assistants

Calvary with a Carthusian Monk (two panels)

c. 1389–95

Oil on oak panel

71a: 56.5 x 45.5 cm

Cleveland, The Cleveland Museum of Art, inv. 1964.454

Exhibited in Dijon and Cleveland

71b: 60 x 48.5 cm

Paris, Musée du Louvre, RF 1967-3

Exhibited in Dijon only

PROV.: Cleveland: Chartreuse de Champmol, Dijon; private collection, Dijon; Wildenstein & Co., New York acquired then bequeathed by Leonard C. Hanna Jr. **Louvre:** Chartreuse de Champmol, Dijon; Lyon Chalandon collection.

BIBL.: Sterling 1955, pp. 57–81; Francis 1966, pp. 329–38; Troescher 1966, pp. 37–59, nos. 8, 9; Wixom 1974, pp. 12–15, no. 5; De Winter 1976, pp. 217–37; De Winter 1987, pp. 407–49; Hedeman 1995, pp. 191–203.

EXH.: Paris 1981, no. 326 (Louvre painting only).

Jean de Beaumetz became official court painter to Philip the Bold in 1376 and was immediately put to work on an enormous variety of tasks designed to reflect the rising position of the duke, including the painting of more than 2,800 escutcheons and flags. Most important were the decoration of the ducal residences at Rouvres, Germolles, and Argilly, and the embellishment of the newly constructed Chartreuse de Champmol—including gilding the rooster on the sanctuary's steeple—which would house the ducal tombs. At the height of his activity Jean de Beaumetz employed up to nineteen assistants in a busy workshop. Between 1389 and 1395 he was occupied with paintings to decorate the cells of the chartreuse—one for each of the twenty-four Carthusian monks (double the usual apostolic number), with two additional paintings destined for other areas of the monastery. The date of this commission is known from existing receipts documenting the delivery of twenty-six oak panels (1388), canvas to be stretched over the panels before the application of gesso (1389), and gold for the gilding of the

panels from the Dijon merchant Thévenin de Sens (1389). Unfortunately, the documents fail to mention the subjects of the paintings; however, the measurements of the oak panels correspond closely to those of the Louvre and Cleveland paintings, making them the only two known to have survived from this grand project (Sterling 1955).

Strikingly similar in composition and palette, the paintings are clearly derived from a shared source. A strong Sienese influence suggests that Beaumetz had studied works such as Simone Martini's *Orsini Polyptych*, which was in Champmol about 1400. The emotional quality and the wrenching figure of Christ are reflections of the Crucifixion in the polyptych, as is the detail of the double gold band that trims the garments in the Cleveland painting. Although similar in composition, there are obvious differences between the two paintings, such as the punched decoration representing the Trees of Life and Knowledge in the Cleveland picture that emphasize the biblical connection between Adam and Christ. The contrast in style and details can be attributed to the participation of assistants such as Girart de la Chapelle (De Winter 1976, p. 234). We can assume that the other paintings in the series used the same formula, each with a Carthusian in the act of devotion.

The Carthusians were particularly devoted to the Passion of Christ and images of the Crucifixion were common in their cells and charterhouses; even the *Well of Moses* (pp. 212–19) supported a Calvary scene. Isolated in their cells, the monks were encouraged to contemplate the sacrifice of Christ as described in early texts such as the *Meditatio vita Christi* by Ludolf the Carthusian (d. 1372) and the *Exposito Missae* by Denys the Carthusian (d. 1471), which specifically encourages the monk to "place his hands on his chest in the form of a cross, in order to express the prayer and the desire to acquire the grace by the virtue and by the merits of the passion of Christ and of his cross," a gesture illustrated in the Cleveland panel. According to these writers, the contemplation of the crucified Christ (aided by the monk's presence at the foot of the cross), produced an empathetic connection with the suffering of the Virgin who "fainted away . . . as if dead in the arms of Mary Magdalen." This idea, and the dramatic emphasis on the blood and wounds of Christ, are described by the Carthusian Guigo de Ponte (d. 1297) in *On Contemplation*: "Be present at his dying to suffer and sorrow with his blessed Mother and blessed John the Apostle, and, with a certain godly curiosity, touch and

feel with your hand each of the wounds your dead Savior suffered for you." The Carthusians considered this compassion, or *co-passio*, important for individual salvation.

T.H.

72

Low Countries

Triptych: The Trinity

Late 14th century

Linden wood

Central panel: 36 x 32 cm

Lateral wings: 36 x 16 cm

Berlin, Gemäldgalerie, inv. 1688

PROV.: Chartreuse de Champmol; mentioned in 1791 in the inventory of objects seized; Henri Baudot sale, Dijon, 1894, no. 12, as originating from the Chartreuse de Champmol; on the Cologne art market, 1895; gift of the heirs of E. F. Weber, Hamburg, 1912.

BIBL.: Monget 1898–1905, 3: p. 78; Michiels 1877, pp. 44–45; Friedländer 1912, col. 285; Chabeuf 1909–13; Berlin 1931, p. 331; Lemoisne 1931, p. 53; Hoogewerf 1936, 1: p. 102; Dupont 1937, p. 15; Ring 1949, no. 29; Panofsky 1953, p. 112; Evans 1958, p. 154; Troescher 1966, p. 56; Verdier 1975, fig. 44–54; Berlin 1975, pp. 296–97; Török 1985, p. 13, fig. 6; Cassagnes-Brouquet 1996, 3: pp. 434–35, 4: fig. 21; Prochno 2002, p. 201, fig. 101.

EXH.: Bruges 1902, no. 2; Paris 1904, no. 8; Dijon 1960, no. 36; Vienna 1962, no. 11.

Exhibited in Dijon only

The triptych, of quatrefoil shape, represents the Trinity in the form of the enthroned Holy Father holding Christ on the cross, who is linked to him by the dove of the Holy Ghost. This figure is set in an eight-pointed star whose contours are defined by a frieze punched into the gilded background. Four angels present the instruments of the Passion in the four foils. On the lateral wings, the Evangelists are seated before lecterns on high-backed seats featuring tracery. They are writing under the dictation of their attributes.

The triptych is described in the 1791 Revolutionary inventory of the Chartreuse de Champmol: "a hinged wood frame

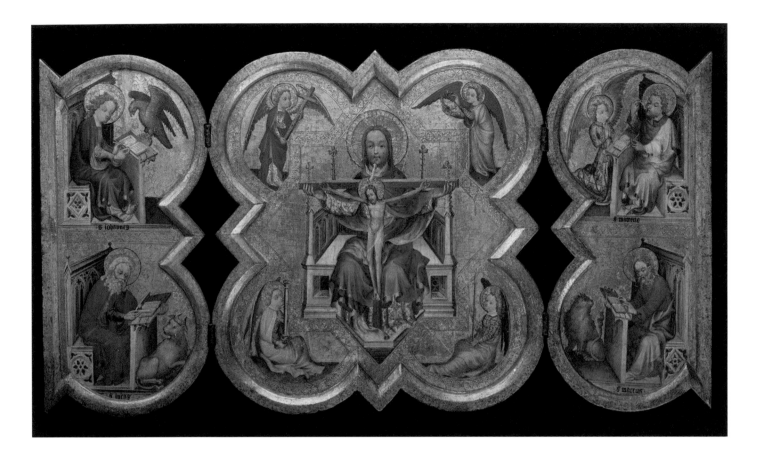

representing Christ and the four Evangelists." At the time, it was kept among the charterhouse's treasures. Sold in 1792, the triptych passed through the collection of the Dijon scholars of the Baudot family, who preserved a record of its origin, which was mentioned in the catalogue of the Henri Baudot sale in 1894.

Though the origin of the triptych can be considered to be definitively established, no earlier trace of it has yet been found in the sources. Thus whether it entered the charterhouse as a commission or as a gift, when it arrived, where it was kept, or, because it was obviously an altarpiece for personal worship, for whom it was intended are not known. Given that the monks' cells each contained a Calvary with Carthusians, it is not unreasonable to imagine that other devotional panels could have been at the monks' disposal. Both the theme of the Trinity and of writing, as illustrated by the Evangelists, were perfectly adapted to the Carthusians.

The triptych takes the unusual shape of a quatrefoil. Beginning with the early fourteenth century, this format was frequently found in sculpture, where it served as a frame for narrative cycles. It was used in the same way in manuscript painting, and with ivory. However, it is exceptional to find it used to define the exterior contours of an independent object: it appears to be an *unicum* in easel painting.

Since the 1930s historians have been aware of the stylistic differences between this painting and the pieces made by the workshop active in Champmol. They have generally agreed that it is probably the work of a Dutch artist, made shortly before 1400, though their opinions diverge on its exact origins and its link to French art. Currently ongoing studies of pre-Eyckian primitives will probably allow for more specific information.

S.J.

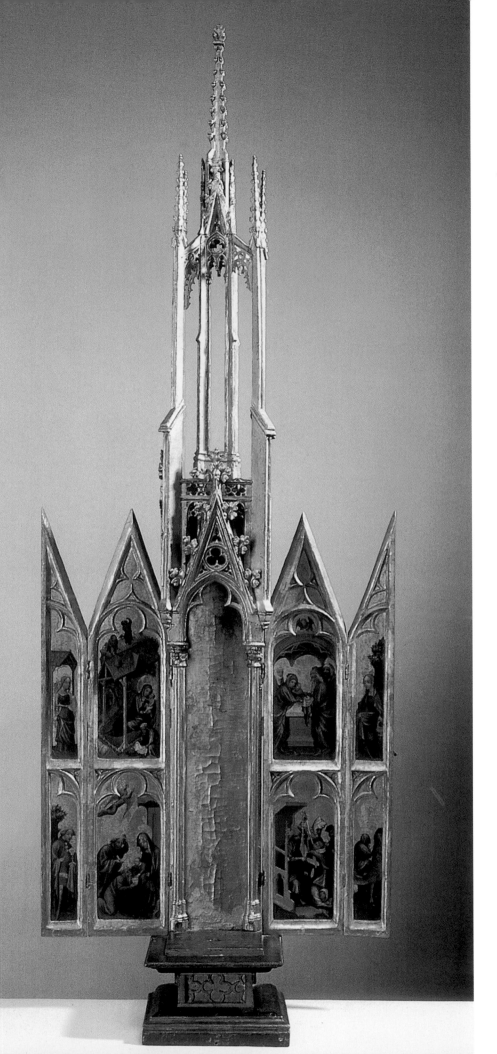

Altarpiece in the Form of a Turret, with Scenes from Christ's Childhood
c. 1390–95

Gilded oak; wings painted in interior
137 x 47.5 x 12 cm
Outer panels: 58 x 11 and 63 cm

Antwerp, Mayer van den Bergh
Museum, inv. no. 2

PROV.: from the Bartholomey collection, Dijon (Paris sale, 13 January 1843, no. 74), reported to have come from Champmol; acquired with the Carlo Micheli collection, from Marie Micheli heiress, in Paris, in 1898.

BIBL.: *Collections du chevalier Mayer Van den Bergh*, pp. 19–20, no. 2; Michel 1924, pp. 42–43; Barnes and De Mazia 1931, pp. 361–62; Jacques 1941, p. 12, no. 1; Ring 1949, p. 194, no. 21; Panofsky 1953, pp. 95–96, 395, no. 95; Sterling 1960, p. 76, no. 6; Troescher 1966, pp. 109–11; Frinta 1967, p. 113; Lapaire 1969, pp. 178–79, 188; Lane 1973, p. 198, no. 64; De Coo 1979, pp. 120–23, no. 359; Van Buren-Hagopian 1986, pp. 107–10; Smeyers 1992, pp. 75–76, 86; Proske-Van Heerdt 1995, p. 116; Smeyers and Cardon 1996, p. 160; Bähr 1996, pp. 96–97; Della Latta 2001, pp. 67–69; Prochno 2002, pp. 199–201; Stroo 2002, pp. 1273–294; Mund, Stroo, Goetghebeur, and Nieuwdorp 2003, pp. 202–53 (with exhaustive bibliography).

EXH.: Cologne 1974, pp. 30, 108–9, 178.

This altarpiece in the form of a turret, with its cycle of paintings depicting Christ's childhood, was recently restored and cleaned, and has been the subject of renewed examination and research. Cyriel Stroo's study of it—the first and only considered critical analysis of the altarpiece, despite the fact that the work is well known and has been frequently mentioned in the literature—was published very recently (Stroo 2002; Mund, Stroo, Goetghebeur, and Nieuwdorp 2003). Here, we can only summarize the most important arguments and conclusions, within the context of this exhibition.

The Antwerp altarpiece is neither a complete work unto itself nor a portable altar. It is a fragment of a larger, monumental piece. In all likelihood this element topped an altarpiece carved in wood, as was common in the Low Countries (there are several representations, in miniatures and paintings, that testify to this, but the Antwerp example is apparently the only one of its kind that has been preserved). While it has been suggested that this work might have surmounted an altarpiece by Jacques de Baerze in Dijon, it is more likely that it

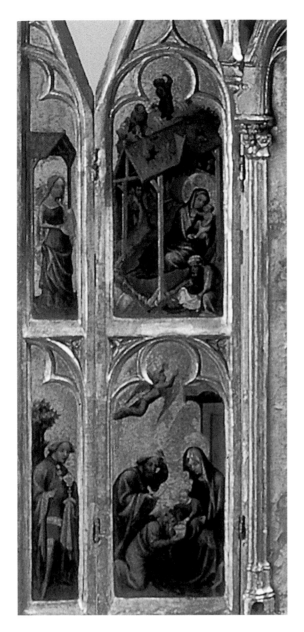

stood atop an altarpiece depicting scenes from Christ's Passion, in which case the scenes from his childhood would take on, by association, a eucharistic significance.

The painter was plainly familiar with miniatures from the ateliers of the Master of the Parement of Narbonne and of Jacquemart de Hesdin, and so must have been active in Paris around 1380. He would thus have been familiar also with the most recent works in French painting; the small format of the paintings on the outer panels of the Antwerp altarpiece bears comparison with the work of the miniaturists employed by the Duke of Berry. At the same time, this artist clearly had an intimate knowledge of the works of Melchior Broederlam, Jacques de Baerze, Jean de Liège, and Claus Sluter, all of whom worked for the Duke of Burgundy in the 1390s. In his style, and in certain iconographic details, this artist reveals himself to be both firmly rooted in the current of pre-Eyckian realism, and at the same time making use of stylistic and thematic models of the Flemish (that is, Brugeois) mode so much in force at the time. He was unquestionably of Flemish stock, but among the "Franco-Flemish" artists who made their careers in France in the service of the Valois.

This work is particularly distinguished by the superb finesse in the ornamentation of its gilding, in which are depicted patrons who bear a strong resemblance to those in De Baerze's altarpieces in Dijon. If this gilding was not the work of the painter, but that of a specialist gilder, it would not be out of the question to suppose that it might have been the same artist, and that his work on the Antwerp altarpiece is simply of higher quality than that at Dijon—a possible result of the latter piece's larger format.

This is the work of a superior artist—who in several respects may be compared to the painters of the Cardon chapel (Paris, Musée du Louvre), of the quadriptych at Antwerp and Baltimore (Mayer Van den Bergh Museum and Walters Art Museum), and of the diptych at the Bargello in Florence—an artist who is still to be identified among the names of the greatest painters of his era.

H.N.

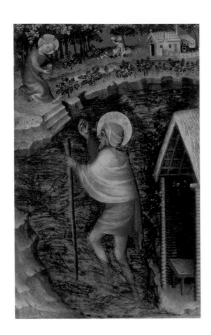

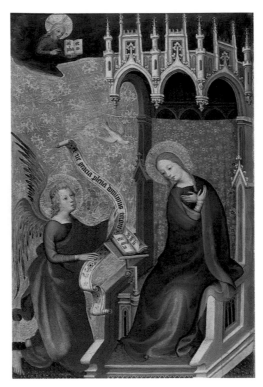

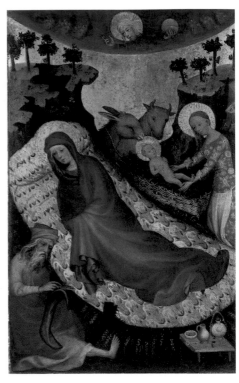

74

Burgundian

Antwerp-Baltimore Quadriptych

c. 1400

Open: *Annunciation* (a), *Nativity* (b), *Crucifixion* (c), *Resurrection* (d)

Closed: *St. John Baptizing Christ* (e, reverse of a) and *St. Christopher* (f, reverse of d)

Linseed oil silver and gold leaves on oak panel

a/e and c: 38 x 26.5 cm

b and d/f: 37.6 x 26.2 cm

Inscribed in black paint:
Annunciation panel: al / pha / et Ω;
Ave gracia plena dominus tecum; Ecce / ancil / la / do / mi / ni
Crucifixion panel: ego / sum / via / vitas; .i.n.r.i.; eloy eloy lamasabatani
Resurrection panel: Gloria in excelsis deo et in terra; .Sanctus.Sanctus. Sanctus.Sanctus

Panels a/e and c: Baltimore, Walters Art Museum, inv. 37.1683 A-C
Panels b and d/f: Antwerp, Museum Mayer van den Bergh, cat. 1, no. 374

Prov.: Antwerp panels: acquired in 1898; Baltimore panels: acquired in 1939.

Bibl.: (selected): Sterling 1938, pp. 36, 37, 40, 150; Panofsky 1953, pp. 93–95, 97, 127, 394–95 n. 447b; De Coo 1958; De Coo 1960; Cutler 1968, pp. 23–24; Meiss 1974, pp. 97, 279; De Coo 1979, pp. 123–29; Châtelet 1980, pp. 21–24, 190–91, no. 5; Nieuwdorp, Guislian-Witterman, and Kockaert 1984–85, pp. 70–98; Zafran 1988, no. 34; Nieuwdorp 1994; Gifford, Halpine Lomax, and Schilling 2003, pp. 107–16; Nieuwdorp and Goetghebeur 2003, pp. 255–87.

Exh.: Paris 1904 (Baltimore panels); Brussels 1951 (Antwerp panels); Detroit 1960, no. 2 (Baltimore panels); Vienna 1962, no. 12 (Antwerp panels); Baltimore 1962, no. 24 (Baltimore panels); Amsterdam 1994, no. 43 (Antwerp and Baltimore panels reassembled).

This quadriptych, a masterpiece of Burgundian court art of around 1400, is reassembled from panels separated by the early nineteenth century and now in the Walters Art Museum and Museum Mayer van den Bergh. It is recorded in the Chartreuse de Champmol before 1772–74 and was apparently used by Philip the Bold as a private devotional image that folded up, accordion style, for transport on his travels.

The theme is the divinity of the incarnate Christ and the certainty of his promise of salvation. The interior depicts the signal moments in Christ's human

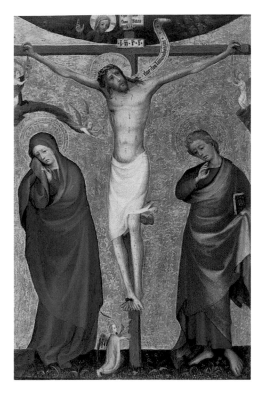

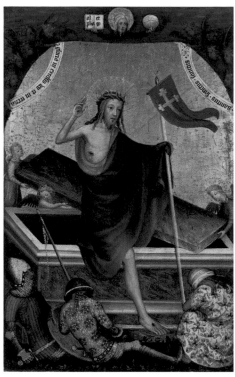

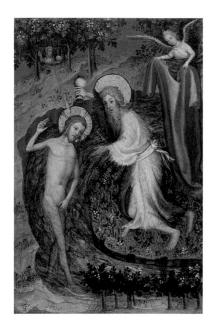

existence—his miraculous conception and birth coupled with his death and resurrection—while the exterior features the revelation of his divinity to St. John the Baptist, the duke's patron saint (Nieuwdorp 1994), and to St. Christopher, protector of travelers. Throughout, traditional elements are combined with homely or unusual ones to prompt meditation. The key is the presence in the *Annunciation* and *Resurrection* panels of God holding a book inscribed with alpha and Ω, the beginning and the end, which does not refer to the beginning and end of Christ's life (Panofsky 1953, Nieuwdorp 1994). As the title of God found in Revelation (1, also 21, 22): "I am Alpha and Omega, the beginning and the ending, saith the Lord, which is, and what was, and which is to come, the Almighty," it is a reminder that the divine promise of salvation held out by Christ's incarnation, death, and resurrection is eternal and certain because God is almighty. In the *Annunciation*, the words of the Virgin's submission to the divine are in a book for her to read; her role in the incarnation was preordained. That Christ was fully human as well as fully divine is charmingly evoked in the *Nativity*; the donkey and ox warm the naked newborn with their breath, while Joseph, in a vignette hardly depicted outside the Rhineland, cuts up his hose for swaddling (of which a relic was venerated

in Aachen). The crucified Christ is shown at the ninth hour when, echoing words from Psalms, he cried: "My God, My God, why have you forsaken me?" The moment was then rarely chosen for art, but it was a focus for meditation by the widely read fourteenth-century mystic St. Bridget of Sweden, in recognition of the doubts that even the most devout may experience. The sequence ends with a conventional interpretation of the Resurrection, Christ stepping out of his tomb.

Examination of the Baltimore panels (Gifford, Halpine Lomax, and Schilling 2003) established linseed oil as the primary medium and the use of pure pigments for colors. In passages such as the drapery, the red lake or ultramarine pigment is mixed with white lead so that the colors exhibit the opacity associated with egg rather than the saturation expected of oil. Perhaps oil was chosen for its preservative qualities while the aesthetic goal was to conform to a traditional look. Nevertheless, the translucency of oil was exploited in glazes over gold leaf for both the ethereal, rainbow-hued feathers of Gabriel's wings and the muddy water around Christ's legs.

The combination of stylistic modes suggests that the artist was trained in the Middle Rhine but executed the paintings in the ambiance of the court. The most thought-provoking attributions situate the

origins of the painter in Guelders (Panofsky 1953, Châtelet 1980), but the present state of knowledge is insufficient to confirm this assertion. The homely or amusing anecdotal detail (as the fish in the rivers), red skies, and loose brushwork on the exterior, as well as the proportions of the figures, point to the Middle Rhine, while the opulence of the interior with the subtle tooling of the gold leaf, as well as the sophistication of the theme, point to princely patronage.

J.S.

Marie-Françoise Damongeot-Bourdat

The Manuscripts of the Chartreuse de Champmol

"To continually cultivate and practice the contemplative life." This was the vocation of those monks who "ceaselessly prayed day and night for the salvation of souls," as stated in the charter of the Chartreuse de Champmol on 15 March 1384, by the Duke of Burgundy. The charterhouse's program also required that the young monastic community be provided with books for the divine service and for individual reading in the monks' cells.[1]

Starting at the end of 1384, Prior Nicolas LeSaintier could be seen "coming, going, and laboring in various places to put together the writings of said books." In 1386, a copying workshop was installed right in Champmol, where professional scribes such as Jehan Le Roux and Jehannin de la Rose took turns working alongside the monks. This workshop remained active for many years. The work dedicated to the preparation and acquisition of books reached its peak in the 1390s, as evidenced by the detailed accounts held by the monk Thiébaut de Besançon from 1389 to 1398. In Dijon and the surrounding area, parchment makers, calligraphers, illuminators, and bookbinders such as Jehan du Moulin and Jacquin Le Clerc were asked to contribute. Parisian booksellers including Jean de Brunech, who came to work in Champmol, Yves Gorgent, and Pierre Damedieu were also called upon. Most of the orders placed were for liturgical books: breviaries, psalters, prayer books, antiphonaries, and missals. Ornamentation was sober, as befitting the Carthusian order: "Illuminate with azure and vermilion and decorate the letters with flowers" is the most commonly found description in the accounts. Only those books intended to be placed on the church altar received a more luxurious treatment. In 1389, the prayer book and the Epistles copied by Thiébaut de Besançon were sent to Paris to be illuminated and bound. The prayer book was bound with two sheets of gold with a clasp by the goldsmith Hennequin de Bruges. For a volume of the Gospels copied by the same monk, Jacquin Le Clerc was asked to make paintings, or "histories," and to create illuminations in gold and azure. One can also follow the preparation of a volume of the Gospels copied by an anonymous monk in that same year. The quires were ruled in Paris by Jean de Brunech, then decorated with three paintings, twenty-five illustrated letters, and four hundred gold and azure letters by an unidentified artist. The final step was the addition of silver clasps bearing enameled medallions carrying the coat of arms of the Duke and Duchess of Burgundy, and made by the same goldsmith, Hennequin de Bruges.[2] However, it is possible that this volume was produced to be offered by the Carthusian monks to their benefactors.

Besides the liturgical books, a library made up principally of theological and spiritual books took shape. Today, we can identify its contents, thanks to the titles given in the accounts. The accounts list the purchase from the Parisian bookseller Yves Gorgent of two volumes of an *Exposition sur la Bible* (Exposition on the Bible) that correspond to the exegetic treatise of the Franciscan Nicolas de Lyre, the transportation from Paris to Dijon of a *Decret* (Decree) by Gratien, and a *Dictionnaire* (Dictionary) in three volumes that was none other than the *Repertorium morale* (Moral Repertorium) by Pierre Bersuire, and, also in Paris, the purchase of Johannes Balbi's *Catholicon*. In Dijon, the bookseller Jehan du Moulin provided a Raymondine, which is the *Summa casibus* by Raymond de Peñafort, as well as a collection of practical medicine entitled *Le Trésor des pouvres* (The Treasure of the Poor). Brother Thibaut also did business with the nuns of the Cistercian abbey in Lieu-Dieu sous Vergy (diocese of Autun) in order to obtain a Bible in two volumes and a copy of St. Gregory the Great's *Dialogues*. Works of spiritual literature written in French can also be noted in the collection: a copy of the famous work by Guillaume de Digulleville, the *Pelerinage de l'humaine peregrination* (The Journey of Man as a Pilgrimage), *L'esguillon de l'amour* (The Stimulus of Love), a translation of *Stimulus amoris* by St. Bonaventure, and the *Chastel perilleux* (Perilous Castle), an work of edification by Robert le Chartreux, which was dedicated to a nun at Fontevrault.

Only a few volumes from this abundant collection have been found. The municipal library in Dijon has a beautiful breviary (MS 116) and an antiphonary (MS 118), both of which were made in Paris, a missal made in Dijon (cat. 75), as well as a ritual (MS 617) and a gradual (MS 1646).[3] Another gradual is in New York (cat. 76). However, two newly identified volumes have recently been added to the list. The first is an antiphonary located in Cape Town, in the National Library of South Africa (MS 4c7). This manuscript, part of the collection donated in 1861 by Sir George Grey, governor of the Cape Province, was recently the subject of a detailed study.[4] The calligraphy and the simple filigreed decorations date the book to the end of the fourteenth century. The copy's contemporary ex libris, "Hic liber est domus sancte Trinitatis ordinis cartusiensis prope Divionem," leaves no doubt as to its origin. Like manuscript 118 in the Bibliothèque Municipale, Dijon, it may have been one of the three antiphonaries written in Paris by Pierre Damedieu and entered in the accounts in 1398.

For our part, we suggest that the beautiful Carthusian breviary conserved in the Hamilton collection at the Berlin

Fig. 1

Staatsbibliothek (Ham. 115) is another manuscript from Champmol.[5] The decorations consist of initials painted on a gold background and extended by a line supporting a framing of foliage made up of gold frames mixed with fruits and flowers. The quality of the illumination and the calligraphy denote the work of a Parisian workshop that, according to François Avril, could date from the years 1410–15. The consecration feast of May 24 was entered in red in the calendar shortly thereafter, and May 24 happens to be the exact date of the consecration of Champmol's church. The volume, which bears no inscription identifying its owner, was part of the collection belonging to the Duke of Hamilton (1757–1862), which contained several manuscripts acquired from Burgundian abbeys. A final determining factor can be found in the very modest decorations on the back of the eighteenth-century binding: a plain floweret imprinted in gold between every band of leather. This characteristic branding can be found on a great many printed volumes that came from the charterhouse and have been kept in the Municipal Library of Dijon. Therefore, this breviary, whose sober decoration shows great refinement, demonstrates that the Carthusians' taste for beautiful books did not come to a conclusion with the end of ducal subsidies in 1398, and that the monks continued to call on the best Parisian illuminators to produce their liturgical books.

NOTES 1. See Monget 1898–1905, 1: pp. 183–91 and 409–20; De Winter 1976, pp. 64–65; Cassagnes-Brouquet 1996, 1: pp. 449–58; 3: passim.
2. ADCO, H 46, first sheaf, fols. [2] and [3v].
3. Zaluska 1991, nos. 195–97, 232, 237.
4. Steyn 2000.
5. Boese 1966, no. 550.

Fig. 1.
Breviary from the
Chartreuse de Champmol,
MS Hamilton. Berlin,
Staatsbibliothek, Ham.
550, fol. 40v.

75

Jacquin Le Clerc
(b. Brittany, d. 1389?)

Carthusian Missal for the Ordinary Service. Crucifixion
Late 14th century

Manuscript on parchment; 299 folios 38 x 26 cm, 2 columns; folio 3 verso, "Iste liber est ad usum sancte Trinitatis ordinis cartusiensis prope Divionem" (contemporary to the manuscript); folios 4–9 verso, calendar used by the Carthusian monastery; folio 153, miniature extending beyond the column margin (14 x 9.5 cm) representing the Crucifixion, burnished gold and paint cover, checkerboard background, frame of gilded beading embellished with a diamond shape at the corners; folio 153, historiated initial by another hand, representing Christ enthroned, holding a sphere and a cross, at the beginning of the *Teigitur*; folios 289 verso–299, mass for the duke and the duchess [of Burgundy] added; binding from the late seventeenth century

Dijon, Bibliothèque Municipale, inv. MS 117

Prov.: Dijon, Carthusian monastery at Champmol.

Bibl.: Monget 1898–1905, 1: p. 188; Fyot 1916, p. 270; De Winter 1976, pp. 64, 356–57, fig. 167; Zaluska 1991, p. 232; Cassagnes-Brouquet 1996, 1: pp. 449–58, 3: pl. 32.

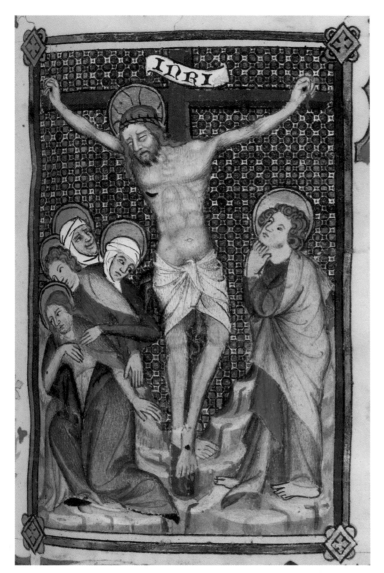

76

Dijon, Chartreuse de Champmol

Gradual
1470

225 folios
36 x 24 cm

New York, The Pierpont Morgan
Library, MS M.115

PROV.: Chartreuse de Champmol; Théophile
Belin; J. Pierpont Morgan (1837–1913);
J. P. Morgan (1867–1943).

BIBL.: Peignot 1841, p. 81.

This manuscript gradual, along with a
missal now in the Dijon Bibliothèque
Municipale (MS 117), are among the few
service books to survive from the monastic
scriptorium at the Chartreuse de
Champmol. A colophon (fol. 225) dates
the gradual to 1470 and localizes it to
Champmol. The contents of the
manuscript include chants for the Mass,
beginning with the introit for Advent. The
calendar includes the feast of the
dedication of the Chartreuse de
Champmol to the Holy Trinity on 2 May.
Obits of dukes and duchesses of Burgundy
occur throughout the calendar.

The decoration of the manuscript is
conservative. It features two large
historiated initials: a Trinity of the
"Gnadenstuhl" type on folio 130 verso
and a seated Virgin and Child attended by
an angel on folio 188 verso. The gradual
also includes numerous pen and ink
flourishes and designs throughout, often
caricatures of monks and bishops. In
honor of the founders of the Chartreuse
de Champmol, the coat of arms of Philip
the Bold impaled with those of Marguerite
of Flanders appears on the margins of
folios 15, 126, 130 verso, and 196 verso.
The arms of the chartreuse itself
(quarterly Burgundy modern and ancient,
supported by two lions) appear on folios
107 and 188 verso. This manuscript
appears in the 1477 inventory of the
library of the dukes of Burgundy.

S.N.F.

Installed in 1384 in a barn of the manor
of La Motte, and placed under the
direction of Dom Thiébaud of Besançon,
the scriptorium of the Carthusian
monastery at Champmol employed many
illuminators of Breton origin until 1398.
These included Jacquin Le Clerc, who was
working here on 20 February 1388, with
Jehan du Moulin, scribe and illuminator.
Employed by the Carthusian monasteries,
they decorated, among other things, a
breviary, a psalter, a martyrology, a group
of collects, and the Gospels. Le Clerc is
mentioned one final time in a ledger from
1389 as an illuminator who received "for
the Canon for a Missal, 1 francs, 8 and one
half gros." The phrase refers to the central
decorative element of manuscript Dijon
117, one of five manuscripts in Dijon that
came from the Carthusian monastery: a
large-scale miniature, facing the Sanctus.
To the left of the Crucifixion is a group
that includes, in the foreground, the
Virgin, swooning and supported by a
haloed figure dressed in red, and in the
background, two female saints dressed in
blue robes and wearing white turbans. At
the right, St. John, his hand beneath his
chin, raises his eyes toward Christ. The
presence of steep boulders shows an Italian
influence, but also recalls the style of the
Flemish artist Melchior Broederlam,
painter and valet de chambre to the duke
from 1385 to 1404, who worked at the
Carthusian monastery.

D.D.

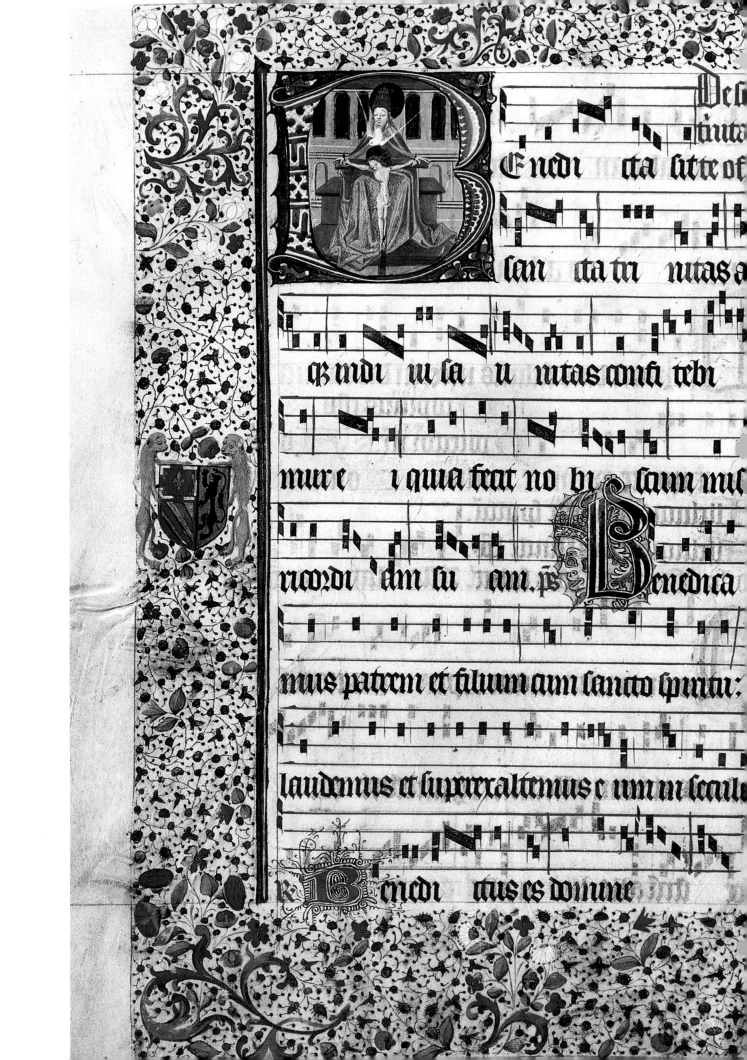

Renate Prochno

The Well of Moses

At the center of the cloister, a hexagonal fountain was built, from the middle of which rises a tall pillar, also hexagonal, adorned with the figures of six prophets; six weeping angels hover above them. Originally, this pillar was topped by a crucifix, at the foot of which were the figures of the Virgin Mary, St. John, and Mary Magdalene. This fountain, crowned with this Calvary group, thus served as both a cemetery cross as well as an irrigation source for the monastery's orchard.

The Calvary figures disappeared during the course of the eighteenth century, thus the prophets are the principal remaining elements. Baudot dubbed this fountain *Le Puits de Moïse (The Well of Moses)*, and the name has been retained.[1] In their capacity as prophets, these figures seem to gaze upon a visionary horizon, or upon their own inner hearts.

The paint that remains is a vestige of Jean Malouel's first version of the piece;[2] its effect is comparable to that of paintings on panel of the same era.

Because a few fragments have been conserved—and with the help of numerous fifteenth-century copies of the work—it is possible to reconstitute the calvary group of Champmol. The figure of Christ is approximately life-size. Mary Magdalene kneels at the foot of the cross, which she clasps, her face turned toward heaven, while Mary and St. John stand beneath the instrument of torture. Mary crosses her arms over her chest, and her eyes are lowered, fully accepting her destiny. St. John raises his eyes to the crucifix, his hands clasped together.

One extant drawing[3] is a rendering of a copy of the *Well of Moses,* which Guillaume Sacquenier, commander of the Order of the Holy Spirit and the abbot of Baume-les-Messieurs, had built in 1508 for Dijon's Hôpital de Saint-Esprit. In contrast to the preceding monument, this carved pillar topped with a calvary group was not connected to a fountain; also, it was never painted. The lower part of the original, with the prophets, has been preserved (at the general hospital, Dijon), while the Crucifixion group has disappeared. Unlike its model, the

Fig. 1.
The Well of Moses.

Fig. 2.
Drawing by Calmelet of the replica of the *Well of Moses* at the Dijon general hospital.

Fig. 2

hospital's cross had two crosspieces—this became the symbolic emblem of the Order of the Holy Spirit.

The fountain of Champmol was built between the spring of 1395 and the summer of 1404.[4] First, the figures of the Crucifixion group were carved and positioned; the angels came next, followed by the prophets. The three groups were painted in the same order. In July 1399, the cross and the figures of Christ and Mary Magdalene were erected on the pedestal of Golgotha.[5] The gilding on the cross and the painting on the other elements began in the first weeks of the summer of 1400,[6] followed in the spring of 1402 by the statues of the Virgin Mary, St. John, and the six angels.[7] Also in the spring of 1402, David, Moses, and Jeremiah were added to the monument[8] to be painted.[9] At the end of the

213

summer of 1402, the three figures beneath the cross, the angels, and the first three prophets received the final touches.[10] The second trio of prophets was carved during the course of 1403.[11] In the final weeks of 1403, or at the beginning of 1404, Zachariah, Daniel, and Isaiah took their places.[12] At this point began the construction of the edges of the well[13]—which had not been erected at an earlier point, as they would have obstructed the work of installing the sculptures. The painting of the monument was probably finished during the summer of 1404. The current covering dates from 1638.[14]

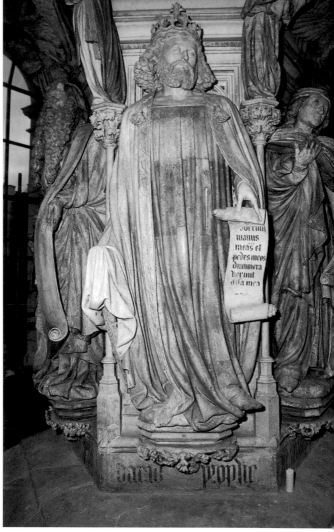

Fig. 4

Fig. 3

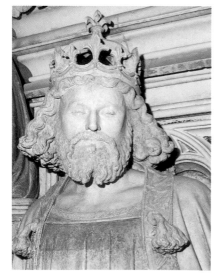

Fig. 4a

Fig. 3.
Replica of the *Well of Moses* at the general hospital.

Figs. 4–4a.
David.

Fig. 5–5a.
Jeremiah.

Figs. 6–6a.
Zachariah.

Figs. 7–7a.
Daniel.

Figs. 8–8a.
Isaiah.

9–9a.
Moses.

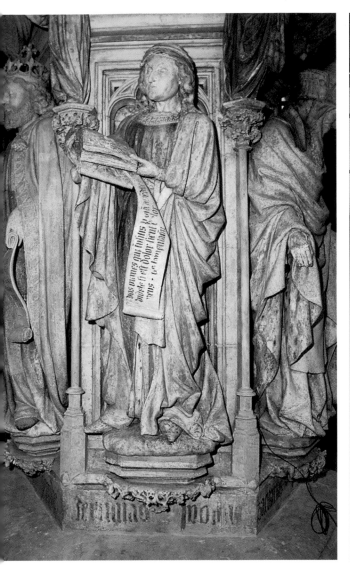

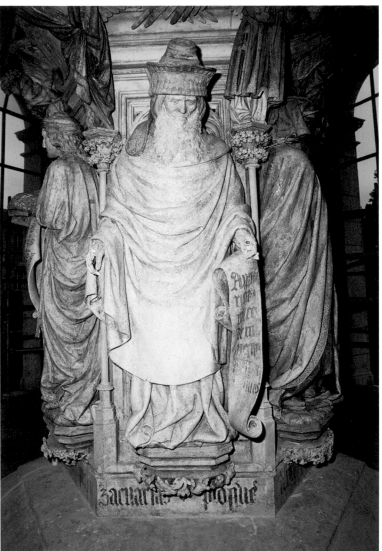

Fig. 6

Fig. 5a

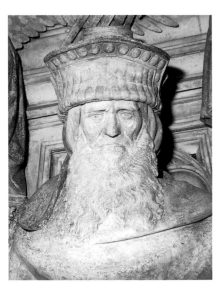

Fig. 6a

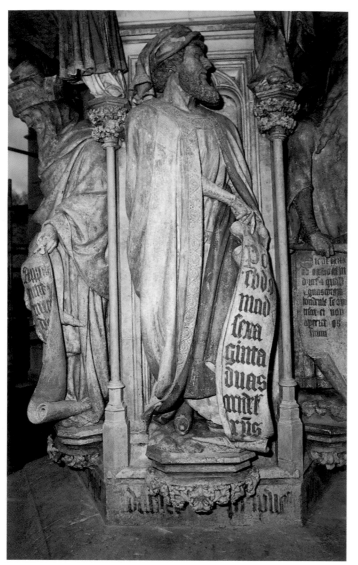

Fig. 7

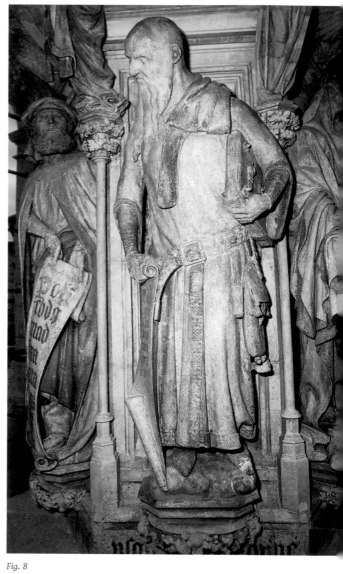

Fig. 8

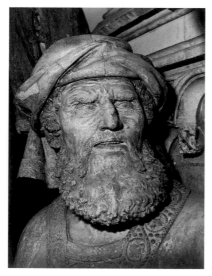

Fig. 7a

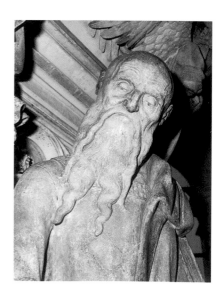

Fig. 8a

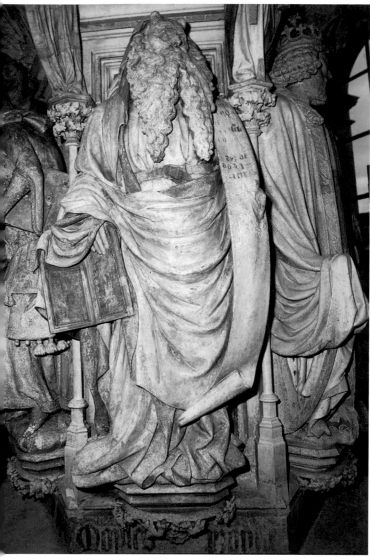

Fig. 9

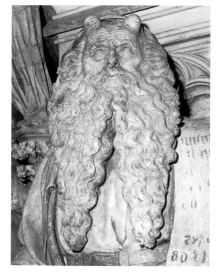

Fig. 9a

The calvary group survived intact until the first half of the eighteenth century[15] and was completely destroyed in 1791 up to the crucifix.[16] In 1841–42, Févret de Saint-Mémin replaced fragments of sculpture found at the bottom of the "well."[17] Other fragments were kept at the archaeological museum, where all trace of most of them was subsequently lost. In 1946, a cleaning of the monument was undertaken.[18]

In 1418, Cardinal Giordano Orsini, legate of the Holy See in France, granted an indulgence of fifty or even one hundred days to all who came to visit the monument to make prayers and give donations to the cloister.[19] In 1432, Cardinal Nicolo Albergati, a Carthusian from 1395 and general of the order from 1407, renewed this indulgence.[20] A third indulgence was decreed in 1445 by the legate Pierre du Mont (Petrus de Monte), bishop of Brescia and ambassador of the Holy See in France.[21] In 1506, Pope Julius II forbade female pilgrims from visiting the *Well of Moses*, as the monument was located within the monastery and there was fear that the sight of the women might disturb the spiritual peace of the monks. However, as their donations were still accepted, women were not deprived of the benefit of the indulgence.[22]

The *Well of Moses* symbolizes the typological interaction between the Old and New Testaments: the prophets announce the Passion of Christ, and the angels deplore his inexorable destiny, which will be fulfilled ultimately in the Crucifixion. Through the angels, Sluter and Malouel created an unprecedented representation of this traditional theme. In the depiction of the Trinity in the *Large Round Pietà*, attributed to Malouel (p. 94, fig. 1), the gestures of the angels weeping for the death of Christ show a striking similarity to those of the angels in the *Well of Moses*. It should not be overlooked also that in both cases the number of angels is six, and they are characterized in both as very young, almost infantile. It is fairly rare to find six young grieving angels in Christian iconography; the coincidence is thus unlikely to be merely fortuitous. The question of whether to attribute this innovation to Sluter or to Malouel remains open.

There is no known precedent of a sculpted fountain with such a combination of motifs—prophets, angels, and Crucifixion—that might have served as a model for Sluter's work. Despite its monumental character, the *Well of Moses* was executed with the greatest attention to detail. The paintings and the gilding add to the impression of being in the presence of a massive "jewel"—as in the ducal oratory. In citing possible sources of inspiration for the formal conception of the well, we should turn to *orfèvrerie*, or goldwork: the structure—with its figures erected on a polygonal pedestal, topped with a Crucifixion and several personages—follows a current model of a table fountain, in particular.[23] Noted in several inven-

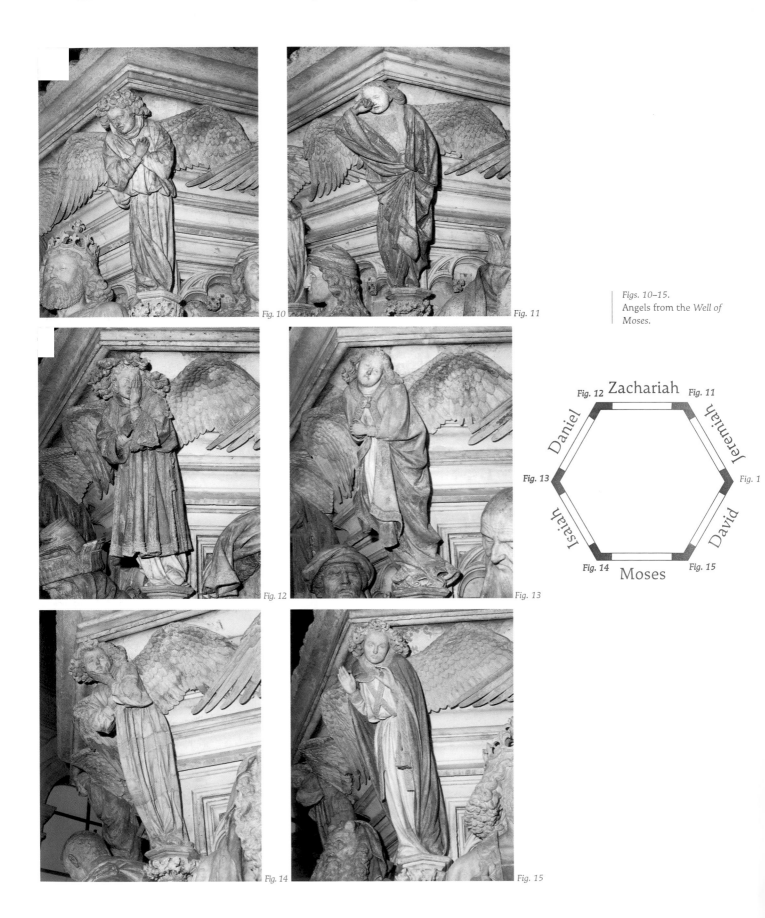

Fig. 10

Fig. 11

Fig. 12

Fig. 13

Fig. 14

Fig. 15

Figs. 10–15. Angels from the *Well of Moses.*

Zachariah

Daniel

Jeremiah

Fig. 12 Fig. 11

Fig. 13 Fig. 1

Isaiah

David

Fig. 14 Moses Fig. 15

218

tories are works that bring together a hexagonal pillar, prophets, angels, and other saints, or sometimes the Virgin Mary.[24] In certain gold crosses of the time, too, this Crucifixion group with angels can be found.[25]

The iconography of the *Well of Moses* most likely refers to the *Meditations Vitae Christi*, written between c. 1348 and 1368. Drawing upon the Passion, Ludolf of Saxony advocated the "imitation of Christ" as the foundation of Christian life.[26] While the *Well of Moses* is more than a mere illustration of Ludolf's work, it is certainly a very personal interpretation of religious fervor. In their meditative concentration, the prophets themselves are models for the possible interiorization and individual confrontation with the Passion of Christ—very like those in Jean de Beaumetz's paintings in the monks' cells.

Symbolically, the scene of the Crucifixion at Golgotha, the site of Christ's death, is seen as the ideal "center of the world."[27] The cult devoted to the Passion is emblematically manifest in the order's motto: "Stat crux dum volvitur orbis" (The cross remains constant while the world turns). The cross, placed at the center of the large cloister, constituted the center of the monks' life, both metaphorically and in fact.

The *Well of Moses* is the only preserved work by Sluter that was entirely of his conception, without any reliance on works by Marville. It thus provides the best opportunity for us to appreciate, without confusion, the traits of his style: Sluter characterized each of his figures individually and in a different fashion. Beyond the gestural and the specifics of physiognomy, what defines his style most insistently is the care he took in the lifelike depictions of surfaces—for example, Zachariah's flaccid skin or Isaiah's wrinkles. And it is this verisimilitude that prevents Sluter from falling into stereotype. It is striking to consider that these figures were created without any reworking.[28] Their realism never slips into the anecdotal: it is controlled by its sustained will toward sculpture in the round and its generous contour lines. The figures are structured by sinuous drapery, often traced with parallel lines. These folds always reveal a delicate stiffness, even in old Zachariah, which gives them a kind of vital tension. At the same time, the parallelism of the folds creates a play of shadows and light that fall in the same direction, making these figures even more lifelike. The deep cuts in the bodies of the sculptures, and their vigorous intrusion into space, further augment this tension. The figures are seen from below, which explains their placement on relatively narrow, fairly shallow pedestals; they gain in corporeality and realism in measure with their height: fidelity to nature achieves its extreme culminating point in the depiction of the figures' faces.

NOTES 1. Baudot, Bibliothèque Municipale Dijon, MS 2471, fol. 36.
2. Chateignère 1992, pp. 91ff.
3. ADCO, 1 J 2476.
4. On the chronology, see Troescher 1932, pp. 85–107; David 1933; Roggen 1936A; David 1951, pp. 84–95; Morand 1991, pp. 337–40. Revisions and comments may be found in Prochno 2002, pp. 221–28.
5. ADCO, B 11673, fol. 42.
6. Ibid., fols. 73v–74, 79v.
7. Ibid., fol. 96v.
8. Ibid., fol. 126, 3 December 1402. On this document, the prophets are erroneously designated by the term "Apostles." It is, however, clearly indicated that these sculptures were intended for the Champmol fountain.
9. Ibid., fols. 150–50v.
10. Ibid., fols. 132v–33, 157, 160.
11. Ibid., fol. 117 (the invoice is dated 28 January 1402; it thus corresponds with the year 1403 of the Gregorian calendar): delivery of stone blocks.
12. This reveals a source that remained unknown until

here. Ibid., fols. 141v–42, invoice of 12 January 1403 (thus January 1404): payment for transportation.
13. Ibid., fol. 142.
14. Févret de Saint-Mémin 1932, p. 71. Quarré 1974–75, p. 161, indicting the date is 1632.
15. Gilquin 1736, cited in Roggen 1936A, p. 45.
16. Roggen 1936A, p. 44, after Monget 1898–1905, 3: p. 96; Quarré 1974–75, p. 161.
17. Chateignère 1992, pp. 89ff, 95ff. The 1841–42 restoration was realized by the sculptor Jouffroy.
18. Quarré 1951, p. 211.
19. ADCO, 46 H 774. This privilege was undoubtedly linked with a visit that the cardinal paid to John the Fearless in 1418, in Dijon.
20. Monget 1898–1901, 2: p. 55.
21. ADCO, 46 H 776.
22. Ibid., H 46, group 774. Morand (1991, pp. 106–10, 341ff) considers Champmol as a prime destination for pilgrimage. The historical sources give no foundation for this hypothesis.
23. Kleinclausz (1905, p. 76), Liebreich (1936,

pp. 443–46), and Roggen (1935, revised 1936A, p. 74) interpret the monument as a *fons vitae*, which Goodgal and Salem (1992, p. 39) do not.
24. Labarte 1879, p. 284, no. 2654, Inventory of Charles V, before 1380. There is mention of this work, without other comment, in Roggen 1936A, p. 79.
25. Inventory of Jean de Berry (Guiffrey 1894, 1: p. 11, no. 3; Guiffrey 1896, 2: p. 95, no. 721; p. 4ff, no. 6).
26. On Ludolf of Saxony and his works, see Baier 1977, pp. 74, 85. *Meditation Vitae Christi* is the title commonly used. The imitation was accomplished according to six paths. Roggen (1936A) supports the notion that this is perhaps the origin of the hexagonal form of the pillar of the Champmol fountain. Ludolf relies notably upon the *De Contemplatione* by Guigues, a companion to St. Bruno, founder of the motherhouse of the order, the Grand Chartreuse near Grenoble.
27. Evans 1952, p. 155.
28. Chateignère 1992, p. 87.

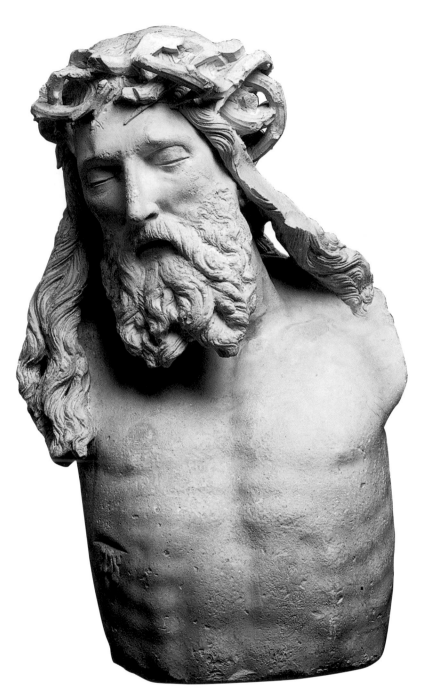

77

77, 78, 79

Claus Sluter (d. Dijon, 1406)

Bust of Christ Crucified and Fragments of Christ's Legs
Completed 1399

Stone, traces of paint
Bust: 61 x 38 cm
Legs: H. 59 cm

Arms of the Virgin Mary
Completed 1402

Stone, traces of paint
W. 35 cm

Dijon, Musée Archéologique,
inv. 1323, 1324, 1325

BIBL.: Liebreich and Henri 1933,
pp. 419–67; Roggen 1936A; Roggen 1937;
Quarré 1951, pp. 211–18; David 1951,
pp. 81–127; Quarré 1974–75, pp. 161–66;
Baudouin 1983, pp. 239–41; Blondaux 1990,
pp. 30–33; Morand 1991, pp. 91–120, 330–49;
Prochno 2002, pp. 215–28.

EXH.: Bust: London 1932, no. 5; Paris 1934,
no. 34; Paris 1936, no. 7; Paris 1937, no. 1000;
Dijon 1949, no. 7; Rotterdam 1950, no. 3;
Amsterdam 1951, no. 165; Dijon 1951,
no. 119; Dijon 1960, nos. 21–23; Vienna
1962, no. 419; Paris 1964, no. 42; Paris 1981,
no. 95; Dijon 1990.

These fragments were part of the
Calvary group of the *Well of Moses*, in
which Christ, the Virgin, and St. John were
depicted, along with Mary Magdalene
kneeling at the foot of the cross.
Fragments of arms and legs were found,
with other debris, at the base of the
fountain of the large cloister during an
1842 excavation. The bust was placed in
an alcove of a house in Dijon. The arms
have been identified as those of the Virgin
(Paris 1981), though Kathleen Morand
identifies them as being those of Mary
Magdalene. Copies of the Champmol
Calvary group clearly show that the
Virgin's arms were clutched close to her
breast, in a gesture of devotion. Mary
Magdalene was represented clasping the
base of the cross. Here, the space between
the forearm and the body is insufficient to
leave space for the post of the cross. In
proportion to the body, the head of Jesus
is slightly oversized—this is accountable by
the effect that the crucifix was intended
to produce at a distance. Sluter's faculty in
rendering such diverse materials and

surfaces is evident in the bust of Christ, particularly the way in which the parched skin of the face reveals the bony structure of the skull.

Claus de Werve, newly engaged in Sluter's studio, sculpted the crucifix and the statue of the Virgin. This was his first work for Champmol. The document that attests to his payment indicates that certain statues were already placed on the pedestal of Golgotha while others were still in the studio. These could only have been the sculptures of St. John and the Virgin, as Mary Magdalene was installed at the same time as the cross. De Werve continued to work on these two statues over the course of the winter of 1400–1401, up until the autumn of 1401. In February 1402, the statues were installed. After a mistake in Monget's transcription, the invoice for this delivery and that of the first three prophets were erroneously linked.

Jean Malouel, and his studio, was assigned to gild the cross and paint the statues, which they began during the first weeks of the summer of 1400. For the statues of the Virgin and of St. John, the work of painting immediately followed their installation. Herman de Couloingne was associated with this work. The wound on Christ's side, which was originally shown running with blood, was surely more striking in its original: the blood must have streamed down the figure's legs, as traces of red paint can still be found on the feet of the crucified figure. On the fragment of arm, on the left wrist, traces of red and blue paint can be seen, while a bit of gold is discernible in the crook of the right arm. The Virgin's gown was certainly decorated thus as well. The painting on the bust of Christ relates, in its stylistic economy, to the unpainted sculptures of the portal. The gilding on the cross must have had the effect of an oversized halo, creating an aureole for the Savior in his glory. A parallel was established here with the sculptures that Sluter made for the "chapel of the angels": St. George, the Archangel Michael, and another statue placed against the northern wall of the building, also works of unpainted stone. Above the wooden paneling, the chapel was entirely gold, indicating that the unpainted statues must certainly have stood out from their golden backdrop.

The second placement of the bust of Christ, in an alcove of a house once belonging to Dijon's general hospital, incited Baudouin (1983, pp. 239–41) to refute, mistakenly we believe, this work's relationship to Sluter, and to attribute it to a "Master of 1508."

R.P.

78

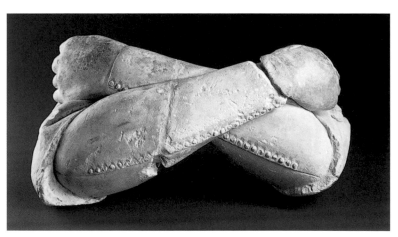

79

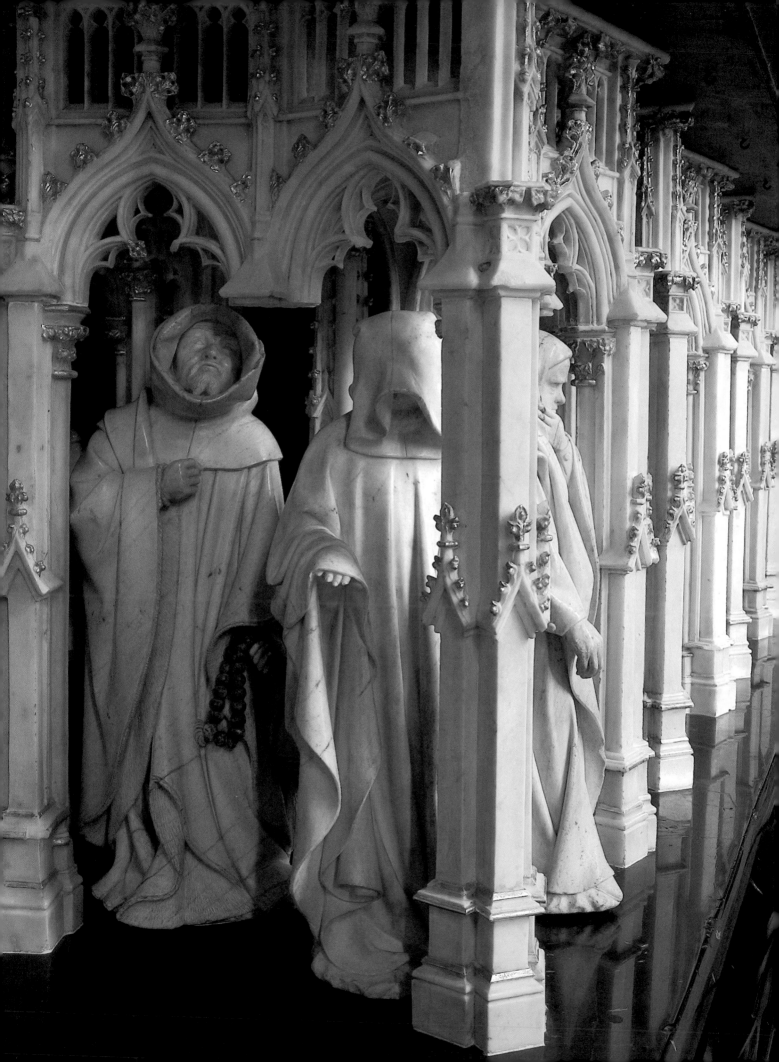

80

Jean de Marville
(Merville?, ?–Dijon, 1389)

Claus Sluter
(Haarlem, c. 1360–Dijon, 1406)

Claus de Werve
(Haarlem, ?–Dijon, 1439)

Tomb of Philip the Bold
1384–1410

Black marble, white marble, and partially polychromed and gilded alabaster

243 x 254 x 360 cm

Dijon, Musée des Beaux-Arts, inv. CA 1416

PROV.: commissioned by Philip the Bold in 1381; installed in the chancel of the church at the Chartreuse de Champmol in 1410; taken apart and reassembled in 1792 in the old abbey church of Saint-Bénigne, which has since become a cathedral; vandalized and taken apart in 1793; restored between 1819 and 1824 and reassembled in the guardroom of the Dijon Musée des Beaux-Arts.
The tomb was cleaned and restored in 2003–4 by a team of restorers under the guidance of Benoît Lafay, with the financial support of the Getty Foundation.

BIBL.: Févret de Saint-Mémin 1847B, pp. 29–31; Dijon 1883, pp. 377–80 and no. 1416, pp. 380–83; Monget, 1898–1905, 1: pp. 68–70, 120–21, 226–27, 250, 268–69, 342–43; Kleinclausz 1905; Drouot 1932; Troescher 1932; Andrieu 1933; David 1934; Roggen 1934; Liebreich 1936, pp. 135–41; Quarré 1944–45; David 1951, pp. 107–28; Roggen 1955–56; Quarré 1960C, no. 9, pl. VI and VIII–XI; Didier 1980, pp. 20–24; Gaal 1990; Morand 1991, pp. 121–32, 174, 350–69; Joubert 1992B; Morganstern 1992; Beaulieu and Beyer 1992, pp. 191–92, 198, 202; Lindquist 1995; Baudoin 1996, pp. 130–32, Dijon 2000, p. 177, fig. 1; Prochno 2000; Prochno 2002, pp. 93–97; Baron and Jugie 2004; Baron, forthcoming; Baron and Jugie, forthcoming.

EXH.: Dijon 1949, appendix A, p. 34, Amsterdam 1951, nos. 179–80; Brussels 1951, nos. 166–68; Dijon 1951, no. 120; York 1957, no. 10; Dijon 1960, no. 24; Dijon 1976, no. 32; Dijon 1990, pp. 39–46, 49; Dijon 1992, no. 1, p. 76.

Exhibited in Dijon only

The tomb of Philip the Bold is deservedly celebrated as one of the most sumptuous and innovative tombs of the late Middle Ages. The original of this recumbent figure on a black marble tombstone was destroyed during the Revolution and was replaced by a reproduction in the nineteenth century. Although this reproduction includes several inaccuracies, the original appearance is known through eighteenth-century drawings. The duke was represented with his eyes open, his hands together, wearing his crown and a coat that covered his armor. His helmet was held by two angels and his feet rested on a lion. The entire structure was painted in natural colors, which heightened the sculpture's realism. The arcades were formed by alternating double archways and triangular niches, which were very finely sculpted. The white marble, which was originally partially gilded, contrasts with the black Dinant marble of the base and of the tombstone on which the figure lies. The cortege of alabaster *pleurants* (mourners), appears beneath these arcades. As during the real ceremony, the priest conducting the asperges is followed by two choir boys, the cross bearer, a deacon, the bishop, three cantors, two Carthusians, then the members of the duke's family, his officers, and the members of his household, all of whom are draped in the mourning robes that were actually distributed during funerals. The faces are characterized, but are not portraits.

The iconography of the recumbent figure and of the cortege of mourners was not new. It prolonged a tradition maintained since the middle of the thirteenth century, and of which the monuments to the kings of France in the abbey of Saint-Denis display numerous examples. What was new, however, was the space given to the mourners on the base. For the first time, the mourners were not isolated in bas-relief under the arcatures, but seemed to slip through the real arcades of a cloister. All the mourners express grief, whether through their facial expressions, a gesture

toward another mourner, or the eloquent folds of their clothing. Another innovative aspect was the importance given to the angels, who kneel directly on the marble tombstone and tenderly watch over the duke with expressions that combine distress and serenity. This composition represented a total break with, for example, the tomb of Charles V in which the recumbent figures of the king and queen were covered by a canopy and surrounded by little niches garnished with angels. The recumbent figure no longer appears as a vertical statue lying in its architectural frame but as an actual supine body, an effect heightened by the folds of the coat that spreads around the figure. Equally unusual were the tomb's monumentality, which placed the representation of the prince nearly beyond the viewer's gaze, the precious nature of the marble and the alabaster, the refinement of the polychromy, and the liveliness of the gold.

Our knowledge of the creation of the tomb of Philip the Bold rests on the accounts of the Chartreuse de Champmol (Drouot, to be completed by Roggen). The various stages of its construction can be recapped as follows: In 1381, Jean de Marville, a sculptor for the duke, was put in charge of "making an alabaster tombstone for him in Dijon." Work began in 1384 with workmen busying themselves with sawing and carving the alabaster for the arcatures. In 1385 Marville bought one large stone and several small pieces of black marble in Dinant. In October 1387 the duke visited the work site "in the residence of the aforementioned Marville." In December, Marville ordered the construction of a wood stand on which he placed the "pieces of alabaster stone in the positions and scale of the tomb," which seems to indicate that work on the arcatures was well advanced. In 1388 two Parisian stone polishers came to work on the alabaster.

The polishing continued after 1389 under the direction of Claus Sluter. In 1390 Philippot van Eram was paid for "hanging canopies," which must correspond to the roses that decorate the niches. These are supplementary elements of the architectural setting, which would logically

FIG. 1. Tomb of Philip the Bold, mourners beneath the arcatures. Dijon, Musée des Beaux-Arts.

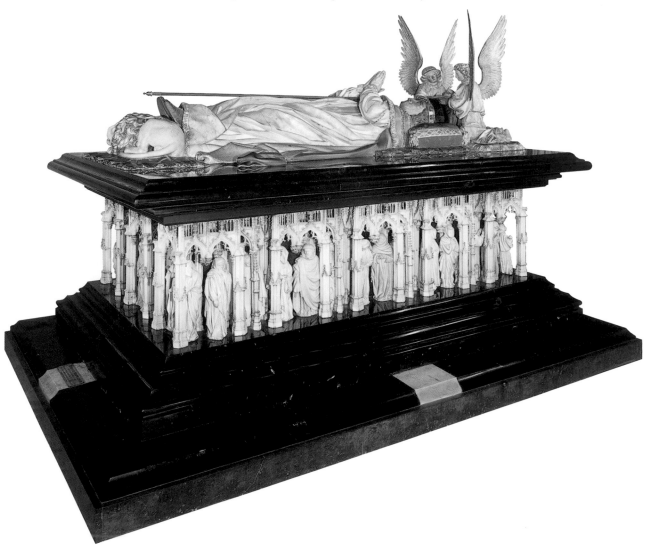

have been made last. In 1391 Sluter bought alabaster from Perrin Beauneveu in order to make the mourners and the cherubs that decorate the niches. This alabaster was described as "grenoble," which leads one to believe it was alabaster from Vizille, near Grenoble. In 1392 Sluter received an "alabaster stone" from Christoffle de la Mer, a Genoese merchant based in Paris, in order to "make a statue for his tomb." In 1397, the finished components were transported to Champmol, and the masonry work on the tomb began. Sluter bought more black marble in Dinant in 1397. The polishing of this marble took another several months. In 1402 it was necessary to breach the wall of the chancel in order to bring in the large slab of black marble intended for the recumbent figure to lie on.

When the duke died in 1404, the tomb was unfinished; of the statuary, only two mourners had been completed. In July 1404 John the Fearless asked Sluter to finish the tomb within four years. At that point,

Sluter had yet to make the recumbent figure, the two angels, the duke's helmet, and the two lions, and to finish the mourners, the cherubs, and the arcatures. Sluter died at the beginning of 1406 without, it appears, having advanced very far, for his nephew and collaborator took over the contract under the same terms. It is therefore Claus de Werve who made the recumbent figure, the lion, the two angels, and nearly all the mourners. The tombstone was put in place in 1410, after having been embellished with polychromy and gilding by Jean Malouel. The nineteenth-century restoration perfectly restores the spirit of the fifteenth-century original, which emphasized the luxury of the materials through partial highlighting. The flesh of the duke and the angels was left unpainted, but their clothing was highlighted with gold and colors. The angels' hair is golden, as is the lion's mane. The little finials on the arcatures have gold highlights, resulting in a liveliness that was probably accentuated by the presence of the small angels, which

had already disappeared by the time of the revolution. As for the mourners, they were only given discrete highlights with color or gold. Only the first six mourners in the cortege—the clergymen—wore deep blue clothing richly decorated with a stylized floral motif. Highlights for the rest of the cortege seem to have been limited to certain accessories such as rosary beads, money purses, and belts, which are painted in red, brown, or gold, and the terraces, which were green.

In monographs dedicated to Claus Sluter (principally Troescher 1932; Liebreich 1936; David 1934 and 1951; Morand 1991), the tomb is always mentioned as being one of his works. However, documentation indicates that Marville was the first to direct the project. The completion of most of the arcades before Sluter took charge lead one to believe that the placing of the mourners under the arcatures had already been decided. Because all other works by Jean de Marville have been lost, his artistic personality can only be conjectured.

Therefore, given the first model he had proposed for the church portal at Champmol, there are reasons to believe that Marville was faithful to the predominant style practiced under Charles V. Although the disappearance or mutilation of earlier tombs deprives us of essential landmarks to understand properly the creation of this work, the artistic approach adopted for this tomb does indeed appear innovative. The three-dimensional effects and the expressive nature of the cortege of mourners are particularly reminiscent of Sluter's work. Fabienne Joubert has suggested that the introduction of the large slab of black marble in 1402, which required the wall of the church's chancel to be breached, could be a clue that Sluter had modified and amplified Jean de Marville's plans for the tomb, as he did for the portal. The purchase of a (new?) larger slab of marble would be a sign of the decision to make the cortege of mourners in three dimensions rather than in bas-relief. Yet, barring a significant gap in the accounts, there is no evidence, as there is for the portal, that completed elements were redone. On the contrary, following the progression of the work and the purchase of materials under Sluter as of July 1389 indicates an admittedly slow but regular advance of the project, without any convincing indication of a change in course (Prochno 2000 and 2002; Baron, forthcoming). Additionally, we have no information as to how work was organized in the workshop, and we do not know whether the workshop's assistants were mere underlings or whether the conception of the work could have been a joint effort. If the latter, it would not be overly far-fetched to imagine that Sluter, who had been part of the workshop since 1385, could have already played a determining role in the conception of the tomb. Further, even if Sluter was not responsible for the execution of the statuary, he probably strongly defined it, given that Claus de Werve very likely had at his disposal precise models by Sluter. The recent restoration of the tomb allowed experts to observe the extraordinary interior of Philip the Bold's helmet, in which the thickness of the red leather lining's padding is recreated with incredible precision, and is held in place by stitches that stretch far into the helmet but are perfectly invisible when it is in place. Claus de Werve probably owed this concern for extreme precision, which was served by an astonishing virtuosity, to Claus Sluter. But his personal style, which is less tense, more tender and supple, can be seen in full glory in the two magnificently graceful angels.

S.J.

81

Claus de Werve
(Haarlem, ?–Dijon, 1439)

Fragment of a Foot from the Recumbent Figure of Philip the Bold
1406–10

Marble, traces of polychromy

10 x 10 x 6.5 cm

Dijon, Musée des Beaux-Arts, inv. 1096/1

Prov.: fragment probably salvaged during the destruction of the recumbent figure of Philip the Bold, between 8 and 10 August 1793; Louis-Bénigne Baudot collection; bought at the Henri Baudot auction in Dijon, 1894.

Bibl.: Quarré 1942–46; Quarré 1960C, no. 10; Baron and Jugie 2004; Baron and Jugie, forthcoming.

Exh.: Dijon 1960, no. 25; Dijon 1990, not in catalogue.

The identification of this fragment of a foot as a remnant of the original recumbent figure of Philip the Bold was established by Pierre Quarré based on the object's provenance. Indeed, the collector Louis-Bénigne Baudot, who owned mourners, structural elements, and

fragments of recumbent figures, wrote in his notes: "I still have . . . the extremity of one of the Duchess's feet." (Dijon, BM, Baudot Archive, MS 325 III, abbey of Saint-Bénigne, fol. 155r).

No matter how mutilated, this admirably detailed fragment allows us to imagine the quality of the lost recumbent figure. The rendering of the interlocking metallic sheets of the armor can be compared with that of the hand of the statue of St. George by Claus Sluter. The fragment perfectly matches the eighteenth-century drawings, which show the duke wearing armor that reveals the opening of his coat on his left side. We know that the contract drawn up between Claus Sluter and John the Fearless on 11 July 1404, specified that "the figure will be armed, or wearing royal habit, depending on the artist's judgment of the most appropriate choice based on its attractiveness." In actuality, Sluter did not choose, and the duke wound up wearing both his armor and a coat, a fact of which the nineteenth-century restorers were not aware because the only source they had was a Maisonneuve engraving (in Plancher 1974, p. 204) showing the duke's right side. Joseph Moreau therefore reconstructed a coat with rather disorderly folds and disproportionate shoes.

The foot fragment is made of marble, as was confirmed by the analyses made during the study prior to the restoration of the tombs, and not of alabaster, as had previously been written. This assertion

had rested on the text of the accounts in which Sluter recognized on 27 December 1392 that he had received from Christoffle de la Mer, a Genoese merchant established in Paris, a delivery of "alabaster stone which my lord had ordered taken and purchased from him in order to have it transported to Burgundy to make a statue of my lord for his tomb" (Drouot 1932, no. 19).

The fact that the original recumbent figure was made of marble has also been verified through three original elements that were inserted in the reconstructed statue by Joseph Moreau; it was already known that the hands were made of marble (Quarré 1942–46), but it had not previously been noticed that the two pieces of drapery spread out on either side of the duke's body are also marble (Baron and Jugie). Yet, the angels, the helmet, and the lion, which are all original, are made of alabaster.

A close examination of the period drawings reveals a difference between the original recumbent figure and the nineteenth-century reconstruction. Indeed, the lateral draperies of the original figure's coat descended lower than the duke's body and surrounded the lion, meaning that the first recumbent figure of the duke was smaller, leaving open space on every side of the black marble tombstone. The current statue, which touches the edges of the black marble, does not replicate this arrangement, a fact that slightly modifies the configuration we can propose of the tomb's original appearance. The recumbent figure was life-size (about 1.65 m), which must have combined with the natural color highlights to heighten the impression that the duke's actual mortal remains were visible during the funeral service.

S.J.

1

82

Jean de Marville (Merville?, ?–Dijon, 1389) followed by **Claus Sluter** (Haarlem, c. 1360–Dijon, 1406) and their studios

Elements from the Arcatures of the Tomb of Philip the Bold
c. 1384–90

The circumstances of the dismantling and subsequent restoration of the tombs of Philip the Good and John the Fearless after the closing of the Chartreuse de Champmol are well known.

The tombs were dismantled in May 1792, under the direction of the sculptor Attiret. The work was done carefully, but did involve the "necessary fractures." The tombs were immediately reassembled in 1792 in the old abbey church of Saint-Bénigne, which has since become a cathedral. According to the Dijon scholar Baudot, the monuments were "reconstructed with such care and so much skill that it seemed they had been transported . . . without the slightest disturbance to the pieces of which they were composed." But, to celebrate the anniversary of 10 August 1792, the general council of the Dijon convention decided on 8 August 1793, that the tombs would be smashed as "monuments to despots" and that "the figures representing the old dukes would be reduced to pieces." A large number of the fragile arcatures were probably irremediably destroyed at this point. During this obliteration, three pairs of hands, about ten mourners, and an undetermined number of architectural elements probably disappeared, to reappear later in private collections. A great portion of the other elements was conserved, however, and sheltered in the old palace, where the objects were recorded in September 1794.

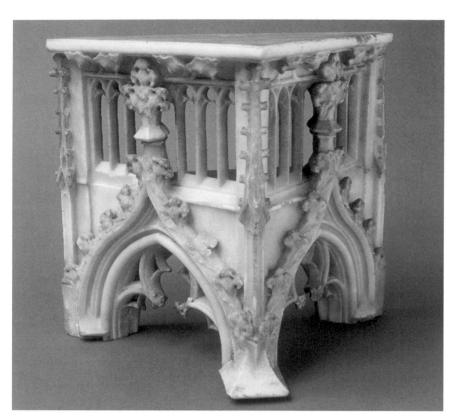

1. Triangular Niche from the Tomb of
Philip the Bold
Marble, gilded highlights
24.5 x 22 x 15 cm

Paris, Musée du Louvre, inv. N 15012a

Prov.: Parisian art market, mid
19th century; acquired in 1850.
Bibl.: Baron 1990; Baron 1996, p. 158.

In the 19th century this canopy was
combined with three small columns,
inspired by those on the tomb, to shelter a
mourner from the tomb of Ann of
Burgundy

4. Triangular Niche
Marble, traces of gilding
22.5 x 26 x 17 cm

Dijon, Musée des Beaux-Arts,
inv. 1991.1.1

Prov.: appeared on the Parisian art market;
gift of the Society of the Friends of the
Museums of Dijon with the participation of
the Ministry of Culture / Regional
Management of Cultural Affairs for Burgundy
and the Burgundy regional council, 1991.
Bibl.: Gras 1992.
Exh.: Dijon 2002, no. D 49.

In 1819, the architect Claude Saint-Père took the initiative of restoring the tombs. He regrouped the pieces conserved in various warehouses and searched for the fragments that had passed into private hands with the help of Févret de Saint-Mémin, the curator of the museum of Dijon. The missing pieces were put back into place—the recumbent figures were reunited with their original hands and faces—and ten mourners were created by the sculptor Joseph Moreau, along with about a third of the arcatures by decorative sculptor Louis Marion.

The two tombs were installed in the guardroom of the ducal palace. The new presentation was inaugurated in 1827.

Following Baron's 1990 study of the niche acquired by the Louvre in 1850 and of the appearance on the Parisian art market of a new niche, the study of these scattered fragments recommenced. It has led to the discovery in museums and on the art market of original architectural fragments that had escaped Févret de Saint-Mémin and Claude Saint-Père.

Besides the niche, which the Musée des Beaux-Arts purchased in 1991, in 2001 the museum was able to acquire a queen post from the tomb of Philip the Bold and one from the tomb of John the Fearless. Also in 2001, the museum received two previously unidentified items as loans from the Musée des Arts Décoratifs in Paris: a small column from the tomb of Philip the Bold and an incomplete niche from the tomb of John the Fearless.

The study of the documents relating to the restoration by Claude Saint-Père has allowed us to make an initial evaluation of the number of elements that were recreated. Despite some confusion in the accounts, the proportion of about one-third given by Févret de Saint-Mémin (1883, pp. 377–80) can be confirmed. One cannot deny the perfection of the restoration work, for it is strictly impossible visually to distinguish the difference between the original elements and those that were recreated. In addition, the old niches were repolished and regilded, and it seemed impossible that a

map of the original elements could ever be established.

Nonetheless, in 1999, during maintenance work on the tomb of Philip the Bold, the art restorer Jean Délivré noticed that the niche purchased in 1991 was made of marble. Until this point, it had generally been agreed that the tomb's base—the arcatures and the mourners—was made of alabaster. Both the nineteenth-century sources (given that the restorers bought their supplies in Salins) and the medieval sources had pointed in this direction. Though the medieval sources are far from explicit regarding the origin of the materials, they always refer to "alabaster stone." While Saint-Mémin had stated that "Gothic architecture" used marble "despite the fact that it is reported that it used alabaster," and Baudot had repeated this assertion, their words had then been totally forgotten.

It only took a piece by piece acid test on each of the various elements of the arcatures (a task executed by Jean Délivré and Annie Blanc, a geologist from the

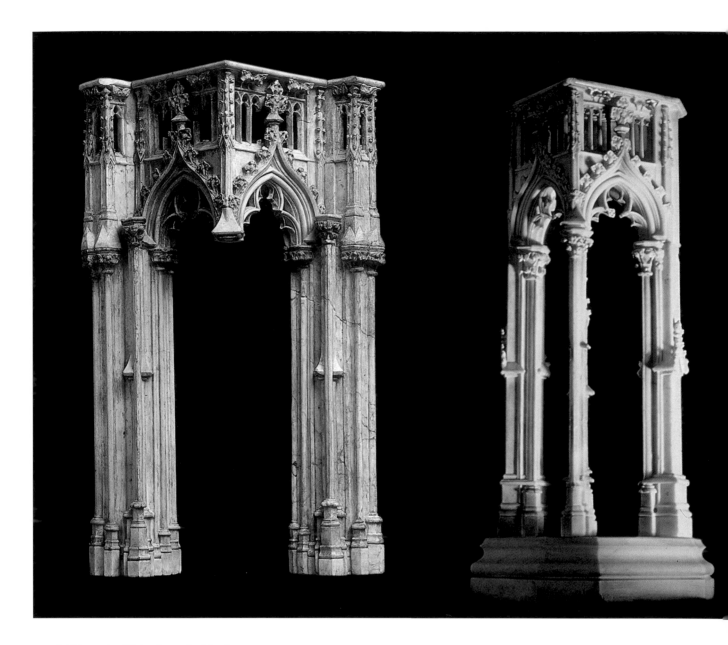

2. Triangular Niche from the Tomb of Philip the Good, combined with two pilasters from the same tomb with modern additions

Marble and alabaster

63.2 x 40.5 cm

Antwerp, Museum Mayer van den Bergh, inv. 139675

PROV.: Micheli collection.

BIBL.: De Coo 1969, pp. 149–50.

3. Triangular Niche from the Tomb of Philip the Bold, combined with a small column belonging to the niche but installed upside down, with two small lateral columns of dubious origin

Marble

H. 63 cm

New York, Memorial Art Gallery of the University of Rochester, R. T. Miller Fund, inv. 49.51

5. Small Column (recut in central part)
Marble, traces of gilding
36.7 x 13 x 8.6 cm

Dijon, Musée des Beaux-Arts,
inv. D 2001–3–1

PROV.: possibly Louis-Bénigne Baudot
collection, then Saint-Thomas?; Peyre bequest
to the Musée des Arts Décoratifs in Paris,
inv. PE 553; placed at the Musée des Beaux-
Arts in Dijon, 2001.

EXH.: Dijon 2002, p. 7.

6. Hanging Keystone
Marble
7 x 6 x 4 cm

Dijon, Musée des Beaux-Arts,
inv. 1096/3

PROV.: Louis-Bénigne Baudot collection;
bought at the Henri Baudot auction, 1984.

BIBL.: Quarré 1942–46.

7. Hanging Keystone
Marble, traces of gilding
5 x 6.5 x 4 cm

Inscription: tombeau de Philippe
le Hardi (handwriting of Louis-Bénigne
Baudot?).

Dijon, Musée des Beaux-Arts,
inv. 2001–7–1

PROV.: Victor Gay collection; Lucien
Mellerio collection; auctioned in Paris,
Hôtel Drouot, July 2001; purchase with
the participation of the Ministry of
Culture/Regional Management of Cultural
Affairs for Burgundy and the Burgundy
regional council, 2001.

BIBL.: on the destruction and restoration
of the tombs of Philip the Bold and John
the Fearless, see Liebreich 1936, pp. 142–43;
David 1951, pp. 163–11; Richard 1990; Baron
and Jugie 2004; Baron and Jugie, forthcoming.

EXH.: Dijon 2002, p. 7, fig. 3.

historical monuments research laboratory,
in 1999) to determine both the exact
number, location, and nature of the
recreated elements, and to certify that the
original architecture was indeed made of
marble. The material used has therefore
also become a criterion of authenticity for
those elements found in museums.

These examinations were continued in
2001–2 by Benoît Lafay, a restorer, in the
course of a preliminary study leading up to
the restoration of both tombs. Attention
was then drawn to the cutting marks
remaining on the base of the niches and
the small columns, on the preparation of
the surfaces for adhesive products, as well
as on the lead casting holes at the base of
the small columns, which correspond to
the original method by which the
arcatures were embedded. Based on the
observations made in 1792, the niches,
which consist of alternating triangular
canopies and double canopies, with the
triple canopies on the corners, were held
in place from above by an assembly of
thick metal. The weight was carried by the
black marble tombstones, which were
27 cm thick and constituted the central
bulk of the tombs. Therefore, the rear
pilasters and the small columns placed in
front did not truly support the niches.

S.J.

83

Claus Sluter
(Haarlem, c. 1360–Dijon, 1406)

Claus de Werve
(Haarlem, ?–Dijon, 1439)

Mourners

Alabaster

Dijon, Musée des Beaux-Arts,
inv. CA 1416

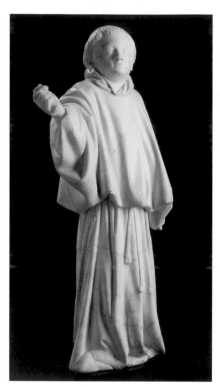 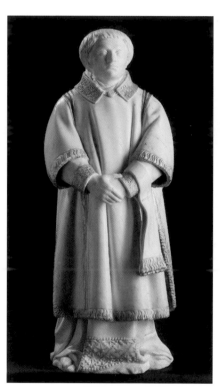 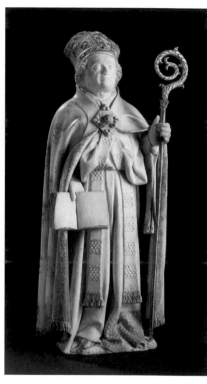

Mourner no. 1: Priest Conducting
the Asperges
H. 35 cm

Mourner no. 4: Deacon
H. 39.5 cm

Mourner no. 5: Bishop
H 43 cm

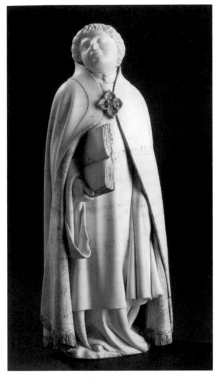

Mourner no. 6: Deacon
H. 40 cm

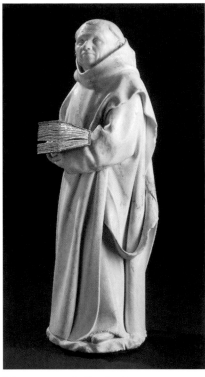

Mourner no. 9: Carthusian
H. 41 cm

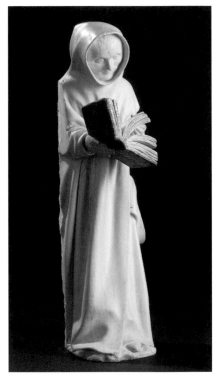

Mourner no. 10: Carthusian
H. 40.1 cm

Mourner no. 20: Mourner without a
Coat
H. 40.9 cm

Mourner no. 21: Mourner Lifting
a Side of His Coat with His Left Hand
H. 41 cm

Mourner no. 24: Mourner with Joined
Hands
H. 40 cm

Mourner

Alabaster

Private collection

PROV.: Louis-Bénigne Baudot; Baudot traded it on 22 January 1813, with Perret *fils*, in exchange for objects found at Meursault.

BIBL.: Andrieu 1913–21; Drouot 1913–21; Chabeuf1915.

 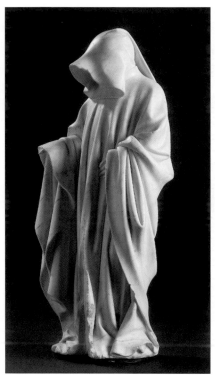 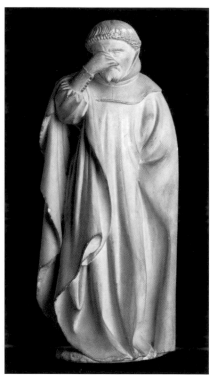

Mourner no. 25: Mourner Consoling the Mourner next to Him

H. 40 cm

Mourner no. 28: Mourner Raising His Right Hand

H. 40 cm

Mourner no. 17: Mourner Drying His Tears

H. 40 cm

Mourner

Alabaster

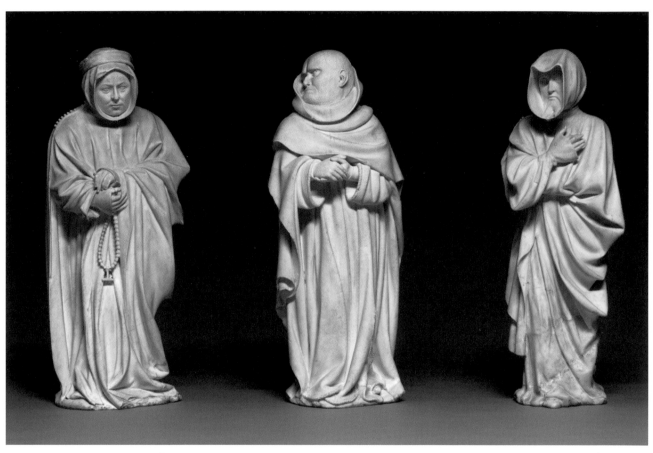

Mourner no. 18: Mourner with a Headband

H. 41.9 cm

Cleveland, The Cleveland Museum of Art, inv. 1940.128

PROV.: Hocquart collection, 1825; following his death, his son in law Édouard de Broissia; Legay, merchant in Nancy, 1876; Stein, merchant in Paris; Schickler collection, Paris, 1913; Pourtalès collection, Paris, 1913; Duveen collection, 1919; Clarence Mackay collection, 1932; acquired with J. H. Wade Fund in 1940.

BIBL.: Andrieu 1913–21; Quarré 1936–39; Milliken 1940; De Winter 1987.

EXH.: Cleveland 1967, no. VI–21.

Mourner no. 35: Mourner Turning His Head Toward the Mourner next to Him

H. 41.6 cm

Cleveland, The Cleveland Museum of Art, inv. 1958.67

PROV.: Hocquart collection, 1825; following his death, his son-in-law Édouard de Broissia; Legay, merchant in Nancy, 1876; Stein, merchant in Paris; Schickler collection, Paris, 1913; Pourtalès collection, Paris, 1913; Duveen collection, 1919; Clarence Mackay collection, 1932; Leonard C. Hanna Jr. collection, Cleveland.

BIBL.: Andrieu 1913–21; Quarré 1936–39; Milliken 1940; De Winter 1987.

EXH.: Cleveland 1967, no. VI–21.

Mourner no. 38: Mourner with His Hand on His Chest

H. 41.3 cm

Cleveland, The Cleveland Museum of Art, inv. 1958.66

PROV.: Hocquart collection, 1825; following his death, his son-in-law Édouard de Broissia; Legay, merchant in Nancy, 1876; Stein, merchant in Paris; Schickler collection, Paris, 1913; Pourtalès collection, Paris, 1913; Duveen collection, 1919; Clarence Mackay collection, 1932; Leonard C. Hanna Jr. collection, Cleveland.

BIBL.: Andrieu 1913–21; Quarré 1936–39; Milliken 1940; De Winter 1987.

EXH.: Cleveland 1967, no. VI–21.

GENERAL BIBLIOGRAPHY:
BIBL.: see cat. 80.
EXH.: Dijon 1971; Dijon 1976.

For the history of the mourners after the Revolution:
BIBL.: Gilquin 1736; Chabeuf 1891; Andrieu 1913–21; Andrieu 1922–26; Andrieu 1933; Liebreich 1936, pp. 143–63; Roggen 1936; Quarré 1948; David 1951, pp. 161–73; Quarré 1952–54; Morand 1991, pp. 365–69; Baron and Jugie, forthcoming (with bibliography).

EXH.: Dijon 1960; Dijon 1965; Dijon 1990; Paris 1994; Dijon 2000.

The mourners are, of course, the most famous elements of the tombs of the dukes of Burgundy. Even when seventeenth- and eighteenth-century taste hardly encouraged viewers to admire Gothic art, these small figures aroused curiosity and admiration, to the point that they were sometimes threatened by indelicate hands. Jean-Pierre Gilquin confirmed this in 1736, with just a touch of exaggeration: "These figures are very well crafted and finished with great care and they are considered so good that visitors stole a few every day; perhaps we would even have lost all these rare pieces if the Carthusians had not known to preserve the remains of this precious work by putting up the metal gates which are still visible around the tombs." And after the reassembly at Saint-Bénigne, on 12 January 1793, an apparently feeble-minded woman, Marie Roger, "was so charmed by the sight of the little marble figures which are around the recumbent figure . . . that she was unable to resist the temptation to take one for herself. She got close to one of the tombs, touched one of the figures, which immediately came off into her hand, and she walked off with it in her apron."

The mourners were placed in the museum in 1799, among other "monuments" that recalled the dukes and medieval Burgundy. In 1813, these mourners were involved in a strange installation: "A society of amateurs of fine arts headed by Mr. Delaloge and Mr. Hoin, the curator of the museum, hired Mr. Donjon, a wood sculptor, to repair the monument fragment called the Chair and place it on a pedestal built for this purpose. Several of the mourners from the tombs of the Duke were exhibited on the surface of the pedestal, which carried the following inscription in Gothic letters: "A la mémoires des ducs et duchesses de Bourgogne" (In memory of the dukes and duchesses of Burgundy). The monument was maintained like this until the mourners were included in the restoration of the tombs of Philip the Bold and John the Fearless. The mourners have been

constant sources of wonder since they have been returned to their place beneath the arcatures of the tombs. Stendhal and Victor Hugo have been among their admirers.

The mourners motif, which had been present in funerary art since the thirteenth century, was indeed completely renewed by these figures, which truly seem to move beneath the golden marble arcatures of the tomb of Philip the Bold. Through an astonishing variety of attitudes, each is an individual expression of mourning. Some turn toward their companions, and attempt a comforting gesture, while others turn in on themselves in meditation and prayer. The shapes of their clothing, whether the large flowing folds of a coat or the strictly vertical drape of another garment, are incredibly diverse. The costume details, which include fur-lined cuffs, small buttons, belts, hats, or elements of secular or regular ecclesiastical costumes, and accessories such as books, purses, and rosary beads are depicted with an obvious narrative pleasure.

Due to the fascination they elicit, the mourners practically constitute an entire chapter of the history of the tombs of the dukes of Burgundy in their own right. From the 1890s to the 1960s the mourners were the subject of an abundant bibliography that was particularly dedicated to finding the trail of those mourners still missing from beneath the arcatures kept in the museum in Dijon. The joint presentation of a selection of the mourners held in Dijon and Cleveland and of the last mourner in a private collection provides us with an opportunity to give the following account of the mourners' history.

After the destruction of the tombs in 1793, a September 1794 text that inventoried the remaining elements of the tombs then in storage in the former abbey palace of Saint-Bénigne listed seventy mourners, including two small ones. It must be recalled that though each tomb only had forty emplacements for mourners, each actually had forty-two figures, the first two being a pair of choir boys placed in the same niche. These seventy mourners were exhibited at the museum, which was opened in 1799, as "monuments" from the time of the dukes.

At that time, ten mourners and two choir boys were missing. These mourners had gone through the Dijon antique shop of Bertholomey into private collections. The erudite collector Louis-Bénigne Baudot had three. He gave no. 17 to his nephew Perret, whose descendants have kept it to this day. In 1823, Baudot sold the remaining two to a M de Saint-Thomas. During the preparations for the restoration of the tombs, Saint-Père and Févret de

Saint-Mémin were able to locate some of the mourners, but Saint-Père was only able to buy the two held by Saint-Thomas. At this point, we completely lose track of the two choir boys mentioned in 1794.

Saint-Père therefore had Joseph Moreau recreate ten mourners. Moreau based six of the new ones on the original mourners, and created new figures with the likeness of the tombs' restorers for the rest. Févret de Saint-Mémin, as a *Mourner Holding a Ten-Line Poem,* and Moreau, as a *Mourner Lifting His Finger to His Ear,* fit right in with the original mourners. Marion de Semur, as a *Mourner Holding a Niche,* follows the tradition of figures of medieval donors holding models of their churches. But Claude Saint-Père, as a *Mourner Holding a Compass,* wearing a buttoned coat beneath his mourning garments, was truly out of place. The arbitrary order in which the mourners were placed in the galleries was another flaw, because the restorers had not based their work on any document other than Plancher's engravings.

In 1876 four mourners reappeared on the art market in the hands of a Mr. Legay in Nancy, to whom they had been sold or consigned for sale by the de Broissia family. The curator Émile Gleize immediately informed the mayor of Dijon, but his repeated appeals were met with silence. After having transited through various collections, these mourners left France in 1921. They are now in the collection of the Cleveland Museum of Art.

When Philippe Gilquin's drawings were discovered in the national library in 1892, it was realized that the order in which the mourners were exhibited was inaccurate. The proper order was reestablished in 1932. From 1890 to 1960, the missing mourners were sought in private collections and museums. Thanks to this work, in 1945 Pierre Quarré, the museum's curator, was able to obtain the return of the mourners that belonged to the Louvre, the Musée de Cluny, and an English collector named Percy Moore. Eight mourners have not been restored to their original positions. In Dijon, the four mourners held by the Cleveland Museum of Art and the single mourner in the Perret collection are represented by castings. The two choir boys from the tomb of Philip the Bold have not been seen since 1793; the priest conducting the asperges from the tomb of John the Fearless, which had been found in the collection of the De Vesvrotte family in the 1820s, is presumed lost.

S.J.

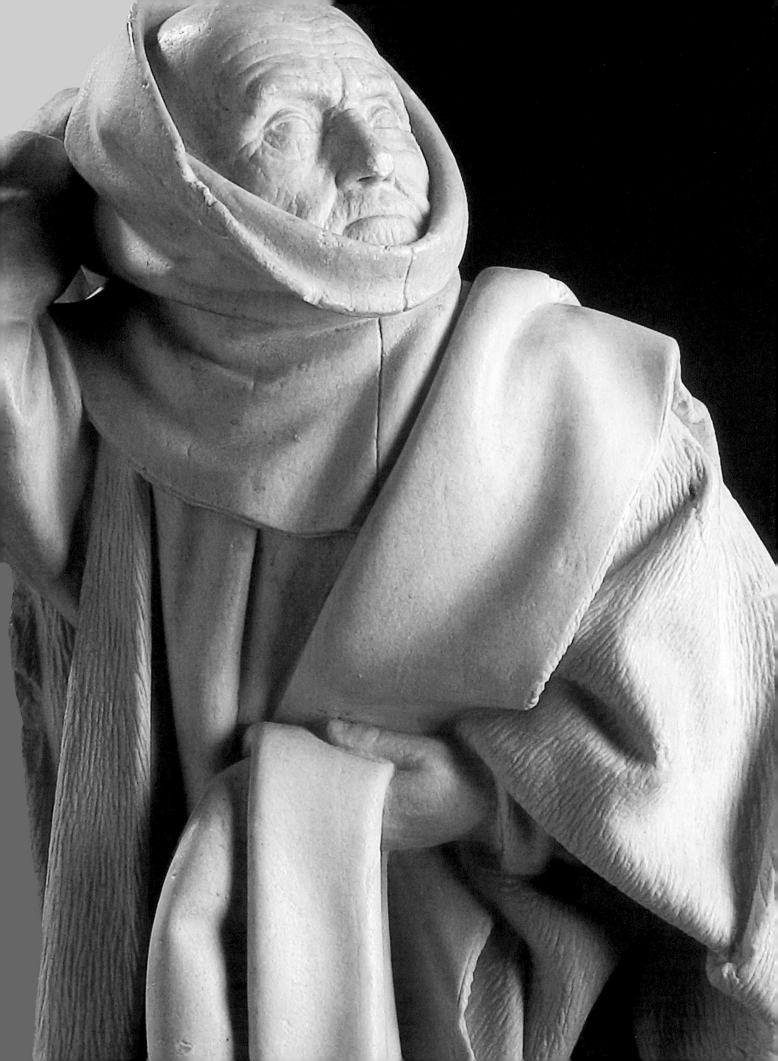

Renate Prochno

Funerary Customs

Champmol was built to serve as the tomb of the ducal dynasty of Burgundy. Once the charterhouse was built, the rules that would govern the funeral ceremonies could be set. Since these rites also served to reinforce the successor's assumption of his title, it was the court that elaborated upon the canon. The clergy were merely performers.

The order of the funeral procession was determined at the beginning of the fourteenth century.[1] When Phillip the Bold died in Halle on 27 April 1404, the cortege that accompanied his remains observed the order throughout the six weeks that it took to reach Dijon. The clergy led the procession, followed by the casket, then the family and the duke's successor.[2] Then came the torchbearers, the officers of the court and the nobility, and representatives of the cities under the rule of the deceased. All wore black mourning clothes, the rank of each mourner distinguishable only by the comparative richness of the fabrics he wore.[3] No documents survive to describe the manner in which Philip's funeral ceremony actually took place. We can, however, assume it remained as simple as the duke had wished in his will.

The coffin was covered in a golden funeral cloth, as it had been during the procession, and lay in state under a funeral structure in the choir of the church, as was the custom for the deceased of high rank. This frame had been hung with black cloth and was surrounded by coats of arms, which attested to the political power of the deceased. During the funerals of members of the nobility, it was always decorated with candles. At its four corners burned imposing candles or torches. This installation was called the blazing, or representation, chapel. A canopy sometimes crowned it. The church was hung with black cloth and sometimes lit by candles.[4]

The funeral rites began the night before the main services, with vigils and readings of psalms. Low masses were also said. They were followed the next day by three masses: the office of the Virgin Mary, that of the Holy Spirit, and the Requiem, which was immediately followed by the offertory, celebrated before the casket was taken down into the vault dug out below the choir. As a rule, some of the poor also attended the funeral;[5] they were dressed in mourning clothes paid for by the deceased or his family. During the ceremony, the poor held torches to which small shields bearing the coat of arms of the departed were sometimes attached.

The funeral procession that accompanied the remains of John the Fearless from Montereau to Champmol, where he was buried on 12 July 1420, was carried out with the same pomp.[6] In addition, a lavish funeral meal was served. Traditionally, women did not participate in princely funerals. However, at the specific request of the duchess, John's funeral was repeated in all its splendor the next day, so that the ladies of the court could attend it.[7] Clearly, such pomp served less to intercede for the deceased than to show off the power and the wealth of his successor. It thus served to demonstrate that he had taken up his new role.

NOTES 1. Erlande-Brandenburg 1975, p. 25; Chiffoleau 1980, pp. 126–30.
2. Giesey 1960, regarding the absence of the heir to the throne during the funeral of the king of France since Charles X.
3. ADCO, B 1538, fols. 238–44, and B 310.
4. Prochno 2002, pp. 113–26.
5. Kroos 1984, pp. 328–31.
6. Schnerb 1982, p. 124 passim, which is based on AND, B 1602, fols. 97–99.
7. It was only with the formal authorization of the duke that Mary of Burgundy, Countess of Charny and daughter of Philip the Good, was permitted to attend the transfer of the remains of her father and those his wife, Isabella of Portugal. Chabeuf 1903; Gaál 1990, p. 24 passim.

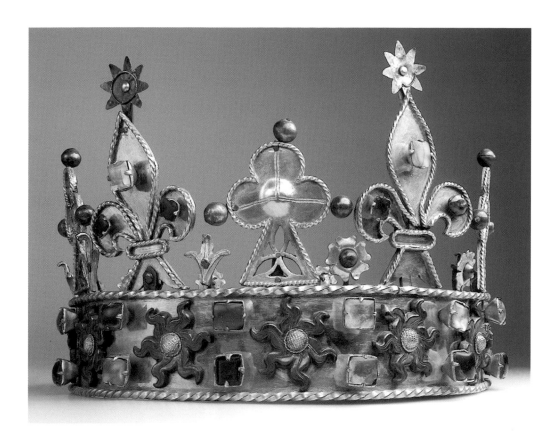

84

Dijon?

Crown

Early 15th century

Gilded and silver brass, stone
cabochons or colored glass

15 x 22 cm

Dijon, Musée des Beaux-Arts,
inv. CA 1467

PROV.: mentioned in the inventory of the
sacristy of the Chartreuse de Champmol,
13 April 1791; Baudot collection; gift of
Mme Adrien Baudot, 1857.

BIBL.: Dijon 1883, no. 1467; Monget
1898–1905, 3: p. 65; Lecat 1986, p. 36;
Breton 1996, pp. 42 and 99–100.

EXH.: Paris 1900A, no. 1749; Dijon 1960,
no. 58.

When it entered the collection of the
Musée des Beaux-Arts in 1857, the crown
was believed to have come from the tomb
of Margaret of Bavaria, whose effigy lies
next to that of John the Fearless, on the
tomb they share. However, this hypothesis
does not seem very plausible, since the
crown is described as being in the sacristy
of Champmol at the time of the inventory
of 1791, which attests to the fact that it
was not in the princess's funeral vault:
"a crown of gilded brass with a few silver
finials and a few precious stones of
variable quality." The description is
specific enough, particularly in its listing
of materials used, to be trusted and to
correspond exactly to the crown held by
the Dijon museum. Indeed, the crown
consists of a gilded brass headband
decorated with silver suns, which
alternate in groups of two with variously
colored stones vertically aligned around
the crown. It is surmounted by two fleurs-
de-lis and three clovers, which are
separated by smaller finials.

Given the luxury of the courts of Philip
the Bold and John the Fearless, it does not
take much to realize that a crown made
with materials of relatively little value
could not have been worn by the duke. In
fact, at the time, the dukes wore crowns
only on exceptional occasions, for major
ceremonies. There are no mentions of
crowns in the inventories of Philip the
Bold in 1404, or of John the Fearless in
1420. It has therefore been suggested that
this crown was used only for the funeral
of one of the two princes. Pierre Quarré has
more specifically suggested that it could
be the crown placed on the effigy for the
funeral of Philip the Bold. However, it
seems that this custom of replacing the
deceased's body with an effigy was not
customary at the court of Burgundy. It is
equally difficult to imagine that it had
been placed on the head of the duke, given
that he had requested to be buried in a
Carthusian's robes. According to Monget,
it could possibly have been placed on a
catafalque or displayed in some other
manner. The crown's limited value points
out the fact that it was unquestionably
made to be seen from afar.

Despite these doubts regarding its exact
purpose, and some confusion in dating it
between 1404 and 1419, the crown can
be considered to be historically dated and
located. It is therefore surprising that it
has not attracted the attention of
specialists in the medieval goldsmith's
craft.

S.J.

The Artistic Influence of the Charterhouse Worksite

Renate Prochno

Influences Among the works of Champmol, the sculptures from the funerary monuments and from *The Well of Moses* have engendered the most prolific posterity. John the Fearless copied the tomb of his father to the smallest detail, but also added, on the dais and by the heads of the recumbent figures, the coats of arms that do not appear on the older monument. Other descendants of Philip imitated some of the grieving figures or the overall structure of the memorial, but it fell to his immediate heirs to copy his tomb precisely.[1]

The mourners on the tomb of Philip the Bold gave rise to a particularly fruitful lineage. The majority of imitators borrowed, above all, the figures' garb and the work's stylistic variety, which were the easiest to realize—see for example the *Mourning Virgin* of Saint-Seine-l'Abbaye or the tomb of Aimé de Chalon at Baume-les-Messieurs. The concealment of the face beneath the ample fall of the hood (Mourners 13, 20, 33) and the vigorous cascade of folds in the mantle (Mourners 11, 21) were often copied, with numerous variations.

The range of expressions of sorrow seen in the calvary group of the *Well of Moses* is found again in the *Mourning Virgin* at Flavigny, and in the sculpted group of the Virgin and St. John at Prémeaux, as well as at Baume,[2] in a relief

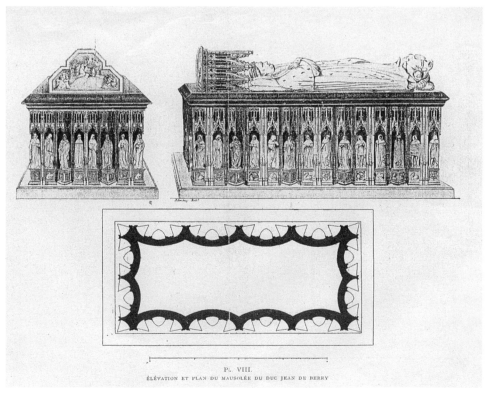

Pl. VIII.
ÉLÉVATION ET PLAN DU MAUSOLÉE DU DUC JEAN DE BERRY

Fig. 1

of the Crucifixion conserved at Dijon,[3] in another sculpture of the Virgin and St. John also at Flavigny,[4] and in several other statues of the Franche-Comté.

The figure of Mary Magdalene, with her long locks falling over her shoulders and down her back, has also been frequently imitated.[5]

The model of the *Well of Moses* was copied twice in its entirety, though the work of the engineers who created the basin was not followed. In 1508, Guillaume Sacquenier, commander of the Order of the Holy Spirit, had a replica made, which was never painted, for the Hôpital de Saint-Esprit in Dijon.[6]

The Champmol model was again followed at Chalon-sur-Saône, and this copy was installed at the center of the cloister of the Cathédrale Saint-Vincent, without further concern for the basin and its hydraulics. That work was destroyed in 1562.[7] In 1601, a third copy of the *Well of Moses* was planned for the charterhouse of the Scala Coeli in Evora, Portugal, but this copy was never executed.[8]

Propriety and, above all, the expense required for such a project would not allow the portal of the Champmol church to be reproduced in its entirety. The tomb of Cardinal Jean de la Grange, bishop of Amiens, in Avignon did reprise, however, the concept of the kneeling donor, depicted life-size under the aegis of his patron saint.

Fig. 2

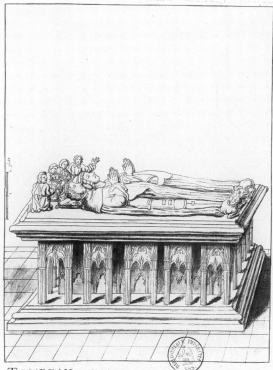

TOMBEAU de CHARLES 1.er Duc de BOURBON & D'Auvergne & D'Agnes de BOURGONGNE Sa femme, dans la Chapelle neuve du Prieuré de Souvigny quil fit bastir,

Fig. 1.
Reconstruction of the tomb of Jean de Berry, after Gauchery, 1919–1920.

Fig. 2.
Tomb of Charles V of Bourbon and Agnes of Burgundy, after Gaignières. Paris, Bibliothèque Nationale de France.

Fig. 3.
Mourning Virgin. Saint-Seine l'Abbaye.

Fig. 3

Of the other figures from the Champmol portal, only that of the Virgin has given rise to faithful imitations, and in fact they were executed in smaller dimensions. The Virgins at the church of Bussy-la-Pesle (cat. 86), the Musée des Beaux-Arts in Dijon, the church of Sennecey,[9] and the Metropolitan Museum in New York[10] are all precise copies of their model.

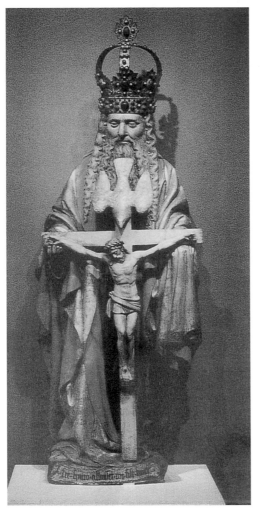

Fig. 4

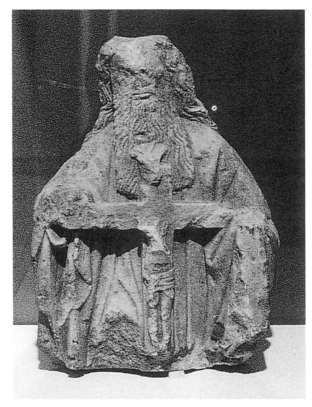

Fig. 5

The influence of the Trinity from Jean de Marville's main altar is also found in statues in Houston, in Genlis (cat. 85), and at the Sainte-Croix chapel in Dijon, as well as in the examples at Dijon's archaeological museum.

The scenes of the Education of the Virgin at Poligny (cat. 90),[11] Fontaine-lès-Dijon,[12] and Bussy-la-Pesle[13] correspond so precisely in format and style that they could easily be considered copies of a lost work from Champmol.

The altarpiece of the Virgin, which was located on the lower level of the ducal oratory, was copied at Rouvres-en-Plaine. One also finds an echo of the Mary from the Champmol altarpiece[14] in the figure known as the *Virgin of the Founder* (cat. 105), which Jean Chousat and Blanche Guillet commissioned for their funerary chapel in the church of Saint-Hippolyte at Poligny.[15] At this same church, Jean Chevrot, bishop of Tournai, had copies of the representations of the Virgin and St. Anthony placed in his chapel. Other versions can be found in the choir of the

Fig. 4.
Trinity. Dijon, general hospital, Chapelle de la Sainte-Croix de Jérusalem.

Fig. 5.
Trinity. Dijon, Musée Archéologique.

Fig. 6.
Bourges, private chapel of Duke Jean de Berry, after Gauchéry, 1919–20.

Fig. 7.
Oratory of Margaret of Austria. Brou, Saint-Nicholas de Tolentin.

Fig. 6

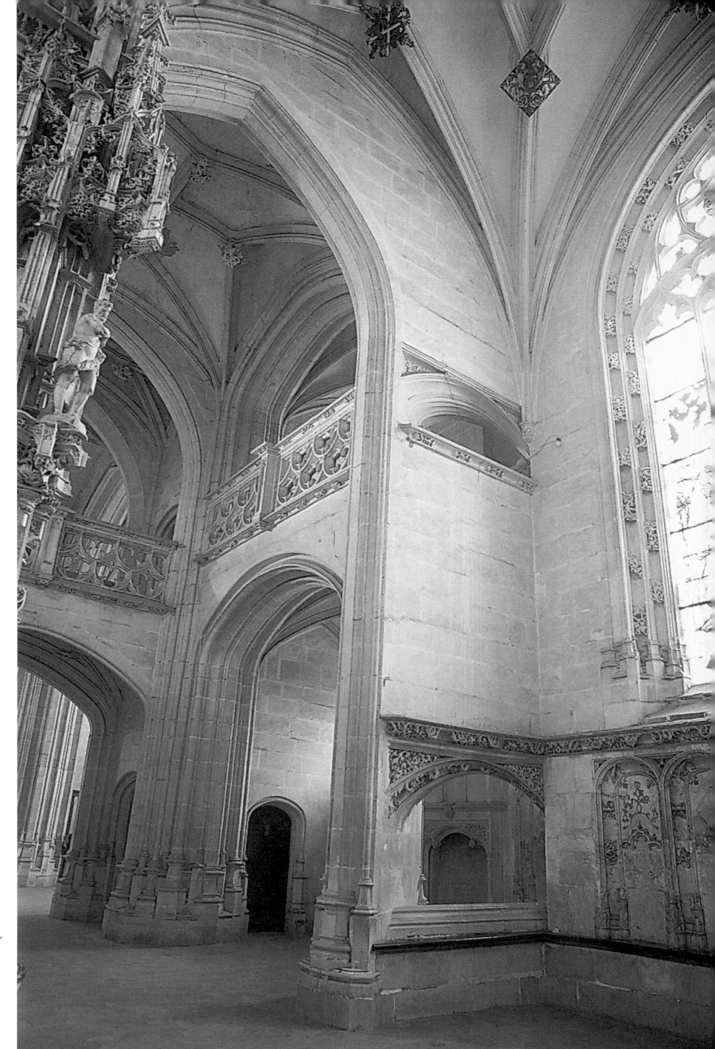

Fig. 7

Fig. 8

Fig. 9

Fig. 8.
Virgin and Child. Detroit, Detroit Institute of Arts.

Fig. 9.
Jean de La Huerta, *The Virgin and St. John,* 1448, and an unknown artist, *St. John the Evangelist,* after 1448. Rouvres-en-Plaine, Église Saint-Jean, altar of the Machefoing family chapel.

collegial church at Dole,[16] at Bézouotte, at the Cleveland Museum of Art,[17] at the Hôpital de Saint-Jean-de-Losne, at Saint-Lothain, and at Aiserey. At Brou, Margaret of Austria, a direct descendant of Philip the Bold, had a monastery built for the Augustinian hermits. As at Champmol, she added to the north side of the church a private chapel on two levels, including an oratory. The singularity of this building is understandable if it is considered a copy of the ducal oratory.[18]

Other buildings borrow characteristics of the Champmol architecture, as in the royal chapel of Vincennes.[19] In building the chapels of Bourges[20] and Riom,[21] Jean de Berry was inspired by Champmol.

What we characterize today as the "Burgundian style" pertains essentially to the personal influences of Jean de Marville and Claus Sluter. The works that they created for Champmol often served as archetypes, above all in sculpture. In painting, the influence was less widespread as—compared with the works of Robert Campin, the Van Eyck brothers, and Rogier van der Weyden—pieces such as the Saint-Denis altarpiece by Jean de Beaumetz seem to date from the Middle Ages. Although they were of very high quality, the paintings made by Beaumetz for the cells of the Carthusian monks gave rise only to copies intended for internal use.

NOTES 1. For example, at Souvigny. On this tomb, see Kleinclausz 1929, p. 23; Prochno 2002, p. 109.
2. Stone, 87 cm; Liebreich and David 1933, p. 467; Troescher 1940, 2: table CXXIX.
3. Dijon 1960, no. 17; Morand 1991, p. 347, 53 x 36 cm. In this relief, St. John holds a book; this depiction is probably a departure from Sluter's model. This book is an allusion intended to signal the identity of the Apostle and the Evangelist.
4. Stone, modern paint, H. 90 cm.
5. Troescher 1932, p. 98; 1940, fig. 323.
6. Calmelet 1772, p. 84; Perrault-Dabot 1922.
7. ADCO, B 11890, fols. 32v–33, published incompletely by Fyot 1934–35; see Gras 1956, p. 103, on a subsequent second copy at Chalon.

8. Monget 1898–1901, 2: p. 280; Liebreich and David 1933, p. 456; Liebreich 1936, p. 86.
9. Stone, H. 59 cm. Marilier 1963–69, p. 127.
10. Troescher 1932, p. 79 and pl. 21; 1940, p. 191 n. 399; Goldschmidt 1931, pp. 6–8; Liebreich and David 1933, p. 453. Goldschmidt attributes these to Sluter.
11. Stone, original paint, H. 111 cm, c. 1420. On these copies, see Prochno 2002, p. 177ff.
12. Stone, painted gray in the modern era, H. 110 cm. David 1933, 1: p. 296, fig. 123.
13. Bussy-la-Pesle, church of Notre-Dame and Saint-Blaise. Stone, traces of original paint work, H. 79.9 cm (85 cm with pedestal). *Inventaire général . . . canton Sombernon* 1977 (p. 508). David 1933, 1: p. 160, fig. 72.

14. Prochno 2002, pp. 151–54.
15. See the contributions in this catalogue of Sabine Witt, "The Statuary of Poligny," pp. 270–72.
16. Stone, H. 164 cm. Troescher 1940, pp. 116–40.
17. The Detroit Institute of Arts, stone with traces of paint, H. 42 cm, presumed provenance: Rouvres-en-Plaine. See Cleveland 1967, p. 22, no. VI.
18. For a detailed study, see Prochno 2002, pp. 166ff., 243–45.
19. Erlande-Jestaz 1989, p. 44ff.
20. Lehoux 1966–68, 2: p. 291, the project was begun in 1391. Lehoux 1966–68, 3: pp. 30–34, the building was consecrated in 1405. Gauchery 1919–20, p. 20.
21. The construction began in 1395. Lehoux 1966–68, 2: pp. 103, 349ff; Kurmann-Schwarz 1988, p. 74.

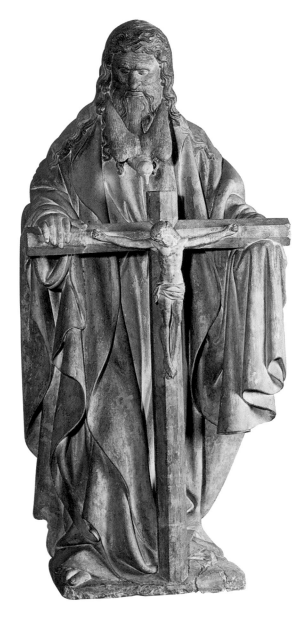

85

Anonymous

The Genlis Trinity

Stone (the head of the dove is
a modern addition)

H. 115 cm

Genlis, church

Bibl.: Baudot, BM Dijon, MS 2081,
pp. 170, 343; David 1933, 1: pp. 37ff.;
Liebreich 1936, p. 29; Troescher 1940, p. 101;
Quarré 1953, pp. 117, 121; Boccador 1974,
2: p. 44; Verdier 1975, pp. 71–73; Quarré
1976B, p. 42; De Winter 1976, p. 691;
Camp 1990, p. 154; Mosneron-Dupin 1990,
pp. 36, 44, 48–52; Morand 1991, p. 62;
Prochno 2002, pp. 69ff.

Exh.: Dijon 1976, p. 42, no. 38; Dijon
1990.

Philip the Good's tomb (which was not
erected until 1474, on the occasion of the
transfer of the third ducal couple's
remains) contained a statue of the Trinity
placed on a pedestal. The piece was
described by Baudot, according to whom
the sculpture was removed by workers
who were hired to demolish the church.
It is unknown whether the work was
preserved afterward (Quarré 1953).
Verdier and Mosneron-Dupin identify it
with the representation of the Trinity that
has adorned the church of Genlis only
since the middle of the nineteenth
century.

There is much debate over the
attribution of the Genlis group: David
discerns in it a stylistic relationship with
the Trinity in the Dijon hospital; similarly,
Liebreich finds echoes of a Champmol
work. Troescher reverses the order of
dependency, however, asserting that it
is the Trinity at the Dijon hospital that
reflects that of Genlis. Quarré (1954)
considers the work, at least in its faces
and clothing, as a copy of Jean de
Marville's *Trinity* and observes marked
differences from the style of Jean de
La Huerta. Verdier, however, argues that
there is a stylistic connection with the
works of Jean de La Huerta. Quarré
(1976B) ultimately attributes the piece
to Claus de Werve—an opinion that De
Winter supports in turn. Boccador sees a
stylistic link with the figures of the church
choir at Saint-Hippolyte in Poligny. Camp
(1990) reiterates Verdier's thesis. For
Morand, the two works at Dijon and
Genlis simply reveal the overall influence
of Sluter. Mosneron-Dupin follows David
in attributing the Trinity of Genlis if not to
the same artist, at least to the same
studio that created the Trinity at the
Dijon hospital.

The problem with this debate is that we
have no work by Marville that can be
attributed with absolute certainty to him
alone. This is also the case for Claus de
Werve, in the works that he realized
independently of Sluter. One can only
observe the parallels of certain motifs. In
the Trinities at Genlis, Houston (cat. 97),
and the Musée d'Archéologique, Dijon
(p. 240, fig. 5), the Eternal Father places
his right hand on the pillar of the cross,
supporting the crossbeam with his left
hand, which is concealed beneath his
cloak. It is only in the group in the
hospital chapel that God is shown with
both hands beneath the crosspiece. The
cloak falls over his left hand in delicate
folds down to his knee, whereas it is raised
above the right hand. We also find this
formal arrangement in the figure of
Mourner no. 78 (cat. 94). In each Trinity,
the dove hovers between the beard of the
Eternal Father and the holy cross. The
Trinity in the Dijon museum reprises this
model. As it is very rare in the iconography
of the Trinity for God to be depicted
standing, and as the works remaining to
us originated in Burgundy, these are most
likely, according to David, Liebreich,
Quarré, and many others, copies of a
sculpture from Champmol, which can in
all likelihood be identified with the Trinity
of the main altar realized by Marville.

R.P.

86

Anonymous

Virgin and Child of Bussy-la-Pesle
Early 16th century

Stone, paint; crown has been lost
H. 90 cm

Bussy-la-Pesle, church of Notre-Dame and Saint-Blaise

BIBL.: Bordet 1927–32, p. 48; Liebreich 1936, p. 59; Troescher 1940, p. 106, fig. 272; Quarré 1949, p. 254; *Inventaire général . . . canton Sombernon*, p. 163; Boccador 1974, 1: pp. 199, 206, figs. 236, 251; Didier 1993, p. 20; Prochno 2002, pp. 29, 44, 178.

EXH.: Dijon 1949, no. 33; Rotterdam 1950, no. 39; Dijon 1968, no. 3; Dijon 1990.

This statue reproduces closely the Virgin that Sluter conceived for the portal of Champmol, leading Boccador to suggest it was probably a work by Claus de Werve. Compared with its model, however, it is less subtly elaborated and its proportions stockier. As in the work of Sluter, this Christ child holds a bird, symbol of the Passion, and his eyes are raised toward heaven, a detail that can only be fully understood when one considers that the statue was mounted on a dais—which at Champmol symbolized heavenly Jerusalem. Whether this dais was likewise taken, perhaps in smaller size, from this copy remains unresolved. The Virgin's crown was not sculpted—as was the case in Sluter's work—but fabricated separately; it was most likely made by a goldsmith. The painting was also an additional element.

This is not the site for which the work was initially intended, as the church of Bussy-la-Pesle was not built until 1750. According to the inventory of the canton of Sombernon, the statue came from the chapel of the "hamlet of Savranges," which was administered by the parish priests of Bussy-la-Pesle. From this same church came the sculpture group of the Education of the Virgin, which was likewise a copy of a work from Champmol. The Dijon exhibition catalog of 1990 and Didier both indicate erroneously that this statue was located in the chapel of the castle of Savranges. Nothing is known of its sponsor; it may have been a donation from the La Baume family, owners of the castle at Bussy-la-Pesle in the fifteenth and sixteenth centuries. This building was destroyed in the eighteenth century.

R.P.

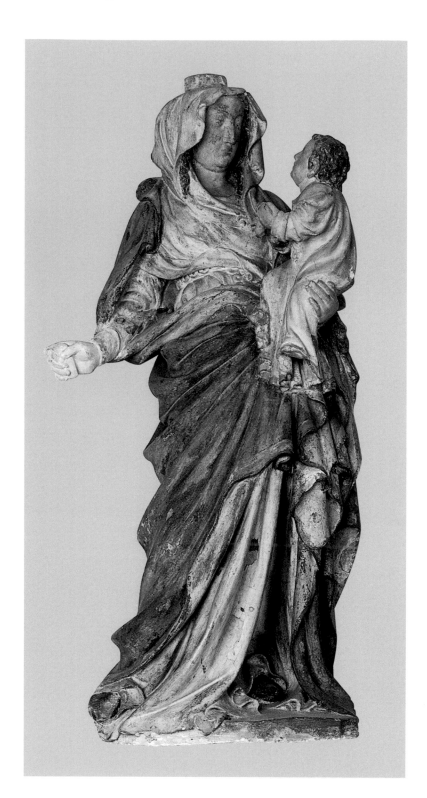

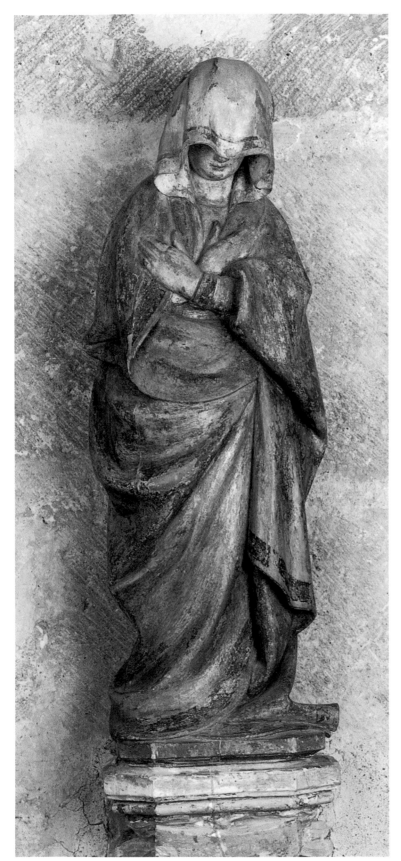

87

Virgin of the Crucifixion
Early 15th century

Polychromed and gilded wood
68 x 21 x 16 cm

Flavigny, church of Saint-Genest

BIBL.: Drouot 1926, p. 153; Troescher 1932, p. 98; David 1933, 1: p. 73; Baudoin 1996, p. 133; Bertrand 1997, 2: no. 74.

EXH.: Dijon 1949, no. 12; Rotterdam 1950, no. 12; Dijon 1976, no. 42.

Mary presses her crossed hands against her chest, in a gesture that eloquently conveys her grief. The folds of the mantle (restored in the front) are supported by the arms pressed against the body. To communicate the nuances of the figure's internalized sorrow, the sculptor had the idea to have her veil descend very far

Fig. 1

FIG. 1. Claus de Werve (?), Weeping Angel from the *Well of Moses*, 1399-1401, stone with traces of polychromy. Chartreuse de Champmol.

FIG. 2. Claus de Werve, *Virgin and Child,* first quarter of the 15th century, stone, 162 x 45 cm, from L'Église de Montigny-sur-Vingeanne. Paris, Musée du Louvre.

FIG. 3. Claus de Werve, *Virgin and Child,* first quarter of the 15th century, stone with traces of polychromy, H. 135 cm. Brétigny-sur-Norges, Église Saint-Georges et Saint-Firmin.

Fig. 2

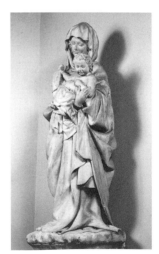

Fig. 3

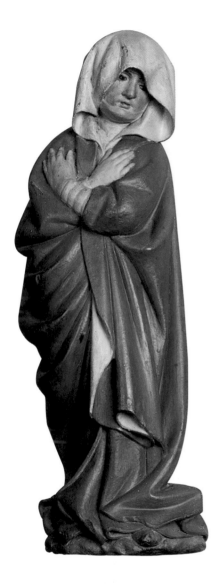

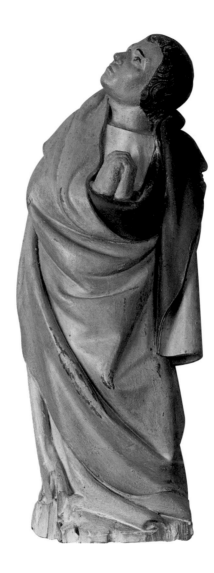

and the distribution of the folds are very close to those in the Montigny-sur-Vingeanne Virgin, now in the Louvre, most likely by the hand of Claus de Werve (fig. 2). The manner in which the edge of the garment crushes the base of the silhouette and then covers the floor recalls a formula used by Claus de Werve in the Brétigny Virgin Mother (fig. 3). In the past there was a tendency to see the Flavigny Virgin as a version of another that Claus de Werve made for the Crucifixion at the Carthusian monastery at Champmol. However, doubts have emerged that suggest a certain prudence in this regard, particularly since we do not know to what degree uncle and nephew individually contributed to the creation of this figure.

V.B.

88

Virgin and St. John of the Cross

Early 15th century

Polychromed wood
Virgin: 58 x 20 x 13 cm
St. John: 57 x 21 x 13 cm

Prémeaux, church of Saint-Marcel

BIBL.: Drouot 1913–21, p. CCLXIII; Drouot 1926, p. 155; Troescher 1940, p. 111; Baudoin 1996, p. 133.

EXH.: Dijon 1976, nos. 43–44, pl. XXII.

The Virgin is enveloped by a mantle, the folds of which are restored in front, forming, at the left, a series of overlapping curvilinear folds and, at the right, a cluster of vertical folds. The head is covered with a veil that descends to the eyebrows, and the bottom of the face is covered by a chin band. The hands are conspicuously crossed on the chest, pressing inward, conveying the figure's sorrow in particularly explicit fashion. The posture and the gestures circumscribe the figure within an ovoid shape and concentrate attention on the face and the hands, the only visible anatomical details. This Virgin is related to the one in Flavigny, wherein echoes of the Champmol Virgin of the Crucifixion (cat. 87) have often been noted. The Flavigny Virgin is much more moving than this one in Prémeaux. Here, the less secretive quality of the face, the fragmented silhouette, the haughty tilt to

down, to the point that the viewer glimpses only the lower portion of her face. One can note the influence of the mourners from the tomb of Philip the Bold, particularly those that are known by numbers 11 and 21 according to Pierre Quarré's nomenclature (Baudoin 1996, figs. 199–200). As with those figures, the emotion-filled sorrow—all the greater here since it seems modest—is revealed in details that are subtler than incipient tears or painfully furrowed brows. Here, there is the apparent withdrawal of the body, the tilt of the head, the drooping shoulders, and the force with which the hands press down express the figure's grief.

The explicit reference to the mourners from the princely monument justify mentioning the influence, seemingly in equal measure, of the art of Claus Sluter and that of Claus de Werve, since the cortege was conceived by the former and sculpted by the latter—with the exception, perhaps, of mourners 39 and 40, which are often attributed to Sluter. Nevertheless, references to works by the nephew seem more numerous. Indeed, the gesture of the hands crossed over the chest definitely brings to mind one of the angels sculpted by Claus de Werve between 1399 and 1401 for the *Well of Moses* (fig. 1). Moreover, the arrangement of the mantle

the neck, and the artificial gesture of the hands combine to diminish the figure's mystery and pathos.

Slightly turned toward the left, with the upper portion of his body tilted to better see the crucified Christ, St. John clasps his hands with fervor. His mantle encloses his body in an utterly original fashion, isolating the two most eloquent details, the clasped hands and the grief-stricken face. As with the figure of the Virgin, the opposition of the folds contributes clearly to the character of the work. Here, the fall of the folds of the mantle seems very modern, forming an almost abstract design that is essential to the structure of the principal motif.

The difference between the formal inventiveness, on the one hand, and the quality of the sculpting, on the other, seems to suggest the possibility that in this case a simple laborer repeated an "image" that was without doubt remarkable and had become well known. The Champmol Crucifixion comes to mind, but our current knowledge does not allow us to draw any definitive conclusion in this regard.

These two statues came from a Crucifixion in the church of Saint-Denis in Nuits-Saint-Georges, which was dismantled in 1756.

<div align="right">V.B.</div>

89

Bust of St. Anthony
Early 15th century

Limestone
48 x 44 x 39 cm

Dijon, Musée Archéologique, inv. Arb. 1350

PROV.: manner and date of entry to museum unknown.

BIBL.: La Marche 1883–88, p. 255; Courajod 1899–1903, 2: p. 382; Kleinclausz 1905, p. 131; Humbert 1913, p. 148; David

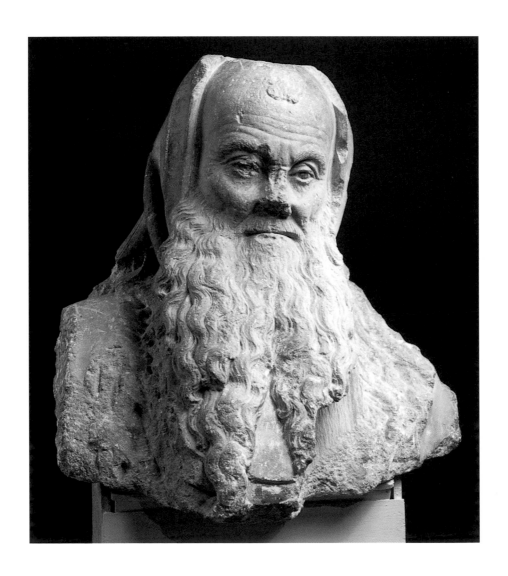

1933A, 1: p. 19; Liebreich 1936, pp. 166–67; Troescher 1940, p. 88; Müller 1966, p. 11; Forsyth 1987, pp. 78–79; Morand 1991, p. 151; Baudoin 1996, p. 125; Bertrand 1997, 2: no. 57; *Sculpture médiévale en Bourgogne*, no. 174.

Exh.: Dijon 1976, no. 55.

It is likely that this bust belonged to a large-scale sculpture in the round, the provenance of which remains unknown. The combination of certain characteristics of the features and clothing allows us to identify the figure as St. Anthony, one of most popular saints in Burgundy. The artist adhered to the traditional iconography and notably endowed his subject with distinctive signs of old age, such as the long wrinkles crossing the forehead, the deep crow's-feet, and the slack eyelids. These skillfully conveyed characteristics are further enhanced in this old sage's face by the qualities of compassion and sweetness, inferred from details such as the softness of the beard, with its slight waves, or the even design of the eyes and eyebrows.

Mentioned here and there in works devoted to Burgundian sculpture, this bust has been attributed in turn to Claus Sluter, to his workshop, and to Claus de Werve. Aenne Liebreich, for example, notes the extent of the restoration of a conception similar to that of the prophets Moses and Zechariah in the famous *Well of Moses*. Yet Sluter's style does not seem to be directly conveyed, but rather is translated through another personality, undoubtedly an assistant who was completely conversant with the master's style. The softness of the head brings to mind Sluter's nephew, Claus de Werve, whose affable figures instead convey that artist's personality. As Françoise Daloz notes, the figure of David is, among all the prophets in the monument, the one that best corresponds to our knowledge of Claus de Werve's artistic expression (*Sculpture médiévale en Bourgogne*, no. 174). But his work on the other prophets, known through archival documents, or the angels in the *Well of Moses*, where the extravagant, stylized hair moves away from his customary naturalism, reveals how his assured talent and authentic artistic temperament permitted him to occasionally nuance his style.

V.B.

90

Anonymous

The Education of the Virgin
c. 1420

Stone, paint
H. 111 cm

Poligny, church of Saint-Hippolyte

Bibl.: Baudot, BM Dijon, MS 2081, p. 277; Troescher 1932, p. 76; David 1933, 1: pp. 160, 175; Quarré 1978, p. 14; Camp 1990, p. 101, fig. p. 97; Morand 1991, pp. 155, 158, fig. 44; Baudouin 1996, pp. 54, 139ff; Prochno 2002, pp. 177ff.

St. Ann and Mary are depicted side by side. The Virgin is dressed in a habit with tight sleeves concealed beneath a flowing cloak, the sleeves of which widen out *en cornet*—a characteristic detail of late fourteenth-century costume. Ann is wrapped in a large cloak, decorated with a wide belt placed beneath her breast; her hair and a large collar lined with deep pleats frame her face. Under her right arm she holds a closed book, while she points to a passage in the book that her daughter holds in her hands. The Virgin points her own writing instrument to the same place in the text. She sits up straight, which underscores the relationship of her absolute independence with what she is reading. The drape of her gown—its nearly vertical fall stops only at the floor, forming

a heap of folds—further emphasizes her self-possession; this motif appears in several of the mourners on Philip's tomb. There are hints that this sculpted group is an echo of a model at Champmol. The comparison with two other very similar works, at Fontaine-de-Dijon and Bussy-la-Pesle, also support this hypothesis; David (1933, p. 175) includes the statue of Beurizot (Côte-d'Or), while Camp mentions the versions at Pichanges and at Chamblanc.

Three high officials of the ducal courts of Burgundy played an important part in founding the collegiate church of Poligny. At Bussy-la-Pesle, there is also a copy of the Virgin from the Champmol portal. This further indicates that these scenes of the Education of the Virgin were copies of a common model at Champmol. In the chapel of Saint-Agnès, Baudot observed a sculpted grouping representing "Saint Elizabeth teaching the Holy Virgin to read." This was likely the piece that Claus de Werve worked on with Sluter, as it pertains to the document of payment to the sculptor for the period of 1 December 1396 to 30 June 1399 ("une autre ymaige de saincte Anne" [another image of St. Ann], ADCO, B 4447, fol. 23v). Morand and Camp also attribute the statue of Champmol to Claus de Werve, although this is not confirmed by available sources. We may suppose that it was this group that the Carthusians wanted to move to the House of the Mirror, their residence in town (ADCO, H46, Carthusian accounts).

R.P.

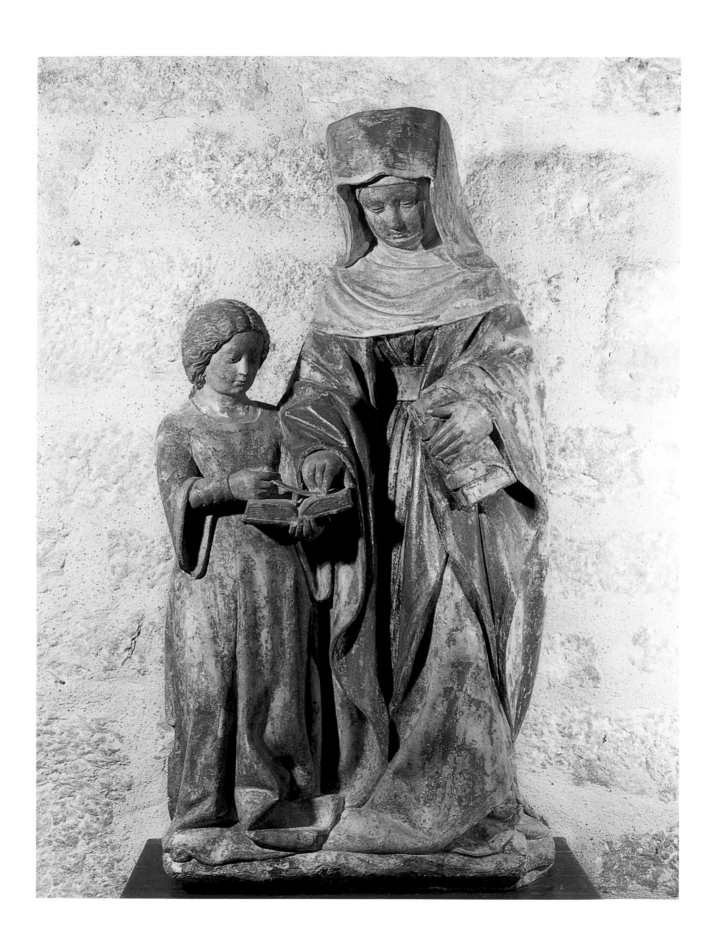

91

Fragments from the Tombs of Louis II de Bourbon and Charles I de Bourbon

Attributed to the atelier of Jean de Cambrai
(Roupy?, mentioned for the first time in 1375/76–Bourges? 1438)

Fragments from the Tomb of Louis II de Bourbon
Beginning of the 15th century

Marble, traces of polychromy
H. 20 cm

Moulins, Musée Anne-de-Beaujeu,
inv. 1054.1, 1054.2

Atelier of Jacques Morel
(Lyon, fourth quarter of
14th century–Angers, 1459?)

Fragment from the Tomb of Charles I de Bourbon and Agnes de Bourgogne
Middle of the 15th century

Marble
H. 36.5 cm

Moulins, Musée Anne-de-Beaujeu,
inv. 1054.3

Bibl.: sources: BNF, Clairambault collection 240, fol. 262; *Bulletin de la Société d'emulation de l'Allier* 1886, p. 30; Baudoin 1998, p. 122.

Exh.: Dijon 1971, no. 2526.

During the same period that Philip the Bold was constructing the abbey of Champmol, Louis II de Bourbon, cousin of the Duke of Burgundy, was also apparently building a chapel on the south side of the church of Saint-Pierre de Souvigny. Like the Burgundian monument, this Benedictine priory had been used a ducal necropolis for the Bourbons.

The first two fragments (1054.1 and 1054.2) come from the tomb of Louis II and his wife, Anne d'Auvergne. Although they have been mutilated, these fragments representing mourners or holy men still bear a scroll decorated with fleur-de-lis motifs with the girdle and motto of the Bourbons, "espérance" (hope).

As described in old documents, the sculptures were integrated into the architecture of three courses on the perimeter of the marble base, surrounding the effigies.

The monument, which dates from the second decade of the fifteenth century, is clearly contemporary with the tomb of Philip the Bold. The works have certain elements in common, particularly discernible in the amplitude of the drapery in the mourners' robes.

In addition, perplexing formal similarities have been noted between the tomb in Souvigny and the tomb of Jean de Berry (who died in 1416) in Bourges, which was the work of Jean de Cambrai. We should be cautious in attributing the Souvigny tomb to the same artist, but is true that the ties between the houses of Bourbon and Berry support this hypothesis. (Marie de Berry, daughter of the duke, married Jean, Count of Clermont and son of Louis II de Bourbon, in 1400.)

These matrimonial ties also explain the major influence of the monument at Champmol on the second tomb in Souvigny, that of Charles I de Bourbon and Agnes de Bourgogne. She was the daughter of John the Fearless, and thus the granddaughter of Philip the Bold. The contract between the Duke of Bourbon and the Lyonnaise sculptor Jacques Morel in fact specifies that the tomb be modeled after that of Philip of Burgundy. Although the tomb of Charles I is not a simple replica of its famous original, we are nevertheless aware of the intimate connections between the two. The later monument has the same general design, and shares certain details, such as the alternating rectangular bays and small triangular galleries on the base (as can be seen in fragment 1054.3).

How familiar was Jacques Morel with the work in Champmol? Because no other work clearly attributable to him has survived, it is difficult to form a judgment.

It is nonetheless obvious that he did not execute the work at Souvigny alone; the allusion to a certain Master Vausy, who appeared some years later in Dijon, is certainly not coincidental. Chance alone also does not explain how Jean Poncelet and Antoine Le Moiturier, who no doubt worked on the tomb of Charles I with Jacques Morel, also participated in the execution of another Burgundian tomb, that of John the Fearless. The links between the tombs of Champmol and Souvigny seem to extend well beyond mere similarities in form; they are evidence of the ties that bound the Burgundian and Bourbon artistic traditions.

M.P.

Overleaf

92

Jean de La Huerta
(Daroca, ?–? after 1462)

Antoine Le Moiturier
(Avignon, c. 1425–Dijon, 1494)

Tomb of John the Fearless and Margaret of Bavaria
1443–70

Black marble, stone painted black, partially polychromed and gilded marble

246 x 376 x 362 cm

Dijon, Musée des Beaux-Arts, inv. CA 1417

PROV.: commissioned by Philip the Good in 1443; installed in the chancel of the church of the Chartreuse de Champmol in 1470; taken apart and reassembled in 1792 in the old abbey church of Saint-Bénigne, which has since become a cathedral; taken apart and vandalized in August 1793; restored between 1819 and 1824 and reassembled in the guardroom of the Musée des Beaux-Arts, Dijon. The tomb will be cleaned and restored in 2004–5 by a team of restorers under the direction of Benoît Lafay, with the financial support of the Getty Foundation.

BIBL.: Févret de Saint-Mémin 1847, pp. 32–35; Dijon 1883, no. 1417; Chabeuf 1891; Monget 1898–1905, 2: pp. 103, 114–16, 125–35, 148–49; Andrieu 1913–21; Andrieu 1933; David 1936; Troescher 1940; Quarré 1947; Quarré 1948; David 1951, pp. 143–60; Quarré 1960C, no. 18, pl. VII and XII–XV; Camp 1990, pp. 74–75, 119–22, 169; Beaulieu and Beyer 1992, pp. 182–84, 186–88; Baudoin 1996, pp. 93, 100, 201, 205; Prochno 2002, pp. 104–7.

EXH.: Dijon 1949, p. 35; Amsterdam 1951, nos. 181–83; Brussels 1951, nos. 169–71; Dijon 1951, no. 129; York 1957, no. 13; Dijon 1960, no. 27; Dijon 1971; Dijon 1990, pp. 42–48; Dijon 1992, no. 2, p. 76.

Exhibited in Dijon only

Shortly after his father's tomb had been installed in the church at Champmol in 1410, John the Fearless expressed the desire to erect "a tombstone similar to my late father's" for himself, but nothing was really begun, even after his death in 1419.

In 1435 Philip the Good renewed the commission and added the project of making his own tombstone. However, Claus de Werve died in 1439 before finding the appropriate alabaster.

Philip the Good finally concluded a deal with Jean de La Huerta on 23 March 1443, for the construction of the tomb of John the Fearless, which was required to be "as good as or better than" the tomb of Philip the Bold, and of the same scale. A "portrait" of the recumbent figures by Claus de Werve was given to La Huerta. The project of a tomb for Philip the Good, however, was no longer mentioned.

After having encountered many difficulties in the creation of the recumbent figures, Jean de La Huerta left Dijon in 1456; the parts of the tomb were brought to Champmol in 1457, indicating that at that point the gallery, the mourners, the angels for the tombstone, the coats of arms, and the helmet had been completed.

In 1461, following the advice of his sister Agnes, Duchess of Bourbon, Philip the Good entrusted the work to Antoine Le Moiturier, the nephew of Jacques Morel, who had made a tomb for Charles de Bourbon and Agnes de Bourgogne in Souvigny (Allier) between 1446 and 1452. Antoine Le Moiturier constructed the recumbent figures from 1466 to 1469, and also finished mourners and the arcatures. In 1470, the tomb was installed in the chancel of the church at Champmol, behind the tomb of Philip the Bold.

According to both John the Fearless and Philip the Good's wishes, the tomb of John the Fearless faithfully reproduces the model of the tomb of Philip the Bold. Working under the obligation to conform to their model, Jean de La Huerta and Antoine Le Moiturier did not have the opportunity to turn the tomb of John the Fearless into an original work.

S.J.

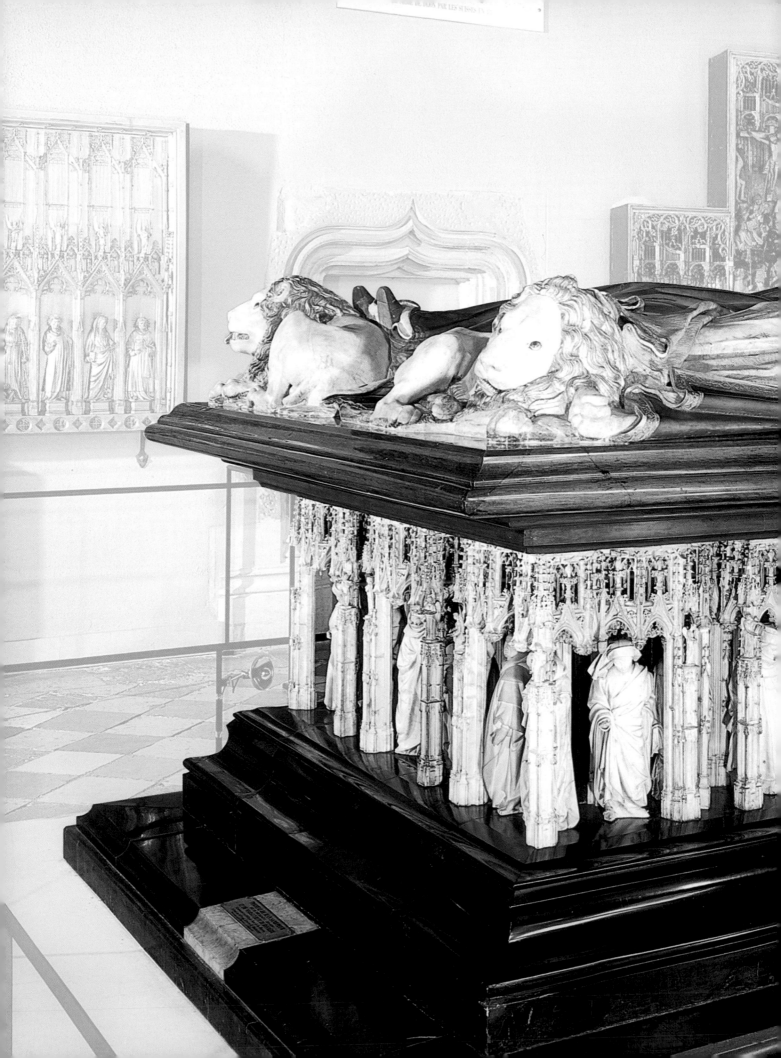

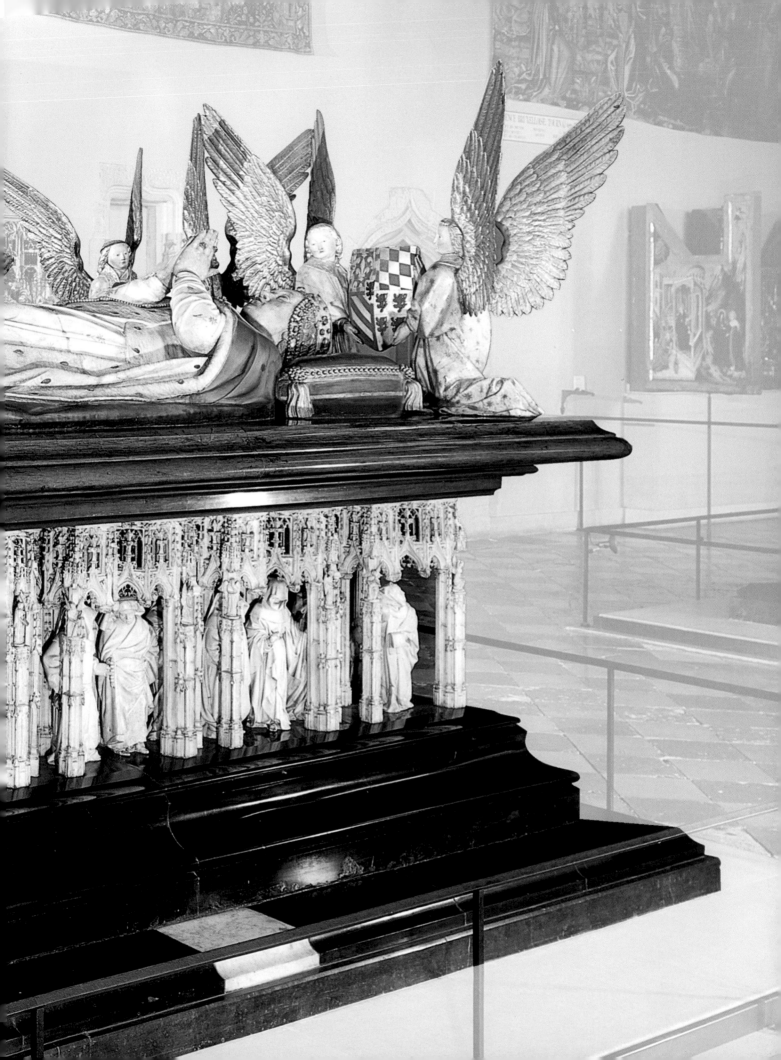

93

Jean de La Huerta
(Daroca, ?–?, after 1462)

Parts of the Arcatures of the Tomb of John the Fearless
1443–55

1. Fragment of a Niche
Alabaster
9 x 20 x 18.7 cm

Dijon, Musée des Beaux-Arts,
inv. D 2001-3-2

 Prov.: Peyre bequest to the Musée des Arts Décoratifs de Paris, inv. Pe 1638; in the collection of the Musée du Louvre from an unknown date (before 1950) to 2001; transferred to the Musée des Beaux-Arts de Dijon, 2001.
 Bibl.: Baron 1996, p. 206 (not identified); Baron and Jugie, forthcoming.
 Exh.: Dijon 2002, p. 7, fig. 4.

2. Colonnette
Alabaster
L. 5 cm

Dijon, Musée des Beaux-Arts,
inv. 2001-7-2

 Prov.: Victor Gay collection; Lucien Mellerio collection; auctioned in Paris, Hôtel Drouot, July 2001; purchase with the participation of the Ministry of Culture/Regional Management of Cultural Affairs for Burgundy and the Burgundy regional council, 2001.

 Bibl.: Baron and Jugie, forthcoming.
 Exh.: Dijon 2002, p. 7.

The tomb of John the Fearless was subjected to the same vicissitudes as the tomb of Philip the Bold (see cat. 82). Sources allow us to confirm that the two pairs of angels, the helmet of John the Fearless, and the coats of arms of Margaret of Bavaria are authentic. The two recumbent figures have been reconstructed, but include the original masks of John the Fearless and Margaret of Bavaria, which were removed in 1793 and stored in the Saint-Bénigne workshop, and the two pairs of hands, which were returned by Baudot. Concerning the arcatures, which were originally made of alabaster and restored in alabaster, there is no scientific means of distinguishing the originals from those that were reconstructed. The accounts of the restoration, despite a certain lack of distinction between the two tombs, lead us to believe that the tomb of John the Fearless was less damaged than Philip the Bold's; according to our estimates, seven niches of a total of twenty-four and four small columns of a total of sixty-four have been reconstructed.
 The tomb of John the Fearless is most different from that of Philip the Bolds in its arcatures, which were designed by Jean de La Huerta. The decorations are noticeably more complex, more "flamboyant." A band on which are sculpted a plane and a hop leaf, the duke's emblems, runs along the superior part of the arcatures. These arcatures appear never to have been gilded.

 S.J.

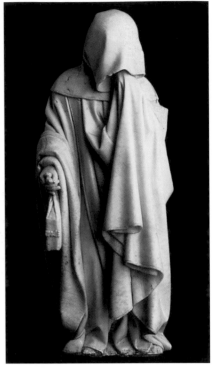

51

94

Jean de La Huerta
(Daroca, ?–?, after 1462)
Antoine Le Moiturier
(Avignon, c. 1425–Dijon, 1494)

Mourners

Mourner no. 51: Mourner Holding a Book in a Purse and Lifting His Coat with His Left Hand to Wipe His Tears
Alabaster
H. 41 cm

Dijon, Musée des Beaux-Arts,
inv. CA 1417

Mourner no. 67: Mourner with a Bare Head
Alabaster
H. 41 cm

The Cleveland Museum of Art,
inv. 1940.129

 Prov.: Hocquart collection, 1825; following his death, his son-in-law Édouard de Broissia; Legay, merchant in Nancy, 1876; Stein, merchant in Paris; Schickler collection, Paris,

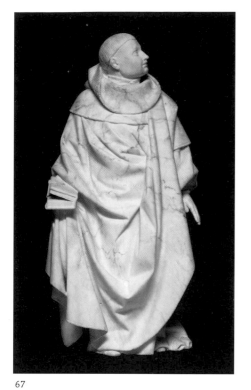

67

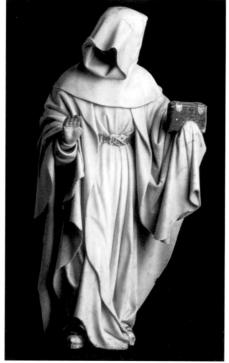

78

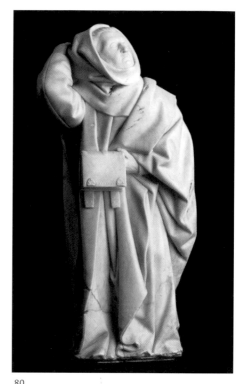

80

1913; Pourtalès collection, Paris, 1913; Duveen collection, 1919; Clarence Mackay collection, 1932; acquired with J. H. Wade Fund in 1940.

BIBL.: Andrieu 1913–21; Milliken 1940; Quarré 1936–39; De Winter 1987.

EXH.: Paris 1900; Paris 1913; Cleveland 1967, no. VII-6.

Mourner no. 78: Mourner Holding a Book in His Left Hand and Lifting His Right Hand
Alabaster
H. 41.3 cm

Mourner no. 80: Mourner Holding a Book in front of His Belt and Turning up His Face
Alabaster
H. 39 cm

Dijon, Musée des Beaux-Arts, inv. CA 1417

GENERAL BIBLIOGRAPHY: see cat. 93.
EXH.: Dijon 1971; Dijon 1972, nos. 13–41; Dijon 1973, nos. 30–38.

On the history of the mourners: Chabeuf 1891; Drouot 1913–21; Andrieu 1933; Liebreich 1936, pp. 143–63; Roggen 1936; Quarré 1947A; Quarré 1948; David 1951, pp. 161–73; Quarré 1952; Morand 1991, pp. 365–69; Baron and Jugie, forthcoming (with bibliography).

EXH.: Dijon 1960; Dijon 1965; Dijon 1990; Dijon 2000.

As the source documents suggest, Jean de La Huerta probably made the greatest number of the mourners on the tomb of John the Fearless because Le Moiturier's contract, signed in 1461, charged him with "perfecting, polishing, and completing the mourners." In his exhibitions dedicated to Jean de La Huerta and Antoine Le Moiturier, Pierre Quarré proposed to divide the mourners by attributing those "who display a demeanor full of movement or wear draped clothing with swirling folds" to La Huerta and those "who have a calm demeanor, very sober draped clothing, and faces with luminous contours" to Le Moiturier. Indeed, it is undeniable that the fullness of the drape of certain mourners' clothing clearly situates them in the school of Sluter, while a simpler conception is expressed in other mourners. But it must be observed that, in keeping with Philip the Good's commission, both sculptors did not finally do much to differentiate their work from the model of Philip the Bold's tomb. Certain mourners are exact copies of the mourners surrounding Philip the Bold, and those who are different remain in the same spirit. In these circumstances, it is difficult to attempt to attribute the mourners to one or another of the sculptors who worked on the tomb.

S.J.

95

Etienne Bobillet
(active mid 15th century)
Paul Mosselman (d. 1467)

Two Mourners from the Tomb of Jean, Duke of Berry
c. 1453

Alabaster
H. 38.7 and 38.4 cm

New York, The Metropolitan Museum of Art, Gift of J. Pierpont Morgan, 17.190.386, 17.190.389

PROV.: from the Tomb of Jean, duc de Berry, choir of Sainte-Chapelle, Bourges (until 1757); Vicomte de Fussy; Georges Hoentschel, Paris; J. Pierpont Morgan, New York.

BIBL.: Pradel 1957, pp. 141–57.

Exhibited in Cleveland only

These two figures of mourners were originally part of the tomb monument of Jean, Duke of Berry, one of Philip the Bold's older brothers. Although administratively weak and politically ineffectual, Jean de Berry distinguished

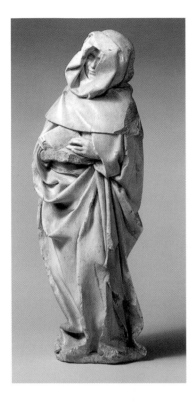

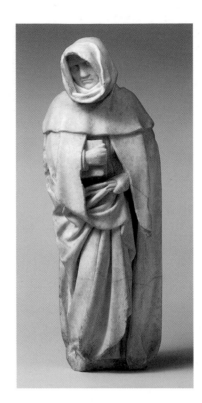

96

Anonymous

Two Carthusian Monks, Kneeling

c. 1400

Marble
H. 25.7 and 24, L. 13.4 and 12.9 cm

Cleveland, The Cleveland Museum of
Art, inv. 1966.113

PROV.: Carlo Micheli collection, Paris;
Mayer van den Bergh collection, Antwerp;
Soullié collection; Octave Homberg collection,
Paris; Jacques Seligmann and Co. collection,
New York; acquired by the John L. Severance
Fund.

BIBL.: Migeon 1904, p. 36; Eisler 1964,
p. 289; De Coo 1965, pp. 345–70, no. 137;
Wixom 1966, pp. 348–55; Boccador 1974,
1: p. 52, fig. 38.

EXH.: Baltimore 1962, no. 92; Cleveland
1967, no. VI–10; Paris 1981, no. 92.

These statuettes of kneeling monks
wear the robes of the Carthusian order.
They are evidently not portraits, which
leads us to suppose that these figures
were rather intended to evoke perpetual
devotion. The object to which their
gesture of veneration is addressed is lost.
These examples are the only extant
representations of kneeling Carthusian
monks, though there are analogous
sculptures depicting members of other
monastic communities (see Boccador
1974).

The style of the figures is distinguished
from that of Sluter by the smoothness of
their features and the drape of their
clothing. The pose of these two holy
brothers finds a comparison in Jean de
Beaumetz's paintings for the monks' cells
at Champmol, which always include a
figure of a kneeling Carthusian monk at
the foot of the cross. It is also tempting—
taking into account the strict piety of this
order for the cults of the holy cross and the
Virgin Mary—to assume that these two
statuettes were associated with a crucifix
or a Madonna. Their small size leads one to
think that they must have been placed on
a small altar, possibly in a monastic cell.
Such an installation accords with the
anagogical "politics" of images practiced by
the order of the Carthusians: each cell
contained an image of the Virgin and a
crucifix, and each monk was allowed to
have a representation of his patron saint.

It has been asserted that these
statuettes came from the Carthusian
monastery in Paris, but it seems more likely

himself as a collector and patron of the
arts. He commissioned both architecture
and sculpture, but in illuminated
manuscripts his taste was luxurious and
his interest seemed boundless. He brought
the finest illuminators to his court at
Bourges and at one point owned more
than 300 manuscripts (cat. 12). Many of
the artists he employed had worked for
one or more of his relatives, which
suggests his taste may have been based in
some part on theirs. For example, the
illuminators Jean Le Noir and the Master
of the Parement de Narbonne had
previously worked for Charles V, the
oldest of John the Good's sons, while the
Limbourg brothers, authors of Jean de
Berry's most famous manuscript, the *Très
Riches Heures*, came into his service only
after the death of Philip the Bold.

The Duke of Berry's refined taste was
easily the equal of Philip's, and there were
many avenues of artistic influence
between Dijon and Bourges. Claus Sluter
and Jean de Beaumetz traveled in 1393 to
Jean de Berry's château at Mehun-sur-
Yèvre, where they would have met his
director of sculpture and painting, André
Beauneveu. Important for the present
discussion is the probable relationship
between André Beauneveu and a certain
Pierre Beauneveu, who is documented as
working alongside Claus Sluter on the
portal sculpture and the duke's tomb at
Champmol.

It was André Beauneveu's assistant and
successor, Jean de Cambrai, who designed
the Duke of Berry's funeral monument,
based on Sluter's recently completed tomb
for Philip the Bold. As in that work, the
deceased's recumbent effigy was placed on
the top of the tomb, with mourning
figures in architectural settings on the
sides (p. 238, fig. 1). The tomb was left
unfinished at the time of Cambrai's death
in 1438, and the project was turned over
to the Flemish sculptors Etienne Bobillet
and Paul Mosselman around 1453. The
tomb suffered severely during the French
Revolution, and only twenty-five of the
original forty mourners survive, in addition
to the effigy of the duke, which has
suffered subsequent defacing from graffiti.

The two mourners from the
Metropolitan Museum of Art were made
after Jean de Cambrai's death and can be
attributed to Bobillet and Mosselman.
Their style is distinctly different from
Cambrai's, which was based on the
Sluterian model of monumental form and
restrained dignity. Cambrai's compositions
tend to be columnar, with an emphasis on
simple vertical folds, whereas the
sculptures of Bobillet and Mosselman
exhibit far more activity in the drapery and
variety in pose, giving the impression of
being more dynamic than dramatic.

T.H.

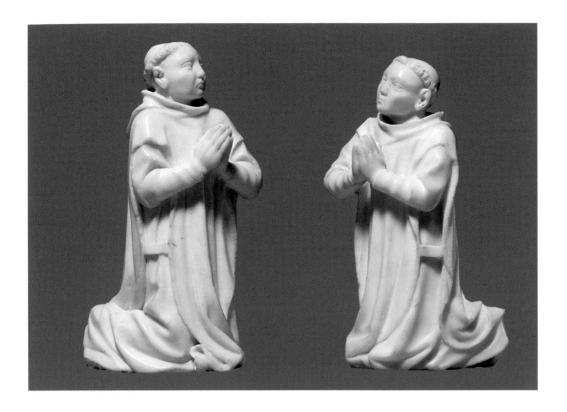

that they were actually at Champmol. The inventory of the Micheli collection describes, under no. 137, an altarpiece accompanied by two kneeling monks: "Altarpiece in Tonnerre stone, from the Dijon Charterhouse, fourteenth century. This monument, of the finest execution, is composed of three parts. The central portion is a pinnacle with a *clocheton*, or pointed turret, carved in openwork: underneath the dais is a statue of the Holy Virgin of great beauty. The two sides, likewise carved in Tonnerre stone, affixed to black marble, each hold a statue of a kneeling monk." The archives of the department of sculpture at the Louvre (Paris 1981) contain old photographs of this group with the Micheli inventory number on the statue of the Virgin, but without the dais. According to this inventory, the group came from Champmol. The two statuettes belong to the same collection as the polyptych panels at Antwerp and Baltimore and from the small altar of the Antwerp tabernacle, which, it has been established with certainty, comes from the charterhouse of Dijon (Prochno 2002, pp. 198–200). The inventory of the Revolutionary era makes no mention of the grouping, but it is possible that it had already disappeared during earlier plundering.

R.P.

97

Franco-Netherlandish (Burgundy)

God the Father from a Trinity Group
Late 14th or early 15th century

Ivory
24.8 x 13 x 7.6 cm

Houston, Museum of Fine Arts, Edith A. and Percy S. Straus Collection, 44.581

Prov.: Henri Garnier, Lyon; Brummer Gallery, New York; purchased by Percy S. Straus on 18 January 1935.

Bibl.: Verdier 1975, pp. 65–90, figs. 44–54; Dupin 1990, pp. 35–65; Morand 1991, pp. 327, 329, fig. 57.

Exh.: Detroit 1997, no. 65.

This exquisite standing figure of God the Father presents a theme now known to be associated with Valois Burgundy, that of the Standing Trinity (as opposed to the more conventional seated version): with both hands, God the Father supports the horizontal members of the cross bearing the figure of the crucified Christ, and, just above the cross, but beneath the mouth of God the Father, floats the dove of the Holy Ghost. Despite the loss of the cross and dove, the subject of this ivory is clear. The iconography of the Standing Trinity has been well studied by Philippe Verdier, I. M. Dupin, and others, and the Houston ivory is replicated by large-scale stone sculptures of the same subject at, for example, Genlis (cat. 85) and the Chapelle de la Sainte-Croix de Jérusalem in Dijon. The draping of the God the Father's left hand would seem to be a unique Burgundian feature; it is found not only on the Houston ivory, but also on monumental treatments of the theme.

The Chartreuse de Champmol, founded by Philip the Bold and Duchess Margaret, was dedicated to the Trinity and provided ample opportunity for iconographical experiments on this theme. The tondo painted by Jean Malouel (Paris, Musée du Louvre) for Duke Philip, for example, depicts the earliest known version of the Trinity, with God the Father mourning over the body of his son. It is known that a sculpture of the Trinity was transported from Jean de Marville's workshop to Champmol on 23 May 1388. It is also known that another sculpture of the Trinity once stood above the outer entrance to the ducal oratory at Champmol. These two sculptures are now lost and few conclusions can be drawn as to their precise iconography. However,

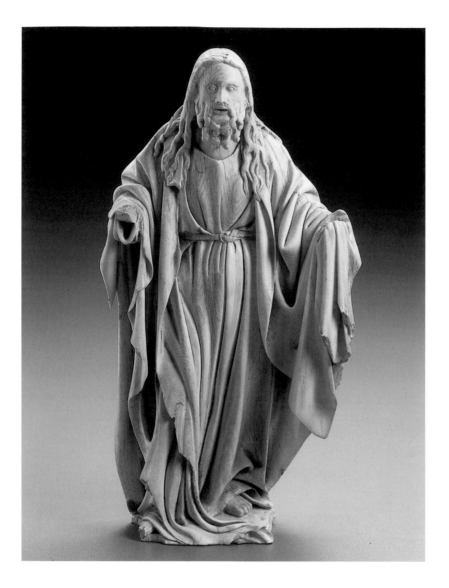

98

Anonymous

Two Statuettes of the Virgin and Saint John
Early 15th century

Gold
Virgin: H. 16.2 cm
St. John: H. 16.5 cm

Paris, Musée du Louvre, inv. OA 7753-7754

Prov.: Gift of E. Corroyer, 1923

Bibl.: Molinier 1900, pp. 356 (St. John), 360–61; Molinier, Marx, and Marcou 1900, no. 1, pl. 32; Marquet de Vasselot 1923, pp. 149–50.

Exh.: Paris 1900, no. 1679; Paris 1981, no. 223.

These two statuettes formed part of a Calvary group. The crucifix, erected at center, was flanked by these statues of the Virgin and St. John on octagonal pedestals adorned with foliage, recalling the prophets on the *Well of Moses*. Although this pair of statuettes has no direct relation with the works of Sluter, his influence is nonetheless apparent in the poignant expression of emotion manifested through the gesture and the clothing of the characters. The Virgin Mary conceals her face beneath a cloak that is pulled over her head, while her hands are clasped together and pressed against her abdomen, indicating the intensity of her interior grief. As though she can no longer support such pain, she turns away from the cross. This detail is echoed in the Virgin of the Cross at Esztergom (p. 129, fig. 1). The treatment of St. John's mantle is more agitated, his affliction more dramatic. The manner in which the Apostle holds his left arm across his chest, and the gesture to hide his face with his right hand, express pure despair. The same contrast in expressions can be found in the two Esztergom figures.

R.P.

Verdier has argued that both were standing versions of the Trinity. Since the Houston ivory probably follows a now-missing prototype, might it have been modeled after one of them? Given the importance of Trinitarian iconography at the chartreuse, it is not difficult to imagine that the Houston ivory was a portable devotional object, a visible connection to the Chartreuse de Champmol meant to accompany the itinerant Philip in his baggage as he moved among his residences.

Association with the chartreuse is supported stylistically: the rich, deep drapery folds relate strongly to the mourners on the ducal tombs. Intermediary models may have provided some link between the pose and drapery patterns that are common to both. It has been suggested that the softer draperies of the Houston ivory indicate the hand of Jean de Marville (d. 1389), Philip the Bold's court sculptor. Marville is known to have worked in ivory, and a document of 1377 reveals the purchase of ivory by the duke from a Parisian supplier for use by Marville. Ultimately, authorship of the ivory cannot be proven, though its association with the Burgundian court, Philip the Bold, and the Chartreuse de Champmol seem apparent.

S.N.F.

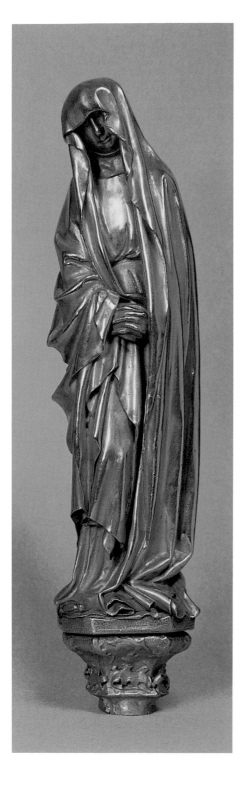
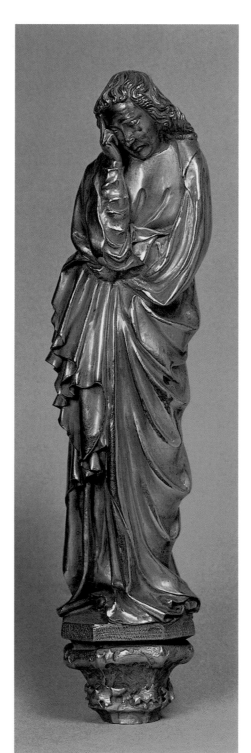

Burgundy

Calvary with Carthusian Monk

c. 1430–40

Oil on wood
57 x 47 cm

Dijon, Musée des Beaux-Arts,
inv. 1980.43.P

Prov.: Chartreuse de Champmol; Champy, Dijon antiquarian; collection of Martin Le Roy; collection of Mme Louise du Luart; acquired with the participation of the State and the Society of Friends of the Museums of Dijon, 1980.

Bibl.: Leprieur 1909, no. 17; Sterling 1942, p. 46, 59, no. 104, pl. 12; Sterling 1955, 1–3: pp. 64–66, p. 75, 78, fig. 7; Laclotte 1960, p. 496; Troescher 1966, pp. 121–22, p. 394, fig. 115; *Gazette des Beaux-Arts* 1982, no. 1358, no. 14, p. 3 repr.; Georgel 1984, pp. 127–28, repr.; Dijon 2000, p. 389, fig. 1; Prochno 2002, p. 222, fig. 104.

Exh.: Paris 1904, no. 95; Dijon 1960, no. 42; Dijon 1976, no. 87; Dijon 1981, no. 5; Dijon 1983, no. 28.

Since it was first exhibited in 1904, when it was still part of the collection of Martin Le Roy, this panel of Christ on the cross between the Virgin Mary and St. John with a praying Carthusian monk at the foot of the cross has confused historians, who are aware of its relative stylistic heterogeneity. Beginning in 1904, it was suggested that the painting, which dates from the mid fifteenth century, could have been inspired by older models.

Charles Sterling was responsible for establishing the panel's origins, in two stages. In 1942, he recognized the model for the Martin Le Roy Calvary, which had been owned by the Dijon antiquarian, Champy, in the late nineteenth century, in a Calvary that was then in the Chalendon collection and is now in the Louvre. Sterling hypothesized that both calvaries came from Champmol. In 1955, he uncovered the circumstances of the two commissions. The Chalendon Calvary and one then in the Wildenstein collection, and since acquired by the Cleveland Museum of Art, both resulted from the 1388 commission given to Jean de Beaumetz for twenty-six devotional panels to be placed in the Carthusians' cells. The Martin Le Roy Calvary was created at the funding of two new cells by Isabel of Portugal on the occasion of the birth of Charles the Bold in 1433. While there is no documentary evidence for this supposition, it can be

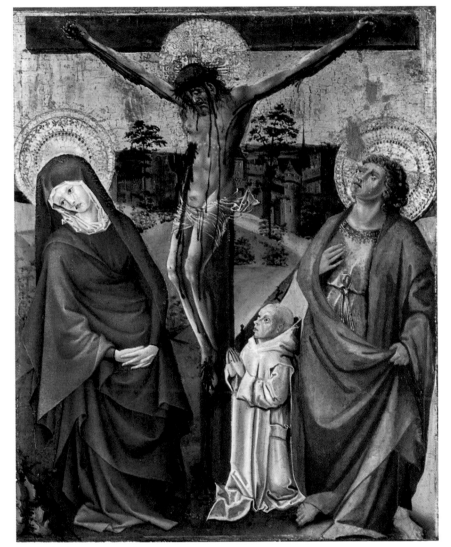

presumed that two additional panels would have been commissioned and created in reference to the panels previously made by Jean de Beaumetz.

This hypothesis has the advantage of accounting for both the resemblance and the differences between the composition of the Martin Le Roy panel and the other panels. Though the holy women do not surround the Virgin Mary in the former, the general composition is the same, and the insistence on Christ's tortured body and the long stream of blood is similar. The gold background, the large punched halos, and the fluid folds of the Virgin's brilliant blue coat all come from the same tradition. However, the solidity of the figure of St. John, the more vigorous touch that breaks the bottom of the Carthusian's cowl and details his unattractive yet fervent face, and the appearance of the urban landscape behind the figures denote a more sorrowful and energetic approach, which is entirely foreign to the courtly style of the 1400s. In a similar fashion to the *Altarpiece of St. George* (cat. 100), which shares this sense of an obligatory reference to an archaic model, the Calvary here remains difficult to situate in fifteenth-century Burgundian painting, of which we do not have enough surviving examples to describe its evolution and its artists.

S.J.

100

Burgundy

Altarpiece of St. George
Middle of the 15th century

Oil on wood transposed to canvas mounted on panel

16.5 x 211.5 cm

Dijon, Musée des Beaux-Arts, inv. D 1968.3 P

Prov.: Chartreuse de Champmol; Bartholomey collection, Dijon; sale, Paris, 1849, no. 2; collection of Jules Maciet; gift of Jules Maciet to Musée du Louvre; loaned by Musée du Louvre, 1968.

Bibl.: Kleinclausz 1906, p. 176; Lemoisne 1929, p. 11; Lemoisne 1931, p. 52; Dupont 1937, p. 157; Sterling 1938, pp. 61–63; Sterling 1942, p. 59, no. 16; Sterling 1955, 1–3, p. 66, 68, 75; Ring 1949, no. 55; Laclotte 1960, p. 496; Sterling and Adhémar 1965, no. 14, pl. 49–51, Troescher 1966, p. 121, fig. 117; Quarré 1968, no. 1, p. 464; Quarré and Geiger 1968, no. 4, pl. 1; Prochno 2002, pp. 56–58, fig. 28.

Exh.: Paris 1904, no. 388; Dijon 1960, no. 39.

Exhibited in Dijon only

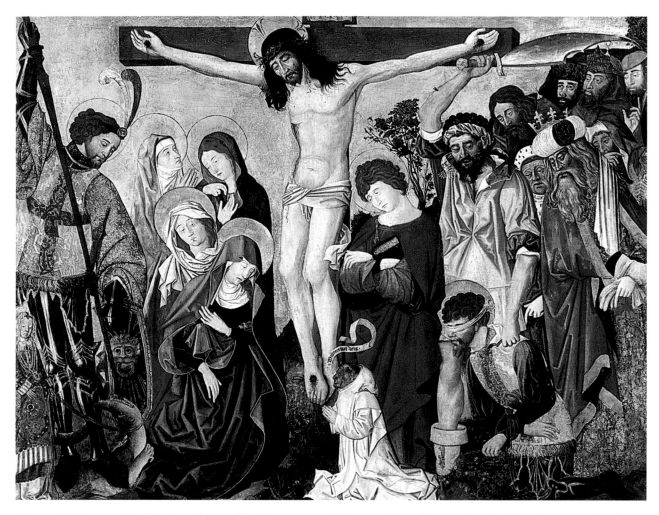

The parallels between the *Altarpiece of St. George* and the *Altarpiece of St. Denis* (p. 199, fig. 1) are evident. Until the *Altarpiece of St. George* was loaned to the Dijon museum, the two altarpieces' histories were linked. After having been part of the Bartholomey collection in Dijon until 1849, both altarpieces were given to the Louvre by Jules Maciet in 1891.

The dimensions of the two panels are the same, and the similarities in composition are obvious. The *Altarpiece of St. Denis* features scenes from the life of the first bishop of Paris painted on a gold background on either side of the Crucifixion. The left side shows the bishop's last communion, brought to him in prison by Christ, and the right side shows his decapitation along with his companions Rusticus and Eleutherius. The same one-dimensional gilded background is found in the *Altarpiece of St. George*, along with the structure by which two episodes from the life of the saint are placed on either side of the crucified Christ at the piece's central axis. The armed executioners' gestures also mirror each other.

The circumstances of the commission of the *Altarpiece of St. Denis* are well established, as part of the completion of the charterhouse's painted decorations. The altarpiece was probably begun by Jean Malouel and, as stated in the archival text, "perfected [completed]" by Henri Bellechose in 1416. The exact circumstances of the commission of the *Altarpiece of St. George* are unknown to us. The presence of a Carthusian in the painting leads us to believe that it may have been an offering by a monk who wanted to finish a decoration that had been left unfinished, rather than a ducal commission or an anonymous picture by a Carthusian intended as a simple aid to prayer. The altarpiece's initial placement can be specified, for it is known that two paintings of identical subject matter, which were painted in 1741 by Carle Van Loo, were installed in the lay choir, on either side of the door leading to the monks' choir. The two altarpieces were probably removed from Champmol at this time, rather than during the Revolution, for they are not included in the inventories drawn

up when the charterhouse was shut down. Several features, such as the solidity of the figures, the broken folds of the drape of the Virgin's robes and the executioner's coats, and the naturalist treatment of the vegetation between the figures, suggest that the *Altarpiece of St. George* was made in the middle of the fifteenth century. The faces of the Virgin Mary and the holy women can also be likened to mid fifteenth-century fragments of stained-glass windows from the Dijon Sainte-Chapelle.

These contradictory characteristics make it difficult to date the painting and identify the painter, particularly given that fifteenth-century Burgundian production has been very poorly conserved and remains little known. The painter was not above a certain awkwardness, as can be seen in the unfortunate rendering of the hands, the wooden drapery, and the cramming of figures into an overly narrow space. Yet to his credit, one must mention the expressive vigor, robustness, and narrative efficiency that account for the charm of Burgundian painting in the period when ducal patronage had waned.　　　　s.j.

101

Southern Low Countries

The Annunciation
c. 1410–30

Wool, 5 to 6 warp yarns per centimeter; a few metal wires
345 x 290 cm

New York, The Metropolitan Museum of Art, inv. 45.76

Prov.: allegedly originates from the treasury of the cathedral of Gerona, where it was allegedly purchased in 1910; Spanish Art Gallery, London; French and Company, New York, shortly before 1922; collection of Harold Irving Pratt, 1924; gift or Harriet Barnes Pratt, in memory of her husband, Harold Irving Pratt, in 1949.

Bibl.: Panofsky 1935; Rorimer 1961–62; Frantz 1972, pp. 3–28; Stucky-Schürer 1972, pp. 93–100, fig. 75; Lestocquoy 1978, p. 48; Cavallo 1993, no. 5 (with bibliography).

Exh.: Chicago 1920, no. 3; San Francisco 1922, no. 1; Cambridge 1927, New York 1927, no. VII; New York 1928, no. 1; Boston 1940, no. 110; Paris 1973, no. 6.

The composition of this tapestry of the *Annunciation* presents many similarities, but also differences of detail, to Melchior Broederlam's Annunciation in the *Altarpiece of the Crucifixion* of Champmol (cat. 70). The Virgin Mary is on the right, in an open room paved in colored tiles, against which we can see a lily in a pottery jar that resembles Spanish-Moorish faience, specifically the production of Manises, near Valencia. The Virgin is sitting on a Gothic throne surmounted by a canopy, with a book placed before her on a lectern. Like Broederlam's Virgin, she is looking back at the archangel Gabriel, with a gesture that suggests surprise. The archangel, arriving from the left with his wings spread out against a background of trees and vegetation, holds a phylactery on which the evangelical salutation is inscribed. In the heavens, God the Father sends the infant Jesus, bearing a cross, to Mary, while the dove of the Holy Spirit has already joined her. Two angels above the room carry a shield, which has long resisted decipherment; it may have been added later, or somehow transformed. Erwin Panofsky even suggested that these two angels, a seraph and a cherub, actually held up a cornerstone. Like Broerderlam's piece, this tapestry contains many rare iconographic details.

Historians have extensively discussed the meaning of the resemblance between the tapestry and the Broederlam altarpiece.

Rorimer wanted to attribute the cartoon to Broederlam, for he did indeed provide Margaret of Bavaria with "little patterns" of shepherds and shepherdesses for tapestries. Geneviève Souchal (in Paris 1973) argued in favor of a common source, underlining the Italian origins of the Annunciation in which the archangel is outside and the Virgin Mary is in a room. In his panels for Dijon, Broederlam was similarly sensitive to Italian models. It has been possible to draw stylistic comparisons with very early fifteenth-century tapestries, such as the Louvre's *Resurrection* or the tapestry of the *Passion* in San Marco in Venice. Paris or, more realistically, Arras, have been put forward as the locations where the tapestry could have been woven, but no characteristic of the materials has proved successful in guiding this line of research.

Unquestionably a product of International Gothic art, the tapestry can be dated to the earlier part of the fifteenth century, and the artist responsible for the cartoon certainly belonged to the artistic circles working for the king of France or for the princes of his family. Philip the Bold bought several representations of Our Lady to be offered as gifts, and in 1423, Philip the Good bought six representations including several scenes of the history of Our Lady from Giovanni Amolfini, in Bruges, in order to offer them to Pope Martin V.

S.J.

102

Austria

The Annunciation
c. 1430

Drawing on paper, pen and wash, gray-black ink and colors (yellow ochre and red)

40.2 x 27.6 cm

Vienna, Graphische Sammlung Albertina, inv. 25447

Prov.: collection Carl Friedrich von Rumohr (1785–1843); acquired in 1927 by the Albertina from the art market.

Bibl.: Benesch 1928, p. 70; Stix 1933, no. 7; Benesch 1936, no. 21; Oettinger 1938, p. 86, pl. 80; Benesch 1964, no. 61; Troescher 1966, p. 104.

Exh.: Vienna 1962, no. 276; Krems an der Donau 1967, no. 47.

Exhibited in Cleveland only

This large drawing, so quickly and confidently executed, may have been a design for a painting or a stained-glass window, as suggested by the summary treatment of the areas of color, principally yellow ochre but also touches of red (notably the image of God the Father, at the upper left, and on the roof of Mary's "house"). Other features argue in favor of a preliminary sketch for a commission, intended for submission for the approval of the patron: the cursory indication of paving stones just to Mary's left and the curious absence of a column to support the shed that shelters the archangel, whom it would have partially obscured.

Shortly after it entered the collection of the Albertina, Otto Benesch suggested an Austrian origin for the drawing of c. 1430, in a stylistic phase between the Master of Saint-Lambert and the Master of the Albrecht Altarpiece. Since then, the correspondence between this sheet and the work of the Master of Saint-Lambert

(active in Vienna, c. 1420–30) has often been noted. The image of the Virgin, with childish features and high forehead framed by symmetrical locks of hair, is reminiscent of Alsatian art, particularly the work of the Master of the Garden of Paradise, a painter active in the first decades of the fifteenth century in Strasbourg, a center of artistic production with ties to Austria.

Ever since Benesch's time, the resemblance of the little structure framing the announcing angel with the architecture in the Annunciation in the *Altarpiece of the Crucifixion* by Melchior Broederlam (cat. 70) has been noted. While tempting at first, such a comparison fails a detailed examination: Broederlam's spatial articulation is far superior. Yet these works do seem related by their method of spatial construction, widespread at the time.

P.L.

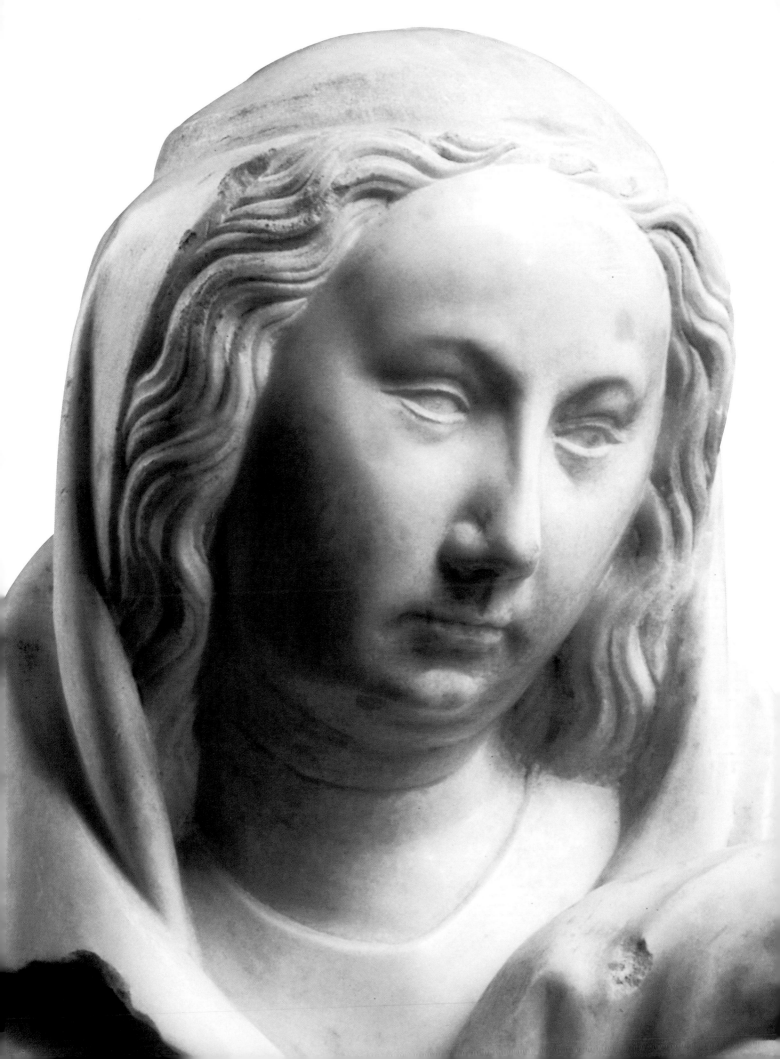

Art in Burgundy, 1360–1420

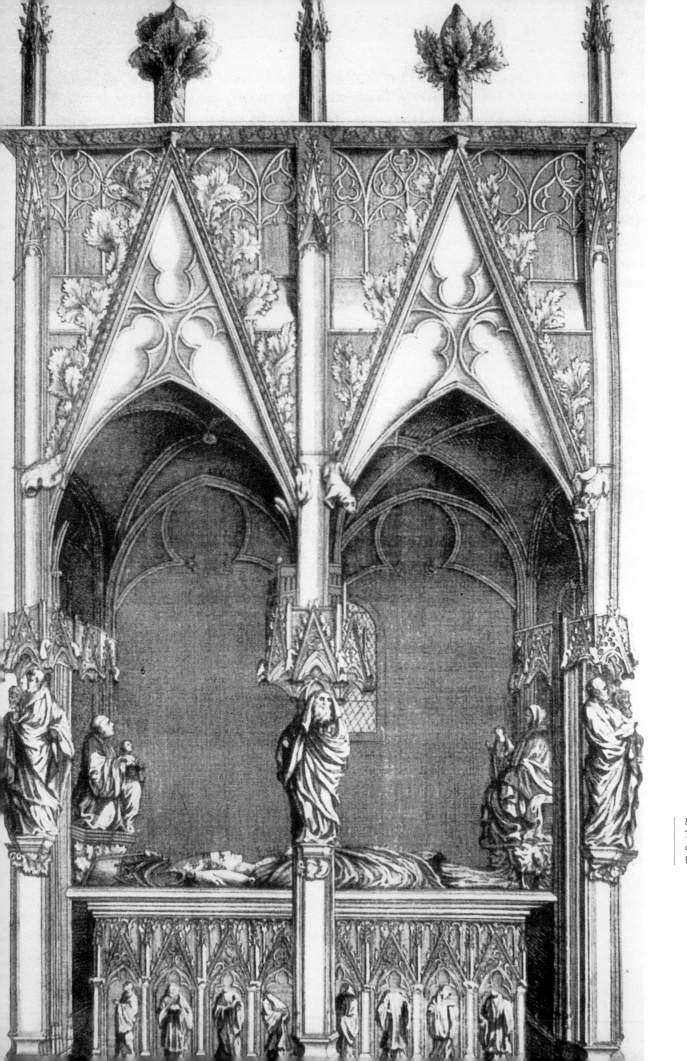

Fig. 1.
Tomb of Guillaume
de Vienne. Saint-Sein
L'Abbaye.

CONDITIONS OF ARTISTIC CREATION

Vincent Tabbagh

Art Patrons in Burgundy

(1360–1420) The churchmen, noblemen, or rich burghers who commissioned objects of daily use or bought them ready-made from artisans did not feel they were accumulating what a later age would consider to be "works of art." While appreciating their beauty and accepting the cost of precious materials and elaborate craft, they valued these objects primarily for spiritual, cultural, or practical reasons, rather than aesthetics. High-quality objects (excluding very elaborate and costly garments) seem to have been owned by a broad segment of the population, as indicated by household inventories of the period.

Churchmen, bishops, abbots of large monasteries, and deans of secular chapters were among the leading owners of luxury objects. Many of them were also architectural patrons. Nicolas de Toulon built a side chapel in his cathedral Saint-Lazare d'Autun, Maurice de Coulanges added a tower to the Dominican convent in his city of Nevers, while Olivier de Martreuil devoted his attention to the châteaux owned by the diocese of Chalon, and Jean d'Arsonval, his successor, bequeathed a thousand pounds to pay for work at the church of Saint-Vincent.[1] Philibert de Saulx, bishop of Amiens after having been archdeacon of Beaune, left in his will 800 francs to add two towers to the collegiate of the town. Nicolas de Veres, in Chalon, managed to make some additions to the cathedral, although he spent large sums to commission perpetual masses. The exceptionally detailed account books of the bishop of Autun, Milon de Grancey, show that in 1412–13 he made gifts to the chapel of the family château in Larrey.[2] Alexandre de Montaigu made significant renovations to the convent of Saint-Bénigne in Dijon. Likewise, the prior of La Charité-sur-Loire spent 2,000 francs in or about 1406, and the abbot of Saint-Seine, Jean de Blaisy, spent all his time rebuilding his church, according to his epitaph. Wishing to be remembered, Nicolas de Veres, the bishop of Auxerre Ferri Cassinel, and Guillaume de Vienne, bishop of Autun at the beginning of his career, planned monumental tombs, the first two in their cathedral and the last one in the abbey of Saint-Seine. A few years later Maurice de Coulanges and Jean d'Arsonval were content with tombstones.

Churchmen collected manuscripts, but their libraries sometimes held old works. Philippe de Sainte-Croix, bishop of Mâcon deceased in 1380, seems to have owned only sixteen books but the library of the abbot of Vézelay, Hugues de Maison-Comte, deceased four years later, had twenty-three books, many of which were worth 10, 20, and even 40 francs.[3] Books were mentioned in the wills of Geoffroi David, bishop of Autun, Michel de Creney, bishop of Auxerre, and Olivier de Martreuil in Chalon; Alexandre de Montaigu gave several books to his abbey of Saint-Bénigne, one of which is still there to this day.[4] Church vestments seem to have had less appeal as only two bishops, Olivier de Martreuil and Michel de Creney, mention them in their last wills. Church vessels were even less prevalent, although the gilded silver monstrance left by Alexandre de Montaigu to Saint-Bénigne seems to have been of high quality.[5] Besides the obligation to provide for the upkeep of their domains, the bishops felt a need to follow a tradition of charity to one's own church as an active art patron, where in earlier times they had founded monasteries and priest or student colleges. Their generosity, embodied in stone, was an expression of their wish to reach personal sainthood by performing good deeds.

Jewels, gold and silver objects, and buildings were the major artistic investments of the nobility, as shown in the historical records. In 1383, Jeanne de Dammartin, wife of Jean de Vienne, ordered a "chapel" or personal shrine made of gold, precious stones, and pearls, which cost at least 200 francs; nine years later, Eudes de Semur, knight, owned a heavy gold cup, and in 1403 a squire, Richard de Chissey, pawned 100 francs worth of jewels with a Dijon draper.[6] Beautiful silver plate—goblets and cups, ewers, and dishes—was given as gifts by the duke to his courtiers. While Thomas de Saulx, lord of Vantoux, felt the need to have himself represented as a rotting corpse on his tombstone in the ducal chapel in Dijon, Guy de La Trémoïlle satisfied his taste for beautiful objects, as well as his religious yearnings, by covering in gold the relics of Saint Lazare kept in the Autun cathedral.[7] Eudes de Grancey and his wife, Béatrice de Bourbon, rebuilt the tower of the Cordelier convent in Dijon and enriched the choir with stained-glass windows[8] after Eudes significantly enlarged a chapel and converted it to a collegiate in 1361. Stained-glass windows also appealed to the lord of Chastellux, Claude de Beauvoir, who used them to decorate the chapel he built in his château around 1415. In his will of 1386 the marshal of Burgundy, Guy de Pontailler, requested that a funerary chapel be built in the church of Talmay. The nobility, however, seemingly lost interest in illuminated books, even those, such as books of hours, that could be used for private prayers.

The members of the middle class, whether merchants, lawyers, or vineyard owners, were actively involved in the quest for beauty. Some of them were major art patrons such as Jacques Germain, deceased in 1424, father of the bishop of Chalon, Jean, who built the nave of the church, a library, and a chapter room in the Carmelite convent in Dijon. Silver was very sought after, and in 1379 a Dijon lawyer owned 8 kilograms of silver plate that he lent to the knight Eudes de Grancey.[9] Simple craftsmen wishing to improve their appearance would own a gold ring embellished with a stone, a finely crafted pouch, a belt embroidered with precious metals; works of craftsmanship adorned the body and the clothes. Small works of tapestry decorated upholstered furniture; they were often illustrated with images such as a "bench cover" made in Arras with four figures of gentlemen and ladies, appraised at 4 francs.[10] Courtly subjects appeared again on a painted panel representing an armed knight, owned in 1398 by a Dijon mason.[11]

Where the patron was a burgher, most of the works of art mentioned in commissions and inventories were intended for religious purposes. Rosary beads made of crystal, amber, or jet, with gold or silver crosses, would run through the fingers while the eyes looked up to an image, a modest wooden diptych removed from its leather case, or else a painted canvas representing the Madonna or the Crucifixion. The records mention the presence of such images in several houses or mansions in Dijon, proof of the good taste and piety of the owner; sometimes the canvases are said to be in the German style or made in Cologne, that is, possibly mass produced. In the house of the widow of Jean de Beauffort, in 1404, two canvas pictures represented the Madonna and St. Christopher, and a Christ on the Cross.[12] In the mansion of Jean Aubert, after the death of his wife in 1413, several pictures hung on the walls of the main room, one of which depicted the Virgin Mary and Jean Aubert himself as a donor. This picture was undoubtedly commissioned by Jean, a clerk in the duke's account room.[13] In 1418, Henri Bellechose, the painter of Philip the Bold, appraised at 2 francs a canvas depicting the Crucifixion and the death of the Virgin found in the house of Perrenot Godin at his death.[14] Pierre Sancenot, a Dijon burgher deceased in 1421, owned at least three paintings, one of which "framed" in wood represents the Annunciation, an uncommon subject in this environment.[15] The duke's tailor, Renaud Chevalier, placed six pictures in the chapel of his mansion in Dijon, most of which were made of painted and gilded wood. One represented the Virgin, and another one, hanging from a silver chain, the Christ on the Cross, while yet another in another room depicted the Resurrection.[16]

Private devotion was also evidenced by small statues or books of hours. The chapel of the already mentioned Renaud Chevalier contained an alabaster statue of the Virgin with a gilded silver crown. Jean Tarlevey, a married man, master of the Saint-Esprit hospital in Dijon, owned four wooden statues on an altar, the Virgin and saints Peter, Paul, and James; he and his wife also owned a brass reliquary in a leather case.[17] In 1389 Guy Gelenier, a lawyer, commissioned from a sculptor in the diocese of Tournai four stone statues about 80 centimeters high, representing the Virgin, St. Claude, St. Anthony and St. Pierre of Luxembourg, but it's not sure that they were for his personal use. There are several mentions of burghers buying prayer books,[18] in particular books of hours devoted to the Virgin, but their low appraised value leads us to think that they were plain books without decoration, with the exception of a manuscript that the burgher Guillaume le Chamois commissioned in 1398, with twelve illustrations enhanced with gold and blue and six other images to illustrate the prayers to the saints.[19] The records of Dijon notaries mention at least two purchases of tombstones, one of them to be delivered to the cemetery of Saint-Philibert,[20] indicating that at least some burghers wished to avoid the anonymity of the cemetery, although nothing leads us to think that these tombstones had sculpted images, unlike those

commissioned by churchmen, some of which are still standing. In spite of the monastic tradition of humility, several Saint-Bénigne monks had tombstones placed on their tombs in the chapter room or the cloister of the monastery.[21] In such cases the work of art serves the memory of an individual but also the honor of a holy rank.

Parish priests owned church vessels, among them chalices. They were particularly friendly with booksellers and writers, such as a priest of Notre-Dame de Dijon, Thibaut de Licey, who commissioned Jean du Moulin to illustrate the initial letters of his prayer book.[22] Monasteries and parishes were not up to large monumental or decorative enterprises; with the exception of personal gifts or endowments provided by bishops, they limited themselves to making modest repairs or new commissions, a new choir book, or a stained-glass window, such as the one representing the Virgin and Child surrounded by St. Ambrose and St. Bernard commissioned in 1383 by the parish of Fontaine-lès-Dijon from the glassmaker Jean le Bourcier,[23] or a renovation: Henri Bellechose was asked in 1415 to repaint the columns and the four angels surrounding the main altar of Notre-Dame de Dijon with the coats of arms of Philip the Bold and John the Fearless. Art commissions also had political objectives.

Luxury crafts were primarily made for private customers and were intended more for intimate pleasure than for ostentatious display; illuminated books are the major example. Men and women of all social classes, enriched by the epidemics that had made them inheritors, decided to commission and purchase quality objects to the extent of their means, following the example of patronage given by the duke. The urban elites seem to have been particularly active as patrons. Their taste for artworks reflected their upward mobility, not only in social but also in cultural terms, attributable to the fact that education had become more widespread. However, the money thus spent went to fulfill many purposes: often personal devotion, but also a newly acquired taste for luxury and the pursuit of beauty in personal appearance and home surroundings. Another goal, of an economic nature, was to hoard valuables that could be used as tokens of exchange.

NOTES 1. Charmasse 1865–1900, p. 398. La Selle 1995, p. 271. The records about churchmen are mostly extracted from their entries in *Gallia christiana*, vols. 4 (Paris, 1728) and 12 (Paris, 1770).
2. ADSL, 2 G 377.
3. Jullien de Pommerol et Montfrin 2001, pp. 441 and 453.
4. Dijon, Bibliothèque Municipale, MS 212 (formerly 174), theological tracts by Jean Gerson, in French.
5. A precise description can be found in Chomton 1900, p. 236.
6. ADCO, B 11292, fol. 48v, 11316, fol. 38, and 11351, fol. 36.
7. Ibid., B 11289, fol. 32v.
8. Dijon, Bibliothèque Municipale, MS 172, fol. 132.
9. ADCO, B 11272, fol. 51v.
10. Ibid., B II 356/2, 1st series, no. 22.
11. Ibid., B II 356/1, no. 34.
12. Ibid., B II 356/1, no.79.
13. Ibid., B II 356/2, 1st series, no. 22.
14. Ibid., B II 356/2, 4th series, no. 14.
15. Ibid., B II 356/2, 6th series, no. 17.
16. Ibid., B II 356/1, no. 17.
17. Ibid., B II 356/1, no. 105.
18. Ibid., B 11302, fol. 223.
19. Ibid., B 11313, fol. 43.
20. Ibid., B 11344, fol. 17.
21. Dumay 1882.
22. ADCO, B 11316, fol. 106.
23. Ibid., B 11292, fol. 64.

Sabine Witt

The Statuary of Poligny: Foundations and Court Art in

Franche-Comté

After the sculptures of the Carthusian monastery of Champmol, those from the various religious buildings of Poligny constitute the largest group of Burgundian statuary from the fifteenth century. In total they comprise nearly twenty monumental statues in limestone and, moreover, attest to the patronage of the court of the Valois dukes in this city.

At the end of the Middle Ages, Poligny was the administrative and political center of the earldom of Burgundy, and it was brought under the jurisdiction of the duchy beginning in 1384.[1] Duchess Margaret of Bavaria followed the reformist tendencies of St. Colette of Corbie, founder of a convent of Poor Clares in Poligny in 1415–17. During the same period, in 1414–15, the first stone was laid for a new parish church, Saint-Hippolyte, and erected within the collegiate church in 1429.[2] The establishment of masses and chaplaincies and the financing of the construction and the private chapels, as well as their furnishings, were overseen by counselors who were highly placed at the Burgundian court and Polinoise in origin: the administrator of ducal finances, Jean Chousat; the bishop of Bayeux, Jean

Langret; and the bishop of Tournai, Jean Chevrot.[3] In the decree that established the college of twelve canons, the description of Duke Philip the Good as "protector and special founder" underscores the prestige and ambition of the project.

Within an extremely refined architectural setting, the sculpted decoration of the collegiate church of Saint-Hippolyte was impressive, thanks to its extraordinary quality, in the tradition of Claus Sluter and the masterpieces at the Carthusian monastery at Champmol.[4] Considering the close relationships between the donors and the Burgundian court, there was a sense of obligation to engage, first the workshop of Claus de Werve, artist to the dukes, and later the workshops of Jean de La Huerta and Antoine Le Moiturier.

The scope of the work can clearly be seen in the private chapels and their sculptural decoration. At the time of the construction of the eastern portion of the church, Jean Langret had built, near the northern side of the choir, a chapel dedicated to St. Leonard. Langret died prematurely in 1418 in Paris, during the conflict between the Armag-

Fig. 1.
Sculpture from the portal of the ancient Dominican church in Dijon, illustration from Pierre Palliot, *La Vraye et Parfaite Science des Armoiries,* 1650. Dijon, Bibliothèque Municipale.

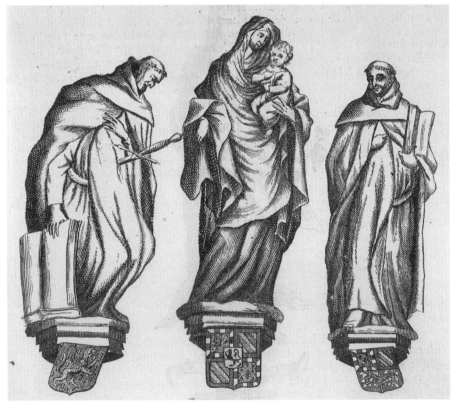

Fig. 1

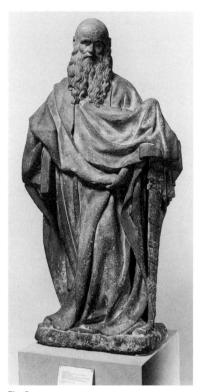

Fig. 2

Fig. 3

nacs and the Burgundians. Although his tomb was destroyed in 1793, the layout of the chapel, including the funerary niche of the mausoleum and the keystone with the bishop's coat of arms, remains almost intact. The chapel's patron saint is represented by a monumental statue that was inspired by the figures of the prophets from Claus Sluter's *Well of Moses,* but it is characterized by a more elegiac note, typical of the style of Claus de Werve, Sluter's nephew and successor as court artist.

The chapel of Our Lady, located to the south of the choir, is thought to have been commissioned by Jean Chousat and his wife, Blanche Guillet. Tax collector for John the Fearless and Philip the Good, Chousat is credited with the construction of the church and was principally responsible for the founding of the college in 1429. An affecting Virgin and Child still stands on the chapel's altar, the frame for which was transformed in the eighteenth century. Identified as the Virgin Mary in the statutes of the college,[5] this work, by virtue of its extraordinary quality, can possibly be attributed to Claus de Werve. Moreover this statue, known as the *Virgin of the Founder,* is close in style to the statues from the south portal of the ancient Dominican church in Dijon. Destroyed during the Revolution but commemorated through an illustration in a work by Pierre Palliot (1650)(fig. 1), these statues are likewise attributed to a ducal workshop.

The most sumptuous example of a private donation is the chapel of St. Anthony, known as St. Anthony Tournai, founded by Jean Chevrot, bishop from 1436 to 1460 and president of Philip the Good's Great Council. During 1440, Chevrot had his private chapel built in the southwest corner of the collegiate church, which he lavishly equipped with liturgical vestments and sacred vessels; moreover, he requested that his heart be interred there. Plundered and destroyed by French troops in 1638, the chapel was rebuilt on a reduced scale around 1735. Today, the sole vestiges preserved in situ are two consoles emblazoned with the badly damaged arms of Chevrot and the bishop of Tournai, and a statue of the prelate, his hands lifted up in prayer. A statue of the patron saint, Anthony, assumed to have come from here, is now in the church of Notre-Dame in the suburb of Mouthier-Vieillard, which in the early Middle Ages formed the center of the town of Poligny. A *Virgin and Child,* probably also from the ancient chapel of Tournai, was placed on the pier of Saint-Hippolyte.

These foundations, at once memory and homage to these statesmen and their native village, continued until around 1500, in the form of the collegiate church of Saint-Hippolyte, as well as the Dominican convent, completed between 1240 and 1270. The church of Notre-Dame remained the burial place favored by the most important bourgeois families, even after the construction of the

271

collegiate church. Two works, originally from a private chapel founded by the Plaine family, have left Poligny. A kneeling statue depicting Thomas de Plaine, head of the Burgundian parliament around 1500, is now in Paris at the Louvre, and a remarkable St. Paul is now in the collection of the Metropolitan Museum of Art in New York. Three other Polinoise statues, *St. John the Baptist*, *St. James the Greater*, and a superb *Seated Virgin*—the latter certainly from the convent of Poor Clares—were acquired by the Metropolitan Museum in the first half of the twentieth century.[6]

The statuary now in Poligny is hardly representative of its original state, instead reflecting the transformations that took place, particularly in the eighteenth century. At the time of the Revolution, all the religious establishments, with the exception of the collegiate church, and particularly the Poor Clares and Dominican convents, not only endured damage but also were secularized and their furnishings dispersed. Although the original condition of the chapels of the collegiate church and its remaining statues was attainable through restoration, the original location of the other sculptures remains difficult to determine. This is especially true in the case of the group of four statues that stood in the apse at the end of the choir: a *St. Theobald*; a *Virgin with the Image of the Holy Shroud*, an extremely rare example of Passion iconography; a *St. John the Evangelist*, which can be compared to two statues, one of the same subject and a *St. Michael* (cat. 109), in the abbey of Baume-les-Messiers (see Sandrine Roser, "Baume-les-Messieurs," pp. 278–80); and a *St. Andrew*. In spite of apparent similarities (identical size, limestone), these works do not belong to a logical iconographic program. Their consoles, wedged between small columns at the corners of the polygonal apse, indicate that this is a later composition. Finally, the Burgundian statuary in Poligny is completed by a group depicting the Education of the Virgin by St. Anne and the three wooden statues on the *poutre de gloire* (glory beam), a heavy beam traversing the bottom of the arch at the entrance to the choir.

NOTES 1. The principal historical source continues to be Chevalier 1767–69.
2. Regarding the history of the construction, see Jenzer 1992 and 1994, vol. 152-IV, pp. 415–58. Beyond this, Quarré has devoted an essay to the statuary of Poligny (1960B, pp. 209–24).

3. Apropos this founding group, and above all the role of Jean Chevrot, see Châtelet 1989, pp. 9–21, although I do not always follow his reasoning.
4. My doctoral thesis (forthcoming, Berlin, Technical University), "Die Skulpturen der Sluter-Nachfolge in Poligny: Stiftertum und Hofkunst in der Franche-

Comté unter den Herzögen von Valois," is devoted to this subject.
5. Translated from a copy in DJ, 1 F 124, fol. 113v–114r.
6. For more on the four statues from Poligny now in New York, see Forsyth 1986, pp. 41–63; 1987, pp. 71–91.

Attributed to the studio of Claus de Werve

Three statues from a group of four placed in the apse at the end of the choir of the collegiate church of Saint-Hippolyte, including *St. Theobald*, a *Virgin and Child* of unusual iconography (Jesus holds a painting of St. Veronica presenting the Holy Shroud), *St. John the Evangelist*, and *St. Andrew*. This heterogeneous composition and the consoles for the sculptures, wedged between small columns at the corners of the polygonal apse, indicate that this composition is later. The original placement of the statue of St. Andrew is not certain, since there was no altar dedicated to the apostle.

103

St. Theobald
First third of the 15th century

Polychromed Asnières-les-Dijon limestone

H. 174 cm

Wide nick in the front vent of the robe; break between the head and neck, and yet the head, perfectly attached, seems original; the falcon restored in 1965.

Poligny, collegiate church of Saint-Hippolyte, classification M. H. 25.2.1897

BIBL.: Troescher 1940, p. 117; Jalabert 1947, p. 21; Jalabert 1958, p. 45, pl. XXIV; Quarré 196B, pp. 215–18; Boccador 1974 1: p. 214; Pidoux de la Maduère 1975, 2: pp. 12–13; Quarré 1977, p. 121; Baudoin 1983, p. 166; Lapaire 1983, pp. 27–33; Camp 1990, p. 86; Morand 1991, pp. 148–50; Baudoin 1996, pp. 89, 139–40, pl. XII.

EXH.: Dijon 1976, no. 69.

Dressed in riding clothes and a long, fur-lined cape thrown over the right shoulder, St. Theobald holds a falcon (restored) on his left fist, and his right hand is slipped into a game-bag hanging from his belt. A representation of a gentleman out hunting with a falcon, the statue refers to the ancestry of this mid eleventh-century saint, the offspring of Champenoise nobility, who chose to live as a hermit. Certain details—for example, the embroidered eyelet belt and the game-bag—bring to mind the prophet Isaiah of Calvary at the Chartreuse de Champmol. And the sweetness of expression of the fleshy-featured face, the half-closed eyelids, and the curly hair are completely in the spirit of figures by Claus de Werve. The example of Sluter is likewise discernible, in the thick, heavy drapery. The Poligny statue was faithfully adopted for other, smaller-scale figures of St. Theobald at the Musée d'Art et d'Histoire in Geneva, at the parish church of Brémur-et-Vaurois (Côte-d'Or), or again, in a more popular style, at the town hall of Arguel (Doubs).

S.W.

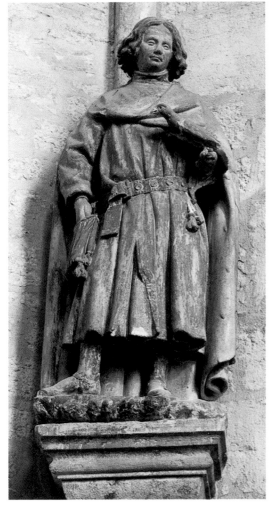

103

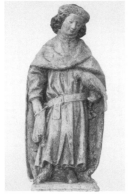

FIG. 1. *St. Theobald,* polychrome, stone. Brémur-et-Vaurois, parish church.

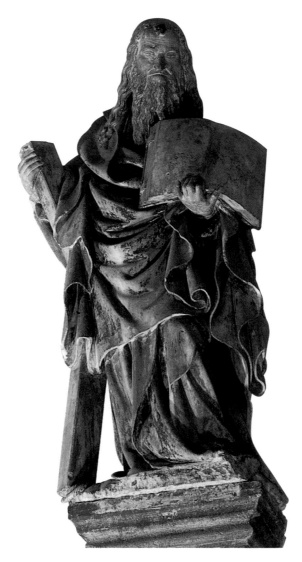

FIG. 1. Face of the prophet Moses, limestone. Chartreuse de Champmol.

104

104

St. Andrew
First third of the 15th century

Polychromed Asnières-les-Dijon limestone

H. 178 cm

Nicks on the pedestal, on the left foot and on the edges of the garments; restored in 1965.

Pierre Quarré discovered in the back of the statue a large initial engraved at the top in a W shape made up of two loops; he interprets this as a worker's identification mark and not as an actual signature.

Poligny, collegiate church of St.-Hippolyte, classification M. H. 25.2.1897

BIBL.: Troescher 1940, p. 118; Quarré 1960, p. 218; Boccador 1974, 1: p. 214; Quarré 1977, p. 123; Camp 1990, p. 86; Morand 1991, pp. 148–49, p. 151; Baudoin 1996, p. 181.

The patron saint of the Valois dukes, dressed in apostolic robes made up of a tunic and a voluminous cape, holds an open book while leaning on the *crux decussata* (the so-called St. Andrew's or X-shaped cross), to his right. The drapery is strongly inspired by the *Virgin of the Founder* (cat. 105), although here the folds are much more dynamic. The bearded face seems to be a copy of that of the prophet and patron saint of the *Well of Moses* from the large Crucifixion in the Chartreuse de Champmol (cat. 89) and that of a bust of a statue of St. Anthony (Dijon, Musée d'Archéologique). Nonetheless, the features of the face in Poligny, with its exaggerated expression, nearly a grimace, are clearly distinct from examples by Claus Sluter.

S.W.

105

Attributed to Claus de Werve
(Haarlem, ?–Dijon, 1439)

Virgin, known as the *Virgin of the Founder*
c. 1420, probably before 1429

Polychromed Asnières-les-Dijon
limestone

163 x 81 x 35 cm

Nicks on the front portion of the veil; nicks in the left hand of the Virgin and the draperies; nicks on the lower horizontal edge of the right portion of the cape, in the slant of the left wrist; the object originally held in the left hand of the Virgin obliterated; the brocade of the garment indicates that it was not originally polychromed.

Poligny, collegiate church of Saint-Hippolyte, classification M. H. 25.2.1897

BIBL.: Troescher 1940, p. 118; Quarré 1960B, pp. 218–19; Quarré 1973, p. 459; Boccador 1974, 1: p. 214; Pidoux de la Maduère 1975, 2: p. 62; Quarré 1977, p. 123; Camp 1990, pp. 76–78; Morand 1991, pp. 154–55; Baudoin 1996, pp. 59, 141; Bertrand 1996, pp. 14–16, 19.

EXH.: Dijon 1976, no. 71.

Today, this statue is located in the chapel, in the end apse at the south side of the collegiate church, on an altar within an interior that was completely modified in the eighteenth century.

The letters patent of Duke Philip the Good regarding the establishment of a college in Saint-Hippolyte in 1429 mention an image of Our Lady, the canons being obliged "each day to go in a procession into said chapel of Our Lady of said church, and to say and sing before this image an antiphon of Our Lady."

Attributed to the founder of the chapterhouse, Jean Chousat, this chapel was dedicated to Our Lady and set aside as his private chapel. Traditionally called the Founder's Chapel, it later became known for "her image" as the chapel of the Virgin of the Founder. Nonetheless, doubts remain regarding this attribution, since the keystone of the chapel does not exhibit the arms of Chousat, but probably those of a confraternity of the Holy Cross.

A rare type of *dexiocratusa*, holding the Christ child in her right arm and gesturing with her left arm, the Virgin spreads her ample cloak into an apron in front of her,

which considerably enlarges the statue's silhouette. The attribute that the Virgin held in her left hand is missing, but her maternal expression and its intimate quality, far from what one would expect of a queen, leads one to believe that this object might have been a fleur-de-lis rather than a scepter. The infant Jesus rests his right hand on a small closed book, referring to the incarnation of the Word.

The divergent gestures of the two sculptures are intimately connected. The child, leaning forward, reaches his left arm around the neck of his mother, who lowers her eyes, while Jesus voluntarily moves toward the faithful at the foot of the altar. The double framing—veil and mantle—of the Virgin's face reinforces her demure demeanor. The apron-cloak is perhaps inspired by the Moses figure from the large Crucifixion in the Chartreuse de Champmol. Although totally different from Sluter's style, the expression of the face is an example of the extraordinary quality of Sluter's nephew and successor, Claus de Werve. And it is precisely this utterly intimate expression that distinguishes the *Virgin of the Founder* from most of the Burgundian Virgins of comparable iconography and type: statues in Échevronne or Bézouotte (Côte-d'Or); the *Virgin and Child* in Hartford (Wadsworth Atheneum); or even the *Virgin and Child* in Poligny (the pier in Saint-Hippolyte), which came from the ancient chapel of Tournai in the collegiate church. Stylistically, this Virgin is much closer to Virgin in the church of the Jacobins in Dijon (p. 270, fig. 1), the *Seated Virgin* (Education of the Virgin) from the convent of the Poor Clares in Poligny (New York, Metropolitan Museum of Art), and a tondo of a *Virgin and Child* painted by Jean Malouel, probably for the Chartreuse de Champmol (Berlin, Gemäldegalerie).

<div style="text-align: right">s.w.</div>

106

Attributed to Claus de Werve
(Haarlem, ?–Dijon, 1439)

St. Leonard
First third of the 15th century

Limestone
178 x 58 x 44 cm
Small nicks on the garment; the staff has been restored; the crosier is missing.

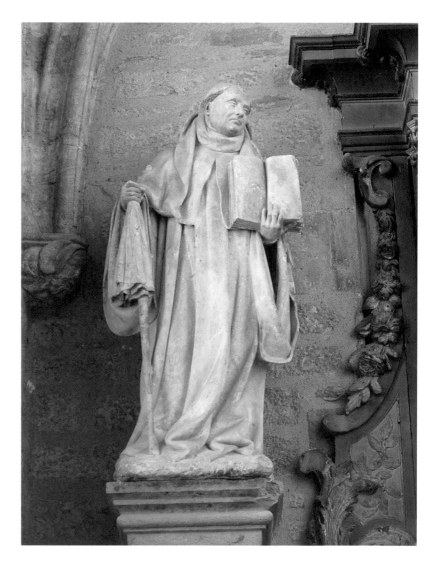

Poligny, collegiate church of Saint-Hippolyte, classification M. H. 25.2.1897

BIBL.: Troescher 1940, p. 117; Quarré 1960B, pp. 219–20; Boccador 1974, 1: p. 214; Pidoux de la Maduère 1975, 2: p. 40; Quarré 1977, p. 123; Camp 1990, pp. 86–88; Morand 1991, p. 154; Baudoin 1996, p. 140.

EXH.: Dijon 1976, no. 72.

This statue was placed on a console near the altar in the apse at the end of the private chapel established by Jean Langret, bishop of Bayeux. Built at the same time as the east portion of the collegiate church (beginning in 1414), on the north side of the choir, it is dedicated to St. Leonard, patron saint of prisoners and greatly venerated after the crusade battle of Nicopolis in 1396. The saint looks toward the left, in the direction of the funerary niche—the bishop's burial place—and toward the faithful praying in the oratory, established to the south in the west bay of the ancient chapel of Bayeux.

Holding his abbatial staff, which is missing the crosier, to his right, this Limoisin abbot saint supports an open book on his left arm and—somewhat hidden by his large sleeve—his traditional attribute, a prisoner's chain with heavy shackles. The statue has great presence and majesty, conveyed by the amplitude of the monastic habit and the great refinement of detail (the hands, the facial features, the pages of the book). His face, which has an authoritarian and serious quality, is strongly inspired by the expressions of the prophets in the *Well of Moses* from the large crucifixion in the Chartreuse de Champmol. As a result, this work falls directly within the tradition of Claus Sluter.

<div style="text-align: right">s.w.</div>

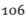

107

Attributed to Jean de La Huerta (?)
(Daroca, c. 1410/20–?, after 1462)

Jean Chevrot, Arms Raised in Prayer
Mid 15th century

Statue, limestone, minor traces of polychromy and gilding

163 x 83 x 48 cm

Small nicks on the habit (restored); crosier is missing.

Poligny, collegiate church of Saint-Hippolyte, classification M. H. 25.02.1899

BIBL.: Troescher 1940, pp. 117–18; Tribout de Morembert 1943–44, pp. 263–64; Quarré 1960B, pp. 211–12, 220–21; Tribout de Morembert 1963–64, pp. 199–207, 216–18; Pidoux de la Maduère 1975, 2: pp. 45, 54–58; Châtelet 1989, pp. 13–14; Camp 1990, p. 89; Baudoin 1996, pp. 98, 170–171; Prochno 2002, p. 153.

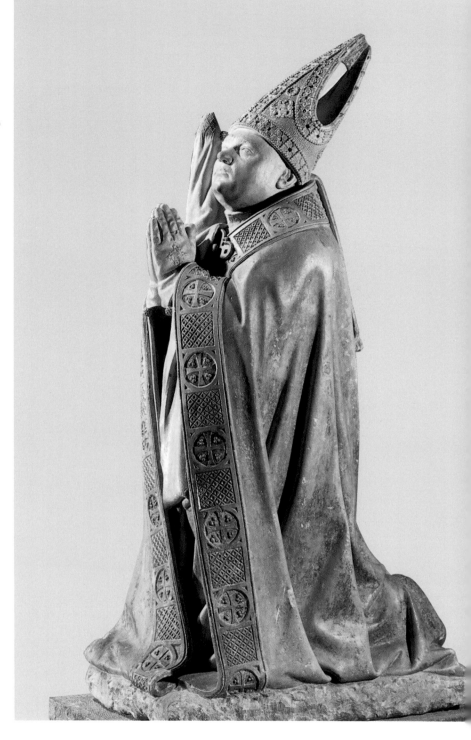

This *orant* (a standing figure, hands raised in prayer) now appears on a modern pedestal in the St. Joseph chapel that makes up the southwest corner of the collegiate church, on the site of the ancient St. Anthony chapel, known as the Tournai chapel. That earlier chapel was founded and opulently furnished by Jean Chevrot, but destroyed in 1638 and completely rebuilt around 1735 (see Sabine Witt, "The Statuary of Poligny," pp. 270–72). A native of Poligny, Chevrot was first president of the great council of Duke Philip the Good and became bishop of Tournai in 1436, an office he held until his death in 1460. Today, the opulent decoration of this private chapel is no longer visible, except in this orant figure. From the mid eighteenth century until 1980 it stood in the chapel of Bayeux, to the right of the choir and in two emblazoned consoles, now badly damaged, which probably bore the arms of Chevrot and the bishop of Tournai.

The right portion of the work is only roughly carved, indicating that it had been placed against a wall. Inspired by the statue of Philip the Bold on the portal of the Chartreuse de Champmol, the prelate is kneeling in prayer, his hands clasped, his face slightly raised in adoration. He is enveloped in a cope trimmed with a heavy orphrey, his bishop's staff (missing its crosier) under one arm. The nicks on the clasp and the miter indicate that the statue had been ornamented with gems.

The refinement of detail and the features of the swollen face lead one to think that this was an actual portrait. The identification with Jean Chevrot rests on certain physiognomic similarities that can be discerned in other "portraits," notably one in the frontispiece of the chronicles of Hainaut (Brussels, BR, MS 9242) and in Rogier van der Weyden's *Seven Sacraments Altarpiece* (Antwerp, Koninklijk Museum voor Schone Kunsten), commissioned by the bishop himself.

S.W.

 276

**Attributed to the workshop
of Jean de La Huerta**

St. Anthony
Mid 15th century

Polychromed limestone
165 x 63 x 36 cm

Mouthier-Vieillard (suburb of Poligny),
parish church of Notre-Dame

Bibl.: Vuillermet 1913, p. 10; Quarré
1959–62, pp. 47–48; Quarré 1960B, p. 222;
Pidoux de la Maduère 1975, 2: p. 147; Baudoin
1996, p. 176.

Exh.: Dijon 1972, no. 45, p. 15; Poligny,
Baume-les-Messieurs, and Saint-Claude 1972,
p. 29.

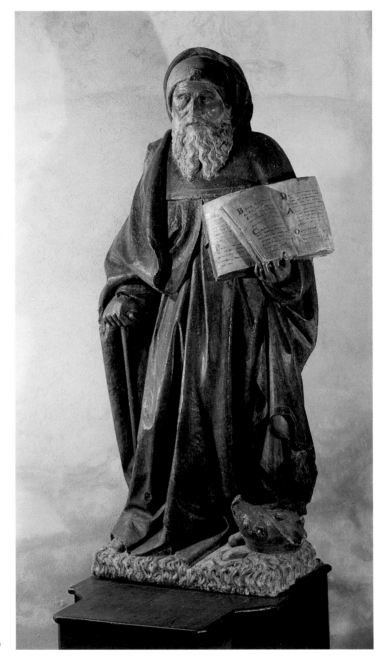

This work comes from the chapel in
Tournai, founded and built by Jean
Chevrot, bishop of Tournai, at the
collegiate church of Saint-Hippolyte in
Poligny in 1440 and dedicated in 1453
specifically to St. Anthony the Hermit.
The chapel was plundered and burned
in 1638 and rebuilt on a smaller scale
around 1735. This private chapel has
been proposed as the original setting for
this *St. Anthony* and for a *Virgin and Child*,
which were thought to have been placed
on two emblazoned consoles (in situ).
The two statues were later moved into
the chapel of the congregation in Poligny.
While after 1968 the *Virgin* was
positioned on the pier of the portal of
Saint-Hippolyte, *St. Anthony* was moved to
the church of Notre-Dame in the suburb
of Mouthier-Vieillard, the town center in
the early Middle Ages and today a
veritable second museum of sculpture in
Poligny.

There are notable differences between
these two sculptures and the kneeling
statue of the founder of the chapel, Bishop
Jean Chevrot (cat. 107), and there is scant
reason to attribute them to the same
hand.

Dressed in a monastic habit, the hermit
holds an open book and his right hand
rests on a T-shaped staff. The pig at his
feet refers to the right of St. Anthony's
order to let these animals wander about
freely. The flames that emerge from the
pedestal bring to mind "St. Anthony's
fire," a disease, cured—or inflicted as
punishment—by St. Anthony, who was
widely venerated in Burgundy. This
Polinoise statue is particularly close to a
sculpture now in Manlay (Côte-d'Or),
attributed to the last of the great medieval
sculptors, Antoine Le Moiturier. Duke
Philip the Bold, who was born on
St. Anthony's feast day, cultivated a
particular devotion for this hermit saint
of Thebes. One statue depicts him,
accompanied by a *Virgin* and a *St. John
the Baptist*, above one of the altars of the
ducal oratory of the Chartreuse de
Champmol.

s.w.

Sandrine Roser

Baume-les-Messieurs

The Cluniac abbey of Baume-les-Messieurs, set afire in 1336, was not restored until the time of the abbacy of Amé de Chalon (1389–1431). Born into the Franche-Comté aristocracy, this prelate maintained close relationships with his family. His position as abbot was not his only responsibility; he had close ties to his nephew, Louis II de Chalon, Count of Tonnerre and Lord of Châtelbelin, and in 1398 he became governor of Louis's lands in Franche-Comté. An extremely dynamic personality, he traveled often throughout Franche-Comté and Berry and to Paris, carrying out various missions on Louis's behalf, including overseeing the building site for the restoration of the château of Châtelbelin (Jura).

In Baume, Amé de Chalon regularly conferred benefices to his family's advantage. He immediately attempted to restore the financial situation of the abbey, which was then in a perilous state. His personal funds and secular revenues allowed him, in 1399, to restore the church and the convent buildings. Benefiting from the proximity of

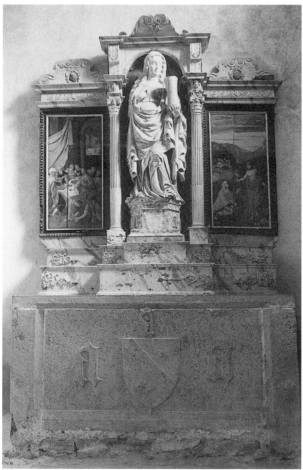

Fig. 1

high-quality materials, he resorted to unpaid labor in order to transport them at a lower cost. Amé de Chalon established his private chapel at the north side of the sanctuary, in the pre-existing chapel, which he had expanded toward the north. It contained his tomb, the tombs of two of his brothers, and that of one niece. Of the convent projects, only the refectory still stands as evidence of his building activity.

After completing the most urgent work, the abbot undertook a vast campaign to decorate the liturgical choir, where he added his coat of arms and initials throughout.

Between the seventh and eighth bays of the nave, he erected a three-arched rood screen, surmounted by a gallery. The screen was reached by a spiral staircase,[1] but the abbot could arrive there directly from his residence, located on the floor of the building wing flanking the church to the west, using the flat roof of the north gallery of the cloister, which was probably rebuilt under his supervision.

The rood screen was destroyed in the late seventeenth century, but the altars from the two chapels and their statues were saved. The *Magdalene* (fig. 1) and the *Virgin*, each executed by a different hand, are atypical in appearance. This work corresponds to the Burgundian sculptural canon from the early fifteenth century, characterized by the considerable enlargement of the silhouette by means of the drapery. And yet many details and the arrangement of the garments reveal elements borrowed from fourteenth-century works, modernized by the treatment of the pleats or of accessories then in fashion, such as the creased veil.

Beyond the rood screen were fifty stalls, divided into two double rows. Reduced by sixteen seats in the modern era and sold in 1752, they were moved to Clairvaux-les-Lacs (Jura), where they remain. These stalls, decorated mainly with plant and heraldic motifs, are similar to sets from the second half of the fourteenth century, such as those from Saulieu and from Bar-le-Régulier, in the Côte-d'Or.

Amé de Chalon also was responsible for a high altar of impressive dimensions, which he placed in the first bay of the architectural choir. It supported two statues of Sts. Paul and Peter, the patrons of the church. Paul's expressive and soft features (fig. 2) recall those of other sculptures from Dijon and Poligny: the prophet Isaiah from the *Well of Moses,* a bust of St. Anthony in the archaeological museum in Dijon, and the *St. Paul* in the church of Saint-Hippolyte in Poligny (p. 271, fig. 2). A *St. John the Evangelist* of Burgundian origin, now in the Louvre, offers a nearly literal but inverted quotation of the cloak of the *Saint Paul,* characterized by the large, central vertical fall at the hem

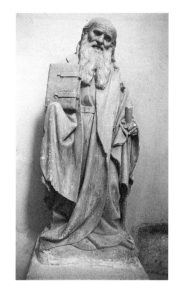

Fig. 2

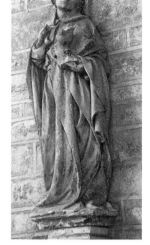

Fig. 3

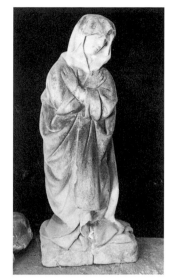

Fig. 4

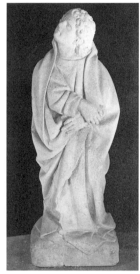

Fig. 5

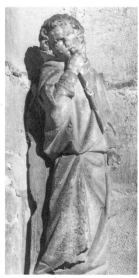

Fig. 6

Fig. 7

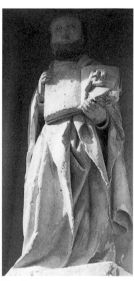

Fig. 8

of the cloak, curved where it comes into contact with the floor, the edge delineating a very elongated S-curve. With the exception of the schematic head, the statue of St. Peter is an exact copy of the *St. John the Evangelist* in Poligny, though somewhat coarsely executed.

The last work is frequently and justly grouped with the *St. John the Evangelist* from Baume (fig. 3), because of the similarity in the folds of the clothing. Yet, the shorter and broader face of the Baume figure is less severe. This figure was not part of the tomb of Amé de Chalon, as was once believed. In reality it once rested on the northeast console of the apse at the end of his chapel, above the altar. The chapel was decorated with an altarpiece representing a Crucifixion, in which the figure of Jesus seems to be a replica of the one in Saint-Bénigne in Dijon, attributed to Claus de Werve (cat. 123). It was accompanied by a *Virgin*

in Mourning and a *St. John*, which are considered possible reflections of the images from the Crucifixion scene at the top of the *Well of Moses*. The *Virgin* is close to the one by Prémeaux.

Finally, Amé de Chalon built himself a sumptuous tomb. This sepulcher is located beneath an arch, built into the north wall to the side of the high altar (fig. 9). It opened onto both the sanctuary and the abbot's chapel. The rarity of this very elitist arrangement merits special mention. Clearly it brings to mind the tomb of Jean Lengret, in Poligny. The sarcophagus is sculpted with seven mourning figures in high relief (fig. 10), the poses copied in part from the mourning figures from the tomb of Philip the Bold. Lay figures, which predominate, alternate with Cluniac religious figures, clearly brothers and nephews of the abbot. He had himself depicted at the center of the composition,

repeated on both sides of the structure. The four Evangelists, writing under the guidance of their animal symbols, which seem to inspire them, are painted on the vault of the arch. The statues decorating the arch, for the most part now vanished, stood on the numerous consoles or were attached to the walls. The iconographic program was organized around the themes of the Last Judgment, to the east, and a specific judgment, to the west. Angels sounding trumpets were placed on the consoles of the piers. The *Christ in Judgment*, showing his stigmata, was accompanied by intercessors: the *Virgin* and, undoubtedly, *St. John the Baptist*. At the west side, near the *St. Michael* (cat. 109), another archangel or an apotropaic saint was depicted.

An angel bearing the cross and nails (p. 279, fig. 7) is similar to the angels with trumpets but surpasses them in plastic qualities. Its mournful expression, admirably rendered, suggests that it may have belonged to an Entombment, no other part of which remains. It is equally possible that it had decorated the entrance arcade of the rood screen, probably surmounted by a crucifix. It was paired with an angel carrying a column, of which only a fragment survives.

The furnishings and statuary in Baume, created between 1415 and 1431, unequivocally reveal the influence of works from Dijon and Poligny and undoubtedly were produced by the same workshops. The organization of the decoration of the private chapel of Amé de Chalon was inspired noticeably by that of the chapel of Jean Lengret in Poligny. To keep the decoration of his church within the style of the day, the abbot recruited artists directly from Dijon or, more simply, from the building site of the new church of Poligny, which opened in 1414, only some dozen meters from a residence he had purchased in 1410.

NOTE

1. See Pérouse de Montclos 1988, p. 3, col. 45, p. 622.

Baume-les-Messieurs, St. Peter's church:

Fig. 9.
Funerary monument of Amé de Chalon, from the south.

Fig. 10.
Tomb of Amé de Chalon, north side.

Fig. 9

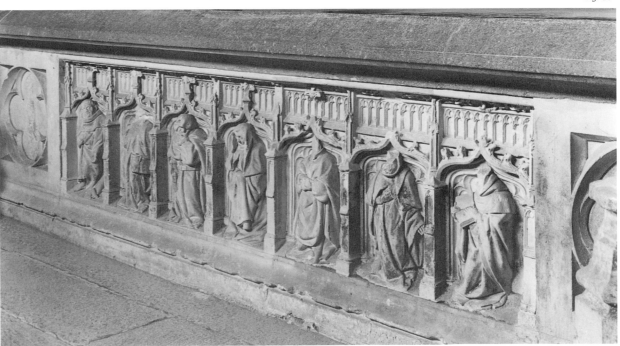

Fig. 10

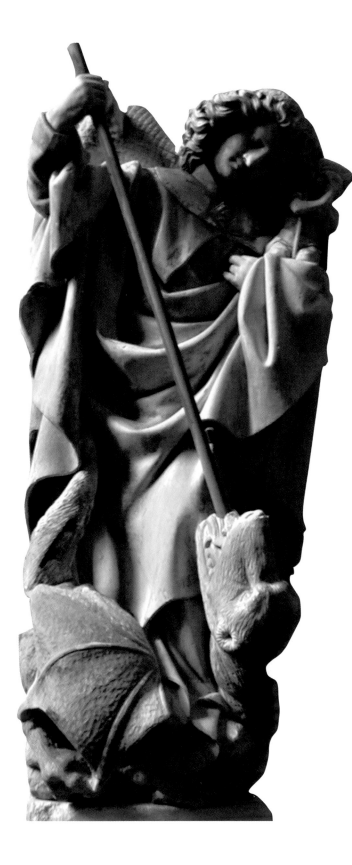

Attributed to Claus de Werve
(Haarlem, ?–Dijon, 1439)

St. Michael Leading the Souls of the Dead, Crushing the Demon
c. 1415–30

Limestone, traces of polychromy and gilding; spear in wood

112 x 35 x 32 cm

St. Michael: toes of left foot broken; tip of right wing missing; drapery of cloak slightly nicked on the left. Demon: rear portion cut off.

Cleaned in 1950; polished in 1960.

Baume-les-Messieurs, abbey church

BIBL.: Monnier 1844, p. 67; Brune 1894, p. 470; Troescher 1940, p. 103; Duhem 1960, p. 196; Müller 1966, p. 50; Quarré 1977, p. 123; Morand 1991, p. 153; Pontefract 1993, p. 32; Baudoin 1996, p. 137; Bertrand 1997, 1: pp. 328–29, 333; 4: p. 32; Roser 2003, 2: pp. 479–91.

EXH.: Dijon 1976, no. 81.

This *St. Michael* is exceptionally distinct in the way it brings together two iconographic themes: the battle with the demon for the possession of the soul, and the saint's role as conveyor of dead souls. The dispute is expressed by the battle waged against the demon, struck down and killed by the archangel's spear. The soul clings, fully trusting, to the archangel's shoulder; before successfully undergoing judgment, it prepares to be taken toward its destination in the hereafter. It seems indifferent to the victor. In truth, its expression and especially fervent, prayerful gratitude lead it toward *Christ in Judgment,* which originally faced the soul from a location to the east, beneath the arch of the tomb (p. 280, fig. 9). It is precisely the soul's pose that makes it possible to restore the statue of St. Michael to its position at the southwest corner of the sepulcher.

The soul, solidly built and equipped with miter and crosier, is extremely individualized. Its face is broad, with prominent cheekbones, with a large and ill-shaven chin. It is totally different from the iconographic tradition, which depicts impersonal souls in the form of naked and androgynous children. This soul is unequivocally a portrait of the abbot Amé de Chalon and forms the connection between the two eschatological themes of

the tomb's decoration. It is the soul on the shoulder of St. Michael, at the moment of individual judgment, and it appears as a body resurrected through its relationship to the Redeemer, on the day of the Last Judgment.

This very subtle play of correspondences established above the tomb is also found in the funerary niche of Guillaume of Vienna, at Saint-Seine, where, to the west, the soul

of the departed, presented by a Benedictine saint, addressed his prayer to the Virgin and to the Christ child, placed to the east, the latter responding to him with a gesture of benediction (p. 266, fig. 1).

It is remarkable that another statue of St. Michael, entirely comparable but later by a half-century, existed in Baume until the early nineteenth century. The wonderful plastic and iconographical qualities of

Amé de Chalon's *St. Michael* assuredly would have served as a model. The face of the archangel has strong affinities with that of the angel to the right of the recumbent statue of Philip the Bold and seems to be a portrait of him at a more advanced age, and it also has similarities with the *St. John the Evangelist* in Poligny, which justifies its attribution to Claus de Werve.

S.R.

Sophie Cassagnes-Brouquet
Atelier Activity and the Status of Artists

Whether settled in the large cities or modest villages of the duchy, whether originally from Burgundy or elsewhere, artists formed a significant social group, the development of which can be viewed through sources from the period. Notaries' files, tax documents, and the princes' accounting records trace the fluctuating outlines of this more or less homogeneous class.

The Status of Artists

Artists' social origins are barely discernable from fourteenth-century sources. Establishing an artist's biography remains in itself a tour de force, with the result most frequently in the form of a general framework, interrupted with breaks of varying lengths.

Lineages

Historians frequently do not know the exact date of an artist's death, between the last time his presence is noted and the first mention of a widow or heirs. The same is true for the date and place of birth, which can only be deduced retroactively. In certain cases, the name indicates the origins. Thus the painter Henriot de Dijon and his contemporary Jean Gentil—who worked with him on the building site of the Carthusian monastery at Champmol under the supervision of Jean de Beaumetz—heralded from the duchy's capital. Other artists came from the countryside, such as Gautier Moreaul, a glass artist working in Dijon during the period 1357–82 who, according to historical sources, came from Saulx-le-Duc. However, the constant mention of artisan lineages in the sources leads one to think that the majority of Burgundian artists came out of the small urban artisan milieu.

Veritable artist dynasties emerge through the flow of historical sources in which all possible family ties appear—father and son, brothers, uncle and nephew. The father-son relationship predominates, and it is common to see two generations at work on a project. A painter from Dijon, Arnoul Picornet, one of the most active painters in that region in the late fourteenth century, worked early on with his son Amiot.

A study in depth of the artistic environment in Burgundy offers a glimpse of this same type of lineage in all the arts. The eldest son often succeeded the father, alongside whom he carried out his apprenticeship, while the younger son was placed with a colleague or within a different profession, with the goal of diversifying the strategies for family success.

Thus the transmission of a craft did not always take place from father to son, and another family member, often the uncle, could play a significant role. Suffice it to mention the relationship between Claus Sluter and his nephew Claus de Werve, or that between Jean Malouel and the Limbourg brothers, to illustrate the importance of this uncle-nephew bond within the context of art history.

The family was the social bond par excellence and constituted a privileged professional framework. This is why, after the death of the earlier generation, represented by the uncle or father, the siblings were a completely natural way to maintain the link. Two brothers worked together in the same atelier or often hired out as assistants on the same work site. Jean Chataul and his brother, the painter Perreaul, frequently worked with each other at the ducal residence in Dijon.[1] It was not unusual for

two brothers to emigrate together. Thévenin and Huguenin Marin, originally from Troyes, settled in Burgundy, near Chalon-sur-Saône in 1373, then in Dijon beginning in 1375. They first worked on ducal construction sites, and after spending a few years working separately on different projects, they once again often found work at the same site. Such sibling partnerships were equally present in the world of sculpture: Jean de Marville and his brother Mahiet; and the Duke of Burgundy's architects, Jacques and Parisot de Neuilly and Drouet and Guy de Dammartin.

While artists were strongly influenced by family ties, some who came from foreign soil remained isolated individuals. In such cases, marriage seemed the best way to become integrated into the local artistic environment. Thus in 1377 Jacques de Bar-sur-Aube, who came from Champagne, married the daughter of a glass artist from Dijon and changed his name to Jehan le Bourset.[2] This union allowed him to participate in projects connected to the atelier of a well-known artist and to be the beneficiary of new commissions. The son- and father-in-law worked both separately and together as a father-and-son team.

The family thus was the most solid social and professional tie in urban society, the bond that both protected and limited the development of individual artistic personalities.

Professional Ties

Ties of proximity among artists were strengthened by a very concentrated distribution of artists in three out of seven parishes in Dijon. In the parish of Saint-Médard, painters, sculptors, and glass artists often lived near one another. This proximity is clearly seen in the choice of witnesses during the drawing up of notarial deeds. It was not unusual for two painters or two illuminators to cosign a deed issued by one of their colleagues.

These professional ties sometimes would supplant those of lineage, particularly when the artist, widow, or bachelor was isolated. On 30 November 1390, before leaving Burgundy for the northern states to work for Duke Philip the Bold, Jean de Beaumetz was careful to name proxies whose numbers included many artists who were accustomed to working under his orders.[3]

This sort of friendship among practitioners of the same profession did not exclude arrangements with the other artistic occupations, and the boundaries between professions were so ill-defined that certain painters did not hesitate to place their sons in apprenticeships with goldsmiths. Artists were accustomed to working together on the building sites opened by the duke, and they also participated in the delivery of their colleagues' works. On 3 August 1399, a committee of experts had the honor to acknowledge receipt of two altarpieces sculpted by Jacques de Baerze and painted by Melchior Broederlam for the church of the Carthusian monastery at Champmol.[4] In the margin of the ledgers, a note in Latin specifies the members of this committee: Amiot Arnaud, Josset de Halle, Claus Sluter, Jean Malouel, Hennequin de Hacht, the goldsmith, and Guillaume de Beaumetz, nephew of the ducal painter Jean de Beaumetz. While it was utterly natural for the new ducal painter Jean Malouel to be present in this reception committee, in is interesting to note the less essential presence of a goldsmith, Hennequin de Hacht, the sculptor Claus Sluter, and a humble personage like Guillaume de Beaumetz, who took the place of his deceased uncle.

Committees of experts were not the only place where artists of different professions could meet. The primary meeting place was the building site, which required a wide range of qualifications. Painters frequented goldsmiths' workshops, where they would purchase gold for altarpiece backgrounds, and they ordered panels for painting from cabinetmakers. Often painters were called upon to paint and gild the statues that emerged from sculpture studios.

The Burgundian Artistic Crucible

Whether or not one can speak of a veritable Burgundian artistic school is a question that has been debated for more than half a century.[5] One has to admit that the list of names of the painters and glass artists attached to the court of the dukes of Burgundy—from Jean de Beaumetz to Claus Sluter, by way of Jean Malouel and Jean de Marville—illustrates the preponderance of artists who came from the North. Attempts are also being made to respond to nagging questions regarding the provenance of artists present in Burgundy under Philip the Bold and John the Fearless.

If the origin of Burgundian artists has not always been well documented, we do know, in any case, that the duchy's capital was responsible for the greatest share. No city numbered as many artists as Dijon. Before the arrival of Philip the Bold, Burgundian artists had the most noticeable presence, with only a few Champenois and Comtois painters and glass artists in the duchy. However, their relative numbers diminished during the second half of the fourteenth century with the arrival of artists from the North—Flanders, Artois, Hainaut, and Holland itself—who were drawn by the ducal court at Dijon and the opening of various building sites, both civil and religious.

The great ducal glass artists came from the North and monopolized the work at the Carthusian monastery and the ducal residence in Dijon, but artists of more humble reputation, Burgundians, worked on other restoration sites at chateaux scattered throughout the territory of the duchy.

While manuscript illumination was undertaken in Burgundy, almost exclusively in Dijon, it was clearly marginal compared to other artistic activities. The proximity of Paris, where the dukes were accustomed to purchase their books from merchants such as Dino and Jacques Rapondi from Lucca, prevented this activity from developing in Burgundy as it had in the northern states. Nonetheless, the presence of a certain number of still-unattributed manuscripts in Burgundian libraries makes it possible to reject the idea of a total absence of illumination workshops in the duchy.

Under the principality of Philip the Bold, Champenois painters and glass artists settled in greater numbers, lured by the opening of the great civil and religious building projects. It is a bit misleading to describe these artists as originating from Champagne, for it was essentially the Troyenne region that exported artists in the direction of the duchy, and it was above all in the area of stained glass that they seemed to demonstrate their artistic talent. These Champenois artists undoubtedly had considerable influence in the field of painting on glass, but how much remains difficult to quantify. None of the glass artists in the second half of the fourteenth century who are mentioned in documents left any trace of their work.

The earldom of Burgundy, another region bordering the duchy, furnished a number of painters, glass artists, and illuminators nearly equal to that from Champagne. These artists hailed from all over the earldom, predominantly from the most important cities, Besançon, Poligny, Salins, and Gray. The artists who came from Paris and the Île-de-France were able to receive recognition from Philip the Bold. Despite the creation of a painting workshop in Dijon, Philip never severed his bonds with the capital of the realm, where he frequently resided, particularly after the death of his brother Charles V and during the regency that followed. His son John the Fearless, more than ever concerned with political affairs, stayed there for long periods of time. In the studios of Paris, Philip met the most significant artists of the day, and it was there that he recruited Jean de Beaumetz.

The turmoil of the time was not the only reason that artists came from distant regions to Burgundy. They were also drawn by the desire to come into contact with artists of renown, who were concentrated in the region's capital. Finally, the greatest numbers of artists were those who, looking for a bit of work, stayed in Burgundy for a short time. The origins of these artists are remote and sometimes unknown. Clearly Parisians dominated, but artists from certain cities that were closer geographically were scarcely represented. The German-speaking regions with which Burgundy had close relations were, naturally, quite well represented.

Along with the Champenois and the Comtois, the Flemish formed the largest contingent of artists in the duchy of Burgundy. In keeping with an old tradition and for the sake of convenience, the term "Flemish" is used somewhat imprecisely. While true natives of Flanders were present in Dijon, such as Hennequin de Bruges or Torquin de Gand (from Ghent), a considerable number of painters originated from other provinces that were joined to the northern possessions of the Duke of Burgundy. They belonged either to the realm of France, such as Artois, or to the empire, such as Brabant. For the entire period, these "Flemish" places of origin were equally represented, however with a slight emphasis on Artois.[6]

The connections between Burgundy and Artois existed even before Philip the Bold took possession of his duchy. They were strengthened when Philip inherited the earldom of Artois, after his marriage in 1369 to that region's heir, Margaret of Flanders. The great patron continuously traveled among his favorite residences in Rouvres, Argilly, and Germolles in Burgundy, and Hesdin in Artois, and his voyages resulted in artistic exchanges among these regions.

The other artists were divided equally among Cambrai, Brabant, Flanders, and Holland. Yet there was a slight lag in time. The Flemish artists from Bruges and Ghent and the painters and glass artists from Brabant appeared in Burgundy very early, after the duke's marriage to Margaret of Flanders. Artists from Cambrai settled there a bit later, in the very late fourteenth century. Moreover the reign of Philip the Bold was a great period of "Flemish" immigration to Burgundy.[7] Toward the end of his patronage and under the principality of John the Fearless, immigration did not dry up, but it tended to fall off, though allowing the introduction of artists with more distant origins, such as Jean Malouel, from Gelder, and Jehan de Thiais, from Limbourg. The Dutch painters and glass artists arrived in Burgundy later, unlike their sculptor compatriots such as Claus Sluter and Claus de Werve, and they were present under the sovereignties of John the Fearless and his son Philip the Good.[8]

The artists from Brabant were present in Burgundy above all during the second half of the fourteenth century, under the protection Duke Philip the Bold extended to this region of the empire.

The unusual personality of Claus Sluter, originally from Haarlem, dominated the principality of Philip the Bold; his nephew Claus de Werve succeeded him, assuring that Dutch artists would continue to dominate the artistic arena.

Limbourg and Gelder, cities whose artistic production was brought to light by Erwin Panofsky in his book *Early Netherlandish Painting*, were equally represented by two

remarkable figures. Jehan de Thiais, perhaps originally from the area around Maastricht, was the first ducal glass artist to settle in Burgundy from 1386 to 1389.[9] Gelder was magnificently represented by Jean Maelweel, or Malouel, the most eminent painter who came to Burgundy. He was the third painter to the duke, from 1397 to 1415, after Jean d'Arbois and Jean de Beaumetz.

Although the Flemish artists were a relatively small contingent in the duchy, they were dominant in terms of the quality of their work. Heading sculpture, painting, and glass workshops, they contributed competence and new techniques, as well as a more modern sensibility. These strong personalities stood out, and the most imaginative Burgundians supported them and were able to appreciate their teachings. While most of them only came to Burgundy for short visits, others settled there. Mixed marriages were frequent and names were gradually Frenchified.[10] In this regard, it is probably the Franco-Flemish designation that most appropriately describes the painting that flourished in Burgundy at the time of the Valois dukes.

Atelier Life

The settlement of artists in the city, grouped around certain parishes, clearly shows the collective nature of their work. Located on the same streets, sometimes next door to each other, ateliers were also creative centers for many different people, where successive generations of the same lineage sometimes rubbed shoulders with foreigners who had come into the family network. These workshops were places of production and commerce and also served as centers for the training of young painters. Ancient knowledge and foreign influences interacted in these principal units of artistic creation, making them places of both tradition and innovation.

The Apprentice

Apprenticeship remained the sole method for training in the mechanical arts, to which the artistic disciplines belonged. The age for entering into apprenticeship varied but generally corresponded to the beginning of adolescence. The apprentice thus was not a young child, but someone who was already fully developed intellectually and physically, and had perhaps received some elementary education. It is convenient to distinguish two types of apprentices, corresponding to two age levels. The first and most common type consisted of adolescents entrusted by their parents to a master so that they might learn a craft. The second was made up of men who had previous training and who often had come from distant regions. They possessed the rudiments of their craft but were seeking further technical training with an acknowledged master. Becoming an apprentice was also an excel-

lent way to create one's own clientele and become integrated into the local artistic milieu.

Dijon's renown as an art center explains the geographical origins of the apprentices there, who, in the mid fourteenth century, came from the city or its environs. Burgundians were dominant, but young men also came from farther afield to work alongside painters such as Arnoul Picornet and Henri Bellechose. Michel Bergeret from Angers and Michel Estellin from Cambrai were probably drawn by the glamour of the ducal building projects. Adults, they came to Dijon more to complete their training and gain entry into the local artistic milieu than to perform actual apprenticeships.

The duration of training varied from three to nine years and seems to have been tied to the age of entry as an apprentice. For painters, the period varied from two to nine years, for illuminators from three to six; for the glass artist Nicaise de Fievin, apprenticeship lasted three years. A study of contracts shows the great diversity in length of apprenticeships, contradicting the extremely rigid rules in force at the time.

Five to six years represented an important stage in the life of an adolescent; his parents and master expected to benefit but in different ways. The parents were inspired by a desire to give their son a profitable profession, often superior to their own. For his part, the master hoped to get the most out of his apprentice, who had to provide him with inexpensive labor, at least during the final years of his apprenticeship. The master sometimes demanded an entrance fee, meant to cover the expenses of food, lodging, and instruction.

In some contracts, the obligations were reciprocal. The master agreed to lodge, feed, clothe, and provide shoes for his student. These material obligations were accompanied by moral responsibilities. The master agreed to raise the apprentice in an environment of good manners and to inculcate morals, somewhat replacing his actual father: *Promittens pater erga filium facere curare*.[11] In all cases, he had to instruct the young man to the best of his abilities and was not supposed to hide from him any secrets of his profession: "to fully and faithfully demonstrate and instruct everything possible about said science."[12]

For his part, the apprentice had to work without reluctance, following the orders of his master, and he had to execute all the works asked of him. Under such conditions, the owner of an atelier often saw the apprentice as a form of cheap labor. If during the early years he was hardly productive, by the time he finished, the apprentice had become an artist in his own right. The question of payment was addressed through various agreements. Most Burgundian contracts made do with proposing payment in kind, that is lodging, clothing, and meals. The

great majority of contracts did not call for any improvement upon these terms and established an annual wage, sometimes absurdly low. Paid apprentices could nonetheless count themselves among the fortunate, since most agreements did not provide for any wages at all.

The contracting parties paid close attention to clauses regarding breach of contract. The apprentice was obliged to remain with his master until the end of his contract, and in cases to the contrary, he had to pay very high damages. Thus apprenticeship was an agreement with reciprocal obligations, but these were tilted very clearly in favor of the master.

The Valet de Chambre

The valet de chambre is without a doubt the most difficult artist's position to define. Clearly a number of texts allude to this role as essential in the creation of the work of art, but always for informational purposes. Thus one learns that a certain master painted or installed some glass works in a chateau, accompanied by one or more valets de chambre, who most often remained anonymous. It is quite difficult to trace the career of these forgotten figures. Work contracts were not at all common; contracts for the hire of valets de chambre are rare and sometimes cannot be distinguished from apprenticeship contracts. In both cases, a fellow worker would make a recommendation to his master. Without a doubt, the divide between apprenticeship and paid work was not as clear as one might think. The apprentice often was compensated during his final years, and the valet de chambre would start his career working without pay at the intermediary status of apprentice-assistant.

One can distinguish two categories of valet. One was made up of artists who had already been trained and who were hired by the day by oral agreement. The other category consisted of temporary workers, recruited for longer periods, whose presence sometimes resulted in the drafting of a contract before a notary. Day wages or payment by the piece were the two most common forms of compensation. One sees a hierarchy of wages that apparently has little relationship to monetary variations, and payment ranged from a minimum wage of 1 gros per day to the higher amount of 6 gros.[13] A payment of 2 gros per day was the average wage for a painter or sculptor. Experienced artists were paid a daily wage that varied between 2-1/2 and 3 gros. As a general rule, the valet's wage was half that of his master. And so the situation of the valet remained somewhat mysterious and his means of payment random. If during periods of tranquillity he was ready to accept a mediocre wage, which he might supplement with small jobs, he was benefiting from an enviable situation, at least at the time of the large work sites under Philip the Bold. The ups and downs also explain the extreme geographic mobility of this group of artists, who tried to seek better wages elsewhere.

The Atelier

All historians agree in emphasizing how difficult it had become in the late Middle Ages for an assistant to move on to the higher status of master and to open an independent atelier. The purchase or lease of a workshop, the acquisition of means of production, and especially the payment of entrance fees to the craft were financial impediments that kept workers in an eternal wage-earning position. One of the most practical ways to overcome these difficulties was for two artists in the same area to form an association. Such arrangements were typically made by artists subject to family ties, as described above, but unrelated parties that came together to share profits and expenses.

Every art historian's most legitimate aspiration is undoubtedly to picture the lives of artists in their studios and how they accomplished their work and received and executed commissions. In the absence of an iconographic source, is it possible to describe these ateliers? The rare documents that exist do convey some scant information. After the death of Jean Malouel, painter to John the Fearless, Henri Bellechose became the new painter and valet de chambre to the duke on 12 August 1415. On 5 August 1416, Malouel's widow, Eloye, had to hand over to the new painter the materials that had been entrusted to her deceased husband. "Said Henry has received the goods that had belonged to Monsieur, which Malouhe's former wife had in her possession: a stone of marble, described as a long piece of brown porphyry, a white stone in six squares, one white cutting wheel (grinder for pigments) and two brown, of porphyry, one sideboard, one chest and one bottle of varnish—which he promises to explain, according to his letter written on 17 March 1415 . . . , one ounce and four estelins of fine azure that the aforementioned Malouey woman had—according to her letter written on 5 August 1416."[14]

The meagerness of this inventory is not surprising. One wonders how, with so little, Jean Malouel was able to create the masterpieces attributed to him. This list refers only to material made available to him by the duke, and the painter must have possessed his own tools, obtained elsewhere, which his widow inherited. For his part, it was imperative for Henri Bellechose to add to what he was given if he wished to fulfill ducal commissions, which were still numerous at that time. This text, though extremely incomplete, is one of the rare documents that indicates the materials used by an artist.

Any discussion of the organization of the painting, illumination, and glass crafts in Burgundy essentially concerns Dijon, the only city where artists were numer-

ous enough to constitute a cohesive professional group. Yet for quite some time the Burgundian capital avoided the traditional pattern of medieval cities, where commercial and artisan activities gathered together in oath-bound groups. Dijon was not an exception, for in fact the crafts were not organized into "corporations" in many French cities, including important places of craft and commerce, such as Lyon, Narbonne, and Bordeaux,[15] where the regulation of crafts was placed under the direct authority of the municipality.

The charter granted in 1187 by the Duke of Burgundy conferred upon the municipality of Dijon the responsibility for regulation the crafts. One of the oldest collections of ecclesiastical charters in Dijon, dating from the thirteenth century, lists the professions represented in the city.[16] Over the two subsequent centuries, artisan and merchant activities in the city were regulated piecemeal by decrees enacted by the viscount-mayor. The mayor of Dijon was the first supreme head of the collection of crafts. The day after his election, he designated jury members and officials or experts charged with overseeing the crafts. These people, chosen from among the masters of their professions, had only limited autonomy and were permanently controlled by jury member-officials. In order to avoid any fraud or controversy, standard weights and measures, as well as reference samples, were kept at the town hall. This control that the municipality of Dijon had over the crafts was quite different from contemporaneous situations in Italy and the Low Countries, where the guilds and the arts had incontestable economic, and indeed political, power. In Dijon, beginning in 1375, the goldsmiths banded together into a confraternity, dedicated, according to custom, to St. Éloi (Eligius). Upon forming an association in November 1381, the carpenters, coopers, and roofers established their offices at the hospital of Saint-Esprit.[17] Sculptors, painters, glass artists, and illuminators did not have any confraternities available to them until the end of the Middle Ages, but without having specific status, artists seemed to be a cohesive professional body, very close to that made up of artisans, and entirely subject to municipal jurisdiction.

NOTES 1. ADCO, Accounts for the territory of Dijon, B 4438, fol. 29.

2. Ibid., Draft by Thierry Quasset, notary in Dijon, B 11238, fol. 33, 26 May 1377.

3. Ibid., Draft by Pierre de Dommartin, notary in Dijon, B 11312, fol. 53.

4. Ibid., General Accounts, B 1501, fol. 90.

5. This designation is debated in Panofsky (1992, pp. 162–73); Sterling upholds it (1978, pp. 5–17).

6. This immigration of painters and glass artists from the North was not an isolated event; Flemish craftsmen were likewise represented in Dijon in the clothing and metal trades. They seemed quite well integrated into the population and did not inhabit a specific neighborhood, but were found in all parishes of the city.

7. Fifty-three out of 100 documented artists in Burgundy were from the North in the second half of the fourteenth century, 38 out of 100 in the first half of the fifteenth century.

8. David 1933; Camp 1990.

9. Panofsky (1992, pp. 176–249) insists on the aristocratic nature of the art of Gueldre and Limbourg, which was open to elegant International Style tendencies, and at the same time more susceptible to the wishes of the princely courts, particularly those of Philip the Bold and John the Fearless.

10. Jean de Beaumetz, Claus de Werve, and Henri Bellechose were married or re-married in Dijon. Claes van der Werve is mentioned again in 1397 (ADCO, B 4447, fol. 23); the ducal artist wished to Frenchify his name to Claus de Werve after 1400. The name Hennequin was invariably changed to Jehan, just as Hennequin Maelweel became Jean Malouel.

11. ADCO, Draft by Gelier Symonet, notary in Dijon, contract of apprenticeship of Perreaul, son of Belin the illuminator, B 11256, fol. 198v, 7 January 1359 (n.s. 1360).

12. Ibid., Draft by Jean le Bon, notary in Dijon, contract of apprenticeship of Pierre Verju, B 11331, fol. 277v, 29 January 1419 (n.s. 1420).

13. For the valets de chambre of Jean de Marville (ibid., B 4426, fols. 28–29).

14. Ibid., General Accounts, B 15, fol. 113r.

15. Fagniez 1900, 2: p. xvii.

16. Chapuis 1906, p. 7.

17. ADCO, B 11288, fol. 8 for goldsmiths; B 11291, fol. 61v for carpenters. Richard 1984, p. 25.

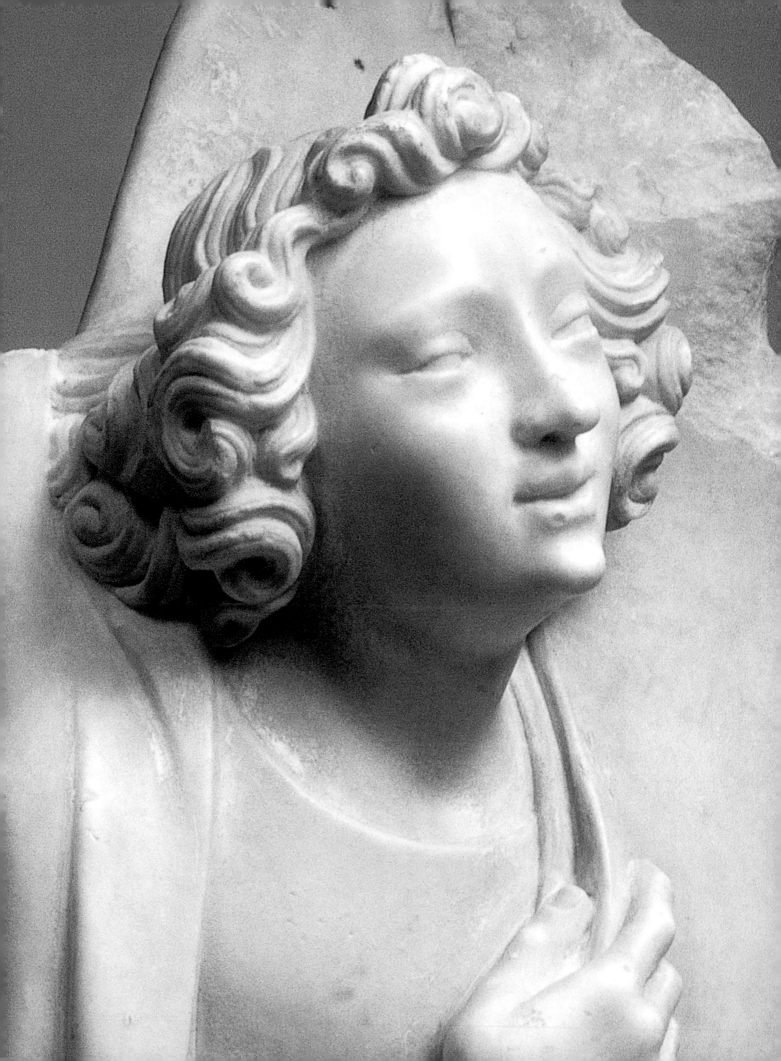

ARTWORKS

Sophie Jugie

Painting in Burgundy

There is a copious bibliography[1] on the history of painting in Burgundy, thanks to the many twentieth-century art historians who studied this field. Many treatises on French painting[2] also discuss works considered to belong to the Burgundian school. But not much is known about Burgundian paintings produced in the years 1360–1420.

Concerning easel paintings in particular, we have reliable data only about the works that can be connected to the Carthusian monastery of Champmol or to the first two Valois princes through mentions in the ducal accounts and inventories, but for other works we lack information or even a reliable list.[3] The research on manuscript illuminations has focused mainly on the most remarkable works, which fall beyond our chronological scope.[4] However, the research on mural paintings[5] carried out by the Burgundy Regional Inventory Agency and the association PACOB (Patrimoine, Ambiances et Couleurs de Bourgogne) has shed light on works that had heretofore been ignored (see Virginie Inguenaud's "Notes on Some Burgundian Painted Wall Decorations," pp. 290–93).

By methodically researching previously disregarded archival sources, Sophie Cassagnes-Brouquet, whose paper *Painters in Burgundy under the Valois Dukes* is described as a "contribution to the study of medieval painting,"[6] has brought about a reassessment of this field. Her article catalogues all the works made in the ducal workshops, even those that have not survived, but also discusses painterly activity that did not rely on the dukes' patronage. The social and professional life of the Burgundian painters who did not work at the ducal workshops is described in detail, thus bringing to light the role of other art patrons, such as religious or administrative institutions, brotherhoods, parishes, and laymen. Overall there wasn't much artistic activity; except for the dukes' undertakings, Burgundy was not a bustling art center. Philip the Bold's patronage did not find many imitators among the nobles or the officials at the ducal court. But the pious did commission some painted decorations on chapel walls, stained-glass windows, or devotional paintings. Burgundian artists also executed mural paintings and stained-glass windows with secular themes, as well as ephemeral decorations for religious and courtly celebrations. The records of the Dijon bishopric also show the presence of illuminators who illustrated devotional books for a local customer base that included laymen and priests.

Cassagnes-Brouquet's paper indicates that paintings on wood were commissioned much less often than wall paintings, stained-glass windows, and polychrome statues, or that perhaps those commissions were poorly recorded. The existing records[7] are dated after 1420. For instance, in 1429 the parishioners of the church of Saint-Michel de Dijon commissioned Henri Bellechose to apply polychromy to a statue of St. Michael, to an altarpiece depicting Christ surrounded by the twelve Apostles, and to an altar front representing the Annunciation.

The existing documentation, which provides knowledge of many destroyed or lost works, does not tell us much about the surviving paintings. However, the major obstacle to compiling an inventory of Burgundian paintings (which would include all the works made for local patrons by painters active in Burgundy) is not the paucity of surviving works and documentation. The crucial issue is the difficulty of defining what constitutes a Burgundian, rather than a Parisian or Flemish, painting. For instance, the Troyes *Pietà*[8] (cat. 111) is generally believed to have been made in the ducal workshops, based on its similarities with other works of that provenance. But no such unanimity of opinion is reached about a group of paintings similar to this *Pietà*, among them the *Small Round Pietà* in the Louvre,[9] the *Entombment* also in the Louvre,[10] and the *Crowning of the Virgin* in Berlin.[11] Some believe these pictures to be of Burgundian origin;[12] others think they belong to the Parisian school.[13] Recent studies on the

works of Flemish primitive painters, and in particular ongoing research about Van Eyck's forerunners, have enabled us to reclassify other works as Dutch. Such is the case of three small altarpieces from Berlin (cat. 72), Antwerp (cat. 73), and Antwerp and Baltimore (cat. 74); their provenance has been traced to Champmol, but they do not appear to have been made in the ducal workshops. The attribution issues arising in connection with the small Beistegui Virgin[14] are another typical example. By its many similarities with the paintings of the Flemish artist Melchior Broederlam, this Madonna could be the work of a Flemish painter. However, it could also have been made by a Burgundian painter inspired by Broederlam's altarpiece installed in the church of Champmol.

Trying to differentiate Burgundian production from Parisian or even Flemish production is futile. For a long time the problem was obviated by describing the Dijon school as "Franco-Flemish," because the painters Jean de Beaumetz, Jean Malouel, and Henri Bellechose, as well as the sculptors Jean de Marville, Claus Sluter, and Claus de

Werve and several of their assistants, all came from the Netherlands. However, Cassagnes-Brouquet's research[15] indicates that, during the reigns of Philip the Bold and John the Fearless, Dijon had painters and glass artists from Flanders, Artois, Brabant, and Holland. Others hailed from Burgundy and neighboring regions, Champagne or Franche-Comté, but also from other French regions including Brittany. Some of them worked on a single project and moved on; others settled down in the area. This phenomenon, explained by the geography of the Burgundian states and the power of attraction of its court, was not unique to Burgundy. From the early fifteenth century on, the artistic environment in Paris was also "Franco-Flemish." Many of the artists who worked for the dukes seem to have lived in Paris. Likewise, the Flemish artists working in Flanders were quite susceptible to French influences. The demonstrated mobility of the artists and the wide-ranging taste of the princes allow us to imagine artistic centers connected by regular exchanges where many diverse styles coexisted.

NOTES 1. Champeaux 1898; Kleinclausz 1906; Sterling 1959A and 1959B; Laclotte 1961; Sterling 1978, 1989.
2. Lemoisne 1931; Dupont 1937; Sterling 1938; Bazin 1941; Sterling 1941; Sterling 1942; Ring 1949; Laclotte 1966; Meiss 1967; Meiss 1971; Meiss 1974; Avril 1975.
3. During an internship at the Dijon Musée des Beaux Arts in 2001, Agnieszka Chevilotte began to compile documentation about medieval painting in Burgundy. I owe her my thanks for this research, which provided a basis for my paper.
4. For instance, Paris 1994, pp. 393–401.
5. Dijon 1992; Dijon 2003.
6. Cassagnes-Brouquet 1996.
7. Ibid., p. 690.
8. Thought to be related to Malouel's *Large Round Pietà*,

and even more so to the *St. Dennis Altarpiece*, according to Sterling (1941, no. 33), Ring (1949, no. 52), Laclotte, (1961, p. 288), which suggests it could be a youthful work by Bellechose; Laclotte 1966, pp. 13–14.
9. Dijon workshop, according to Sterling 1941, no. 29; Châtelet 1980, no. 7; probably French, according to Ring 1949, no. 8, Sterling and Adhémar 1965, no. 7; Laclotte 1966, p. 14.
10. Dijon workshop, according to Sterling 1941, no. 28; Châtelet 1980, no. 12; probably French, according to Ring 1949, no. 9, Sterling and Adhémar 1965, no. 6; Laclotte 1966, p. 14.
11. Dijon workshop, according to Sterling 1941, no. 30; Dijon or Paris, according to Ring 1949, no. 49; Paris, according to Troescher 1966, pp. 162, 164; Paris,

Bourges, or Dijon, according to Laclotte 1966, p. 14.
12. Troescher (1966, pp. 62–65) even suggested that the two paintings in the Louvre and the Troyes *Pietà* should be attributed to Arnoul Picornet, the closest collaborator of Jean de Beaumetz. This is obviously a groundless speculation.
13. Sterling 1987, pp. 250–59, 280–85, 336–39.
14. Burgundian workshop, according to Sterling 1941, no. 35; probably French, according to Ring 1949, no. 51; Dijon, according to Sterling and Adhémar 1965, no. 10; Burgundian, according to Laclotte 1966, p. 14; attributed to Malouel, according to Troescher 1966, pp. 76–77.
15. Cassagnes-Brouquet 1996, pp. 119–53.

Virginie Inguenaud

Notes on Some Burgundian Painted Wall Decorations

There are so many Gothic mural paintings in Burgundy that we cannot attempt to discuss them all here. Because of their appearance, their condition, and the fragmentary or nonexistent documentation concerning them, we are not always able to date these paintings to the reigns of Philip the Bold and his son John the Fearless. For the same reasons, it is difficult to assess whether a particular iconographic theme was popular or unusual at that time. In any case, we can present the highlights of mural painting from the 1370s to the 1420s by referring to the painted decorations still existing at certain sites that have been spared by time and historical vicissitude.

Former Collegiate Church of Notre-Dame at Semur-en-Auxois

A painting representing St. Christopher (cat. 110) was discovered in 1977 on the north aisle of the collegiate church when an altarpiece was being restored. It was removed from the wall and is now exhibited in the municipal museum. This mural, painted c. 1370–75, shows many stylistic analogies with the *Apocalypse* tapestry in Angers, woven after a cartoon by Jean de Bruges. It is the most beautiful example of wall decoration from that period still existing in Burgundy.[1]

Parish Church of Saint-Laurent at Verneuil

Three young people leading a dissolute life meet three corpses at different stages of decomposition. "We were like you, you will become like us," say the corpses to the youths, encouraging them to reform. This story, whose first version appeared at the beginning of the thirteenth century and was written down by Baudoin de Condé, introduces the theme of death in poetry. It soon took on a religious meaning, made more relevant by the plague epidemics of the fourteenth and fifteenth centuries. Scenes representing this traumatic encounter were often depicted in books of hours and church walls at the end of the fourteenth and during the fifteenth centuries. Although the survival of painted decorations is haphazard, there are many representations of this theme in France (almost 100), and the nave of the Verneuil parish church (fig. 1) displays one of the oldest examples.[2] The scene is here associated with an Annunciation; a churchman believed to be the donor kneels at its base. A frame made up of small quadrilobes wrapped in colored bands separates the two scenes. The St. Anthony shown on the right, framed by folded ribbons, is probably a monumental ex-voto.[3]

The Chapel of Saint-Jacques at Cuiseaux

The chapel of Saint-Jacques was built in 1406 inside what was then the cemetery of the old hospital. The founders were Jaquemet Thurtel and his wife.[4] Although the chapel is small (10.5 x 6 m) and plain (a single nave covered by a lancet-arched vault with a height of 7.5 m), it was classified as a historical monument in 1904[5] because of its good preservation and mural paintings. The choir (fig. 2) has both painted and sculpted decoration, somewhat deteriorated and distorted by inept restorations.[6] Architectural niches ornamented with gables and pinnacles frame the painted figures of saints and a bas-relief representing St. James (the founder's patron saint) on the side of the epistle. An Annunciation is depicted in the embrasure of the axial window. Just above the Annunciation we can still see a Crucifixion, though a wooden Christ on the cross that used to be part of the scene has been lost (only the hanging hooks remain). The combination of the two scenes represents the Redemption.[7] It is not known to which extent the founders were involved in

Fig. 1.
Overall view of the scene between the three corpses and the three youths. Verneuil, parish church of Saint-Laurent.

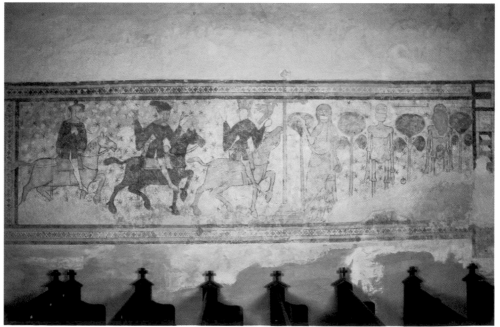

Fig. 1

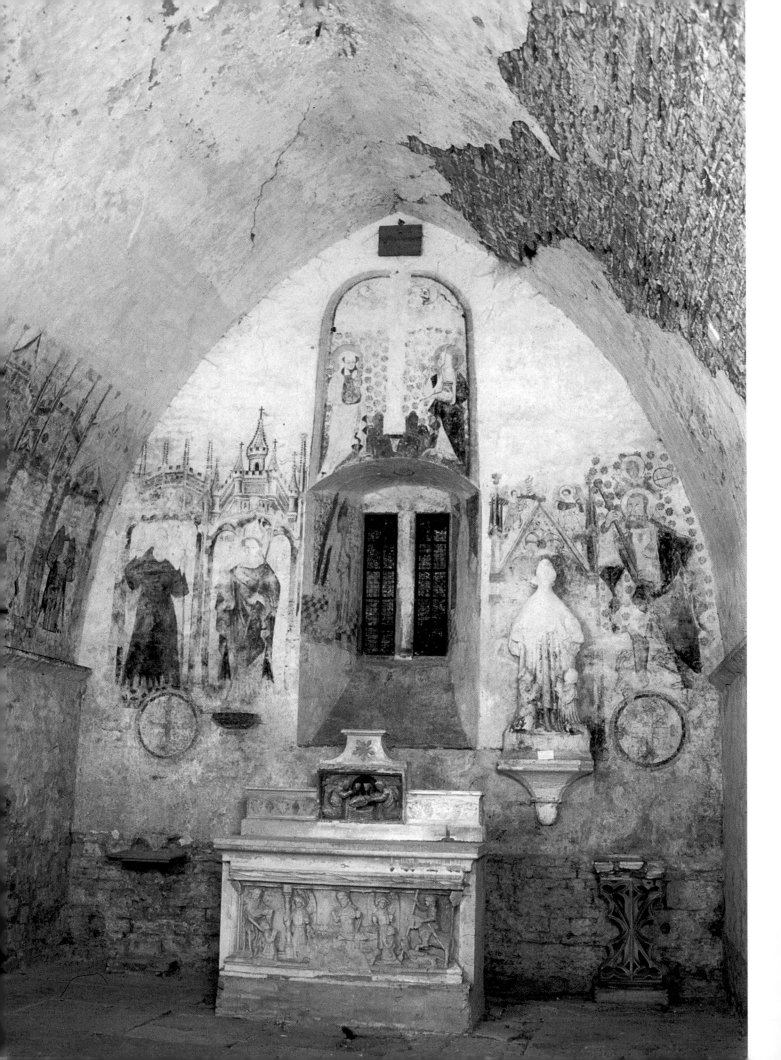

Fig. 2.
Overall view of the choir and its decoration. Cuiseaux, chapel of Saint-Jacques.
Fig. 3.
Detail of the cupola and its decoration. La Clayette, chapel of the château.

Fig. 3

planning the iconographic program of the chapel. In any case, their images appear twice: sculpted (at St. James's feet) and painted (behind St. Paul).

The Chapel of the Château of La Clayette

Although it is first mentioned in the documentary sources in 1420, the chapel appears to have been built in 1380–81, and therefore the painted decoration could not have been made before then. The vault of the chapel is entirely covered by murals, whose composition follows the circular structure of the cupola (fig. 3). The main motif is Christ's face, which appears surrounded by two concentric circles of musician angels, playing all the instruments known in medieval times. Probably there were other paint-

ings on the walls, as an angel emerging from a cloud holds a legend on which we can read "PUER NATUS EST," a quote from the prophet Isaiah meaning "the child is born," which would be recited during the Christmas liturgy. This image seems to suggest that there was a representation of the Nativity or the angels' announcement to the shepherds. Perhaps the Lespinasse family, owners of the château, had a particular devotion to the Nativity, or this lone angel was the beginning of a cycle, now lost, depicting the childhood of Christ. In any case, although the theme of the musician angels was a common one at the time, the colors and the composition used at La Clayette are unusual. The style of the paintings confirms the dates derived from historical data.[8]

NOTES 1. Burgundy DRAC, Regional Inventory Agency, thematic study on mural painting, section Semur-en-Auxois. See Sandrine Balan's *Saint Christopher* (cat. 110).
2. Research group on mural painting. *Vifs nous sommes*, pp. 152–53.
3. Médiathèque de l'Architecture et du Patrimoine (Architecture and Heritage Library), Centre de Recherche des Monuments Historiques (Historical Monuments Research Center). Photographs by Charles Hurault in 1952, by Thierry Prat in 1989; plans by Marcel Rouillard in 1892. Burgundy DRAC,

Regional Inventory Agency, thematic study on mural painting, section Verneuil. The church was classified as a historical monument by decree of 16 February 1895.
4. Courtépée and Béguillet 1967, p. 309.
5. Perrault-Dabot 1907, pp. 55–57. Quoted almost in its entirety in Guillemaut [undated], pp. 48, 65–66.
6. Médiathèque de l'Architecture et du Patrimoine (Architecture and Heritage Library), Centre de Recherche des Monuments Historiques (Historical Monuments Research Center), photos by Charles Hurault in 1953. Burgundy DRAC, Regional Inventory

Agency, thematic study on mural painting, section Cuiseaux.
7. Dijon 1992, p. 37.
8. Médiathèque de l'Architecture et du Patrimoine (Architecture and Heritage Library), Centre de Recherche des Monuments Historiques (Historical Monuments Research Center), photos by Jacquetin in 1950 and plans by Léon Raffin in 1951. Burgundy DRAC, Regional Inventory Agency, thematic study on mural painting, section La Clayette. The château was classified as a historical monument by decree of 19 May 1950. Thibout 1953, pp. 135–40.

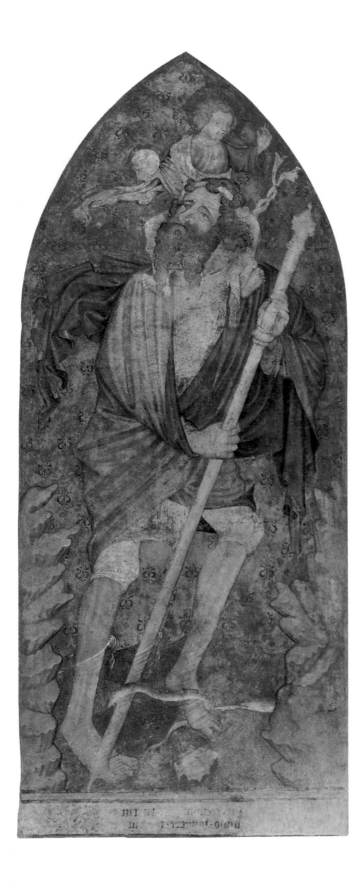

Attributed to Jean de Bruges

St. Christopher
c. 1370–75

Mural painting in tempera
302 x 126.5 x 25 cm

Semur-en-Auxois, Musée Municipal,
inv. 989.16.1

PROV.: placed at the museum in 1977.

BIBL.: Joubert 1992A, p. 10.

EXH.: Autun, Auxerre, and Dijon 1992;
Dijon 2003.

This exceptional mural painting of
St. Christopher was discovered in 1977
during the restoration of the altarpiece of
the Tree of Jesse, in the north aisle of the
choir of the collegial church of Notre-Dame
in Semur-en-Auxois. Hidden at an
undetermined date by the sixteenth-
century altarpiece, the painting was located
near the entrance of the Porte des Bleds, a
position that confirms the protective role
the work played for the visiting faithful.

The tall figure of St. Christopher
carrying the infant Jesus on his shoulders
stands out against a vermilion background
ornamented with small reverse S motifs.
Two rocky elements frame a stream with
many species of swimming fish, including
an eel that grasps the saint's foot. In the
lower portion, a band with decorative
motifs at the ends contains an inscription,
now nearly illegible, that must have
referred to worship of the saint.

The care given to details, the evident
attention to naturalism, the vividness of
the colors, and the expressiveness of the
figures make this painting a key work in
the pictorial production of Burgundy.
The decorative motifs repeated in the
background are also found in the
illuminated manuscripts created within
the circle of Charles V and make it
possible to attribute this work to an artist
of great significance.

Fabienne Joubert has advanced the
name of Jean de Bruges, a Flemish artist in
the service of the king beginning in 1368.
In fact, this work is very close to another
project by this artist, namely the cartoons
created for the wall hanging of the
Apocalypse in Angers. These two works
show the same sense of naturalism in the
physiognomies, musculature, movement,
and representation of the draperies. In
addition to these stylistic similarities,
references to a "Hanequin the painter"
and a "Jehan the painter from Bruges" in

the ledgers of the revenue court of Dijon in 1371 and 1372 can be interpreted as corroboration for this proposed attribution. Jean de Bruges could have worked for Philip the Bold, brother of Charles V, during the last third of the fourteenth century, and he may have followed the duke in his moves to Montbard and to Semur-en-Auxois.

Now in the Musée Municipal, the work underscores the high quality and excellence of artistic output in Auxois during the medieval era, likewise confirmed by sculptural production.

S.B.

111

Dijon?

Pietà
1390–1400

Tempera on wood
39 x 62 cm

Troyes, Musée des Beaux-Arts, inv. 855.3

Prov.: Gift of M. Fléchey, architect in Troyes, 1855.

Bibl.: Schmitz 1855; Le Brun-Delbanne 1872; Champeaux 1898, p. 130; Durrieu 1918; Lemoisne 1931, p. 58, fig. 49; Sterling 1938, pp. 58–60, fig. 49; Sterling 1941, Index A, p. 10, no. 33; Ring 1949, pp. 26, 198, no. 52, fig. 28; Dupont and Gnudi 1954, p. 146; Laclotte 1961, p. 288; Vergnet-Ruiz and Laclotte 1962, pp. 15, 20, fig. 7; Laclotte 1963, p. 22; Stalter 1963, p. 118; Laclotte 1966, pp. 13–14; Sterling 1976, p. 46, no. 117; Châtelet 1980, pp. 193–94, fig. 157, no. 13; Cassagnes-Brouquet 1996, 3: p. 555.

Exh.: Paris 1904, no. 14; Paris 1950, no. 14 (Dijon studio, early 15th century); Dijon 1951, no. 4 (attributed to Malouel); Antwerp 1954, p. 18, no. 47; Dijon 1960, pp. 13, 39, no. 38.

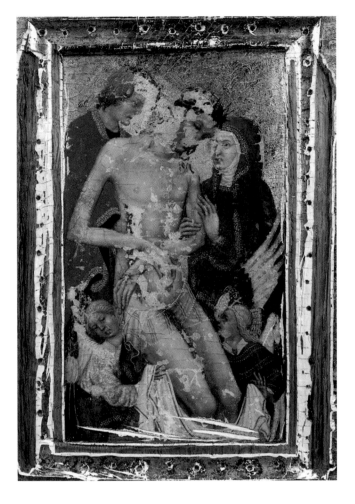

Although very damaged, this small devotional painting still retains an echo of its refinement and style. Its original frame was composed of a gilded edge, decorated with pseudo-Kufic characters on a *poinçonné* (stippled) background. On the inside, a gilded molding presents traces of elements that have now disappeared, possibly flowerets like those on the frames of Jacques de Baerze's altarpieces. The painting itself has also suffered great damage and has many major lacunae, in particular on the faces of Christ and St. John. The characters stand out from their delicately poinçonné gold background. The nearly vertical body of Christ is supported by the Virgin and St. John, as two angels drape the lower part of his body with a white cloth.

The connection with the *Large Round Pietà* in the Louvre (p. 94, fig. 1)—suggested by the similarity of composition as well as certain iconographic details, such as the diadems, decorated with crosses of angels, or other ornamental motifs—is longstanding, as is that between the pseudo-Kufic pattern on the frame and that on the veil in the *Madonna of the Butterflies* at the Berlin museum (p. 97, fig. 2), or on Jeremy's orphrey in the *Well of Moses*. This connection has implied that the work should be attributed to Jean Malouel—but it does not bear comparison to the *Large Round Pietà* or the *Madonna of the Butterflies*, which are of far superior quality. The parallel is more convincing with the *Altarpiece of St. Denis* at the Louvre—particularly with the angels in its upper portion; Michel Laclotte has suggested also correspondence with an early work of Henri Bellechose.

The Troyes Pietà also shares numerous points with certain small works ostensibly from Burgundy—but recently identified by Sterling as being from Paris—such as the *Small Round Pietà* and the *Entombment* at the Louvre; here we see border trim ornamented with pseudo-Kufic writings on the cloaks of the Virgin, St. John, and the angel to the left, a play of dotted lines that emphasizes the Virgin's veil, Christ's loincloth, and the robes of the angel on the right.

The similarity of motifs has been rarely underscored: the poinçonné branches of the background with those of the *Calvary with Carthusian Monk* at the Cleveland Museum of Art, and the Virgin's focused expression of grief with those of the holy women in the two Calvary groups with Carthusian monks at the Louvre and at Cleveland. Without going so far as to suggest (as Troescher does) a "Studio of the Pietà," which would have operated in Dijon around Arnoul Picornet at the time of Jean de Beaumetz, we might see in this painting an example of Dijonnais painting that was closer to Jean de Beaumetz than to Jean Malouel or to Henri Bellechose.

S.J.

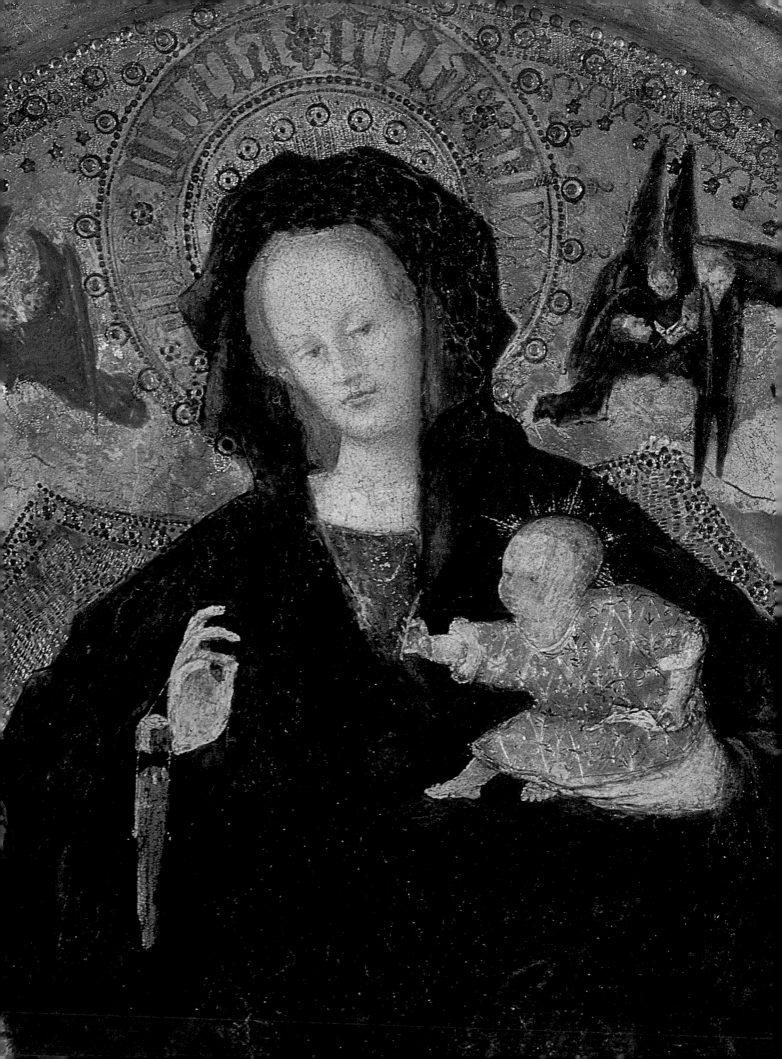

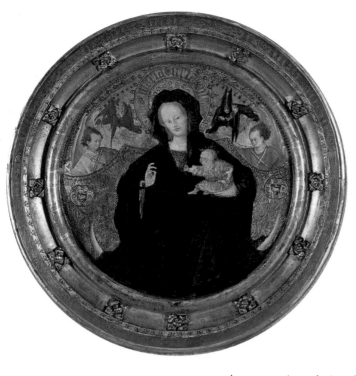

"Je suis bien," inscribed five times on the frame, is most likely a personal motto of the patron. It might be read as "tout va bien," and compared to "en bien" found on the crown of Charles VI and "je le doy," used by Louis d'Anjou. Here, it could be a joyous assertion of good fortune ascribed to the Virgin's intervention.

Now abraded, the surfaces, with simulated brocades and intricate punchwork in the gold leaf ground, were originally very rich. While the mirror format, elegance, and motto suggest a Burgundian court commission, the exuberance of the presentation and aspects of the execution (the Virgin's punched and inscribed halo, pattern and stippling of fabric, the faces) again prompt a comparison with Conrad von Soest, as in the *Annunciation* of the *Niederwildungen Altarpiece*, 1403 (SS Mari, Elisabeth, and Nikolaus, Bad Wildungen, Germany). The unknown artist may have trained in the region around Cologne, perhaps in Conrad's circle.

J.S.

112

Burgundy

Virgin and Child Writing: The Mirror of Virtue
c. 1415

Oil and gold leaf on panel
D. 22.3 cm

Inscribed on the Virgin's halo: * AVE * MARIA * GR[AT]IA* PLENA
On the frame, repeated five times: IE. SUIS. BIEN

Baltimore, The Walters Art Museum, 37.2404

PROV.: Acquired 1964.

BIBL.: Miner 1966, pp. 40–43, 60–64; Meiss 1974, p. 226; Verdier 1981, pp. 247–56; Belting 1990, p. 472; Wilson 1998, pp. 43–44; Olson 2002, pp. 168–70.

This "mirror of the Virgin" is the most complex of the surviving devotional paintings mimicking small convex mirrors that, according to inventories, were popular at Valois courts in the early fifteenth century. Usually honoring the virtues of Mary, they apparently functioned as *images de chevet* (images hung over the bed).

The symbolism is subtle. The Virgin, holding her child, is humbly seated on the crescent moon of Revelation 12, signaling her own purity and triumph over sin, while Gabriel's salutation, abbreviated in her halo, alludes to her role in the incarnation of the Word. The cloth of honor, decorated with the "device" of her son, the sacrificial lamb, and held by angels, acknowledges her as Mother of God and Queen of Heaven. As "seat of wisdom" she facilitates Christ's engagement with his destiny, holding the cords of an open pen holder (and perhaps originally an ink pot, but the area is abraded), toward which the child reaches with a tiny quill pen. Scholars have speculated on the text—the names of the saved, a personal communication to the owner, or Christ's future teachings—but without resolution. The subject is treated similarly in a painting, attributable to Conrad von Soest (known through copies; see *Art Bulletin* 23 [1941], p. 293), which, however, lacks the delicacy of the Walters painting.

The carved, gilded "mirror" frame, integral to the painting, exhibits the profile and decorative rosettes imitative of contemporary goldsmith work. The image seen in the mirror conforms to the elongation of form around the perimeters characteristic of a convex mirror, but without its distortion. A mirror over a bed can only function symbolically. It reflects the highest virtue—represented perfectly by the Virgin—which the owner aspires to reflect in life and person. The mirror and the Virgin are one here, the *Speculum sine maecula*, the spotless mirror. In this (unique?) combination with the writing child, the role of that purity in human affairs is made manifest.

113

Burgundy, Dijon?

Collection of documents of the City of Dijon: Crucifixion
1415

Manuscript on parchment, II-XIV–110 lengthwise folios, 26 x 20.5 cm; fol. Iv, miniature inscribed in a frame (15.5 x 12.5 cm), surmounted by a semicircle (D. 8.3 cm, H. 3.0 cm); fol. II, incipit of the Gospel according to St. John; fols. III–VIII, calendar for use in Dijon; fols. IX–XII, table; fol. 1, collection of documents, written c. 1407; fol. 7v, copy of book legal customs of Soissons; fol. 82, list of vassals; fol. 88 verso, book of legal customs of Dijon; ornamented initials; binding from 18th-century, fawn-colored calf

Dijon, Bibliothèque Municipale, inv. Ms 740

BIBL.: Zaluska 1991, p. 235; Sterling 1955, pp. 57–81, fig. 5.

EXH.: Rotterdam 1950, no. 51; Brussels 1951, no. 65 (mistakenly classified under 470); Dijon 1951, no. 56; New York 1975, no. 12; Ingelheim 1986, no. 16.

Executed in 1415 on behalf of Guy Poissonnier, mayor of Dijon, the collection of *Charters . . . of the freedoms and privileges of the city and municipality of Dijon, both in Latin and in French* is one of the first Burgundian compilations of privileges, statutory texts, and principles of legal customs. It opens facing the initial verses of the Gospel according to St. John, with a full-page miniature, unique in this work. The figure of Christ can perhaps be compared to that in Malouel's *Large Round Pietà* in the Louvre (p. 97, fig. 1), painted for the dukes of Burgundy.

Guy Poissonnier, protégé of the duke, was mayor of Dijon from 1407 to 1410, again from 1410 to 1413, and held a third municipal office from 1415 to 1416. He had himself depicted kneeling at the foot of the cross in ceremonial dress, appearing with the coat of arms of John the Fearless as well as those of Dijon. "The main portion in red: in the first band, blue scattered with gold fleurs-de-lis edged by a border of silver and red, in the second band six pieces of gold and blue with a red border."

The depiction of the Crucifixion opposite the incipit of the Gospel according to St. John attests to the medieval custom of taking oaths, which spread throughout both civil and ecclesiastic milieus. It was on this biblical fragment that an oath was taken before all presiding officials. This piece appears to be by the hand of one of the Flemish artists employed in the workshops in Dijon to create manuscripts for the dukes' library.

D.D.

114

Dijon?

Stained-Glass Window of the Annunciation and the Crucifixion
c. 1415–20

Stained-glass (individually colored pieces of glass, grisaille, silver stain)

190 x 120 cm

Inscription: On scrolls at the tips of the lancets: or pleut adieu (now he weeps farewell), motto of the patron, the Marshal of Chastellux

Chastellux-sur-Cure, château de Chastellux

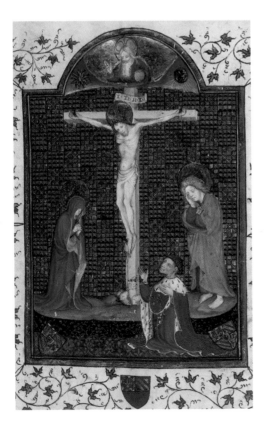

BIBL.: Chaillou des Barres 1840, p. 174; *Les Vitraux de Bourgogne*, pp. 16, 135.

Among rare French stained glass from the early fourteenth century, this example, which has survived to the present day at Chastellux, is exceptionally privileged to remain in its original location in a private residence. It dominates the altar of the chateau chapel, adjoining the so-called Archives Tower, erected in 1414. The work's patron, Claude de Beauvoir (c. 1385–1453), son of a councilor and chamberlain to Philip the Bold, held the same position at a very young age under John the Fearless (Bozzolo and Loyau 1982, p. 149 n. 252). In 1418 he was appointed councilor to Charles VI, who named him marshal of France.

Two panels (not exhibited), with the arms of the marshal and his successive wives, were inserted around 1830 at the base of the window. This reinstallation required some modifications, including trimming the architectural canopy to gain height and filling the gaps with older pieces. This restoration, undoubtedly the only one carried out before 2004, left the two scenes nearly intact.

The window is composed as a diptych, pairing the Incarnation and the Redemption in twin niches. We do not know if it was commissioned in Dijon or in Paris, both centers of production that Claude de Beauvoir had every reason to frequent. The execution is meticulous, seen in the masterly handling of the scroll of the angel's salutation and in the variety of damasked fabrics, painted freehand in the red hangings, and in the stencil work for the gold embroidery of the garments. The figures, however, are characterized by shapes without any strong plastic foundation, and the linear faces have almost no modeling. As seen in the lectern in the Annunciation, the glass painter was clearly observant, meticulously translating the details that must have existed in the cartoons. These preparatory documents must have been provided by a painter familiar with the large altarpiece by Melchior Broederlam (cat. 70), indirectly echoed in the figure of the archangel. This interesting artist, who fits easily within the international style, combines a gentle approach with a certain stiffness. Perhaps his hand will come to be recognized in works executed in other techniques.

F.G.

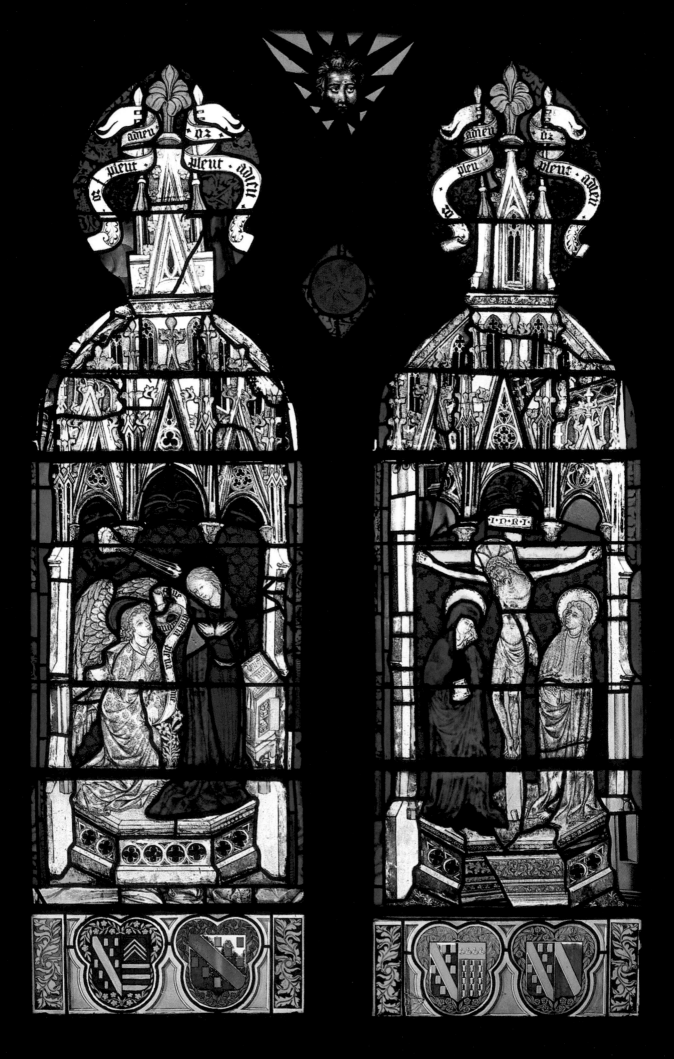

Denise Borlée

"For a Representation of Our Lady": Sculpture in Fourteenth-Century Burgundy

Historiography

Occupying a dominant position on the artistic landscape, sculpture was incontestably a major art of the Middle Ages in Burgundy, as Joseph Calmette noted with a touch of the picturesque in his speech before the Dijon Academy on 20 April 1910.[1] At that time, the great Romanesque constructions in southern Burgundy and the statuary of the late Middle Ages, stimulated by the work of the renowned artists of the Chartreuse de Champmol in Dijon, had already attracted the admiration of historians and art historians, as well as abundant literature. Indeed, as early as 1854, Arcisse de Caumont, who was then formulating his doctrine known as the Geography of Styles, included Burgundy as one of the seven Romanesque "schools" he had identified on the French territory.[2] Following Caumont, numerous writers interested in sculpture produced in southern Burgundy incorporated the notion of a "school" into their own work, though they frequently derived their own meanings from the original notion (among which prevailed the ideas of territory, space, and location).[3]

Louis Courajod was the first to celebrate the "Burgundian school of sculpture," referring to the works made in Dijon and its surroundings at the end of the fourteenth century and over the course of the fifteenth.[4] He was also largely and lastingly followed, and the expression was still being used recently.[5] Numerous researchers turned their attention to this fascinating area of artistic production, which was largely due to the construction of the Chartreuse de Champmol. Indeed, to work on the charterhouse, artists from the North and from Paris established themselves in Dijon for relatively long periods, undoubtedly training artists from Burgundy in their turn. Pierre Quarré, who was long the curator of the Dijon Musée des Beaux-Arts, made notable contributions to our knowledge of many of these artistic works and personalities, both

through the exhibitions he curated on the subject[6] and through the studies he devoted to it.[7]

Between these periods of intense creation and innovation, which the history of art long considered the only ones worthy of being remembered, "two centuries went by during which sculptors' efforts did not appear to equal the brilliance of the glory days. The land of St. Bernard seemed to entirely devote itself to the development of its architecture: yet Notre-Dame de Dijon, Notre-Dame de Semur, the churches of Saint-Thibault, of Saint-Seine, of Auxonne, of Saint-Bénigne de Dijon and the cathedral of Auxerre testify to the fact that stonecarvers were not idle in the thirteenth and fourteenth centuries. Nonetheless, their work remains less well known than the achievements of their predecessors or successors. Sluterian themes and the advent of a so-called realism obscured historical perspective with long discussions about the origins and importance of 'modern' art."[8] These lines are drawn from Claude Schaefer's introduction to his book on fourteenth-century sculpture in Burgundy, the only book to have been published on the subject.

A similar conclusion is drawn in the first pages of my thesis on the region's figurative sculpture in the thirteenth century, the subject of more scholarship than the following period, which is the current object of our interest.[9] It must be stated that nothing has been published on the subject since Schaefer's book in 1954. In fact, this deficiency reflects the absence of overviews of plastic art in fourteenth-century France, which are admittedly difficult to establish. In Burgundy, outside of the works made for the Chartreuse de Champmol in the last two decades of the century, which, as we have noted, have drawn the attention of multiple researchers, not a single statue or group of statues has been the subject of an article. At most, The *Virgin Mary and Infant Jesus* of Châteauneuf (cat. 115) was included among the works

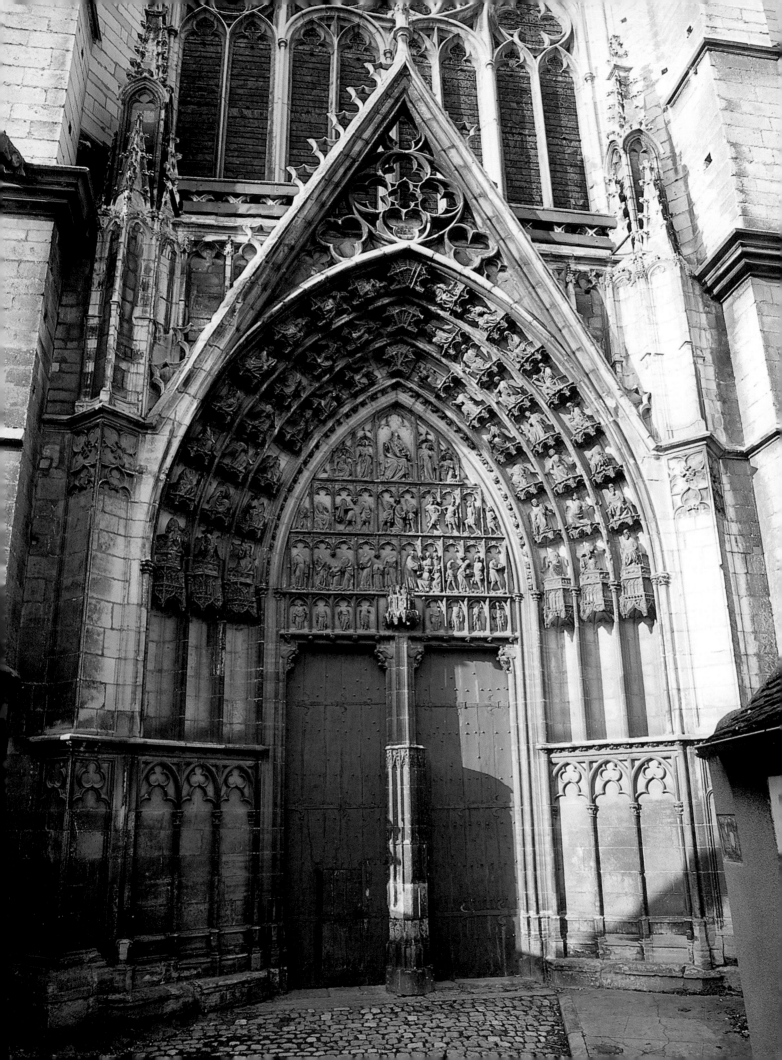

presented in the 1949 and 1969 exhibitions organized by Pierre Quarré, but was not even given a real explanatory note.[10] Other works that will be mentioned herein or are the subjects of explanatory notes in this catalogue have certainly been cited from time to time but, for the most part, without any detailed commentary.

These are the works I would like to reflect upon in the following pages. These reflections are not based on the results of in-depth research, which remains to be accomplished, but are the fruit of a consideration of various sculptures whose character, quality, and variety invite a deeper knowledge.

Major Construction

Although quite a few churches were constructed or partially reconstructed in northern Burgundy in the thirteenth century,[11] large-scale building in the following century did not die out, but it did slow down, as was the trend throughout the rest of the territory. Founded in Tonnerre at the end of the thirteenth century by Margaret of Burgundy, the widow of Charles I d'Anjou, the hospital of Notre-Dame-de-Fontenilles is a magnificent example of civil architecture built at the request of members of the royal entourage between 1293 and 1295.[12] The memory of its founder lives on through her presumed effigy, which has been kept in situ. The piece in question consists of a life-size wood statue presenting a full-length representation of the Countess of Tonnerre with her hands joined in prayer, like a votive effigy. The act of charity is thereby seen in an eschatological perspective.[13]

In Saint-Germain d'Auxerre, where the choir was rebuilt beginning in 1277, the transept was only erected over the course of the second decade of the fourteenth century, and the north wing was given a portal opening on the cloister, whose historiated tympanum recounts the story of the venerable bishop who founded the abbey.[14]

Also in Auxerre, the last decades of the thirteenth century—around 1260–70—witnessed the erection of the right portal and the bases of the central portal of the western side of the Saint-Étienne cathedral.[15] Though the style and the motifs of the former (St. John the Baptist portal) are undeniably reminiscent of the portal on the south wing of the transept of Notre-Dame de Paris,[16] the latter's studded quatrefoil motif combined with the trefoiled arch and the geometric and plant-patterned panels decorating the base of the jamb liners herald the forms privileged by early fourteenth-century artists.

Some time later—probably before 1358, and more specifically around the 1330s—the St. Étienne portal (fig. 1)[17] was built on the south wing of the transept. Episodes from the life of the martyr, which follow one another on three different levels, are placed on the tympanum in a completely original way, in an architectural setting with twinned arches in the style of ivory diptychs or triptychs. Yet the style of the figures in relief so closely resembles older works that it can hardly be considered particularly innovative. The prophets on the lintel, for example, recall the jamb liner statues on the portal of the south wing of the transept of the cathedral of Meaux, as Jean-Pierre Cassagnes has so accurately pointed out, both through their positions and the organization and treatment of the drape of their clothing.[18] The faces of St. Étienne and of one of his female listeners in the scene of the sermon on the first level of the Auxerre tympanum are very similar to the face of the rider in the third seal of the relief of the Apocalypse on the southwest buttress of the western side of the cathedral of Reims. The head of the standing male listener more or less literally reproduces certain details of the head of a Jew in the corresponding episode on the south wing of the transept of Notre-Dame de Paris. Shared details include the straight wrinkles deeply embedded at the root of the nose and the thick locks of hair rolled into two fat coils hanging along the temples and the face.

These several similarities could be explained by a common source, given that the portal in Meaux, which is a near exact replica of the St. Étienne portal on the southern side of the Paris monument, was certainly executed by a crew of carvers who came from the capital in the years 1285–90.[19] As for the relief in Reims, it was allegedly also carved by sculptors from Paris, but about twenty years earlier.[20] The southern portal in Auxerre therefore demonstrates the continuing use of forms that had been defined some seventy years earlier by a Parisian workshop and had already been used on the St. John the Baptist portal of the western side around 1260–70. The subject selected to be illustrated on both these southern portals probably had nothing to do with this choice, though the approach used for its setting was original.

About 30 kilometers to the north, the portal of the church in Dixmont (Yonne) is an example of this kind of undertaking at the turn of the thirteenth and fourteenth centuries in a more modest building. Though the Crowning of the Virgin Mary on the tympanum has suffered a great deal of damage, the figurines on the archivolts and the Annunciation group on the jamb liners once again display craftsmanship that is of a high quality and extremely refined.

Around 1300, this time in the heart of the duchy of Burgundy, work began on the beautiful radiating choir of the priory of Saint-Thibault (Côte-d'Or).[21] Its highly refined elevation includes four levels, which alternate between blind and openwork ornamentation, and reaches the vault through the interaction of small columns and traceries that create light, ethereal bars in front of the wall. These bars give an impression that the space is an

immense luminous cage. As it has been previously noted, this type of construction is in the tradition of the experiments carried out towards the beginning of the thirteenth century in buildings such as Saint-Sulpice-de-Favières and, to a certain extent, Saint-Urbain de Troyes. In any case, it testifies to the extraordinary ambition of the monks of this priory, given that the work on the choir began after the erection of the historiated portal of the transept's north wing and the adjoining construction of the Saint-Gilles chapel in the years 1260–65.

Not too far away, but in a more sober style, a neighboring hill was the site of a new collegiate church, which Jean, lord of Thil-en-Auxois, founded on 10 March 1341.[22]

Furnishings

Although, generally speaking, few fourteenth-century altarpieces have survived, two very good examples exist in Burgundy, in Fontenay (town of Marmagne, Côte-d'Or) and in Saint-Thibault.[23] Given its scale, the former, which is made of stone, probably decorated the high altar of the ex-abbey church, where it can still be found.[24] At the center of the composition, the Crucifixion is set beneath a large trefoil arch framed by the Church and the Synagogue. On either side, twelve scenes inscribed in elegant quatrefoils on two levels retrace the Childhood of Christ—which is followed by the Dormition and Crowning of the Virgin Mary—and the Passion. Though, as it has been underlined, the design of the quatrefoils is identical to those of the base of the central portal of the western side of the cathedral of Auxerre, the style of the figures, which is more precious and mannered, indicates a later execution, during the first decades of the fourteenth century.[25]

In Saint-Thibault, the altarpiece is supplemented by an antependium, thereby forming a harmonious whole made of polychromed sculpted wood (fig. 2).[26] Once again dominated by an imposing Crucifixion, the scenes carved in high relief illustrate various episodes in the life of St. Thibault and are placed under an arcature, the design of which differs from one level to the next. While these scenes display a homogeneous style, some of them show evidence of the involvement of a more audacious and gifted hand in the rendering of volumes for the figures and, especially, their clothing. Witness the superb Crucifixion, in which the protagonists placed in the foreground are wrapped in ample drapery, or the elegant scene of the Prediction in which the grandmother of the future saint resembles the Virgin Mary at the Annunciation (fig. 3). Additionally, her posture, gestures, hairstyle, and facial features are reminiscent of the little alabaster Virgin from Javernant (Aube) (fig. 4).[27] This kind of parallel—which would probably be an interesting subject for further reflection—and the gesture by which the young Thibault caresses his mother's chin therefore allow us to date this decoration toward the middle of the fourteenth century.[28]

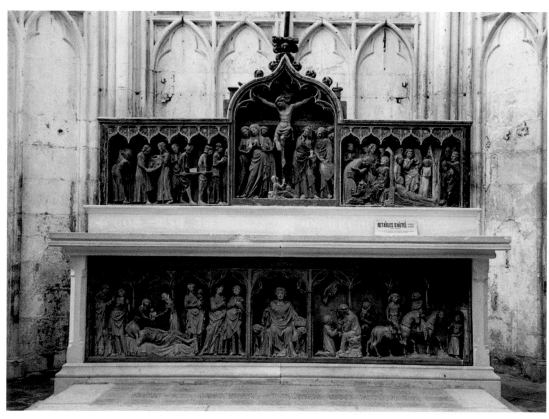

Fig. 1. South wing of the transept, St. Étienne portal. Saint-Étienne cathedral, Auxerre.

Fig. 2. High altar, altarpiece and antependium, polychromed wood. Saint-Thibault church, Saint-Thibault (Côte-d'Or).

Aside from tombstones, which we cannot consider here due to lack of space, sculpted furnishings generally consist of statues. In Burgundy, as elsewhere, most of the devotional images that were increasingly popular throughout the fourteenth century represented the Virgin Mary and the infant Jesus. A limited number of statues do attest to the widespread practice of worshipping saints, such as the impressive St. John the Baptist in Rouvres-en-Plaine (Côte-d'Or), sculpted around 1305–10 and attributed to the workshop of Mussy-l'Évêque because of the similarities linking it to the statue of the Precursor in the church in Mussy-sur-Seine (Aube).[29] Also in Saint-Thibault, a sculp-

and over the course of the following century.[30] In Burgundy, one of these pieces seems to have decorated the ducal château of Argilly (Côte-d'Or), but has completely disappeared. According to a 1519 survey, "toward the middle of said château, there was a beautiful chapel, mostly made of leaded tiles, in which the representations of the twelve Apostles and several other quite sumptuous illustrations and paintings had been constructed, along with two oratories which were ruinous with paintings and other decorations."[31] The ducal accounts mention these twelve Apostles twice: in the month of July in 1388, Jean d'Auxonne and Jean de Beaumetz made an agreement

Fig. 3. Antependium of the high altar, polychromed wood. Saint-Thibault church, Saint-Thibault (Côte-d'Or).

Fig. 4. Virgin Mary of the Annunciation from the church of Javernant (Aube), alabaster. Paris, Musée du Louvre.

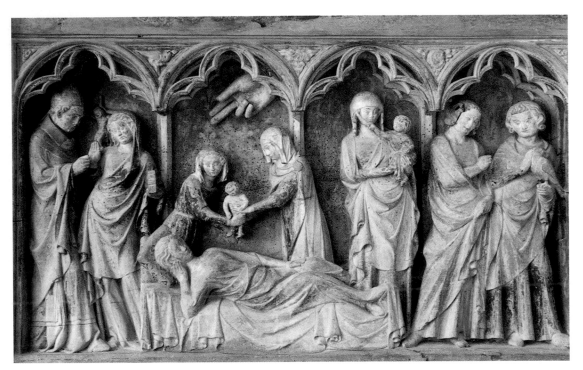

Fig. 3

ture in the round, which is difficult to date precisely, represents the patron saint of the church in the manner of the central figure of the altar front, sitting on a curule chair, giving his blessing with his right hand and holding the book of Gospels in his left hand, with his index finger slipped between the pages. As for St. Catherine, who is considered the most powerful intercessor with God after the Virgin and who was one of the most venerated saints of the end of the Middle Ages, her statue on the portal of the church of Champmol is well known, but another statuette of her image, to which we will return later, is completely forgotten, despite its high quality. Today it can be seen in the decorations of the rood loft in the church of Saint-Florentin (Yonne).

Probably illustrated for the first time in the Sainte-Chapelle in Paris in the 1240s, the theme of the apostolic college was repeated throughout the thirteenth century

with the painter Arnoul Picornet to have him "paint the twelve apostles around the chapel of Argilly, in the fashion which Beaumetz will instruct him to," while on the following 31 January, payment was made to Beaumetz "for having painted in gold, azure and *offroise* the twelve apostles who are in the chapel of my lord in his château of Argilly along with the tabernacles of said apostles and the consoles, and behind each apostle a large banner bearing the coat of arms of the countries of Mgr. and Mme."[32] The latter indications are precious in that they allow us to dismiss any doubt regarding the nature of these representations: they must have consisted of statues placed at a certain height, along the walls, on consoles and under canopies (tabernacles), before a background colored in the manner of a hanging. Not a single element from this series of Apostles has survived to the present day. The theory that a statue of St. Peter as a pope

currently in the church at Argilly belongs to the series does not stand up to consideration of its iconography and its dating (cat. 126).

Despite this relative diversity of statuary, representations of the Virgin Mary and infant Jesus seem to have been a very popular choice and remain the most frequent subject of statues that have been preserved. However, references to works that have since disappeared or remain unidentified, sporadically found in archival documents, lead us to think that the losses have been numerous. This is the case of "the representation of Our Lady which is above the high altar" in the chapel of the Saint-Esprit

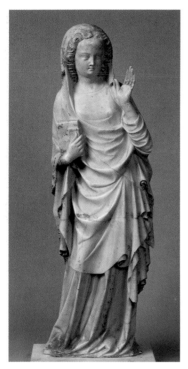

Fig. 4

hospital in Dijon and which was built on the orders of Pierre d'Auxonne, the master of the house, who died on 23 September 1335,[33] or of the alabaster statue mentioned in 1356 on the occasion of the carpentry work for the altar of the chapel of the ducal palace in Dijon.[34]

We also know that in 1383 a "large representation of Our Lady" was transported by Jean de Beaumetz from Tournai to Dijon,[35] and that on 23 May 1388, the day before the dedication of the charterhouse's church, the "representation of Our Lady which was in said place"[36] was brought down from the ducal château of Talant. At a time when none of the statues for Champmol's portal had yet been sculpted, this sculpture may have been placed on the pier on the occasion of the ceremony, under the canopy that had already been in place for several months.[37]

An exhaustive inventory of fourteenth-century statuary in Burgundy remains to be accomplished, but the various

statues of the Virgin Mary and infant Jesus listed in Schaefer's book richly illustrate this tradition. A wood statuette in the Saint-Marcel church in Vix (Côte-d'Or) reveals a precocious treatment carried out by literally following the previous century's formulas: a narrow coat open over a robe with a belt at the waist and decorated with an imposing clasp, and an air of detachment on the infant's face as he sits rigidly on his mother's left arm without looking at her.[38] The *Virgin Mary with a Smile* in Saint-Thibault in Joigny is also reminiscent of older works, such as the gilded Virgin on the portal of the south wing of the transept of the cathedral of Amiens.[39] Though the infant's gestures must be interpreted with caution, due to heavy restoration work, the mother's general bearing, the set of sharp folds that fit into one another along the free leg and the frank smile Mary is directing at her son are all thirteenth-century characteristics, which continued to be seen in a certain number of statues over the course of the second quarter of the following century. One such example is the statue in Muneville-le-Bingard (Manche), which dates from 1343 and is relatively similar to the one in Joigny.[40]

The Virgin and Infant Jesus in Saint-Thibault is of a completely different, probably slightly more contemporary, aspect (fig. 5). This relatively unknown wood statue is of very high quality, as can be seen by a subtle polychromy brought to light since the publication of Schaefer's book, and is certainly worthy of our attention.[41] The crowned Virgin Mary carries the infant Jesus on her left arm. She once probably held a lily branch, now broken, in her right hand. She is wearing a blue robe over which we see a red coat lined with ermine and a vast white veil trimmed with gold lace and scattered with green diamond-shaped motifs.[42] Mary tenderly looks at Jesus as he holds a bird that pecks at his finger and spreads its wings. The infant is bare-chested, legs draped in white swaddling clothes fringed with a gilded braid, which are extended by his right foot and from which the left foot hangs free.

This piece belongs to a recognized type of statue essentially characterized by the mantle pulled back to the chest and stomach, which it underlines with a horizontal line. A pointed tail of the coat hangs to the left, and to the right, a beautiful stream of folds is regularly interrupted by the sinuous line of the hem. Failing to recognize this type of statue in the Paris prototype suggested by Robert Didier, Françoise Baron situated the model in Normandy in an explanatory note dedicated to the Virgin Mary in Beauficel (Eure).[43] Though the latter does indeed display very close similarities with the piece described above, it also seems relevant to recall the figure known as the Virgin of Gosnay, attributed to Jean Pépin de Huy, a sculptor from the Meuse whose presence in Paris between

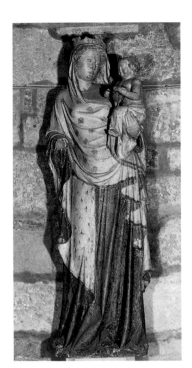

Fig. 5

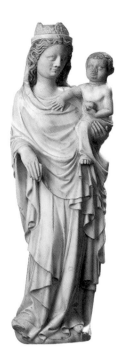

Fig. 6

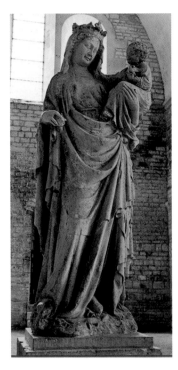

Fig. 7

1311 and 1329 is attested to (fig. 6).[44] Though the materials and dimensions are different, similar methods can be noted in the Virgin of the North, notably the mantle pulled back against the front of the body at waist-height, which is framed by beautiful unsymmetrical draperies, and the large rounded fold of the robe that falls between Mary's feet and gently breaks against the pedestal. The slight thrust of the hips, the large face turned toward the infant Jesus and lit up by a slight smile, the rendering of the hair in thick undulating locks, and, especially, the small curl locked into these "meanders" at ear level are all common characteristics that allow us to make an objective parallel between the two pieces. Not that this should be seen as a direct model of "Burgundian" statuary, but perhaps rather as a plausible source for a type that this artist—originally from Huy but active in Paris—would have helped to disseminate in the west, the north,[45] and, to a lesser extent, in the duchy of Burgundy.

While the Virgins in Châteauneuf-en-Auxois (cat. 115) and Moutiers-Saint-Jean (Côte-d'Or) have relatively similar faces and identical hairstyles, their clothing, which is less fluid and cut of thick cloth, expands the figure through its greater fullness and is distinctively arranged. Given these elements, the creation of these pieces could be dated a little later, toward the middle of the century.

Very different in its proportions, the Virgin of Fontenay, which can be seen in the north wing of the transept of the ex-abbey church, is striking in its monumentality and its singular type (fig. 7).[46] Crowned and probably once holding a scepter in her right hand, the Virgin queen rests her right foot on a lion and, with her other foot, treads on what remains of a naked female figure, prone, facing a dragon. Though the lion, who is mirrored by a second lion placed at the opposite corner of the pedestal, probably refers to the Virgin as fount of wisdom through the Nativity, both the dragon, a symbol of anger according to St. Bernard,[47] and the female figure with the disheveled hair (Eve?), who is being crushed by the point of Mary's shoe, show Mary as a new Eve, victorious over the forces of evil.[48]

Swaying under the effect of a slight thrust of the hips and clothed in a long belted robe that we can see through the loose grip of the coat on the front of her body, the Virgin Mother carries her child as he grasps her veil and holds a bird in his left hand. He smiles at his mother, who smiles back at him with a tender look. This moving exchange is what makes the piece so powerful, for the look on Mary's face is a far cry from the distant look seen on so many contemporary statues. This Mary is attentive to her child, and a natural beauty and grace seem to emanate from her gentle face, in perfect accord with the infant's chubby features and laughing eyes, all of which affirm the sculptor's extraordinary ability to subtly reproduce the mother-child osmosis, which is astonishingly lifelike in this piece. Filled with the breath of life, the Virgin

Mary and infant Jesus of Fontenay constitutes a very personal piece which is undoubtedly—though paradoxically little known—a significant work in the landscape of Burgundian art, even in comparison with the Sluterian creations for the Chartreuse de Champmol, and particularly with the Virgin Mary on the pier (p. 176, fig. 3). Although the last piece is a later work in a totally different style, it is notable for a similar attempt to translate the feeling of maternal love, with, in this case, a more verist touch that becomes increasingly frequent in the work of sculptors starting in the 1360s–70s, as can be seen in examples such as the funeral effigy of Charles V, which André Beauneveu carved *ad vivum*.

While the capital of the kingdom experienced a new and notable artistic blossoming under the reign of Charles V, Burgundy did not lag behind under the rule of his brother, Philip the Bold, installed by their father, King John the Good, following the death of the last of the Capetian dukes in 1361. A few years later, the first Valois duke took the decision to found a charterhouse intended to shelter his tomb and those of his descendants near Dijon. A large work site was opened, where intense artistic activity was cultivated for a good thirty years. The direction of sculptural work was given to Jean de Marville, who was hired by Philip the Bold in Rouen in 1372 when he was working with Jean de Liège.[49] Having settled in Dijon at the beginning of the year, Jean de Marville was commissioned by the duke to make his tombstone in 1384, shortly after construction had begun on the charterhouse. Marville died in 1389, therefore leaving both the tombstone and the church's portal unfinished, to be transformed and completed by his successor, Claus Sluter.[50] Jean de Marville was also the author of a Trinity that was transported to the charterhouse's church on 23 May 1388,[51] and has since been lost. Though payments mentioned in the accounts inform us that he must have been responsible for other pieces, no other work by Marville is attested to, which has given rise to various attributions.[52] Some scholars have also occasionally proposed that certain extant pieces be seen as "reflections" of Marville's art. Proponents of this approach include Pierre Camp and Robert Didier, who proposed in 1993 a list of statues that might "echo" the master's lost work.[53]

The sculpture workshop Jean de Marville headed included fourteen workmen, most of whom, probably including Marville himself, were originally from the North. Gilles Tailleleu, "from the bishopric of Tournai," was among those who simultaneously committed on 6 January 1389 (n.s.) to provide Guy Gelenier with four 2 1/2-foot stone statues representing the Virgin Mary, St. Claude, St. Anthony, and St. Pierre of Luxembourg.[54] Also present was Claus de Haine, who was brought from Tournai by Philip the Bold to provide assistance with the construc-

tion of his tombstone; he was remunerated for 187 days, from 28 August 1386 to 18 May 1387.[55]

The Virgins of Arbois (cat. 117) and Meursault (p. 308, fig. 8) are sometimes attributed to him due to their marked Tournai touches.[56] In Meursault, Mary looks at her child with a gentle and tender maternal glance and wears an ample mantle (which was once gilded) over a blue robe with gold brocades. The mantle is folded high across her chest, and one piece of it hangs over her right forearm in an elegant stream of fluted folds. Along with the position of the fingers of the hand holding the tip of a lily stem, this is an arrangement also found in the Virgin in Arbois and, even more obviously, in the Virgin in Hal (p. 308, fig. 9). As Jacques Baudoin very aptly pointed out, the infant Jesus in that statue also displays a demeanor and a profile so closely resembling those of the Meursault statue that some have seen the "Burgundian" Virgin Mary as an answer to[57] or even a copy of the Flemish Virgin Mary.[58] However, the opposite crossing of the coat tails, the absence of a crown in the Meursault statue, and, especially, a face whose features and expressions are noticeably different should call for greater discernment, though we should also not underestimate the potential role as a model of the "large representation of Our Lady" that the duke's painter Jean de Beaumetz transported from Tournai to Dijon.[59] Rather than seeing the Meursault Virgin as an imported statue, it is quite tempting to imagine that it was made on the premises by a talented artist who was able to produce a masterly synthesis between "Tournai" lines and motifs, taken from the model-statue, and "Sluterian" touches inspired by the female statues on the portal.[60] If that were the case, this piece could only have been executed before 1390, perhaps by a member of Sluter's workshop who had to honor a potential commission from Philip the Bold for his property in Meursault.

The statue of Étienne Porcher in Joigny (cat. 116),[61] which has occasionally been attributed to Jean de Marville, is actually to be connected to Parisian artistic circles—admittedly familiar to the ducal sculptor. A bourgeois dignitary of the court of Charles V, Étienne Porcher was the sergeant at arms and master of the duke's wine supply.[62] After being ennobled by the monarch in June 1364, he founded a chapel and erected an altar in honor of the Trinity, the Virgin Mary, St. John the Baptist, and St. John the Evangelist in the church of Saint-Jean-en-Grève in Paris.[63] And just as Jean de la Grange, a close relation of Charles V, would have himself represented a few years later on the *Beau Pilier* (beautiful pillar) of the cathedral of Amiens, surrounded by three advisors to the king, Étienne Porcher had an effigy of himself praying before the Virgin Mary and Infant Jesus installed in the chapel he had built near the Saint-Thibault church in Joigny, his native city. The patron's activity in the capital, the naturalist charac-

Fig. 8. Virgin Mary and Infant Jesus, polychromed stone. Saint-Nicolas church, Meursault (Côte-d'Or).

Fig. 9. Virgin Mary and Infant Jesus, stone. South portal, Notre-Dame church, Hal (Belgium).

Fig. 10. St. Catherine, marble. Saint-Florentin church, Saint-Florentin (Yonne).

Fig. 9

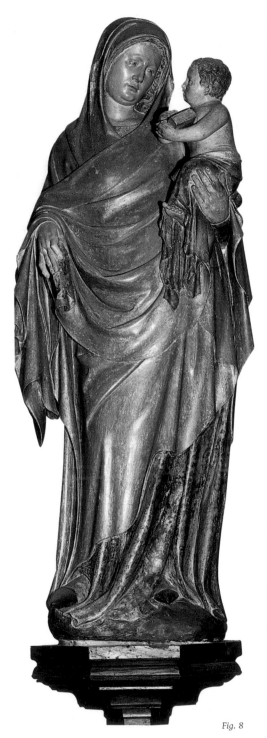

Fig. 8

Fig. 10

teristics of his "portrait," and the deep rounded folds of the coat, which are reminiscent of the art of André Beauneveu, lead us to situate the execution of this piece in Paris artistic circles in the last quarter of the fourteenth century.

The beautiful Virgin Mary nursing the Infant Jesus in Monceaux-le-Comte (cat. 118), the statuette of St. Catherine in the Saint-Florentin church (fig. 10), and the *Angel of the Annunciation* in New York (cat. 120) are certainly also products of this same center of activity. Though the latter relief has frequently been compared to the work of Jean de Liège, who was working for the king at the same time as Beauneveu, the small alabaster St. Catherine has curiously not retained the attention of sculpture historians, with the exception of Claude Schaefer, despite the fact that it is in a similar stylistic vein.[64] Yet its treatment is hardly devoid of interest, and in many ways recalls the work of the Parisian sculptor and his entourage. While it should certainly not be mistaken for the work of a master, certain characteristics, such as the softness of the drapes and the treatment of the hands, with their long, supple fingers, suggest affinities with, for example, the effigies on the tombs of the entrails of Charles IV the Fair and of Jeanne d'Évreux, made by Jean de Liège in 1372, and the statue of the Virgin Mary and infant Jesus in the Gulbenkian collection (Lisbon), which is attributed to de Liège. And the face, through its large and round shape, its small pronounced chin, straight nose, and, especially, the shape of the eyes, which are barely open, with the eyelids largely covering the eyeballs, is reminiscent of the same group of pieces, and most specifically of the faces of Mary and her lady-in-waiting in the very touching Presentation in the Temple in the Musée

National du Moyen Âge. All these similarities—to which we could add the question of materials—allow us to place the execution of this piece in Paris artistic circles during the last quarter of the fourteenth century. Despite the absence of documentation attesting to its initial destination, this piece magnificently testifies to the dissemination in "the provinces" of Parisian works that penetrated to the very heart of the duchy of Burgundy. This influence can be seen in the angel discovered in Alise-Saint-Reine (Côte-d'Or), not too far from the ducal château of Montbard, whose chapel was undergoing glass work in 1377 and for which we could therefore surmise the simultaneous commission from a sculptor in the entourage of Jean de Liège of an altarpiece illustrating scenes from the childhood of Christ.[65]

As can be seen, sculptural production in Burgundy over the course of the fourteenth century is far from a dull, provincial art devoid of any substance. Granted, ambitious enterprises were less numerous than over the course of previous centuries. But in the area of moveable sculptures, based on the works that have been preserved, commissions do not appear to have been lacking, and many of them were awarded to competent sculptors who were aware of stylistic approaches then in fashion or imported from occasionally distant artistic centers, such as Paris, which played a role similar to the one held by the North and Flanders in the preceding century. The statuary of the region clearly illustrates its privileged geographic situation, which allowed for direct contact with the Île-de-France, notably through the valley of the Yonne. Sculpture also testifies to the important political and territorial changes in the region following the marriage of Philip the Bold and Margaret of Flanders in 1369. Given this context and the significant extent to which it is reflected in the works in question, it becomes quite difficult to refer to fourteenth-century sculpture as Burgundian and, even more so, to a "Burgundian school," as had been suggested by Louise Lefrançois-Pillion in 1954.[66]

NOTES 1. Calmette 1910, p. 121.
2. Caumont 1854, p. 202.
3. For instance, Viollet-le-Duc 1854–68, 1: p. 279, and 8: p. 108; Michel 1905, pp. 634–46; Oursel 1928.
4. Courajod 1892.
5. Baudoin 1994, p. 113.
6. Dijon 1949; Dijon 1969; Dijon 1972; Dijon 1973; Dijon 1974; Dijon 1976.
7. Quarré 1947, pp. 27–39; Quarré 1951, pp. 211–18; Quarré 1966, pp. 5–12; Quarré 1974–75, pp. 161–66; Quarré 1976A, pp. 161–66.
8. Schaefer 1954, p. 5.
9. Borlée 1997, pp. 6–10.
10. Dijon 1949, no. 6, 1969, no. 8.
11. This area corresponds to the modern departments of Yonne and Côte-d'Or.
12. Pin 1997.
13. Regarding this statue, see, most recently, Paris 1998, no. 65.
14. Raymond-Clergue 2000, pp. 169–74.
15. Quednau 1979, p. 60.
16. On this subject, see Kimpel 1971, pp. 192–93; Kurmann 1987, p. 285; Borlée 1997, pp. 349–50.
17. Cassagnes 1996, pp. 30–32, 158.
18. Ibid., p. 149.
19. Kurmann 1971, p. 94.
20. Ibid., p. 289.
21. Freigang-Kurmann 1986, pp. 271–90.
22. Ravaux 1986, pp. 203–9.
23. A stone sculpture from the beginning of the fourteenth century is still in place above the altar of the Saint-Pierre chapel in the north wing of the transept of the ex-church abbey of Saint Germain, in Auxerre; however, only the architectural frame has survived. On this subject, see Raymond-Clergue 2000, pp. 175–76.
24. Approximately 88.5 x 331 x 19 cm; these dimensions include the reconstruction of the left extremity, which was probably damaged, like most of the faces, when the piece was reinstalled in a pavement.
25. Aubert 1947, 1: p. 309; Bégule 1984, p. 59; Auberger 2001, p. 79.
26. The joined pieces were placed back on the altar by Viollet-le-Duc in 1846 when the church was restored (on this subject, see Aubert 1928, p. 263). At that time, the altarpiece was covered in a layer of gray paint, which was removed for the 1949 exhibition in which the pieces were shown (Dijon 1949, nos. 3–4).
27. On the Jauvernant Annunciation, see Paris 1981, no. 60.
28. Enlart (1929, 1: 2, p. 668) dates it to about 1360; Lefrançois-Pillion (1922, p. 153) situates the whole thing after 1320; Aubert (1947, p. 263) proposes the years 1320–30; according to Oursel (1953, p. 111), finally, the work must have been executed in the second half of the fourteenth century.
29. Regarding the John the Baptist in Rouvres-en-Plaine, see, most recently, Paris 1998, no. 64.

30. For instance, in the choir of the cathedral of Saint-Nazaire, in Carcassone, for which the statues of the Apostles were made between 1280 and 1300; in the chapel of the Saint-Jacques-aux-Pèlerins hospital in Paris, for which the statues were carved by Robert de Lannoy and Guillaume de Nourriche between 1319 and 1327, or also in the Notre-Dame de Rieux chapel which was founded by Bishop Jean Tissandier of the Franciscans of Toulouse and was built between 1324 and 1343.
31. ADCO, B 474, 1519 survey describing the château of Argilly, fols. 7v–8. The transcription of the documents is by Bernard Prost (1902–8, 1: fasc. 1, p. 22 n. 4).
32. ADCO, B 11402, register of adjournments before the ducal council and the Chamber of Accounts, fol. 55, B 4431, account of Jean d'Auxonne for the leasing of the Dijonnais 1387–88, fol. 28v.
33. Troyes, Bibliothèque Municipale, Memorial of the Saint-Esprit of Dijon, MS 1324, fol. 13. Though the document does not mention it, this statue was identified as a Virgin of Mercy (Cornereau 1889–95, pp. 229–30; Boissellier 1993, pp. 35–37).
34. "And to make an altar in the chapel of said palace recessed on all sides containing II niches to place books and ornaments, make a long shelf over said altar also recessed to place candles and torches. And to make on this shelf an open pedestal of multiple levels on which stands a representation of Our Lady in alabaster" (ADCO, B 11302, accounts of the receipts and expenses made by dymenche de vitel General Collector and Seedsman of the duchy of Burgundy, fol. 62v).
35. ADCO, B 1460, accounts of Amiot Arnaud, general collector of the finances of the Duke of Burgundy 1382–83, fol. 92. This document is quoted by canon Dehaisnes (1886, 2: pp. 594–95).
36. ADCO, B 11671, accounts of Amiot Arnaud, general collector of the finances of the Duke of Burgundy, fol. 173v.
37. "To him for the carving and sculpting of V tabernacles one of which is seated on the portal of said champmol" (ADCO, B 11671, accounts of Amiot Arnaud, general collector of the finances of the Duke of Burgundy, fol. 97v, receipt of 31 December 1387).
38. Chantavoine 1918–19, pp. 160–65; Schaefer 1954, p. 179 and pl. 25.
39. Schaefer 1954, pp. 75, 165, and pl. 16; Paris 1981, no. 39.
40. Paris 1981, no. 38.
41. Schaefer 1954, pp. 133, 169–70 and pl. 40. At the time, the author noted (and the photograph illustrating his comments attested to it): "the [gray] colorwash and the gilded border which disfigure this statue in the same way as so many other Virgins in Burgundy and Champagne." Regarding this statue, also see Aubert 1947, p. 265; Lefrançois-Pillon and Lafond 1954, p. 157; Colombet 1982, p. 39.

42. The coat is clearly individualized thanks to painted motifs differing from those on the veil.
43. Didier 1970, pp. 48–72; Paris 1981, no. 42.
44. The sculpture know as the Virgin of Gosnay (Pas-de-Calais), dating from 1329, is in the Musée des Beaux-Arts, Arras. See Paris 1981, no. 8. Regarding its attribution to Jean Pépin de Huy, see Baron 1960, pp. 92–94. Regarding Jean Pépin de Huy, see Beaulieu and Beyer 1992, pp. 81–82.
45. See Didier 1970.
46. H. 210 cm.
47. Sermon XIII (in Bernard 1990, p. 359).
48. The female figure, like the dragon's head, is quite mutilated; however, the remains of an arm and especially of a leg assure us that it was not a siren.
49. Regarding Jean de Marville, see Beaulieu and Beyer 1992, p. 192.
50. Goodgal-Salem 1987–89, pp. 263–83.
51. Mosneron-Dupin, 1992, p. 194.
52. A rapid overview of these attributions is given by Beaulieu and Beyer 1992, p. 192.
53. Camp 1985, p. 560; Camp 1990, p. 36; Didier 1993, pp. 26–27.
54. ADCO, B 11302, protocol of Dijon notaries 1386–89, fol. 223: "Gilles Tailleleu of the bishopric of Tournai craftsman of carved images, residing in Dijon, agrees with Guy Gélinier, bourgeois, to make him four stone sculptures two and a half feet tall representing Our Lady, St. Claude, St. Anthony and St. Pierre of Luxembourg, with a flowered tabernacle above the sculpture [of] Our Lady and above St. Pierre an angel rising from a cloud carrying a cardinal's hat with pendants as a tabernacle," all for the sum of 16 francs and an emine of wheat.
55. Beaulieu and Beyer 1992, p. 180.
56. Ibid., and Baudoin 1994, p. 111.
57. Baudoin 1994, p. 110.
58. Beaulieu and Beyer 1992, p. 180; for the infant Jesus, see Camp 1990, p. 36.
59. See note 35.
60. The Meursault Virgin Mary displays the same oval, the same round chin with a dimple and the same double chin found on the faces of the Virgin Mary and St. Catherine on the portal of Champmol. A similar process probably guided the creation of the Virgin in Toucy (Yonne), which is also reminiscent of the Virgin on the southern portal of Notre-Dame de Hal in Belgium; a photograph of it is reproduced in Camp 1985, p. 34.
61. Camp 1990, p. 36, and Beaulieu and Beyer 1992, p. 192.
62. Demay 1876, p. 187.
63. Demay 1880, pp. 219–21.
64. Schaefer 1954, pp. 82–84, 169 and pl. 49.
65. Regarding the work on the chapel's glass, see Prost (1902–8, 1: fasc. 3, no. 3212, p. 608).
66. Lefrançois-Pillion and Lafont 1954, p. 95.

115

The Virgin Mary and the Infant Jesus
Mid 14th century

Limestone; traces of polychromy
134 x 48 x 39 cm

Châteauneuf-en-Auxois, Saint-Philippe and Saint-Jacques church

PROV.: Burgundy regional inventory file.

BIBL.: David 1933, 1: p. 3; Oursel 1953, p. 112; Schaefer 1954, pp. 139–42 and 161, pl. 44; Camp 1990, pp. 35–36.

EXH.: Dijon 1949, no. 6, p. 16; Dijon 1957, p. 17; Dijon 1969, pp. 21, 34.

FIG. 1. *Virgin and Child,* stone. Mouthier-Saint-Jean (Côte d'Or), hospital.

Holding the infant Jesus on her left arm, the Châteauneuf Virgin is draped in thick fabric as she treads on the figure of a demon with a human face. A lion bites the demon's ear. As Queen of Heaven, Mary once held a blossoming branch in her right hand and wore a gold-plated crown on her veiled head, as shown by the diadem on which the crown was intended to fit.

With her head gently tilted forward, Mary tenderly gazes at her child, who returns her gaze while caressing her cheek. This touching and relatively rare gesture is reminiscent of other works, such as the Virgin of Mainneville, and also the vermeil Virgin offered to the abbey of Saint-Denis by Queen Jeanne d'Évreux in 1339, in which the infant has a similar bearing.

Yet the proportions of the Burgundian piece are entirely different. Indeed, the figure, which is less extended, is widened by thick draperies that reinforce the thrust of the hips. The layering of garments cut out of thick cloth does, however, demonstrate a nice fluidity, which is notably visible in the swaddling clothes that surround the infant Jesus's legs, as his little feet stretch them out. This is an original touch, which can also be found— along with the perfect imbrication of the folds of fabric of various thicknesses—in *The Virgin Mary and Infant Jesus* in nearby Moutiers-Saint-Jean.

The relatively summary treatment of the face, which is devoid of contours or lines of expression—the cut of the eyes, in which the eyeball does not swell the lower eyelid, and the perfectly straight lips that do not allow even a hint of a smile—all contribute to a somewhat distant expression reminiscent of early fourteenth-century statuary. Yet it must also be said that the sculptor, whose skill is of the same order as the mastery with which he constructed and placed the bodies and organized and rendered the drape of the clothing, put great care into rendering the nails and dimples of the figures' hands, the feathers of the bird pecking at Christ's index finger, and the beautiful gesture of tenderness through which the infant Christ's humanity is crystallized.

Given the latter elements, the creation of this statue can be roughly dated to the middle of the fourteenth century.

D.B.

116

Étienne Porcher at Prayer

c. 1370–75

Polychromed stone
130 x 50 x 50 cm

Joigny, Saint-Thibault church

BIBL.: Demay 1876, pp. 185–216; Demay 1903, pp. 93–107; Aubert 1927, p. 40; Schaefer 1954, pp. 76–79, pl. 52; Valléry-Radot 1958, p. 136; Schwarz 1986, pp. 159–61; Camp 1990, p. 36 and pl. II; Quantin 1991, pp. 155–56; Beaulieu and Beyer 1992, pp. 191–92; Baudoin 1994, p. 96; Prochno 2002, p. 38; Recht 2003, p. 208.

The piece most probably originates from the chapel of Notre-Dame de la Conception, founded by Étienne Porcher in 1368 to the south of the Saint-Thibault church, which was razed by a severe fire, along with the chapel and a good part of the town, in 1530.

Étienne Porcher was both the sergeant at arms and the master of the king's wine supply at the court of Charles V; in recognition of his loyal services, the ruler ennobled him in June 1364. Yet this dignitary of the royal court did not abandon his native town, where he founded a hospital and the chapel of Notre-Dame de la Conception, which he endowed with an annuity of 40 livres and furnishings, now lost, including his effigy.

Porcher chose to have himself represented kneeling, as a donor, and praying, probably at the feet of the Virgin. Bareheaded, he is wearing a tunic whose narrow sleeves are closed by a series of small buttons; over the tunic, he wears an ample hooded coat that reveals his right arm. The high, bald forehead lengthens the face, with its slightly loose flesh and powerful jaw. The wrinkles rising from the corners of the mouth, the slightly detached ears, and the veins on the hands also contribute to the realistic effect of this portrait.

Despite the heavy modern polychromy modifying its appearance, this piece continues to demonstrate the skill of its author, who was probably one of the numerous court artists whom Porcher would have had no trouble commissioning. Though the names of Jean de Marville (Camp, Beaulieu and Beyer) and André Beauneveu or his workshop (Schwarz) have been put forth, it must be recalled that a large number of these artists remain anonymous or that their work has disappeared.

D.B.

117

Tournai workshop

Virgin and Writing Child

Between 1375 and 1378

Limestone
H. 184 cm

The top of the fleur-de-lis held by the Virgin on her right hand is missing; there are chips on the folds of her garments and her crown.

Arbois, church of Saint-Just, main altar of the Chapel of the Virgin

BIBL.: Girard 1934, p. 12; Girard 1935, pp. 176, 181; Pidoux de la Maduère 1939, p. 70; Schmoll Gen. Eisenwerth 1962, p. 136 n. 33; Didier, Henss, and Schmoll Gen. Eisenwerth 1970, pp. 93–113; Baron 1981, p. 132; Verdier 1981, p. 249; Camp 1990, p. 36; Morand 1991, pp. 63–64; Steyaert 1994, p. 51; Baudoin 1996, pp. 109–11.

EXH.: Cologne 1978, 1: p. 61.

Exhibited in Cleveland only

Mary, a figure of majestic monumentality, carries the Christ child on her hip while holding him with her left arm. She looks tenderly and meditatively at him. The child, who faces the viewer, is holding an open book and writing on it with a stylus.

The statue is in all likelihood a gift from Philippe d'Arbois, bishop of Tournai from 1351 until his death in 1378, a leading churchman and diplomat who worked for the courts of France, Flanders, and Burgundy. The gift is probably connected to the 1375 foundation of four chapels, known as the Tournai chapels, at the church of Saint-Just in his native Arbois.

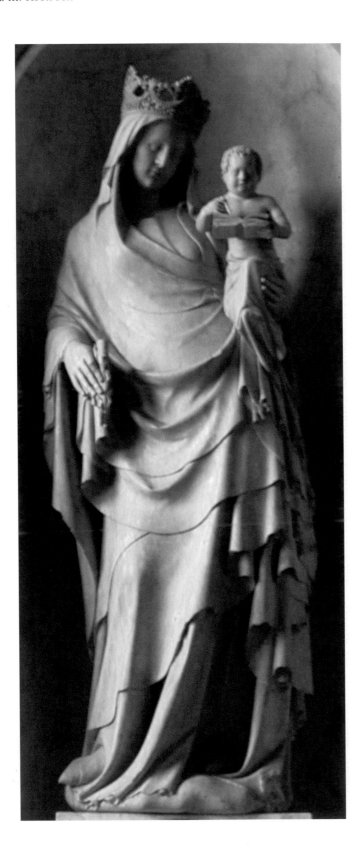

Philippe, a devotee of the Madonna, also endowed and decorated the chapels (Didier, Henss, and Schmoll Gen. Eisenwerth 1970). By its strong stylistic and typological similarities with the statue of St. Catherine of Alexandria by André Beauneveu (p. 59, fig. 1), the Arbois Madonna marks the starting point of a new era in the history of Tournai sculpture. The statues of the Virgin in the south portal (c. 1380; p. 308, fig. 9) and in the north portal (c. 1410) of the church of Saint-Martin de Hal are other examples of this style (Schmoll Gen. Eisenwerth 1962; Didier, Henss, and Schmoll Gen. Eisenwerth 1970).

The typological formula of the Courtrai and Arbois statues dates back to the second half of the thirteenth century (exemplified by a small statue of the Virgin and Child, now lost, that was part of the reliquary of Sainte-Gertrude de Nivelles, c. 1272–98). These figures are endowed with a new balance and natural proportions. Very likely the Arbois Madonna was at the origin of the popularity of this type of representation of the Virgin in Burgundy (examples are a Tournai Virgin, whereabouts unknown, sent to Dijon by order of Philip the Bold between 1382 and 1383 [Dehaisnes 1886] and the Meursault Madonna [p. 308, fig. 8], of higher artistic quality, exhibiting the typical style of Tournai sculpture).

However, it is the iconography, that is, the image of the writing child, that was widely imitated in Parisian artistic circles and at the courts of Berry and Burgundy, as well as in the Rhineland. The theme created in Tournai follows an ancient tradition where the child holds in his hands an open or closed book as a symbol of the divine Word transmitted to mankind. The Arbois Madonna—an early example of the theme of the Christ child-Savior writing the words of the new law under the attentive gaze of the Virgin-Church—depicts one of the most interesting innovations related to the iconography of the Virgin during the international style period.

In a variant of this theme, the child reads the text or follows it with his finger (Virgin and Child on the north portal of the church of Saint-Martin de Hal; Meursault Virgin and Child; Virgin and Child in New York, from the Clare convent at Poligny (cat. 122). When the book is replaced with a scroll (Bézouotte Virgin and Child [Côte-d'Or]), the image becomes the Virgin of the Petition, a type much appreciated in fifteenth-century Burgundian sculpture (*Virgin and Child*, The Detroit Institute of Arts, inv. 22.30).

A.L.-C.

The Virgin Mary with the Nursing Child

Last quarter of the 14th century

Marble
63 x 20 x 15.5 cm

Monceaux-le-Comte, Saint-Georges church

PROV.: Burgundy regional inventory file.

BIBL.: Anfray 1964, p. 213; Scher 1971, p. 23; Didier and Recht 1980, pp. 194 and 199; Camp 1990, pp. 36 and 38; Baudoin 1994, pp. 58–59.

EXH.: Paris 1981, pp. 140–41, no. 90; Nevers 1990, pp. 27–28, no. 12.

The theme of the Virgin breast-feeding does not appear often in statuary before the fourteenth century and is only represented by a limited number of works. Here, Mary is carrying the infant Jesus on her right arm, as is most often the case in this type of work, and holding the lily branch in her left hand. With her head slightly tilted forward, she watches him take her breast in both hands.

Some have seen an echo of the St. Catherine of Courtrai attributed to André Beauneveu in this statue, noting that it repeats the St. Catherine's composition, though in reverse, and perhaps the two long locks of hair that slip out of the veil. We must nonetheless note a widening of the figure and a more complicated arrangement of the clothing. Indeed, the part of the coat

FIG. 1. *Virgin and Child* from the Cistercian abbey of Cour-Dieu. Orléans, Musée des Beaux-Arts.

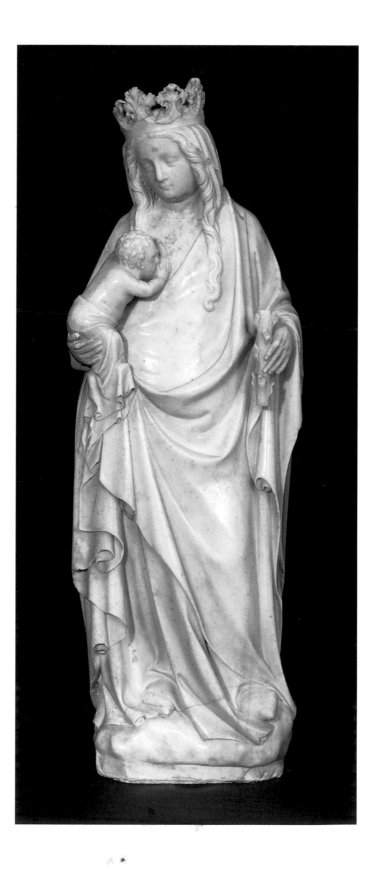

pulled back beneath the right arm displays a nice stream of fluted folds that follows the sinuous line of the hem as it blends with the admittedly less voluminous fabric of the infant's swaddling clothes. Yet the Virgin's body does not totally disappear beneath the clothing, for example, the knee of the free leg, which can be seen under the robe and the coat, traces a long diagonal fold on the front of the statue and a triangle on its left side.

Previously noted striking similarities draw parallels between the Virgins of Monceaux and the Cistercian abbey of Cour-Dieu (fig. 1). The two pieces are so similar—aside from their dimensions—that they could have been executed in the same workshop, or from a common model heavily influenced by the formal innovations of Parisian sculpture in the 1380s. Despite documents to the contrary, the Virgin of Monceaux could also come from a nearby Cistercian abbey, Notre-Dame du Réconfort, as did another statue kept in the church. In this case we could envision the circulation of such a model within Cistercian circles for a statue whose subject is closely related to Bernardine spirituality.

D.B.

119

Bust of the Virgin and Child
Late 14th century

White marble

29 x 36 x 20 cm

Dijon, Musée Archéologique, inv. Arb. 1335

Prov.: origin and acquisition date unknown.

Bibl.: La Marche 1894, pp. 252–53; Quarré 1976A, pp. 121–22; *Sculpture médiévale en Burgundy*, no. 173.

Exh.: Dijon 1976, no. 64.

With her left arm Mary holds the Christ child, who wears a short tunic and clutches a bird with extended wings. Mary's head is covered with a veil, originally held in place by a crown. Rather than evoking the Queen of Heaven, her round face with coarse features reminds us of a mortal woman, perhaps a contemporary of the sculptor. Her face lacks harmony and balance; for example, her narrow eyes and eyebrows are placed above the median line, the length of her nose is equal to the height of the forehead, and the mouth, too small and pouty, sits between a receding chin and a too-deep nasal fold. Her thick neck matches her rustic features, which would nevertheless have moderated the predictable monumentality of the figure and her crown, now lost. While this Virgin-Mother appears to be an ordinary woman, this is less due to the sculptor's lack of skill than to the desire to give her a humanity that fosters feelings of empathy.

We have already noted the resemblance of this Virgin to the St. Catherine on the portal of the church at Champmol. In both cases the depiction of physical imperfections humanizes these holy figures.

In 1976, Pierre Quarré selected this work for an exhibition devoted to Claus de Werve. Although the coarseness of the Virgin's features is inconsistent with the perfectionist touch that characterizes Claus's figures, individualized but always harmonious, this attribution is not totally outlandish because the posture of the child or the gesture of his little right hand announce the heights of naturalism that will be achieved by this artist. Details that

appear in this work, such as the eloquent pressure of the mother's hand or her loving gaze, are similar to the ones subtly used by Claus de Werve.

V.B.

120

Angel of the Annunciation
Last quarter of the 14th century

Marble
61 x 14 x 15.2 cm

New York, The Metropolitan Museum of Art, inv. 17–190–390

PROV.: Sarcus collection, château de Bussy-Rabutin (Côte-d'Or); Pierpont-Morgan collection, New York.

BIBL.: Sarcus 1854, p. 107; Vitry 1914, p. 435; Schmidt 1971, pp. 96–98; Beaulieu and Beyer 1992, p. 72, Schmidt 1992, 1: pp. 89–91; 2: fig. 76.

EXH.: Boston 1940, no. 184; Paris 1981, no. 80; Paris 2001, pp. 191 and 193.

This *Angel of the Annunciation* was surely part of an altarpiece. While its exact origin is not known for certain, its presence was noted in 1854 (Sarcus) in the library-gallery of the château of Bussy-Rabutin. Among other things, the text mentions that this marble angel was "found in Sainte-Reine," not far from Flavigny, a proximity that has led many to consider the large Benedictine abbey as the probable source of the statue. Though of course this hypothesis cannot be discounted, the oratory of the ducal château of Montbard, which is barely any further away, could also be a plausible place of origin for this fragment.

As various authors have noted, the piece displays such striking similarities with the *Presentation in the Temple* relief at the Musée National du Moyen Âge (cat. 16) that it has been suggested that they belong to the same group. Aside from their very similar dimensions, the figure of the angel seems to combine the position of Simeon's body and the drape of the Virgin's coat. As for the facial features, if we extend the field of comparison, the slit eyes with the covering eyelids and the small round chin also echo the works of Jean de Liège or of his numerous collaborators.

The introduction in Burgundy of a work whose style evokes one of the big names of Parisian sculpture of the 1360s to 80s should not be surprising when we recall that Philip the Bold hired his sculptor Jean

de Marville in Rouen, who had collaborated with Jean de Liège himself on the tomb of the heart of Charles V several years before. It is entirely plausible that the Duke of Burgundy could have taken advantage of this situation to commission an altarpiece intended for his Montbard residence from one of the members of the famous Parisian sculptor's workshop.

D.B.

121

Burgundy

Figure of an Apostle or Prophet
c. 1400

Limestone
67.1 x 25.2 x 18.5 cm

Boston, Museum of Fine Arts, Harriet Otis Cruft Fund, 1939.760

Prov.: Count and Countess de Kermaingant (Kermaingant sale, American Art Galleries, New York, 27 November 1926, lot 126); Dikran G. Kélékian, New York; sold to Museum of Fine Arts, Boston, 1939.

Bibl.: Didier and Recht 1980, pp. 173–219, fig. 21 bis; Morganstern 1989, pp. 30–33, no. 18.

Exh.: Ithaca 1968, no. 91.

The identity of this figure is impossible to determine because of its state of preservation. The book the figure held, which may have revealed some identifying marks, is largely missing, along with the left forearm and hand and the fingers of the right hand. In its present state, the figure could represent either a prophet or an apostle. Equally enigmatic is the position this work occupies in the development of Burgundian sculpture. Considered by many to be from the workshop of Claus Sluter (Ithaca 1968), others have attributed the work to André Beauneveu (Morganstern 1989) or denied its Burgundian heritage altogether (Didier and Recht 1980). This author believes the Boston sculpture represents an intersection between the Parisian Gothic style as executed by Beauneveu and the naturalistic and emotionally penetrating style of Claus Sluter.

Elements of the Boston figure evoke the graceful qualities typical of the courtly style in Paris at the end of the fourteenth century such as the gentle sway of the body, an effect accentuated by the damage to the proper lower left of the sculpture. This trait can also be seen in the work of André Beauneveu (cat. 117), who worked in Paris and then later for the Duke of Berry at Mehun-sur-Yèvre from 1386 until the artist's death in 1397. Indeed, the face of the Boston Apostle/Prophet is strikingly similar to a head from Mehun-sur-Yèvre attributed to Beauneveu (Meiss 1967, fig. 596). A comparison of the two faces reveals a strong resemblance in the treatment of the facial features, especially the brow, eyes, and nose. Yet the hair and beard of the Boston figure are far more active, detailed and deeply chiseled, giving the hair and face a dynamic quality that is lacking in the work of Beauneveu.

This Apostle/Prophet commands his immediate space with a physical, emotional, and psychological presence that can only be explained by knowledge of the work of Sluter at Champmol and, in fact, the handling of drapery is very close to that seen in Sluter's figure of St. John the Baptist from the portal of the charterhouse, completed in 1391. Furthermore, the vigorous and powerful effect of the pose and expression, in concert with the dramatic play of shadow, recalls the prophets from the *Well of Moses*. Sluter did make a trip to Mehun-sur-Yèvre in 1393 at the request of Philip the Bold, the brother of Jean de Berry. If the present sculpture can be associated with Beauneveu it seems necessary to date the work to after this contact. It seems more likely, however, that the Boston Apostle/Prophet is the work of a talented third artist, possibly from the workshop of Beauneveu or Sluter, drawing on the court style of the two Valois dukes.

T.H.

Véronique Boucherat

A New Approach
to the Sculpture of
Claus de Werve

In the late fourteenth century, the founding of the Carthusian monastery of Champmol by Duke Philip the Bold and Duchess Margaret of Flanders attracted to Dijon many sculptors from the Netherlands. Among them was Claus Sluter, listed among the stone carvers of Brussels, who in 1389 succeeded Jean de Marville as the duke's "carver of images." Although a foreigner, Sluter brought remarkable originality and identity to Burgundian sculpture.

Sluter redesigned the portal of the Champmol church; his new sculptural program placed a Virgin on the *trumeau*, and the duke and the duchess with their patron saints on the lateral door jambs. The kinetic qualities of these figures blur the boundary between imaginary and real spaces while inventively involving the viewer. He also executed a Calvary, placed in 1396 in the center of the cloister; all that remains are some fragments and the pedestal, known as the *Well of Moses*. This famous work, meant to illustrate the links between the Old and the New Testaments, comprises six skillfully differentiated and impressively lifelike figures representing the prophets who foretold the Passion.

Another sculptor or "ouvrier d'images," Claus de Werve, a nephew of Sluter,[1] arrived in Burgundy in late 1396. His name appears in the account books as Claes ven den Verwe or van de Verve, or else Claus Vuiwerve or Claus de Warve. The inscription on his tombstone in the church of Saint-Étienne in Dijon, copied in the seventeenth century, states he was born in "Hathein in the county of Holland." Contemporary critics have come to agree that this probably means the town of Hattem in the Gelderland.

Claus de Werve soon began to receive major assignments. According to account books, he worked on the Champmol Calvary, in particular on the crying angels placed around the top register of the pedestal, and on a Virgin and a Christ on the cross.[2] However, the Champmol Calvary, like many other medieval monuments, was created by the collective efforts of a workshop. The numerous assistants who toiled on such an ambitious project were subject to many constraints, among them being faithful to the master's style, adhering to the patron's wishes, keeping consistency among the various elements of the ensemble, following a model, or sometimes taking advantage of the freedom to express a personal style. It is not always easy to tell who did what in such a monumental work, in particular which sections can be attributed to the hand of the master and his best disciples. The fact that Claus de Werve is recorded as working on the crying angels from 1 January 1399 to 31 March 1400 would indicate that these figures are attributable almost exclusively to his own hand.[3] These angels are, however, stylistically close to Sluter's original project; their sadness is indicated by their gestures and also by the stylized curls of their hair. The theatrical feeling created by the angels' unnatural facial expressions and hairstyles is counterbalanced by the prophets' dignified bearing, though their *gravitas* is seemingly animated by a burning spirituality (p. 245, fig. 1).

The document that records the salary paid to Claus de Werve for his work on the Virgin and the Christ for the Calvary also mentions "another image of Saint Anne"—probably an Education of the Virgin that was placed in the chapel of the angels in the Champmol church, before being moved in 1416 to the House of the Mirror owned by the Carthusian monks.[4] Claus de Werve also worked on the prophets, as his personal style is recognizable in

Fig. 1
Claus de Werve, chorister
from the tomb of Philip
the Bold, c. 1406–10,
alabaster. Dijon, Musée
des Beaux-Arts.

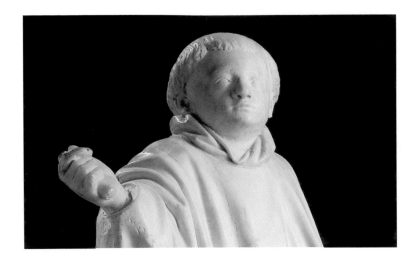

the David and also, but less surely so, in the figure of Isaiah (p. 214, fig. 4).

However, Claus de Werve's most important documented work is the tomb of Philip the Bold, designed by his predecessors Jean de Marville and Sluter. After Philip's death, his son and heir, John the Fearless, came to an agreement with Sluter about the design of the tomb. Two angels, a lion, and forty mourners would be added to the recumbent effigy of the dead duke. The finished monument, today at the Musée des Beaux-Arts in Dijon, follows surprisingly closely the terms of the contract, in spite of many unforeseen contretemps during its execution.[5]

Not much work was done on the tomb between 1404 (date of Philip's death) and January 1406 (date of Sluter's death), as Sluter was devoting all his time to finishing the Champmol Calvary. The tomb was basically executed by Claus de Werve, who worked on it from 1406 to 1410, as proven by several documents. When Claus succeeded his uncle at the head of the sculpture workshop, the design for the mourners' procession was practically completed. A documentary source mentions that two mourners were already finished when Claus was asked to take over.[6] The procession of mourners along the sides of the tomb captures for posterity an idealized image of those who paid homage to the duke's memory at his funeral (fig. 1). This gallery of portraits depicts with astonishing realism the feelings of sadness, contained anger, or dejection inspired by the dreadful event. Every gesture, expression, or posture, every detail of the design, works toward highlighting the individual personalities and their range of feelings, though they are all subsumed into the collective sadness. The folds of the cloaks worn by the mourners contribute to the suggestion of subtly individualized states of mind. Claus de Werve did not execute this series of mourners by himself, but was helped by several assistants, which can be seen in easily noticeable differences in quality or style. As was the case for the angels of the *Well of Moses*, the personal style of each artist was somewhat restrained by the wish to follow Sluter's design for the monument.[7]

Under Sluter, the sculpture workshop seems to have worked exclusively on the duke's commissions, among them the ambitious Champmol project. However, during the period when Claus de Werve was at the helm, the workshop changed its goals. Claus skillfully adapted to a new environment, that is, the new duke's shaky finances and his lesser appreciation for the arts and their political benefits. The documentary sources and the works themselves indicate that Claus diversified his customer base to enable his workshop to survive and even to grow. We know for instance that the Carthusian monks commissioned a sculpted decoration for the façade of the House of the Mirror, a townhouse purchased in 1413 so the monks could flee to Dijon in case of danger. The decoration, which consisted of a statue of the Trinity between two praying monks, was probably destroyed in 1767 when the house was demolished. In November 1415, the workshop received another commission from the clergy to make repairs to the altar of the church of Notre-Dame de Dijon.[8] The municipal authorities also called upon Claus de Werve and proposed a barter deal: on 8 September 1431, he was granted a tax exemption on condition that he would execute a statue of St. Andrew for the new tower behind the convent of the Recollect monks and a statue of the Virgin for the Fourmerot gate.[9] Yet other works commissioned by the nobility, the municipal authorities, and the clergy can be stylistically attributed either to Claus de Werve or to the workshop.

On the basis of his reputation, many of his contemporaries called upon Claus de Werve as a sculptor and artistic advisor. For instance, on 20 January 1409, he was called to Savoy by Duke Amedeus VIII, brother-in-law of John the Fearless, to work on the sainte-chapelle at Chambéry.[10] The many documentary references to professional trips convey the image of a very busy sculptor whose opinion was sought far and wide for all matters related to his art. In early 1412 he was called to Paris by John the Fearless, perhaps to work on the d'Artois mansion, but was sent back to Dijon to focus on the duke's tomb, which was thought to have higher priority.[11] Eight years later, the new duke, Philip the Good, appointed him "carver of images."[12] In June–July 1436, he went to the Vizille alabaster quarries, near Grenoble, to select the best blocks for the tombs of John the Fearless and Philip the Good.[13] He appears to us as a well-rounded artist with many high-level skills, wanted by many people who knew his work or his reputation.[14] The high income earned by Claus and the wide-ranging activity of his workshop, indicated by a few surviving contracts and the works of art themselves, have been confirmed by Pierre Camp's analysis of the account books.[15] After living a very full life, as evidenced by the historical and accounting records and by his surviving works, Claus de Werve died on 8 October 1439.[16]

It is difficult to determine which of the many Burgundian sculptures produced during his working life were personally executed by Claus de Werve. There are complex relationships among these sculptures, as some of them deliberately imitated the style of the official sculptor and others followed traditional formulas.[17] However, the account books provide evidence of a master who efficiently managed his workshop, a sculptor who became well integrated in his adopted city, where he was seen as a respectable and rich man. The works that can be attributed to him through documentary sources or by some credible analysis are the "products" that enabled him to run such a busy workshop and to be taxed at a high rate.

With so much documentary evidence, how can critics still attribute to Claus de Werve poorly executed or mediocre works and describe him as only a pale shadow of his famous uncle? Although Claus was for too long considered "a skilled but very uneven artist,"[18] fortunately, the 1976 exhibition was instrumental in rehabilitating him. Nowadays, critics have a more positive view of Claus, quite unlike the negative opinions expressed in 1936 by Anne Liebreich, who criticized the allegedly weak and poorly articulated images of the angels on the tomb of Philip the Bold, going as far as to assert that "the restoration and the painting have enhanced their mediocre plastic value." [19]

The Angels on the Tomb of Philip the Bold

Unlike the angels we see in many tombs of medieval princes, often hieratic and stereotyped, the angels conceived by Claus de Werve are real people. The sculptor brings them to life by individualizing their looks, giving them the suggestion of a personality, and posing them in naturalistic attitudes (p. 320, figs. 2 and 3). The left angel's very long and wavy hair looks as if it had been plaited, then undone and carefully brushed. His head is bent toward his right shoulder as he solemnly holds the duke's helmet, but his mind seems to be elsewhere as can be clearly seen by his dreamy expression. His pouty features are surrounded by delicate details such as the fluffy and weightless hair but also the collar, adorned with innumerable little pleats that make it seem even lighter than the rest of his vestment. We should pay close attention to the design of this head, as this angel is one of only two figures that can be attributed to Claus de Werve with full certainty. We will be able to identify some of the mourners executed by his hand, such as the altar boy who leads the procession, by stylistic similarities with this angel. Indeed, the boy's delicate features and dreamy expression have a stunning similarity with the left angel.

The right angel is in many ways different from his neighbor, thus contributing to give interest and liveliness to the monument (fig. 3). He is looking at the recumbent figure of the duke and, although he also appears to be wrapped up in his thoughts, his expression is unlike his neighbor's. He seems to be anchored in the reality of the moment and wondering what to do next. His face, with delicate features—small mouth and almond-shaped eyes topped by thick eyebrows—is framed by a shoulder-length mane of curly hair. Although it is as luxuriant as the hair of the melancholic angel, the strong shapes of the serpentine curls convey a feeling of strength and vigor. This angel's alertness and other details, such as the wide embroidered collar and the stiff pleats of his vestment, help convey the idea of strength, mastery, and masculinity. The postures of both angels are also in keeping with their personality traits.

Through the depiction of their subtle differences, Claus de Werve gives life to these two representatives of the celestial host and reveals to us the broad range of angels' physical and spiritual beauty. Contrary to the traditional representations of angels, similar to each other and too perfect, these are two clearly differentiated individuals. As we look closely at each of them, and then at both together, we find that they illustrate two sets of universal qualities. With his natural grace, his round features, and his melancholic expression, the left angel embodies the feminine qualities. The right angel, with his sun-like

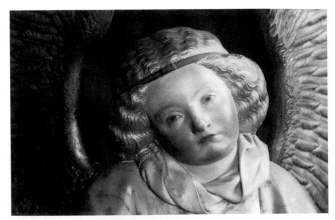

Fig. 2

Fig. 2.
Claus de Werve, left angel from the tomb of Philip the Bold, c. 1406–10, alabaster with polychromy and gilding. Dijon, Musée des Beaux-Arts.

Fig. 3.
Claus de Werve, right angel f rom the tomb of Philip the Bold, c. 1406–10, alabaster with polychromy and gilding. Dijon, Musée des Beaux-Arts.

Fig. 4.
Studio of Claus de Werve, *Altarpiece of the Passion*, detail of Christ's arrest, c. 1439, polychromed stone. Bessey-lès-Citeaux, Église Saint-Vincent.

Fig. 5.
Studio of Claus de Werve, *Altarpiece of the Passion*, detail of Christ before Caiphas, c. 1439, polychromed stone. Bessey-lès-Citeaux, Église Saint-Vincent.

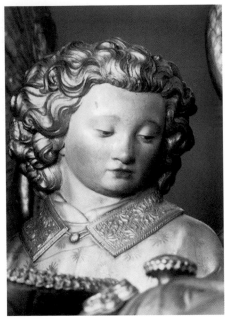

Fig. 3

mane, symbolizes the masculine qualities. The presence of both angels, heavenly creatures but also symbols of universal opposites, shows how not only the heavens but the whole of Creation is mourning the dead duke.

These angels are the work of a fully mature artist, with a pronounced taste for elaborate design, nuances of style, effects of complementarity, and figures full of sweetness. Claus's personality is clearly different from Sluter's, whose most characteristic works are the prophets of the *Well of Moses*, animated by an inner life so strong it is even reflected in the billowing folds of their garments.[20] The concept of the two angels keeping watch over the dead prince, so totally different from anything that could have been conceived by Sluter and yet so very similar to some of the best works in subsequent decades, is clearly a major work executed, but also designed, by the nephew. Sluter, a talented sculptor, must have realized the benefits he could derive from an artistic personality so different from his own and yet so complementary and able to express itself with such skill. The fact that the young man's talent was fairly appreciated is evidenced by the importance of the contribution he was allowed to make to the Champmol Calvary. It is generally admitted that he worked on the figure of David—a crucial figure, as it is the first one seen by the viewer, characterized by a round face and a singular treatment of the hair falling softly in fluffy waves.

Reasons for the Misapprehensions about Claus

Why have critics attributed to Claus de Werve poorly executed or mediocre works when he is the author of such figures and such original designs? One reason for such negative views seems to be the altarpiece at Bessey-lès-Cîteaux. Commissioned by Jean de Noes, a monk in Troyes and confessor of the duchess Margaret of Bavaria, this work illustrates the episodes of the Passion. Its long legend reads in part "per Claus fabrifactum" (made by Claus). However, Jules d'Arbaumont noted that the inscription requested prayers not only for the soul of the patron but also for Claus de Werve himself. Thus, Claus must then have been dead. Indeed, Pierre Camp concludes that the altarpiece was completed in late 1439 after the deaths of both the donor and the master of the workshop. The real authors, Claus de Werve's assistants, must have thought that the mention of their master's name would enhance the status of a rather clumsy work.[21]

In spite of its poor quality as a sculpture, the Bessey altarpiece is a crucial piece because it is dated and shows the influence of fourteenth-century Sienese painting, in particular of the Orsini polyptych painted by Simone Martini and owned by the charterhouse since the end of

the fourteenth century.[22] Pierre Quarré discovered that the Bessey altarpiece is indebted to the inventive composition of the Italian polyptych. For some reliefs, a model of higher artistic quality—perhaps an illuminated manuscript or oil on panel—or a drawn copy of the Italian work may have been used. Others are executed more clumsily and their composition is artless, for instance, the *Arrest of Christ* and *Christ before Caiphas*, in which the author of the preparatory drawings has used the same silhouette seen from the back and violently twisted for the furious soldier (figs. 4 and 5).[23] We must then surmise that this work was fully executed by Claus's

Fig. 4 *Fig. 5*

assistants who copied, modified, or combined Italian models. Even his intellectual contribution is doubtful in view of the lack of subtlety of certain formal repetitions, so far from the significant originality of his works.

The other reason for critics' negative views about Claus has to do with a "long illness that lasted for four years or so," mentioned in a document that recorded a gift from the duke as thanks for "good and agreeable services" rendered.[24] This illness must have had a significant impact on the work of Claus de Werve, affecting his activity as a sculptor more than the less physical work as manager of the workshop. Claus's many requests for tax reductions have led researchers to believe that the illness had a very damaging effect on his work. Quarré points out that his complaints to the tax authorities

would lead us to think that the sculptor "was always sick and unable to work,"[25] but he insists it is not true that Claus did almost no work from 1418—the beginning of the long illness—to his death. The responses of the tax authorities to his requests for lower taxes show that Claus de Werve was able to contribute personally to the activity of his workshop after 1422. As discussed above, the mayor and the aldermen of Dijon granted him a tax abatement in 1431 on condition that he execute statues of the Virgin and St. Andrew for the city gates.[26]

The High Quality of Claus's Works

Pierre Quarré points out that almost all sculptures by Claus de Werve have been dated to the end of his career, as their design and strong naturalism make them appear exceedingly original and modern. After the angels for the tomb of Philip the Bold, the first definite milestone in the study of his artistic personality is the *Virgin as Educator* from the Poor Clares convent in Poligny (cat. 122). The documents about this foundation enable us to date this work to the years 1415–17.[27] Its style has strong similarities with the angels on the duke's tomb: a careful rendition of physical and psychological nuances, a warmth in the depiction of the figures, the illusionistic suggestion of atmosphere and an affectionate relationship between the characters. The Christ child in particular is depicted with high naturalism, having the body, the physical details, the reactions, and the gestures of a real small child. Another characteristic of the early works of Claus de Werve, often neglected by attribution studies, is a high level of technical skill.

Another significant work made for the abbey church of Baume-les-Messieurs, also in Franche-Comté, is attributed to Claus de Werve on the basis of comparisons with the right angel on the tomb of Philip the Bold and the David of the *Well of Moses*. It is the figure of St. Michael, which was part of the sculpted decoration in a niche over the tomb of the abbot Amé de Chalon (cat. 109).[28] In all these sculptures the faces are round and smooth with regular features. Sandrine Roser points out that the modeling is rendered similarly in all of them: "The transitions between the various parts of the face are obtained by subtle depressions or blending; sharp folds determine the thickness of the lower lids, the corners of the mouth, and the sides of the nose."[29] Every detail, from the folds of the mantle to the treatment of the draperies, has been carefully contrived to produce a charming representation of the saint. We find similar stylistic characteristics and quality in the St. John the Evangelist in the church of Saint-Hippolyte at Poligny, also attributed to Claus de Werve.

The *Virgin of the Grapes* in the church of Notre-Dame in Auxonne, very early on recognized as a masterpiece of

Fig. 6.
Claus de Werve, *Virgin and Child*, first quarter of the 15th century, stone with traces of polychromy, H. 135 cm. Brétigny-sur-Norges, Église Saint-Georges and Saint-Firmin.

Fig. 7.
Claus de Werve, *Virgin and Child*, first quarter of the 15th century, stone, H. 162 cm, from the church of Montigny-sur-Vingeanne. Paris, Musée du Louvre.

Fig. 8.
Claus de Werve, *Virgin and Child*, before 1431, poly-chromed stone, H. 145 cm. Bézoutte, Église Saint-Martin.

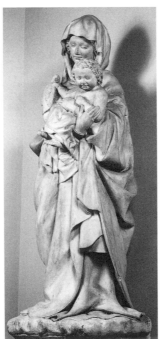

Fig. 6

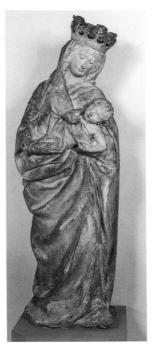

Fig. 7

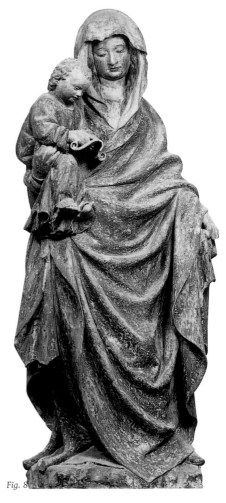

Fig. 8

this period, is also attributed to Claus de Werve (cat. 124).[30] The treatment of the draperies and the gestures lead the viewer to move around the work, a strategy already discussed in connection with the angels on the duke's tomb. Seen from the front, the *Virgin of the Grapes* impresses the viewer, persuading him that Mary has power to intercede for sinners. However, attention soon focuses on the lifelike child. The two figures and their relationship are so convincingly depicted that the viewer feels as if she is interrupting a moment of family intimacy. Representations of the Virgin and Child often suggested a relationship between a mother and her son, but Claus de Werve, alone among the sculptors of his time, excelled in the depiction of such human intimacy. Such strong feeling and complicity between mother and child is only found in Tuscan paintings of the Trecento, in particular the works of the Lorenzetti brothers or Lippo Vanni. In the Madonnas by Ambrogio or Ugolino Loren-zetti, or by Claus de Werve, family intimacy is evoked by formal innovations, such as gestures, and by a very natu-ralistic depiction of the Christ child. Everything points to the influence of fourteenth-century Tuscan painting on this sculptor active in Burgundy.[31]

The Virgin and Child of Brétigny-sur-Norges (fig. 6)[32] is also part of this group of statues attributable to Claus de Werve and datable to the years 1415–25. This work, which lost its polychromy after an injudicious cleaning

and which is hard to see inside a dark church, has been unfairly ignored by scholars. It is, however, a remarkable piece and a good example of the style of Claus de Werve. The face is a typical Claus face, which he knew how to modulate to give it male or female features, or to convey a serious, melancholy, smiling, or concerned expression. The work also exemplifies Claus's major artistic princi-ples: the blending of fictitious and real space and the sophisticated message conveyed by a work that at first appears to be simple. The lively treatment of the drapery folds reminds us of the mourners in the funeral proces-sion on the tomb of Philip the Bold.

Far from a generic representation, the child is depicted with extraordinary realism. The oblique line determined by the joining of his arm with that of the Virgin makes the viewer focus on a crucial detail: a thrush violently biting the child's thumb, an omen of his future martyrdom. Such naturalistic depiction combines with the allusion to the upcoming sacrifice to produce a

strong emotion in the viewer. This device was also used by the best European Baroque sculptors.

Another work of the same period attributed to Claus is the Virgin from the church of Montigny-sur-Vingeanne (Paris, Musée du Louvre). Once more we find amazing similarities between Mary's face and the faces of the right angel on the duke's tomb and the St. Michael from the Baume church (fig. 7).[33] The treatment of the draperies and Mary's gaze are meant to lead the viewer to focus on the child. His naturalistic contortions, the way in which he grabs his mother's hand, and his illusionistic appearance incite the viewer to linger and to walk around the statue in order to discover new and pleasing viewpoints.

The Bézouotte Virgin shares some common characteristics with the series of Virgin-Mothers discussed here, though it also has significant original features (fig. 8).[34] In this work, once more the arrangement of the drapery folds, the naturalism of the characters, and the anecdotal nature of their spontaneous gestures induce the viewer to move around. Seen from the side, the work is not as ceremonial, and the convergence of curved lines on the back of the child (Mary's veil and the child's head, as well as their sloping shoulders) expresses a crucial relationship that is only suggested by the frontal view.[35]

Quarré notes the similarities of this sculpture with the *Virgin of the Founder* in the church of Saint-Hippolyte de Poligny, a real masterpiece, though obscured by the polychromy applied in a modern restoration (cat. 105).[36] This statue, which also has parallels with the *Virgin of the Butterflies* painted by Jean Malouel, shares with the other Virgins we have discussed a three-dimensionality that invites the viewer to consider it from all angles.[37] This very modern connection between the work and the viewer unveils new aspects of a Virgin that glorifies the personal relationship between mother and child (fig. 1). The significant similarities between the heads of the Poligny child and the angel of the Saint-Seine *Annunciation* or the angel of the nails in the abbey church of Baume-les-Messieurs, as well as the feminine features and the high level of originality and technical skill, persuade us that this work was personally executed by Claus de Werve.[38]

Both the Poligny and Bézouotte Virgins can be dated fairly accurately, as documentary evidence proves that they were made before the years 1429–30. The Poligny Virgin is mentioned in a religious document by Jean Chousat, dating from 1429, which ordered the canons of the collegiate church to go in procession to the chapel and to chant a hymn to the Virgin "in front of the image."[39] The Bézouotte Virgin can likely be dated from the construction of a chapel dedicated to the cult of Mary—construction that predated the death of Gauthier

de Charmes (deceased in 1431), as evidenced by a document mentioned by canon Marilier to Pierre Camp.[40]

Quarré was able to add to Claus de Werve's œuvre by confirming attribution of two essential works, the Saint-Bénigne Christ in Dijon (cat. 123), discovered in 1963,[41] and the recumbent Christ in the convent of the Annonciate nuns at Langres, part of an Entombment in the cathedral adorning the tomb of canon Jean Marchand, who had created a endowment for the church on 14 May 1420 (fig. 9, and cat. 123).[42] The two Christs have great stylistic similarities: sweet expressions, idealized features, tidy beards, flowing and wavy hair, even the feeling of liberation expressed in their faces. It has often been noted that the Christ in the Dijon archeological museum is very different from the moving Christ by Sluter.[43] Although it is true that Claus de Werve found pathos incompatible with his personality, he was able to develop other formal ideas to arouse subtle emotion and spiritual feeling in the viewer. For example, the face of the entombed Christ is dramatized by the detail of a mouth half-opened in the throes of death, but such pathos is tempered by the calmness of the face (as if he was sleeping) and by the beauty of the perfectly coifed hair (an allusion to the care given to the body prior to burial).[44]

Other recently identified works by Claus de Werve allow us to cast more light on this artist, in particular the Virgin and Child in the church of Château-Chalon and the altarpiece entitled *Déploration sur le Christ mort*, acquired in 1988 by the Musée National du Moyen Âge in Paris. The first one, a sculpture of high quality in spite of its fragmented condition, can be attributed to Claus on the basis of comparisons with works demonstrably executed by him. The series of Virgin-Mothers produced by Claus are a stunningly rich set of variations on the theme of the humanity of Mary, of Christ, and their moving relationship (cat. 125).[45]

The private-devotion altarpiece, a fragile and sumptuous piece, can be attributed to Claus in spite of some noticeable weaknesses in the figure of Mary Magdalene because the sculptural skill and the harmonious and inventive composition are in line with what we know about him (fig. 10).[46] The figure of St. John is similar to the St. Michael from Baume, while the face of Mary has an expression similar to the "Bulliot Virgin," the masterpiece of the Musée Rolin (cat. 129).[47] The famous Bulliot Virgin created for the church of Notre-Dame-du-Châtel in Autun—the parish church of the Rolin family— sublimely suggests the essential link between Mother and Son while evoking Mary's consent to the sacrifice. It was a well-known and celebrated work, as can be seen by the number of copies and interpretations, in particular the Lhomme Virgin from Autun,[48] also in the Musée

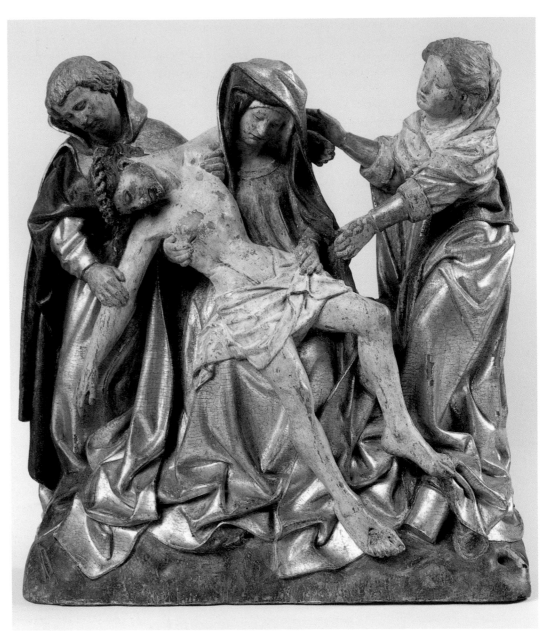

Fig. 10

Fig. 9

Fig. 9.
The Entombment, before 1420,
stone, 33 x 180 cm. Langres,
convent of the Annonciate nuns.

Fig. 10.
Claus de Werve, *Altarpiece of the
Lamentation*, c. 1425–35,
polychromed and gilded wood.
Paris, Musée National du Moyen
Âge–Thermes de Cluny.

Fig. 11.
Pierre-Joseph Antoine, *The Old
House of the Carthusians in Dijon*
(detail), pen and wash,
58.8 x 36 cm. Dijon, Bibliothèque
Municipale.

Rolin, and the Virgin in the hospital of Nuits-Saint-Georges.[49]

The altarpiece at the Musée National du Moyen Âge and the Virgin of Château-Chalon are significant because they closely match the style and the spirit of the works by Claus de Werve. Also of interest is the fact that these are wooden sculptures, while most Burgundian works (or at least most of the works that have come down to us) are made of stone.

Iconographic Documents

Some iconographic documents provide a deeper knowledge of the work of Claus de Werve. A drawing by Pierre-Joseph Antoine dating from 1767, at the Dijon Bibliothèque Municipale, represents the sculpted decoration on the façade of the House of the Mirror (fig. 11)[50] executed by Claus de Werve from 1414 to 1415. This decoration consisted of an image of the Trinity surrounded on either side by the figures of two Carthusian monks standing on consoles decorated with the arms of Burgundy.[51] Although Antoine's drawing is not very accurate, it helps us better understand Claus's work. The Trinity of the House of the Mirror has been thought to be quite similar to the Genlis Trinity, but this is not so, as the latter is a standing Trinity.[52] Rather, it has more in common with the seated Trinity in the church of Buvilly, in the Jura.

Other lost works can also be attributed to Claus de Werve, for instance the three statues on the south portal of the old church of the Jacobins in Dijon (fig. 12). We only know them through a drawing in *La Vraye and parfaite science des armoiries published* in Dijon by Pierre Palliot in 1650, a drawing that perfectly fits the description of the portal given in the *Almanach de la Province de Bourgogne* in 1778.[53] The statues, a Virgin-Mother between St. Pierre of Verona, a Dominican martyr, and St. Hyacinth, are standing on consoles bearing the arms of Burgundy on the left and the arms of the city of Dijon on the right, and between them the arms of John the Fearless. The *Almanach* states, "It is believed that the portal facing the street was made by the duke John the Fearless . . . because his arms appear below the image of the Holy Virgin."[54]

Does the presence of the duke's arms indicate that this sculpted decoration was executed before his death in 1419? Two documents dated August 1427 mention work on the portal of the Jacobins church by Brother Philippe d'Auxonne. For this work, the city of Dijon grants him 2 francs "because brother Philippe will cause the arms of the city to be placed twice on the said portal."[55] As noted by Pierre Camp, in 1427 the reigning duke was Philip the Good, but he used his father's coat of arms without modifications until October 1430, when

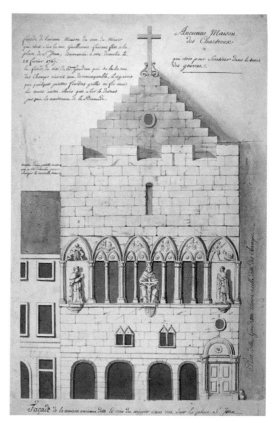

Fig. 11

he became Duke of Lothier, Brabant, and Limbourg.[56] Thus, the coat of arms on the console of the Virgin could belong to Philip the Good at the beginning of his reign. In any case, the coat of arms suggests the duke was involved in picking the artist to execute this artistic commission. And at the time Claus de Werve was the official sculptor of the Burgundian court.

What can we learn about this lost work from the "figures" in the drawing published by Palliot? The two saints on either side of the Virgin-Mother, St. Peter of Verona and St. Hyacinth, have three purposes: to inform the viewer about their legends, to present the books of the Bible, and finally to direct the viewer's gaze toward the central figure. The sketch in *La Vraye science des armoiries* shows the essential qualities of the sculptor: a sense of composition and contrast,[57] a taste for naturalism and eloquent draping, and the ability to arouse empathy in the viewer by means of an eloquent depiction of the feelings between mother and child.

The portal of the Jacobins church was destroyed during the French Revolution, and it was believed that there were no other direct or indirect records of this sculptural ensemble. However, Henri David's book on late medieval Burgundian sculpture reproduces a statue very similar to

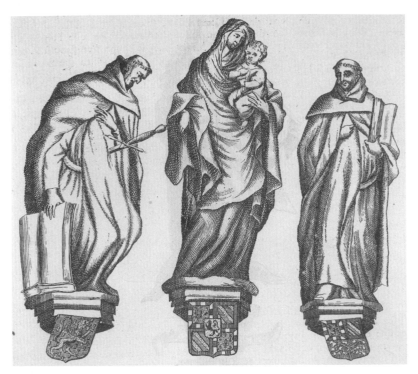

Fig. 12

Fig. 12.
Sculpture from the portal of the ancient Dominican church in Dijon, illustration from Pierre Palliot, *La Vraye et Parfaite Science des Armoiries*, 1650. Dijon, Bibliothèque Municipale.

Fig. 13.
Photograph by Henry David from before 1930, of a statue in a house in Leugny. Dijon, Bibliothèque Municipale, inv. MS 2234.

Fig. 14.
Photograph by Henry David from before 1930, of a statue in a private property in Chenôve. Dijon, Bibliothèque Municipale, inv. MS 2235.

Fig. 15.
Claus de Werve, *St. Michael* (detail), c. 1415–31, stone with traces of polychromy. Baume-les-Messieurs, abbey church.

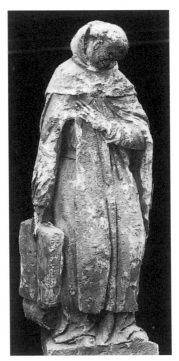

Fig. 13

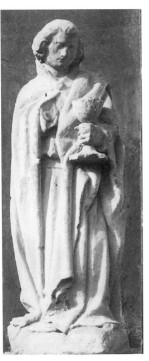

Fig. 14

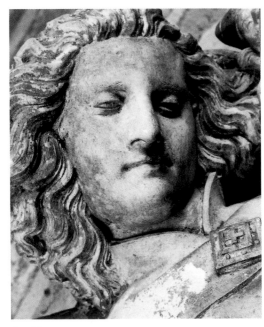

Fig. 15

the St. Peter of Verona depicted in the 1650 drawing (fig. 13).[58] According to David, this statue was on a wall niche in a house located in the village of Leugny belonging to the municipality of La Roche-Vanneau. The photograph taken in the 1930s shows the work was in very poor condition.[59] It depicts a monk holding an open book, so heavy it actually seems to distend his arm. The worth of the book is suggested by its great size and by its position between the monk's hand and another voluminous book, which is closed and placed on the floor. What powerfully singularizes this figure, according to David, is its strange sinuosity, the head exaggeratedly bent toward the shoulder, and the inelegant bending of the legs as if the man were fainting. All these characteristics are exactly similar to the St. Peter Martyr on the portal of the church of the Jacobins.[60] Field research indicates that the statue of St. Peter Martyr was in the niche of a barn at one end of the rue du Reposoir in the village of Leugny.

Another iconographic document allows us to identify a sculpture by Claus de Werve: a photograph taken by Henri David in the 1930s, at the Dijon Bibliothèque Municipale, reproduces a statue of St. John the Evangelist which was at the time exposed in an outside niche in a private property at Chenôve (fig. 14).[61] An investigation of the site did not enable us to find the sculpture, which is not very visible in the photograph. However, we can see enough to appreciate a work of very high quality, in which the nobility of the draperies gives the figure a majesty animated by the elegant contrapposto of the shoulders.

The quality of this work is confirmed by the study of photographic enlargements. We see a fluffy and thick head of hair, reminding us of the figures by Claus de Werve, and a sinuous lock of hair combed back from a wide forehead, following a formula common to the St. Michael of Baume and the St. John of Poligny (fig. 15). The face has the bone structure and features of the sculptures we have discussed above, in particular the Poligny Virgin, the Auxonne and Brétigny Virgins, and the St. Michael of Baume.

A careful study of Claus de Werve's work will make us reconsider his place in the pantheon. Although Sluter's genius in unquestionable, his nephew was a very competent artist and it is wrong to attribute to him mediocre or pedestrian works. Claus's technical skill and his ability to develop a personal style were undoubtedly appreciated by Sluter, his uncle. Claus de Werve's taste for sweetness, for pleasing figures and scenes of family intimacy, reveal a man in sync with the tastes and the beliefs of his times, but the Arcadian nature of characters or scenes should not make us forget the polysemous richness of his work.

Claus de Werve was unable to give his full measure under John the Fearless because of the climate of political instability, economic crisis, and the duke's preference for his Flemish possessions rather than his Burgundian lands. However, Claus was able to successfully manage his career while being a highly original and innovative artist, as proven by the discovery of works that can be attributed to him because of their high sculptural quality and their idiosyncratic style. Perhaps other works by Claus will still be discovered in Burgundy or in Franche-Comté, where one of his most exceptional pieces was located until the 1920s.[62] Claus's activity in Franche-Comté is explained by the presence of dynamic patrons who already knew the artist's talent. One of them was St. Colette, who appreciated him as an inspired translator of Franciscan beliefs, such as the promotion of peace and the cult of the Virgin.

NOTES 1. The major reference work is still the catalog of the exhibition on Claus de Werve (Dijon 1976), with an exhaustive bibliography. Although this catalog, written by the curator of the exhibition, Pierre Quarré, includes works of very uneven quality, it is the first study that focuses on the works and the personality of Claus de Werve, debunking some widely held negative views about this artist (see above). We should also mention the article by Boccador (1986) and the interesting paper that Forsyth (1986) devoted to the Virgin as Educator (cat. 122). Other authors have studied the sculptor in monographs or more general works, for instance Camp 1990, pp. 64–105; Morand 1991, pp. 133–59; Baudoin 1996, pp. 129–44. Joubert (1990) discusses a devotional altarpiece made of polychrome wood, acquired by the National Museum of the Middle Ages, that was probably made in Claus de Werve's workshop (see above). Finally, see Beaulieu's paper in Beaulieu and Beyer 1992, pp. 201–4.

2. ADCO, B 4447, fol. 23v. Claus de Werve worked on the figures of the Christ and the Virgin during 108 weeks, from 1 December 1396 to 30 June 1399.

3. Ibid., B 4449, fol. 19v.

4. Ibid., H 46. See also Monget 1898–1905, 2: p. 46. This sculpture is lost but it is believed that it had similarities with the Education of the Virgin in the church of Saint-Hippolyte in Poligny, probably executed by an assistant of Claus de Werve.

5. These events caused the recumbent effigy to be replaced with a modern reproduction, except for the hands, which are original.

6. ADCO, B 1534, fol. 63. It is generally believed that the figures executed by Sluter are mourners nos. 39 and 40 in Pierre Quarré's list—these naturalistic mourners are less idealized and more vigorous.

7. It is however possible to attribute some of the figures to Claus de Werve (see above).

8. ADCO, B 4471, fol. 89v. After 1 January 1415, Claus de Werve's salary was 8 gros per day or 243 francs 4 gros per year, to be paid out of the income generated by the Salins saltworks. The accounting records show payment of this salary in 1416, in 1417, from 1420 to 1424, and in 1426 (see Dijon 1976, no. 15).

9. Dijon, AM, B 153, fol. 16v.

10. In the end Claus de Werve did not execute this work. Instead, Hennequin de Prindale, another gifted assistant in Sluter's workshop, went to Chambéry. See Perret 1978, p. 36.

11. ADCO, B 1570, fol. 192.

12. Ibid., B 15, fol. 140.

13. Ibid., B 1659, fol. 145v.

14. As we will see below, the works that can be plausibly attributed to Claus de Werve confirm that he traveled to satisfy his many patrons in Burgundy but also in Franche-Comté. Perhaps the discovery of new works or documents will bring to light more information about his private patrons.

15. Camp 1990, pp. 64–71.

16. ADCO, B 5995, fol. 240v.

17. About formal citations in late medieval Burgundian sculpture, see Lapaire 1983 and Bertrand 1996.

18. Humbert 1913, p. 111.

19. Liebreich 1936, p. 151.

20. About the originality of Claus Sluter's style, that is, the interrelationship of fictitious and real space and the means to multiply the illusionism of figures, see the papers by Goodgal-Salem 1987–89 and Joubert 1992C and 1999.

21. Camp 1990, pp. 71–73.

22. See cat. 102 (Lorentz).

23. The influence of Claus de Werve's personal style is not apparent except in the fluffy, wavy long hair and the sweet countenance of figures such as the Christ in the Entombment.

24. ADCO, B 1631, fol. 146.

25. Dijon 1976, p. 8.

26. Dijon, AM, B 153, fol. 16v.

27. See cat. 122.

28. About this sculpture, see Roser 2003, 2: pp. 488–90. A peculiar treatment of the hair, combed away from a smooth forehead, is common to both figures. Their features are subtly different to indicate diverse personalities, ages, and states of mind.

29. Roser 2003, p. 489.

30. See cat. 109.

31. Because of this cultural heritage, some of Claus de Werve's sculptures are more similar to contemporary Italian paintings, such as Masaccio's Madonna del solletico, c. 1426 (Florence, Uffizi Gallery), than to geographically closer works. About Masaccio's Madonna, see Borsi 1998, pp. 176, 242–43.

32. H. 135 cm; Camp 1985, p. 562; Camp 1990, p. 96; Bertrand 1997, 2: no. 39.

33. H. 162 cm; Aubert and Beaulieu 1950, no. 335; Baron 1996, 1: p. 192.

34. H. 145 cm; Camp 1990, pp. 96–97 repr.; Baudoin 1996, pp. 140–41, fig. 223; Bertrand 1996, 2: no. 39.

35. The diversity of angles used when reproducing Claus de Werve's statues exemplifies how the viewer is compelled to move around seeking different viewpoints. See in particular the illustrations in Forsyth 1986, and in Boccador 1974, 1: p. 201, 2: p. 324.

36. Dijon 1976, no. 71. See cat. 105 (Witt).

37. About the painting by Malouel, in the Berlin Gemäldegalerie, see cat. 102 (Lorentz). Pierre Quarré made a very convincing comparison between the *Virgin of the Butterflies* and the majestic Poligny Virgin (Dijon 1976, no. 71).

38. See cat. 105.

39. Quarré 1960B, 2: p. 219.

40. Camp 1990, p. 96. ADCO, B 443.

41. See cat. 123.

42. 33 x 180 x 52 cm; Marcel 1918; Quarré 1971; Baudoin 1996, p. 138.

43. About Sluter's Christ, see Boucherat, in *Sculpture médiévale en Burgundy*, pp. 179–80, and cat. 77 (Prochno).

44. The left index finger wrapped around the right forearm is a detail that intrigues the viewer and leads him to further explore a figure whose enigmatic countenance skillfully denotes an unusual character.

45. See cat. 125.

46. About this sculpture, see Joubert 1990.

47. See cat. 129.

48. H. 79 cm. Reproduced in Baudoin 1996, fig. 263.

49. H. 74 cm. Reproduced in Camp 1990, pl. IV.

50. Ink and wash, 58 x 36 cm, Dijon, Bibliothèque Municipale; Dijon 1976, no. 91.

51. ADCO, 46 H, fol. 49v.

52. H. 115 cm; Verdier 1975; Mosneron-Dupin 1990, 1992; Baudoin 1996, p. 77, 150; Bertrand 1997, 2: no. 79.

53. Palliot 1650, 1: p. 291; Dijon 1976, no. 90.

54. *Almanach de la province de Bourgogne*, p. 238.

55. ADCO, M 57, decree of 19 August 1427, and B 152*, fol. 7v, 29 August 1427.

56. Camp 1990, p. 76.

57. The figure of the Virgin Mother opposes different but complementary values, for example, the ideal majesty of her appearance vs. the moving humanity of the suggested relationships.

58. David 1933, 2: p. 104.

59. David (ibid., p. 103), who analyzed the statue in situ, was barely able to see "fine-grained stone . . . with many pockmarks due to the fact it is used for target shooting."

60. The study of the details confirms a close relationship between the two figures. Although the Leugny statue has lost its sword, we can still see under the cuff of the left sleeve the trace of the spot where it was broken off.

61. Dijon, Bibliothèque Municipale (iconographic library), MS 2235, file 101-150, document no. 137. About the history of Chenôve, and in particular the town center under the dukes of Burgundy, see Beck, Canat, and Lauvergeon 1999.

62. The *Virgin as Educator* from the convent of Poor Clares at Poligny. See cat. 122.

122

Claus de Werve
(Haarlem, ?–Dijon, 1439)

Enthroned Virgin and Child

c. 1415–17

Polychromed limestone
135 x 114 x 71 cm

Inscription: Ab. ini/tio. et/ante/secula/creata./sum

New York, The Metropolitan Museum of Art, Rogers Fund, inv. 33.23

PROV.: Convent of the Poor Clares, Poligny; sold in 1920 to a prominent local figure and acquired by the Metropolitan Museum in New York in 1933.

BIBL.: Rorimer 1938, pp. 112–16; Rorimer 1951, p. 183; Müller 1966, p. 57; Hoving 1970, pp. 212–13; Quarré 1973A, p. 42; Boccador 1974, 1, p. 178; Quarré 1976B, p. 10; Baudoin 1983, p. 166; Camp 1985, p. 562, Forsyth 1986, pp. 41–63; Leclercq 1987, pp. 107–16; Camp 1990, pp. 89, 96; Baudoin 1996, p. 139.

EXH.: Paris 1994, no. 37.

Exhibited in Cleveland only

Seated on a stone bench and enveloped in a mantle with majestic folds, Mary holds the Christ child on her knees, in accordance with a passage from the scriptures. The sculptor reaches the heights of his rather clear ambitions, for example glorifying the Mother of God and touchingly evoking a moment of familial intimacy. It is a particularly innovative composition, where the principal view is enriched by secondary views that complete our appreciation of the two figures, as well as the scene as a whole. While the sculpture is modern in the way it invites the viewer to discover the work from a variety of viewpoints, it is also elementary in this regard, persuading the senses and touching the emotions simultaneously.

This piece comes from the convent of the Poor Clares in Poligny, established by John the Fearless at the instigation of his wife, Margaret of Bavaria, and directed by St. Colette, a reformist member of the Franciscan order. William Forsyth (1986, p. 42) sees the work as another expression of the duke's generosity and dates the commission to between June 1415, when the duke donated land and buildings, and October 1417, when the religious order moved into the convent. The sculpture was recognized early on as a major work by Claus de Werve, on the basis of

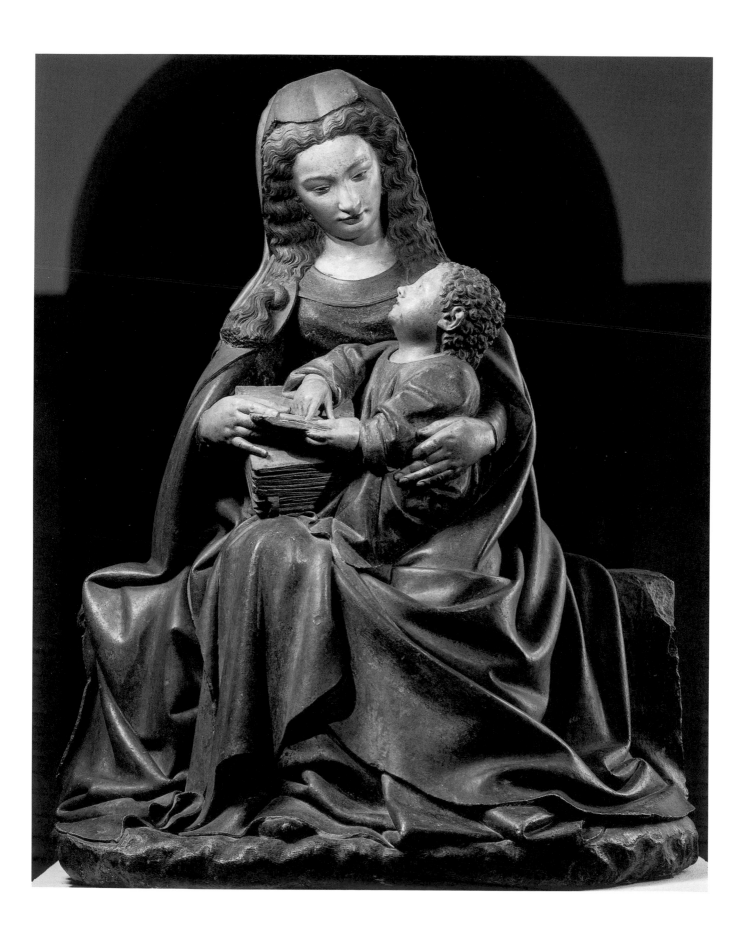

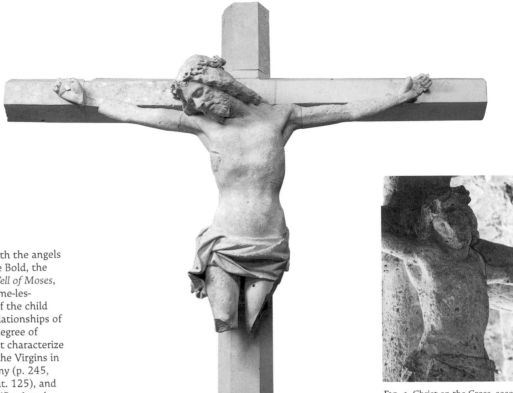

FIG. 1. Christ on the Cross, second quarter of the 15th century (?), stone. Puley, ruins of the priory church.

compelling comparisons with the angels from the tomb of Philip the Bold, the figure of David from the *Well of Moses*, and the St. Michael in Baume-les-Messieurs. The rendering of the child shows an aptness in the relationships of proportion, volumes, and degree of stability equal to those that characterize the Christ child figures in the Virgins in Auxonne (cat. 124), Brétigny (p. 245, fig. 3), Château-Chalon (cat. 125), and Saint-Hippolyte in Poligny (fig. 1 and cat. 105).

Finally, the sculpture is admirable in the way it depicts the impalpable—not two figures so much as the essential bond that unites them. Along with the Madonna figures cited above, this work illustrates, in its profound humanity, Mary's most empathic moment of intimacy. The consistently subtle marriage of astonishingly spontaneous gestures, nuanced glances, and eloquent caresses is akin to the fugue-like development of a theme: the power of maternal feeling and the sacrifice of the Mother of God.

V.B.

FIG. 1. Claus de Werve, *Virgin of the Founder* (detail), before 1429, polychromed stone. Poligny, Église Saint-Hippolyte.

123

Claus de Werve
(Haarlem, ?–Dijon, 1439)

Christ on the Cross
First quarter of the 15th century

Limestone

Cross: 115 x 146.5 cm

Christ: 80 x 115 cm

Dijon, Musée Archéologique, inv. 63.5

PROV.: entered the museum collection in 1963.

BIBL.: Quarré 1966; Quarré 1971; Bertrand 1997, 2, no. 58; *Sculpture médiévale en Bourgogne*, no. 60.

EXH.: Dijon 1976, no. 33.

On a cross that is hexagonal in section, Christ bows his head on his shoulder. He is noteworthy for the sweetness of his appearance and a sense of abandon that is not unlike that of sleep. The regular features, the half-open mouth, and the naturalism of the thick, luxurious hair enhance this impression of extreme softness.

Pierre Quarré discovered the sculpture in 1963, during work carried out on the floor

of the monks' room in the ancient Benedictine abbey that became the archeological museum of the city of Dijon. Thus at some unspecified date, the most important fragments of the Crucifixion would have been buried within the floor of the lower story of this part of the eastern wing of the large cloister. Quarré has proposed that the splendid Crucifixion created by Claus Sluter for the Chartreuse de Champmol, in the very early years of the fifteenth century, must have persuaded the abbot of Saint-Bénigne to have a work of the same type made, but on a more modest scale. It must have been placed within the sacred enclosure of Saint-Bénigne, and outdoors, as seen by the numerous erosion marks on the stone.

The dominant quality of the work, a sweetness that nuances every detail or aspect of the design, points to the hand of Sluter's successor, Claus de Werve. This authorship is confirmed by the most significant stylistic or formal traits, such as regular features distributed over the surface of a full face, and thick hair, similar to that of the left angel from the tomb of Philip the Bold.

Radically different from the version that Sluter conceived for the Crucifixion at Champmol—a version that is more open and more absolute in its impact on the viewer—the Saint-Bénigne Crucifixion nonetheless must have made an impression

on Claus de Werve's contemporaries. In fact, numerous Burgundian Christ figures share the same characteristics, apparently inaugurated by this figure, which is of superior quality. Indeed, in the churches of Roche-Vanneau and Châteauneuf, and perhaps even more in the priory of Puley in Saône-et-Loire, the Christ figures have the same general look, the same resignation in the head, and identical relationships of proportions (fig. 1). They also are characterized by soft hair, a narrow torso, extremely thin joints and arms, and deeply hollowed armpits, the same qualities that are remarkably combined in the figure in the Musée Archéologique.

V. B.

124

Claus de Werve
(Haarlem, ?–Dijon, 1439)

Virgin and Child
c. 1415–20

Limestone
130 x 65 x 32 cm

Auxonne, church of Notre-Dame

Bibl.: Aubert 1930, p. 59; David 1933, 1: pp. 23–24; Troescher 1940, p. 107; Aubert 1946, p. 382; Jullian 1965, p. 228; Müller 1966, p. 50; Camp 1969, p. 68; Boccador 1974, p. 196; Baudoin 1996, p. 142; Bertrand 1997, 2, no. 22.

Exh.: Paris 1937, no. 1100; Dijon 1949, no. 9; Rotterdam 1950, no. 11; Amsterdam 1951, no. 195; Brussels 1951, no. 182; Dijon 1951, no. 123; Dijon 1976, no. 66.

Mary holds the Christ child in her left arm and gazes tenderly at him; in the opposite hand she holds a lush grape. Rolled up into a hood, her mantle generously cloaks her right arm, before it reappears in front, on her apron. To the left, the extension of the fabric is a pretext for the return of the ample folds, granting the garment an almost organic dynamism.

The sophisticated look of the mantle imparts a desirable elegance and majesty to the figure. In spite of the silhouette's increased lateral dimension, the figure is characterized by a lively appearance, which results in youthful features and a marked sinuosity. The sweetness of the face and the maternal gestures contrast ideally with the virile lyricism of the drapery. Likewise the play of light and shadow in the garments magnify, by contrast, the ideal nature of the youthful face.

The dynamism of the figure and the drapery are envisioned in such a way that the qualities of the individual vary,

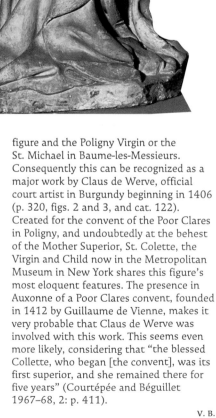

depending on the angle of observation. From the front, the Virgin appears as the glorious Mother of God, solemn and supreme. From the right side, the suggestion of emotion prevails (fig. 1).

The artist has brilliantly brought out the complicity between mother and child, as in a moment of intimacy where each is becoming familiar with the other. The child plays an essential role in the work's subtle meaning. His arm rests on the Virgin's chest, he plays with his curled up toes while he and his mother look upon each other with mutual eagerness and pleasure. The technical skill and the effectiveness of a few original ideas give this private conversation a disquieting authenticity and an equally remarkable empathic power.

Significant similarities exist between this Virgin and the angels from the tomb of Philip the Bold, but also between this

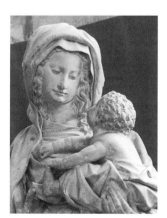

FIG. 1. The Virgin's face.

figure and the Poligny Virgin or the St. Michael in Baume-les-Messieurs. Consequently this can be recognized as a major work by Claus de Werve, official court artist in Burgundy beginning in 1406 (p. 320, figs. 2 and 3, and cat. 122). Created for the convent of the Poor Clares in Poligny, and undoubtedly at the behest of the Mother Superior, St. Colette, the Virgin and Child now in the Metropolitan Museum in New York shares this figure's most eloquent features. The presence in Auxonne of a Poor Clares convent, founded in 1412 by Guillaume de Vienne, makes it very probable that Claus de Werve was involved with this work. This seems even more likely, considering that "the blessed Collette, who began [the convent], was its first superior, and she remained there for five years" (Courtépée and Béguillet 1967–68, 2: p. 411).

V. B.

125

Claus de Werve
(Haarlem, ?–Dijon, 1439)

Virgin and Child
First quarter of the 15th century

Wood with traces of polychromy and gilding
39 x 27 x 13 cm

Château-Chalon, church of Saint-Pierre

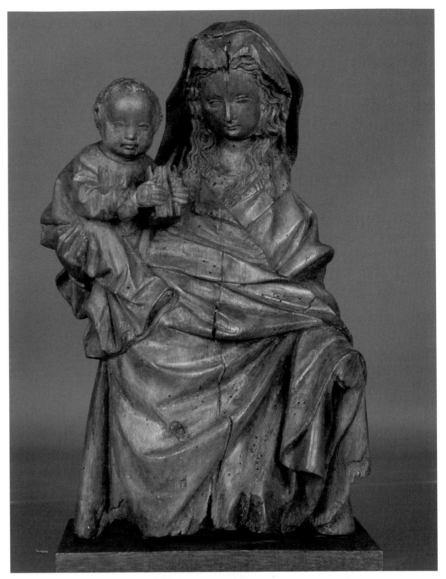

Mary holds the Christ child in her right arm; he crosses his legs and curls up against his mother's chest. The naturalism of the young boy is defined by the spontaneously playful nature of his movements; he handles a book, his small fingers buried among the pages. He exhibits neither studious interest nor reverence toward this object, but holds it very precisely, just as a child of his age would do, clumsily and without any awareness of any symbolic value. Because the spine of the book is flattened against the child's small torso, the viewer can see only a section of manuscript that remains closed. The sculptor exhibits exemplary inventiveness in this work, and while he introduces a predictable sacred element—the book containing the scriptures—he avoids treating the work in a traditional manner.

Mary holds the child up quite high in order to present him to the viewer, with a look of skillfully suggested pride. Her body is held in balance by the sinuous curve of her posture, which helps emphasize the delicacy of her face, already magnified by her thick hair and polygonal veil. The sculptor's talent and concern for naturalism can be seen in the treatment of the child's small head, with its unusual, down-like hair, and in the arrangement of the features, which correspond to those of very young children.

A comparison of the profiles of this Virgin and the left angel from the tomb of Philip the Bold reveals similar features and identical proportions (figs. 1 and 2). In the figure of Mary, the lower portion of the profile is simply made more feminine, indeed more childlike. Comparison with the left angel from the ducal tomb makes clear other significant similarities. In addition to the sweetness of face, the two figures exhibit the same eyes, shaped like thin reverse crescents, giving subtle nuance to the expression.

The presence of a Poor Clares convent at Château-Chalon, in the fifteenth century, again points to Claus de Werve. It

FIG. 1. *Virgin and Child*, detail.

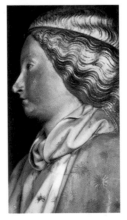

FIG. 2. Claus de Werve, left angel from the tomb of Philip the Bold (detail), c. 1406–10, alabaster with gilding and polychromy. Dijon, Musée des Beaux-Arts.

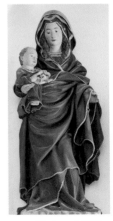

FIG. 3. *Virgin and Child*, first quarter of the 15th century, polychromed stone. Échevronne church.

is conceivable that the members of a sister convent in Poligny, the original setting for one of Claus's masterpieces, the *Virgin and Child* now at the Metropolitan Museum of Art in New York, might have recommended the artist. The incontestable quality of this piece, despite its fragmentary state, and the originality of the interpretation, in any case indicate a prestigious commission, of which the Virgins in Ouges and Échevronne, in the Côte-d'Or, are but pale echoes (fig. 3).

V.B.

126

Claus de Werve?
(Haarlem, ?–Dijon, 1439)

St. Peter as Pope
First quarter of the 15th century

Polychrome limestone
128 x 45 x 31 cm

Argilly, church

BIBL.: David 1933, 1: pp. 27–28; Liebreich 1936, pp. 172–73; Aubert 1946, p. 383; Quarré, 1963–69, pp. 99–101; Baudoin 1996, p. 141.

EXH.: Amsterdam 1951, no. 190; Brussels 1951, no. 177; Dijon 1951, no. 121; Dijon 1976, no. 57.

St. Peter is depicted as pope, in his capacity as the highest dignitary of the Catholic Church. His right hand holds what is most likely a scroll, while his left hand holds an open book, turned toward his gaze. This precise orientation gives the saint's attribute great significance; his stern regard warns us not to stray from Biblical teaching.

The various elements of clothing attest to absolute mastery in the rendering of fabric; the majestic folds of the cope contrast with the more energetic folds of the robe and the gloves. The ornate clothing, the solemnity of the gestures, and the expression give the figure a grandeur that is heightened by the elegance of the contrapposto. It has been suggested that this figure might be the sole extant element from an apostolic college, and that it once embellished the chapel of the château of Argilly in the fourteenth century. This seems unlikely since we know of no apostolic college

where there was a St. Peter depicted as a pope and not as an apostle like his companions (Quarré, 1963–69).

Quarré also feels that the style of the sculpture invalidates this hypothesis. The structure and features of the face (tapered eyes, substantial nose, melancholy glance) recall those of David from the *Well of Moses*, where we recognize the hand of Claus de Werve, with the help of comparison with some of the heads, particularly those of women, created by that artist (p. 214, fig. 4). St. Peter's smooth features, the feeling of great sweetness that is conveyed, and the pensive expression also bring to mind the left angel from the tomb of Philip the Bold, a known work by Claus de Werve (p. 320, fig. 2). Both seem to belong to the same family, sharing the same physical features and the same spiritual tendencies. Only the difference in age and type of rendering—more idealized for the angel—distinguish the two figures.

During the first third of the fifteenth century, two of the lords of the château of Argilly were named Pierre—Pierre Rainval (r. 1414–22), and then Pierre Lemoyne (r. 1429–34). In addition to the stylistic indications of a work that can be dated to the first quarter of the fifteenth century, this bit of information encourages the hypothesis of a sculpted representation of the saint bearing the same name as one of the lords of Argilly.

V.B.

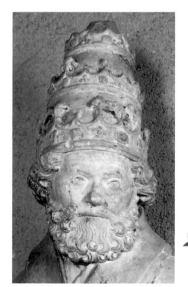

FIG. 1. *St. Peter,* detail.

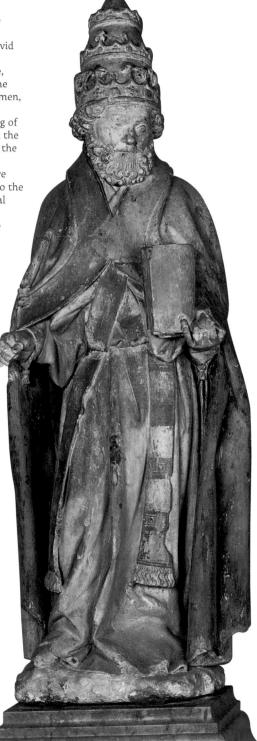

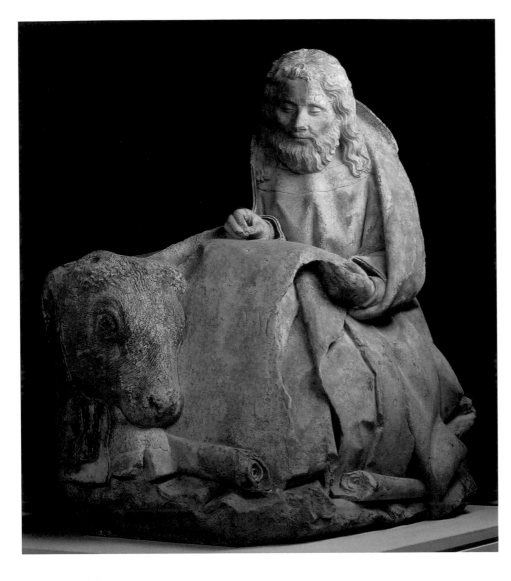

comparison with which to piece together the origins of the work.

Yet the statue can been fairly certainly placed within the circle of Claus de Werve. The bull's coat is treated much like that of the lion from the tomb of Philip the Bold and even like the fur on the train of the duke's cloak. But it is above all the delicacy of the face, the rendering of the wrinkles and the eyebrows, the treatment of the eyes, that evokes that of the Christ of Saint-Bénigne (cat. 123), and even more closely the figure of St. Anthony at the Musée Archéologique in Dijon (cat. 89).

<div align="right">S.J.</div>

128

Burgundy

Virgin and St. John of the Cross

First quarter of the 15th century

Polychromed wood
Virgin: 147 x 48 x 36 cm
St. John: 147 x 48 x 36 cm

Salins, chapel of Notre-Dame Libératrice

BIBL.: Lacroix 1972, p. 127; Camp 1990, p. 22.

EXH.: Dijon 1976, nos. 45–46.

These statues of the Virgin and St. John, like those from the church of Saint-Hippolyte in Poligny, belonged to a glory beam. In keeping with iconographic tradition, they appeared on either side of a crucified Christ, but undoubtedly different from the one with which they are associated today.

With its feverishly clasped hands and the modulation of its silhouette, the figure of St. John is rather traditional. In contrast, the figure of Mary is noteworthy in the way it scarcely corresponds to the usual representations of the subject. She wears a simple garment devoid of all accessories, covered by a mantle of thin cloth. The long vertical edges of the mantle are turned back, but their scant sinuosity prevents them from in any manner achieving the fluid lines that so strongly characterize the figure. Upright, arms along her body, hands crossed in front, Mary stares at the ground, pierced by profound sorrow, seen in her brooding look, her hypnotic stare, and the held breath that makes her tighten her chest.

127

Attributed to Claus de Werve or his studio

Saint Luke Writing the Gospel

First third of the 15th century

Stone, traces of paint
74 x 67 cm

Dijon, Musée des Beaux-Arts, inv. 2820

PROV.: belonged to the community of the Sisters of Charity, rue Saumaise in Dijon; held at the Bureau de Bienfaisance, 1922.

BIBL.: Quarré 1960C, no. 13, pl. I; Camp 1990, p. 96, repr. p. 100.

EXH.: Amsterdam 1951, no. 191; Brussels 1951, no. 178; Dijon 1951, no. 122; Dijon 1976, no. 56, pl. XXXI; Dijon 2000, p. 382, no. D 43; Dijon 2002 (not in catalogue).

This statue's recent restoration permits us a new appreciation of its fine quality. St. Luke is identified with the bull, whose head appears by his feet, near the end of a scroll in which the Evangelist is writing. He is enveloped in a mantle that covers him from his neck to his feet, and is creased in large, flat folds. His hair and beard are wavy. His features, regular and serene, lined with wrinkles, delineate a gentle smile.

Seated figures are rare in the art of Burgundy. Should we see in this statue an isolated work, intended perhaps for a niche, or the single surviving element from a group of the four Evangelists? In either case, there is no convincing basis of

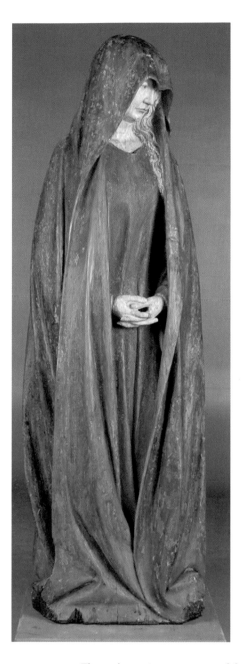

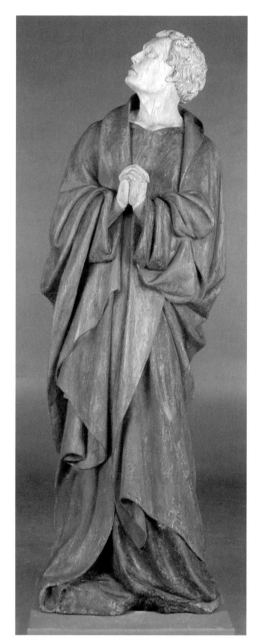

FIG. 1. *St. Mary Magdalene,* second quarter of the 15th century, stone, detail of the Entombment. Dijon, Église Saint-Michel.

The sculptor gives us a masterful interpretation of the figure of Mary, whose static quality should not be interpreted as simple resignation. Looking at this statue, one can compare the enveloping mantle to a sort of layer from which the figure of Mary unobtrusively emerges. In any case, the details—the held breath, the crossed fingers, the hopeless gaze—allow the viewer to understand her feelings.

The artist shows a complete knowledge of the formal reality of the drapery and its aesthetic and moral quality. There is no doubt that the mourners from the tomb of Philip the Bold made a lasting impression on artists of this period. Burgundian sculptors working at the same time as the project at Champmol and contemporary with Claus de Werve must have perceived the extremely exemplary manner of his expressive rendering of the fabric. And the bereaved mother emerging from her cloth covering has the same cultural lineage as the St. Madeleine in the *Entombment* from the church of Saint-Michel in Dijon, an elderly fisherwoman with clasped hands, whose "lip" of an encasing mantle can be compared to that of the figure of Jonas (fig. 1).

V.B.

129

Claus de Werve
(Haarlem, ?–Dijon, 1439)

Virgin and Child, known as the *Bulliot Virgin*
First quarter of the 15th century

Polychromed limestone
117 x 36 x 20 cm

Autun, Musée Rolin, inv. M.L. 558

Bɪʙʟ.: Vitry 1901, pp. 69–70; Mâle 1908, p. 150; David 1933, 1: pp. 59, 123, 160, 226; Aubert 1946, p. 422; Müller 1966, p. 56; Camp 1985, p. 562; Camp, 1990, pp. 255, 257; Baudoin 1996, p. 167; Bertrand 1997, 2: no. 20; Jérôme 1997–98; Bresc-Bautier Chevillot, and Ducros 1998, no. 218.

Exʜ.: Autun 2002, pp. 68–69.

Exhibited in Dijon only

Clothed in a robe covered with a mantle, Mary holds the Christ child against her chest; he is swaddled and gazes at her with tenderness. Her forearms squeeze against the little body, above and below, emphasizing the shape of the newborn child, upon which the viewer's attention logically rests. The work stands out because of the unusual appearance of the child and the manner in which he is carried, both figures reciprocally enhancing each other. Mary's arms form a cradle, and the weight that she carries is emphasized by the clean silhouette of both figures. In Mary's face, with its delicate features, the

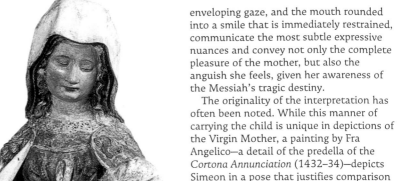

enveloping gaze, and the mouth rounded into a smile that is immediately restrained, communicate the most subtle expressive nuances and convey not only the complete pleasure of the mother, but also the anguish she feels, given her awareness of the Messiah's tragic destiny.

The originality of the interpretation has often been noted. While this manner of carrying the child is unique in depictions of the Virgin Mother, a painting by Fra Angelico—a detail of the predella of the *Cortona Annunciation* (1432–34)—depicts Simeon in a pose that justifies comparison with this statue (fig. 2). The posture and gestures are only similar, but they translate with equal measure the infinite tenderness of the older figure and convey "a delicate and touching grace" that makes the *Bulliot Virgin* so successful.

The skill with which the artist suggests the absolute love of mother for child, the originality of the ideas, and the artistry with which he weds the contrasts within a single figure, all point decisively to the style of Claus de Werve.

A more detailed examination reveals the relationship between the features of the Virgin and those of the right angel from the tomb of Philip the Bold, which are just slightly more masculine (p. 320, fig. 3). Despite the Virgin's slightly plumper neck, her profile is more convincingly similar to that of the Château-Chalon Madonna (cat. 125). A comparison with the face of the Virgin in the altarpiece of the *Lamentation over the Dead Christ*, in the Musée National du Moyen Âge in Paris, attests to other correspondences that support the intervention here of the same hand (p. 324, fig. 10).

V.B.

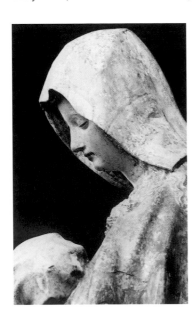

Fɪɢ. 1. *Virgin and Child* (Bulliot Virgin), detail.

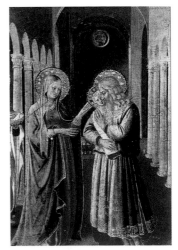

Fɪɢ. 2. Fra Angelico, *Presentation in the Temple,* detail of the predella of the Cortona Annunciation, c. 1432–34, tempera on wood. Cortona, Museo Diocesano.

Burgundy

St. Anthony
First quarter of the 15th century

Stone, a few traces of polychromy
H. 80 cm

Paris, Musée National du Moyen Âge–
Thermes de Cluny, inv. Cl 14277

PROV.: bought at the Gaillard sale, 1904, with the arrears from the Baron Adolphe de Rothschild bequest.

BIBL.: Haraucourt and Moncremy 1922, no. 300; Baudoin 1996, p. 109.

The saint is standing wearing a robe that hangs in large vertical folds and a coat whose tail is lifted over his right shoulder. His bare left foot protrudes from under the coat. His head is buried in a bonnet covered by a hood. His face and heavy wavy beard bend toward the book he holds in his left hand. Small flames that symbolize the fire of St. Anthony are indicated on the sculpture's base. The pig that frequently accompanies representations of the saint was probably also present on the base, which displays evidence of a break. The piece was originally entirely polychromed, but only a few very small traces of paint have survived to the present day.

While the provenance of this statue is unfortunately not known, placing it in Burgundian sculpture of the first quarter of the fifteenth century is not difficult. Saints reading a book, whether truly reading or just inclining the head in a meditative attitude, were frequent in Burgundy. St. Anthony's wavy beard, his pronounced features, and his profoundly meditative expression are all clearly inspired by Sluter's approach. The vertical folds of his coat can be found in certain mourners on the tomb of Philip the Bold, such as no. 35, in the Cleveland collection (cat. 83), or in the Poligny *St. Leonard* (cat. 106). The statue must therefore date from the first quarter of the fifteenth century. Baudoin's suggestion (1996) that it be attributed to Gilles Tailleleu, a collaborator of Jean de Marville who was remunerated in 1389 for an altarpiece with four 2-ft. stone statues, including a *St. Anthony*, is, of course, unacceptable.

This statue is undoubtedly closest to the *St. Anthony* by Mouthier-Vieillard (cat. 108). It is probably in reference to the latter that the tau cross that St. Anthony holds in his right hand was added sometime after the statue entered the museum's collection. Yet other statues in Manlay and Thoisy-le-Désert (Côte-d'Or) have the same composition. Perhaps they are derived from an older model. One cannot help but think of the statue of *St. Anthony* in the ducal oratory in Champmol, but it is difficult to go any further without knowing what it looked like.

S.J.

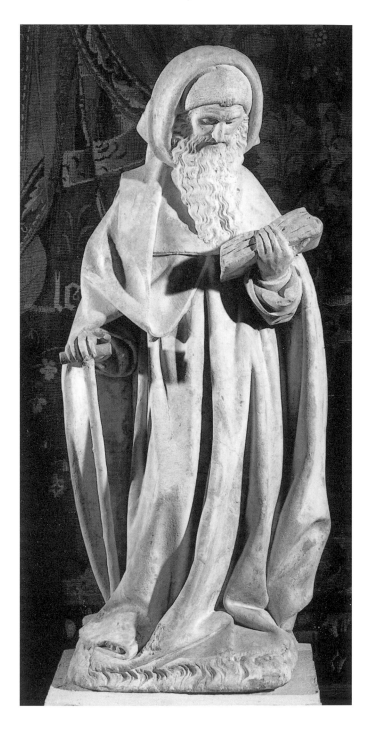

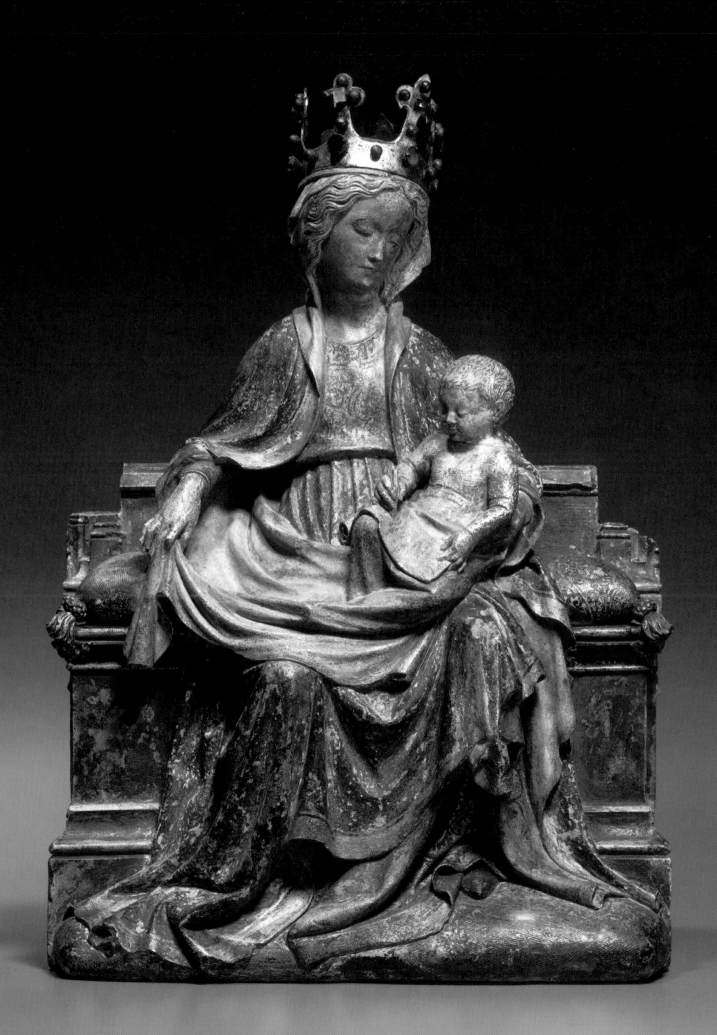

131

Franco-Netherlandish, probably Île-de-France

Enthroned Virgin with the Writing Christ Child
Beginning of the 15th century

Limestone with polychromy and gilding
H. 44.8 cm

FIG. 1. *Enthroned Virgin with the Writing Christ Child*, detail.

Cleveland, The Cleveland Museum of Art, John L. Severance Fund, inv. 1970.13

PROV.: Kurt Rossacher, Salzburg.

BIBL.: Wixom 1970, pp. 287–302; Forsyth 1986, p. 52, fig. 15.

EXH.: Paris 1981, pp. 163–65, cat. 116.

Exhibited in Cleveland only

Certain aspects of this small devotional sculpture strongly suggest its date and place of origin, and link it to a tradition of seated Virgins familiar in Netherlandish art of the decades around 1400 that is also associated with the Valois courts at Paris, Dijon, and Bourges. These features include the exposed strands of wavy hair that frame the Virgin's face, her high forehead, rounded chin, and the mantle draped across her lap and left arm that partially covers the child; the exposure of a portion of the Virgin's foot beneath her robes has been observed in sculptures by Claus de Werve.

Examples in illumination, drawing, painting, and sculpture include the *Enthroned Virgin with the Writing and Nursing Christ Child* in the *Très Belles Heures* (fig. 1), the large sculpture *Seated Virgin and Christ Child* from Poligny by Claus de Werve (cat. 105), and the tondo *Seated Virgin with the Writing Christ Child* in Baltimore (cat. 112), to mention but a few. The theme of the Christ child writing in an open book or on a vellum banderole emerged during the third quarter of the fourteenth century and clearly had appeal to both clergy and aristocracy. It undoubtedly refers to the educating and nurturing role of the mother, and to the future of the adult Christ as author and teacher.

The intimate scale of the Cleveland sculpture and the fact that its back is uncarved suggest it was made to be placed in a small alcove or niche, perhaps in a chapel or oratory. The sculpture would have been seen primarily from the front and perhaps from slightly below.

S.N.F.

132

Burgundy

Standing Virgin
c. 1440–60

Limestone with partial polychromy and gilding
H. 104.7 cm
Inscriptions on reverse

Cleveland, The Cleveland Museum of Art, inv. 1986.92

PROV.: Unknown, said to derive from a private collection near Dijon; New York art market, 1986.

BIBL.: De Winter 1987, pp. 426–29, 432–35.

Exhibited in Cleveland only

This standing figure of the Virgin now lacks the child she once cradled in her left arm. It has been suggested that the sculpture was damaged in the Revolution by falling onto its face. It was carved from soft white limestone of a type known to be quarried at Asnières-lès-Dijon, near Champmol.

Authorship of this sculpture has not been established. The figure recalls many of the hallmarks of the style assimilated by Claus de Werve from his uncle, Claus Sluter: slightly squat in proportion, the Virgin has a sweet, round face that is also smooth and fleshy, her eyelids droop pensively, and her nose is strong and elongated. The Virgin is engulfed in rich voluminous draperies that cascade in deep tubular folds. These traits have invited comparison with the lamenting angels on the upper part of the *Well of Moses*, as well as with many of Claus de Werve's numerous Virgin and Child commissions, leading to the only known publication of this work, in 1987, as attributed to Claus de Werve. However, his workshop was large and his influence widespread, both during his lifetime and after his death in 1439.

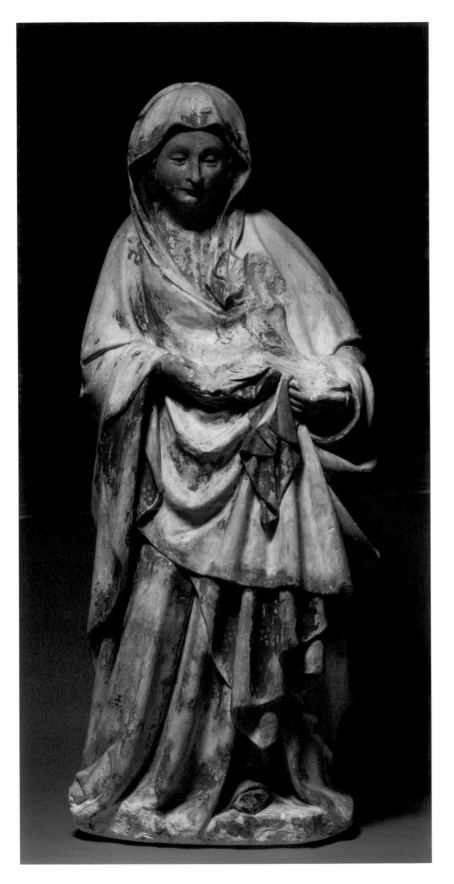

The Cleveland *Standing Virgin* appears to lack the precise carving, monumental folds, and strongly delineated features of Claus de Werve's major works. His *Seated Virgin and Child*, carved for the Poor Clares at Poligny around 1420 (cat. 120), for example, displays a higher level of carving and the aristocratic physiognomy for which his figures are well known. The Cleveland sculpture should instead be seen as a charming reflection of his many Virgin and Child groups. It was probably carved by a follower closely acquainted with his style in the middle of the century and shortly after his death.

The back of the sculpture is not fully carved, suggesting that it was placed against a wall or an architectural element, and the downward gaze would indicate a position high on a socle. Tool marks and minute, almost illegible inscriptions on the back in a fifteenth-century script—apparently workshop notations—provide no firm clues as to authorship. Similar inscriptions have been noted by Pierre Quarré on the portal sculptures at Champmol and other related Burgundian sculptures, and remain to be fully assessed.

S.N.F.

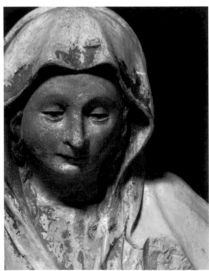

FIG. 1. *Standing Virgin*, detail.

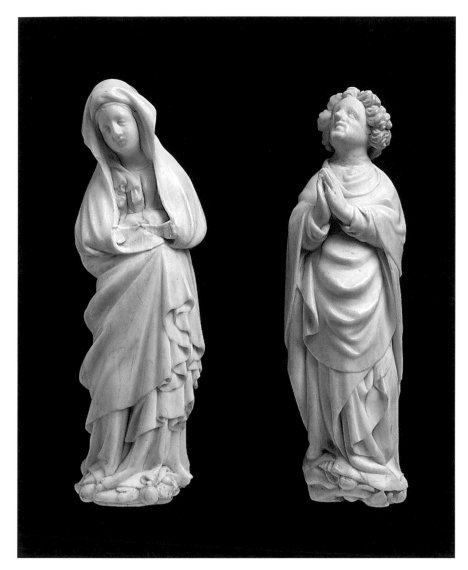

FIG. 1. *St. John* from the glory beam, c. 1410–20, polychromed wood. Poligny, Église Saint-Hippolyte.

133

Virgin and St. John of the Cross
c. 1400–1420

Ivory
Virgin: 102 x 34 cm
St. John: 99 x 29 cm

Boston, Museum of Fine Arts, inv. 49.486 and inv. 49.487

BIBL.: Ithaca 1968, pp. 163–64 n. 90; Randall 1993, no. 27.

EXH.: New York 1949, no. 683; Detroit 1997, no. 66.

From time to time, these two small ivory statues, originally part of a Crucifixion scene, have been compared to the figures of angels created by Claus Sluter and his workshop between 1399 and 1401 for the pedestal of the Crucifixion at the Chartreuse de Champmol. The influence of stylistic developments specific to artistic circles in Dijon around 1400 has been recognized in the significance of the drapery and the extremely curly hair of St. John. The general appearance of the Virgin brings to mind one of the angels from the famous *Well of Moses*, with the mantle encasing the shoulders and the arms bent forward, to form a ring of fluted folds. The St. John, however, bears scarcely any resemblance to the male figures sculpted by Claus Sluter and his workshop. The flatness of the cheeks, the angular appearance of the jaws, and the stylization of the thick, well-differentiated curls have more in common with more "classical" Flemish statues, which were not, or were only slightly, influenced by the expressive force and disquieting naturalism of Sluter's figures. In this regard, the comparison, instead, of the Evangelist to the St. John from the glory beam in the church of Saint-Hippolyte in Poligny proves interesting, particularly in terms of the treatment of the head (fig. 1).

Details that are sufficiently defined to merit attention, such as the lowered eyes of the Virgin and the St. John, must be viewed in the spirit of a group study, within a more specific definition of the artistic milieu it reflects. These are quite different from Sluter's physical types and incompatible with his naturalistic orientation.

V.B.

Céline Vandeuren-David

Metalwork and Metalworkers under Philip the Bold and John the Fearless:

Dijon

To assure buyers impeccable quality and to protect the commercial reputation of the city, the town council of Dijon regulated the metalworking trade beginning in 1375, and again in 1391, but the most comprehensive order was issued in 1443. The council maintained strict control over raw materials and weights, and also held sway over the trade by using its right to seize defective materials, confiscate property, and even banish persons guilty of fraud. The brotherhood of St. Eligius also trained and supervised metalsmiths. We know that it existed as early as 1375, but it was in 1421 that the bishop of Langres authorized the deed of foundation.

The metalsmiths' clientele included both patrons and buyers, and comprised three groups: the municipal authorities, the ducal family, and private individuals.

The town council placed orders either for its own use (stamps for sealing bolts of cloth, enameled cartularies) or to offer as gifts to important personages such as the duke, the duchess, or foreign emissaries. To give a few examples: in 1404, the town council presented John the Fearless with silver and gilt tableware. The people of Dijon presented the duchess with 20 marcs of silver in dishes and jewels. In 1420, Jehan Robert made a silver candy dish for the widow of the duke.

Ducal orders also increased during this period, especially for raw materials such as diamonds and pearls. The duchess also asked Parisot l'Orfevre, in 1411, to make her some knives and a sheath. In 1401, the duke bought a silver beaker from Thomas Lorote for the Viscountess of Murat, and, in 1417, twenty-four silver cups. Satisfied with this work, he gave "one franc . . . certain foreign workers who in [lostel] the aforementioned Thomas had made for my aforementioned lord the said cups."

Private individuals purchased two kinds of metalwork. The first was already made and generally met the criteria of fashion. The second was produced to satisfy a client's personal desire to own a unique object that could be easily identified, which was far from unimportant in case of theft. Indeed, precious objects that were stolen almost immediately found a place in the economic system by being sold to the highest bidder. Cut up, melted down, or transformed, it was not long before they reappeared, modified or unchanged, in the stalls of metalsmiths or haberdashers.

One can distinguish clearly between two types of products. The first was what one would commonly call metalwork. It consisted of more impressive objects, such as tableware (cups, vessels, etc., in silver or silver gilt) or liturgical objects (reliquaries, chalices, crosses, etc.). Objects of finery were the second type of goods made by the metalsmiths of Dijon. We have an impressive number of descriptions, thanks to estate inventories, of such items as girdles, purse ornaments, rings, brooches, rosaries, and garment pins. But it is difficult to know if these were produced locally or if they were imported.

The metalsmiths did not limit themselves to production or sales. We also know that they did repairs and maintenance as well as recycling (melting down, reuse). An order sent to Jehannin Foucet, Dijon metalsmith from 1369 to 1395, illustrates the process well because he "confess[es] . . . to have received from Adam of Coone, castellan of Duesme [canton of Aignay-le-Duc] a silver chalice weighing seven and a half ounces, which he promises he will return and deliver to him remade and matched sufficiently and well."

Metalsmiths were relatively numerous in Dijon; some, either because they had financial problems or because they wished to diversify their sources of income, engaged in other professional activities. Others specialized in one specific type of work—engraving seals, enameling—and hired out as subcontractors.

134

Jacques the enamelist

Two Plates Bearing the Coat of Arms of the City of Dijon: Decorating the Binding of the Cartulary of the City of Dijon
1430

Plates: enameled and gilded copper
8 x 8 cm
Cartulary: parchment, leather binding
31 x 26 x 6 cm

Dijon, Archives Municipales,
inv. B 114

PROV.: Collection of the municipality of Dijon.

Exhibited in Dijon only

This cartulary (binder for official documents), known as the Philip the Bold cartulary, is decorated with two copper plates. Each is enameled in blue and red, one plate adorning the front cover and the other on the back. The plates were commissioned by the city hall around 1430. The interest of this cartulary, besides its contents, resides in the fact that it is one of the few such objects to have reached us for which we have at our disposal the object, the commission, and the cost of making it: "To Perrenet the glover for a half skin of red cord to cover the city's cartulary III gros which is VI sols VIII deniers tournois / Idem to Jehan Pastinien for having covered said cartulary the XXth of September VI blans which is II sols VI deniers tournois / Idem to Jaquet Lemmailleur a gold salut which is worth XVI half gros for having put two copper plates gilded and enameled with the coat of arms of said city worth said XVI half gros XXVII sols VI deniers tournois. / Idem to Jehan Bon Jour for several small

nails used to nail the large nails of said cartulary II gros which is III sols IIII deniers" (municipal commission for the cover of cartulary B 114, kept in Dijon, AM, M 62 bis, fol. 10).

Looking at this cartulary also allows us to visualize the various techniques, including enameling, used by Dijon goldsmiths at the end of the Middle Ages. The municipal council called on four artisans, all of whom lived on or near the Rue des Forges (Ironworks Street), the city's economic heart. Although the profession of enamelist is mentioned following several patronymics, which are found here and there in the source documents from that period, the corpus of professional ordinances does not give any indication of this activity in Dijon. Yet, upon reading postmortem inventories, it is clear that enamel was used to decorate small religious furniture as well as lay objects that required gold and silver plating, such as belts, brooches, and rings, but even more often for small garment accessories such as nails, mordants, and buttons. It should therefore not surprise us to learn that this work was done by goldsmiths, who found their raw materials at the haberdasher's. While the cartulary's plates are made of copper, Dijon sources clearly show that the favored materials on which to apply enamel were gold, silver, and gilded silver. Color is mentioned relatively rarely, except in the case of white and black.

C.V.-D.

135

Paris or Dijon?

Pastoral Ring
c. 1400

Gilded copper, stippled punchmarks, cabochon in crystal on gold foil leaf
H. 45 cm

Dijon, Musée des Beaux-Arts,
inv. 1014-2

PROV.: discovered in the choir of the Church of Saint-Étienne during excavations begun in

1887 by the Historic Monuments Department (service des Monuments historiques); Paris, Musée de Cluny (Musée National du Moyen Âge); warehouse of the Musée National du Moyen Âge, 1892.

BIBL.: Quarré 1945–47; Stratford 1995, p. 137, fig. 85.

EXH.: Paris 1900, no. 1961; Amsterdam 1951, no. 242; Dijon 1951, no. 169; Brussels 1951, no. 222; Dijon 1957, no. 75; Ingelheim 1986, no. 78.

This object, discovered during the excavations begun in 1886 in the choir of the Church of Saint-Étienne of Dijon, seems to be a pastoral ring. Its dimensions indicate that it adorned a gloved hand. The ring is characterized by a design of interlaced plants bearing flowers and fruit and its stippled setting corresponds to the decorative style of the end of the fourteenth century and of the fifteenth century, as seen in the reliquary of Charles the Bold, which is kept in Liège. The stone found in the bezel is without value and is apparently a relatively recent addition. But the original stone was not necessarily precious either. The metalsmith's ordinance of 1443 only prohibited the use of artificial stones in pieces made of gold. The municipality, in the following text, recognized that valueless stones were in general use: "We prohibit all metalsmiths now present or coming to reside in Dijon, even apprentices, henceforth from setting or allowing to be set any artificial stone in any work of gold" (Dijon, AM, fol. 14). One must also note that the rules were equally restrictive with regard to the use of gilded copper on the "jewels" of the Church. Indeed, far from being prohibited, gilded copper could serve the unique purpose of informing the client by leaving a revealing trace of the materials used. "Furthermore, we have ordered, and we order that from now on no reliquary or church jewel shall be made in any manner whatsoever of gilded or silver-plated copper unless there is [oud] on that reliquary or jewel some clearly visible place left bare so that one can see that [led] said reliquary or jewel is made of gilded or silver-plated copper. And not of silver so that the uninformed won't buy it thinking it is silver. And this is on pain of a fine of 100 tournois sous to be levied and enforced as above" (Dijon, AM, G3, fol. 14v).

The cavity of the bezel is covered in gold. The Dijon metalsmiths regularly resorted to using gold leaf, as did the painters. They obtained supplies at the grocers or the haberdashers, the price varying between 3.5 and 4.5 francs depending on the size of the leaf.

Given the inexpensive materials used and the diameter of the ring, it seems that it was intended to adorn someone's mortal remains.

C.V.-D.

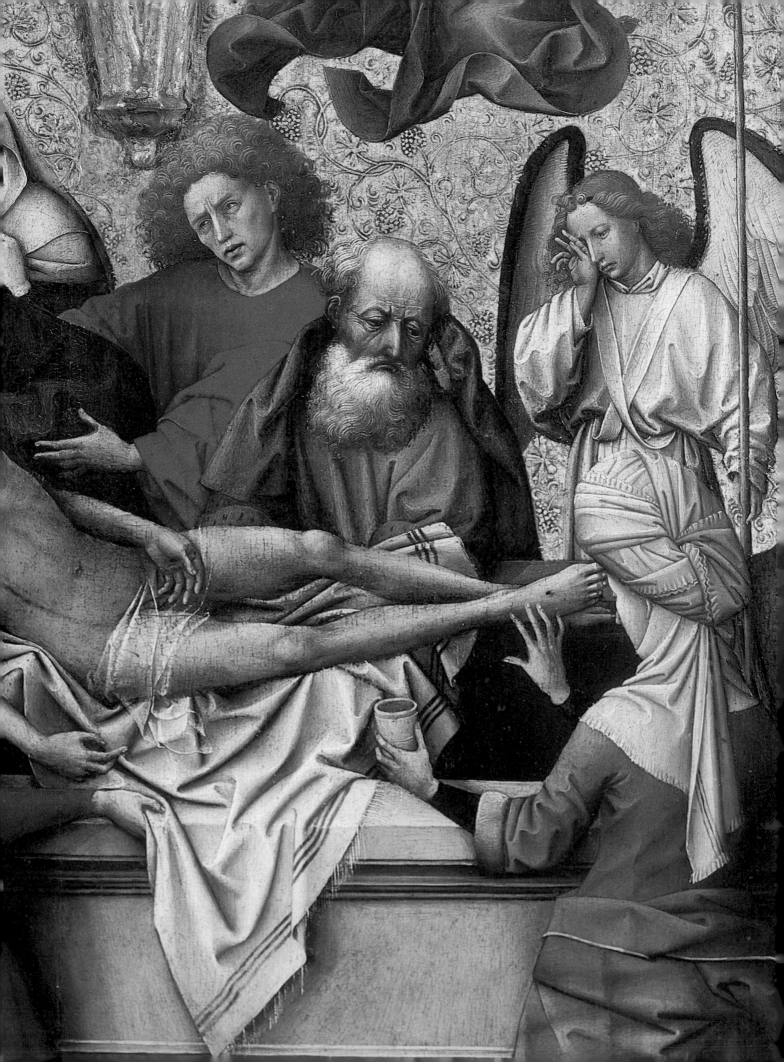

By Way of a Conclusion

Till-Holger Borchert

Claus Sluter and Early Netherlandish Painting: Robert Campin and Jan Van Eyck

The fundamental contribution of the sculptor Claus Sluter to overcoming the normative formal canons of the International Gothic style in Northern Europe during the period around 1400 was recognized early on by art historians, who, while constructing evolutionary models of history, fully recognized the individual achievement of an extraordinary artist.[1] Characteristically, scholars were mainly interested in Sluter's role as one of the most important precursors and pioneers of the revolutionary painting of the early "Flemish Primitives," that is, the paintings of Jan Van Eyck and Robert Campin (originally known as the Master of Flémalle)[2] and, to a lesser extent, Rogier van der Weyden. The importance, however, of Sluter's work to the development of Northern large-scale sculpture and his relationship to the Franco-Flemish sculptural tradition of the fourteenth century were considered less significant.

This assessment had to do, on the one hand, with the fact that Sluter, who worked in Dijon as a Burgundian court artist for the first Valois Duke of Burgundy, was considered one of the predecessors of Jan Van Eyck, who entered the service of Philip the Good as valet de chambre in 1425.[3] Yet, the relative neglect of Sluter's impact on sculpture largely stemmed from the idea, first fully developed by Max Dvorak,[4] that the artistically rich and realistic painting of the early Netherlanders did not evolve unconditioned, but rather was based on the achievements of other art forms created in the last third of the fourteenth century in the immediate circle of the courts of the dukes of Valois: initially in Paris, and later in Bourges, Angers, Dijon, and in their other princely residences. These art forms were, primarily, illuminated manuscripts, but also magnificent tapestries, precious goldsmithery, and, of course, monumental stone sculpture.

Some of the most significant innovations in the panel painting that flourished in the Netherlandish cities of the 1430s had already been anticipated decades earlier in the art forms of the Valois courts that had traditionally been practiced by migrant artists from the Netherlands and Flanders. From this perspective scholars began to comprehend the achievements of the early Flemish panel painters as a unique synthesis of artistic trends articulated by the immediately preceding generation of artists. This is why much attention was focused on the patronage of the first two Burgundian dukes from the house of Valois, Philip the Bold and Jean the Fearless, and the Netherlandish artists prominent in the construction and furnishing of the Chartreuse de Champmol.

In Champmol, in the paintings of Jean de Beaumetz, Jean Malouel, and Melchoir Broederlam and, in particular, in the sculptures of Claus Sluter, Netherlandish art appears to have first significantly broken free of the basic norms of the dominant Parisian court art. A characteristic and independent form of expression was invented, one that can be identified, despite the generally rudimentary art records from those years, as the basis of panel painting in the Burgundian Netherlands that flourished under the rule of Philip the Good (1419–67). In particular, the three-dimensional corporeality, portrait realism, and meticulous naturalism of Sluter's sculptures for Champmol foreshadow the paintings of Van Eyck, Campin, and van der Weyden, and it is this peculiar relationship between sculpture and painting that provoked scholars to further inquire this matter.

Erwin Panofsky credited the Flemish painters with the ability to gain knowledge from sculpture, with its "kind

Fig. 1. Robert Campin, *Triptych of the Lamentation,* detail: the angel in tears. London, Courtauld Institute.

345

of prenatal lead over painting," from which they had learned "to impart to their figures a plastic solidity that made them look like sculpture turned into flesh."[5] Panofsky attributed this mainly to the commissions that the Duke of Burgundy granted to Sluter, a representative of Netherlandish monumental sculpture. Sluter, originally from Haarlem, achieved the final separation of three-dimensional stone sculpture from the architectural continuum typical of the great tradition of Gothic stonemason's lodges, as may be most clearly observed in Sluter's majestic portal of the Chartreuse de Champmol.

Unlike Franco-Flemish illuminated manuscripts or tapestries, it is relatively easy to isolate the formative influence of sculpture in the Burgundian Netherlands on early Netherlandish panel painting. This is because the works of the Netherlandish panel painters of the first generation —Van Eyck, Campin, and van der Weyden— are characterized not only by the prominent three-dimensionality of their figures, but also by their remarkably pronounced and artistically motivated interest in reproducing nature and artificial sculpture. Using the characteristic expressive means of painting, early Netherlandish painters aimed for the complete illusion of three-dimensional sculpture, thus convincingly demonstrating their claim that they had won the contest between the arts. Parallels have rightly been drawn between this hierarchical claim and the theoretical *paragone* debate in Italy.[6]

The lower outer register of the "founding work" of early Netherlandish painting, the *Ghent Altarpiece* completed by Van Eyck in 1432 (fig. 2), already pointedly shows trompe-l'oeil depictions of niche statues of John the Baptist and the Evangelists, resembling fully three-dimensionally molded, monochrome stone sculptures. Here the effect is further intensified by the comparison of the grisailles with the donor portraits, also praying figures in niches. While, for example, the faces and the drapery of the hair in Van Eyck's painted sculptures look more stereotyped than, for example, Sluter's figures in the *Well of Moses*, Van Eyck's portraits of Jodocus Vijd and Elisabeth Borluut are distinctly reminiscent of the monumental donor portraits on the portals of the Chartreuse de Champmol, which Sluter had finished thirty years earlier. Both there and on the *Ghent Altarpiece* the sculptures are largely separated from their architectural context, strongly suggesting that Van Eyck may have been inspired by the Burgundian works of the Haarlem master, whom he, a widely traveled court painter of the Duke of Burgundy, certainly must have known, and who also fashioned furnishing pieces for the Chartreuse de Champmol.[7]

Similarly prominent painted sculptures are also found on the so-called Flémalle panels, the fragment of a lost

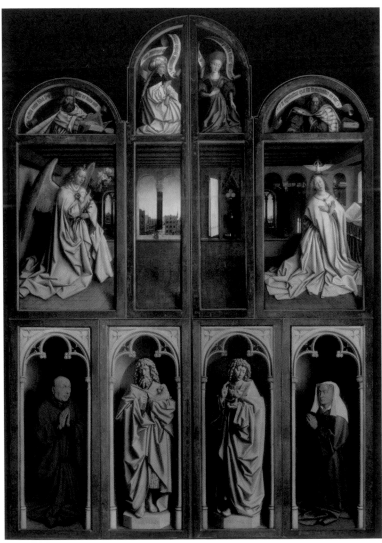

Fig. 2

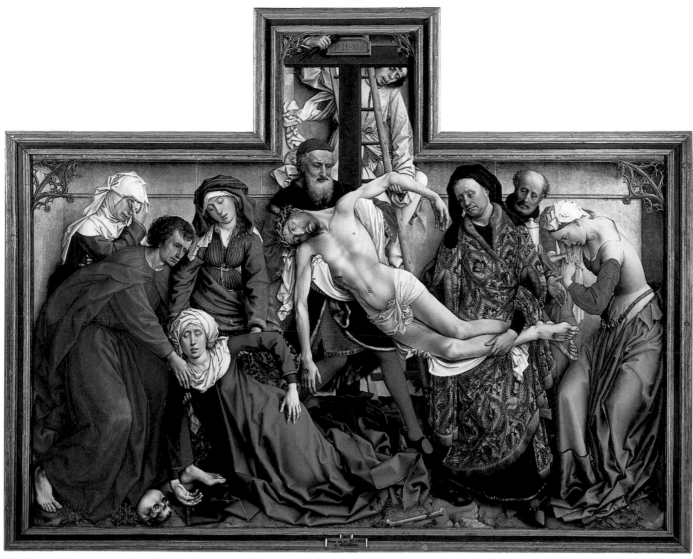

Fig. 4

Fig. 2.
Jan and Hubert Van Eyck,
The Ghent Altarpiece,
closed, oil on wood.
Ghent, Saint-Bavon
cathedral.

Fig. 3.
Robert Campin, *St.
Veronica/the Trinity*.
Frankfurt, Städelmuseum.

Fig. 4.
Rogier van der Weyden,
The Deposition, c. 1435.
Madrid, Museo del Prado.

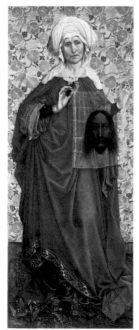

Fig. 3

masterpiece by Campin and his Tournai workshop from around 1430, in the Frankfurt Städelmuseum (fig. 3). These panels may have originally been part of a two-sided folding altarpiece with double wings, with a feast day side consisting of a carved shrine, such as the *Dijon Passion Retable* by Jacques de Baerze.[8] The *Madonna* and *St. Veronica*, which subtly evoke painted wooden statues, and two other panels may have been the front side. What remains of the back of the altarpiece is a trinity, a group of figures that seems to project three-dimensionally from a niche set in a painted masonry wall. This is a particularly impressive trompe-l'oeil painting effect, which, unlike the practice of Sluter and Van Eyck, is based on the idea of architecture-linked sculpture from the tradition of the late Gothic stone-mason's lodges.

Early Netherlandish panel painting was fascinated with sculpture. Take, for example, Van Eyck's and Campin's grisailles, or the sovereign illusion of the polychrome box retable that van der Weyden used as a subject in the mid 1430s in his famous *Deposition Altarpiece* (fig. 4) created for the Louvain crossbowmen, a painting that can truly be called "sculpture made flesh."[9]

Also the copy of a polychrome figure retable created by van der Weyden was closer to normal studio practice of the time, characterized by cooperation between painters and sculptors, and most of all wood carvers, than to Campin's and Van Eyck's false monochrome grisailles. This is because during this period, sculptures were generally painted or gilt. It seems that toward the end of the fourteenth century, with the development of specialized studios, the actual sculpting and painting were increasingly executed in different studios. The fact that Broederlam gilded Jacques de Baerze's sculptures and Malouel, the court painter of Philip the Bold, painted Sluter's *Well of Moses* is an especially revealing aspect of the cooperation of Burgundian court artists in Dijon, although this practice seems to have started in the urban craftsman milieu of Flanders rather than in the court studios.[10] In any case, Sluter also possessed the necessary competence to evaluate the artisanship of Baerze's wood carvings and Broederlam's painting.[11]

At the beginning of the fifteenth century, panel painters in Flanders were normally charged with both the polychroming and gilding of three-dimensional sculptures. Occasionally they provided the sculpture studios with preliminary sketches.

We have one source for each artist proving that Van Eyck and van der Weyden painted sculptures. In 1435, Van Eyck was occupied with the coloring of stone statues on the façade of the Bruges town hall. The sculpture project—the genealogy of the dukes of Flanders—had been commissioned from Louis de Male, and begun in

1376 under the direction of Jean de Valenciennes, a stonecutter presumably trained by the court sculptor André Beauneveau, from Valenciennes.[12] In 1439, van der Weyden was commissioned to decorate a stone monument with the Madonna and the Duchess of Brabant and Guelders. They had been made by the Brabant sculptor Jan van Evere and erected in the Brussels Franciscan church.[13]

The commissions for the polychroming and gilding of stone and wooden sculptures are especially well documented for Campin and his Tournai studio. Between 1405, the first documented mention of the master in Tournai, and 1446, the year of his death, a large number of documents prove that, in addition to commissions for frescos, escutcheons, banners, and altarpieces, Campin also received regular commissions to paint stone and, most of all, wooden statues.[14] This line of work therefore provided a substantial source of income for Campin's workshop from an early date, for at the time Tournai was one of the most important centers of sculpture in Northern France and Flanders, where there was a special demand for polychroming. Although in particular, recent Campin literature has suggested that the master largely left to his workshop the task of coloring sculpture,[15] this hypothesis is by no means corroborated by known sources. To the contrary, on a commission by the renowned Tournai sculptor Jacques de Brabant, Campin had painted his sculptures as early as 1406, which allows us to conclude that the painter must have had a reputation as a polychromist at this early date. Campin regularly received commissions from the City of Tournai and from the city's church maintenance fund to paint prominent sculptures, for example, the statues of the belfry or the triumphal cross group of St. Brice, which also supports the master's prominent role in such painting. Interestingly enough, it seems that Campin worked closely with some sculptors based in Tournai, for example, the sculptor and architect Jean Daret, father of Jacques Daret, who later became Campin's apprentice;[16] and the wording of at least one document leads us to believe that the Tournai studio may have been entrusted with sketches and the execution of sculptures.[17] Presumably, in this case Campin acted with his studio as general contractor, entrusting the sculpture work to an independent studio. The coloring of the Annunciation figures created by the Tournai sculptor Jean Delemer—though disfigured by subsequent re-paintings—is the only remaining evidence of Campin's work in this area.[18]

In any case, more than Van Eyck's oeuvre, Campin's paintings and those attributed to his studio are characterized by the remarkable monumental plasticity of their figures. In particular, the draperies and voluminous folds of the garments and the pose of the figures are closely

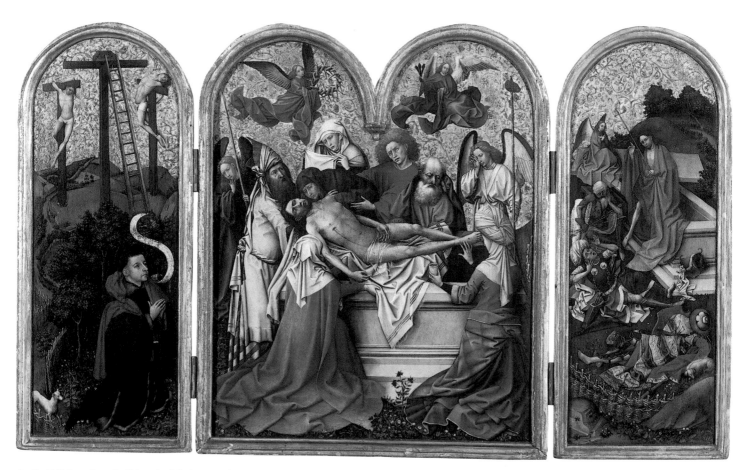

Fig. 5. Robert Campin, *Triptych of the Lamentation*.
London, Courtauld Institute.

related to three-dimensional works. This observation made scholars hope long ago that they could use stylistic criticism of the remarkable affinity of Campin's painting with Franco-Flemish sculptures to draw conclusions about the master's Tournai apprenticeship.

One of the greatest obstacles in the search for Campin's artistic roots in the Franco-Flemish sculpture of the late fourteenth century was the fragmentary tradition of three-dimensional sculptures from those years, hardly ever seeming to come together into truly historically substantiated groups; also, given the stylistic heterogeneity of the works ascribed to Campin and the disputed dating of the paintings, the painter's training and origin are at best hypothetical. Which of the paintings in the Campin studio should be attributed to the master himself, and which should be assigned to the assistants of the stature of van der Weyden? These questions divide scholars today more than ever. Even if we date Campin's work to very early in his career, as Albert Châtelet does, there is a significant distance from the main examples of Franco-Flemish sculpture and even from Sluter's works dating from his Burgundian period;

the crucial influence of sculpture on Campin's oeuvre must supposedly have been particularly strong in his early career and decreased afterward.[19]

All the more interesting is the fact that one of Campin's undisputed early works, the small triptych with the *Entombment of Christ* in London (fig. 5), clearly shares motifs with Sluter's *Well of Moses*: the pose, gesture, face, and wings of the two tiny angels at Christ's sepulcher are surprisingly similar to Sluter's monumental angels on the Champmol *Well of Moses* (see p. 218). How then did the Tournai painter receive Sluter's repertoire of motifs?[20] Campin's familiarity with the *Well of Moses* is also supported by the lasting influence of Sluter's portraits—in particular the prophets and the donor figures of the portal—on Campin's male heads (fig. 6), especially those with beards.[21] The extent to which Sluter's lost furnishings for the Burgundian ducal palace of Germolles also influenced the pastoral mood of, for example, Campin's *Birth of Christ* remains a matter of pure speculation.[22]

The painter's presumed birth and death dates and geographic origin lend a certain plausibility to Châtelet's

Fig. 6. Robert Campin, *Portrait of Robert de Masmines*. Madrid, Thyssen collection.

Fig. 7. Attributed to the studio of André Beauneveu, *Head of an Apostle*, from the chapel of the château of Mehun-sur-Yèvre, end of the 14th century. Paris, Musée du Louvre.

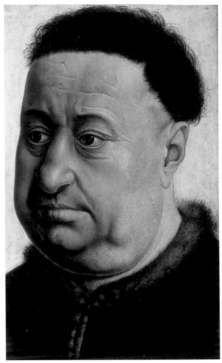

Fig. 6

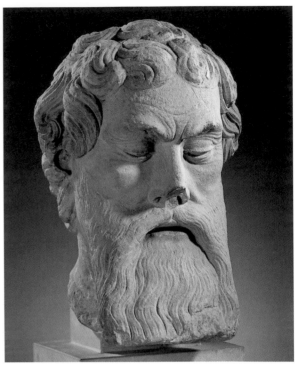

Fig. 7

fascinating hypothesis that before settling in Tournai in 1405–6, Campin was a journeyman in the Malouel, Bellechose, and Sluter milieu in Dijon and could have helped decorate the Chartreuse de Champmol.

Born probably in Valenciennes in the 1370s, Campin was a contemporary of Jean de Cambrai, whose portal sculptures in the Sainte-Chapelle of Bourges are inconceivable without the model of Sluter's donor portal in Champmol. Jean de Cambrai was a colleague and successor of the sculptor André Beauneveu (born around 1330) at the court of Jean de Berry. While in Valenciennes, Campin must have seen the sculpture significantly influenced by Beauneveu, who, after serving Charles V in Paris, worked on the decorative sculptures of the deputy mayor's palace, leaving a lasting influence on the local art production in Valenciennes and the neighboring cities.[23]

The sculptor's style was doubtlessly also crucial for the young Sluter, who entered the Brussels stonemason's guild in 1379, where he apparently worked on the most significant Brussels construction site of the time—Saint Gudule—while Beauneveu was working on the sculptures of the Mechel city hall and its belfry, just 30 kilometers away, a commission from the Duke of Flanders.[24] There should be no doubt that Beauneveau and Sluter must have met at the time and that the younger man was

familiar with the works of the renowned older master (fig. 7), given the close relations among the late medieval stonemason's lodges. After all, as late as 1393, it was Sluter who selected the legendary furnishing work of the deceased Beauneveu in Mehun-sur-Yèvre.[25]

The fact that Campin was from Valenciennes and was familiar with the tradition founded by Beauneveu may have led him to other work in Dijon and Champmol. In addition to sharing motifs with Sluter's sculptures in Burgundy, in which the Haarlem sculptor outgrew the sculpture tradition, Campin's early work also has an unmistakable affinity with the Burgundian paintings of Malouel and Bellechose, thus supporting Châtelet's thesis. In this case, however, Campin genuinely evolved in painting, albeit under the influence of Van Eyck's works, as the Flémalle panels show. At the same time he linked the innovations of Van Eyck's *ars nova* with the achievements of Sluter's sculpture.

It is also clear that as a painter, Campin was initially too bound to the old Beauneveu tradition to head in new directions on his own, based on the experience of Sluter's sculpture. Campin would have needed the guidance of younger masters such as Van Eyck and van der Weyden, who were able to approach Sluter's art with fresh detachment, as has been illustrated by the idiosyncratic emulation of Sluter's innovations in the *Ghent Altarpiece*.

NOTES

1. For a summary of the complex situation regarding Sluter research, see Morand 1991, pp. 7–12.
2. See Châtelet 1996, pp. 7–13; Kemperdick 1997, pp. 5–11; Vos 1999, pp. 42–84.
3. Paviot 1990, pp. 210–15.
4. Dvorak 1903, pp. 161–317.
5. Panofsky 1960, pp. 170, 172.
6. See Panofsky 1953, pp. 162; Preimesberger 1991, pp. 459–89, esp. 472–82; see also Borchert 1997, pp. 61–63.
7. Goodgal-Salem 1997, pp. 517–27.
8. For a comprehensive treatment of the reconstruction of the Flémalle panels, see Kemperdick 1997, pp. 12–28; see also Châtelet 1996, pp. 286–88; the bold attempt at a reconstruction found in Thürlemann 2002, 109–30, is not convincing.
9. Most recently, Vos 2003, pp. 73–82.
10. Morand 1991, pp. 118–20.
11. Monget 1898–1905, 1: pp. 207–8; Comblen-Sonkes 1984, pp. 138–39, no. 11; Bichler 1992, pp. 23–30.
12. Janssens de Bisthoven 1944, pp. 7–81, esp. 30–33; Duverger 1955, pp. 83–120, 101; Dhanens 1980, pp. 149–54; Martens 1992, pp. 90–93.
13. Dhanens 1995, pp. 100–101; Vos 1999, pp. 60.
14. See the compilation of the documents on Robert Campin in Châtelet 1996, pp. 345–58, and Thürlemann 2002, pp. 336–61.
15. Thürlemann 2002, p. 11.
16. On Jean Daret, see Châtelet 1996, p. 283; Kemperdick 1997, p. 156.
17. Châtelet 1996, p. 351; Thürlemann 2002, p. 348 no. 36; for the opposing view, see Kemperdick 1997, pp. 151 and 199 n. 11.
18. Rolland 1932, pp. 49–57; Châtelet 1996, p. 324; Kemperdick 1997, p. 151.
19. Châtelet 1996, pp. 45–159 and 283–306; see also the arguments in Kemperdick 1997, pp. 149–64, esp. 151.
20. Châtelet 1996, pp. 52–60 and 284–86; Kemperdick 1997, pp. 67–73; Thürlemann 2002, pp. 28–37 and 255–57; most recently, Nys 2003.
21. Pächt 1989, pp. 40–41, stresses Sluter's possible influence on old Netherlandish portrait painting using Campin.
22. Châtelet 1996, pp. 15–31. Châtelet bases his assumption on Robert Campin's origin on the archival information on Martin Campin from that city, presumably a relative of the painter (pp. 359–61).
23. On Beauneveu, see Scher 1967; Meiss 1967; Hilger 1978, 1: pp. 43–49; concerning Beaneveu and Jean de Cambrai, see Zeman 1995, pp. 165–214.
24. Duverger 1933; Scher 1968, pp. 3–14; Morand 1991, pp. 23–47, esp. 27–42.
25. Monget 1898–1905, 1: p. 248; Morand 1991, p 379.

136

Robert Campin
(about 1375–1444)

St. John the Baptist
c. 1410

Oil on oak panel
17.2 x 12.2 cm
On the back of the panel, inscribed into the gesso: ALBERDE[И]R [?]

Cleveland, The Cleveland Museum of Art, inv. 1966.238

PROV.: (according to a letter from Thomas P. Grange in the files of the Cleveland Museum of Art): in the family of the ducs de Clermont-Tonnerre; Nettancourt-Vaubecourt family [Gaspard-Louis-Aimé de Clermont-Tonnerre, duc de Clermont-Tonnerre married Anne-Marie de Nettancourt-Vaubecourt in 1847]; Le Molt, Bourbon-les-Bains; his niece; Christie's, London (26 June 1964), no. 44, as "School of Cologne"; Thomas P. Grange.

BIBL.: Pieper 1966, pp. 279–82; Van Gelder 1967, pp. 1–17, no. 12, 13; Lurie 1974, pp. 147–49, no. 52; Châtelet 1996, pp. 60–61, 284, no. 2; Thomas 1998, pp. 160–62, no. 57; Thürlemann 2002, pp. 15–18, 255, no. 1.2.

This small panel, trimmed along the lower edge, originally depicted a full-length John the Baptist and formed the right wing of a triptych. In this position, St. John's glance would have likely rested upon a central image of the Virgin (possibly seated), the Holy Family, the Trinity, or if the panel is part of a *deësis* group as suggested by Thomas (1998), Christ Pantokrator. Campin appears to have responded to Eastern representations

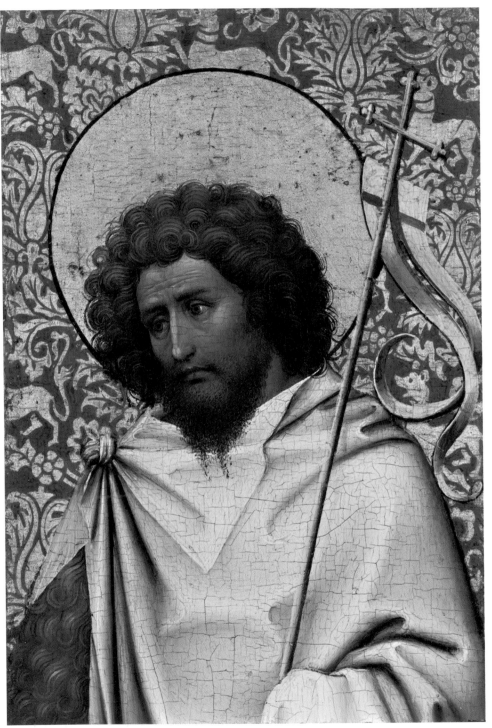

of the saint with a Christ-like image consistent with the Greek Orthodox interpretation of John the Baptist as *Prodromos* (forerunner) of Christ (Malachi 3:1). He carries a thin reed cross bearing a split banner with a red cross on a white ground, symbolic of Christ's triumph over death (as seen in the *Resurrection* panel of Campin's *Seilern Triptych*, about 1415) and wears a white cloak partially covering the usually prominent hair shirt described in the gospels. In the background, the animal and vegetal motives on the green and gold silk—probably produced in Lucca or Venice around 1400—imitate more expensive Eastern fabrics.

Despite a lack of documentary evidence, Robert Campin's connection early in his career to the court of Burgundy, and especially to Dijon, has generally been supported by stylistic analysis. The Cleveland painting and the slightly later *Seilern Triptych* reveal an intimate knowledge of the emotional and psychological realism of Claus Sluter's work at the Chartreuse de Champmol at the end of the fourteenth century. The contemplative expressions, downward glances, and wrinkled foreheads of Sluter's prophets for the *Well of Moses* (pp. 214–17) find a painted companion in the figure of John the Baptist, whose covered left hand, an unusual detail, derives from the Sluterian idea of heightening drama through enveloping drapery. Even the voluminous curly hair of John the Baptist (repeated in the figure of John the Evangelist in the Seilern picture) can be traced to the distraught angel between David and Jeremiah from the *Well of Moses*.

The Cleveland panel is dated to the first decade of the fifteenth century based on its relationship to the Seilern picture and the influence of Sluter's sculpture, which is more direct in the Cleveland painting. This date is also supported by the textile design and Campin's uncommon use of an untooled nimbus surrounded by a dark outline set against an elaborate brocade background, which can be found in manuscripts from the early fifteenth century such as the *St. Peter Martyr* from the *Boucicaut Hours* dated between 1405–8 (Paris, Musée Jacquemart-André, MS 2, fol. 30v.).

T.H.

Biographies of Painters and Sculptors

Active at the Chartreuse de Champmol
or the Ducal Residences in Burgundy

NOTE: Because the bibliography on these famous artists is abundant, we have emphasized dictionaries, monographs, and surveys published in the last thirty years. Earlier bibliographies can be consulted in these more recent volumes. Source documents have principally been published by: Dehaisnes 1886; Monget 1898–1905; Prost 1902–8; Cassagnes-Brouquet 1996; and Prochno 2002.

The Ducal Painting Workshop

The collaborators of Jean de Beaumetz, Jean Malouel, and Henri Bellechose left numerous traces in the ducal accounts, which attest to their activities alongside the heads of the workshops in Champmol, Montbard, Rouvres-en-Plaine, Argilly, Germolles, and sometimes in Villaines-en-Duesmois, Salmaise, Talant, among other places, as well as on countless items such as coats of arms, banners, wagons, and harnesses. Arnoul Picornet, Jean de Beaumetz's principal collaborator, appears in the ducal accounts beginning in 1377. Beaumetz evidently put Picornet in charge of certain jobs when other work monopolized his own attention. Picornet also played a major role in the decoration of the chapel of the châteaux at Argilly and Germolles from 1384 to 1390, while Beaumetz was primarily occupied with working in Champmol.

BIBL.: Cassagnes-Brouquet 1996, 3: see Amant (Colin), Bâle (Henri de), Bar-sur-Aube (Jacques de), Casin, Chapelle (Girard de), Cologne (Hermann de), Francheville (Guillaume de), Gand (Torquin de), Gasse (Guillaume de), Gentil or Gentilhomme (Jean); Guillaume, Henriot or Horriot, LeFort (Girard), Marin (Huguenin), Marin (Thevenin), Nivelles (Girard de), Perreau, Picornet (Amiot), Picornet (Arnoul).

The Ducal Sculpture Workshop

From 1372 to about 1410 numerous collaborators assisted the duke's successive sculptors. The workshop included sculptors from the Low Countries such as Hennequin de Prindale, who is first recorded as being present in Brussels, Claus de Haine and Gilles Tailleleu, both from Tournai; French sculptors such as Perrin Beauneveu, who was probably a relative of André Beauneveu; and, occasionally, Burgundian sculptors such as Guillaume de Benoisy, from Côte d'Or. Certain sculptors appear regularly over the course of many years, others only appear sporadically. Their numbers vary depending on the work.

Despite the large amount of information provided by the accounting documents, it remains difficult to determine the organization of the work site and the division of labor between the head of the workshop, his principal collaborators, and the least skilled assistants. Some of these artists were active before and after their stay at this work site and were themselves the heads of important sites. For instance, the reconstructed career of Hennequin de Prindale shows that from 1409 to 1424 he worked for Duke Amedeus VII of Savoy. It would be useful to know to what extent the work of the ducal workshop reflected the individual sensibility of the head of the workshop or whether his principal collaborators had a hand in the work's conception. This raises the whole question of the participation of Claus de Werve in the *Well of Moses*, or, even more delicate, given that no pieces definitively attributed to Jean de Marville have survived and that his artistic personality can therefore only be the subject of conjecture, the question of Claus Sluter's contribution to the two principal jobs undertaken by Jean de Marville at Champmol, the portal of the chapel and the tomb of Philip the Bold.

BIBL.: Camp 1990, pp. 58–63; Beaulieu and Beyer 1992, pp. 171–204, see Ami (Guillaume), Aplemain (Pierre), Arviet (Jehannin), Baumerchier (Heinne de), Beauneveu (Perrin), Beaurain (Gilet), Belot (Jean), Benoisy (Guillaume de), Bonnet (Gilles), Bruxelles (Hennequin de), Cotelle (Antoine), Franquette (Jacques), Frapart (Jehannin), Haine (Armant de), Haine (Claus de), Haine (Liévin), Hulst (Jean de), Lambillon (Humbert), Lefèvre (Thomas), Le Mire (Perrin), Liquerque (Pierre), Maclart, Marate (François), Midey (Jean), Rigny (Jean de), Rot (Mas de), Selles (Jean de), Semont (Gilles de), Tailleleu (Gilles), Tailleleu (Tassin), Toicy (Perrin de), Van Busegem (Franquin), Van Erain (Philippe), Vasciquien (Hennequin), Vauclaire (Hennequin), Vauclaire (Thierry), Westerhen (Roger de); regarding Prindale (Hennequin de) see Romano 1994, pp. 178–79, and Trento 2002, nos. 58 and 59; regarding the carpenter Liège (Jean de), see Richard 1992.

Baerze (Jacques de, active in Termonde, end of the 14th century)

The accounts of the duchy of Burgundy and for the general receipts of Flanders allow us to establish that this sculptor based in Termonde (eastern Flanders) was in charge of the construction of the *Altarpiece of Saints and Martyrs* (cat. 67) and the *Altarpiece of the Crucifixion* (cat. 68) for the Chartreuse de Champmol and, perhaps, of a third altarpiece for the high altar; payments are spread out from 1392 to 1396. It is possible that Jacques de Baerze worked for a few years in Dijon, but his style does not seem particularly influenced by those of Sluter and the ducal workshop. There are no works that can be attributed to him in Flanders.

BIBL.: Didier and Recht 1978; Comblen-Sonkes 1986; Beaulieu and Beyer 1992, pp. 173–74; Bichler 1992.

Beaumetz (Jean de, ? c. 1335–Dijon, 1396)

Several villages in the Pas-de-Calais or the Somme could be matched with Jean de Beaumetz's name. In any case, he was a man from the north of France, who is first

documented as being in Valenciennes in 1361. There is evidence of a stay in Paris in 1371. In 1376, he was hired by Philip the Bold as a painter and valet de chambre and settled in Dijon, in the outbuildings of the ducal palace. He initially worked in the chapel of the ducal palace in Dijon and was in charge of painting the duchess's cart. Banners, escutcheons, and decorations for jousts were perennial tasks. He also renovated Jacquemart's polychromy on Notre-Dame de Dijon. In 1379 he executed a painting of the Virgin Mary, St. John, and other saints destined for the Chartreuse de Lugny on the duke's behalf. He worked in various ducal residences: Montbard in 1381, Argilly in 1384–88, Rouvres-en-Plaine in 1387, then, in 1388–90, Germolles, where certain decorations can still be seen. His workshop's activities in Champmol are particularly well documented: the church in 1387–88, the ducal oratory in 1389–90, including three statues of the Virgin Mary, St. John the Baptist, and St. Anthony; they were placed at the altar, and he was also responsible for their polychromy. In 1389 the painter received a commission for twenty-six devotional panels for the cells of the Carthusian monks, two of which have been preserved (cat. 71a–b), and of four altarpieces, the subject of one of which we know: the crowning of the Virgin Mary between the Annunciation and the Visitation.

In 1393 he took a trip to Mehun-sur-Yèvres with Sluter to see the work done by André Beauneveu. In 1394, he took another trip, to Bruges. Beaumetz died in October 1396.

BIBL.: Laveissière 1980, pp. 32–34; *Allgemeines Künstlerlexicon* 8: p. 74; Cassagnes-Brouquet 1996, 3: pp. 38–74.

Bellechose (Henri, d. 1445)

Originally from Bréda, in the Brabant region, Bellechose is first recorded in Burgundy in 1415, when he was appointed painter and valet de chambre to John the Fearless as a replacement for Jean Malouel. Like his predecessors, he made coats of arms, banners, and decorations for feasts and funeral chariots. At Champmol, he completed the work left unfinished by the death of Malouel. In 1415 he was put in charge of "perfecting" a painting of the life of St. Denis), his only surviving work, which he finished in 1416 (p. 199, fig. 1). In 1417, he made paintings in the ducal palace. After the death of John the Fearless, Philip the Good confirmed Bellechose's appointment, but ducal commissions became rarer: like Claus de

Werve, Bellechose found his clientele in the private and municipal sectors. In 1425, he was commissioned to make a painting of the Virgin and Child featuring John the Fearless being presented by St. John the Baptist and Philip the Good presented by St. Claude. This painting was intended for the chapel of the chateau of Saulx-le-Duc. Like Beaumetz, he renovated the polychromy of the Jacquemart in Notre-Dame de Dijon in 1427, as well as the paint on three statues of the new door of the ducal palace. In 1429, he was commissioned to execute a tabernacle, the polychromy of a statue of St. Michael, an altarpiece featuring Christ and the twelve apostles, and an antependium featuring the Annunciation for the Saint-Michel church in Dijon. His last known work was the decoration of a door in the ducal palace. We have limited knowledge of the end of his life. He died in 1445.

BIBL.: Laveissière 1980, pp. 36–37; *Allgemeines Künstlerlexicon*, 8: pp. 452–53; Cassagnes-Brouquet 1996, 3: pp. 80–107.

Broederlam (Melchior, active in Ypres, 1381–1410)

Melchior Broederlam was established in Ypres. He was the appointed painter of the Count of Flanders, Louis de Male, between 1381 and 1384, before entering the service of Philip the Bold in 1384. Decorating pennants, standards, coats of arms, and jousting saddlery was a major part of his activities both for Louis de Male and Philip the Bold. Between 1386 and 1392 he worked in the château d'Hesdin. He supervised the renovation of the galleries in which some of the famous automatons were kept, executed murals, and, perhaps, sketches for tapestries. He seems to have worked with themes from the Trojan War and the Golden Fleece. The only work by Broederlam that has been preserved is a pair of shutters from the *Altarpiece of the Crucifixion* (cat. 70), as well as the gilding and the polychromy from the sculpted part of this altarpiece and the *Altarpiece of Saints and Martyrs*, a commission from the duke for the Chartreuse de Champmol. The two altarpieces were brought to Broederlam's workshop by the sculptor Jacques de Baerze in 1393 and, once finished, were transported to Dijon by the painter in 1399. Broederlam returned to Dijon in 1403 for an unspecified job. After the duke's death in 1404, he continued to work for the duchess, for whom he decorated, among other things, a litter. His last documented works were a portrait of Philip the Bold and a portrait of Margaret of Flanders for the Sainte-Catherine chapel,

the chapel of the counts of Flanders in the Notre-Dame de Courtrai church. These two paintings were to be integrated into the series of portraits of the counts of Flanders. Broederlam also worked for the town of Ypres. He provided the sketches for objects to be made by silversmiths. Broederlam died in 1410. Beyond the documented altarpieces of Dijon, it has been proposed that other works such as the *Polyptych of the Life of Christ* of Antwerp and Baltimore (cat. 74) be attributed to him or to his school, but there is no documentary evidence for this.

BIBL.: Comblen-Sonkes 1986, 1: pp. 70–158; *Allgemeines Künstlerlexicon* 14: pp. 326–27; Cassagnes-Brouquet 1996, pp. 436–40.

Malouel (Jean, d. 1415)

Jean Malouel was born to a family from Nimègue, in the duchy of Gueldre. His father, Wilhelm, was a painter of standards and blazons at the court of Gueldre, and Jean himself was the uncle of the miniaturists Jean, Paul, and Hermann de Limbourg. There is evidence that Malouel was working for Isabeau of Bavaria in Paris in 1396–97. He was responsible for drawing patterns for ornaments and coats of arms. It was probably through this work that he was noticed by Philip the Bold, who appointed him painter and valet de chambre as a replacement for Jean de Beaumetz. Malouel then moved to Dijon. In 1398, he was paid for a painting depicting the apostles and St. Anthony and intended for the charterhouse's ducal oratory. He executed other altarpieces and antependiums for the charterhouse, the iconography of which are unknown to us, as well as numerous mural decorations, including those in the parlor, and paintings above the main doors of the monastery. He traveled to Paris to paint a decoration above a door of the hôtel de Conflans, then to Arras, where he made joust decorations with Melchior Broederlam. Like other painters, he made coats of arms, banners, and decorations for feasts. He was in charge of the polychromy of the *Well of Moses* of 1402, while continuing to paint altarpieces for Champmol. After the death of Philip the Bold, John the Fearless confirmed his appointment in 1406. His first projects were joust decorations in Paris and in Compiègne. In 1410 he painted the polychromy for the tomb of Philip the Bold. In 1413 he painted a portrait of John the Fearless for the king of Portugal. He died in March 1415. There are no surviving works that are documented as having been executed by Malouel. The *Large Round Pietà* (p. 94, fig. 1) bears the arms of Philip the

Bold and is mentioned in the ducal inventory of 1420; it would be logical to attribute the work to an official painter of Philip the Bold's, who cannot be Beaumetz, whose style can be seen in the two *Crucifixions with a Carthusian Monk* in Paris and Cleveland. It would therefore be plausible to attribute this masterpiece to Malouel, who died in 1415. Based on this initial attribution, it has been proposed that the *Virgin with Butterflies* in Berlin (p. 97, fig. 2) be attributed to him. Other proposed attributions, such as the Virgin in the Aynard collection in the Louvre, the *Portrait of a Lady* in Washington (National Gallery of Art), and the original sketches for the portraits of John the Fearless in the Louvre and of Wenceslas of Luxembourg in the Thyssen collection are not documented and are far from unanimously accepted.

BIBL.: Cassagnes-Brouquet 1996, 3: pp. 465–89; Paris 2004, pp. 292–93.

Marville (Jean de, Merville?, ? 1366–Dijon, 1389)

Possibly from the area of Liège, Marville is first recorded in Lille in 1366. In 1369 he was paid for "pictures and masonry" in the chapel containing the tomb of the heart of Charles V in Rouen. It is therefore on a royal worksite that Philip the Bold hired Marville as a sculptor and valet de chambre, that is, as his appointed sculptor. In 1372 Marville moved to Dijon, and lived there until his death in 1389. He worked principally at Champmol, where in 1384 he began work on the tomb of Philip the Bold (cat. 80). The monument's arcatures were made under his direction. In 1388, he delivered the statue for the high altar of the charterhouse, a statue of the Trinity, whose influence can probably be seen in the Trinity by Genlis (cat. 85). Before his death, he may have had the time to make the three statues for Champmol's oratory, the Virgin Mary between St. John the Baptist and St. Anthony, which were installed in 1390. In 1388 he also began working on the sculpted decorations of the church's portal (p. 175). Outside of Champmol, he made the statues of an apostolic college for the chapel of the château d'Argilly in 1388, a Virgin and Child for the chapel of the château of Talant, and probably participated in the decoration of the château of Germolles.

The question of the artistic personality of Jean de Marville, of whose work we have no examples, remains an insoluble problem. It has been deduced that it was Sluter who broke with the style that flourished under Charles V, because Jean de Marville belonged to the previous generation and had been active at a royal worksite. Therefore, when looking at the portal of Champmol, the evidence of Sluter's modifications of the prior layout has led experts to contrast a traditional Jean de Marville with an innovative Sluter, all the while forgetting that the architect could have been responsible for the design of the portal with three vertical statues and that the duke could have requested the switch to five statues for iconographic reasons. Reading the accounts for the tomb of Philip the Bold in which the construction of the arcades appears leads one to believe that the conception of the galleries was indeed by Marville. Given these facts, the attempts to attribute to him certain important Burgundian statues bearing traces of stylistic characteristics of the fourteenth century (the Virgin and Child in Toucy, the statue of Étienne Porcher praying in Joigny) seem unfounded.

BIBL.: Camp 1990, pp. 22–29; Beaulieu and Beyer 1992, pp. 191–92; Schmidt 1992; Morand 1992; Didier 1993, pp. 25–27.

Sluter (Claus. Haarlem, c. 1360–Dijon, 1406)

Born in Haarlem, Sluter is first recorded in a register for the Brussels stonecutters, masons, and figurine sculptors' guild in 1379–80. The duchy of Burgundy's accounts allow us to follow his activities at the service of Philip the Bold, then John the Fearless. As of 1385, Sluter was hired as a workman under the direction of Jean de Marville, who had been the head of the ducal workshop since 1372. After Marville's death, Sluter became the head of the ducal workshop in 1389 and remained in that position until his death in 1406. Sluter worked exclusively for the duke, and only in Burgundy, but his activities were not limited to the charterhouse. In 1393, the duke sent him with Jean de Beaumetz to become acquainted with the work done by André Beauneveu for Jean de Berry at the château de Mehun-sur-Yèvre. He also had the opportunity to go to Flanders and Paris to buy supplies. He worked on the chapel of the ducal palace and the residence of the Duchess of Germolles (Saône-et-Loire), where, in 1400, he finished a "pastoral" that has since been lost, and which represented the duke and duchess under a tree, surrounded by ewes. His first work for the Chartreuse de Champmol was the portal, made between 1389 and 1393 (p. 175). He also made numerous sculptures that were unfortunately destroyed during the Revolution, and of which only a few fragments were found (p. 184 and cat. 65).

His most impressive work is undeniably the *Well of Moses* (p. 213). He also took part in the construction of the tomb of Philip the Bold (cats. 80–83), which was made between 1381 and 1410.

BIBL.: Morand 1991; Beaulieu and Beyer 1992, pp. 195–200.

Werve (Claus de, Haarlem, ?–Dijon, 1439)

Originally from Holland or from Gueldre, Claus de Werve arrived in Dijon in 1396 to assist his uncle, Claus Sluter. The work then underway was the *Well of Moses* (p. 213). According to documents, he worked on the statues of the Virgin and of Christ, then on the prophets. It is believed that his contribution was most specifically on the figures of David and Isaiah. He may have sculpted an *Education of the Virgin* (see cat. 90). Claus de Werve was responsible for finishing the tomb of Philip the Good (cats. 80–83), including the recumbent figures, the angels, and nearly all the mourners. The work was entirely completed by 1410. John the Fearless then commissioned Claus de Werve to make his tombstone, but apparently it was never truly begun. At a time when ducal commissions in Burgundy were no longer as frequent, Claus de Werve resorted to a private clientele, probably unlike Marville, and certainly unlike Sluter. In 1414–15 he was paid for the decoration of the House of the Mirror, the Carthusian monks' house in Dijon. It is also known that, in order to reimburse a tax debt, he made a Virgin and Child and a St. Andrew for the mayor and the aldermen of Dijon, and perhaps, a praying figure of Dino Rapondi for the Dijon Sainte-Chapelle, which today is only known through a drawing. Other statues have been attributed to Claus de Werve for stylistic reasons, by comparison with the angels on the tomb of Philip the Bold, but without any supporting evidence from written sources. Works attributed to him include the *Virgin Mary as Teacher* at the Clarist convent of Poligny (cat. 122), the *Virgin of the Founder* (cat. 105), *St. Thibaut* (cat. 103) and *St. Leonard* (cat. 106) at the collegiate church of Poligny, and the Christ at Saint-Bénigne. Though of mediocre quality, the altarpiece at Bessey-les-Cîteaux was donated by Jean de Noes, the confessor of Margaret of Bavaria, and bears the inscription "per Claus fabricatum," but it seems very unlikely that it was made by Claus de Werve.

BIBL.: Camp 1990, pp. 64–105; Beaulieu and Beyer 1992, pp. 201–4.

Bibliography

ACNSS: Actes du Congrès national des sociétés savantes
BSNAF: Bulletin de la Société nationale des antiquaires de France
CMA Bulletin: Bulletin of the Cleveland Museum of Art
GBA: Gazette des Beaux-Arts
MCACO: Mémoires de la Commission des antiquités du département
de la Côte-d'Or
RBAHA: Revue belge d'archéologie et d'histoire de l'art

ADHÉMAR, Hélène.
1961. "La date d'un portrait de Jean sans Peur, duc
de Bourgogne. Étude d'après un exemplaire conservé
au musée du Louvre." Revue du Louvre et des Musées
de France 9.
1962/1995. "Le portrait de Jean sans Peur." In Les
Primitifs flamands. Le Musée national du Louvre, Paris.
3 vols. Vol. 1 is no. 5 of Corpus de la peinture des
anciens Pays-Bas méridionaux au quinzième siècle.
Brussels, 1962. Vols. 2 and 3 are no. 17 of Corpus
de la peinture des anciens Pays-Bas méridionaux au
quinzième siècle. Paris/Brussels, 1995.
ADHÉMAR, Jean, and Gertrude DORDO. 1974.
"Les Tombeaux de la Collection Gaignières. Dessins
d'Archéologie du XVIIe siècle, Teil I." GBA, 6e série,
no. 84.
ALLEMAGNE, Henry René d'. 1928. Les Accessoires du
costume et du mobilier. Paris.
Allgemeines Künstlerlexicon. 1922. Munich/Leipzig.
ANDRIEU, Ernest.
1914. "Les pleurants aux tombeaux des ducs de
Bourgogne." La Revue de Bourgogne.
1913–21. "Le pleurant de la collection Perret-Carnot
est le no. 17" and "Les pleurants Pourtalès passés en
Amérique." MCACO 17.
1922–26. "Tentative de vol d'un pleurant à Saint-
Bénigne en 1793." MCACO 18.
1933. "Les tombeaux des ducs de Bourgogne au
musée de Dijon." Bulletin monumental.
ANFRAY, Marcel. 1964. La Cathédrale de Nevers et les
églises gothiques du Nivernais. Paris.
ANIEL, Jean-Pierre. 1983. Les Maisons de Chartreux.
Des Origines à la Chartreuse de Pavie. Geneva.
ANTWERP. 1958. Walter Vandeselaere. Musée Royal
des Beaux-Arts, Anvers. Catalogue descriptif. Maîtres
anciens.
ARASSE, Daniel. 1981. "Entre dévotion et culture:
fonctions de l'image religieuse au XVe siècle." Faire
croire. Modalités de la diffusion et de la réception des
messages religieux du XIIe au XVe siècle. Rome.
ARMAND-CALLIAT, Louis. 1940. "Carreaux historiés
de provenance chalonnaise." Mémoires de la Société
d'histoire et d'archéologie de Chalon-sur-Saône 19.
ARMSTRONG, C. A. J. 1983. "La politique
matrimoniale des ducs de Bourgogne." England,
France and Burgundy in the Fifteenth Century. London.
AUBERGER, Jean-Baptiste. 2001. Mystère de Fontenay.
La-Pierre-qui-Vire.
AUBERT, Marcel.
1927. Les Richesses d'art de la France. La Bourgogne.
La sculpture. Paris.
1928. "La Chartreuse de Champmol" and "Saint-
Thibault-en-Auxois." Congrès archéologique de France
91, pp. 110–20 and 252–66.
1930. La Bourgogne, la sculpture. Paris.
1946. La Sculpture française au Moyen Âge. Paris.
1947. L'Architecture cistercienne en France. Vol. 1.
Paris.
AUBERT, Marcel, and Michèle BEAULIEU. 1950.
Description raisonnée des sculptures du Moyen Âge, de
la Renaissance, et des Temps modernes. Vol. 1. Moyen
Âge. Paris.
AUBERT DE LA CHENAYE-DESBOIS, François-
Alexandre. 1969. Dictionnaire de la noblesse. 19 vols.
3rd ed. Nachdruck Nendeln/Liechtenstein (first
published in Paris, 1868–76).
AUCHINCLOSS, Louis. 1990. J. P. Morgan,
The Financier as Collector. New York.

AULOY, Gilles, Patrice BECK, Laurence BLONDAUX,
et al. 2002. Vie de cour en Bourgogne à la fin du
Moyen Âge. Saint-Cyr-sur-Loire.
AUTRAND, Françoise.
1969. "Offices et officiers royaux en France sous
Charles VI." Revue historique 242.
1986. Charles VI. Paris.
1994. Charles V. Paris.
2000. Jean de Berry. Paris.
AVRIL, François.
1969. "Trois manuscrits napolitains." Bibliothèque de
l'École des chartes, no. 127, pp. 291–328.
1975. "La peinture française au temps de Jean
de Berry." Revue de l'art, no. 28, pp. 40–52.
1978. L'enluminure à la cour de France au XIVe siècle.
New York/Paris.

BACKHOUSE, Janet. 1990. The Bedford Hours.
London.
BAERTEN. 1969. Het graafschap Loon. Assen.
BÄHR, I. 1996. "Zur Entwicklung des Altarretabels und
seiner Bekrönungen vor 1475." Städel Jahrbuch 15,
pp. 85–120.
BAIER, Walter. 1977. Untersuchungen zu den
Passionsbetrachtungen in der "Vita Christi" des Ludolf
von Sachsen. Ein quellenkritischer Beitrag zu Leben und
Werk Ludolfs undzur Geschichte der Passionstheologie.
Ph. D. diss. University of Regensburg. 3 vols.
(Analecta cartusiana 44). Salzburg.
BAPST, Germain. 1887. Études sur l'orfèvrerie française
au XVIIIe siècle: Les Germain, orfèvres-sculpteurs du
Roy. Paris.
BARBIER, L. N. 1857. Esquisse historique sur l'ivoirerie
(Beaux-Arts et Industrie). Paris.
BARNES, A., and V. DE MAZIA. 1931. The French
Primitives and Their Forms. From Their Origin to the
End of the Fifteenth Century. Merion, Pennsylvania.
BARON, Françoise.
1960. "Un artiste du XIVe siècle: Jean Pépin de Huy.
Problèmes d'attribution." Bulletin de la Société de
l'histoire de l'art français, pp. 89–94.
1981. "Sculptures." In Paris 1981.
1990. "Le décor du soubassement du tombeau
d'Anne de Bourgogne, duchesse de Bedford." BSNAF,
pp. 262–74.
1996. Sculpture française. Musée du Louvre.
Département des sculptures du Moyen Âge, de la
Renaissance, et des Temps modernes. Vol. 1. Moyen
Âge. Paris.
Forthcoming. "Le tombeau de Philippe le Hardi (titre
provisoire)." Bulletin des musées de Dijon.
BARON, Françoise, and Sophie JUGIE.
2004. "Précisions sur le tombeau de Philippe le Hardi
à partir de l'étude de sa restauration au XIXe siècle."
BSNAF.
Forthcoming. La Restauration des tombeaux des ducs
de Bourgogne, du XIXe au XXIe siècles.
BARROIS, J. 1830. Bibliothèque protypographique ou
Librairies des fils du roi Jean, Charles V, Jean de Berri,
Philippe de Bourgogne et les siens. 3 vols. Paris.
BASTIN, J. 1946. "Le traité de Théodore Paléologue
dans la traduction de Jean de Vignai." In Études
romanes dédiées à Mario Roques. Paris.
BAUDOIN, Jacques.
1983. La sculpture flamboyante. Vol. 1. Les Grands
Imagiers d'Occident. Nonette.
1996. La Sculpture flamboyante en Bourgogne et
Franche-Comté. Nonette/Créer.

1998. La Sculpture flamboyante en Auvergne,
Bourbonnais, Forez. Nonnette/Créer.
BAYOT, A. s.d. Catalogue des manuscrits français de la
Bibliothèque royale de Belgique, s. l.
BAZIN, Germain. 1941. L'École franco-flamande,
les trésors de la peinture française. Geneva.
BEAULIEU, Michèle, and Jeanne BAYLE. 1956.
Le Costume en Bourgogne de Philippe le Hardi à la mort
de Charles le Téméraire (1364–1477). Paris.
BEAULIEU, Michèle, and Victor BEYER. 1992. Dic-
tionnaire des sculpteurs français du Moyen Âge. (Biblio-
thèque de la Société Française d'Archéologie). Paris.
BEAUVALOT, Yves. 1981. La Construction du palais des
États de Bourgogne et la place royale à Dijon
(1674–1725). Dijon.
BECK, Corinne, and Patrice BECK. 1996. "La nature
aménagée. Le parc du château d'Aisey-sur-Seine
(Bourgogne XIVe–XVIe siècle)," pp. 22–29. In
L'Homme et la nature au Moyen Âge. Actes du
Ve Congrès international d'Archéologie médiévale.
Paris.
BECK, Corinne, Patrice BECK, and François
DUCEPPE-LAMARRE. 2001. "Les parcs et jardins
des résidences des ducs de Bourgogne au XIVe siècle.
Réalités et représentations," pp. 135–43. In Annie,
"Aux marches du palais" Qu'est-ce qu'un palais
médiéval? Actes du VIIe Congrès international
d'archéologie médiévale. Université du Maine,
Publications du LHAM.
BECK, Patrice. 1992. "Fontaines et fontainiers des ducs
de Bourgogne." Mélanges de l'École française de Rome,
Moyen Âge 104, pp. 495–506.
BECK, Patrice, Christine CANAT, Bernard
LAUVERGEON, et al. 1999. Le Clos de Chenôve
(Côte-d'Or). La cuverie et les pressoirs des ducs de
Bourgogne. Histoire, archéologie, ethnologie
(XIIIe–XXe siècles). Inventaire général, direction
régionale des affaires culturelles de Bourgogne
(Images du Patrimoine, 190). Ed. Faton (Dossier de
l'Art, hors série no. 1). Dijon.
BÉGULE, Lucien. 1984. L'Abbaye de Fontenay. 6th ed.,
s. l. Belles Heures de Jean de Berry. New York.
BELTING, Hans. 1990. Bild und Kult: Eine Geschichte
des Bildes vor dem Zeitalter der Kunst. Munich.
BENESCH, Otto.
1928. "Zur altösterreichischen Tafelmalerei. I: Der
Meister der Linzer Kreuzigung." Jahrbuch der
kunsthistorischen Sammlungen in Wien 2, pp. 63–76.
1936. Österreichische Handzeichnungen des XV. und
XVI. Jahrhunderts. (Die Meisterzeichnung, 5).
Fribourg-en-Brisgau.
1964. Meisterzeichnungen der Albertina, Europäische
Schulen von der Gotik bis zum Klassizismus. Salzburg.
BERCÉ, Françoise. 1979. Les Premiers Travaux de la
Commission des Monuments historiques.
BERGER, Samuel. 1884. La Bible française au Moyen
Âge. Étude sur les plus anciennes versions de la Bible
écrites en prose de langue d'oïl. Paris.
BERGERET, E. 1899–1900. "Briques et pavages
émaillés; l'atelier d'Argilly sous les ducs de
Bourgogne." Mémoires de la Société d'histoire,
d'archéologie et de littérature de l'arrondissement de
Beaune 14 (1899) and 15 (1900).
BERGMANS, A. 1998. Middeleeuwse muurschilderingen
in de 19de eeuw. Louvain.
BERLIN. 1931. Beschreibendes Verzeichnis der Gemälde
im Kaiser-Friedrich-Museum und Deutschen Museum.
Berlin.

BERLIN. 1975. *Gemäldegalerie Berlin, Katalog der ausgestellten Gemälde des 13.–18. Jahrhunderts.* Berlin.

BERNARD (St.). 1990. *Sermons pour l'année.* Ed. Pierre-Yves Emery. Turnhout-Taizé.

BERTRAND, Sylvaine.
1996. "Trois vierges à l'enfant du XVe siècle aux environs de Beaune. Leur type, leur style et leur place dans la production bourguignonne du XVe siècle." *Centre beaunois d'études historiques,* no. 76, pp. 11–22.
1997. *Contribution à l'étude de la sculpture au XVe siècle: l'élaboration des oeuvres dans les ateliers bourguignons.* 4 vols. Ph.D. diss. Université de Bourgogne, Dijon.

BEURRIER, Louys. 1634. *Histoire du monastère et convent des Pères Célestins de Paris, contenant ses antiquités et privilèges, ensemble les tombeaux et épitaphes des rois, des ducs d'Orléans.* Paris.

BICHLER, Susanne. 1992. "Les Retables de Jacques de Baerze." In *Actes des Journées internationales Claus Sluter.* Dijon.

BIGARNE, Charles. 1891. "Le Château ducal de Bourgogne." *Mémoire de la Société d'histoire et d'archéologie de Beaune* (SHAB) 14, pp. 191–202.

BILLIOUD, J. 1922. *Les États de Bourgogne aux XIVe et XVe siècles.* Dijon.

BINSKI, Paul. 1996. *Medieval Death: Ritual and Representation.* Ithaca, New York.

BIZOUARD, J.-Th. 1888. *Histoire de sainte Colette et des clarisses en Franche-Comté, d'après des documents inédits.* Besançon/Paris.

BLANC, Odile. 1997. *Parades et Parures. L'invention du corps de mode à la fin du Moyen Âge.* Paris.

BLOCKMANS, W. P. 1978. *De volksvertegenwoording in Vlaanderen van Middeleeuwen naar Nieuwe Tijden (1384– 1506).* Brussels.

BLOCKMANS, W., and W. PREVENIER. 1999. "A New European Power in the Making, 1363–1405." In *The Promised Lands. The Low Countries under Burgundian Rule, 1369–1530.* Trans. E. Fackelman. Philadelphia.

BLONDAUX, Laurence. 1990. "Regards sur le Puits de Moïse." In *Claus Sluter en Bourgogne. Mythe et représentations.* Dijon.

BOBER, H. 1947–48. "Flemish Miniatures from the Atelier of Jean de Grise, MS 11142 of the Bibliothèque Royale de Belgique." *RBAHA* 17.

BOCCADOR, Jacqueline.
1974. *Statuaire médiévale en France de 1400 à 1530.* 2 vol. Zug.
1986. "Étude sur Claux de Werve et son atelier." *Les Antiquaires au Grand Palais, XIIIe Biennale internationale,* pp. 45–87.

BOEREN, P. C.
1979. *Catalogus van de handschriften van het Rijks-museum Meermanno-Westreenianum.* The Hague.
1988. *Catalogus van de liturgische handschriften van de Koninklijke Bibliotheek.* The Hague.

BOESE, Helmut. 1966. *Die Lateinischen Handschriften der Sammlung Hamilton zu Berlin.* Wiesbaden.

BOISSELLIER, Pascale. 1993. *Le Décor de la chapelle Sainte-Croix de Jérusalem à l'hôpital du Saint-Esprit de Dijon.* Master's thesis. Université de Bourgogne, Dijon.

BON, Philippe. 1992. *Les premiers "bleus" de France. Les carreaux de faïence au décor peint fabriqués pour le duc de Berry, 1384.* Mehun-sur-Yèvre.

BOONE, M.
1990A. *Gent en de Bourgondische hertogen ca. 1384 ca. 1453. Een sociaal-politieke studie van een staatsvormingsproces.* Brussels.
1990B. *Geld en Macht. De Gentse stadsfinanciën en de Bourgondische staatsvorming (1384–1453).* Ghent.
2002. "Les ducs, les villes et l'argent des contribuables. Le rêve d'un impôt princier permanent en Flandre à l'époque bourguignonne." In *L'Impôt au Moyen Âge. L'impôt public et le prélèvement seigneurial, fin XIIe début XVIe siècle.* Vol. 2. *Les Espaces fiscaux.* Actes du colloque tenu à Bercy. Paris.

BOONE, M., and T. de HEMPTINNE. 1997. "Espace urbain et ambitions princières: les présences matérielles de l'autorité princière dans le Gand médiéval (XIIe siècle–1540)," pp. 279–304. In *Zeremoniell und Raum.* Ed. W. Paravicini. Sigmaringen.

BORCHERT, Till-Holger.
1997. "Rogier's Saint Luke: A Case for Corporate Identification." In Carol J. Purtle. *Rogier van der Weyden: St. Luke Drawing the Virgin. Selected Essays in Context.* Turnhout.

2002. "Introduction: l'influence de Jan van Eyck et de son atelier." *Le Siècle de Van Eyck 1430–1530. Le monde méditerranéen et les primitifs flamands.* Exh. cat. for *Jan van Eyck, les primitifs flamands et le Sud.* Bruges, Groeningemuseum. Ghent/Amsterdam.

BORDET, Chanoine. 1927–32. "La Vierge de Bussy-la-Pesle." *MCACO* 19.

BORLÉE, Denise. 1997. *La Sculpture figurée du XIIIe siècle en Bourgogne.* Ph.D. diss. Université de Bourgogne, Dijon.

BORSI, Franco, and Stefano Borsi. 1998. *Masaccio.* Paris.

BOTTINEAU, Y. 1973. "L'architecture des premiers Valois." *GBA,* no. 82.

BOUCQUEY, D. 1991. "Enguerrand de Monstrelet, historien trop longtemps oublié." *Publications du Centre européen d'études bourguignonnes,* no. 31.

BOUILLART, Jacques. 1724. *Histoire de l'abbaye royale de Saint Germain des Prez.* Paris.

BOUSMANNE, Bernard. 1997. *Item a Guillaume Wyelant aussi enlumineur.* Brussels/Turnhout.

BOUSMANNE, Bernard, and Céline VAN HOOREBEECK. 2000. *La librairie des ducs de Bourgogne.* Turnhout.

BOUSMANNE, Bernard, Pierre COCKSHAW, and Gerhard SCHMIDT. 1996. *Book of Hours (Ms. Heures de Bruxelles).* Lucerne.

BOZZOLO, Carla. 1973. *Manuscrits des traductions françaises d'oeuvres de Boccace, XV siècle.* (Medioevo e Umanesimo, 15). Padua.

BOZZOLO, Carla, and Hélène LOYAU. 1982. *La Cour amoureuse, dite de Charles VI.* Vol. I. Paris.

BRASSAT, W. 1992. *Tapisserien und Politik. Funktionen, Kontexte und Rezeption eines repräsentativen Mediums.* Berlin.

BRECK, J. 1933. "A Late Gothic Sculpture." *Metropolitan Museum Art Bulletin* 28, pp. 74–76.

BRESC-BAUTIER, Geneviève, C. CHEVILLOT, F. DUCROS, et al. 1998. *Mille Sculptures des Musées de France.* Paris.

BRETON, Émilie. 1996. *Les Funérailles des ducs de Bourgogne, de Philippe le Hardi à Charles le Téméraire.* Master's thesis. Université de Rouen.

BROCART, Henry.
1900. "L'Annonciation du musée de Langres (XIVe siècle)." *Bulletin de la Société historique et archéologique de Langres,* fasc. 60, pp. 359–68.
1917. "Tableau en ivoire représentant l'Annonciation." *Bulletin de la Société historique et archéologique de Langres,* fasc. 98 and 99, no. 440, pp. 295–96.

BROILLET, Philippe, and Nicolas SCHÄTTI. 1994. "Jean de Liège, un architecte au service de la Savoie au Moyen Âge." *L'histoire en Savoie,* no. 6, pp. 1–7.

BRUNE, Paul. 1894. "Le mobilier et les oeuvres d'art de l'église de Baume-les-Messieurs." *Bulletin archéologique du comité des travaux historiques et scientifiques,* pp. 458–78.

BRUZELIUS, Caroline. 1991. *The Brummer Collection of Medieval Art.* Durham/London.

BUETTNER, Brigitte.
1996. *Boccaccio's Des cleres et nobles femmes: Systems of Signification in an Illuminated Manuscript.* Seattle/London.
2002. "Past Presents: New Year's Gifts at the Valois Courts, ca. 1400." *Art Bulletin* 88, pp. 598–625.

Bulletin of the Museum of Fine Arts, Boston. 1957. No. 50.

BURGER, W. 1930. *Abenländische Schmelzarbeiten.* Berlin.

CALMELET, François. 1772. *Histoire de la Maison Magistrale, Conventuelle, & Hospitalière du Saint Esprit.*

CALMETTE, Joseph. 1910. "Le génie sculptural de la Bourgogne et le dualisme gothique." *Mémoires de l'Académie des sciences, arts et belles-lettres de Dijon,* pp. 121–33.

CAMILLE, M. 1996. *Master of Death, the Lifeless Art of Pierre Remiet.* New Haven.

CAMP, Pierre.
1969. *Guide illustré d'Auxonne.* Dole.
1985. "Des éléments nouveaux pour une histoire des imagiers bourguignons." *Pays de Bourgogne* 131, pp. 559–64.

1990. "Les Imageurs ou Imagiers bourguignons de la fin du Moyen Âge." *Les Cahiers du Vieux-Dijon,* no. 17–18.

CAMPBELL, Lorne.
1988. "The Tomb of Joanna, Duchess of Brabant." *Renaissance Studies,* no. 2.
1991. *Renaissance Portraits. European Portrait-Painting in the 14th, 15th, and 16th Centuries.* New Haven/London.

CANAT, M. 1860. *Marguerite de Flandre, duchesse de Bourgogne. Sa vie intime et l'état de sa maison.* Paris.

CARLVANT, K. B. E. 1978. *Thirteenth Century Illumination in Bruges and Ghent.* Ph.D. diss. Columbia University (Ann Arbor, Michigan: University Microfilms).

CARON, Marie-Thérèse. 1987. *La Noblesse dans le duché de Bourgogne, 1315–1477.* Lille.

CARTELLIERI, Otto. 1970. *The Court of Burgundy.* Rev. ed. New York.

CASSAGNES, Jean-Pierre. 1996. *Le Portail Saint-Étienne du bras sud du transept de la cathédrale d'Auxerre.* Master's thesis. Université de Bourgogne, Dijon.

CASSAGNES-BROUQUET, Sophie. 1996. *Contribution à l'étude de la peinture médiévale, les peintres en Bourgogne sous les ducs de Valois, 1363– 1477.* Ph.D. diss. Université de Bourgogne, Dijon.

Catalogue 100. 1970. Based on research by Millard Meiss. "The Master of the Breviary of Jean sans Peur and the Limbourgs." Paper delivered at conference on aspects of art. Henriette Hertz Trust of the British Academy, Oxford. New York.

CAUMONT, Arcisse de. 1854. *Abécédaire ou rudiment d'archéologie.* Paris.

CAVALLO, Adolfo Salvatore. 1993. *Medieval Tapestries in The Metropolitan Museum of Art.* New York.

CAZELLES, R.
1958. *La Société politique et la crise de la royauté sous Philippe de Valois.* Paris.
1982. *Société politique, noblesse et couronne sous Jean le Bon et Charles V.* Geneva/Paris.

CHABEUF, Henri.
1889–95. "Les dessins de Gilquin." *MCACO* 12, pp. CVIII–CIX.
1891. "Jean de La Huerta, Antoine Le Moiturier, et le tombeau de Jean sans Peur." *Mémoires de l'Académie de Dijon,* 4e série, 1, no. 2, pp. 137–271.
1897. *Dijon à travers les âges.* Dijon.
1903. "Charles le Téméraire à Dijon." *Mémoires de la Société Bourguignonne de Géographie et d'histoire* 18, pp. 79–349.
1906–10. "Le Christ du Retable de la Crucifixion," *MCACO* 15, pp. CXXII–CXXIV.
1909–13. "Panneau de menuiserie au musée de Dijon." *MCACO* 16, pp. XXXV–XXXIX.
1913–21. "Le pleurant de la collection Perret-Carnot." *MCACO* 17, pp. CXLVII–CL.

CHAILLOU DES BARRES, Claude-Étienne. 1840. "Chastellux," 4: pp. 154–206. In *Annuaire statistique du Département de l'Yonne.*

CHAMAGNE, Joseph. 1980. *Artistes et artisans au temps de Philippe le Hardi.* Master's thesis. Université de Bourgogne, Dijon.

CHAMPEAUX, Alfred de. 1885. *Le Meuble.* Vol. 1. *Antiquité, Moyen Âge, et Renaissance.* Paris.

CHAMPEAUX, Anatole de. 1898. "L'ancienne école de peinture en Bourgogne." *GBA.*

CHANTAVOINE, Jean. 1918–19. "Un chef-d'oeuvre qui l'a échappé belle. La Vierge du Mont Saint-Marcel." *Revue de Bourgogne,* pp. 160–65.

CHANU, Myriam. 1994. *Inventaire et analyse de la sculpture dans le bailliage de l'Auxois sous les ducs Valois (1364–1477).* Master's thesis. Université de Bourgogne, Dijon.

CHAPUIS, A. V. 1906. *Les Anciennes Corporations dijonnaises, règlements et statuts.* Dijon.

CHARAGEAT, Marguerite. 1950. "Le parc d'Hesdin. Création monumentale du XIIIe siècle. Ses origines arabes. Son influence sur les miniatures de l'épître d'Othéa." *Bulletin de la Société de l'art français,* pp. 94–106.

CHARLES, Corinne. 1999. *Stalles sculptées du XVe siècle: Genève et le duché de Savoie.* Paris.

CHARMASSE, Anatole de. 1865–1900. *Cartulaire de l'église d'Autun,* p. 398. Paris.

CHASTEL, André. 1992. "La pré-Renaissance," pp. 193–99. In *Histoire et société, Mélanges offerts à Georges Duby.* Vol. 4. *La mémoire, l'écriture, et l'histoire.* Presse universitaire de Provence.

CHATEIGNÈRE, Myriam. 1992. "Problèmes posés par la restauration du Puits de Moïse. Aspects techniques," pp. 85–96. In *Actes des Journées internationales Claus Sluter.* Dijon.

CHÂTELET, Albert.
1980. *Les Primitifs hollandais. La peinture dans les Pays-Bas du Nord au XVe siècle.* Paris. English ed. *Early Dutch Painting: Painting in the Northern Netherlands in the Fifteenth Century.* Trans. C. Brown and A. Turner. New York, 1981.
1989. "Rogier van der Weyden et le lobby polinois." *Revue de l'art,* no. 84, pp. 9–21.
1994. "Un peintre et un brodeur à la cour de Bourgogne: Thierry du Chastel et Hue de Boulogne." *Festchrift für Herman Fillits, Künstblatter,* no. 60.
1996. *Robert Campin, le maître de Flémalle: la fascination au quotidien.* Antwerp.
1999. "Jardin d'amour ou commémoration?" *Bulletin des musées de Dijon,* no. 5, pp. 70–75, 77.
2000. *L'Âge d'or du manuscrit à peintures en France au temps de Charles VI et les Heures du Maréchal Boucicaut.* Dijon.
2003. "Nouvelles de l'enluminure: Recension of *Medieval Mastery. Book Illumination from Charlemagne to Charles the Bold, 800–1475,* Louvain, 2002." In *Art de l'Enluminure,* no. 5, pp. 58–62.
Forthcoming. *À propos d'une Annonciation de Cleveland: Une peinture entre la France, les Pays-Bas et l'Italie.*

CHÂTELET, Albert, and Giorgio FAGGIN. 1969. *Tout l'oeuvre peint des frères van Eyck.* Paris.

CHÉDEAU, Catherine. 1999. "Réflexions sur l'organisation des ateliers de sculpteurs en Bourgogne et en France aux XVe et XVIe siècles: les modèles d'atelier." In *Pierre, lumière, couleur: études d'histoire de l'art du Moyen Âge en l'honneur d'Anne Prache.* Paris.

CHESTRET DE HANEFFE. 1901. "Arnould d'Oreye." *Biographie nationale de Belgique* XVI.

CHEVALIER, François-Félix. 1767–69. *Mémoires historiques sur la ville et seigneurie de Poligny.* 2 vols. Lons-le-Saunier.

CHEYNS-CONDÉ, M. 1985. "La tapisserie à la cour de Bourgogne. Contribution d'un art mineur à la grandeur d'une dynastie." *Publication du Centre européen d'études bourguignonnes (XIVe–XVIe s.)* (Rencontres de Fribourg 14–16 September 1984: "Activités artistiques et pouvoirs dans les États des ducs de Bourgogne et des Habsbourg et les régions voisines"). Basel.

CHICAGO. 1993. James Wood and Sally May. *The Art Institute Essentiel Guide.* Chicago.

CHIFFOLEAU, Jacques. 1980. *La Comptabilité de l'au-delà, les hommes, la mort et la religion dans la région d'Avignon à la fin du Moyen Âge (vers 1320–vers 1480).* Rome.

CHOMTON, Louis. 1900. *Histoire de l'église Saint-Bénigne de Dijon.* Dijon.

Chronique du religieux de Saint-Denys (Chronique de Charles VI). 1839–52. 6 vols. (Collection de documents inédits sur l'histoire de France 40). Paris.

CLÉTY, Anne Élisabeth. 1997. "Les machines extraordinaires d'Hesdin aux XIVe et XVe siècles." *Sucellus—Dossiers archéologiques, historique, et culturels du Nord–Pas-de-Calais,* no. 44.

Collections du Chevalier Mayer van den Bergh. 1904. Antwerp.

COLOMBET, Albert. 1982. *Saint-Thibault. L'église et ses oeuvres d'art.* 3rd ed. Dijon.

COMBLEN-SONKES, Micheline.
1984. *Guide bibliographique de la peinture flamande au XVe siècle.* Brussels.
1986. *Le musée des Beaux-Arts de Dijon* (Primitifs flamands, 14). With N. Veronee-Verhaeghen. 2 vols. Brussels.

CORNEREAU, Armand. 1889–95. "Épigraphie Bourguignonne. Les Hôpitaux du Saint-Esprit et de Notre-Dame de la Charité à Dijon." *MCACO* 12, pp. 223–30.

CORTISSOZ, Royal. 1931. *The Clarence H. Mackay Collection, Harbor Hill, Roslyn, Long Island.* Privately published.

COURAJOD, Louis.
1885. "Une statue de Philippe VI au musée du Louvre, et l'influence de l'art flamand dans la sculpture française du XIVe siècle." *GBA,* no. 31.
1892. *La Sculpture d'un l'école bourguignonne à la fin du XIVe siècle et pendant le XVe siècle.* Paris.
1899–1903. *Leçons de l'École du Louvre (1887–1896).* 3 vols. Paris.

COURTÉPÉE, Claude.
1777. *Description historique et topographique du duché de Bourgogne.* 2 vols. Dijon.
1967. *Description générale et particulière du duché de Bourgogne.* 2 vols. 3rd ed. Paris, Horvath. 2d ed. Dijon, 1847.

COURTÉPÉE, Claude, and BÉGUILLET. 1967–68. *Description générale et particulière du duché de Bourgogne.* 3rd ed. Preface, notes, and corrections by Pierre Gras and Jean Richard. 4 vols. Avallon/Paris (first published in 1774–85).

CUTLER, Charles. 1968. *Northern Painting, From Pucelle to Bruegel, Fourteenth, Fifteenth, and Sixteenth Centuries,* New York.

CYROT, Louis. 1876. *Le Pourpris de l'ancien castrum belnense.* Beaune.

DARGENTOLE, H. 1935. "De la propriété du parc Buffon." *Bulletin de la Société archéologique et biographique du canton de Montbard,* no. 21, pp. 10–18.

DAVID, Henri.
1933. *De Sluter à Sambin. Essai critique sur la sculpture et le décor monumental en Bourgogne au XVe et au XVIe siècles.* 2 vols. Paris.
1934. "Claus Sluter, tombier ducal." *Bulletin monumental,* pp. 409–43.
1936. "Quelques artistes méridionaux en Bourgogne," 47: pp. 44–364. In *Annales de Midi.*
1937. *Philippe le Hardi, duc de Bourgogne, protecteur des arts.* Dijon.
1944. "Philippe le Hardi au début du XVe siècle." *Annales de Bourgogne* 16, no. 63 and 64, pp. 137–57.
1945. "Philippe le Hardi au début du XVe siècle. Extraits somptuaires." Extra issue of *Annales de Bourgogne.*
1947. *Philippe le Hardi, duc de Bourgogne et co-régent de France (1392–1404). Le train somptuaire d'un grand Valois.* Dijon.
1951. *Claus Sluter.* Preface by F. Salet. Paris.

DAVIES, Martin. 1973. *Rogier van der Weyden.* Brussels.

DEBAE, Marguerite. 1995. *La Bibliothèque de Marguerite d'Autriche. Essai de reconstitution d'après l'inventaire de 1523–1524.* Louvain/Paris.

DE BUSSCHER, E. 1872. "Les armoiries des comtes de Flandre." *Bulletin de la Commission royale d'art et d'archéologie* 11.

DE COO, Jozef.
1958. "De unieke voorstelling van de "Jozefs-kousen" in het veeluik Antwerpen-Baltimore van ca. 1400." *Oud Holland* no. 70, pp. 186–98.
1960. "De voorstelling van de "Jozefs-kousen" in het veeluik Antwerpen-Baltimore toch niet uniek." *Oud Holland,* no. 72, pp. 222–28.
1965. "L'ancienne Collection Micheli." *GBA,* 6e série, no. 66, pp. 345–70.
1969. *Museum Mayer van der Bergh, Catalogue 2: Beeldhouwkunst, Plaketten, Antiek,* Antwerp. 3rd ed. 1979.
1979. *Museum Mayer van der Bergh, Catalogue 1: Schilderijen, verluchte handschriften, tekeningen.* Antwerp. 3rd ed.

DE CUYPER, J. 1962. "De Gravenkapel van Kortrijk opbouw (+1370–1374) en herstel na de ramp van 1382." *De Leiegouw* 4.

DEHAISNES, Chrétien-César-Auguste.
1886. *Documents et extraits concernant l'histoire de l'art dans la Flandre, l'Artois, et le Hainaut avant le XVe siècle, 1374–1401.* Vol. 2. Lille.
1887. *Le Peintre Melchior Broederlam* [excerpts of "Annales du Comité flamand de France," pp. 165–182]. Dunkerque.

DELAHAYE, Élisabeth.
2001. "L'orfèvre Jean Nicolas et deux clients princiers: Marie de France et Louis de Guyenne." *Revue du Louvre et des musées de France,* no. 5, pp. 29–34.
2004. "Vie de cour et vie artistique en France vers 1400." *La France et les arts en 1400.* Paris.

DELAISSÉ, L. M. J.
1957A. "Scriptores en miniaturisten." *Flandria Nostra* 1, pp. 227–63.
1957B. "Enluminure et peinture dans les Pays-Bas. À propos du livre de E. Panofsky." *Scriptorium* 11, pp. 109–18.

DELARUELLE Étienne, Edmond-René LABANDE, and Paul OURLIAC. 1964. *L'Église au temps du Grand Schisme et de la crise conciliaire (1378–1449).* Histoire de l'Église depuis les origines jusqu'à nos jours. Vol. 14, part 2. Belgium.

DELISLE, L.
1880. *Mélanges de paléographie et de bibliographie.* Paris.
1907. *Recherches sur la librairie de Charles V.* 2 vols. Paris.

DELISSEY, Joseph. 1941. *Le Vieux Beaune.* Beaune.

DELLA LATTA, Allessandro. 2001. "À propos d'un coffret en cuir. Les 'Scènes de la Passion'" de Lucques: arts décoratifs et arts majeurs en Flandre vers 1400.'" *Revue de l'art,* no. 134, pp. 61–74.

DEMAY, Charles.
1876. "Estienne Porcher de Joigny et sa descendance." *Bulletin de la Société des sciences historiques et naturelles de l'Yonne* 30, pp. 185–216.
1880. "Appendice à la notice intitulée Estienne Porcher et sa descendance." *Bulletin de la Société des sciences historiques et naturelles de l'Yonne* 34, pp. 219–21.
1903. "La chapelle Notre-Dame de la Conception ou des Porcher en l'église Saint-Thibault de Joigny (1369–1790)." *Bulletin de la Société des sciences historiques et naturelles de l'Yonne* 57, pp. 93–107.

DEMBOWSKI, P. F. 1969. *Joudain de Blaye.* Chicago.

DEMONTS, L. 1936. "Une collection française de Primitifs." *Revue de l'art ancien et moderne,* no. 70.

DENNISON, L.
1986. "The Artistic Context of Fourteenth Century Flemish Brasses." *Transactions of the Monumental Brass Society* 14, no 1, pp. 1–38.
1988. *The Stylistic Sources, Dating and Development of the Bohun Workshop, ca 1340–1400.* Ph.D. diss. Westfield College, University of London.
2002. "The Dating and Localisation of the Hague Missal (Meermanno-Westreenianum MS 10 A 14) and the Connection between English and Flemish Miniature Painting in the Mid Fourteenth Century." *"Als ich can." Liber Amicorum in Memory of Professor Dr. Maurits Smeyers.* (Corpus van verluchte handschriften, 11). Louvain.

DE PAUW, N. 1899. "Les premiers peintres et sculpteurs gantois." *Bulletijn der Maatschappij van Geschied-en Oudheidkunde te Gent* 7, pp. 239–77.

DESPRIET, P. 1990. "De koninklijke Burcht van Kortrijk." *Bijdrage tot de Studie van de zuid-west-vlaamse burchten en kastelen* (Archeologische en historische monografieën van Zuid-West-Vlaanderen, 21). Courtrai.

DESVIGNES, Jacques. 1972. "Le château de Germolles." *Archéologia,* no. 49, pp. 26–32.

DEUCHLER, Florens. 1963. *Die Burgundebeute.* Bern.

DEVLIEGHER, L. 1973. *De Onze-Lieve-Vrouwekerk te Kortrijk* (Kunstpatrimonium van West-Vlaanderen, 6). Lannoo/Tielt/Utrecht.

DE WINTER, Patrick M.
1976. *The Patronage of Philippe le Hardi, Duke of Burgundy (1364–1404).* Ph.D. diss. New York University (Ann Arbor, Michigan: University Microfilms).
1978. "Copistes, éditeurs, et enlumineurs de la fin du XIVe siècle, la production à Paris de manuscrits à miniatures." *ACNSS* 101. Paris.
1982A. "Christine de Pizan, ses enlumineurs et ses rapports avec le milieu bourguignon." *ACNSS* 104.
1982B. "The *Grandes Heures* of Philip the Bold, Duke of Burgundy: The Copyist Jean L'Avenant and His Patrons at the French Court." *Speculum,* no. 57, pp. 786–842.
1983. "Castles and Town Residences of Philip the Bold, Duke of Burgundy (1364–1404)." *Artibus et historiae,* no. 8.
1985A. *La Bibliothèque de Philippe le Hardi, duc de Bourgogne (1364–1404). Étude sur les manuscrits à peintures d'une collection princière à l'époque du style gothique international.* Paris.
1985B. "The Sacral Treasure of the Guelphs." *CMA Bulletin* 72, pp. 1–160.
1987. "Art from the Duchy of Burgundy." *CMA Bulletin* 74, pp. 405–49.

DHANENS, Elisabeth.
1980. *Hubert et Jan Van Eyck.* Trans. Jacques Gengoux. Antwerp.
1995. *Rogier van der Weyden. Revisie van de documenten.* Brussels.

Dictionnaire des lettres françaises. 1992. Vol. 1. *Le Moyen Âge.* 2nd ed. Ed. G. Hasenohr and M. Zink. Paris.

DIDIER, Robert.
1967. "Les retables de Ternant." *Congrès archéologique de France* 125, pp. 258–76.
1970. "Contribution à l'étude d'un type de Vierge française du XIVe siècle. À propos d'une réplique de

la Vierge de Poissy à Herresbach." *Revue des archéologues et historiens d'art de Louvain* 3, pp. 48–72.

1971. "Les sculptures du musée Mayer van den Bergh à bibliographie Antwerp. À propos d'un catalogue récent." *Revue des archéologues et historiens d'art de Louvain* 4, pp. 230ff.

1975. "Gentse Beeldhouwkunst van de Middeleeuven," pp. 457–58. In *Gent, Duizend jaar kunst en kultuur.* Vol. 1. Ghent.

1978. "Kreuzreliquiar," p. 71. In *Die Parler und der Schöne Stil 1350–1400. Europäische Kunst unter den Luxemburgern.* Vol. 1. Cologne.

1980. "Le monument funéraire de Philippe le Hardi, duc de Bourgogne (1342–1404): Jean de Marville, Claus Sluter, Claus de Werve." In *Die Parler und der Schöne Stil 1350–1400: Sonderdruck aus dem Resultatband zur Ausstellung des Schnütgen-Museums in der Kunsthalle Köln.* Cologne.

1984. "De H. Cornelius van het Sint-Janshospitaal en de Brugse beeldhouwkunst omstreeks 1400," pp. 19–52. In *Rond derestauratie van het 14de-eeuwse Corneliusbeeld.* Brugge.

1993. *Claus Sluter. Publication extraordinaire de la Société archéologique de Namur.* Namur.

DIDIER, Robert, Michael HENSS, and J. Adoph SCHMOLL GEN. EISENWERTH. 1970. "Une Vierge tournaisienne à Arbois (Jura) et le problème des Vierges de Hal." *Bulletin monumental* 128, pp. 93–113.

DIDIER, Robert, and Roland RECHT. 1980. "Paris, Prague, Cologne et la sculpture de la seconde moitié du XIVe siècle. À propos de l'exposition des Parler à Cologne." *Bulletin monumental* 138, pp. 173–219.

DIDIER, Robert, and John STEYAERT. 1978. "Passionsaltar. Gent, Jacques de Baerze," pp. 56–58. *Die Parler und der Schöne Stil 1350–1400. Europäische Kunst unter den Luxemburgern.* Vol. 1. Cologne.

DIJON. 1883. *Catalogue historique et descriptif du musée de Dijon: peintures, sculptures, dessins, antiquités.* Dijon.

DIMIER, Louis. 1936. "Les primitifs Français, Règnes de Charles V et de Charles VI." *GBA*, 6e série, no. 16, pp. 205–32.

DOGAER, G. 1977. "Einflussder Randverzierung der sog. Gent-Brügger Schule auf die deutsche Buchmalerei um 1500," pp. 211–27. In *Bibliothek-Buch-Geschichte: Kurt Köster zum 65. Geburstag.* Frankfurt.

DOUTREPONT, Georges.
1909. "La Littérature française à la cour des ducs de Bourgogne: Philippe le Hardi, Jean sans Peur, Philippe le Bon, Charles le Téméraire." *Bibliothèque du XVe siècle,* no. 8.
1977. *Inventaire de la "Librairie" de Philippe le Bon (1420).* 2nd ed. Geneva (first published in Brussels, 1906).

DROUOT, Henri.
1913–21. "Le pleurant de la collection Perret-Carnot." *MCACO* 17, p. XXIX.
1926. "Figures bourguignonnes de Calvaires." *Revue de l'art,* no. 49, pp. 123–26, 151–59.
1932. "L'atelier de Dijon et l'exécution du tombeau de Philippe le Hardi." *RBAHA* 2, pp. 11–39.

DUBY, Georges, and Philippe ARIES. 1982. *Histoire de la vie privée. De l'Europe féodale à la Renaissance.* Vol. 2. Paris.

DUCEPPE-LAMARRE, François.
2001. "Le parc à gibier d'Hesdin. Mises au point et nouvelles orientations de recherches." *Revue du Nord Archéologie de la Picardie et du Nord de la France* 83, no. 43, pp. 175–84.
2002. "Une économie de l'imaginaire à l'oeuvre. Le cas de la réserve cynégétique d'Hesdin (Artois, XIIIe–XVe siècle)." In *La Forêt en Europe (XIIIe–XXe siècle).* 24es Journées internationales d'histoire de Flaran.

DUCREST, François. 1917. "Inventaire de la sacristie de la Collégiale de Fribourg (1766 et 1777)." *Annales fribourgeoises* 5, pp. 154–69.

DUHEM, Gustave. 1960. "Baume-les-Messieurs," pp. 189–200. In *Congrès archéologique de France, Franche-Comté.* Paris.

DUMAY, Gabriel. 1882. *Épigraphie bourguignonne. Église et abbaye Saint-Bénigne de Dijon.* Paris/Dijon.

DUMOULIN, J., and J. PYCKE. 1992. *La Grande Procession de Tournai (1090–1992),* Tournai/Louvain-la-Neuve.

DUPIN, I. M. 1990. "La Trinité debout en ivoire de Houston et les Trinités bourguignonnes de Jean de Marville à Jean de La Huerta." *Weiner Jahrbuch,* no. 43.

DUPONT, Jacques. 1937. *Les Primitifs français (1350–1500).* Paris.

DUPONT, Jacques, and Cesare GNUDI. 1954. *La Peinture gothique.* Paris. English ed. *Gothic Painting.* Geneva, 1954.

DURRIEU, Paul.
1895. "Manuscrits de luxe exécutés pour des princes ou des grands seigneurs français." *Le Manuscrit* 2, pp. 81–87.
1907. *La Peinture en France. II, Le règne de Charles VI.* In *Histoire de l'art depuis les premiers temps chrétiens jusqu'à nos jours.* Ed. A. Michel. 3 vols. Paris.
1918. "Les tableaux du duc de Berry." *Bibliothèque de l'école des Chartes* 79, pp. 265–70.
1918–19. "Une 'Pitié de Notre-Seigneur,' tableau français de l'époque du règne de Charles VI donné au musée du Louvre." *Fondation Eugène Piot. Monuments et Mémoires publiés par l'Académie des inscriptions et belleslettre* 23.

DU SOMMERARD, Alexandre. 1838–46. *Les Arts au Moyen Âge.* Paris.

DUVERGER, Jozef.
1933. *De Brusselse Steenbickeleren der XIVe eeuw, met een aanhangsel over Klaus Sluter en zijn Brusselse medewerker te Dijon.* Ghent.
1955. "Brugse schilders ten tijde van Van Eyck." *Bulletin van de Koninklijke Musea voor Schone Kunsten van België,* no. 4.
1977. "Jan van Eyck as Court Painter." *Connoisseur,* pp. 172–79.

DVORAK, Max. 1903. "Das Rätsel der Kunst der Gebrüder Van Eyck." *Jahrbuch der Kunsthistorischen Sammlungen des Allerhöchsten Kaiserhauses,* no. 24.

EGBERT, Virginia Wylie. 1970. "The Reliquary of Saint-Germain." *Burlington Magazine* 112, pp. 355–64.

EICHBERGER, Dagmar. 2002. *Leben mit Kunst, Wirken durch Kunst. Sammelwesen und Hofkunst unter Margarete von Österreich, Regentin der Niederlande.* Turnhout.

EISLER, Colin. 1964. "Le gothique international." *Art de France,* no. 4, pp. 288–90.

ENLART, Camille. 1929. *Manuel d'archéologie française depuis les temps mérovingiens jusqu'à la Renaissance. Architecture religieuse.* Vol. 1, part 2. Paris.

ERLANDE-BRANDENBURG, Alain.
1972A. "Aspects du mécénat de Charles V. La sculpture décorative." *Bulletin monumental* 130, pp. 303–45.
1972B. "Jean de Thoiry sculpteur de Charles V." *Journal des savants,* pp. 210–27.
1983. *L'Art gothique.* Paris.
1975. *Le Roi est mort. Étude sur les funérailles, les sépultures et les tombeaux des rois de France jusqu'à la fin du XIIIe siècle* (Bibliothèque de la Société française d'archéologie, 7). Geneva.

ERLANDE-BRANDENBURG, Alain, and Bertrand JESTAZ. 1989. *Le Château de Vincennes.* Paris.

ESTHER, J. P. 1970. "Jan van der Asselt," col. 22–26. *Nationaal Biografisch Woordenboek.* Vol. 4.

EVANS, Joan.
1948. *Art in Medieval France 987–1498.* London/New York. 2nd ed., 1952.
1958. *Art in Medieval France.* London/New York.

EWERT, U. 2000. "Gabe und Gegengabe." *Vierteljahrschrift für Sozial- und Wirtschaftgeschichte,* no. 87.

FAGNIEZ, Gustave. 1900. *Documents relatifs à l'histoire et à l'industrie du commerce en France.* Paris.

FALKE, Otto von. 1908. "L'Orfèvrerie et l'émaillerie au XVe siècle," pp. 865–96. In André Michel. *Histoire de l'art.* Vol. 3, part 2. Paris.

FAMIGLIETTI, R. C. 1986. *Royal Intrigue. Crisis at the Court of Charles VI 1392–1420.* New York.

FEUCHTMÜLLER, Rupert. 1978. "Herzog Rudolf IV. und die Wiener Stephanskirche," pp. 415–23. In *Die Parler und der Schöne Stil 1350–1400. Europäische Kunst unter den Luxemburgern.* Vol. 2. Cologne.

FÉVRET DE SAINT-MÉMIN, Charles-Balthazar.
1832. *Rapport à la Commission départementale des antiquités de la Côte-d'Or sur les restes des monuments de l'ancienne chartreuse de Dijon.* Dijon. Reprinted in *MCACO* 2 (1847).
1847. "Description du tombeau de Jean sans Peur," "Description du tombeau de Philippe le Hardi," and "Deux tables (tableaux) ou retables d'autel de genre gothique." *MCACO* 2.

FINOT, J. 1892. *Inventaire sommaire des Archives départementales antérieures à 1790—Nord. Archives civiles Série B.* Vol. 7. Lille.

FLETCHER, J. 1984. "The Study of Early Paintings on Flemish Panels." In *Jaarboek Anvers,* p. 7ff.

FLIEGEL, Stephen N.
1998. *Arms and Armor: The Cleveland Museum of Art.* Cleveland.
2002. "The Cleveland Table Fountain and Gothic Automata," *Cleveland Studies in the History of Art* 7, pp. 6–49.

FOISTER, Susan, et al. 2000. *Investigating Jan van Eyck.* Turnhout.

FORSYTH, William H.
1970. *The Entombment of Christ, French Sculptures of the XVth and XVIth Centuries.* Cambridge, Massachusetts.
1986. "A Fifteenth-Century Virgin and Child Attributed to Claus de Werve." *Metropolitan Museum Journal* 21, pp. 41–63.
1987. "Three Fifteenth-Century Sculptures from Poligny." *Metropolitan Museum Journal* 22, pp. 71–91.

FRANCIS, Henry. 1966. "Jean de Beaumetz Calvary with a Carthusian Monk." *CMA Bulletin* 53, pp. 329–38.

FRANKE, Brigit. "Tapisserie 'portable grandeur' und Medium der Erzählkunst," pp. 121–39. In Franke and Welzel 1997.

FRANKE, Brigit, and Barbara WELZEL. 1997. *Die Kunst der burgundischen Niederlande.* Berlin.

FRANTZ, James H. 1972. *The Annunciation Tapestry in the Metropolitan Museum of Art and the International Gothic Style in Early Franco-Flemish Tapestries.* Master's thesis. Institute of Fine Arts, New York University.

FREIGANG, Christian, and Peter KURMANN. 1986. "L'église de l'ancien prieuré de Saint-Thibault-en-Auxois: sa chronologie, ses restaurations, sa place dans l'architecture gothique." *Congrès archéologique,* pp. 271–90.

Fribourg artistique à travers les âges. Publications des sociétés des amis des beaux-arts et des ingénieurs et architectes. 1890. Pl. IX. Fribourg.

FRIEDLÄNDER, Max. 1912. *Amtl. Berichte,* no. 33.

FRIEDRICH, Winkler. 1914. "Zur Pariser Miniaturamalerei im dritten und vierten Jahrzehnt des 15. Jahrhunderts." *Beitr. Forsch.: Stud. & Mitt. Antiqua. Jacques Rosenthal* 4/5, pp. 114–20.

FRIGNET, Georges. *Rouvres, la châtellenie, le château, au temps des deux premiers ducs Valois de Bourgogne (c. 1360–c. 1420).* Ph.D. diss. Forthcoming.

FRINTA, Mojmír.
1965. "An Investigation of the Punched Decoration of Mediaeval Italian and Non-Italian Panel Paintings." *Art Bulletin,* pp. 261–65.
1967. "The Closing Tabernacle. A Fanciful Innovation of Medieval Design." *Art Quarterly* 30, pp. 102–17.
1995. "Bohemian Painting vis-à-vis Southern Netherlands," pp. 75–92. In *Flanders in a European Perspective. Manuscript Illumination around 1400 in Flanders and Abroad.* Ed. M. Smeyers and B. Cardon. (Corpus van verluchte handschriften, 8). Louvain.

FRISCH, Teresa. 1971. *Gothic Art 1140–c. 1450: Sources and Documents,* Englewood, Cliffs, New Jersey.

FRITZ, Johan Michael.
1982. *Goldschiedekunst der Gotik in Mitteleuropa.* Munich.
1986. "Deckelbecher mit 'Bauchbinde': Zu einem wenig bekannten Typus profaner Goldschiedekunt der Gotik." *Weltkunst,* pp. 3320–326.

FYOT, Eugène.
1913–21. *MCACO* 17.
1934–35. "Les spoliations commises par les calvinistes en 1562 dans la cathédrale Saint-Vincent de Chalon." *Mémoires de la Société d'histoire de Chalon* 26, pp. 124–40.
1960. *Dijon, son passé évoqué par ses rues.* Dijon (first published in 1927).

GAAL, Elfriede. 1990. "Zur Ikonographie des Grabmals von Philippe le Hardi in Dijon," pp. 7–33. In *Wiener Jahrbuch für Kunstgeschichte.* Vol. 43. Vienna/Cologne.

GABORIT-CHOPIN, Danielle.
1970. "Les ivoires gothiques, à propos d'un article récent." *Bulletin monumental,* pp. 128–33.
1978. *Ivoires du Moyen Âge.* Fribourg.
1987. "Les collections d'orfèvrerie des princes français au milieu du XIVe siècle d'après les comptes

et inventaires," pp. 46–52. In *Hommage à Hubert Landais. Art, Objets d'art, collections*. Paris.

GACHARD, L.-P. 1837. *Inventaire des Archives des comptes, précédé d'une notice historique*. Vol. 1. Brussels.

GAGNEBIN, Bernard. 1957. "Le Boccace du duc de Berry." *Genava, Musée d'art et d'histoire Genève*, no. 5.

GAGNEBIN, Bernard, et al. 1976. *L'enluminure de Charlemagne à François Ier. Manuscrits de la Bibliothèque publique et universitaire de Genève*. Geneva.

GAIER, C. 1977. "Les Mémoriaux d'Antoine de Succa et l'archéologie du costume militaire du XIIe au XVIe siècle," pp. 59–69. In *Mémoriaux d'Antoine de Succa*. Vol. 1.

GAILLIARD, J. 1847. *Bruges, son histoire, et ses monuments ou relations chronologiques des événements qui se sont passés dans la ville de Bruges, depuis les temps les plus reculés jusqu'à nos jours*. Bruges.

GANDELOT (abbé). 1772. *Histoire de la ville de Beaune et de ses antiquités*. Dijon.

GASPAR, Camille, and Frédéric LYNA.
1984. *Les Principaux Manuscrits à peintures de la Bibliothèque royale de Belgique*. 2 vols. Paris/Brussels (reprint of the original 1937 publication by the Société Française de Reproductions de Manuscrits à Peintures).
1987. *Les Principaux Manuscrits à peintures de la Bibliothèque royale de Belgique*. 2 vols. Paris/Brussels (reprint of the original 1945 publication by the Société Française de Reproductions de Manuscrits à Peintures).

GAUCHERY, Paul. 1919–20. "Le Palais du Duc Jean et la Sainte-Chapelle de Bourges." *Mémoires de la Société des antiquaires du Centre* 39, pp. 37–77.

GAUDRY, Jean-Marie. 1978. *Le Palais des ducs de Bourgogne à Beaune XIVe–XVe siècle*. Master's thesis. Université de Dijon.

GAY, Victor. 1887. *Glossaire archéologique du Moyen Âge et de la Renaissance*. Paris.

GAYET, Robert. 1987. *Histoire de l'hôpital du Saint-Esprit de Dijon*. Dijon.

GBA. 1982. *La Chronique des Arts*. Supplement to the GBA, March.

GELAUDE F., M. HELSKENS, M.-C. LALEMAN, D. LAPORTE, and G. STOOPS. 2000. "Tussen Wal en Hof." In *Het Prinselijk Hof ten Walle in Gent* (Stadsarcheologie. Bodem en monument in Gent). Ghent.

GEORGEL, Pierre. 1976–81. "Acquisitions au musée des Beaux-Arts avec la participation de la Société." *Bulletin de la Société des amis des musées de Dijon*. Dijon.

GERMAIN, Alphonse. 1909. *Les Néerlandais en Bourgogne*. Brussels.

GIESEY, Ralph E.
1960. *The Royal Funerary Ceremony in Renaissance France*. (Travaux d'Humanisme et Renaissance, 37). Geneva.
1987. *Cérémonial et puissance souveraine. France, XVe–XVIIe siècles*. (Cahiers des Annales, 41). Paris.

GIFFORD, E. Melanie. 1995. "A Pre-Eyckian Altapiece in the Context of European Painting Materials and Techniques around 1400," pp. 357–70. In *Flanders in a European Perspective. Manuscript Illumination around 1400 in Flanders and Abroad*. Ed. M. Smeyers and B. Cardon. (Corpus van verluchte handschriften, 8). Louvain.

GIFFORD, E. Melanie, Susana HALPINE, Suzanne Quillen LOMAX, and Michael SCHILLING. 2003. "Interpreting Analyses of the Painting Medium: A Case Study of a Pre-Eyckian Altarpiece," pp. 107–16, 202–6. In *Recent Developments in the Technical Examination of Early Netherlandish Painting: Methodology, Limitations & Perspectives*. Ed. Molly Faries and Ron Spronk. Cambridge, Massachusetts.

GILQUIN, Philippe. 1752. *Explication des dessins des tombeaux des ducs de Bourgogne qui sont encore à la Chartreuse de Dijon*, pp. 5–6. Dijon (first published in 1736).

GIRARD, J.
1934. *L'Église Saint-Just d'Arbois. Le monument d'histoire*, p. 12. Arbois.
1935. *Un prélat franc-comtois du XIVe siècle. Philippe d'Arbois, évêque de Tournai*, pp. 176, 181. Besançon.

GOETZ, Oswald. 1950. "Der Gekrenzte des Jacques de Baerze," pp. 158–67. In *Festschrift für Carl Goerg Heisen*. Berlin.

GOLDSCHMIDT, Adolph. 1931. "Plastiken des Sluterkreises in Amerika." *Sitzungsberichte der kunstgeschichtlichen Gesellschaft Berlin*, pp. 6–8.

GOODGAL-SALEM, Dana.
1987–89. "Sluter et la transformation de portail à Champmol." *MCACO* 35, pp. 263–83.
1992. Review of Kathleen Morand, *Claus Sluter: Artist at the Court of Burgundy* (1991). *Burlington Magazine* 134, pp. 37–40.
1997. "The Influence of Claus Sluter's Sulpture on Jan van Eyck's Realism." In *Flanders in a European Perspective. Manuscript Illumination around 1400 in Flanders and Abroad*. Ed. M. Smeyers and B. Cardon. (Corpus van verluchte handschriften, 8). Louvain.

GORCE, M.-M. 1923. *Saint Vincent Ferrier (1350–1419)*. Paris.

GORISSEN, E. 1954. "Jean Maelwael und die Brüder Limburg, Eine Nimweger Künstler Familie um die Wende des XIVe Jhs." *Gelre* 56, pp. 153–80.

GOUSSET, Marie-Thérèse. 1999. *Le Livre des Merveilles: extrait du Livre des Merveilles du Monde (Ms. fr. 2810) / Marco Polo*. Tournai.

GRAF, K. 2001. " 'Der Adel dem Purger tregt ha.' Feinbilder und Konflikte zwischen städtischen Bürgertum und landrässigem Adel in späten Mittelalter," pp. 191–204. In *Adelige und burgerliche Erinnerungskulturen des Spätmittelalters und der Frühen*. Ed. W. Rösener. Göttingen.

GRAS, Catherine. 1992. "Fragment architectural (dais), provenant du tombeau du duc de Bourgogne, Philippe le Hardi." *Revue du Louvre* 2, pp. 56–57.

GRAS, Pierre.
1957. "Deux puits de Moïse à Chalon-sur-Saône," pp. 101–4. In *Miscellanea Prof. D. Roggen*. Antwerp.
1981. *Histoire de Dijon*. Toulouse.

GRAY. 1990. *La Chapelle des Carmélites de Gray*. Gray.

GRODECKI, Louis. 1947. *Ivoires français*. Paris.

GRUYS, A. 1976–78. *Cartusiana, un instrument heuristique*. 3 vols. Paris.

GUENÉE, Bernard. 1992. *Un meurtre, une société. L'assassinat du duc d'Orléans 23 novembre 1407*. Paris.

GUIFFREY, Jules.
1883. "Nicolas Bataille, tapissier parisien du XIVe siècle." *Mémoires de la Société de l'histoire de Paris et de l'Ile de-France* 10.
1886. *Histoire de la tapisserie depuis le Moyen Âge jusqu'à nos jours*. Tours.
1887. "Inventaire des tapisseries du roi Charles VI vendues par les Anglais en 1422." *Bibliothèque de l'École des chartes* 48.
1894–896. *Inventaires de Jean duc de Berry (1401–16)*. 2 vols. Paris.

GUILHERMY, François de. 1848. *Monographie de l'église royale de Saint-Denis. Tombeaux et figures historiques*. Paris.

GUILLEMAUT, Lucien. s. l., s. d. *Notice sur Cuiseaux et son canton*.

HAMBURGER, Jeffrey. 1988. "The Casanatense Missal and Painting in Guelders in the Early Fifteenth Century," *Wallraf-Richartz-Jahrbuch*, no. 48–49, pp. 7–44.

HARAUCOURT, Edmond, and François de MONTREMY. 1922. *Musée des thermes et de l'Hôtel de Cluny. Catalogue général*. Vol. 1. *La pierre, le marbre et l'albâtre*. Paris.

HASSE, Max
1977. "Studien zur Skulptur des ausgehenden 14. Jahrhunderts." *Städel Jahrbuch* 6, pp. 99–128.
1978. "Paralele Entwicklungen." In *Cologne 1978*, 3: p. 43.

HAWLEY, Henry. 1991. "Directorship of William M. Milliken." In Evan H. Turner, *Object Lessons: Cleveland Creates an Art Museum*. Cleveland.

HEDEMAN, Anne D.
1991. *The Royal Image: Illustrations of the Grandes Chroniques de France*, pp. 233–34. Berkeley, California.
1995. "Roger van der Weyden's Escorial *Crucifixion*" and "Carthusian Devotional Practice." In *The Sacred Image East and West*. Chicago.
2003. "Visual Translation: Illustrating Laurent de Premierfait's French Versions of Boccaccio *De casibus*." In *Un traducteur et un humaniste de l'époque de Charles VI, Laurent de Premierfait*. Ed. C. Bozzolo. Paris.

HEINRICHS-SCHREIBER, Ulrike. 1997. *Vincennes und die höfische Skulptur. Die Bildhauerkunst in Paris 1360–1420*. Berlin.

HENWOOD, P.
1981. "Peintres et sculpteurs parisiens des années 1400: Colart de Laon et les statuts de 1391." *GBA*, 6e série, no. 123.

1982. "Les orfèvres parisiens pendant le règne de Charles VI (1380–1422)." *Bulletin archéologique du Comité des travaux historiques et scientifiques*, n. s. 15, pp. 85–180.

HILBER, Paul. 1919. *Die kirchliche Goldschmiedekunst in Freiburg*, pp. 24ff. Fribourg.

HILGER, Hans Peter. 1978. "André Beauneveu, Bildhauer und Maler." In *Cologne 1978*.

HINDMANN, Sandra.
1983A. "The Composition of the Manuscript of Christine de Pisan's Collected Works in the British Library: A Reassesment." *British Library Journal*, no. 9.
1983B. "The Iconography of Queen Isabeau de Bavière (1410—1415): An Essay in Method." *GBA*, 6e série, no. 102.

HINKEY, D. M. 1976. *The Dijon Altarpiece by Melchior Broederlam and Jacques de Baerze: A Study of Its Iconographic Integrity*. Ph.D. diss. University of California, Los Angeles (Ann Arbor, Michigan: University Microfilms).

HIRSCHAUER, C. 1923. *Les États d'Artois de leurs origines à l'occupation française, 1340–1640*. 2 vols. Paris.

HIRSCHBIEGEL, J. 2003. *Etrennes. Untersuchungen zum höfischen Geschenkverkehr im spätmittelalterlichen Frankreich der zeit König Karls VI (1380–1422)*. Oldenbourg.

HOOGEWERF, G. J. 1936. *De Noord-nederlandsche Schilderkuns*. The Hague.

HOUSTON.
1981. *A Guide to the Collection*. Houston.
1989. *A Permanent Legacy. 150 Works from the Collection of the Museum of Fine Arts*. New York.

HOVING, T. 1970. "Director's Choice." *Metropolitan Museum Art Bulletin*, n. s. 28, pp. 212–13.

HUGHES, M. J. 1984. "The Library of Margaret of York, Duchess of Burgundy." *The Private Library*, 3e série, 7, no. 2, pp. 53–78.

HUIZINGA, Johan.
2002. *Le Déclin du Moyen Âge*. Rev. ed.
1919. "Petite Bibliothèque Payot." In *L'Automne du Moyen Âge*. Trans. J. Bastien. Paris.

HULST, Roger A. d'. 1960. *Tapisseries flamandes du XIVe au XVIIIe siècle*. Brussels.

HUMBERT, A. 1913. *La Sculpture sous les ducs de Bourgogne, 1361–1483*. Paris.

HUSSON, Éric. 1990. "Le portail de l'église de la chartreuse de Champmol." In *Dijon 1990*, pp. 25–29.

ICKOWICZ, Pierre. 1990–92. "Archéologie et histoire d'un jardin: le parc Buffon à Montbard." *MCACO* 36, pp. 339–52.

Inventaire général des Monuments et des Richesses artistiques de la France, Commission régionale de Bourgogne, Côte-d'Or, canton Sombernon. 1977. Paris.

JACOBS, Lynn F. 1998. *Early Netherlandish Carved Altarpieces 1380–1550*. Cambridge.

JACQUES, Charles. 1941. *La Peinture française. Les peintres du Moyen Âge*. Paris.

JALABERT, Denise.
1947. "Deux statues de l'église de Poligny." *Musées de France*, pp. 18–22.
1958. *Musée national des monuments français. La sculpture française III: Époque gothique (II) XIVe et XVe siècles*. Paris.

JANSSENS DE BISTHOVEN, Aquilin. 1944. "Het beeldhouwwerk van het Brugse stadshuis." *Gentse bijdragen tot de kunstgeschiedenis*, no. 10.

JENZER, Muriel.
1992. *Saint-Hippolyte de Poligny Histoire de la construction*. Master's thesis. Université de Besançon.
1994. "Le chantier de Saint-Hippolyte de Poligny (1414–1457) d'après les comptes de construction." *Bulletin monumental* 152, pp. 415–58.

JÉRÔME, Céline. 1997–98. *La Vierge Bulliot du musée Rolin à Autun. Monographie de muséologie; École du Louvre*.

JOHAN, F. 2003. "Catalogue–ms 9475." In *La Librairie des ducs de Bourgogne. Manuscrits conservés à la Bibliothèque royale de Belgique*. Vol. 2. *Textes didactiques*. Ed. B. Bousmanne, F. Johan, and C. Van Hoorebeeck. Turnhout.

JOHNSTON, William R. 1999. *William and Henry Walters*. Baltimore/London.

JOLIET, Albert. 1922. "Les retables de J. de Baerze." *Bulletin de l'académie de Dijon*, pp. 141–44.

JONES, E. Alfred. 1930. "Some Old Foreign Silver in the Collection of Mr. William Randoph Hearst." *The Connoisseur*, no. 86, pp. 220–25.

JOUBERT, Fabienne.
1990. "Les 'tapissiers' de Philippe le Hardi." In *Artistes, artisans, et production artistique au Moyen Âge*. Vol. 10. *Fabrication et consommation de l'oeuvre*. Ed. Barral i Altet. Paris.
1992A. "Le saint Christophe de Semur-en-Auxois: Jean de Bruges en Bourgogne?" *Bulletin monumental* 150, no. 2.
1992B. "Le Tombeau de Philippe le Hardi," pp. 729–39. In *Künstlerischer Austausch—Artistic Exchange: Akten des XXVIII. Internationalen Kongresses für Kunstgeschichte Berlin*. Berlin.
1992C. "Un retable de l'entourage de Claux de Werve," pp. 115–26. In *Actes des Journées internationales Claus Sluter*. Dijon.
1992. In *Allgemeines KünstlerLexikon*. Vol. 8. Munich/Leipzig.
1999. "Illusionnisme monumental à la fin du XIVe siècle: les recherches d'André Beauneveu à Bourges et de Claus Sluter à Dijon," pp. 367–84. In *Pierre, lumière, couleur. Études d'Histoire de l'Art du Moyen Âge en l'honneur d'Anne Prache*. Ed. F. Joubert and D. Sandron. Paris.

JOUBERT, Fabienne, Amaury LEFÉBURE, and Pascal-François BERTRAND. 1995. *Histoire de la tapisserie en Europe du Moyen Âge à nos jours*, pp. 8–75. Paris.

JOURNET, René. *Deux Retables du Quinzième Siècle à Ternant (Nièvre)* (Annales Littéraires de l'université de Besançon, 49). Paris.

JSKBW. 1966: "Badisches Landesmuseum. Neuerwerbungen 1965." *Jahrbuch der Staatlichen Kunstsammlungenin Baden-Württemberg*, no. 3, pp. 238, no. 167, pp. 239.

JUGIE, Sophie.
1997. "Les portraits des ducs de Bourgogne." *Publications du Centre européen d'études bourguignonnes*, no. 37, pp. 49–86.
1999. "Une fête champêtre à la cour de Bourgogne." *Bulletin des musées de Dijon*, no. 5, pp. 59–69, 76–77.
2000. "Les carreaux de faïence de Philippe le Hardi, duc de Bourgogne," pp. 65–72. In *Bourg-en-Bresse 2000*.

JULLIAN, René. 1965. *La Sculpture gothique*. Paris.

JULLIEN DE POMMEROL, Marie-Henriette, and Jacques MONTFRIN. 2001. *Bibliothèques ecclésiastiques au temps de la papauté d'Avignon*. Paris.

KARLSRUHE. 1976. *Badisches Landesmuseum Karlsruhe, Bildkatalog*. Karlsruhe.

KELDERS, A. 2003. "Catalogue—ms. 11042." In *La Librairie des ducs de Bourgogne. Manuscrits conservés à la Bibliothèque royale de Belgique*. Vol. 2. *Textes didactiques*. Ed. B. Bousmanne, F. Johan, and C. Van Horebeeck. Turnhout.

KEMPERDICK, Stephan. 1997. *Der Meister von Flémalle. Die Werkstatt Robert Campins und Rogier van der Weyden*. Turnhout.

KIMPEL, Dieter. 1971. *Die Querhausarme von Notre-Dame zu Paris und ihre Skulpturen*. Bonn.

KIPLING, Gordon. 1977. *The Triumph of Honour, Burgundian Origins of the Elizabethan Renaissance*. Leyde.

KITTELL, E. E. 1991. *From Ad Hoc to Routine. A Case Study in Medieval Bureaucracy*. Philadelphia.

KLEINCLAUSZ, Arthur.
1905. *Claus Sluter et la sculpture bourguignonne au XVe siècle*. Paris.
1906. "Les peintres des Ducs de Bourgogne." *Revue de l'art*, pp. 161–76 and 253–68.
1929. "L'art bourguignon dans la vallée du Rhône." *Annales de Bourgogne* 1, pp. 11–26.

KLINCKAERT, J. 1983–84. "Beeldhouwer Jacques de Baerze." *Tijdingen. Tijdschrift van het Justus de Hardewijn genootschap*, no. 13–14, pp. 10–19.

KNOWLES, C.
1952. "Les *Catalogue ms. 11042* enseignements de Théodore Paléologue." *Byzantion* 22, pp. 389–94.
1954. "Jean de Vignay, un traducteur du XIVe siècle." *Romania* 75, pp. 353–83.

KOECHLIN, Raymond. 1924. *Les Ivoires gothiques français*. Paris.

KOSEGARTEN, Antje. 1960. *Plastik am Wiener Stefansdom*. Ph.D. diss. Fribourg.

KÖSTER, Kurt M.
1965. "Religiöse Medaillen und Wallfahrts-Devotionalien in der flämischen Buchmalerei des 15. und frühen 16. Jahrhunderts, das Buch und Welt," pp. 459–504. In *Festschrift für Gustav Hofman*. Weisbaden.
1979. "Kollektionen metallener Wallfahrts-Devotionalien und kleiner Andachtsbilder, eingenält in spätmittelalterlichen Gebetbuch-Handschriften," 1: pp. 77–130. In *Das Buch und sein Haus. Gerhard Liebers gewidmet zur Vollendung des 65. Lebensjahres. F. Erlesenes aus der Welt des Buches*. Ed. B. Haller. Weisbaden.
1984. "Gemalte Kollektionen von Pilgerzeichen und religiösen Medaillen in flämischen Gebet-und Stundenbüchern des 15. Jahrhunderts. Neue Funde in Handschriften des Gent-Brügger Schule." In *Liber Amicorum Herman Leibaers*. Brussels.

KOVÁCS, E.
1975. "Problèmes de style autour de 1400. L'orfèvrerie parisienne et ses sources." *Revue de l'art*, no. 28, pp. 25–33.
1983. *The Calvary of King Matthias Corvinuz in the Treasury of Esztergom Cathedral*. Budapest.
1997. *L'Estoire del saint Graal*. Ed. Jean-Paul Ponceau. (Classiques français du Moyen Âge). Paris.
2004. *Ouvrage posthume comportant l'ensemble des études consacrées par l'historienne à l'orfèvrerie française des XIVe et XVe siècles, certaines déjà publiées d'autres inédites* Ed. Faton, forthcoming.

KREYTENBERG, Gert. 1985. "Zur Komposition des Skulpturenzuklus am sogenannten Mosesbrunnen von Claus Sluter." *Pantheon* 43, pp. 15–20.

KROOS, Renate. 1984. "Grabbräuche Grabbilder." In *Memoria. Der geschichtliche Zeugniswert des liturgischen Gedenkens im Mittelalter*. Ed. K. Schmid and J. Wollasch. Munich.

KURMANN, Peter.
1971. *La Cathédrale Saint-Étienne de Meaux*. Paris/Geneva.
1987. *La Façade de la cathédrale de Reims*. Lausanne/Paris.

KURMANN-SCHWARZ, Brigitte. 1988. *Französische Glasmalereien um 1450. Ein Atelier in Bourges und Riom*. Bern.

KURTZ, Otto. 1956. "A Fishing Party of the Court of Willem VI, Count of Holland, Zeeland and Hainaut." *Oud Holland*, no. 70, fasc. 3, pp. 117–31.

LABARTE, Jules. 1879. *Inventaire du mobilier de Charles V, Roi de France* (collections des documents inédits). Paris.

LABORDE, A. de. 1927. *Étude sur la Bible moralisée illustrée*. 5 vols. Paris.

LABORDE, L. de. 1849–52. *Les Ducs de Bourgogne. Études sur les lettres, les arts et l'industrie pendant le XVe siècle et plus particulièrement dans les Pays-Bas et le duché de Bourgogne*. 3 vols. Paris.

LACLOTTE, Michel.
1960. "Chartreuse de Champmol: Exhibition at Dijon," *Burlington Magazine*, pp. 495–96.
1961. "La peinture en Bourgogne au XVe siècle." *Art de France* 1, pp. 287–88.
1963. "Tableaux à chevalet français vers 1400." *Art de France*.
1966. *Primitifs français*. Paris.

LACROIX, Pierre
1972. *Art sacré dans le Jura*. Poligny.
1981. *Églises jurassiennes romanes et gothiques*. Besançon.
1988. *Le Jura, terre mariale. Marie dans l'histoire et le patrimoine du Jura*. Lons-le-Saunier.

LAIOU, A. E. 1968. "A Byzantine Prince Latinized: Theodore Palaeologus, Marquis of Monferrat." *Byzantion* 38, pp. 386–410.
1978–83. *Lancelot: roman en prose du XIIIe siècle*. Ed. A. Micha. Geneva.

LALEMAN, M.-C., and G. STOOPS. 2000. "De Wal in de 13de en de 14de eeuw," pp. 13–23. In *Het Prinselijk Hof ten Walle in Gent*. (Stadsarcheologie. Bodem en monument in Gent). Ghent.

LALLEMAND, Jean-Baptiste. 1787. *Voyage pittoresque de la France par une société de gens de lettres*. Paris.

LA MARCHE, Olivier de. 1883–88. *Mémoires d'Olivier de La Marche, maître d'hôtel et capitaine des gardes de Charles le Téméraire*. Ed. H. Beaune and J. d'Arbaumont, 4 vols. Paris.

LANE, B. 1973. "An Immaculist Cycle in the Hours of Catherine of Cleves." *Oud Holland* 87, pp. 177–204.

LANG, Caspar. 1692. *Historisch-theologischer Grundriss der altund jeweiligen christlichen Welt*. Einsiedeln.

LAPAIRE, Claude.
1969. "Les retables à baldaquin gothiques." *Zeitschrift für Schweizerische Archäologie und Kunstgeschichte* 26, pp. 169–90.
1983. "Une statue bourguignonne de saint Thibaut et l'usage des modèles, répliques et réductions dans les ateliers de sculpture du XVe siècle." *Genava, Musée d'art et d'histoire Genève*, n. s., no. 31, pp. 27–33.

LA SELLE, Xavier de. 1995. *Le Service des âmes à la cour. Confesseurs et aumôniers des rois de France du XIIIe au XVe siècle*, p. 271. Paris.

LA TRÉMOILLE, Louis de. 1887. *Livre des comptes, 1395–1406, Guy de Trémoille et Marie de Sully*. Nantes (published after the original by Louis de La Trémoille).

LAURENT, Jacques, ed. 1907–11. *Cartulaires de l'abbaye de Molesme, ancien diocèse de Langres, 916–1250: recueil de documents sur le Nord de la Bourgogne et le Midi de la Champagne*. 2 vols. Paris.

LAVALLEYE, J. 1930. "Le Château de Courtrai. Contribution à l'histoire de l'architecture militaire en Belgique." *Annales de la Société royale d'archéologie de Brussels* 35.

LAVEISSIÈRE, Sylvain. 1980. *Dictionnaire des artistes et ouvriers d'art de Bourgogne*. Paris.

LE BRUN-DELBANNE. 1872. "Les tableaux des inconnus dans le musée de Troyes." *Mémoires de la Société académique de l'Aube*, pp. 88–94.

LECAT, Jean-Philippe. 1986. *Le Siècle de la Toison d'or*. Paris.

LECLERCQ, J. 1987. "Marie à la lecture du Christ." *Collectanea Cisterciensia* 49, pp. 107–16.

LECOMTE, Christine. 1996–97. *Le Culte des reliques en Côte d'Or à la fin du Moyen Âge*. Master's thesis. Université de Bourgogne, Dijon.

LE COUTEULX, Charles. 1887–91. *Annales Ordinis cartusiensis ab anno 1084 ad annum 1429*. 8 vols. Monstroli.

LEEUWENBERG, Jaap. 1969. "Early Nineteenth-Century Gothic Ivories." *Aachener Kunstblätter*, pp. 111–48.

LEFRANÇOIS-PILLION, Louise. 1922. "L'église de Saint-Thibault-en-Auxois et ses oeuvres de sculpture." *GBA*, no. 1, pp. 137–57.

LEFRANÇOIS-PILLION, Louise, and Jean LAFOND. 1954. *L'Art du XIVe siècle en France*. Paris.

LE GOFF, Jacques, and René REMOND. 1988. "La religion flamboyante, 1320–1520." In *Du christianisme flamboyant à l'aube des Lumières XIVe–XVIIIe siècle. Histoire de la France religieuse*. Vol. 2, chapter 1. Paris.

LEHOUX, Françoise. 1966–68. *Jean de France, duc de Berri. Sa vie, son action politique (1340–1416)*. 4 vols. Paris.

LEMAIRE, C. 1994. "Remarques relatives aux inventaires de la Librairie de Bourgogne réalisés en 1467–1469, 1477, 1485, 1487 et aux manuscrits des duchesses." *Scriptorium* 48, no. 2, pp. 294–98.

LEMOISNE, P.-A.
1929. *La Peinture au musée du Louvre: École française, XIVe–XVIe siècles*. Paris.
1931. *La Peinture française à l'époque gothique. XIVe et XVe siècle*. Paris.

LEPRIEUR, P. 1909. *Catalogue raisonné de la collection Martin le Roy, fasc. V: Peintures*. Paris.

LEROQUAIS, Victor.
1927. *Les Livres d'heures manuscrits de la Bibliothèque nationale*. Vol. 1. Paris.
1939. *Un livre d'heures de Jean sans Peur, duc de Bourgogne (1404–1419)*. Paris.

LESTOCQUOY, J.
1978. "Deux siècles de l'histoire de la tapisserie (1300–1500)." In *Mémoires de la Commission départementale des Monuments historiques du Pas-de-Calais*. Vol. 19. Arras.

LIEBREICH, Aenne.
1933–35. "Quelques portraits de Philippe le Hardi." *MCACO* 20, pp. 89–96.
1936. *Claus Sluter*. Brussels.

LIEBREICH, Aenne, and Henri DAVID.
1933. "Le Calvaire de Champmol et l'art de Sluter" and "Première partie: Considérations générales." *Bulletin monumental* 92, pp. 419–41 and 441–67.
1935. "Le portail de l'église de Champmol. Chronologie de la construction." *Bulletin monumental* 94, pp. 329–52.

LIGHTBOWN, Ronald W.
1978. Secular Goldsmiths' Work in Medieval France: A History. London.
1992. Medieval European Jewellery. London.
LINDQUIST, Sherry Christine Maday.
1995. Patronage, Piety and Politics in the Art and Architectural Programs at the Chartreuse de Champmol in Dijon. Ph.D. diss. Northwestern University, Evanston, Illinois (Ann Arbor, Michigan: University Microfilms).
2002. "Accounting for the Status of Artists at the Chartreuse de Champmol." Gesta 41, no. 1.
LOPEZ, E. 2000. "L'observance franciscaine et la politique religieuse des ducs de Bourgogne." Annales de Bourgogne 72.
LORENTZ, Philippe. 2004. "Jean Malouel et les frères de Limbourg." In Paris 1400: Les arts sous Charles VI. Paris.
LORY, Ernest-Léon. 1865–69. "Les obsèques de Philippe le Bon, duc de Bourgogne, mort à Bruges en 1467." MCACO 7, pp. 215–46.
LUGT, Frits. 1968. Musée du Louvre. Inventaire général des dessins des écoles du Nord. Maîtres des Anciens Pays-Bas nés avant 1550. Paris.
LURIE, Ann Tzeutschler. 1974. European Paintings before 1500. Cleveland.
LYNA, Frédéric. 1946–47. "Les miniatures du ms du 'Ci nous dit' et le réalisme pré-eyckien." Scriptorium 1, pp. 106–18.

MÂLE, Émile. 1995. L'Art religieux de la fin du Moyen Âge en France, étude sur l'iconographie du Moyen Âge et sur ses sources d'inspiration. Rev. ed. Paris (first published in 1908).
MALLARD, Louis, and M. NADAULT DE BUFFO. 1881. Mémoires pour servir à l'histoire de la ville de Montbard d'après le manuscrit inédit de Jean Nadault. Paris/Dijon.
MANE, Perrine, and Françoise PIPONNIER. 1995. Se vêtir au Moyen Âge, p. 206. Paris.
MANSI, J.-D. 1903–27. Sacrorum conciliorum nova et amplissima collectio. Paris.
MARCEL, L. 1918. "L'ancien sépulcre de la cathédrale de Langres." Bulletin de la Société historique et archéologique de Langres 7, pp. 359–94.
MARILIER. 1963–69. MCACO 26, p. 127.
MARIX, J. 1939. Histoire de la musique et des musiciens de la cour de Bourgogne sous le règne de Philippe le Bon (1420–1467). Strasbourg.
MARQUET DE VASSELOT, J. J. 1923. "La donation Corroyer au musée du Louvre." Beaux-Arts, pp. 149–50.
MARTENS, P. J. Maximiliaan. 1992. Artistic Patronage in Bruges Institutions, ca. 1440–1482. Ann Arbor, Michigan.
MARTIN, H.
1899. Histoire de la bibliothèque de l'Arsenal. Paris.
1911. Le Boccace de Jean sans Peur. Paris,
MARTINDALE, A. 1972. The Rise of the Artist in the Middle Ages and Early Renaissance. London.
MATTER, Jacques. 1846. Lettres et pièces rares ou inédites, publiées et accompagnées d'introduction et de notes: Une collection de livres d'une femme du monde du XIVe au commencement du XVe siècle: bibliothèque de Marguerite de Flandre, pp. 19–49. Paris.
MAURAIGE, Amélie de. 2000. "Le 'fâcheux accident' d'Antoine Monseigneur. Un traitement princier de la rage à la cour du premier grand duc de Bourgogne." Annales de Bourgogne 72, fasc. 1, pp. 105–35.
MEISS, Millard.
1963A. "A Lost Portrait of Jean de Berry by the Limbourgs." Burlington Magazine 107.
1963B. "French and Italian Variations of an Early Fifteenth Century Theme. St Jerome in His Study." GBA, no. 62, pp. 147–70.
1967. French Painting in the Time of Jean de Berry. The Late Fourteenth Century and the Patronage of the Duke. London/New York.
1968. French Painting in the Time of Jean de Berry. The Boucicaut Master. London/New York.
1974. French Painting in the Time of Jean de Berry. The Limbourgs and Their Contemporaries. New York.
MEISS, Millard, and Elizabeth BEATSON.
1974. The Belles Heures of Jean, Duke of Berry. New York.
1975. Les Belles Heures du duc Jean de Berry. Trans. Bella Bessard. Paris.

MEISS, Millard, and Colin EISLER.
1960. "A New French Primitive." Burlington Magazine 102, no. 687, pp. 232–40.
1977. Les Mémoriaux d'Antoine de Succa, un contemporain de P. P. Rubens. Dessins du XVIIe siècle. 2 vols. Primitifs Flamands 7. Brussels.
MENUT, Albert Douglas. 1940. Le livre de éthiques d'Aristotle. New York.
MÉRINDOL, Christian de.
1987. Le Roi René et la seconde maison d'Anjou. Emblématique, art, histoire. Paris.
1988. "Nouvelles observations sur la symbolique royale à la fin du Moyen Âge. Le couple de saint Jean-Baptiste et de sainte Catherine au portail de l'église de la chartreuse de Champmol." BSNAF, pp. 288–302.
1989. "Art, spiritualité et politique: Philippe le Hardi et la chartreuse de Champmol, nouvel aperçu," pp. 93–115. In Les Chartreux et l'Art, XIVe–XVIIIe siècle, Actes du Xe colloque international d'histoire et de spiritualité cartusiennes. Paris.
1992. "Claus Sluter et le double programme décoratif de la chartreuse de Champmol: nouvelles lectures," pp. 165–73. In Actes des journées internationales Claus Sluter. Dijon.
2001. "Le décor peint et armorié en France à l'époque médiévale: les châteaux et résidences des comtes d'Artois. Bilan et perspective," pp. 1–18. In Liber Amicorum Raphaël de Smedt. Vol. 2 of Artium Historia. Ed. J. Vander Auwera. (Miscellanea Neerlandica 24). Louvain.
MERSMANN, Wiltrud. 1969. "Jacques de Baerze und Claus Sluter." Aachener Kunstblätter 34, pp. 149–59.
MESQUI, Jean. 1997. "Germolles," pp. 185–86. In Châteaux forts et fortifications en France. Paris.
MICHA, A. 1960. "Les manuscrits du Lancelot en prose." Romania 81, pp. 180–82.
MICHEL, André. 1905. Histoire de l'art depuis les premiers temps chrétiens jusqu'à nos jours. I. Des débuts de l'art chrétien à la fin de la période romane. Paris.
MICHEL, Édouard. 1924. "Le musée Mayer van den Bergh à Anvers." GBA, no. 2, pp. 41–58.
MICHIELS, A. 1877. L'Art flamand dans l'est et le midi de la France. Rapport au gouvernement français. Paris.
MIGEON, Gaston. 1904. Musée national du Louvre. Catalogue des bronzes et cuivres du Moyen Âge, de la Renaissance et des temps modernes. Paris.
MILLAR, E. G. 1936. The Bohun Manuscripts, Roxburghe Club. Oxford.
MILLIKEN, William M.
1925. "A Table Fountain of the 14th Century." CMA Bulletin 12, pp. 36–39.
1940. "Two Pleurants from the Tombs of the Dukes of Burgundy." CMA Bulletin 27, pp. 119–21.
1947. CMA Bulletin 34, repr. p. 228.
MINER, Dorothy. 1966. "Madonna with Child Writing." Art News 64, no. 10.
MINOTT, C. 1994. "The Meaning of the Baerze-Broederlam Altarpiece," pp. 131–41. In A Tribute to Robert A. Koch. Studies in the Northern Renaissance. Princeton, New Jersey.
MIROT, Léon. 1903. "La messe de Requiem de du Guesclin en 1384." Revue des questions historiques 37, pp. 228–33.
MOENCH, E. 1986. "Stefano da Verona: la quête d'une double paternité." Zeitschrift für Kunstgeschichte 49, no. 2.
MOLINIER, Émile.
1896. Histoire générale des arts appliqués à l'industrie. Vol. 1. Paris.
1900. "L'exposition universelle en 1900, les Beaux-Arts et les Arts décoratifs." GBA, 3e série, no. 42, pp. 349–65.
MOLINIER, Émile, R. MARX, and F. MARCOU. 1900. L'Exposition rétrospective de l'art français des origines à nos jours. Paris.
MOLLAT, M., and R. FAVREAU. 1965–66. Comptes généraux de l'État bourguignon entre 1416 et 1420. 2 vols. (R. Fawtier, Recueil des historiens de la France. Documents financiers). Paris.
MONGET, Cyprien. 1898–1905. La Chartreuse de Dijon d'après les documents des archives de Bourgogne. 3 vols. Montreuil-sur-Mer/Tournai.
MONNIER, Désiré. 1844. Annuaire du Jura. Lons-le-Saunier.
MONSTRELET, Enguerrand de. 1857–62. Chroniques. Louis Douët-d'Arcq. 6 vols. Paris
MONTFAUCON, Bernard de. 1745. Thésor des Antiquitez de la Couronne de France. The Hague.

MOORE, E. B. 2002. "The Urban Fabric and Framework of Ghent in the Margins of Oxford, Bodleian Library, MSS Douce 5–6." "Als ich can." Liber Amicorum in Memory of Professor Dr. Maurits Smeyers. (Corpus van verluchte handschriften, 11). Louvain.
MORAND, Kathleen. 1991. Claus Sluter, Artist at the Court of Burgundy. London.
MORGANSTERN, Anne McGee.
1989. Entry in Gothic Sculpture in America. Vol. 1. The New England Museums, pp. 30–33, no. 18. Ed. Dorothy Gillerman. New York.
1992. "Le tombeau de Philippe le Hardi et ses antécédents," pp. 175–91. In Actes des Journées internationales Claus Sluter. Dijon.
2000. Gothic Tombs of Kinship in France, the Low Countries and England. University Park, Pennsylvania.
MOSNERON-DUPIN, Isabelle.
1990. "La Trinité debout en ivoire de Houston et les Trinités bourguignonnes. De Jean de Marville à Jean de La Huerta." Wiener Jahrbuch für Kunstgeschichte 43, pp. 35–65.
1992. "Les Trinités en Bourgogne, de Jean de Marville à Jean de La Huerta. Réflexion sur l'usage des modèles dans les ateliers de sculpture bourguignonne," pp. 193–210. In Actes des Journées internationales Claus Sluter. Dijon.
MOUILLEBOUCHE, Hervé. 2002. Les Maisons fortes en Bourgogne du nord du XIIIe au XVIe siècle. Dijon.
MÜLLER, Theodor. 1966. Sculpture in the Netherlands, Germany, France, and Spain: 1400–1500. Munich/Baltimore.
MÜLLER, Theodor, and Erich STEINGRÄBER. 1954. "Die französische Goldemailerplastik um 1400." Münchner Jahrbuch der bildenen Kunst 5, p. 76, no. 26, fig. 66.
MUND, Hélène, Cyriel STROO, Nicole GOETGHEBEUR, and Hans NIEUWDORP. 2003. The Mayer van den Bergh Museum Antwerp. Corpus of Fifteenth-Century Painting in the Southern Netherlands and the Principality of Liège. Vol. 20. Brussels.
Musée national du Louvre. Catalogue des sculptures du Moyen Âge, de la Renaissance et des temps modernes. 1922. Paris.

NETZER, N. 1991. Catalogue of Medieval Objects, Metalwork. Boston.
NICHOLAS, D. 1992. Medieval Flanders. London/New York.
NIEUWDORP, Hans.
1980. "Museum Mayer van den Bergh Antwerpen." Openbaar Kunstbezit in Vlaanderen 1.
1992. "Musée Mayer van den Bergh." Musea Nostra 26.
1994. "The Antwerp-Baltimore Polyptych: A Portable Altarpiece Belonging to Philip the Bold, Duke of Burgundy," pp. 137–50. In Amsterdam 1994.
NIEUWDORP, Hans, and M. ANNAERT. 1976–77. "Het laat-14deeeuws mariabeeld uit Brugge in het museum Mayer van den Bergh en haar polychromie." Bulletin de l'Institut royal du Patrimoine artistique 16, pp. 27–35.
NIEUWDORP, Hans, and GOETGHEBEUR N. 2003. "Anonymous Master, Two Panels of the "Antwerp-Baltimore Quadriptych," pp. 255–87. In Mund, Stroo, Goetghebeur, and Nieuwdorp 2003.
NIEUWDORP, Hans, Regine GUISLIAN-WITTERMAN, and Leopold KOCKAERT. 1984–85. "Het Pre-Eyckiaanse Vierluik Antwerpen-Baltimore." Bulletin, l'Institut royal du patrimoine artistique, no. 20, pp. 70–98.
NILGEN, U. 1967. "The Epiphany and the Eucharist. On the Interpretation of Eucharistic Motifs in Medieval Epiphany Scenes." Art Bulletin 49, pp. 311–16.
NINANE, Lucie. 1985–88. "Un portrait de famille des ducs de Bavière, comte de Hollande, Zélande et Hainaut." Bulletin des Musées royaux des Beaux-Arts de Belgique 1–3, pp. 63–74.
NODET, Victor. 1911. L'Église de Brou. Paris.
NORDENFALK, Carl Adam Johan.
1955. Kung praktiks och drottning Teoris jaktbok. Le livre des deduis du roi Modus et de la reine Ratio. Stockholm.
1977. "Hatred, Hunting, and Love: Three Themes Relative to Some Manuscripts of Jean sans Peur." In Studies in Late Medieval and Renaissance Painting in Honor of Millard Meiss.

NORTON, Christopher.
1982. "Les carreaux de pavage de la Bourgogne médiévale," *Archéologia*, no. 165, pp. 34–44.
1984. "Medieval Tin-Glazed Painted Tiles in North-West Europe." *Medieval Archaeology* 28.
NYS, Ludovic. 2003. "Le triptyque Seilern: une nouvelle hypothèse." *Revue de l'art*, no. 139, 5–20.

Obituaires de la province de Sens. 1902–23. 4 vols. Paris.
OETTINGER, Karl. 1938. *Hans von Tübingen und seine Schule.* Berlin.
OLIVER, J. H. 1995. "The Herkenrode Indulgence, Avignon and Pre-Eyckian Painting of the Mid-Fourteenth-Century Low Countries," pp. 187–200. In *Flanders in a European Perspective. Manuscript Illumination around 1400 in Flanders and Abroad.* Ed. M. Smeyers and B. Cardon. (Corpus van verluchte handschriften, 8). Louvain.
OLSON, Roberta. 2002. "Observations on Renaissance Paintings, Drawings, and Prints in Round Formats North of the Alps." *Arte Christiana* 90, no. 810.
OTAVSKY, Karel. 1985. "Deux plaques d'argent portant le nom, les armes et la devise de Guillaume de Grandson (+ 1389)," pp. 7–14. In *Publication du centre européen d'études bourguignonnes (XIXe–XVIe s.)* 25. Basel.
O'MEARA, Cara Ferguson. 2001. *Monarchy and Consent: The Coronation Book of Charles V.* London.
OMONT, Henri. 1895–96. *Catalogue Général des manuscrits français.* 3 vols. Paris.
OURSEL, Charles.
1928. *L'Art roman de Bourgogne. Études d'histoire et d'archéologie.* Dijon/Boston.
1953. *L'Art de Bourgogne.* Paris.
OUY, Gilbert, and Christine M. RENO. 1980, "Identification des autographes de Christine de Pizan." *Scriptorium* 32, no. 2, pp. 221–38.

PÄCHT, Otto.
1963A. "Zur Entstehung des "Hieronymus in Gehäuse." *Pantheon*, no. 21, pp. 131–42.
1963B. "The Limbourgs and Pisanello." *GBA*, no. 62, pp. 109–22.
1989. *Van Eyck. Die Begründer der altniederländischen Malerei.* Munich/New York.
PÄCHT, Otto, and Jean-Bernard de VAIVRE. 1986. "Portraits oubliés de Philippe le Hardi, duc de Bourgogne," pp. 702–29. In *Compte rendus de l'Académie des inscriptions.*
PALLIOT, Pierre. 1650. *La vraye et parfaite science des armoiries.* Dijon.
PANOFSKY, Erwin.
1935. "The Friedman Annunciation and the Problem of the Ghent Altarpiece." *Art Bulletin*, no. 17, p. 450, no. 32, fig. 25.
1953. *Early Netherlandish Painting.* 2 vols. Cambridge, Massachusetts.
1954. *Galileo as a Critic of the Arts.* The Hague.
1960. *Renaissance and Renascenes in Western Art.* Stockholm. French ed. *La Renaissance et ses avantcourriers dans l'art d'occident.* Paris, 1990.
1992. *Les Primitifs flamands.* Paris.
PARAVICINI, Werner.
1991A. "The Court of the Dukes of Burgundy: A Model for Europe?" In Ronald Asch and Adolf M. Birke. *Princes, Patronage, and the Nobility: The Court at the Beginning of the Modern Age, c. 1450–1650.* Oxford.
1991B. "Die Residenzen der Herzöge von Burgund 1363–1477." *Fürstliche Residenzen in spätmittelalterlichen Europa.* Vorträge und Forschungen 36. Sigmaringen.
PARAVICINI, W., and Bertrand SCHNERB.
Forthcoming. "Les fondations religieuses des ducs de Bourgogne à Paris." In *Paris, capitale des ducs de Bourgogne.*
PASTOUREAU, M. 1996. "La Toison d'or, sa légende, ses symboles, son influence sur l'histoire littéraire." *Ordre de la Toison d'or.*
PAUPHILET, Albert. 1938. *Historiens et Chroniqueurs du Moyen Âge. Robert de Clari, Villehardouin, Joinville, Froissart, Commynes. Texte établi et annoté par Albert Pauphilet.* Paris.
PAUWELS, P. G. 1983. "Het nieuw Kasteel van Kortrijk 1394–1684. Bouwgeschiedenis en Ikonografie." *Handelingen van de Koninklijke Geschied- en Oudheidkundige Kring van Kortrijk*, n. s. 50.

PAVIOT, Jacques. 1990. "La vie de Jan van Eyck selon des documents écrits." *Revue des archéologues et historiens de l'art de Louvain*, no. 23.
PEIGNOT, G. 1841. *Catalogue d'une partie des livres composant la bibliothèque des ducs de Bourgogne au XVe siècle*, pp. 35–36. 2nd ed. Dijon.
PÉROUSE DE MONTCLOS, J.-M. 1988. *Architecture. Vocabulaire.* Paris.
PERRAULT-DABOT, Anatole.
1907. "Cuiseaux: un coin du Jura dans la Bresse." *Annales de l'académie de Mâcon* 12.
1922. "Une réplique du puits de Moïse à Dijon." *Bulletin monumental* 81, pp. 415–23.
PERRET, André. 1978. "L'atelier de sculpture et le chantier de la sainte-chapelle de Chambéry." *Annesci*, fasc. 21, p. 36.
PETIT, Ernest.
1885. *Entrée du roi Charles VI à Dijon sous Philippe le Hardi.* Dijon,
1885–1905. *Histoire des ducs de Bourgogne de la race capétienne, avec des documents inédits et des pièces justificatives.* 9 vols. Dijon.
PETIT, Étienne. 1888. *Itinéraires de Philippe le Hardi et de Jean sans Peur, ducs de Bourgogne (1363–1419).* Paris.
PEUVOT, Roland. 1970. *La Commune de Beaune 1203–1478.* Master's thesis. Dijon.
PICARD, Étienne.
1894. "Les Jardins du château de Rouvres au quatorzième siècle." *Mémoires de la société Éduenne* 22.
1912. "Le château de Germolles et Marguerite de Flandre." *Mémoires de la Société Éduenne* 40.
PIDOUX DE LA MADUÈRE, A. 1939. *Le Vieil Arbois. La rive gauche et les origines*, p. 70. Dijon.
PIDOUX DE LA MADUÈRE, Sylvaine. 1975. *Mon vieux Poligny.* 2 vols. 2nd ed. Dijon.
PIEPER, Paul. 1966. "Eine Tafel von Robert Campin." *Pantheon*, no. 24.
PIN, Céline. 1997. *L'Hôtel-Dieu de Tonnerre 1292–1350 d'après ses livres de comptes.* Master's thesis. Université de Bourgogne, Dijon.
PINET, Marie-Josèphe. 1974. *Christine de Pisan, 1364–1430, étude biographique et littéraire.* Geneva.
PINETTE, Matthieu. 1984. "De la couleur dans l'édifice médiéval: carreaux et carrelages gothiques. La Bourgogne au temps de Philippe le Hardi." *Revue de l'art*, no. 63, pp. 73–74.
PIZAN, Christine de.
1959–66. *Le Livre de la Mutacion de Fortune.* 4 vols. Société des Anciens Textes français 88. Paris (published after manuscripts by Suzanne Solente).
1974. *Le Livre du Chemin de long estude.* Geneva (reprinted from the German, 1887).
PLAGNIEUX, Philippe.
1994. "Robert de Helbuterne, un charpentier devenu maître des oeuvres de maçonnerie de la ville de Paris et général maître des oeuvres de Jean sans Peur, duc de Bourgogne." *BSNAF*, pp. 153–64.
1998. "La tour 'Jean sans Peur' une épave de la résidence parisienne des ducs de Bourgogne." *Histoire de l'art* 1, no. 2, pp. 11–20.
PLANCHER, Urbain. 1739–81. *Histoire générale et particulière de Bourgogne.* 4 vols. Paris.
POCQUET DU HAUT, Jussé. 1937. "Les chefs des finances ducales de Bourgogne." *Mémoires de la Société pour l'histoire du droit et des institutions des anciens pays bourguignons, comtois et romands* 4.
POIRION, Daniel. 1983. *Précis de littérature française du Moyen Âge.* Paris.
PONTEFRACT, Bernard. 1993. *L'Abbaye de Baume-les-Messieurs (Jura).* Paris.
PORCHER, Jean.
1953. *Les Belles Heures de Jean de France, duc de Berry.* Paris.
1959. "L'enluminure française." *Arts et metiers graphiques.* Paris.
PRADEL, Pierre.
1951. "Les tombeaux de Charles V." *Bulletin monumental* 109, pp. 273–96.
1957. "Nouveaux Documents sur le Tombeau de Jean de Berry," pp.141–57. In *Fondation Eugène Piot: Monuments et Mémoires.* Paris.
PREIMESBERGER, Rudolf. 1991. "Zu Jan van Eycks Diptychon in der Sammlung Thyssen-Bornemisza." *Zeitschrift für Kunstgeschichte*, no. 60,
PREVENIER, W. 1961. *De Leden en de Staten van Vlaanderen (1384–1405).* Brussels.

PREVENIER, W., and W. BLOCKMANS.
1983. *Les Pays-Bas bourguignons.* Paris.
1999. *The Promised Lands. The Low Countries under Burgundian Rule, 1369–1530.* Philadelphia (originally published as *In de Ban van Bourgondië* in the Netherlands, 1988).
PRIGENT, Christiane. 1999. *Art et société en France au XVe siècle.* Paris.
PROCHNO, Renate.
2000. "Das Grabmal Philipps des Kühnen (1363–1404) für Champmol," pp. 5–102, fig. 2. In W. Maier, W. Schmid, and M. V. Schwarz. *Grabmäler: Tendenzen der Forschung an Beispielen aus Mittelalter und Früher Neuzeit.* Vol. 1. Berlin.
2002. *Die Kartause von Champmol. Grablege der burgundischen Herzöge 1364–1477.* Berlin.
PROSKE-VAN HEERDT, D. 1995. "Realism at the Cradle of Illumination in the Northern Netherlands," pp. 111–26. In *Flanders in a European Perspective. Manuscript Illumination around 1400 in Flanders and Abroad.* Ed. M. Smeyers and B. Cardon. (Corpus van verluchte handschriften, 8). Louvain.
PROST, Bernard, and Henri PROST.
1890–91. "Quelques acquisitions de manuscrits by les ducs de Bourgogne Philippe le Hardi et Jean sans Peur." *Archives historiques, artistiques et littéraires* 2, pp. 349–59.
1902–8. *Inventaires mobiliers et extrait des comptes des ducs de Bourgogne de la Maison de Valois.* 2 vols: vol. 1 (for 1363–77), vol. 2 (for 1378–90). Paris.
1908–13. *Inventaires mobiliers et extrait des comptes des ducs de Bourgogne de la Maison de Valois (1390–1477).* Paris.

QUANTIN, Maximilien. 1991. *Département de l'Yonne. Répertoire Archéologique.* Paris.
QUARRÉ, Pierre.
1936–39. "Les pleurants de la collection Clarence Mackay." *MCACO* 21, p. 397.
1942–46. "Deux fragments du tombeau de Philippe le Hardi provenant de la collection Baudot: clef pendante et pied de Philippe le Hardi" and "Les dessins de Joannès Lesage représentant les tombeaux des ducs." *MCACO* 22, fasc. 2 and 3, pp. 426, 477, and 506.
1944–45. "La reconstitution des tombeaux des ducs de Bourgogne." *Bulletin de la Société des amis des musées de Dijon*, pp. 34–42.
1945–47. "Les mains du duc Philippe le Hardi sur son tombeau et au portail de la chartreuse de Champmol." *BSNAF*, pp. 267–81.
1947. "Le couple d'enfants de choeur du tombeau de Jean sans Peur." *Bulletin monumental*, pp.
1947–53. "Fouilles à la chartreuse de Champmol" and "Les carreaux de pavement de l'oratoire ducal à la chartreuse de Champmol." *MCACO* 23, pp. 66–67 and 234–40.
1948. "Les pleurants des tombeaux des ducs de Bourgogne, mutations et réintégrations." *BSNAF*, pp. 124–32.
1949. "Sculptures Bourguignonnes du XIVe au XVIe siècle au musée de Dijon." *Musées de France* 9, pp. 250–56.
1950. "La crosse et l'anneau découverts à Saint-Étienne de Dijon." *BSNAF*, pp. 26–30.
1951. "La polychromie du Puits de Moïse." *Arts plastiques* 5, pp. 211–18.
1952–54. "Les fouilles de la chartreuse de Champmol." *Bulletin de la Société des amis du musée de Dijon*, pp. 25–28.
1953. "Les caveaux des ducs de Bourgogne à la Chartreuse de Champmol." *RBAHA* 22, pp. 115–21.
1954. "Les statues de l'oratoire ducal à la chartreuse de Champmol." *Recueil publié à l'occasion du cent cinquantenaire de la Société nationale des antiquaires de France* 83, pp. 245–55.
1954–58. "Les Noms tracés sur les statues du portail de la chartreuse de Champmol" and "Carreaux de pavement du château d'Argilly." *MCACO* 24, pp. 185–90.
1957. "Un décor de chaire de la chartreuse de Champmol, oeuvre de Jean de Liège," pp. 219–28. In *Miscellanea Prof. Dr. D. Roggen.* Antwerp.
1959–62. "Une Vierge de Poligny attribuée à Jean de La Huerta." *MCACO* 25.
1960A. "Influence de Simone Martini sur la sculpture bourguignonne." *BSNAF*, pp. 53–55.

1960B. "La collégiale Saint-Hippolyte de Poligny et ses statues," pp. 209–24. In *Congrès archéologique de France, Franche-Comté*.

1960C. *Musée des Beaux-Arts de Dijon: Catalogue des sculptures*. Dijon.

1963–69. "Hôpital" and "Compte rendu des fouilles effectuées en 1967 sur le site du château d'Argilly." and *MCACO* 26, pp. 113 and 99–103.

1966. "Le Christ en croix de Saint-Bénigne de Dijon." *Revue du Louvre* 1, pp. 5–12.

1968. "Musée des Beaux-Arts de Dijon. Acquisitions (1965–1968)." *La Revue du Louvre et des Musées de France* 1, pp. 463–74.

1971. "Le Christ de la Mise au tombeau de Langres." *Revue de l'art*, no. 13, pp. 68–71.

1973A. "La sculpture bourguignonne au XVe siècle, de Claus Sluter à Antoine Le Moiturier." *Les Monuments historiques de la France* 2, pp. 38–44.

1973B. "Le retable de la Capilla de los Corporales de la Collegiale de Daroca, et le sculpteur Jean de La Huerta," pp. 455–64. In *Actes du 23e congrès international d'histoire de l'art*. Granada.

1973–75. "Claux de Werve, collaborateur et successeur de Claus Sluter." *Bulletin de la Société des amis des musées de Dijon*, pp. 33–36.

1974–75. "L'implantation du Calvaire du 'Puits de Moïse' à la chartreuse de Champmol." *MCACO* 29, pp. 161–66.

1976A. "Sculpture bourguignonne et sculpture languedocienne." *ACNSS* 96, no. 2.

1976B. "Claux de Werve et la sculpture bourguignonne dans le premier tiers du XVe siècle," pp. 3–12. In *Claux de Werve, imagier des ducs de Bourgogne*. Dijon.

1977. "Les statues de Claus de Werve en Franche-Comté." *ACNSS* 99, pp. 117–27.

1978. *La Sculpture en Bourgogne à la fin du Moyen Âge*. Fribourg/Paris.

1981. "Mellecey—château de Germolles," pp. 108–10. In *Le Guide des châteaux de France Saône-et-Loire*. Paris.

QUARRÉ, Pierre, and Monique GEIGER. 1968. *Musée des Beaux-Arts de Dijon: Catalogue des peintures françaises*. Dijon.

QUEDNAU, Ursula. 1979. *Die Westportale der Kathedrale von Auxerre*. Wiesbaden.

QUICKE, F. 1947. "L'échec du projet de mariage anglo-flamand." Chapter 8 in *Les Pays-Bas à la veille de la période bourguignonne 1356–1384. Contribution à l'histoire politique et diplomatique de l'Europe occidentale dans la seconde moitié du XIVe siècle*. Paris/Brussels.

RANDALL, Lilian M. C. 1997. *Medieval and Renaissance Manuscripts in the Walters Art Gallery*. Vol. 3. *Belgium, 1250–1530*. 2 parts. Baltimore/London.

RANDALL, Richard H.

1979. *Jewelry, Ancient to Modern*. New York.

1985. *Masterpieces of Ivory from the Walters Art Gallery*. New York.

1993. *The Golden Age of Ivory. Gothic Carvings in North American Collections*. New York.

RAPP, Francis. 1971. *L'Église et la vie religieuse en Occident médiéval à la fin du Moyen Âge*. Paris.

RAUWEL, Alain. 1993. *La Dévotion mariale des Dijonnais aux XIVe et XVe siècles*. Master's thesis.

RAUZIER, J. 1996. *Finances et gestion d'une principauté au XIVe siècle. Le duché de Bourgogne de Philippe le Hardi (1364–1384)*. Paris.

RAVAUX, Jean-Pierre. 1986. "La collégiale de Thil-en-Auxois." *Congrès archéologique*, pp. 203–209.

RAYMOND-CLERGUE, Nadège. 2000. "Saint-Germain et la sculpture gothique," pp. 169–74. In Christian Sapin. *Archéologie et architecture d'un site monastique Ve–XXe siècles. 10 ans de recherches à l'abbaye Saint-Germain d'Auxerre*. Paris.

RÉAU, Louis. 1955–59. *Iconographie de l'art chrétien*. 3 vols. in 6 parts. Paris.

RECHT, Roland. 2003. "La rhétorique formelle de Claus Sluter, sculpteur du duc de Bourgogne," pp. 205–17. In *Das Porträt vor der Erfindung des Porträts*. Ed. Martin Büchsel and Peter Schmidt. Mainz.

REINERS, Heribert. 1943. *Budgundisch-alemannische Plastik*. Strasbourg.

RÉVEILLON, Élisabeth. 1999. *Dictionnaire des poinçons de l'orfèvrerie française. Les orfèvres de Bourgogne*. (Cahiers du Patrimoine, 52). Paris.

REY, Fabrice.

2000–2001. *La Piété princière à la fin du Moyen Âge: Marguerite de Flandre et Marguerite de Bavière, duchesses Valois de Bourgogne (1369–1423)*. Master's thesis. Université de Bourgogne, Dijon.

2002. *Les Collections de tapisseries de Philippe le Hardi et de Marguerite de Flandre, duc et duchesse Valois de Bourgogne (1364–1405)*. Master's thesis. Université de Bourgogne, Dijon.

Forthcoming. "Bibliophilie et désir d'ostentation: les ouvrages à caractère religieux dans les librairies de Marguerite de Flandre et de Marguerite de Bavière, duchesses Valois de Bourgogne (1369–1423)." *Annales de Bourgogne*.

REY, Maurice. 1966. "Philippe le Hardi et la Franche-Comté." *Publications du Centre européen d'études bourgondomédianes* 8, pp. 55–62.

REYNAUD, M.-R. 2000. *Le Temps des princes. Louis II et Louis III d'Anjou-Provence 1384–1434*. Lyon.

REYNAUD, Nicole.

1961. "À propos du Martyre de saint Denis." *Revue du Louvre*, no. 4–5.

1992. "Travailler avec Charles Sterling: un témoignage." In *Des Primitifs à Matisse. Hommage à Charles Sterling*. Les dossiers du département des Peintures 40. Paris.

RIANDEY, Paul. 1908. *L'Organisation financière de la Bourgogne sous Philippe le Hardi*, p. 175. Dijon.

RICHARD, J.

1984. "Confréries de métier et confréries de dévotion de Bourgogne au Moyen Âge," p. 2. *ACNSS* 109.

1986. *Les Ducs de Bourgogne et la formation du duché du XIe au XIVe siècle*. Paris (first published in Geneva, 1954).

RICHARD, Jean-M. 1890. "Documents des XIIIe et XIVe siècles relatifs à l'hôtel de Bourgogne (ancien hôtel d'Artois) tirés du trésor des chartes d'Artois." *Bulletin de la Société de l'histoire de Paris et de l'Ile-de-France*, no. 17, pp. 137–59.

RICHARD (Richard-Rivoire), Monique.

1990. "Les tombeaux des ducs de Bourgogne, démontage et restauration," pp. 47–48. In *Claus Sluter en Bourgogne. Mythe et représentations*. Dijon.

1992. "Le décor sur bois à la chartreuse de Champmol au temps des ducs Valois," pp. 249–56. In *Actes des Journées internationales Claus Sluter*. Dijon.

RICHETON, Anne. 1993. *Les Sites médiévaux repérés par photographie aérienne oblique en Bourgogne, de la Saône au Bazois*. (Mémoire de DEA). Dijon.

RING, Grete.

1949. *A Century of French Painting 1400–1500*. London/New York. French ed. *La peinture française du XVe siècle*. London/Paris.

ROBB, David. 1936. "The Iconography of the Annunciation in the Fourteenth and Fifteenth Centuries." *Art Bulletin*, pp. 490, 493, no. 13.

ROBIN, F. 1985. *La Cour d'Anjou-Provence. La vie artistique sous le règne de René*. Paris.

ROGGEN, Domien.

1934. "De twee retabels van de Baerze te Dijon" and "Hennequin de Marville en zijn atelier te Dijon." *Gentsche Bijdragen tot de Kunstgeschiedenis* 1, pp. 91–107 and 173–205.

1935. "De 'Fons Vitae' van Klaas Sluter te Dijon." *RBAHA* 5, pp. 107–18.

1936A. "De Kalvarieberg van Champmol." *Gentsche Bijdragen tot de Kunstgeschiedenis* 3, pp. 31–85.

1936B. *Les Pleurants de Klaas Sluter à Dijon*. Antwerp.

1937. "De Rekeningen betreffende het Atelier van Klaas Sluter." *Gentsche Bijdragen tot de Kunstgeschiedenis* 4, pp. 151–71.

1954. "A. Beauneveu en het Katharinabeeld van Kortrijk." *Gentsche Bijdragen tot de Kunstgeschiedenis* 15, pp. 223–30.

1955–56. "Prae-sluteriaanse, post-sluteriaanse Nederlandse sculptuur." *Gentse Bijdragen tot de Kunstgeschiedenis* 16, pp. 138–40.

ROGGHÉ, P. 1958. "Simon de Mirabello in Vlaanderen." *Appeltjes van het Meetjesland* 9.

ROLLAND, Paul. 1932. "Une sculpture encore existante polychromée par Robert Campin." *RBAHA* 2.

ROLLET, N. 1998. *L'Iconographie du Lancelot en prose à la fin du Moyen Âge*.

ROMANO, Giovanni. 1994. "Tra la Francia e l'Italia: note su Giacomo Jacquerio e una proposta per Enguerrand Quarton." In *Hommage à Michel Laclotte*. Paris.

RORIMER, James J.

1938. "Une statue bourguignonne du XVe siècle au Metropolitan Museum de New York." *Bulletin monumental* 97, pp. 112–16.

1951. *The Metropolitan Museum of Art. The Cloisters: The Building and the Collection of Medieval Art in Fort Tryon Park*. New York.

1961–62. "The Annunciation Tapestry." *Metropolitan Museum of Art Bulletin* 20, pp. 145–46.

ROSEN, Jean. 2001. *Faïenceries françaises du Grand Est, inventaire Bourgogne Champagne-Ardenne (XIVe–XIXe siècle)*. Paris.

ROSEN, Jean, and Maurice PICON. 2003. "Recherches de laboratoire concernant quelques ateliers bourguignons ayant produit des carreaux de pavement médiévaux." In *Mélanges Jean-Paul Thevenot*. Sens.

ROSER, Sandrine. 2003. *L'Art à l'abbaye de Baume-les-Messieurs dans la première moitié du XVe siècle*. 4 vols. Ph.D. diss. Université de Franche-Comté, Besançon.

ROSSIGNOL, Claude. 1977. *Histoire de Beaune*. Marseille.

ROUSE R., and M. Rouse. 2000. *Manuscripts and their makers: commercial book producers in medieval Paris 1200–1500*. London.

RUPIN, Ernest. 1890. *L'Oeuvre de Limoges*. Paris.

SAINTE-MARTHE, Louis, and Scévole de SAINTE-MARTHE. 1667. *Histoire généalogique de la maison de La Trémoille, tirée d'un manuscrit de MM. de Sainte-Marthe, . . . et mise en abrégé par M. Pierre-Scévole de Sainte-Marthe*. Paris.

SALET, Francis.

1957. "Une coupe ayant appartenu à Jean sans Peur." *BSNAF*, p. 97.

1985. "Mécénat royal et princier au Moyen Âge." *Comptes rendus de l'Académie des inscriptions et belles-lettres*.

1988. "Remarques sur le vocabulaire ancien de la tapisserie." *Bulletin monumental* 143, pp. 211–29.

1990. "Emblématique et histoire de l'art." *Revue de l'art*, no. 87, pp. 13–28.

SAMARAN, Charles, and Robert MARICHAL. 1981. *Catalogue des manuscrits en écriture latine portant des indications de date, de lieu, ou de copiste*. 4 vols. Paris.

SANGER, Martha Frick Symington. 1998. *Henry Clay Frick*. New York.

SARCUS, A. de. 1854. *Notice historique et descriptive sur le château de Bussy-Rabutin*. Dijon.

SCHAEFER, Claude. 1954. *La Sculpture en ronde bosse au XIVe siècle dans le duché de Bourgogne*. Paris.

SCHAEFER, Lucie. 1937. "Die Illustrationen zu den Handschriften der Christine de Pisan." *Marburger Jahrbuch für Kunstwissenschaft* 10, pp. 119–208.

SCHEIFELE, E. 1999. "Richard II and the Visual Arts." In *Richard II. The Art of Kingship*. Ed. A. Goodman, and J. L. Gillespie. Oxford.

SCHER, Stephen K.

1966. *The Sculpture of Andre Beauneveu*. Ph. D diss. Yale Univeristy (Ann Arbor, Michigan: University Microfilms).

1968. "André Beauneveu and Claus Sluter." *Gesta*, no. 7.

1971. "Un problème de la sculpture en Berry. Les statues de Morogues." *Revue de l'art*, no. 13, pp. 11–24.

1992. "Bourges et Dijon: observations sur les relations entre André Beauneveu, Jean de Cambrai, et Claus Sluter." In *Actes des Journées internationales Claus Sluter*. Dijon.

SCHLOSSER, Julius von. 1899. "Der Werkstatt der Embriachi in Venedig." *Jahrbuch der Kunsthistorischen Sammlungen des allerh kaiserhauses* 20, p. 241.

SCHMIDT, Anne McGee. 1992. "Jean de Marville: artiste suranné ou innovateur," pp. 295–304. In *Actes des Journées internationales Claus Sluter*. Dijon.

SCHMIDT, Gerhard.

1971. "Beiträge zu Stil und Oeuvre des Jean de Liège," *Metropolitan Museum Journal* 4, pp. 81–105.

1975. "Zur Datierung des 'kleinen' Bargello-Diptychons und der Verkündigungstafel in Cleveland," pp. 47–63. In *Études d'art français offertes à Charles Sterling*. Paris.

1978. "Zu einem Buch über den 'Meister der Schönen Madonnen.'" *Zeitschrift für Kunstgeschichte* 41, pp. 61–92.

1992. *Gotische Bildwerke und ihre Meister*. 2 vols. Vienna/Cologne/Weimar.

1993. Review of Kathleen Morand 1991. *Kunstchronik* 46, pp. 139–59.

SCHMITZ. 1855. "Notice sur une peinture ancienne donnée par M. Fléchey." *Mémoires de la Société académique de l'Aube* 35–36, pp. 177–81.

SCHMOLL GEN. EISENWERTH, J. A. 1962. "Lothringische Madonnen. Statuetten des 14. Jahrhunderts," p. 136, no. 33, fig. 21. *Variae Formae Veritas Una. Kunsthistorische Studien. Festschrift Friedrich Gerke.* Baden-Baden.

SCHNERB, Bertrand.
1982. "Les funérailles de Jean sans Peur." *Annales de Bourgogne* 54, pp. 122–34.
1988. *Les Armagnacs et les Bourguignons. La maudite guerre.* Paris.
1999. *L'État bourguignon, 1363–1477.* Paris.

SCHÖPFER, Hermann. 1979–80. "Ein Freiburger Kathedralinventar von 1661." *Freiburger Geschichtsblätter* 62, pp. 135–75.

SCHWARZ, Michael Viktor. 1986. *Höfische Skulptur im 14 Jahrundert. Entwicklungsphasen und Vermittlungswege im Vorfeld des Weichen Stils* (Manuskripte zur Kunstwissenschaft). 2 vol. Worms.

SCHWARZKOPF, U. 1971. "Zum höfischen Dienstrecht im 15. Jahrhundert: das burgundische Beispiel." *Festschrift für Hermann Heimpel zum 70. Geburtstag am 19. 3. vols. Veröffentlichungen des Max-Plancks-Instituts für Geschichte, 36-II. Göttingen.

SCILLIA, Diane. 1995. "The Cleveland Annunciation and the Origins of Flemish Painting," pp. 345–56. In *Flanders in a European Perspective. Manuscript Illumination around 1400 in Flanders and Abroad.* Ed. M. Smeyers and B. Cardon. (Corpus van verluchte handschriften, 8). Louvain.

Sculpture médiévale en Bourgogne. Collection lapidaire du musée archéologique de Dijon. 1999. M. Jannet and F. Joubert. Dijon.

SELIGMANN, Germain. 1961. *Merchants of Art: 1880–1960, Eighty Years of Collecting Art.* New York.

SEVCENKO, I. 1962. *Études sur la polémique entre Théodore Métochite et Nicéphore Choumnos. La vie intellectuelle et politique à Byzance sous les premiers Paléologues.* (Corpus Bruxellense historiae Byzantinae, Subsidia 3). Brussels.

SEYMOUR DE RICCI, 1912. *Catalogue of a Collection of Ancient Rings Formed by the Late E. Guilhou.* Paris (original place of publication).

SHERBORNE, J. W. 1983. "Aspects of English Court Culture in the Later Fourteenth Century." In *English Court Culture in the Later Middle Ages.* Ed. V. J. Scattergood and J. W. Sherborne. London.

SHERMAN, Claire Richter.
1969. *The Portraits of Charles V of France (1338–1380).* Monographs on Archaeology and the Fine Arts 9. New York.
1995. *Imaging Aristotle: Verbal and Visual Representation in Fourteenth-Century France.* Berkeley, California.

SMEYERS, Maurits.
1992. "De 'Taferelen uit het Leven van Maria' uit de Koninklijke Musea te Brussel en het zgn. pre-Eyckiaans realisme." *Musées royaux des Beaux-Arts de Belgique Bulletin (Miscellanea Henri Pauwels)* 38–40, 1–3 (1889–1991), pp. 65–90.
1996. In *The Dictionary of Art.* Vol. 3. Ed. Jane Turner. London/New York.

SMEYERS, Maurits, and Bert CARDON. 1996 "Campin and Illumination," pp. 159–69. In *Robert Campin. New Directions in Scholarship.* Ed. S. Foister, and S. Nash. Turnhout.

SMITH, Elizabeth Bradford. 1996. *Medieval Art in America: Patterns of Collecting, 1800–1940.* University Park, Pennsylvania.

SMITH, Jeffrey Chipps.
1982. "Jean de Maisoncelle's Portrait of Philippe le Bon for the Chartreuse de Champmol: A Study in Burgundial Political Symbolism." *GBA,* no. 93, pp. 7–12.
1983. "The Cincinnati Portraits of the Valois Dukes of Burgundy." *The Cincinnati Art Museum Bulletin* 12, pp. 4–7.
1985. "The Chartreuse de Champmol in 1486, the Earliest Visitor's Account." *GBA,* no. 106, pp. 1–6.

SNYDER, James. 1985. *Northern Renaissance Art, Painting, Sculpture, the Graphic Arts from 1350–1575.* New York.

SOMERS COCKS, Anna. 1977. "The Myth of 'Burgundian' Goldsmithing and the Function of Plate

at the Burgundian Court." *The Connoisseur* 194, no. 781, pp. 180–86.

SPEVACEK, Jiri. 1978. "Die Epoche Karls IV," pp. 585–605. *Die Parler und der Schöne Stil 1350–1400. Europäische Kunst unter den Luxemburgern.* Vol. 2. Cologne.

SQUILBECK, Jean. 1941. "Les Lutrins dinantais de Venise et de Gênes." *Bulletin de l'Institut historique belge de Rome* 21, pp. 347–56.

STALTER, M.-A. 1963. "La peinture de chevalet dans l'école de Paris à la fin du XIVe et au début du XVe siècle." *L'Information d'histoire de l'art* 3, pp. 112–21.

STECHOW, Wolfgang. 1974. In *The Cleveland Museum of Art. European Paintings before 1500. Catalogue of Paintings, Part One.* Cleveland.

STEINGRÄBER, Erich.
1956. *Alter Schmuck.* Munich.
1960. "Email." *Reallexikon zur deutschen Kunstgeschichte,* no. V, col. 1–65.

STERLING, Charles.
1938. *La Peinture française. Les Primitifs.* Paris.
1941. *Les Peintres du Moyen Âge. La peinture française, XIVe siècle.* Paris.
1942. *Les Peintres du Moyen Âge.* Paris.
1955. "Oeuvres retrouvées de Jean de Beaumetz, peintre de Philippe le Hardi." *Miscellanea E. Panofsky. Bulletin des Musées royaux des Beaux-Arts.* Brussels.
1959A. "Un tableau inédit et la peinture de portrait à la cour de Bourgogne au début du XVe siècle." *Archives de l'art français,* nouvelle pér., 22, pp. 39–57.
1959B. "La peinture de portrait à la cour de Bourgogne au début du XVe siècle." *Critica d'Arte* 6, pp. 289–312.
1960. "Une Madone tchèque au musée du Louvre." *Revue des Arts,* 10, pp. 75–86.
1962. "Die Malerei in Europa um 1400." In *Vienna* 1962.
1976. "Jan van Eyck avant 1432." *Revue de l'art,* no. 33, pp. 7–82.
1978. "La peinture de tableaux en Bourgogne au XVe siècle." *Annales de Bourgogne,* no. 197, pp. 5–17.
1987. *La Peinture médiévale à Paris, 1300–1500.* Vol. 1. Paris.
1989. "Carnet bourguignon." *L'OEil,* no. 413, pp. 26–35.

STERLING, Charles, and Hélène ADHÉMAR. 1965. *La Peinture au musée du Louvre: École française, XIVe–XVIe siècles.* Paris.

STEYAERT, John W.
1974. *The Sculpture of St. Martin's in Halle and related Netherlandish Works.* Vol. 1. Ph.D. diss. The University of Michigan (Ann Arbor, Michigan: University Microfilms).
1994. *Laat-gotische beeldhouwkunst in de Bourgondische Nederlanden / Late Gothic Sculpture. The Burgundian Netherlands.* Ghent.

STEYN, Carol Frances. 2000. *Three Unknown Carthusian Liturgical Manuscripts, with Music of the 14th to the 16th Centuries in the Grey Collection.* 2 vols. (Analecta Cartusiana 167). Salzburg.

STIX, Alfred. 1933. *Beschreibender Katalog der Handzeichnungen in der Graphischen Sammlung Albertina.* Vol. 4. Vienna.

STRATFORD, Neil. 1995. "De opere punctili? Beobachtungen zur Technik der Punktpunzierung um 1400," pp. 131–45. In *Das Goldene Rössel. Ein Meisterwerk der Pariser Hofkunst.* Munich.

STROO, C. 2002. "The Antwerp Infancy Cycle: A disregarded Masterpiece of early Netherlandish Painting around 1400." In *"Als ich can." Liber Amicorum in Memory of Professor Dr. Maurits Smeyers.* (Corpus van verluchte handschriften, 11). Louvain.

STRUB, Marcel. 1956. *Les Monuments d'art et d'histoire du canton de Fribourg.* Vol. 2. Basel.

STUCKY-SCHÜRER, M. 1972. *Die passionteppiche von San Marco in Venedig.* Bern.

TABOUROT, Étienne. 1587. *Icones et Epitaphia quatuor postremorum Ducorum Burgundiae.* Paris.

TAIT, Hugh. 1992. "Reinhold Vasters: Goldsmith, Restorer and Prolific Faker." In *Why Fakes Matter.* Ed. Mark Jones. London.

TARBOCHEZ, Gaëlle. 1996–97. *Les Fondations de la sainte chapelle de Dijon à la fin du Moyen Âge.* Master's thesis. Université de Bourgogne, Dijon.

TARDY. 1966. *Les Ivoires.* Paris.

TESNIÈRE, M. H.
1999. "I codici illustrati del Boccaccio." In *Boccaccio visualizzao, narrare per parole e per immagini fra Medioevo e Rinascimento.* Ed. V. Branca. Biblioteca di storia dell'arte 30. Turin.
2002. "La réception des *cas des hommes et femmes de Boccace* en France au XVe siècle." In *Autori e lettori di Boccaccio, atti del convegno internazionale di Certaldo.* Florence.

THIBOUT, Marc. 1953. "Le concert d'anges de la chapelle du château de La Clayette." *Revue des arts,* 3e année.

THIÉBAUT, D. 1981. *Les Fastes du Gothique: Le siècle de Charles V.* Paris.

THOMAS, Marcel. 1979. *The Golden Age: Manuscript Painting at the Time of Jean, Duke of Berry.* New York.

THOMAS, Stanton. 1998. *Forging the Missing Links: Robert Campin and Byzantine Icons.* Ph.D. diss. Case Western Reserve University, Cleveland.

THOSS, Dagmar. 1978. *Französische Gotik und Renaissance in Meisterwerken der Buchmalerei.* Graz.

THÜRLEMANN, Felix. 2002. *Robert Campin.* Munich/New York.

TILANDER, G. 1932. "Les livres du roy Modus et de la royne Ratio." Société des anciens textes français. Paris.

TINBERGEN, Dirk Cornelis. 1900–1907. *Des "Coninx Summe."* Leiden.

TOMASI, Michele. 2001. "Baldassarre Ubriaachi, le maître public." *Revue de l'art,* no. 134, pp. 51–60.

TONNERRE, N.-Y., and E. VERRY. 2003. *Les Princes angevins du XIIIe au XVe siècle. Un destin européen.* Rennes.

TÖRÖK, Gyöngyi. 1985. "Beiträge zur Verbreitung einer niederländischen Dreifaltigkeitsdarstellung im 15. Jahrhundert. Eine Elfenbeintafel aus dem Besitze Philipps des Guten von Burgund." *Jahrbuch der kunsthistorischen Sammlungen in Wien* 81, N.F. 45, pp. 7–31.

TOURNEUR, V. 1956. "Les origines de l'Ordre de la Toison d'or et la symbolique des insignes de celui-ci." *Bulletin de la classe des Lettres et des Sciences morales et politiques,* Académie royale de Belgique, 5e série.

TOVELL, Ruth Massey. 1950. *Flemish Artists of the Valois Courts.* Toronto.

TRENTO. 2002. *Il Gotico nelle Alpi.* Castello del Buonconsiglio.

TREXLER, Richard C. 1978. "The Magi Enter Florence. The Ubriachi of Florence and Venice." *Studies in Medieval and Renaissance History (The University of British Columbia)* 1, pp. 127–278.

TRIBOUT DE MOREMBERT, Henri.
1943–44. Untitled article. *Bulletin de la société nationale des Antiquaires de France,* pp. 262–68.
1963–64. "Jean Chevrot, évêque de Tournai et de Toul vers 1395–1460." *Mémoires de l'Académie Nationale de Metz* 9, pp. 173–220.

TRNEK, H. 2001. "Ein köstlich creuz, so von dem haus Burgundi Herkomt," pp. 201–20. In *Studien zur europäischen Goldschmiedekunst des 14. Bis 20. Jahrhunderts. Festschrift für Helmut Seling zum 80.* Munich.

TROESCHER, Georg.
1932. *Claus Sluter und die burgundische Plastik um die Wendedes XIV. Jahrhunderts.* Vol. 1. *Die herzogliche Bildhauerwerkstatt in Dijon unter ihren Leitern Jean de Marville, Claus Sluter und Claus de Werve.* Fribourgen Brisgau.
1940. *Die burgundische Plastik des ausgehenden Mittelalters und ihre Wirkungen auf die Europäische Kunst.* 2 vols. Frankfurt am Main.
1966. *Bürgundische Malereï, Maler, und Malwerke um 1400 in Burgund, dem Berry mit der Auvergne und im Savoyen mit ihren Quellen und Ausstralhungen.* Berlin. Mann Verlag.

TURCSÁNY, Zsuzsa. 1989. "Hungarian National Gallery," pp. 32–41, pl. 50–72. In *Museums in Budapest.* Budapest.

VAIVRE, Jean-Bernard de. 1985. "Chasse à l'oiseau et cour d'amour. Note sur deux tableaux de Dijon et Versailles." *Journal des savants,* pp. 313–39.

VALE, M. 2001. *The Princely Court. Medieval Courts and Culture in North-West Europe 1270–1380.* Oxford.

Valenciennes aux XIVe et XVe siècles, Art et histoire. 1996. Ed. L. Nys and A. Salamagne. Valenciennes.

VALLÉRY-RADOT, Jean.
1955. "L'église Saint-Florentin à Saint-Florentin." *Congrès archéologique,* pp. 417–37.

1958. "Joigny. Église Saint-Thibault." *Congrès archéologique*, pp. 135–42.

VAN BUREN, Anne.
1973. "Books for a Burgundian courtier: Evidence for Two Early Flemish Illuminators' Shops." *Princeton University Library Chronicle* 34, no. 2.
1996. In *The Dictionary of Art*. Ed. Jane Turner. Vol. 4. London/New York.

VAN BUREN, Anne, James H. MARROW, and Silvana PETTENATI. 1996. *Heures de Turin-Milan inv. No 47. Museo Civicod'Arte Antica, Torino. Commentaire*. Lucerne.
s. d. "Le château d'Hesdin: son plan et sa décoration artistique, d'après les documents d'archives." *Commission d'histoire et d'archéologie du Pas-de-Calais*.

VAN BUREN-HAGOPIAN, Anne.
1985A. "Trois inventaires de la chapelle du château d'Hesdin (1384–1469). Vêtements liturgiques, manuscrits, et un reliquaire de saint Louis." *Publications du Centre d'études bourguignonnes (XIVe–XVIe siècles)*, no. 25. Basel.
1985B. "Un jardin d'amour de Philippe le Bon au parc de Hesdin. Le rôle de Van Eyck dans une commande ducale." *Revue du Louvre*, no. 3, pp. 185–92.
1986. "Thoughts, Old and New, on the Sources of Early Netherlandish Painting." *Simiolus* 16, pp. 93–112.
1996. "Images monumentales de la Toison d'or: aux murs du château d'Hesdin et en tapisserie," pp. 26–233. In *L'Ordre de la Toison d'or, de Philippe le Bon à Philippe le Beau (1430–1505): idéal ou reflet d'une société?* Turnhout.

VANDECAPELLE-HAAGDORENS, L. 1983. *Het zgn. Missaal van Lodewijk van Male (Brussel, Koninklijke Bibliotheek, ms. 9217). Bijdrage tot de studie van de miniatuurkunst in het Maasland tijdens het derde kwart van de 14e eeuw*. Thesis. Katholieke Universiteit, Louvain.

VAN DEN GHEYN, J. 1901–48. *Catalogue des manuscrits de la Bibliothèque royale de Belgique*. 13 vols. Brussels.

VANDENBROEK, Paul. 1985. *Koninklijk Museum voor Schone Kunsten Antwerpen. Catalogus schlidereijen 14de en 15de eeuw*, pp. 28–32. Antwerp.

VAN DE PUTTE, F. 1875. *La Chapelle des comtes de Flandre à Courtrai*. Bruges.

VAN DER HAEGHEN, V. 1908. "Asselt, Jan van der." In *Allgemeines Lexikon der Bildenden Künstler von der Antike bis zur Gegenwart*. Vol. 2. Leipzig.

VANDERJAGT, A. J. 1985. *Laurens Pignon, O.P: Confessor of Philip the Good*. Venlo.

VAN DORPE, H. 1964. "De St-Katharinakapel of Gravenkapel te Kortrijk voor 1944." *Handelingen van de koninklijke Geschied-en Oudheidkundige Kring van Kortrijk*, n. s., 33.

VAN ELSLANDE, R.
1987 "Jan Van der Asselt. De hoschilder van Lodewijk Van Male." *De Leiegouw* 29, no. 4, pp. 419–45.
1995. "Kunstenaars werkzaam in de grafelijke residenties te Gent tijdens de 14e eeuw." *Ghendtsche Tijdinghem* 24, no. 1, pp. 325–34.

VAN GELDER, J. G. 1967. "An Early Work by Robert Campin." *Oud Holland*, no. 82.

VAN LEMMEN, Hans. 1993. *Décors de céramique*. Paris.

VAN LUTTERVELT, R. 1975. "Bijdragen tot de Iconographie van de Graven van Holland, naar aanleidin van de beelden uit de Amsterdamse vierscharr." *Oud Holland*, no. 71, fasc. 3, pp. 73–91, 139–50, 218–34.

VAN NIEUWENHUYSEN, Andrée. 1984. *Les Finances du duc de Bourgogne Philippe le Hardi (1384–1404): économie et politique*. Brussels.

VAN PUYVELDE, M. 1912. *Schilderkunst en tooneelvertooningen op het einde van de Middeleeuwen. Een Bijdrage tot de Kunstgeschiedenis vooral van de Nederlanden*. Koninklijk Vlaamse Academie voor Taal en Letterkunde. Ghent.

VANROOSE, (M.). 1970: *Enkele aspecten van de Brugse beeldhouwkunst tijdens de periode 1376–1467*. Thesis. L'Université royale de Gand, Ghent.

VANWIJNSBERGHE. 1955. "Mise au point concernant l'enluminure tournaisienne au XVe siècle." *Mémoires de la Société Royale d'Histoire et d'Archéologie de Tournai*, 8, pp. 33–60.

VAUGHAN, Richard.
1962. *Philip the Bold. The Formation of the Burgundian State*. London. 3rd ed. Woodbridge, 2002.
1966/1973. *John the Fearless. The Growth of Burgundian Power*. London. 3rd ed. Woodbridge, 2002.

1975. *Valois Burgundy*. London.
2002A. *Charles the Bold. The Last Valois Duke of Burgundy*. 2nd ed. Woodbridge.
2002B. *Philip the Good. The Apogee of Burgundy*. 2nd ed. Woodbridge.

VEENSTRA, J. R. 1998. *Magic and Divination at the Courts of Burgundy and France: Text and Context of Laurens Pignon's Contre les devineurs (1411)*. Leiden/New York.

VENTURELLI, Paola. 2003. "Smalti 'en ronde bosse' per I Visconti," pp. 15–57. In *Smalto, oro, e preziosi. Oreficeria e artisuntuarie nel Ducato di Milano tra Visconti et Sforza*. Venice.

VERDIER, Philippe.
1961. "A Medallion of the "Ara Coeli" and the Netherlandish Enamels of the Fifteenth Century." *Journal of the Walters Art Gallery*, no. 24.
1967. *The Walters Art Gallery: Catalogue of the Painted Enamels of the Renaissance*. Baltimore.
1975. "La Trinité debout de Champmol," pp. 65–90. In *Études d'art français offertes à Charles Sterling, réunies et publiées par A. Châtelet et N. Reynaud*. Paris.
1980. *Le couronnement de la Vierge: les origines et les premiers développements d'un thème iconographique*. Montréal/Paris.
1981. "La Vierge à l'encrier et à l'Enfant qui écrit." *Gesta* 20, no. 1 (Essays in Honor of Harry Bober), pp. 247–56.
1982. "La Naissance à Rome de la Vision de l'Ara Coeli." *Mélanges de l'école française de Rome, Moyen Âge Temps Modernes* 94, no. 1.

VERGNET-RUIZ, Jacques, and Michel LACLOTTE.
1962. *Petits et grands musées de France. La peinture française des primitifs à nos jours*. Paris.

VERMEERSCH, Valentin. 1976. *Gramonumenten te Brugge voor 1578*. Vol. 2. Bruges.

VERONESE, J. 2001. "Jean sans Peur et la 'fole secte' des devins: enjeux et circonstances de la rédaction du traité Contre les devineurs (1411) de Laurent Pignon." *Médiévales* 40.

VIDIER, Alexandre-Charles-Philippe. 1903. "Un tombier liégois à Paris au XIVe siècle." *Mémoires de la Société d'histoire de Paris* 30, pp. 281–308.

VIELLE, Célestin. 1930. *Saint Louis d'Anjou, évêque de Toulouse, sa vie, son temps, son culte, d'après une biographie contemporaine, le procès de canonisation et de nombreux documents inédits ou peu connus*. Vanves.

Vifs nous sommes . . . , morts nous serons. 2001. Vendôme.

VIGNIER, Françoise. 1980. *Dictionnaire des châteaux de France*. Vol. 9. *Bourgogne-Nivernais*. Paris.

VIOLLET-LE-DUC, Eugène. 1854–68. *Dictionnaire raisonné de l'architecture française du XIe au XVIe siècles*. 10 vols. Paris.

Les Vitraux de Bourgogne, de Franche-Comté et de Rhône-Alpes. 1986. *Corpus Vitrearum, Recensement des vitraux de la France*, vol. 3. Paris.

VITRY, Paul.
1907. "Le Christ de Jacques de la Baerze," pp. 3–7. In *Annales du XXe Congrès archéologique et historique de Belgique*. Ghent.
1914. "Les collections Pierpont Morgan." *GBA*, pp. 425–40.

VOS, Dirk de.
1999. *Rogier van der Weyden*. Antwerp.
2003. *The Flemish Primitives. The Masterpieces*. Cambridge, Massachusetts.

VUILLERMET, M. F. 1913. *Poligny. Monuments, curiosités, beaux sites*. Poligny.

WALTHER, Ingo F., and Norbert WOLF. 2001. *Codices Illustres: The World's Most Famous Illuminated Manuscripts, 400 to 1600*, Cologne.

WARNKE, M. 1989. *L'Artiste à la cour: Aux origines de l'artiste moderne*. Trans. S. Bollack. Paris.

WASHINGTON. 1993. *The Collections of the National Gallery of Art Systematic Catalogue. Western Decorative Arts. Part 1*. Rudolf Distelberger, Alison Luchs, Philippe Verdier, Timothy H. Wilson. Washington.

WEBER, R. E. J. 1966. "The Messenger-Box as a Distinctive of the Foot-Messenger." *The Antiquaries Journal* 46, pp. 88–101 (first published in French, *La Boîte de messager en tant que signe distinctif du messager à pied*, Haarlem, 1972).

WILSON, Jean. 1998. *Painting in Bruges at the Close of the Middle Ages: Studies in Society and Visual Culture*. University Park, Pennsylvania.

WIXOM, Nancy Coe. 1974. *The Cleveland Museum of Art. European Paintings before 1500. Catalogue of Paintings, Part One*. Cleveland.

WIXOM, William D.
1963. "A Missal for a King." *CMA Bulletin* 50, pp. 157–99.
1966. "Three Gothic Sculptures." *CMA Bulletin* 53, pp. 348–55.
1970. "An Enthroned Madonna with the Writing Christ Child." *CMA Bulletin* 57, pp. 287–30.

WORMALD, Francis and Phyllis GILES. 1982. *A Descriptive Catalogue of the Additional Manuscripts in the Fitzwilliam Museum Acquired between 1985 and 1979 (Excluding the McClean Collection)*. Cambridge.

WRIGHT, C. 1979. *Music at the Court of Burgundy 1364–1419. A Documentary History*, Brooklyn/Henryville.

ZAFRAN, Eric. 1988. *Fifty Old Master Paintings from the Walters Art Gallery*. Baltimore.

ZALUSKA, Yolande. 1991. *Manuscrits enluminés de Dijon*. Paris.

ZEMAN, Georg. 1995. "Studien zur Skulptur am Hofe des Jean de Berry: Stilfragen." *Wiener Jahrbuch für Kunstgeschichte*, no. 48.

ZINK, Michel. 1972. *La Pastourelle. Poésie et folklore au Moyen Âge*. France.

ZOETE, A. 1994. *De beden in het graafschap Vlaanderen onder hertogen jan zonder Vrees en Filips de Goede (1405– 1467)*. Brussels.

Exhibitions

AMIENS. 1983. *La Vie musicale en Picardie au temps des Puys*. Musée de Picardie.

AMSTERDAM.
1951. *Bourgondische Pracht van Philips de Stoute tot Philips de Schone*. Rijksmuseum.
1994. *The Art of Devotion in the Late Middle Ages in Europe 1300–1500*. Rijksmuseum.

ANTWERP.
1933. *Antwerpse verzamelingen*. 2 vols. Musée des Beaux-Arts.
1954. *De Madonna in de Kunst*.

ATHENS. 1986. *Trésor de la cathédrale Saint-Nicolas de Fribourg*. Musée Benaki.

AUTUN.
1981. *Les Carreaux de pavage dans la Bourgogne médiévale*. Musée Rolin.
2002. *Les Passions selon Bulliot*. Musée Rolin.

AUTUN, AUXERRE, and DIJON. 1992. *D'ocre et d'azur: peintures murales en Bourgogne*. Musée Rolin, Musée d'Art et d'Histoire, and Musée Archéologique.

BALTIMORE.
1962. *The International Style: The Arts in Europe Around 1400*. The Walters Art Gallery.

BERN.
1936. *Burgunderbeute*. Historisches Museum.
1969. *Die Burgunderbeute und Werke burgundischer Hofkunst*. Bernisches Historisches Museum.

BOSTON. 1940. *Art of the Middle Ages. A Loan Exhibition*. Museum of Fine Arts.

BOURG-EN-BRESSE. 2000. *Images du pouvoir: les pavements de faïence en France du XIIIe au XVIIe siècle*. Musée de Brou.

BRUGES.
1902. *Exposition des Primitifs flamands*.
1927. *Tentoonstelling van miniaturen en boekbanden*.
1953. *Het portret in de Nederlanden*, Groeningenmuseum.
1960. *De eeuw der Vlaamse Primitieven*, Groeningenmuseum.

BRUSSELS.
1939. *Bibliothèque royale de Belgique. Centenaire de l'ouverture au public*. Bibliothèque Royale de Belgique.
1951. *Le Siècle de Bourgogne*. Palais des Beaux-Arts.
1953. *Bruxelles au XVe siècle*. Musée Communal.
1953. *Chefs-d'oeuvre d'art ancien des musées et collections de Belgique*. Palais des Beaux-Arts.
1958. *Miniatures médiévales à la cour de Bourgogne*. Bibliothèque Royale de Belgique.
1967. *La Librairie de Philippe le Bon. Exposition organisée à l'occasion du 500e anniversaire de la mort du duc*. Bibliothèque Royale de Belgique.

1972. *La Bibliothèque de Marguerite d'Autriche*. Bibliothèque Royale de Belgique.
1977. *Les Mémoriaux d'Antoine de Succa. Un contemporain de P. P. Rubens*. Bibliothèque Royale Albert 1.
1985A. *L'Héraldique dans les manuscrits antérieurs à 1600*. Bibliothèque Royale de Belgique.
1985B. *Manuscrits à peintures du IXe au début du XVe siècle*. Bibliothèque Royale de Belgique.
1986. *Miniatures en grisaille*. Bibliothèque Royale de Belgique.

CAMBRIDGE. 1993. *Splendours of Flanders*. Fitzwilliam Museum.
CAMBRIDGE, Massachusetts. 1927. *Opening Exhibition in the New Museum*. William Hayes Fogg Art Museum.
CHALON-SUR-SAÔNE. 1973. *Pavements de Germolles*. Musée Denon.
CHICAGO. 1920. *An Exhibition of Gothic Tapestries of France and Flanders*. The Art Institute of Chicago.
CLEVELAND.
1963. *Gothic Art 1360–1440*. The Cleveland Museum of Art.
1967. *Treasures from Medieval France*. The Cleveland Museum of Art.
COLOGNE.
1974. *Vor Stefan Lochner. Die Kölner Maler von 1300 bis 1430*. Wallraf-Richartz-Museum.
1978. *Die Parler und der Schöne Stil 1350–1400. Europäische Kunst unter den Luxemburgern. Ein Handbuch zur Ausstellung des Schnütgen-Museums in der kunsthalle Köln*. 3 vols. Vol. 4, 1980. Kunsthalle.
COLOGNE and BRUSSELS. 1972. *Rhein und Maas, Kunst und Kultur 800–1400*. Kunsthalle and Musées Royaux d'Art et d'Histoire.
COPPET. 1967. *Les Grandes Heures de l'amitié francosuisse*. Château de Coppet.

DETROIT.
1928. *French Gothic Art*. Detroit Institute of Arts.
1960. *Masterpieces of Flemish Art: Van Eyck to Bosch*. Detroit Institue of Arts. Catalogue titled *Flanders in the Fifteenth Century: Art and Civilization*.
1997. *Images in Ivory, Precious Objects of the Gothic Age*. Detroit Institute of Arts.
DIJON.
1949. *Le Grand Siècle des ducs de Bourgogne*. Musée des Beaux-Arts.
1951. *Chefs-d'oeuvre de la sculpture bourguignonne du XIVe au XVIe siècle*. Musée des Beaux-Arts.
1956. *Palais des ducs et palais des États de Bourgogne*. Musée des Beaux-Arts.
1957A. *Art sacré en Bourgogne et Comté*. Ancienne Église Saint-Philibert.
1957B. *Le Diocèse de Dijon: Histoire et art*.
1960. *La Chartreuse de Champmol, foyer d'art au temps des ducs Valois*. Musée des Beaux-Arts.
1961. *Le Goût du gothique chez les collectionneurs du XIXe siècle*. Musée des Beaux-Arts.
1965. *Charles-Balthazar Julien Févret de Saint-Mémin*. Musée des Beaux-Arts.
1965. *La Musique dans l'art ancien au musée des Beaux-Arts de Dijon*. Musée des Beaux-Arts.
1968. *Inventaire général des monuments et richesses artistiques de la France: Canton de Sombernon, Côte-d'Or, Sculptures XVe–XVIe siècles*. Musée des Beaux-Arts.
1969. *Canton de Pouilly-en-Auxois, Côte-d'Or. Statues, XIIIe au XVIIe siècle*. Musée des Beaux-Arts.
1971A. *Les Pleurants dans l'art du Moyen Âge en Europe*. Musée des Beaux-Arts.
1971B. *Les Pleurants des tombeaux des ducs de Bourgogne*. Musée des Beaux-Arts.
1972. *Jean de La Huerta et la sculpture bourguignonne au milieu du XVe siècle*. Musée des Beaux-Arts.
1973. *Antoine Le Moiturier, le dernier des grands imagiers des Ducs de Bourgogne*. Musée des Beaux-Arts.
1974. *La Sculpture bourguignonne en Auxois et en Autunois à la fin du XVe siècle*. Musée des Beaux-Arts.
1976. *Claus de Werve, imagier des ducs de Bourgogne / Claus de Werve et la sculpture bourguignonne dans le premier tiers du XVe siècle*. Musée des Beaux-Arts.
1981. *Acquisitions récentes 1975–80*. Musée des Beaux-Arts.
1983. *Conservation et restauration: Peintures des musées de Dijon*. Musée Magnin.

1984. *Dijon vu par Victor Hugo*. Musée de la Vie Bourguignonne.
1990. *Claus Sluter en Bourgogne: Mythe et représentations*. Musée des Beaux-Arts.
1992. *D'ocre et d'azur, Peintures murales en Bourgogne*. Musée Archéologique.
1992. *Portraits sculptés XVe–XVIIIe siècles: Collections du musée du Louvre et des musées des Beaux-Arts de Dijon et d'Orléans*. Musée des Beaux-Arts.
2000. *L'Art des collections: Bicentenaire du musée des Beaux-Arts de Dijon*. Musée des Beaux-Arts.
2002–3. *L'Archange et l'esquisse. Restaurations et acquisitions 2000–2002*. Musée des Beaux-Arts.
2003. *Couleurs de temps, fragments d'histoire. Peintures murales en Bourgogne, XIIe–XXe siècles*. Musée Archéologique.

EDINBURG and BRUSSELS. 1963. *Treasures of Belgian Libraries*. National Library of Scotland and Bibliothèque Royale de Belgique.

FRIBOURG.
1955. *Trésors de Fribourg*. Musée d'Art et d'Histoire.
1957. *Exposition du huitième centenaire*. Musée d'Art et d'Histoire.
1983. *Trésor de la cathédrale Saint-Nicolas*. Musée d'Art et d'Histoire.

GENEVA. 1896. *Exposition nationale suisse*.
GHENT.
1975. *Mille Ans d'art et de culture*. Musée des Beaux-Arts.
1994. *Laat-gotische beeldhouwkunst in de Bourgondische Nederlanden/ Late Gothic sculpture. The Burgundian Netherlands*. Musée des Beaux-Arts.

INGELHEIM. 1986. *Burgund: Burgund im Spätmittelalter 12. bis 15. Jh*. Rhein-Alten Rathaus.
ITHACA, New York. 1968. *A Medieval Treasury: An Exhibition of Medieval Art from the Third to the Sixteenth Century*. Andrew Dickson White Museum of Art, Cornell University.

KARLSRUHE. 1966. *Badisches Landesmuseum. Neuerwerbungen 1952–66*. Badisches Landesmuseum.
KREMS AN DER DONAU. 1967. *Gotik in Österreich*. Minoritenkirche Krems-Stein.

LIÈGE.
1951. *Art mosan et anciens pays de Liège*. Musée des Arts Décoratifs.
1968. *Liège et Bourgogne*. Musée de l'Art Wallon.
LONDON.
1897. *European Enamels to the End of the XVII Century*. Burlington Fine Arts Club.
1901. *Exhibition of a Collection of Silver Smith's Work of European Origin*. Burlington Fine Arts Club.
1927. *Flemish and Belgian Art 1300–1900*. Royal Academy of Arts.
1932. *French Art 1200–1900*. Royal Academy of Arts, Burlington House.
LOUVAIN.
1986. *Handschriften uit de abdij van Sint Truiden*.
1993. *Naer Natueren Ghelike. Vlaamse miniaturen voor Van Eyck (ca. 1350– ca. 1420)*. Culturael Centrum Romaanse Poort.

MECHELEN. 1973. *500 Jaar Grote Raad (1473–1973), Tentoonstelling van Karel de Stoute tot Keizer Karel*. Cultureed Centrum.
MUNICH.
1992. *Schatskammerstücke aus der Herbstzeit des Mittelalters, Das Regensburger Emailkästchen und sein Umkreis*. Bayerischen Nationalmuseum.
1995. *Das Goldene Rössl. Ein Meisterwerk der Pariser Hofkunst um 1400*. Bayerischen Nationalmuseum.

NANTES. 1972. *Trésors de Fribourg, Collections du musée de Fribourg*. Musée Thomas-Dobrée.
NEVERS. 1990. *Trésors cachés des églises de la Nièvre*.
NEW YORK.
1927. *Loan Exhibition of Religious Art for the Benefit of the Basilica of the Sacré-Coeur of Paris*. Jacques Seligmann & Co. Galleries.
1928. *French Gothic Tapestries: A Loan Exhibition*. The Metropolitan Museum of Art.

1975. *The Secular Spirit: Life and Art at the End of the Middle Ages*. The Metropolitan Museum of Art.

PARIS.
1889. *Exposition rétrospective de l'art français au Trocadéro*. Palais du Trocadéro.
1900. *Les Primitifs français au Palais du Louvre et à la Bibliothèque Nationale*. Musée du Louvre/Bibliothèque Nationale.
1900A. *Exposition rétrospective de l'art français des origines à 1800*. Petit Palais.
1900B. *Exposition universelle internationale*. Champs de-Mars.
1904. *L'Exposition des primitifs français: la peinture en France sous les Valois*. Lieu d'exposition.
1913. *Exposition d'objets d'art*. Palais de Sagan.
1923. *L'Art belge ancien et moderne*. Musée du Jeu de Paume.
1934. *La Passion du Christ dans l'art français*. Musée de Sculpture Comparée du Trocadéro.
1936. *Art bourguignon et Bourgogne*. Galerie Charpentier.
1937. *Chefs-d'oeuvre de l'art français*. Palais National des Arts.
1950. *La Vierge dans l'art français*. Petit Palais.
1951. *Trésors d'art de la vallée de la Meuse*.
1960. *Trésor national du Louvre. Exposition de 700 tableaux de toutes les écoles antérieurs à 1800 tirés des réserves du département des Peintures*.
1964A. *Emblèmes totems blasons*. Musée Guimet.
1964B. *Huit Siècles de sculpture française, chefs-d'oeuvre des musées de France*. Musée du Louvre.
1967. *Les Grandes Heures de l'amitié franco-suisse*. Hôtel de Rohan.
1973. *Chefs-d'oeuvre de la tapisserie du XIVe au XVIe siècle*. Grand Palais.
1975. *Boccace en France, de l'humanisme à l'érotisme*. Bibliothèque Nationale de France.
1980. *Trésors de la bibliothèque de l'Arsenal*. Bibliothèque Nationale de France.
1981. *Les Fastes du gothique: Le siècle de Charles V*. Galeries Nationales du Grand Palais.
1994A. *Beauté et pauvreté. L'art chez les clarisses de France*. Centre Culturel du Panthéon.
1994B. *La Jeunesse des musées*. Musée d'Orsay.
1994C. *Les Manuscrits à peintures en France 1440–1520*. Bibliothèque Nationale de France.
1998. *L'Art au temps des rois maudits. Philippe le Bel et ses fils 1285–1328*. Galeries Nationales du Grand Palais.
2001. *Paris et Charles V. Arts et Architecture*. Bibliothèque Forney.
2004. *Paris 1400: Les Arts sous Charles VI*. Musée du Louvre.
POLIGNY, BAUME-LES-MESSIEURS and SAINT-CLAUDE. 1972. *Art sacré dans le Jura du Moyen Âge au XVIIIe siècle*.

RIQUEWIHR. 1971. *Les Messagers de ville dans la vallée du Rhin du XVe au XVIIe siècle*. Musée des Postes et Télécommunications.
ROTTERDAM. 1950. *Claus Sluter an de kunst te Dijon van de XIV tot de XVI eeuw. Meesterwerken de Beeldhouwkunst afkonstig uit Musea en Kerken uit Dijon en Omgeving*. Museum Boymans-Van Beuningen.
ROUEN and PARIS. 1956. *Jeanne d'Arc et son temps. Commémoration du Ve centenaire de la réhabilitation de Jeanne d'Arc, 1456–1956*. Musée des Beaux-Arts and Archives Nationales.

SAN FRANCISCO. 1922. *Catalogue of the Retrospective Loan Exhibition of European Tapestries*. San Francisco Museum of Art.

TERMONDE. 1970. *Johannes Ockeghem en zijn tijd*. Musée Communal.
TURIN. 1979. *Giacomo Jaquerio e il gotici internazionale*.

VIENNA. 1962. *Europäische Kunst um 1400. Achte Ausstellung unter den Auspizien des Europarates / L'art européen vers 1400*. Kunsthistorisches Museum.

YORK. 1957. *Art from Burgundy*, York, City of York Gallery.

A publication of the Département de l'Édition,
directed by Catherine Marquet

English editors
Barbara J. Bradley, Laurence Channing, Jane Takac Panza
with the assistance of Geneviève Rudolf at the RMN

French editor
Sophie Laporte

Translations from the French by
Cynthia Calder, Alison Dundy, Nicholas Elliott,
Elizabeth G. Heard, Eileen B. Hennessy, Catherine A. Reep
Marguerite Shore, Sue Ellen Silber, Diana Stoll, Teresa Waldes

From the German by
David Marinelli

Translation coordinator
Molly Stevens

Graphic design
HDL Design: Gilles Huot

Imaging
Bussière, Paris

Printed and bound in August 2004 by
L'Imprimerie Mame in Tours, France.

Dépôt Légal: August 2004
ISBN: 2-7118-4864-7
EK 38 0065